Apollinaire
and the
International
Avant-Garde

D1452767

SUNY Series, The Margins of Literature
Edited by Mihai I. Spariosu

Apollinaire and the International Avant-Garde

Willard Bohn

STATE UNIVERSITY OF NEW YORK PRESS

Published by
State University of New York Press, Albany

For information, address State University of New York Press,
State University Plaza, Albany, N.Y., 12246

Production by Cathleen Collins
Marketing by Bernadette LaManna

Library of Congress Cataloging in Publication Data

Bohn, Willard, 1939–
 Apollinaire and the international avant-garde / Willard Bohn.
 p. cm. — (SUNY series, the margins of literature)
 Includes bibliographical references and index.
 ISBN 0–7914–3195–9 (alk. paper). — ISBN 0–7914–3196–7 (pbk. : alk.
paper)
 1. Apollinaire, Guillaume, 1880–1918—Criticism and
interpretation. 2. Apollinaire, Guillaume, 1880–1918—Influence.
 3. Avant-garde (Aesthetics) 4. Literature, Experimental—History and
criticism. I. Title. II. Series.
PQ2601.P6Z5733 1997
841'.912—dc20 96–11930
 CIP

10 9 8 7 6 5 4 3 2 1

For Anita and Heather
With All My Love

Contents

Acknowledgments ix

1 Introduction 1

2 Apollinaire and the English Muse 9

3 The New Spirit in North America 43

4 Among the German Expressionists 75

5 Homage from Catalonia 129

6 Apollinaire's Reign in Spain 169

7 Along the Río de la Plata 225

8 The Mexican Revolution 263

Notes 305

Index 359

Acknowledgments

The following study was supported by the American Council of Learned Societies, by the American Philosophical Society, and by the National Endowment for the Humanities. Preliminary research for the Spanish and Catalan chapters was conducted under a grant-in-aid from the first organization, which allowed me to consult materials in Spain. As the project progressed, a grant from the second organization allowed me to examine important documents in France, and a Travel to Collections Grant from the third institution made it possible to consult manuscripts and letters in the Harry Ransom Humanities Research Center at the University of Texas. Prior to that a grant from the Graduate Division, University of California at Berkeley enabled me to carry out research at the Beinecke Rare Book and Manuscript Library at Yale University. A grant from the Graduate School, Illinois State University, allowed me to reproduce Robert Mortier's drawing on the cover. Last but certainly not least, four University Research Grants from the latter institution permitted me to complete the project and to do much of the actual writing.

Earlier versions of several sections appeared in the following publications and are reprinted with their kind permission: "Thoughts That Join Like Spokes," *Paideuma*, 17.1–2 (Spring-Fall 1989): 129–45; "Apollinaire's Reign in Spain," *Symposium* 35.3 (Fall 1981): 186–214; "Guillaume Apollinaire: Homage from Catalonia," *Symposium* 33.2 (Summer 1979): 101–17; and "Guillaume Apollinaire and the New York Avant-Garde," *Comparative Literature Studies* 13.1 (March 1976): 40–51. The second and third articles are reprinted from *Symposium* with the permission of the Helen Dwight Reid Educational Foundation (published by Heldref Publications, 1319 18th Street, N.W., Washington, D.C. 20036–1802. Copyright 1981 and 1979).

I owe a special debt of gratitude to Norah Borges de Torre for sharing her memories of Ultra with me and for providing numerous rare documents. My warmest thanks go as well to Gloria Videla de Rivero, who provided invaluable assistance in locating elusive publications. I am also grateful to Cathy Henderson, Research Librarian at the Harry Ransom Humanities Research Center, University of Texas, who aided my work in several different ways. Similarly, I wish to thank Judith Rivera, formerly Jefe Administrativo of the reference section of the Hemeroteca Nacional in Mexico City, for help that went far beyond the call of duty. I am also indebted to the late Germán Vargas for information concerning the review *Voces* as well as to Dr. Darío Jaramillo Agudelo, Subgerente Cultural of the Banco de la República in Bogotá, and to Lina Espitaleta de Villegas, Directora of the latter institution's Biblioteca Luis-Angel Arango, for copies of this journal. Thanks are due as well to Adriana Méndez, Bibliotecóloga at the Biblioteca Nacional in Montevideo, for copies of *Los Nuevos* and to Nora Bagoyhar de Moreira, Bibliotecóloga Jefe at the same library, for copies of *Grecia*. Her predecessor, Martha Levrero de Kenny, also provided valuable assistance on several occasions.

It remains to thank the late Georgia O'Keeffe, Rodrigo de Zayas, and Yale University for allowing me to examine and publish excerpts from letters in the Beinecke Rare Book and Manuscript Library. Similar thanks are due to: the Harry Ransom Humanities Research Center, the University of Texas at Austin, for permission to examine and publish documents connected with Apollinaire and with F. S. Flint and to reproduce Robert Mortier's portrait of Apollinaire; the Staatsbibliothek Preussischer Kulturbesitz in Berlin for permission to include letters from Apollinaire to Herwarth Walden; Bulzoni Editore for permission to quote four letters from Apollinaire to Joan Perez-Jorba; and the Montclair Art Museum, Montclair, New Jersey, for permission to publish letters from Apollinaire to Morgan Russell. Apollinaire's letters and excerpts from his correspondence are reproduced with the kind permission of Gilbert Boudar. The following individuals were also of great help to me in my research: Palmira Pueyo, Directora de la Biblioteca, Instituto Internacional, Madrid; Francisco Pérez-Serrano Marquínez, director, Casa Municipal de Cultura "Zenobia y Juan Ramón," Moguer; Margarita Vásquez de Parga, Instituto Bibliografico Hispanico, Madrid; and Manuel Revuelta Sañudo, director, Biblioteca de Menéndez Pelayo, Santander. The staff of the Biblioteca de Catalunya and the Biblioteca Central in Barcelona were particularly accommodating, as were the librarians at the Biblioteca Nacional and the Hemeroteca Nacional in Madrid. Finally, special thanks go to Helga

Whitcomb, Carol Ruyle, and the Interlibrary Loan staff at Milner Library, Illinois State University, who showed great ingenuity in locating and obtaining copies of rare publications that had seemingly disappeared from the surface of the earth.

CHAPTER ONE

Introduction

The following study seeks to analyze Guillaume Apollinaire's literary and artistic reception by members of the European and American avant-gardes during the early twentieth century. In order to reduce this task to manageable proportions it has been necessary to define its parameters fairly closely. Without a set of controls, it would have required highly specialized linguistic skills and would have occupied several volumes. At the very beginning, therefore, I decided to limit the investigation's scope in three important ways. In the first place, the latter is concerned with tracing the impact of Apollinaire's ideas as they radiated outward in increasingly larger circles from Paris. As such the project focuses almost exclusively on his presence outside France. Although it necessarily touches on the poet's relations with his French colleagues from time to time, it concentrates on his international significance.

In the second place, I chose to limit the inquiry to the period leading up to 1920. Since Apollinaire died in 1918, his initial influence was restricted to his contemporaries and to those writers and artists who came immediately after him. At this point, however, it is necessary to insert a brief disclaimer. Although it may appear to violate my preliminary guidelines, the period of study has been extended to 1930 in the case of Latin America. Since the rise of the avant-garde in this part of the world dates from about 1920, its members encountered Apollinaire's writings somewhat later. Despite the apparent chronological discrepancy, therefore, the underlying principle remains the same. What interests us is Apollinaire's initial reception in avant-garde circles on both sides of the Atlantic Ocean. In both instances this would seem to have been the period when his presence was the most keenly felt. Interestingly, this period coincided with the

initial phases of the avant-garde itself whose direction he helped in so many ways to determine.

Another advantage to choosing 1920 (or 1930) as our cut-off point is that the data we will be examining is still relatively fresh. The large number of commentaries, translations, testimonials, and other documents that have come down to us still bear the imprint of Apollinaire himself. In many cases, as we will see, the poet corresponded with the individuals in question and sent them copies of his publications. In some instances he met avant-garde representatives during trips abroad and/or welcomed them to Paris when they came to visit. Shortly after Apollinaire's death, however, a process of myth-making set in that was responsible for much of the subsequent confusion that surrounded his career. By the end of the 1920s Apollinaire's mythic status was secure in France and in most of the Western Hemisphere. While there is no shortage of anecdotes that illustrate this transformation, one account, by a South American author, will demonstrate the extent of this process. Writing to his brother from Paris in 1929, the Argentine poet Raúl González Tuñón described a new literary cabaret called La Boule Blanche. The opening ceremonies, he reported, were dedicated to the memory of two of Montparnasse's most beloved denizens: Modigliani and Apollinaire.[1] By this time both men had undergone a sort of avant-garde apotheosis. In the space of some ten years they had become the patron saints of the modern movement.

The third limitation is concerned with the avant-garde itself, or rather with its international aspect. For several reasons I decided to restrict the study to the major European and American nations. For one thing, these were the countries in which avant-garde experimentation flourished during the early years of this century. For another thing, these countries were destined to make the most important contributions to modern literature and modern art. What concerns us primarily, therefore, are the main lines of development linking Apollinaire to the international avant-garde. This is not to deny that many other countries were aware of Apollinaire or that they profited from his writings. To the contrary the poet seems to have had admirers virtually everywhere one chooses to look. In Scandinavia, for instance, the Danish periodical *Klingen* (*The Sword*) included an article devoted to Matisse, while the Swedish playwright Pär Lagerkvist read and reread *Les Peintres cubistes* "as if it were gospel."[2] Similarly, among the various Low Countries, the Flemish review *De Goedendag* (*Good Day*) featured an article on Apollinaire and Verlaine, while Herman van den Bergh published several studies of the poet in *De Vrije Bladen* (*The Free Press*) in Holland.[3] Traces of Apollinaire, including a number of substantial texts, appeared in Eastern Europe with considerable frequency as

well. In addition to *Ma* (*Today*) which was headquartered in Budapest, the Ukrainian review *Nova Generatsiia* (*The New Generation*) and a host of other Slavic publications published translations of his works.[4] Additional examples, taken from Latin American as well as European periodicals, could be multiplied almost at will.

Although it would be interesting to study Apollinaire's reception in some of these lesser known areas, the following pages are devoted to the literary and artistic mainstream. To the extent that it has been possible, and despite considerable overlap on more than one occasion, the chapters are arranged in approximately chronological order. The second chapter (following the Introduction) is concerned with Apollinaire and the British avant-garde, which paradoxically included several Americans. The third chapter extends the investigation to North America and centers around the New York avant-garde. Returning to Europe, the fourth chapter examines the poet's presence in Germany and in neighboring areas with German-speaking populations. The remaining chapters concentrate on Apollinaire's Hispanic reception, which assumed a number of different guises. Beginning in Catalonia and then expanding to cover the rest of Spain, the investigation culminates in Latin America where the poet played a significant role in Argentina, Uruguay, and Mexico. Among the various movements that one encounters during this avant-garde odyssey are Cubism, Dramatism, Orphism, Simultanism, Imagism, Vorticism, Expressionism, Pathetism, Dada, Surrealism, Ultraism, Creationism, Simplism, Stridentism, and the Contemporary School.

Despite the ambitious itinerary outlined above, some readers may object to the absence of one or more countries that are known to have made important avant-garde contributions. In a study such as this, one would expect to find a chapter concerned with Apollinaire's presence in Italy, for example, and perhaps even in Switzerland. And since it includes Latin America as well, one may wonder why there is no discussion of the poet's role in Brasil. If anything, avant-garde activities in the latter country were even more pronounced than they were in Argentina and Mexico. Let it be said at the outset that unlike the rest of Latin America, the Brasilian artists and writers were not particularly interested in Apollinaire. Instead, for reasons that appear to have been largely accidental, they were drawn to another French poet: Blaise Cendrars, who visited Brasil on several occasions. Not only was Cendrars popular among the avant-garde there, but he heavily influenced several of its members.[5]

The absence of Switzerland, which is perhaps more apparent than real, does not pose a serious problem. For one thing, references to Apollinaire that appeared in German-language periodicals are discussed

in the chapter devoted to Germany. For another thing, the French references that appeared in Switzerland, which have recently been examined by Pierre Caizergues, tended to occupy a peripheral position in the international avant-garde.[6] Despite the undeniable interest of these references, like those by Belgian writers, they do not belong to the historical mainstream. The major exception to this rule is offered by Tristan Tzara, who corresponded with Apollinaire during the war and who published a moving poem on the occasion of his death.[7] Under Tzara's aegis the latter's poetry was recited at various Dada soirées in Zurich, and references to his work appeared from time to time in *Cabaret Voltaire* and *Dada*. In addition the former review published a *poème simultané* by Apollinaire entitled "Arbre."[8] Nevertheless, since the poet's influence was neither decisive nor widespread, there is not enough material to merit a separate chapter. In any case Tzara abandoned Zurich for Paris before long, where he joined the French avant-garde.[9]

The absence of a chapter devoted to Italy, as readers who are familiar with Apollinaire will attest, is much more surprising. There is certainly no shortage of documents to examine or of interesting conclusions to be drawn. In an important work, which has since become a classic, P. A. Jannini demonstrated in 1965 that Italian artists and writers were unusually receptive to Apollinaire's aesthetic message.[10] Indeed, more and more examples of his influence have surfaced in the years since Jannini's book appeared. As subsequent studies have shown, even some of the Futurists were seduced by Apollinaire's achievements and strove to incorporate them into their rival aesthetic. Unfortunately, several considerations have prevented me from including the Italian avant-garde in the present volume.

In the first place, as Jannini discovered, there is simply too much material. The volume of the primary documents alone would have necessitated a book-length treatment. In the second place, my own role would have been drastically altered. This is a problem that confronts anyone who attempts to summarize someone else's work. On the whole, the subject of Apollinaire's reception outside France has received remarkably little attention. Of necessity, therefore, the scholarship that has gone into making *Apollinaire and the International Avant-Garde* is almost entirely original. In the absence of existing studies, I have attempted to reconstruct the relations between the poet and his foreign colleagues based on what I could discover from the primary sources. Rather than devote a chapter to Apollinaire in Italy, which would merely have repeated Jannini's findings, I have preferred to refer readers to the primary texts on the subject. This decision was rendered all the more necessary by the recent publica-

tion of two volumes of letters by Apollinaire to Italian correspondents, many of which are previously unknown.[11]

As the reader will rapidly discover, the guidelines described above are somewhat elastic. Since the study seeks to illuminate the main paths of exchange between Apollinaire and other avant-garde figures, not to falsify them, it seemed wise to avoid unnecessary constraints. Whenever the nature of the material calls for it, therefore, they have been temporarily suspended. This is especially true of the first two guidelines, which impose not only chronological but geographical limitations. In point of fact it has not always been possible to restrict the discussion to areas outside France. For one thing, much of Apollinaire's avant-garde activity expressed itself in articles which he wrote on behalf of one foreign cause or another. For another, several individuals with whom he corresponded, such as Ramón Gómez de la Serna and Herwarth Walden, sought him out whenever they came to Paris. Furthermore, many members of the international avant-garde resided in Paris themselves for long periods of time. Any attempt to describe their relations with Apollinaire must take this fact into account as well.

In addition, it has been necessary to ignore the study's chronological restrictions on several occasions. Whenever a particular author's evolution, or the evolution in his attitude toward Apollinaire, extends past the cut-off date, I have followed it as far as necessary. This policy also applies to a few movements that continued to develop in significant ways in subsequent years. In most cases the period in question exceeds the 1920 (or 1930) limit by only a few years. Thus the various chronological transgressions are relatively minor. The principal exception to this rule concerns individuals who were destined to play a major role in modern literature, a number of whom have since become famous.

Confronted by authors such as Ezra Pound or Jorge Luis Borges, I found it impossible to ignore their later development. To have abandoned them so early in their careers would have been not only frustrating but irresponsible. In order to discover what these writers really thought of Apollinaire, therefore, I have expanded the discussion to include their entire *oeuvre*.

Although Apollinaire eventually rose to become the head of the French avant-garde, his origins were extremely humble. The illegitimate son of a Polish adventuress, he spent his formative years first in Italy, where he was born, and then in Monaco where he went to school. Ironically, the future poet of Paris, whose glories he was to celebrate in so many works, did not settle in the French capital until he was nineteen. During the next ten years he eked out a miserable existence as a bank clerk

and part-time journalist but succeeded in establishing himself as a poet, novelist, and critic of modern art. By 1911, when he published *Le Bestiaire* with Raoul Dufy and was awarded a column in *Le Mercure de France*, Apollinaire found himself poised on the brink of success. Before he could capitalize on his good fortune, however, the scale tipped in the opposite direction and threatened to destroy everything he had worked so hard to accomplish. Without warning Apollinaire was arrested in connection with the theft of the *Mona Lisa*, which had recently disappeared from the Louvre, and threatened with permanent expulsion from France.

The story of Apollinaire's imprisonment and his subsequent release has been told many times.[12] What interests us here is the immense amount of publicity that it generated and its effect on his international reputation. Before this bizarre episode relatively few people had ever heard of the poet outside France. Suddenly, thanks to a gratuitous incident, he acquired instant worldwide recognition. His career was subjected to public scrutiny not only by the French authorities but by the international press. Concentrating on Géry Pieret, who was suspected of being the actual thief, the *London Times* described the proceedings as follows: "Two separate individuals are attracting attention as having possibly been concerned in the disappearance of *La Gioconda*. One is a former associate of M. Apollinaire, who was arrested on September 8 for having harboured the thief of the Phoenician statuette [which had been stolen previously]. This individual, who was allowed to escape by M. Apollinaire, is in correspondance with *Paris-Journal*, to which he sold the statuette for £200."[13] In contrast to its British counterpart, which was preoccupied with the details of the theft, the *New York Times* focused on Apollinaire himself. Four days later the following account appeared which portrayed the latter as a respectable *homme de lettres*:

> M. Apollinaire, a well-known Russian literary man living in Paris, was recently arrested and underwent a searching examination on the charge of having shielded Pieret from the law. . . . In June M. Apollinaire employed him as his private secretary, but learning of his past history, on August 20 he showed him the door. . . . M. Apollinaire, who is very popular in Paris in literary and journalistic circles, was accused of having put his delinquent secretary on a train for Marseille and given him the sum of $32 to quit the country. After a searching cross-examination by the investigating magistrate, M. Apollinaire has been set at liberty provisionally.
>
> Among the interesting details of his relations with the alleged thief of *Mona Lisa* and the latter's tale of many adven-

tures, Apollinaire said that Pieret was known for a considerable time under the name of Baron Ignace Dormeson.

Le Journal publishes a letter from Berlin signed "Baron Dormeson," in which the writer emphatically states that Apollinaire had nothing whatever to do with the theft of the picture.[14]

Thus the first reference to Apollinaire in the United States, as in most other countries, was occasioned by the theft of the Mona Lisa. Although the article was generally favorable, it implied that he had somehow been an accomplice and implicated him in the growing scandal. This pattern was repeated in the other nations we will be studying, where it generated a certain amount of negative publicity. However, since the incident itself was of no interest to the international avant-garde, it has been excluded from the remainder of this volume. The members of the latter group were preoccupied above all with aesthetic issues. The decade stretching from 1910 to 1920 witnessed a tremendous burst of creative energy as one revolutionary invention led to another in quick succession. Significantly, this was the most important period in Apollinaire's career as well. During these years he published two major collections of poetry, a book of short stories, a ground-breaking study of Cubist painting, an avant-garde novel, two influential manifestos, and a revolutionary play in addition to a host of other works. The outbreak of the First World War, in which he actively participated, scarcely seems to have made a dent in his various projects.

Apollinaire's chief rival during this period was none other than F. T. Marinetti, the founder of Italian Futurism. Beginning in 1909, the Futurist movement received considerable publicity in both Europe and the Americas and counted numerous artists and writers among its adherents. Since Marinetti was independently wealthy, he was able to travel all over the globe writing explosive manifestos and lecturing on Futurist goals. However, since Apollinaire was virtually penniless, he was forced to carry out his own campaign to modernize art and literature in a number of other ways—mainly through the medium of the written word. While his books and articles covered a wide variety of topics, he was associated primarily with Cubism during his lifetime. Thus the principal competition during the early part of the century was between the Futurists, on the one hand, and the Cubists on the other. The former explored the connection between modern art and the new technology, while the latter investigated the nature of contemporary reality. In contrast to Futurism's infatuation with the machine, Cubism adopted an aesthetic that was based on fragmentation and rupture.

During this same period the members of the international avant-garde were searching for a fresh means of expression that would enable them to capture the unique spirit of the twentieth century. As we will discover, Apollinaire provided them with many of the things they were looking for. Some of these, such as concepts, themes, and techniques, represent instances of direct influence. Others, such as attitudes and ideas in general, are less easy to identify. In this context, which is related to the history of ideas and to the history of aesthetics, it is instructive to study Apollinaire's reception: how his work was received by various artists and writers and what they thought of it. Above all, I hope to determine the nature of his contribution to the different avant-gardes and the manner in which it was adapted to the specific needs of the countries in question. In analyzing the different ways in which Apollinaire's writings were utilized I also hope to shed new light on the paths of aesthetic exchange that characterized France's relationship with the rest of Europe and with the Americas.

Apollinaire and the English Muse

Ironically, the first person in Great Britain to become aware of Apollinaire professionally was not an Englishman but an Albanian. Residing in London, where he edited the review *Albania*, Faïk beg Konitza (also known as Trank Spiro Beg) came to know the poet originally through his articles in *L'Européen*.[1] Not only did Apollinaire stay with Konitza in 1903 when he came to London to convince Annie Playden to marry him, but Konitza published several items by Apollinaire in his review. By its very nature, however, the latter appealed to a highly selective audience. Not until 1909 did Apollinaire begin to make an impression on the British literary establishment—with the publication of "La Chanson du mal-aimé." Even so, his name did not appear in print until two years later. Between 1912 and 1920 Apollinaire's reputation in England was determined largely by individuals associated with the Imagist movement. Although Ezra Pound was the acknowledged head of the school— before it was kidnapped by Amy Lowell—his familiarity with French literature was limited initially to the Middle Ages. For knowledge of more recent trends the Imagists relied on the expertise of Frank Stewart Flint. With regard to modern French poetry in particular, as René Taupin has noted, the latter served as their "maître d'école."[2]

F. S. FLINT

For all intents and purposes the renewal in Anglo-American letters at the beginning of this century was the result of contact with the French. This was essentially a two-pronged attack in which the English and the

Americans remedied their ignorance of nineteenth-century French literature and also emulated members of the twentieth-century avant-garde. As the member of the group who was most familiar with contemporary developments, Flint played a crucial role in shaping Imagist poetry. Indeed the name of the movement itself was suggested by his enthusiasm for the innumerable "-isms" that had sprung up in France.[3] Not only did Flint know more about the new French poetry than any of his colleagues, but it is generally agreed that he was better informed than anyone else in England or America.[4] As such he was in a unique position to serve as a spokesman for a whole generation of French poets.

Although Flint maintained that all his books and records had been destroyed during World War II, fortunately a great many documents have survived.[5] The collection at the University of Texas, for example, demonstrates that his interest in modern French poetry began as early as 1905 when he published an article on José Maria de Hérédia. Thereafter several notebooks chronicle his continued interest in this area and reveal that he was a habitual reader of the *Mercure de France*. The most interesting for our purposes is a commonplace book dating from 1909, which contains a mixture of shorthand notes, German vocabulary, quotations, poems, and aphorisms such as "The foundation stone of pornography is Puritanism." Juxtaposed with the latter observation are two lines from "La Chanson du mal-aimé":

> Et moi j'ai le coeur aussi gros
> Qu'un cul de dame damascène
> Guillaume Apollinaire
> Mercure in May [19] 09.[6]

Interestingly, although Flint read Apollinaire's masterpiece as soon as it appeared, he does not seem to have recognized its originality. Instead, what appealed to him was the kind of thing that would appeal to the Imagists when the movement was founded four years later—the emotive power of individual metaphors. Isolated from the rest of the poem, the lines exemplify the Imagist preoccupation with concise diction, spontaneous rhythm, and metaphoric precision. Except for their unusual imagery, they would not have been out of place in any of the Imagist anthologies. In this they resembled similar experiments by T. E. Hulme at about this time, who is often cited as the founder of Imagism.[7] Whereas Hulme's metaphors exploit surprise, however, the importance of Apollinaire's example lies in its shock value. Indeed, the purpose of Flint's aphorism seems to be to protect the French poet against the charge of indecency. Since obscenity lies in the eye of the beholder, it implies, the

intelligent reader should be shocked rather than scandalized. The presence of the poem in the *Mercure de France* was proof enough of its respectability.

Apart from the reference discussed above, there is no mention of Apollinaire in Flint's public or private writings until 1912. Most of that year was devoted to an ambitious project culminating in a lengthy article in August. Commissioned by the editor of *The Poetry Review*, Harold Monro, to undertake a study of contemporary French poetry, Flint began by acquiring every book he could get his hands on and by writing directly to the poets involved. The total correspondence amounted to some two hundred letters and included virtually every poet of note. Alexandre Mercereau, who was one of the founders of Dramatism and the co-editor of *Vers et Prose*, served as chief advisor to the project. Writing to Monro toward the end of March at the instigation of his publisher, whom the former had contacted initially, Mercereau enclosed a list of recommendations and a copy of his book *La Littérature et les idées nouvelles* (1912).[8] In addition to being one of the recommended poets, Apollinaire was the subject of a section in the volume as well. Monro forwarded this material to Flint who sent Mercereau a working list of poets on April 17th, including Apollinaire, whom he planned to discuss in his article. Mercereau replied with various suggestions and reported that he had asked Ernest Florian-Parmentier to send Flint a copy of his *La Littérature et l'époque: histoire de la littérature française de 1885 à nos jours* (1912). We know from a letter to Flint, dated April 29, 1912, that Florian-Parmentier sent him both the volume mentioned by Mercereau and a brief outline of modern French literature in which Apollinaire was included among "nos jeunes poètes de talent." As before, a discussion of his work could be found in the book itself.

According to a letter from Flint to Mercereau written the same day, the latter had agreed to contact some of the poets on Flint's behalf and to ask them to send him examples of their work. By this time Apollinaire's presence in the article was assured. If Flint had any reservations about his suitability, a letter from Jacques Nayral, the literary editor for Figuière et Cie, would have assuaged his doubts. Dated May 4, 1912, it listed twelve poets including Apollinaire as "les meilleurs espoirs actuels de notre poésie." While Flint had begun to divide the poets into schools, he was unable to classify Apollinaire since he had received no samples of his poetry.[9] By the end of the month, however, this problem had been remedied. At Mercereau's urging, Apollinaire wrote to Flint in late May 1912 and enclosed several poems. In addition to providing a detailed bibliography, he stressed his accomplishments in the area of art criticism. "Comme critique d'art," he observed, "j'ai été longtemps le seul à défendre les

écoles avancées de peinture et de sculpture (Fauves, cubistes, etc.)."
Elsewhere he commented on recent developments in French poetry:

> La littérature actuelle prend une tendance qui me séduit infini-
> ment parce qu'elle est la mienne: c'est la tendance du
> Dramatisme qui succède au Romantisme. Ceux que je préfère
> parmi les jeunes sont Théo Varlet, A. Mercereau, H. M. Barzun,
> H. Hertz, F. Fleuret, Max Jacob, T. de Visan, Deubel, Royère, etc.
> etc.

Ironically, Apollinaire's belated response to Flint's request (through
Mercereau) was of little use to either of them. In a letter to Mercereau
dated June 4th Flint complained that the poems were incomprehensible.
"Apollinaire m'a envoyé quelques poèmes," he remarks; "Je ne saurais
trop quoi en dire." As in 1909 he was unable to grasp the originality of the
poet's achievement because it was simply too revolutionary. The problem
was compounded by the fact that Flint had already exceeded the space
allotted him. The best he could do, he reported one week later, was to rec-
ommend the remaining poets with a few brief words of praise. The
absence of a section devoted to them was simply a matter of chance.
Mercereau's response on June 28th underlined the problem inherent in
Flint's method (or lack of one). "Il est dommage," he protested, "que vous
ne puissiez citer un peu Apollinaire, Deubel, Salmon, Mandrin, car ce sont
de très bons poètes, bien plus intéressants que Duhamel."

Shortly thereafter, apparently, Mercereau wrote to suggest ways of
minimizing the unfortunate omissions. In Apollinaire's case he advised
Flint to draw on his own discussion in *La Littérature et les idées nouvelles*
and included the following evaluation: "Le poète est curieux, fantaisiste,
raffiné, très souple, expert en notations subtiles, aiguës, rares."[10] Not only
was Mercereau's advice gratefully accepted, it was incorporated whole-
sale into Flint's article. Lamenting the impossibility of doing justice to
modern French poetry, the author evoked the names of poets he was
forced to exclude including "Guillaume Apollinaire, a curious, fantastic,
keen, supple poet, expert in subtle and piercing notations."[11] For the
moment Mercereau's words provided him with a way out of the impasse
represented by Apollinaire's poetics. On August 17th he received a card
from the former complimenting him on the article but deploring the
absence of Apollinaire and several other poets.

Despite his initial neglect of Apollinaire, Flint continually encoun-
tered the latter's name the following year in his capacity as French critic
for *Poetry and Drama*. By 1913 the French poet had become a prominent
member of the avant-garde, and his work was attracting more and more

attention. In June, for example, in a column devoted to Henri-Martin Barzun's classification of French poetry, Flint reported that Apollinaire was a "visionary" rather than an "intuitive" poet and that he referred to himself as an Orphic dramatist.[12] Midway through the month he received a letter from Mercereau impugning the Unanimist school and praising the work of four Dramatist authors as vastly superior.[13] One of the authors was Apollinaire, whose collection of short stories *L'Hérésiarque et Cie* (1910) was singled out for praise. Flint replied on June 19th that he would be willing to give them a "full-dress show" if only they would send him copies of their works. In addition to *L'Hérésiarque et Cie* he specifically wanted to see *Alcools*, which had been published two months earlier. During the same month the rivalry between the Dramatists and the Unanimists suddenly heated up, culminating in Georges Duhamel's scathing review of *Alcools* in the *Mercure de France* on June 15th. In a letter dated July 1st, Mercereau denounced Duhamel for engaging in a series of dirty tricks including distributing circulars defaming Apollinaire and other writers.

The September issue of *Poetry and Drama* contained three separate references to the poet. Identifying Apollinaire as the author of *Alcools* and "the defender of the Cubists," Flint noted that he had just issued a Futurist manifesto entitled *L'Antitradition futuriste*. Elsewhere in his column he reported that the controversy in the *Mercure de France* over Walt Whitman's burial, which Apollinaire had started in April, was continuing. Finally he acknowledged that he had received a review copy of *Alcools*.[14] Besides this volume, Flint's library was eventually to include *La Femme assise* (1920) and *Calligrammes* (1918) as well.[15] In December he finally got around to discussing Apollinaire. Although the few pages he devoted to the poet were far from a full-dress show, Flint made amends for his previous neglect:

> I have two books of verse that have pleased me for the same and for opposite reasons: *Les Servitudes*, by Philéas Lebesgue, and *Alcools*, by Guillaume Apollinaire. . . . There is poetry in both, but in the first it springs from contact with simple, natural things; in the second, from a complex of culture and phantasy. . . . M. Apollinaire [sings] all the subtle fancies, images, symbols that his mind weaves into the stuff of his emotions; his portrait by Pablo Picasso is given as a—cryptic—frontispiece; he has suppressed all punctuation in his verses; he is exotic, deliberately artificial, and willingly obscure. But both are poets, M. Lebesgue appealing to the brain through the heart; M. Apollinaire to the heart through the brain.[16]

This passage reveals that Flint responded to Apollinaire's poetry at a certain level but that he was daunted by some of it as well. In contrast to the twin Imagist virtues of simplicity and clarity, the author of *Alcools* was fond of learned allusions and complex constructions. To illustrate his work Flint chose two of the more accessible poems—"La Maison des morts" (*Oeuvres poétiques* [OP], 66–72) and "La Synagogue" (OP, 113). Quoting the second and third stanzas of the former, he summarized the rest of the text as follows: "And then the poet and the dead march off to the strange inconsequent adventures that one has in dreams—a curious, remarkable poem." " 'La Synagogue,' " he continued, "is a poem of a kind that seems new in French." Here Flint quoted the first three stanzas, omitting verses 6–8 for reasons of propriety. Like *Les Servitudes*, he concluded, "*Alcools* should be read by all who are interested in contemporary French poetry." While his discussion of the book's significance left much to be desired, he was beginning at last to appreciate Apollinaire's contribution to modern poetry.

The year 1914 was marked by additional references to Apollinaire in Flint's column and by increased contact between the two men. In the March issue of *Poetry and Drama*, Flint revealed that he had finally determined how the French poet should be classified. Together with a large number of other writers, Apollinaire was listed as a *Fantaisiste*.[17] The column itself was prompted by an anthology of Fantasist poems published in *Vers et Prose* (October–December 1913). Reminding his readers of his previous discussion of *Alcools*, Flint quoted Apollinaire's "Montparnasse" (OP, 353) in its entirety together with other works taken from the anthology.[18] Somehow, probably through the intermediary of Mercereau, Apollinaire obtained a copy of the column and wrote to Flint concerning his recent review. Written on the letterhead of his journal *Les Soirées de Paris*, the letter is dated 20 March 1914. In order to preserve its distinctive flavor, no attempt has been made to correct Apollinaire's grammar or spelling.

<div align="center">20 mars 1914</div>

Mr Flint
I have read in your *French Chronicle* of *Poetry and Drama* (March 1914) you must have reviewed in December last my poeme book *Alcools*.

I will be very glad if I can to read your interesting critic.
Please sent to me and excuse me for my bad english.

> Your's truely
> Guillaume Apollinaire
> Paris 202 Bd St. Germain

This document is of considerable interest for two reasons. In the first place, it is the earliest evidence of direct contact between Flint and Apollinaire, allowing us to date the beginning of their "collaboration" with a high degree of accuracy. In the second place, it is virtually the only record of Apollinaire's ability to speak (or to write) English. While his attempt to express himself in the language of the reviewer was praiseworthy, his command of the language itself was rudimentary. Full of misspellings and ungrammaticalities, the message was translated literally from the French. Among other things this helps us to understand his unsuccessful courtship of Annie Playden a dozen years before. Since Annie's French was minimal at best, one of their principal problems seems to have been communication. Although no copies of *Poetry and Drama* are to be found in Apollinaire's library, Flint presumably complied with his request to send him the December issue.[19] From circumstantial evidence, moreover, they appear to have agreed to exchange publications, a common practice among members of the avant-garde. Thus the June issue of *Poetry and Drama* contained a brief description of the February and March issues of *Les Soirées de Paris*, which was described as "a very modern review, futurist, cubist."[20] Similarly, Apollinaire received a review copy of the anthology *Des Imagistes* one or two months earlier which, if not sent by Flint, was surely sent at his suggestion.[21]

Although much of the correspondence is missing at this point, Apollinaire's response was to ask Flint to write the review of *Des Imagistes* himself. Since he was a member of the Imagist school and since his command of French was excellent, he was eminently qualified to undertake the project. Flint accepted this interesting commission, and Apollinaire wrote his name and address in his address book in anticipation of future correspondence between them.[22] The only trace of the preparations for this project that remains, however, is a picturesque postcard from Apollinaire postmarked 7 June 1914.[23] The message is scrawled across a picture of a kirsch distillery at the Abbaye de Fontgombault which occupies most of the card:

> Cher Monsieur, nous attendons votre article avec impatience. Il sera mis au point. Je crois au demeurant qu'il n'y aura rien à changer, car vous écrivez le français fort bien.
>
> Merci donc et cordialement à vous
>
> Guillaume Apollinaire
> 202 Bd. St. Germain

Avez-vous reçu le no. de mai des *Soirées*?

Simply entitled "Imagistes," Flint's review appeared without alterations in the July-August issue of *Les Soirées de Paris*.[24] Besides poems by Richard Aldington, H. D., William Carlos Williams, Ezra Pound, and himself, it included a lengthy discussion of the Imagist credo.[25]

Despite Apollinaire's refusal to be classified as a Fantasist in the May issue of *Les Soirées de Paris*, Flint persisted in grouping him with that school in his September column.[26] While he welcomed the demise of Symbolism, whose last relics were being swept away, he hoped that Apollinaire and the others would not lose their taste for fantasy. By this time, however, the war had broken out, and any further contact with Apollinaire was out of the question. Enlisting in the army in December, the latter soon found himself at the front where he remained until 1916. All Flint could do was to follow his column in the *Mercure de France* when it resumed on June 1, 1915. In 1916 he was reminded of the French poet by an unfortunate incident connected with an article by Leigh Henry in The *Egoist*.[27] In a study seeking to relate the Fantasist authors to modern French music, the author, following Flint's lead, cited Apollinaire among the members of the school. Apparently some of Henry's remarks hit a nerve, for Flint sent him an irate letter accusing him of plagiarism. On 24 May he received a reply from the former who by then had become a German prisoner of war. Protesting his innocence, Henry insisted that he had become familiar with many of the writers before reading Flint's articles, especially with "a great deal of Apollinaire (in whom my friend F. T. Marinetti was very interested during the time I was in Italy)." In point of fact, although Flint had probably forgotten it, Henry had attempted to relate Apollinaire's poetry to contemporary music two years earlier. Writing in *The Egoist* in 1914, he described several musical procedures that seemed analogous to experiments with poetic simultanism. "In addition to these developments," he remarked, "we have the later poems of Guillaume Apollinaire, which dispense with punctuation, and the form of which is, in spirit, closely allied to the repudiation of bar divisions and time signatures evinced in the works of Ernest Austin and Erik Satie."[28] While Henry acknowledged that Flint had introduced him to a number of authors, his interest in Apollinaire was apparently longstanding.

On January 13, 1917, Richard Aldington wrote to Flint from France, where he was stationed in the British army, to recommend a recent anthology "with contributions from Apollinaire and his gang." Entitled *Almanach des lettres et des arts, 1917* (Paris: Martine, 1916), the latter included Apollinaire's short story *Mon Cher Ludovic*, which introduced the concept of tactile art.[29] After an absence of five years, the poet reappeared in Flint's writings in 1919, where he figured prominently. In

October Flint published two important studies of modern French poetry, one in *The Monthly Chapbook* and the other in the *Times Literary Supplement*. A mathematics notebook in the University of Texas collection is filled with notes taken from the *Mercure de France* in preparation for these articles. Besides the date of the poet's death, the references to Apollinaire's writings, sometimes in shorthand, include the following subjects: *Les Soirées de Paris*, the soldier-poet René Berthier (June 1, 1915), an announcement for *Case d'armons* (October 1, 1915), the poets in his battery (November 1, 1915), and the correspondence in verse between Apollinaire and the poet Léo Larguier (April 1, 1916). In addition Flint copied two hemistiches from Apollinaire's poem to the latter: "Et si nous revenons / Dieu! que de souvenirs!" (OP, 599). The last few items were integrated into his article in *The Monthly Chapbook* which, like its companion, served as a belated epitaph:

> M. Guillaume Apollinaire found several poets in his battery, a shop-assistant, a weaver, a clerk in an iron-mongery store. Their verses, he said, had that natural tone which is much the most agreeable thing in poetry. He quotes a poem by Driver Alexandre Coulon, a weaver of Saint-Quentin: [Flint reproduces the poem from the *Mercure de France*, November 1, 1915]. And so he continues, describing, as M. Apollinaire says, "in a striking fashion the life of an artillery-driver in the fighting-line."
>
> One could perhaps find here the argument that, given leisure, men turn to some form of art for distraction. Quite a number of French poets beguiled the tedium of military life by writing rhyming epistles to one another. In March 1916 *Le Double Bouquet* published two such epistles which had passed between M. Léo Larguier and Guillaume Apollinaire: [Flint quotes both poems].
>
> Guillaume Apollinaire died of influenza two days before the signing of the Armistice. His resistance had been weakened by a shell-wound in the head. Apollinaire was a man of many interests, a man attracted by the intellectually complex and by the humanly simple. He wrote a treatise on cubist art, and he admired the naive poetry, quoted above, of the men of his battery. An untiring collector of anecdotes of all kinds—an anecdote is a morsel of life cut fresh—he contributed his finds to the *Mercure de France* under the heading, *La Vie Anecdotique*. His joviality made him a popular man among soldiers. The bulk of Apollinaire's poems are in the two volumes, *Alcools* and *Calligrammes, poèmes de la paix at de la guerre (1913–1916)*. There

are many eccentricities in the latter volume, the least of them being the absence of punctuation; but words arranged in the form of pipes, trees, cravats, and in complicated designs, and rain trickling down the page in single letters were amusements which kept Apollinaire's mind alert. He was an adventurer of the mind, but a fine poet always when the right mood came. The man and the poet both appear in "La Jolie Rousse," from *Calligrammes*.[30]

Flint's sympathetic review ended with the latter poem, which served as Apollinaire's poetic testament. Despite his reservations concerning the latter's experiments with visual poetry, Flint clearly admired the man and his work.

Although the article in the *Times Literary Supplement* appeared anonymously, as was the custom, an almost identical draft in Flint's mathematics notebook proves that he was the author. While the study followed its companion piece fairly closely, it gave Flint a chance to develop some of his previous ideas in more detail:

M. Guillaume Apollinaire, who, two days before the signing of the Armistice, died of influenza following a shell-wound in the head, was almost the type of the soldier-poet. He accepted the war with Gallic, even Rabelaisian, good humour and courage, although he was Polish in origin; and he made the section of the line in which he happened to be the jollier for his jovial presence. His mind received all the sights and sounds that a brave man with no political passions could find curious, moving and interesting in the long, stationary battle. Apollinaire was one of the clever young men of France. He has described himself in the opening lines of his poem, "La Jolie Rousse," in *Calligrammes, poèmes de la paix et de la guerre*: [Flint quotes the first fifteen lines]. There is no punctuation in that passage. It was one of M. Apollinaire's fancies to print his poems without stops. Another—and there are a score or more examples in *Calligrammes*—was to arrange words in pictorial form—a watch, a cravat, a pipe, a house, the rain coming down the page in trickles of type, and other eccentricities indescribable with words. But the world has seen this kind of thing before. It is the sign of a weary generation. It can be found in the Greek Anthology and the last, tired displays of Elizabethan lyricism; with the Persians it is a decorative art. But, if Apollinaire played in this way with the fatigue of his generation, he himself was exhuberant with

energy. His curiosity was insatiable; he was every-ready to acclaim and to defend every artistic audacity; he was the pen of Picasso, and he wrote a treatise on Cubist art; nothing in art or life, ancient or modern, left him indifferent, and, to crown all, he was a poet, and a fine poet. There is enough clear, definite poetry in *Calligrammes* alone, to say nothing of his earlier book, *Alcools*, to make the reputation of a poet. The eccentricities (with which must be grouped those poems that attempt to present a state of mind at a particular moment, with all the odds and ends of memories that can crowd the mind simultaneously) were the stimulant that kept him freshly receptive and ready to speak when the right moment came. How rich those moments were, love poems like "Chevaux de Frise " are there to witness.

Apollinaire was an artist and human:

Qui donc saura que de fois j'ai pleuré
Ma génération sur son trépas sacré?[31]

While the reader received the impression that the couplet was taken from "Chevaux de Frise" (OP, 302–3), in reality it came from another poem in *Calligrammes* entitled "Chant de l'honneur" (OP, 306). Once again Flint singled out visual poetry as unworthy of Apollinaire's attention. Although he likewise classed the abolition of punctuation and the creation of the *poème simultané* as eccentricities, his admiration for the French poet in general was evident. Thereafter references to Apollinaire in his work were few and far between. Besides an allusion to *Les Soirées de Paris* in December, Flint linked the latter's style to his Symbolist precursors in September of the following year. In November he repeated his allegation that Apollinaire's literary cubism was indebted to Symbolism and evoked *Les Soirées de Paris* once more.[32] Despite his occasional shortcomings Flint had come a long way since his 1912 survey of modern French poetry. In particular, he probably had a better grasp of Apollinaire's poetics by this time than anyone else in England. Unfortunately, 1920 marks the end of his career both as a poet and as a critic. A personal tragedy in 1921 caused him to withdraw from the world of letters and to devote his energy to other causes.

RICHARD ALDINGTON AND *THE EGOIST*

With the exception of F. S. Flint, few writers in England found occasion to mention Apollinaire's name before 1914. Not surprisingly, the first professional reference (outside of *Albania*) occurred in l911 in a highly fran-

cophilic review entitled *Rhythm*, edited by John Middleton Murray, who included a woodcut by André Derain in its third issue which was identified as coming from *L'Enchanteur pourrissant* (1909) by Guillaume Apollinaire.[33] While this mention was rather marginal, the following year the French poet Francis Carco, writing for the same journal, classed Apollinaire among "nos meilleurs écrivains" and linked him to Naturism. On the following page, he added that *L'Hérésiarque et Cie* (1910) had nearly been awarded the Prix Goncourt the year before "pour la saveur des écrits qu'il contient, leur virtuosité, leur fermeté."[34] In 1913 Apollinaire continued to be associated with Derain's illustrations for *L'Enchanteur pourrissant*, which also attracted the attention of a writer on art and drama named Huntly Carter.[35] Following Flint's article on contemporary French poetry in August 1912, Apollinaire's reputation as a writer of verse began to grow. While the publication of *Les Peintres cubistes* in 1913 established him as a serious art critic, in England and elsewhere, the appearance of *Alcools* the same year established him as a serious poet. As a result of Flint's article, moreover, the Imagists began to acquire a taste for modern French poetry.

After Flint the second most qualified person in this area was probably Richard Aldington, who frequently acknowledged his debt to his friend and colleague. The immense amount of correspondence between them, which is preserved at the University of Texas, allows us to follow his development in detail. Returning from a lengthy stay in France and Italy, Aldington embraced the new poetry enthusiastically in September 1913 and quickly became something of an expert. He even experimented with a brand of simultanism developed by Henri-Martin Barzun, to whom he sent "the first poem in simultaneity written in English"—entitled "Les Cloches de Rome."[36] Beginning in 1914, Aldington's appointment to the position of assistant editor for *The Egoist* provided him with a forum in which to display his newly acquired knowledge of French literature. Not until June did he feel like tackling the contemporary poets who, as he noted, were exceedingly numerous. To underline his point he cited a typical encounter with Flint, who, hurriedly greeting him, replied: "I'm afraid I can't stop now because I have six new Fantaisiste authors, two volumes of Apollinaire, and thirty-two other books by representatives of sixteen different schools to review by Saturday."[37]

Although Aldington's portrait of the harried reviewer was meant to be amusing, it is revealing in more ways than one. The fact that Apollinaire was the only poet to be cited by name indicates that he had acquired a certain prestige among the Imagists, who certainly were aware of Flint's forthcoming article in *Les Soirées de Paris*. Moreover, the fact that

Aldington spoke of two books suggests that, like Flint, he was familiar with *Alcools* and *Les Peintres cubistes*, which had attracted a good deal of attention. Toward the end of the article he returned to the subject of Apollinaire and quoted two poems taken from *Les Soirées de Paris*: "Inscription pour le tombeau du peintre Henri Rousseau Douanier" (OP, 654) and "À travers l'Europe" (OP, 201–2).[38] He was sorry, he reported, to have to reprint the poems from other sources, but as yet he had not seen a copy of this publication. "From what I can hear," he continued, "this review, edited by M. Guillaume Apollinaire, is one of the most up-to-date and interesting of the French journals."

Whereas Flint had previously shied away from Apollinaire's more difficult poetry, Aldington chose to include one of his more enigmatic texts. Not only did he not find the obscurity of "À travers l'Europe" threatening, but he actually liked the poem. Introducing the latter, he remarked: "It will be observed that M. Apollinaire has decided to dispense with punctuation, except in certain places. The result is rather pleasing." Since he himself had written a simultaneous poem, he understood what the French poet was up to. In keeping with the increasingly closer contact between Apollinaire and the Imagists, Aldington wrote to him shortly after finishing the article to propose several projects. In a letter dated 7 June he solicited books to review by Apollinaire and his friends as well as a selection of poems from *Les Soirées de Paris* for publication in *The Egoist*. In addition he suggested that they agree to exchange their respective reviews.[39] Thereafter Apollinaire received each issue of *The Egoist* as soon as it appeared and most of the back issues.[40] Judging from the next number, he responded in kind and sent Aldington several issues of *Les Soirées de Paris*. Although the latter was unable to discuss them, being short of space, he promised to review the journal in a future issue.[41] For reasons undoubtedly connected with the outbreak of the war he was never able to keep that promise. In August, however, he translated an article by the French poet Nicolas Beauduin, part of whose poetic program he attributed to Apollinaire.[42]

The year 1914 was marked by two additional events in England in which Apollinaire likewise figured. The first was the publication of a translation of Wassily Kandinsky's *Über das Geistige in der Kunst* (*On the Spiritual in Art*) by M. T. H. Sadler. While the artist himself made no references to Apollinaire, the translator alluded to him twice—once in connection with *L'Enchanteur pourrissant* and again with regard to *Les Peintres cubistes*.[43] The former received high praise for the quality of Derain's woodcuts, and the latter was listed as one of two authoritative studies of Cubism. The second event was the publication on 20 June of the first issue

of *Blast*, which bore the subtitle: *Review of the Great English Vortex*. The brainchild of Wyndham Lewis and Ezra Pound, it flaunted a shocking pink cover and contained a virulent manifesto modeled in part on Apollinaire's *L'Antitradition futuriste* (1913).[44] Just as the latter awarded either roses or *merde* to various institutions and individuals, the Vorticists alternately "blasted" and "blessed" a long list of deserving candidates.

Interestingly, the publication made its way to France almost immediately where a copy caught Apollinaire's eye. On 1 August he noted with pleasure that "mon manifeste milanais . . . vient d'être imité avec bonheur par les nouveaux artistes et poètes anglais, dans le premier numéro de leur revue trimestrielle: *Blast*."[45] Apart from this particular structural device Apollinaire's influence was absent from the rest of the volume. At best an allusion to the theft of the *Mona Lisa* in 1911 referred indirectly to his imprisonment as a suspected accomplice.[46] Ironically, although the Vorticists denied the influence of continental models, they were eager to be recognized by the very schools they rejected. At about the time the first issue of *Blast* appeared, one of them sent Apollinaire a lengthy article (in English) for publication in *Les Soirées de Paris*. Entitled "Some Modern Tendencies in English Art," the anonymous manuscript is preserved today in the Bibliothèque littéraire Jacques Doucet in Paris (MS 7563). While it mentions a number of different artists, the bulk of the article is devoted to individuals associated with the Rebel Art Centre including Wyndham Lewis, Edward Wadsworth, David Bomberg, Malcolm Arbuthnot, Jacob Epstein, C. R. W. Nevinson, and Henri Gaudier-Brzeska.

For the next few years, references to Apollinaire in *The Egoist* were scattered as the war disrupted the paths of communication that the avant-garde had established. With the exception of a single article in *The Little Review*, Aldington did not refer to him again in print until 1920. Even this article had little to do with Apollinaire, who was simply included in a list of "delightful and readable" French poets.[47] In August 1915 the second issue of *Blast* received a less than enthusiastic review from someone who chose to remain anonymous. "Not one of the Vorticists has a personal style," the reviewer complained; "In literature they imitate Soffici and Guillaume Apollinaire—whose Milan manifesto, so he says, is the model for *Blast*—and in art Picasso and Severini."[48] By this time the history of the Vorticist manifesto had come full circle. Just as Apollinaire recognized the latter's debt to his own manifesto, the Vorticists were forced to recognize his recognition of that indebtedness. They knew that he knew that they had followed *L'Antitradition futuriste*. Equally interesting is the suggestion that Apollinaire was so well known by the middle of 1915 that his style was not only recognizable but subject to imitation.

Later the same year another writer compared the German review *Der Sturm* to *Les Soirées de Paris* and mentioned that Apollinaire had contributed to it in the past. The following year Muriel Ciolkowska reported that the poet had been promoted to second lieutenant. *The Egoist* also published a poem in French by Sebastien Voirol addressed to Apollinaire and other artists and writers who were fighting at the front.[49] On January 13, 1917, as mentioned, Aldington wrote Flint that he had acquired a copy of the *Almanach des lettres et des arts, 1917* with contributions by "Apollinaire and his gang." While these included *Mon cher Ludovic* (*Prose I*, 497–99), an imaginative short story, that year it was the drama *Les Mamelles de Tirésias* that captured everyone's attention. Performed on June 24, 1917, one month after Jean Cocteau's *Parade*, it coincided with the promulgation of the anti-realistic aesthetic that Apollinaire baptized "surrealism." One of the members of the audience for the Cocteau production was Huntly Carter who, recalling his experience a few months later, wrote:

> I think a direct outcome of this ballet was Guillaume Apollinaire's *Les Mamelles de Tirésias*, a "sur-réaliste" play with "simultané" decorations by MM. Férat, Steinberg, and Irène Lagut and clever music by Germaine Albert-Birot. It had the effect of producing a split in the camp of the progressives, some of whom complained that they could not see Apollinaire for the maze of decorative ideas. Others saw Apollo quite clearly in his simultaneous get-up pleading for the simultaneous repopulation of France. It was all very gay and significant. And it told us that livingness was once more afoot seeking to crown the drama. In this and many ways it seeks to crown France.[50]

As the author noted, the play provoked a fierce dispute between some of the Cubist painters, who felt they were being mocked, and the partisans of Apollinaire. While Carter was mistaken in implying that *Les Mamelles* was inspired by *Parade*, this was an understandable error given the short time separating the two performances. Decidedly the Parisian avant-garde was beginning to regain its former spirit. The publication of Apollinaire's drama in book form the following year led to another review which focused on the play itself. In her column "Passing Paris," published in *The Egoist* in April 1918, Muriel Ciolkowska examined some of the principles underlying this new mode of expression:

> *Surréaliste* is the denomination M. Guillaume Apollinaire—there is no doubt his astounding name continues to have good reasons for keeping well in evidence—has attached to his play, *Les Mamelles de Tirésias*, which has just appeared *en librairie* (édi-

tions—SIC). Thus he must be credited with the foundation of a successor to the *Unanimiste and Simultanéiste* schools. Anticipating the interrogation provoked by this novel definition he has found a rather delightful, though entirely fallacious, image. "When man, " he says in the preface, "wished to imitate his own walk, he created the wheel; he thus made super-realism," and, he adds, "without knowing he did." Because it has taken from the first wheelwright to M. Apollinaire to think of that word, "Wheelwright No. 1" was an unconscious agent. We thus have an example of the philosophical theory that the thought follows the term. That super-realism may be accompanied by a form of humour, which for lack of a definition we may hazard as "super-humour," is the opinion of those who attended the play.

M. Apollinaire also wishes his work to be known as a drama, "a term," he says, "signifying action to establish what separates it from the *comédies de moeurs, comédies dramatiques*, and the *comédies légères* which have, for half a century, furnished the stage with works, many of which are excellent but second-rate and which are called simply—plays." Can M. Apollinaire be dodged into committing himself to the opinion that his, therefore, is first rate? And why shouldn't he? (p. 56)

By concentrating on Apollinaire's preface (OP, 865), which was the source of both quotations, Ciolkowska went right to the heart of the matter. Above all, she set about elucidating the principles contained in the play's subtitle: "drame surréaliste." Whereas the first term stood for action, she explained, the second was illustrated by the comparison between the human leg and the wheel. Although she disapproved of the latter on logical grounds, personally she found it "delightful." In fact, analogical development was at the heart of Apollinaire's new aesthetics, together with a calculated emphasis on surprise that Ciolkowska dubbed "superhumour." While Apollinaire's surrealism was eventually to be eclipsed by André Breton's, she rightfully perceived that it represented a radical new departure.

Following the publication of *Calligrammes* the same year, which Flint duly commented on, the readers of *The Egoist* were shaken to learn of Apollinaire's death in November. The official notice was provided by Huntly Carter who forwarded the following note from Gino Severini in Paris:

J'ai la douleur de vous annoncer la mort de notre ami Guillaume Apollinaire. Vous me feriez le plus grand plaisir en la faisant

connaître aux lecteurs de la belle revue *L'Egoist* en lui rendant honneur, ainsi que sa grande valeur lui en donne le droit. Nous perdons un grand poète, et notre défenseur le plus averti et le plus autorisé. Aussi les artistes d'avant-garde à Paris sont en deuil profond.[51]

Judging from a remark later in the year, and from the fact that he knew Severini, Carter may have known Apollinaire himself. Speaking of "the late Guillaume Apollinaire, the sometime leader of the advance-guard," he evoked "his wonderful little flat in the Boulevard St. Germain packed with Negro sculpture"—which suggests that he visited it on at least one occasion.[52] Severini's sentiments were echoed by Muriel Ciolkowska in the next issue who devoted a third of her column to Apollinaire's death and funeral.[53] She was saddened by his sudden death, at such a young age and leaving a brand-new bride behind, and she praised the impulse that caused him to join the army when he could have remained safely on the sidelines.

Despite England's cordial reception of Apollinaire's literary efforts during his lifetime, his reputation underwent a sudden reversal in 1920, largely at the hands of Richard Aldington. Whereas the latter had previously admired Apollinaire's accomplishments, he returned from the war a confirmed literary conservative with no patience for the experiments taking place around him. While Flint remained remarkably tolerant, even going so far as to praise the Dada movement, his friend denounced every innovative text he encountered. In some respects the stage was set by Harold Monro, who, in a discussion of *vers libre* the same year, attributed its demise to Apollinaire. "With the late Guillaume Apollinaire and others," he observed, "a mischievous instinct for destruction set in: they exhibited a desire to smash up the whole idea of verse-form."[54] Aldington undoubtedly concurred with this assessment, for in January he also deplored the excesses of the modern movement which had displaced Symbolism, he claimed, while proving far less fertile. Directing his wrath at what he perceived as the two chief tendencies of modern literature, he described the first as "a movement of affected dilettantism, languid and sterile, which is largely the humourous invention of the late Guillaume Apollinaire. . . . 'Dadaism,' which is a cult of pure imbecility disguised by intentional obscurity, is the latest symptom of the same disease."[55]

Six months later Aldington returned to the attack in a scathing review of *La Femme assise* (1920).[56] Although his remarks are much too long to quote in their entirety, a selection will provide some idea of the original article. Admittedly Apollinaire's novel suffered from serious defects. Assembled after the poet's death by his widow, it bore little relation to his

original project and was eventually replaced by a more faithful version. Despite, or perhaps because of, his animosity, Aldington's evaluation of the volume was remarkably astute. "The book is so loosely put together," he complained, "that one hesitates to call it a novel. It reads as if his literary executors had found among his papers and bundled together the opening of a rather indecent novel, a history of Mormonism, notes on the revival of dancing in Paris in 1914, a critique of Gavarni and a short soldier's diary." In fact this was an excellent description of the version he had before him. However, the review itself occupied less than one-fifth of the article. The remainder was devoted to Apollinaire in general and summarized most of his career.

Aldington began with some biographical data and the following opinion: "It would not be easy to convince many English readers that Apollinaire was either a fine poet or a trustworthy guide to modern art." This comment seems to have been motivated by Flint's articles the preceding year in which he insisted at least twice that Apollinaire was "a fine poet." While it quickly became apparent that Aldington did not share this view, he inserted a number of backhanded compliments in an attempt to be "fair." "It would be hypocritical to pretend that his writings have permanent value," he asserted, "but it would be obtuse to think that he was not 'a person of importance in his time' and one who influenced many young men of talent." Dismissing *Calligrammes* as "mostly nonsense," Aldington attacked Apollinaire's use of simultanism, accused him of amusing himself at the expense of others, and held him responsible for the birth of Dada. Apart from his introductions, he concluded, there was not much of his prose worth keeping, his art criticism was terribly dated, and much of his poetry had little meaning except to a handful of friends. At the same time, he conceded that his subject was neither ignorant nor a snob nor close-minded. "He had talent," Aldington admitted, "though he made some queer uses of it; he really cared for art; in spite of his affectations, he never compromised for the sake of money, and, still better, never cultivated the popular *genre ennuyeux*."

Writing in October Aldington reiterated his dislike of the new school of French poets, whom he portrayed as the literary heirs of Gertrude Stein. Since this article was signed, he abandoned his customary diatribe in favor of biting sarcasm:

> I begin with the late Guillaume Apollinaire, a man of considerable erudition and a writer of novels and literary criticism. Like other French disciples of Miss Stein, Apollinaire omitted the triviality of punctuation. [Here he inserted a prose transla-

tion of "À travers l'Europe" (OP, 201–2), formerly entitled "Rotsoge."]

 This work is entitled "Rotsoge," a word I cannot find in any dictionary; nor can anyone tell me what it means. The poem itself does not suggest to my incomplete intelligence what "Rotsoge" means. Indeed, I do not know what the poem "means," but the syntax proves it a masterpiece. . . . Apollinaire . . . may be considered the first French apostle of Steinism

 Americans, who believe with me that literature is something more than a series of little jokes, "leg-pullings," "astonishing the grocers," and so on, must forgive me for throwing the ultimate responsibility for this "new art" upon America.[57]

Incredibly, Aldington not only attacked simultanist poetry, a genre he himself had practiced, but he chose to ridicule the very poem he had singled out for praise six years before. He even used the same version, published in *Les Soirées de Paris*, although Apollinaire had since revised the poem and included it in *Calligrammes*. Decidedly, his view of poetry had undergone a radical shift since the days when he identified with the French avant-garde. The following year Aldington published an equally scathing review of *L'Enchanteur pourrissant*. As before, he insisted that the author was lacking in originality and that he simply had "an acquired novelty of manner."[58] While his postwar hostility was directed at the modern movement in general, he tended to pick on Apollinaire and F. T. Marinetti, whom he accused of having perverted the aims of Symbolism. As the acknowledged leaders of the French and Italian avant-gardes— which he referred to as the "wild West and aeroplane schools"—they were deserving of his fullest contempt.[59] Not only had Aldington's scale of aesthetic values changed since 1914, but the war seems to have greatly embittered him. In turning his back on his prewar experience, he sought to deny the validity not only of aesthetic experimentation but of his own link with the past.

EZRA POUND

Like Richard Aldington, who was steeped in the classical tradition, Ezra Pound originally knew very little about modern French verse. Arriving in London in 1908, he continued to pursue two interests he had developed in the United States: medieval Romance literature and contemporary poetry in English. Under the tutelage of F. S. Flint, however, he gradually became acquainted with recent developments in France. In 1911 and again in 1912 Pound spent several months in Paris, where he met a few poets and

gained access to the group associated with the *Mercure de France*. Although his knowledge of modern French literature was rudimentary at this stage, he returned to England impressed by what he had seen. Flint's detailed survey in August 1912 confirmed his impression and revealed the astonishing diversity of French poetic practice. By the following January Pound had concluded that the French were years ahead of their English and American counterparts. "The important work of the last twenty-five years has been done in Paris," he announced, adding that it deserved to be emulated.[60]

Returning to Paris the same year, Pound spent the month of April in the company of the Unanimist poets, whom he met by accident.[61] The latter included Jules Romains, Charles Vildrac, Georges Duhamel, Georges Chennevière, and, at that time, Pierre Jean Jouve. During his stay he participated in a magnificent Unanimist hoax involving a banquet in honor of the naïve philosopher Jean Pierre Brisset.[62] Fortified by his experience in Paris, which seems to have been exhilarating, Pound returned to London full of enthusiasm for Unanimism in particular. Although his interest in modern French poetry had originally been fueled by Flint, he soon began to develop a taste of his own. Whereas Flint thought that Emile Verhaeren was the greatest European poet, for example, Pound preferred Francis Jammes, Remy de Gourmont, and the Unanimists.[63] By September 1913 he had become so convinced of the superiority of French poetry that he wrote: "For the best part of a thousand years English poets have gone to school to the French, or one might as well say that there never were any English poets until they began to study the French. The history of English poetic glory is a history of successful steals from the French."[64]

On September 4th Pound published the first of seven columns in *The New Age* devoted to the new poetry in France. From the beginning he insisted that the choice of poets merely reflected his own interests and was not meant to be comprehensive. "I reserve the privilege of dragging in anything else I like," he added, "from [Théophile Gautier's] *Émaux et camées* to *Alcools* by Apollinaire."[65] Whether Pound had actually read *Alcools* by this date is difficult to say. Although the volume appeared on April 20th, while he was still in Paris, he would have had to buy a copy almost immediately before leaving for Venice. Thereafter, however, he had ample opportunity to acquaint himself with Apollinaire's poetry in London. By this time both Flint and Aldington were writing about the French poet, and the former had received a review copy of *Alcools*. In a letter to James Laughlin twenty years later, Pound confided that Apollinaire had sent him a copy as well.[66] In addition Pound may have come across the book in John Gould Fletcher's collection of contemporary French

poetry, which he borrowed for his columns.[67] Since Fletcher had only recently moved to London from Paris, he may have brought *Alcools* with him.

Regardless of the source of Pound's information, one thing seems clear: in his eyes Gautier and Apollinaire represented two important tendencies in modern French poetry. Just as the former was situated at the beginning of the tradition, the latter was its most recent practitioner. Both men played a significant role in developing modern poetics. The author of *Alcools* was not only the latest in a long line of eminent poets, but his work constituted a signficant advance over what had come before. While the following articles were mostly concerned with the Unanimists, Pound returned to Apollinaire in October in his very last column. Once again, although he referred to the poet only in passing, the way in which the reference was couched is revealing. "Among the younger men Jouve seems to me to show promise," he observed, "and Apollinaire has brought out a clever book."[68] This judgment was echoed the same month in another article published in *Poetry*. Summarizing the seven columns in *The New Age* for his American readers, Pound recorded a number of observations and concluded: "Also *Alcools*, by Guillaume Apollinaire (Mercure), is clever."[69]

Brief as they are, these comments supplement his previous remark and provide a more detailed portrait of Apollinaire. In the first place, although they appear to be identical, they differ in one important respect. Despite Pound's high regard for Unanimism, including the work of Pierre Jean Jouve, he omitted the latter from the second article because of limited space. Forced to choose between Jouve and Apollinaire, he opted for the author of *Alcools*, whom he judged to be more important. In the second place, although "clever" has become synonymous with superficial facility, it was high praise at the turn of the century. When Flint wrote that "Apollinaire was one of the clever young men of France" in 1919, he was paying tribute to the poet's talent. The same observation applies to Huntly Carter who in 1917 praised the "clever" music that accompanied the performance of *Les Mamelles de Tirésias*. Thus while Pound seems at first glance to be dismissing Apollinaire's achievement, the reverse was actually true. Despite his attraction to the Unanimists and other poets who were writing in the same vein (derived from Walt Whitman), he recognized Apollinaire's exceptional merit.[70]

The second text by Apollinaire to catch Pound's eye that year was the manifesto *L'Antitradition futuriste* (*Prose* II, 937–39). Dated 29 June 1913, the latter seems to have made quite an impression on the English avant-garde, who were unaccustomed to seeing the word for excrement set to

music. Although the first issue of *Blast* was partially inspired by this document, as previously noted, it did not appear in print until a year later. In the meanwhile Pound amused himself by adopting Apollinaire's battlecry on various occasions. Writing under a pseudonym in January 1914, for example, he attacked the "systemized smugness" of the London *Times.* "There is within us nothing to say beyond the Gallic 'five letters,' " he exclaimed in frustration. As tempting as this response appeared, however, it presented an unusual problem which he addressed in the following paragraph: "Are we . . . expected to stretch the one word *merde* over eighteen elaborate paragraphs?"[71] Certainly this would have been a logical solution and one that was richly deserved. The next month Pound made use of Apollinaire's epithet again in the context of a recent lecture by T. E. Hulme on "The Vital and the Geometrical in Art." While he disagreed with Hulme's characterization of modern art, the latter was not the target of his attack. Rather his anger was directed at the English artistic establishment, which was incapable of appreciating works by such modern masters as Jacob Epstein and Henri Gaudier-Brzeska. "To the present condition of things," Pound protested, "we have nothing to say but '*merde*'; and this new wild sculpture says it."[72]

On June 20th, these and countless other objections to the status quo were formalized in the first issue of *Blast.* Although Pound and Lewis would undoubtedly have preferred the English equivalent of *merde* as their slogan, its presence in the volume, let alone splashed across the cover, would have caused the review to be confiscated. While "blast" did not have the same shock effect, it was a whole lot safer. Underlying the English euphemism, however, were traces of the original epithet which Pound associated with the initial phases of Vorticism. In the second issue, published in June 1915, the term surfaced again in a poem entitled "Et Faim Saillir Les Loups Des Boys." Devoted to the theme of implicit censorship, the latter assailed "cowardly editors" for presuming to tell him what to write. "If I dare / Say this or that, or speak my open mind," he complained, "They will cut down my wage, force me to sing their cant, / Uphold the press, and be before all a model of literary decorum. / Merde!"[73] The same year also saw the creation of "L'Homme Moyen Sensuel," which mercilessly satirized the American Way of Life. Singling out the American literary establishment for special attention, Pound wrote: "All one can say of this refining medium / Is 'Zut! Cinque lettres!' a banished gallic idiom."[74] Once again, as in the preceding works, the poet attacked the smugness and lack of comprehension of the arbiters of public taste.

The third text by Apollinaire that Pound encountered in 1913 was *Les Peintres cubistes*. Although exactly when and how he came to read the volume is unknown, by the spring of 1914 he was sufficiently familiar with it to quote from it during a lecture. Presented at the Rebel Art Centre at 38 Great Ormand Street, the latter was eventually published in September under the title "Vorticism."[75] One of the key texts in the history of the Vorticist movement, the article contained an equally important discussion of Imagism including the genesis of the ur-text "In a Station of the Metro." For our purposes, however, Pound's introductory remarks hold more interest. Distinguishing between Picasso and Kandinsky on the one hand and the Futurists on the other, he observed:

> We are all futurists to the extent of believing with Guillaume Apollinaire that "On ne peut pas porter partout avec soi le cadavre de son père." But "futurism," when it gets into art, is, for the most part, a descendent of impressionism. It is a sort of accelerated impressionism. (p. 461)

This brief paragraph is more complex than it first appears. Ironically, while Apollinaire's statement is taken from *Les Peintres cubistes*, it is inserted into a discussion of Italian Futurism.[76] Among other things, this is one more indication that Pound was familiar with *L'Antitradition futuriste*, for this is the only document linking Apollinaire to the movement. Although Pound may have had some questions about the poet's aesthetics, he certainly knew he was not a Futurist. Indeed the paragraph distinguishes between a general tendency in the first sentence and the organized school in the second. The whole point of the French quotation is that it addresses a common avant-garde concern. Whereas Futurism was concerned with a specific program, which Pound alludes to, English artists and writers were primarily rebelling against the past—like Apollinaire. Seen in this perspective, the quotation proclaimed their solidarity with one of the poet's goals. Like Apollinaire, Pound and his friends were striving to free themselves from the burden of tradition. In this context Apollinaire's remark provided them with an excellent slogan.

As noted, the First World War interrupted Apollinaire's literary activities for some time. Although his name did not appear in Pound's writings for more than a year, in 1916 it reappeared in several places. In particular Pound reprinted his "Vorticism" article in a book entitled *Gaudier-Brzeska: A Memoir* (pp. 94–109), which included the quote from *Les Peintres cubistes*. For those who were fighting on the artistic front, Apollinaire's slogan was as valid as ever. In April, moreover, Pound published an article in *Poetry* in which he assessed recent developments in

French poetry. "Even France . . . will not leave us hopelessly in the rear," he reported; "We may estimate the weight of her younger generation at more or less that of Jules Romains, Charles Vildrac, M. Jouve, and MM. Klingsor, Jacob, Apollinaire etc."[77] By this date, as the second sentence demonstrates, Pound had replaced some of his earlier enthusiasms and had narrowed the field to six poets who had clearly proved their worth. Whereas the first three belonged to the Unanimist school, the second three were associated with the Fantasist group. To be sure, Apollinaire was not really a *fantaisiste*, but this was a popular misconception. That his name occurs in connection with Tristan Klingsor and Max Jacob confirms that Pound did not associate him with Futurism. Interestingly, although Apollinaire had been fighting at the front for well over a year, his reputation does not seem to have suffered. In Pound's eyes at least he was one of the best French poets.

By the end of June Pound had revised the above list to include a talented newcomer. One of Flint's favorite authors, Jean de Bosschère had recently settled in Paris, where he corresponded with the Imagists in London. Writing to Margaret Anderson, who together with Jane Heap edited *The Little Review*, Pound urged her to publish a selection of Bosschère's poetry in a forthcoming issue. "He is undoubtedly the most 'modern' writer Paris can boast," he declared, "not excluding Apollinaire." In response to Pound's recommendation Bosschère's "L'Offre de plebs" appeared in the November issue of *The Little Review*, in French, preceded by an anonymous introduction in English. Seeking to establish the Belgian poet's credentials, the author cited Pound's opinion nearly verbatim.[78] What is interesting about the latter is not that Apollinaire had supposedly been dethroned by Bosschère but that Pound previously thought he was the most modern poet in Paris. While he had dropped to second place since April, presumably he was just as modern as before. Not only was Apollinaire an excellent poet, therefore, but he was associated in Pound's mind with poetic progress. In his capacity as head of the French avant-garde, he was committed to aesthetic change.

Under Pound's tutelage *The Little Review* began to prosper and soon established itself as a serious forum for modern poetry. Wishing to expand the review's scope, he advised the editors to include modern art in addition. The presence of a number of photographs in each issue, for example, would give the review greater visual appeal and would stress its commitment to modern aesthetics in general. "There is a chance to do what the *Soirées de Paris* was doing before the war," Pound wrote on September 13, 1917, adding "(Only we have real literature as well.) They will start up again, I suppose, after the war but that's no reason why we

shouldn't start first."[79] Although his suggestion was not immediately accepted, it was destined to bear fruit four years later when *The Little Review* began to include artists among its contributors. In any case this is the earliest indication we have that, like Flint and Aldington, Pound was familiar with Apollinaire's journal. While he evidently preferred the artists who graced its pages to its literary collaborators, he was acquainted with all it had to offer. Not only did Pound suggest that *The Little Review* model itself on *Les Soirées de Paris*, moreover, but he advised Margaret Anderson to include a column modeled on Apollinaire's "La Vie anecdotique" in the *Mercure de France*. In a letter dated November 5, 1917 and packed with bits of advice, he wrote: "Will you take on a rubric of the L. R. as Gustave Kahn, Apollinaire etc. do on the *Mercure*?"[80] As these two examples demonstrate, Apollinaire was associated in Pound's mind not only with modern poetry and art but with successful literary reviews as well.

Over the next few years Pound added little to his previous evaluation(s) of Apollinaire. Although the latter published a number of other works, including *Calligrammes* in 1918, the few references that occurred were to his prewar publications. In April 1918, for instance, Pound again singled out *Les Soirées de Paris* for praise. Reviewing an exhibition at the Alpine Club Gallery, using a pseudonym, he wrote:

> There are, doubtless, many people still alive . . . who would find some of the Friday Club products "startling." But anyone who has followed current work; anyone who has even glanced at a few numbers of *Les Soirées de Paris*, will see that this group of painters is simply in the current of the time. . . . They must not be attacked as fumistes, or as a dangerous revolution.[81]

Among other things, Pound's remarks imply that Apollinaire's review was at least four years ahead of its time. Ironically, paintings that had appeared in its pages before the war were still "startling" many viewers.

Like the preceding example, a second reference a few months later evoked the ferment that characterized the Imagist and Vorticist period. As we have seen, the latter coincided not only with Apollinaire's increased visibility but with Pound's initial exposure to the poet. In the first of a five-part series entitled "What America Has To Live Down," published in August, Pound recalled another event from this period. Reacting indignantly to American intolerance, he noted that Walt Whitman's translator, Léon Bazalgette, might not be invited to visit the United States as a result of "a sprightly letter which appeared some years ago in the *Mercure de France*." Despite Bazalgette's contribution to Franco-American relations,

he added, "there is extant a description of Walt Whitman's funeral which presumably scandalizes Mr. Traubell."[82] Pound was alluding, not to a transgression on the translator's part but to a celebrated incident five years earlier involving another author. In 1913, apparently at the instigation of Blaise Cendrars, Apollinaire published an April Fools column that scandalized a great many people. The latter seem to have included the dean of American Whitmanists, Horace Traubel, who concluded that French critics were not to be trusted. Purporting to be an eye-witness account of Whitman's funeral, the column portrayed the latter as a drunken brawl between hordes of pederasts and the poet's homosexual lovers.[83] For Pound the incident dramatized the difference between American prudery and the more enlightened attitude adopted by France. While the joke may have been in bad taste, as critics charged, Apollinaire was free to publish whatever he wished. In addition Pound undoubtedly found the incident amusing. Although he had recently overcome his long aversion to Whitman's poetry, one suspects that he enjoyed seeing his former adversary manhandled by Apollinaire.[84]

While the preceding evauations of Apollinaire speak for themselves, perhaps the most telling reference appeared toward the end of 1920. In many ways it summarized the period surrounding World War I and anticipated the poet's reputation during the twenties. Discussing the recent emergence of Dada in Paris, Pound turned his attention to the writers who were associated with the review *Littérature*. "Which brings us to the young and very ferocious," he remarked; "The young and very ferocious are going to 'understand' Guillaume Apollinaire as their elders 'understood' Mallarmé."[85] Although their styles were vastly different, the comparison between Apollinaire and Mallarmé is revealing. In the first place, since the latter's work was highly resistant to interpretation, it suggests that Pound found Apollinaire's poetry to be equally difficult. While many of the texts were perfectly accessible, he seems to have been impressed by poems such as "Arbre" (OP, 178–89) or "Les Fiançailles" (OP, 128–36) which at first glance seem impenetrable. Indeed Pound's comment implies that Apollinaire's poetry, like Mallarmé's, is constructed in such a way that its meaning is continually deferred. Whence the irony directed at "the young and very ferocious," who thought they could determine the latter for once and for all.

In the second place, since Mallarmé epitomized a whole generation of poets (of which he was the leader), the comparison suggests that Apollinaire played an analogous role for the succeeding generation. This was in fact the case, as Pound well knew. Like his predecessor, Apollinaire not only expressed the goals of an entire generation but deter-

mined the criteria by which the new poetry was to be judged. The work of both men served to illustrate their respective theoretical programs. In the third place, Pound's comment suggests that by 1920 Apollinaire had acquired a stature among his contemporaries comparable to that of Mallarmé. For the poets of the twenties he was both an authority figure and the symbol of an era. His very name was synonymous with modern aesthetics.

Although Apollinaire's reputation continued to grow during the next ten years, Pound ceased to think about him as he busied himself with innumerable projects. In April 1921 he left London for Paris, where he spent the next three years. The same month he wrote Wyndham Lewis that henceforth *The Little Review* would include twenty photographs of a single artist in each issue, in the tradition of *Les Soirées de Paris*.[86] The following year, coinciding with its own move to Paris, *The Little Review* printed a translation of *Les Peintres cubistes* in three installments. While the volume had a certain historic interest, Cubist painting had undergone a great many changes since 1913. In a letter to Lewis, who was also in touch with the editors, Pound wrote: "You might also tell em that Guillaume Apollinaire died some years ago, and that his book on Cubism is a little out of date."[87] Subsequent references to the French poet were even more fleeting and/or indirect. In 1929, for example, Pound advised Charles Henri Ford how to go about forming a literary group and a manifesto based on Apollinaire's model. "List the revered and unreverend authors you approve or disapprove of," he suggested, remembering his own experience with *Blast*.[88]

On June 30, 1931, the poet Louis Zukofsky, who had become a frequent correspondent, wrote to Pound about a new project he was undertaking. At the request of René Taupin, he declared, he had agreed to write a book on Apollinaire which Taupin would then translate into French.[89] The work itself, which was eventually entitled *Le Style Apollinaire*, occupied Zukofsky for the next two years and was the subject of a number of letters to Pound. On July 12th, for example, Zukofsky urged him to pressure Samuel Putnam to send him some rare Apollinaire material he owned. In exchange he enclosed his translation of Apollinaire's "La Cueillette" (OP 318), an uninspired work published posthumously, which he may have intended to include in the volume. When Pound eventually received the completed manuscript he read the first six pages and fired off a letter full of criticism. Zukofsky replied on 15 December 1932 that he was proud of the work and defended himself against Pound's accusations. In 1933 Zukofsky was able to visit Pound in Rapallo where he had settled in 1925. According to Charles Norman, Pound still didn't like the

book and frankly said so. "Perhaps three people understood your Henry Adams," he exclaimed, "but only two will understand your Apollinaire. How do you expect to live?"[90] Notwithstanding his objections, *Le Style Apollinaire* was published in 1934 by Les Presses Modernes. Co-authored with Taupin, it displayed a high regard for its subject but was composed in an idiosyncratic style.

As World War II approached, Pound inadvertently contributed to the flourishing mythology that had grown up around Apollinaire since his death. Inexplicably, his *Guide to Kulchur* (1938) contained the following statement: "Before 'lifting' large chunks of the Congo collection from the Musée du Trocadéro, Guillaume Apollinaire had called Frobenius 'father.' "[91] While he presented this information as if it were an established fact, Pound was mistaken on both accounts. In the first place, in his haste to trace French writings on African art back to Leo Frobenius, he invented a link between the latter and Apollinaire that in fact never existed. As far as can be ascertained, despite his lively interest in this subject Apollinaire was unaware of the German anthropologist's studies. In the second place, there is no evidence that the French poet ever stole anything from the African museum in Paris, although he frequently visited it. Pound liked this story so much that he repeated it on other occasions, for example to Wyndham Lewis in 1949.[92] Unfortunately, he seems to have confused Apollinaire's writings on African art with his imprisonment in 1911 on suspicion of being an accomplice to the theft of the *Mona Lisa*. The fact that an acquaintance had stolen several Iberian (not African) statuettes from the Louvre (not the Trocadéro), which came to light during the investigation, undoubtedly contributed to the confusion.[93]

Although the Frobenius story portrayed Apollinaire in a favorable light, as someone who early recognized the anthropologist's genius, the last serious reference to the poet appeared in *The Criterion* in 1930. In a wide-ranging essay devoted to contemporary modes of expression, Pound compared the situation of the modern writer to that of the scientist. The following excerpts capture the gist of his argument:

> As far as writing goes we are laggards, I mean in relation to scientists; we still cling to modes of expression and verbal arrangements sprung from, and limited by, scholastic logic. French suffers from a worse paralysis than English. The verbal stirring of Apollinaire and Cocteau is not yet comprehended. . . . The biologist is familiar with, and capable of distinguishing, an infinite number of states, things, differences for which there are no verbal equivalents.

We no longer think or need to think in terms of monolinear logic, the sentence structure, subject, predicate, object, etc.

We are as capable or almost as capable as the biologist of thinking thoughts that join like spokes in a wheel-hub and that fuse in hyper-geometric amalgams.[94]

As the preceding passage demonstrates, this extraordinary article functions on several levels at once. Although it masquerades as an attempt at self-criticism, among other things it represents an implicit apologia for Pound's later poetry. Despite his use of the first person plural, he was entirely innocent of the crime he was denouncing. Unlike the writers he was attacking, his work exemplified the mode of expression recommended in the article. The only reason English literature was healthier than the French, if indeed it was, was due to the efforts of Pound and his friends. While the foregoing constituted the essay's subtext, its immediate subject was the expressive model developed by science. In this context two authors were singled out as examples of the scientific approach to literature: Apollinaire and his successor Jean Cocteau. As the article makes clear, their role was nothing short of heroic in the face of widespread incomprehension. Their poetry was so advanced that it was still not understood by most of their contemporaries. As Pound well knew, the basic technique originated with Apollinaire who bequeathed it to Cocteau (and others) after his death. By 1930, therefore, Pound had come to regard Apollinaire as the founder of twentieth-century French poetry. Only he and his disciples were capable of dissipating the poetic paralysis that had gripped the nation.

Interestingly, Apollinaire had previously explored the rivalry between poet and scientist in his essay "L'Esprit nouveau et les poètes," which appeared in the *Mercure de France* in 1918. Even more interestingly, he came to much the same conclusion as Pound writing twelve years later. Like the latter he concluded that poetry had fallen behind science in its ability to express subtle distinctions. "Déjà, la langue scientifique est en désaccord profond avec celle des poètes," he noted. "C'est un état de choses insupportable."[95] As Pound intimated, Apollinaire's poetry attempted to redress the balance by following the program outlined in his (Pound's) article. Described in "L'Esprit nouveau et les poètes" and else-where, this involved a two-step process. The first step required the poet to cultivate a modern sensibility. In keeping with the revolution in communication and transportation that had recently taken place, thought and perception were to be telescoped into one. The second step required the poet to find a way to translate his new consciousness into words. The difficulty here, Pound explained, was that many modern impressions had no

verbal equivalents. Eschewing the pitfalls of "monolinear logic," the poet could partially overcome this handicap by structuring his verses "like spokes in a wheel-hub." By refusing to privilege any one verse over the others he could encourage the reader to reconstruct the situation mentally. In fact this is an excellent definition of cubist poetry. By adopting the tenets of simultanism, Apollinaire sought to overcome the limitations of the written word and to stimulate the reader's imagination. The same thing may also be said of Pound.

The convergence of these two aesthetic doctrines points to a question that recurs again and again in the literature devoted to the two poets. What, if any, was Pound's debt to Apollinaire? On the one hand, Herbert Read, who knew many of the Imagists and the Vorticists personally, claims Apollinaire helped to modify Browning's influence on Pound's early work.[96] On the other hand, Zukofsky once told an interviewer that Pound didn't care for Apollinaire since James Joyce and William Carlos Williams had done the same thing earlier.[97] Andrew Clearfield concludes from this that Pound developed an intense dislike for the French poet in later years and suggests that he resented the latter's playfulness.[98] Not only is Zukofsky's chronology obviously incorrect, however, as Clearfield remarks, but it contradicts the portrait of Apollinaire that has emerged during the course of this investigation, which has remained consistently positive. Writing to James Laughlin in 1934, Pound criticized Zukofsky's book on Apollinaire for being overly analytical, an approach that in his opinion should be reserved for perfection or for "a prevalent disease." "And I don't think Apollinaire/Cohen von Salembergstein was either," he added. "I mean his work. He was I believe very useful while on the hoof."[99]

Clearfield discerns three distinct areas in which Pound may have been indebted to Apollinaire: in the "Moeurs Contemporaines" series (1918), in his use of ideographic technique, and in the *Cantos*. In retrospect the first category seems to be the least likely of the lot. The ironic social commentary in the "Moeurs Contemporaines" (*Personae*, 178–83) is almost entirely absent from Apollinaire's poetry. If anything, it recalls several poems by T. S. Eliot that are written in French. Whereas the first possibility represents a dead-end, two earlier texts are highly reminiscent of *Alcools*.[100] Both thematically and in terms of their diction, "Pan is Dead" (*Personae*, 72), which dates from 1912, and "Dans Un Omnibus de Londres" (1916) (*Personae*, 160) resemble Apollinaire's attempts to inject new vigor into Symbolist poetics. The resemblance is increased, moreover, by the existence of potential models for each of these works. Not only did Apollinaire write a poem entitled "Mort de Pan" (OP, 707), but

he anticipated the second work in "La Maison des morts" (OP, 66–72). Although the two Pan poems have much in common, the fact that the French version was published posthumously rules out any possible influence. Pound and Apollinaire were simply attracted to the same theme.

With regard to the second work, which is written entirely in French, the situation is more complex. In "La Maison des morts," which Pound knew from *Alcools*, Apollinaire recounts his visit to a cemetery in Munich where the corpses that were waiting to be buried were displayed in a window like mannequins. Coming back to life in the poem, they form amorous couples with passers-by and go for a walk in the country before returning to the window for good. Pound's text begins with a verse that seems to recall Apollinaire's surprise before the mortuary window: "Les yeux d'une morte aimée / M'ont salué." Like the characters in "La Maison des morts," moreover, the lady in question is simultaneously dead and alive since the narrator encounters her on a London bus. The rest of the poem consists of memories of a previous walk taken together in the Parc Monceau in Paris. Despite a number of intriguing parallels, however, Pound's inspiration is fundamentally different from that of Apollinaire. The likelihood of influence is further decreased by the discovery that the first line was taken from two poems in *Riposte* (1912), where it appeared in English.[101]

The remaining two categories present problems that are analogous to the first. While it is true that Apollinaire called his first visual poems "idéogrammes lyriques," Pound's experiments with ideographic technique antedated his own by some two years. Whereas the former dated from 1914, the latter were inaugurated by "In a Station of the Metro," which was conceived in 1911 and composed in 1912.[102] Where there appears to be a certain amount of overlap is in the term Pound chose to describe his attempt at creating an indigenous haiku. In "Vorticism," published in September 1914, he explained that "In a Station of the Metro" was "a form of super-position, that is to say it is one idea set on top of another."[103] While the word "superposition" exists in English (without a hyphen), it is rarely used. Instead, one commonly speaks of the superimposition of one thing on another. This fact suggests that Pound borrowed the term from the French or rather from a French author he had been reading. However, a survey of the major texts of the period reveals that, like their English colleagues, critics in France preferred to speak of "juxtaposition" in such circumstances. Rather than superimposing things, they insisted on placing them side by side.

A notable exception to this rule occurred in an important theoretical text by Apollinaire devoted to simultanism. In "Simultanisme-

Librettisme," published in *Les Soirées de Paris* on June 15, 1914, he praised Blaise Cendrars and Sonia Delaunay for having created the first truly simultaneous work. In *La Prose du transsibérien*, Apollinaire declared, "des contrasts de couleurs habituaient l'oeil à lire d'un seul regard l'ensemble [du] poème, comme un chef d'orchestre lit d'un seul coup les notes super-posées dans la partition."[104] The fact that Pound employed the same termi-nology less than three months later—in an article in which he referred to two other texts by Apollinaire—suggests that he had read "Simultanisme-Librettisme" as well. It also suggests that he appropriated some of Apollinaire's ideas in the search for a solution to his aesthetic problems. After all, the poetry of superposition, which he was in the process of elabo-rating, was essentially a poetry of simultaneity. Although Pound's experi-ments with superposition began with a single image, they allowed him to create simultaneous structures of tremendous complexity, first in "Homage to Sextus Propertius" (1917) and then in the *Cantos*. His 1930 arti-cle, in which he rails against "monolinear logic," shows just how well he understood what Apollinaire had been doing. As noted, it reveals that Pound had an excellent grasp of cubist poetics which he exploited in his own poetry. While this comes as no surprise to readers who are familiar with the *Cantos*, it needs to be reiterated. In the last analysis, this seems to be the area in which Apollinaire had the greatest influence. Pound appears to have benefited, not just from his discussion in 1914 but also from his general example.[105]

The question that naturally arises, therefore, is why Pound did not refer to Apollinaire more often. Why did he devote column after column to so many French poets but never to the author of *Alcools*? At times Pound seems to be deliberately avoiding the poet as if he made him uneasy. Perhaps this explains why he consistently misspelled Apollinaire's name. His apparent ambivalence is all the more remarkable since the two men closely resembled each other. Clearfield lists the following similarities between them: a common interest in a spare, free verse; the inclusion of extrapoetic materials in their poetry; the abolition of transitions between masses of materials; a tendency to deflate their poetry at the climactic moment; an interest in spatial form; a self-conscious role as innovator; the desire to become an arbiter of taste in all the arts; a flair for self-publicity; and conservative political views.[106]

To be sure, Pound's initial exposure to Apollinaire was tempered by the fact that the Unanimists were ill-disposed toward him. As a member of the rival Dramatist group, Apollinaire was the object of considerable animus on their part.[107] Nevertheless, this hardly suffices to explain how Pound could continue to neglect him after he began to recognize his tal-

ent. One explanation is undoubtedly that he thought the French poet was Jewish. The reference to "Apollinaire/Cohen von Salembergstein" reflects his antisemitic bias all too clearly. Another explanation is that Apollinaire and Pound were professional rivals. As prominent leaders of the avant-garde they occupied identical positions on each side of the English Channel. While this was of little consequence to Apollinaire, it seems to have played a part in determining Pound's treatment of him in print. Ironically, one of the problems with Pound and Apollinaire was that they had too much in common.

The New Spirit
in North America

That the expatriate experience in France during the 1920s played a crucial role in the development of American literature is widely recognized. It furnished American writers with vital stimuli and fresh perspectives much as had French Symbolism a decade or more before—although the importance of the latter has perhaps been exaggerated.[1] Until relatively recently, the period between these two experiences had been largely neglected insofar as contemporaneous French influence was concerned. The little work that had been done tended to concentrate on the Gertrude Stein circle in Paris and the Pound-Eliot group in London. In the last few years, more and more critics have turned their attention to artists and writers who were working in the United States. Not only were their experiments equally important, as we have come to realize, but in many cases they were motivated by those of their French colleagues. As these Americans sought to learn more about recent developments in France, moreover, they encountered Apollinaire's name with increasing frequency.[2]

Prior to 1913 Apollinaire was virtually unknown in the United States. Although a handful of individuals were familiar with his column in the *Mercure de France*, few if any suspected he was an important art critic and poet. That year and the next, however, Apollinaire attracted the attention of the American avant-garde in connection with two separate events. Although one of these was of minor importance, the other was destined to have longlasting repercussions. As noted in the previous chapter, the publication of his April Fools' Day column describing Walt Whitman's orgiastic funeral generated a wave of protest. According to a letter from

Adelaide Estelle Bear, who wrote to request a copy of his article, Apollinaire's "attack" on Whitman even received coverage in the American press.[3] Among the letters that appeared subsequently in the *Mercure de France* was one from the author Benjamin de Casseres, who frequented the Alfred Stieglitz circle in New York. In a letter dated May 8, 1913, he wrote to defend Whitman's honor and added: "Nous qui, en Amérique, lisons le *Mercure de France* (et, pour ma part, je ne saurais exister sans cela), avons été stupéfaits par la description des cérémonies funèbres. . . . Depuis des années j'admire M. Apollinaire, mais parler de 'mauvais goût' . . . n'est pas suffisamment fort."[4]

While Casseres' words of praise were overshadowed by the rest of his letter, which discussed Whitman's funeral, there is no reason to doubt the sincerity of these remarks. Indeed, as he himself stated, he seems to have been an avid reader of "La Vie Anecdotique" from its inception in 1911. We know, for example, that in 1912 Casseres sent Apollinaire a copy of a prose poem he had written entitled "Prelude." Responding to what he evidently felt was a kindred soul, he concluded that the French writer was one of the few persons capable of appreciating his recent work. Presumably Casseres' outrage the following year was assuaged by his admiration for the poet and by the latter's apology in the *Mercure de France* on 16 December. One assumes that he remained a loyal fan of Apollinaire's for many years to come. There is even some indication that the two men corresponded briefly. Ironically, as he reported in the *Mercure de France*, Apollinaire concluded from the handwriting on the envelope in 1912 that "Prelude" had been composed by his old friend Faïk beg Konitza (see chapter 2), who had adopted yet another alias after emigrating to America. When *Les Peintres cubistes* appeared the following year, he sent a copy to Casseres with the inscription: "A Faik-Bèg-Konitza / A Thrank-Spirobeg / A Thrank-Spiriberg / A Pyrrhus Bardily / A Benjamin De Casseres / A l'ami perdu / Guillaume Apollinaire."[5] Although Casseres must have been surprised by the initial confusion between himself and Konitza, he had not bothered to disabuse Apollinaire. Possibly he shrugged it off as an authorial eccentricity. The arrival of an autographed copy of Apollinaire's latest book, however, proved that it was a case of mistaken identity. What transpired at this point is open to speculation. Judging from a manuscript in the Bibliothèque littéraire Jacques Doucet (MS 7562), Casseres wrote to Apollinaire subsequently and enclosed an article for publication in the *Mercure de France*. While the manuscript is unsigned, a number of factors point to Casseres as the author. A satirical attack on the institution of poetry in America, it is written in the latter's characteristic style and dis-

plays great familiarity with poetry being written in New York—including his own work.

The second event that aroused the interest of the American avant-garde was the publication of *Les Peintres cubistes* on 17 March 1913. More than anything, the source of that interest was the gigantic art exhibition known as the Armory Show, which opened in New York and traveled to Chicago and Boston. Although the New York show had closed its doors a few days earlier, it generated a lot of curiosity about Cubism. In addition the painter Francis Picabia, who was in town for the exhibition, spent considerable time and effort publicizing Apollinaire's book, succeeding in one instance in persuading a major bookstore—Brentano's—to order several copies.[6] Whenever and wherever he could, Picabia publicized Apollinaire and the Orphist painters. It was undoubtedly due to his efforts, for example, that John Weichsel quoted several passages from *Les Peintres cubistes* in April of the same year. As far as can be determined Weichsel was the first person in America to mention Apollinaire's name in print. Writing in Stieglitz' journal *Camera Work* about recent developments in France, he chose to include three different excerpts. The first stressed the relativity of aesthetic guidelines, the second focused on modern art's need to break with the past, and the third discussed the principles underlying abstract art.

> "Ce monstre de la beauté n'est pas éternel," exclaims Apollinaire. L'Art moderne repousse, généralement, la plupart des moyens de plaire mis en oeuvre par les grands artistes des temps passés. . . . On s'achemine ainsi vers un art entièrement nouveau, qui sera à la peinture, telle qu'on l'avait envisagée jusqu'ici, ce que la musique est à la littérature. Ce sera de la peinture pure, de même que la musique est de la littérature pure. L'amateur de musique éprouve, en entendant un concert, une joie d'un ordre différent de la joie qu'il éprouve en écoutant les bruits naturels, comme le murmure d'un ruisseau, le fracas d'un torrent, le sifflement du vent dans une forêt, ou les harmonies du langage humain fondées sur la raison et non sur l'esthétique. De même, les peintres nouveaux procureront à leurs admirateurs des sensations artistiques uniquement dues à l'harmonie des lumières impaires."[7]

Although Apollinaire's observations were prompted primarily by the short-lived Orphist movement, in fact they provided an excellent introduction to modern art. Equally interesting is Weichsel's off-hand manner

of indicating their source, which assumes that his readers were familiar with the book in question.

Writing in *The International Studio* the following month, the art critic Christian Brinton elaborated in greater detail on Orphist practice, which he linked both to Picabla and to Apollinaire. "It is in the production of Picabia," he declared, "that we are permitted to note the transition from Cubism to Orphism, which is the latest phase of present-day artistic development in France. It is the poetic and erudite Guillaume Apollinaire who has given the group the characteristic name of Orphists, their work being in essence an evocation, an appeal to intellectual and emotional sensibility, rather than a transcription or recollection of reality."[8] Ironically, while Apollinaire was becoming known in America as an authority on the Cubists, he was portrayed as the leader of the school that had replaced them. Here again, as in most of the articles on modern French painting occasioned by the Armory Show, much of the information was provided by Picabia.

With the publication of *Les Peintres cubistes*, an additional source became available. Writers like John Weichsel could supplement what Picabia told them with information drawn from Apollinaire. The contrast between Christian Brinton's commentary and an article by Maurice Aisen, published in *Camera Work* in June, is instructive. Whereas the former is forced to qualify his definition of modern art repeatedly, in an attempt to cover every eventuality, the latter gets right to the heart of the matter. "The painting of today," Aisen remarks, "is but just born; but we are already conscious that it is the emotion of the *réalité* of conception that the new movement tries to produce and not the *réalité* of vision, the painting of yesterday."[9] This distinction, which opposes the aesthetics of vision to that of conception, is taken almost word for word from Apollinaire's book, where it opens the famous section on Cubism's four tendencies.[10] Indeed, one encounters a discussion of these tendencies—scientific, physical, instinctive, and Orphic—a little later in the same issue of *Camera Work*. This discussion takes the form of an anonymous article written in French and entitled "Vers l'amorphisme." Published previously in *Les Hommes du Jour* according to a footnote, it introduces the reader to Apollinaire's Cubist taxonomy and then discusses the Orphic tendency in detail. Elsewhere in the article the author quotes the celebrated phrase: "Un Picasso étudie un objet comme un chirurgien dissèque un cadavre"— also taken from *Les Peintres cubistes*.[11] Despite the essay's cloak of anonymity, William Agee believes that it was authored by Picabia.[12]

Not all the critical reaction to Apollinaire's volume was favorable, of course. In the United States, as in France, *Les Peintres cubistes* attracted the

ire of conservative critics to whom modern art was anathema. Writing in *The Nation* the following year, for example, Frank Jewett Mather, Jr. complained that it was "hopelessly unintelligible" compared to Wassily Kandinsky's *On the Spiritual in Art*.[13] What he evidently objected to was the fact that Apollinaire's book was not written in expository prose. Expecting to learn about principles and methods, he was disconcerted to find that it consisted of a series of poetic meditations. On the other hand, 1914 saw the publication of a lengthy study in which Apollinaire's work was treated with respect. In one of the first volumes on modern art to appear in America, entitled *Cubists and Post-Impressionists*, Arthur J. Eddy quoted him fairly extensively and listed a number of his publications. Closely paraphrasing section VII of *Les Peintres cubistes* in one place, he not only traced the history of Cubism but presented the four tendencies detected by Apollinaire. Quoting three paragraphs from section II in another, he reproduced the latter's analysis of the new painting in terms of Euclidian and non-Euclidian geometry.[14] In contrast to Mather, Eddy valued Apollinaire's discussion of modern art and found it to be perfectly comprehensible.

Although references to *Les Peintres cubistes* were relatively frequent during the period preceding the war, Apollinaire's poetry was almost totally disregarded even after the publication of *Alcools* in 1913. Whereas the Imagists were relatively quick to realize the worth of the latter volume, the American response was much more subdued. In 1913 only one or two individuals came across *Alcools* who were capable of appreciating its significance and of bringing it to the attention of the American avant-garde. In his memoirs, published fifty years later, Man Ray recalls how Adon Lacroix and he lived together in an artists' colony in Ridgefield, New Jersey, before their marriage. In October 1913, on the day that she moved in with him, he found her unpacking a crate of French books by authors such as Baudelaire, Mallarmé, Lautréamont, and Rimbaud. "Then there was Apollinaire," he adds, "whose calligrammes played havoc with typography, who defended the young Cubists."[15] While Ray does not mention *Alcools* by name, the fact that Apollinaire is included in the company of such distinguished poets suggests that Lacroix owned a copy. His second collection of poetry, *Calligrammes*, did not appear until five years later. Since Lacroix was Belgian, moreover, and since she was interested in modern poetry, she could easily have obtained the volume from France. The second person to introduce Apollinaire's book into an American context was Ezra Pound. Although he was living in London, he published an account of modern French poetry in *Poetry* in October 1913 that included the following sentence: "Also *Alcools*, by Guillaume Apollinaire

(Mercure), is clever."[16] As we saw in chapter 2, this brief mention is more significant than it first appears. Forced to reduce seven previous articles to one, he retained only those poets whom he thought were truly important. To Pound therefore goes the honor of being the first person in America to refer to *Alcools* in print.

MARIUS DE ZAYAS

The fact that the first American to call attention to Apollinaire's poetry lived in England is symptomatic of the general neglect that prevailed in the United States at that time. In 1914 and especially in 1915, this neglect was partially rectified through the work of one of Alfred Stieglitz' colleagues, Marius de Zayas. An artist and critic of Mexican origin, de Zayas had been closely associated with *Camera Work* and the "291" gallery for many years. In May 1913 he arrived in Paris with the intention of obtaining art works for the gallery and of making several abstract portraits of famous individuals.[17] He was welcomed by Francis Picabia, who in gratitude for de Zayas' artistic hospitality in New York the previous year helped him in numerous ways. Picabia also presented him to Apollinaire and the group associated with *Les Soirées de Paris*. On 25 May Apollinaire wrote in his column in *Paris-Journal*: "M. de Zayas, qui a renouvelé avec un talent extraordinaire l'art de la caricature et qui a introduit en Amérique Picasso et Picabia . . . se trouve en ce moment à Paris, dans le but de faire la caricature des hommes les plus nouveaux de tous les arts, la littérature et la musique."[18]

De Zayas' correspondence with Stieglitz reveals that he and Apollinaire quickly became friends and arranged to exchange their respective journals, including the back issues. Although Apollinaire and his colleagues were not totally unknown in New York, de Zayas succeeded in establishing close relations between the two avant-garde groups. On June 3rd Stieglitz wrote to him: "That the *Soirées de Paris* crowd must be interesting goes without saying. [Paul B.] Haviland, you know, gets its magazine. And I have heard about it from other sources." On June 9th at de Zayas' suggestion he sent several copies of *Camera Work* with the hope that they would go to "the right people." "Above all I will be only too glad to know Apollinaire gets it," he added. "I would have sent copies to him long ago, but I did not want to make it look as if we wanted to get something out of him." On July 1st de Zayas wrote to Stieglitz: "The last word in Paris is the 'Simultanism' in literature. Apollinaire is the father of it. I recommend you to read in the last number of the *Soirées* his "Carte-Océan" ["Lettre-Océan"]. It is really very amus-

ing. This Apollinaire is really the deepest observer of superficiality. We have become good friends."

One week later Apollinaire devoted his entire column in *Paris-Journal* to an enthusiastic review of de Zayas' caricatures, repeatedly expressing his admiration for the artist and his drawings, which in his opinions were "d'accord avec l'art des peintres contemporains les plus audacieux."[19] In a letter to Stieglitz the next day (July 9th), de Zayas wrote: "I am working hard in making these people understand the convenience of a commerce of ideas with America. And I want to absorb the spirit of what they are doing to bring it to '291.' We need a closer contact with Paris, there is no question about it. The *Soirées de Paris* is going to publish four of my carica-tures in the next number: Vollard's, Apollinaire's, Picabia's, and yours. They asked for them and I thought it would be good for all of us to really get in with this crowd."

The four caricatures appeared in the next issue of *Les Soirées de Paris* as planned. De Zayas added that he had obtained a series of articles from Apollinaire on the Douanier Rousseau, which he hoped to publish in book form in the United States, and discussed Apollinaire's experiments with visual poetry: "I also have gotten from him some of the originals of his new poems which are creating among the crowd of modernists a real sen-sation. He is doing in poetry what Picasso is doing in painting. He uses actual forms made up with letters. All these show a tendency towards the fusion of the so-called arts. I am sure that this mode of expression will interest you."

Unfortunately, the outbreak of World War I three weeks later put an end to the projected booklet on Rousseau. According to the correspon-dence, de Zayas and Stieglitz were also planning an exhibition of the Douanier's paintings at "291," including several works lent by "a Russian girl." Because of the war, however, de Zayas had to leave the paintings behind when he returned to the United States. All he brought back with him was a collection of African sculpture on loan from the Galerie Paul Guillaume. It is significant that de Zayas associated Apollinaire's cal-ligrams with Picasso's paintings rather than with the works of the Futurists, with which a resemblance was more immediately discernible. One wonders if he was not simply repeating something he had heard Apollinaire say. Among other things, his comment suggests that the cal-ligrams are best viewed as literary manifestations of synthetic Cubism.

One final literary contact with Apollinaire remains to be mentioned. In July 1914 de Zayas collaborated with the latter on a pantomime based on his poem "Le Musicien de Saint-Merry."[20] Conceived as a revolution-ary avant-garde creation, it featured deliberately nonsensical characters

performing absurd acts and included advanced stage effects, such as moving pictures projected from the stage into the audience. Since one of the pantomime's intents was to shock the spectators, the emphasis was on novelty and surprise. Apollinaire's scenario for this important precursor of the Dada movement, which has recently been rediscovered, reveals that de Zayas was responsible for the *mise en scène*, Picabia for the scenery, and Alberto Savinio for the music. Not the least astonishing aspect of this work is the fact that the collaborators were planning a series of performances in the United States sponsored by Stieglitz and "291." Like the Douanier Rousseau book, these plans were interrupted by the war.

When de Zayas finally returned to New York in September 1914, he brought several Apollinaire manuscripts with him.[21] His letters to Stieglitz indicate that he was thoroughly impregnated with enthusiasm for the artistic and literary experiments he had witnessed in Paris, primarily those associated with *Les Soirées de Paris*. Indeed, he was determined to continue those experiments in America and to introduce the American avant-garde to the latest developments in France. His plans, which called for establishing both an art gallery and a literary journal, bore fruit the following year. In October 1915 he opened the Modern Gallery, a venture patterned on galleries in Paris, which unlike the "291" enterprise was frankly commercial. Similarly, in March 1915 he published the first issue of an avant-garde magazine called *291* (to underline its affiliation with Stieglitz, but it was distinct from the latter's *Camera Work*, which was modeled on *Les Soirées de Paris*). It was destined to be followed by eleven more issues before its demise in February 1916. Throughout the history of this review, Apollinaire provided the chief literary inspiration and Picasso the primary artistic inspiration. In particular, virtually every poem in *291* was composed according to simultanist precepts.

As de Zayas noted, this cubist technique was all the rage in Paris during 1913 and 1914. That Apollinaire was the father of it, however, was hotly disputed by Henri-Martin Barzun and others. Word of the dispute reached Stieglitz in July 1914 in a letter from the artist Samuel Halpert, who wrote: "Delaunay asked me to please send you a copy of his 'livre simultané' which I take the liberty of doing. . . . A warm debate is taking place in the *Paris-Journal* between Apollinaire and Barzun as to who is the originator of 'simultanism.' "[22] Regardless of simultanism's paternity, by this date Apollinaire was its most famous practitioner. Beginning with "Zone" in 1912 and following the trail blazed by the Cubist painters, he elaborated a new literary method of expressing contemporary reality. In a world where each day's events—unrelated in substance, distance, or time—were juxtaposed on the single page of a newspaper, time and space

were converging toward a single point. In a world that was rapidly shrinking to the size of a single nation (thanks to wireless telegraphy and new forms of transportation), traditional poetry was becoming obsolete. In order to facilitate simultaneous perception as well as simultaneous conception, artists and writers began to experiment with simultaneity in their works. The most common solution was to juxtapose disparate elements without attempting to link them—perspectives, planes, and objects in painting; words, verses, and images in poetry.

The very first issue of *291* (March 1915) included an unsigned note by de Zayas, entitled "Simultanism," which presented the following explanation:

> The idea of Simultanism is expressed in painting by the simultaneous representation of the different figures of a form seen from different points of view, as Picasso and Braque did some time ago; or by the simultaneous representation of the figure of several forms as the Futurists are doing.
>
> In literature the idea is expressed by the polyphony of simultaneous voices which say different things. Of course, printing is not an adequate medium, for succession in this medium is unavoidable and a phonograph is more suitable.
>
> That the idea of simultanism is essentially naturalistic is obvious; that the polyphony of interwoven sounds and meanings has a decided effect upon our senses is unquestionable, and that we can get at the spirit of things through this system is demonstrable.

Appearing in the initial issue, this text served as the group's manifesto and indicated the direction that the review would take. If one interprets the phrase "simultaneous voices which say different things" in its broadest sense—that is, voices that are not necessarily spoken—this is an excellent definition. Significantly, de Zayas took the first two paragraphs almost verbatim from Apollinaire's essay "Simultanisme-Librettisme," which had appeared in *Les Soirées de Paris* while he was in Paris.[23] In addition to exploring theoretical concerns the latter accompanied the publication of the very first calligram: the same "Lettre-Océan" (OP, 183–85) that de Zayas had praised in a letter to Stieglitz.

In general Apollinaire's use of simultaneity assumes three configurations. First, there are the *poèmes-conversations* in which, as he explains in "Simultanisme-Librettisme," "le poète au centre de la vie enregistre en quelque sorte le lyrisme ambiant."[24] In "Lundi rue Christine" (OP, 180–82), for instance, he reproduces a series of supposedly random noises

and phrases overheard in a restaurant. In reality the poem is ordered in such a way that the reader can reconstruct three or four conversations. Then there are the so-called *poèmes simultanés*, such as "Les Fenêtres" (OP, 168–69), which are more ambitious. While they may include bits of conversation, typically they juxtapose the poet's visual perceptions with the ideas and associations these evoke. To this Apollinaire often adds another dimension which tends to universalize the experience. He will suddenly cut to actions that have occurred in the past or that are occurring elsewhere at the same time as events in the poem. Finally, there are the visual poems. As de Zayas told Stieglitz, Apollinaire was doing in poetry what Picasso was doing in painting—with a slight difference. Whereas the artist was incorporating letters and words into his pictures, the poet was introducing pictorial elements into his poetry. In both cases the final product, the fusion of word and image, derived part of its inspiration from contemporary advertising. Assuming such shapes as hearts, mirrors, cravats, and pocket-watches, the calligrams delighted Apollinaire by their instantaneous impact. The words themselves still had to be read successively, but the pictorial component transcended this traditional limitation. Simultaneously painting and poem, the calligram communicated on two different levels at the same time.

While all three types of Apollinarian simultanism figured in *291*, the influence of the visual poetry was the most pervasive. In particular, this reflected the magazine's dual commitment to modern art and to modern literature. References to "Lettre-Océan"(OP, 183–85) were especially common, and one issue even reproduced de Zayas' evaluation of the poet in his July 1st letter to Stieglitz. "Apollinaire that profound observer of the superficial," he wrote, "brought to artistic significance the squeaking of 'the new shoes of the poet.' "[25] This refers to the section in which the Eiffel Tower broadcasts some typical Parisian sounds including the "cré, cré, cré" of the shoes Apollinaire has just purchased. The presence of the poet himself was especially noticeable in the first issue of *291*. His most exciting contribution was a calligram entitled "Voyage" (OP, 198–99), that had appeared in *Les Soirées de Paris* in July 1914. Like "Lettre-Océan" it was actually three calligrams in one: a cloud and a bird were positioned above a magnificent locomotive. These were held together by the themes of travel, communication, and disappointment in love. Significantly, de Zayas gave it the place of honor—the exact center of the triptych formed by opening the review's pages. In this setting it created a striking impression and established the dominant tone of the entire series.

To illustrate his discussion of simultanism, de Zayas also included a *poème-conversation* of his own composition. Entitled "At the Arden

Gallery, 599 Fifth Avenue," it consists of a series of phrases supposedly recorded at that location.

> Oh, come on, let's go to Maillard's.
> I sat next Rev. ——— at Gladys' luncheon.
> Nobody could look human in these full skirts.
> Do you think her husband knows it?
> She says she's a neutral but. . . .
> Why don't they serve tea here?

Although these phrases are listed in tabular order, they are meant to be "uttered simultaneously" according to a note at the bottom of the page. From a traditional standpoint "At the Arden Gallery" leaves much to be desired. It is lacking in lyric qualities, in complexity, and in development. Not only is the poem completely static, but it is prosaic to the point of banality. These observations not withstanding, it is a faithful rendition of a conversation poem. Following Apollinaire's example, de Zayas juxtaposes six phrases uttered by half a dozen people at the same time. This in turn implies the existence of another six people (at least) who are listening to the first six. From these facts one can reconstruct the basic situation of the poem: a fairly large group of people are engaged in animated conversation. All the phrases are complete sentences except the fifth, which trails off mysteriously. Two of them are questions, suggesting the give and take of a conversation *in medias res*.

If this is all there were to the poem, it would still be a significant achievement. The key to "At the Arden Gallery" lies precisely in its triviality. Indeed, this characteristic testifies to its authenticity. By definition a conversation poem consists of everyday reality captured in everyday speech. In the present instance the use of banality may also be seen as ironic commentary. As far as one can tell, for example, all the speakers are women. The first one is bored and suggests that she and her friend go somewhere else. Located on Fifth Street just off Fifth Avenue, Maillard's was a combination confectionery and restaurant where the two women could chat over a sandwich and a cup of tea.[26] The second speaker, who is thrilled to have been a minister's partner at a luncheon, is prim and proper. Her use of "next" rather than "next to" is probably a British affectation. The third speaker is preoccupied with fashion. The fourth is discussing a married woman who is having an affair. The fifth is questioning the sincerity of a third person who has adopted a position of neutrality in the war. The sixth thinks it would be a good idea to serve refreshments at the gallery.

At first glance the poem appears to be an amusing little sketch. A second glance reveals a devastating group portrait. These women haven't a brain in their heads. Their conversation revolves around food, status, fashion, scandal, and gossip. In short they are petty people with petty minds. If they evidently haven't a care in the world, they also have nothing to do. Their days are divided between shopping, luncheon parties, visiting museums, and patronizing tea-rooms. From the context de Zayas is clearly satirizing the so-called "society woman," whose wealth gives her a certain independence but fails to compensate for a lack of intelligence. In a note at the end the author added that the Arden Gallery was showing paintings, sculpture, furniture, tapistries, and textiles from the seventh to the seventeenth century. Surrounded by the splendors of the ages, the women lack the taste and sensitivity to appreciate them. They have come to be entertained not instructed and, finding the exhibit boring, prefer to devote their time to gossip. As they themselves suggest, they would find shopping or having tea and scones more exciting.

De Zayas' attitude toward the Arden Gallery itself is more ambivalent. On the one hand, the poem serves to advertise the recently opened gallery and to draw customers. This is why he gives the address in the title. Noting that the gallery's goal is to "encourage the Arts and Crafts in New York," de Zayas gives every sign of supporting the new venture. On the other hand, the relationship between the society women and the gallery is ambiguous. Certainly, the fact that the women do not like the show is reassuring. But the fact that they are there at all confuses the issue. It is scarcely good advertising to juxtapose one's product with unattractive consumers—inevitably the two will be equated. Thus while de Zayas seems to have liked the gallery, he may have objected to this particular show. Or again, he may have admired the gallery's goals but objected to its exhibition policy. Despite its stated objectives, the Arden Gallery did not give much encouragement to local artists and rarely showed modern works.

A recently published volume of Apollinaire's letters reveals that he and de Zayas exchanged considerable correspondence during the war, even though Apollinaire was stationed at the front much of the time.[27] Among other things, de Zayas sent him a copy of each issue of *291* as it appeared. The first such exchange is the most interesting. Fired by the success of the issue containing Apollinaire's visual poem, de Zayas wrote to propose an exhibition of his calligrams in New York, presumably under Stieglitz' sponsorship at the "291" gallery. A letter dated 21 April 1915, reveals that Apollinaire was excited by this offer. One suspects that the curious volume entitled *Case d'armons* (OP, 219–44), which he wrote and

published on army mimeograph machines during this period, owes much of its typographical experimentation to de Zayas' proposal. Some of the poetry—perhaps the entire volume— was undoubtedly written for this exhibition. For some unknown reason the projected show never took place, but it provides an interesting example of de Zayas' continuing high regard for Apollinaire's visual poetry while he was editing *291*.

The second issue of *291* (April 1915) continued the experiments that were initiated in the first. Combining visual and verbal simultanism, "Mental Reactions" is both a text and a drawing.[28] The former is a *poème simultané* by Agnes Ernst Meyer which juxtaposes her reflections with her physical surroundings. The latter is an abstract composition by de Zayas who illustrates and interprets the poem at the same time. Part of it is modeled on Apollinaire's calligram in the shape of a pocket-watch in "La Cravate et la montre" (OP, 197). Another section, consisting of adroit typographical imitations of perfume labels, was suggested by a line from "Le Musicien de Saint-Merry": "Rivalise donc poète avec les étiquettes des parfumeurs" (OP, 189). For that matter the general format probably derives from Apollinaire as well, who advised poets in "Zone" (OP, 39) to imitate posters and handbills.

The third issue of *291* (May 1915) contains two visual compositions, one of which was the result of a triple collaboration. For our purposes, however, the second is the most interesting. Composed by J. B. Kerfoot and situated beneath the reference to "Lettre-Océan" cited previously, it is visibly indebted to the latter work. Like several calligrams, including "Voyage," "Lettre-Océan" (OP, 183–85) consists of three separate figures. A postcard is juxtaposed with a telegraphic message (transmitted in concentric waves) and several keys on a ring.[29] Entitled "A Bunch of Keys," Kerfoot's poem reproduces the latter image visually and adds a humorous element. In contrast to Apollinaire, who evokes a political demonstration, he describes the rewards of a comfortable bourgeois existence. The phrases themselves are arranged as follows: (the chain) "On this chain hangs the ring"—(the ring) "Round which runs my life"—(the keys) "Frontdoor key," "[Ci]gar humidor," "Winecellar door," "My office desk," "Safe deposit box," and—archly— "Don't you wish you knew?" Like Apollinaire's visual poetry, this clever little poem functions metonymically to define the boundaries of its author's existence. His is a life which revolves about the office and the home and which is characterized by repetitive indulgence in good cigars, fine wines, expensive items such as jewelry, and sex. Moreover, it is an existence to which he is *chained* by his physical appetites.

Other examples could be cited to illustrate Apollinaire's impact on *291*, but the general pattern is clear. It should be added that the readership of *291* was not limited to the relatively small group gathered around Stieglitz but included most of the American avant-garde, if not all of it. For that matter, it included most of the English avant-garde as well—including Ezra Pound and his friends in London.[30] The precise circulation figures are not known, but judging from the de Zayas-Stieglitz correspondence, most issues numbered about 1,000 copies and several amounted to 2,000. The readership encompassed, for example, the various bohemian coteries in Greenwich Village, such as that headed by Guido Bruno. It included the Walter Arensberg faction at 33 West 67th Street and the group centered around Alfred Kreymborg and his review *Others*. It reached across the Hudson to the artist colony at Ridgefield, New Jersey—which included William Carlos Williams and Man Ray.

291's readership even extended as far as Boston. There, one of its readers—albeit reluctantly—was Amy Lowell, who had recently kidnapped the Imagist movement away from Ezra Pound and who had her own ideas about how ideogrammatic poetry should be written. Writing in *The New Republic* in 1916, she roundly condemned the visual movement and singled out the Apollinaire poem in *291* ("Voyage") for special comment. Dismissing it as an "extreme fad," she attacked what she called:

> "Fantaisisme," with Guillaume Apollinaire as chief priest, who wrote so-called "ideographic poetry," or poems printed so as to represent a picture of a railroad train with puffing smoke, or some other thing of the sort. That these "notions" . . . will survive the war is inconceivable.[31]

That Amy Lowell was mistaken is now a matter of historical record. The varieties of poetic expression that we have been discussing were destined to have widespread repercussions both here and abroad. In America, William Carlos Williams and E. E. Cummings appear to have benefited in particular from the experiments in *291*. Ironically, as George Wickes has shown, Lowell's article in *The New Republic* seems to have introduced Cummings to Apollinaire's visual poetry.[32] Wickes even believes he can discern references in one of his poems to her article, which Cummings either read or heard as a lecture.

ADDITIONAL AUTHORS

For the most part, Apollinaire's American reputation during 1915 was in the hands of Marius de Zayas and *291*. With the exception of the latter

review, few written traces exist of his presence in the United States. Interestingly, two of the three authors who chose to mention his name were not Americans at all. As we saw in the previous chapter, Richard Aldington published an article in *The Little Review* in February in which he described Apollinaire as a "delightful and readable" poet.[33] Similarly, in October *Bruno's Weekly* reprinted an article from *The Egoist* in which Alec W. G. Randall mentioned that Apollinaire had written criticism for *Der Sturm* before the war.[34] While Apollinaire was beginning to gain a reputation as an avant-garde poet in America, he was most firmly entrenched among the artists and art critics, who viewed him as an important spokesman for modern art. In 1915 and 1916 the Washington Square Gallery, located in Greenwich Village, even carried *L'Enchanteur pourrissant* (1909).[35] Apparently recommended to the proprietor by Gertrude Stein, its illustrations by André Derain made it an extremely attractive *livre d'artiste*.

More importantly, Apollinaire's name began to appear in books and articles by the influential critic Willard Huntington Wright. In 1915 his important study *Modern Painting: Its Tendency and Meaning* recognized Apollinaire's contributions to the modern movement in France. Since the space devoted to the latter was brief, Wright wasted little time in getting to the point. "Guillaume Apollinaire, editor of *Les Soirées de Paris*," he announced, "has done more intelligent service for the younger heretics in France than any other man."[36] In two studies published the following year, Wright amplified his earlier remark and explained what it was that made Apollinaire such a superior critic. Devoted to "The Aesthetic Struggle in America," the first was a scathing attack on the art establishment in the United States. "In Europe," the author declared, "there are capable men of the Roger Fry, Clive Bell, and Apollinaire type. These men differ in conclusions, but [unlike American critics] they at least take artistic effort seriously and do not attempt to hide their lack of knowledge behind a veneer of scorn and patronage."[37] The second study was devoted, not to American criticism but to those individuals in Europe who promised to revolutionize the way in which criticism was conducted. As such it attacked the principles associated with the European art establishment:

> It is only in very recent years that the philosophic and the scientific minds have, in going directly to art, discovered that the field is more than worthy of their profoundest concern. As a result, analytic thinking is supplanting the merely sensitized impressionism of yesterday's art critics. The Apollinaires are succeeding the Baudelaire's; and the Clive Bells and Roger Frys are taking the place of the Arthur Symonses.[38]

Above all, Wright seems to say, Apollinaire possessed valuable analytical skills and an innate respect for what modern art was trying to accomplish. In addition to bringing promising young artists to the attention of the public, moreover, he helped many of them to find dealers and patrons. Although Wright does not mention this aspect of Apollinaire's "intelligent service," he had certainly heard about it from American artists living in Paris. Among the numerous painters who had benefited from Apollinaire's generosity, and who knew him personally, was his own half-brother—Stanton MacDonald-Wright. One of a group of Americans who were centered around Robert Delaunay, including Patrick Henry Bruce, Morgan Russell, Arthur B. Frost, Jr., and Samuel Halpert, MacDonald-Wright had lived in Paris for many years. In 1913 he and Russell founded the Synchromist movement, which sought to create the illusion of volume and movement by systematically juxtaposing various colors.

While Apollinaire knew a great many Americans who were living in Paris, the history of their relations exceeds the scope of the present study.[39] Unlike most of his colleagues, however, Morgan Russell served at one point as an intermediary between Apollinaire and the avant-garde in the United States. Apollinaire probably met the future co-founder of Synchromism at one of Gertrude Stein's gatherings about 1908. Over the next six years he followed Russell's career, supported him in print, and invited him to his apartment.[40] At the beginning of 1916, while Apollinaire was serving at the front, Russell wrote him that he was planning to return to America and asked for a letter of recommendation to Alfred Stieglitz. Apollinaire sent him the recommendation on 29 January and even enclosed a stamp so Russell (who was extremely poor) could mail it if he wished to.[41]

29 janvier 1916

Mon cher ami je vous envoie ci-joint une lettre p[ou]r le directeur du 291 et un timbre au cas où vous en manqueriez. Vous l'enverrez vous-même si elle vous convient. Je vous souhaite qu'elle vous soit très utile.

Je vous remercie des détails que vous me donnez sur vos travaux d'artiste. Je ne puis qu'approuver la direction que vous prenez et vous souhaitant avec la réussite toutes les joies artistiques possibles je vous serre la main en vous [priant] de m'écrire

Guillaume Apollinaire

Accompanied by an envelope addressed to "Monsieur Stieglitz," the letter of recommendation itself reads as follows:

le 29 janvier 1916

Monsieur,

Je m'autorise de l'intérêt que vous avez toujours témoigné pour mes ouvrages et de nos goûts artistiques qui sont souvent les mêmes pour vous recommander très chaleureusement un jeune peintre américain de grand talent dont les oeuvres ont causé une réelle sensation dans Paris même qui est le centre artistique universel par excellence.

Je crois que vous rendriez service à la gloire même de votre pays en vous occupant des oeuvres du jeune peintre Morgan Russel [sic] qui demeure à Paris, 20 rue Ernest-Cresson (XIV arrt). La guerre a désorganisé la vie de ce jeune artiste qui mérite qu'on s'occupe de lui, car il travaille dans un sens moderne et intéressant avec un talent véritable.

Croyez, Monsieur, à ma considération très distinguée.

Guillaume Apollinaire

Shortly thereafter Russell left for New York, where he learned that an important event was to take place in March, the Forum Exhibition of Modern American Painters. With little time to spare, he painted fourteen works which he succeeded in entering in the show. While he was engaged in these preparations, Russell managed to meet Alfred Stieglitz on February 18th, probably through the intermediary of one of his friends. In a hasty letter dated February 25th he apologized for not coming to see Stieglitz and enclosed the recommendation Apollinaire had written for him.

Dear Sir,

Being very busy getting ready in the show I have not been able to come around as you so kindly asked me to but shall do so next week.

Before hearing of this exhibition I had thought of the possibility of interesting you as everyone said you were the most impartial and had the best artistic taste of all the gallery owners here. Not knowing you I sought for an introduction and enclose you one Mon. Guillaume Apollinaire gave me saying he did not know you personally but would risk it just the same. . . .

I was greatly pleased at your amiable reception of me last Friday, in fact it helped to make my return quite cheerful.

The Forum Exhibition was held several weeks later with great success. Presided over by Willard Huntington Wright, it presented 193 bold new works to the public and testified to an evolution in American taste since the Armory Show. Among the numerous paintings that were sold was one by Russell, which was purchased by Alfred Stieglitz. The artist was so touched by this sign of confidence that he made him a present of a second painting. In a letter dated April 24th in which he thanked Russell for his gift, Stieglitz wrote: "I am looking forward to the watching of your development. I am glad we came into each others lives just in the way we did." It goes without saying that Apollinaire's recommendation helped to determine the nature of that meeting.

The last document, which probably dates from fall 1916, was exhibited several years ago at the Centre Pompidou in Paris. Two weeks after returning from the United States, Russell was astonished to see Apollinaire in a sidewalk café with a huge bandage around his head. In a letter to the poet, who had left before he could speak to him, he suggested they get together to exchange news. Stieglitz was pleased to receive the recommendation, he reported, but he himself wanted to hear what had happened to Apollinaire while he was gone.

In 1916, as during the preceding year, several of the published references to Apollinaire came from writers who were living abroad. In January, for instance, *Bruno's Weekly* reprinted Muriel Ciolkowska's report that the poet had been promoted to second lieutenant (see chapter 2).[42] More importantly, Ezra Pound described Apollinaire on two separate occasions as one of the best modern French poets. In the first place, as noted in the previous chapter, he ranked him among the top six poets in an article published in *Poetry*. In the second, he insinuated in *The Little Review* that he was "the most 'modern' writer Paris can boast" after Jean de Bosschère.[43]

Not unexpectedly, Marius de Zayas continued to have the greatest respect for Apollinaire during this period, both as an art critic and as a poet. Writing in *Arts and Decoration* in April, he saturated his discussion of Cubism with references to *Les Peintres cubistes*. "It was Derain, according to Apollinaire," he declared, "who first combined with Picasso to work in this new method of representation, soon following the path which his own personality imposed on him. Georges Braque then became the working companion of Picasso." Elsewhere in the article he quoted at length from Apollinaire's book, especially his definitions of the four types of

Cubism.[44] Writing in *Camera Work* in October, de Zayas mentioned Apollinaire's name three separate times. In addition to identifying the French poet as a contributor to *291*, he acknowledged the influence of his calligrams on the visual experiments that had appeared in the review.[45] While these references are important gauges of Apollinaire's presence in America, the most exciting event was the publication of one of his poems. Translated into English by an anonymous hand, "Lundi rue Christine" (OP, 180–82) appeared in *Rogue* in December.

In many respects, 1917 marks the high point of Apollinaire's reception in the United States. Not only the quantity but the variety of the printed references to his work indicate that he was becoming fairly well known. That year, for example, the respected critic James Huneker mentioned him in connection with a history of modern French literature by Ernest Florian-Parmentier. Like certain other members of the generation of 1900, he reported, Apollinaire was a "worker in the vast inane, [a] dweller on the threshold of the future."[46] In March Apollinaire's name appeared several times in a lengthy obituary devoted to the poet Alan Seeger, who had joined the French Foreign Legion and had been killed at the front. Published in *The New Republic* by Harrison Reeves, it recounted how Seeger had admired various members of the Parisian avant-garde including "Guillaume Apollinaire, a Polish Italian writing somewhat in Whitman's tradition in French."[47] On the following page the author described Seeger's attempts to grasp the principles underlying the radical experimentation that was going on around him. One of the persons who had revolutionized traditional poetry, he added, was "Apollinaire [who] employed mechanical symbols and pictures of objects in exquisite lyrics." Like Alan Seeger himself, Harrison Reeves was a member of the American colony in Paris and a friend of Apollinaire's. Both he and Seeger had known the poet for a number of years and frequented the same circle of acquaintances. In 1914, moreover, they each published an article in *Les Soirées de Paris* on popular culture in America. Although Seeger led a fairly insular existence, Reeves served as yet another intermediary between Apollinaire and the United States. A foreign correspondent for a newspaper in New York, he often invited the poet to meet visitors from America and vice versa.[48]

Just as Francis Picabia had helped to further Apollinaire's reputation in 1913, the presence of Marcel Duchamp and Henri-Pierre Roché in New York during the war had a similar effect. The most tangible symbol of their role, which was less deliberate than Picabia's, is a composition by Duchamp entitled *Apolinère Enameled*. Dated "1916–1917," the latter depicts a little girl who is engaged in painting an iron bed-stead.[49] While

Apollinaire himself is nowhere to be seen, the fact that the title is plastered across the top of the work in large letters continually reminds the viewer of his presence. In its original setting in Walter Arensberg's apartment, *Apolinère Enameled* attracted the attention of much of the American avant-garde from 1917 to 1921. An analogous role was played by two reviews entitled *The Blindman* and *Rongwrong*, which date from the same period and which issued from the same milieu. Edited by Duchamp, Roché, and Beatrice Wood, they served as sites of artistic exchange between France and America.[50]

One of the more interesting examples of Franco-American exchange involves a poem by Mina Loy that appeared in the second issue of *The Blindman* (May 1917). An artist as well as a writer, Loy was an Englishwoman who had spent a large amount of time on the continent, mostly in Italy, before settling in New York during the war. Despite occasional statements by critics to the contrary, there is no evidence that she ever knew Apollinaire. Indeed, she seems to have been influenced primarily by the Italian Futurists. The poem that appeared in *The Blindman*, however, differs from the rest of her poetry in one important respect: it is a *poème-conversation*. Since the latter genre was intimately associated with Apollinaire, on this occasion at least she seems to have been inspired by his example. As Peter Read astutely observes, the poem is an American version of "Lundi rue Christine" (OP, 180–82).[51] Entitled "O Marcel – – – otherwise I Also Have Been to Louise's," it is situated in a café in New York:

> I don't like a lady in evening dress, salting
> From here she has black eyes, no mouth
> some – – – – Will you bring a perfection,
> well bring a bottle – – – Two perfections
> WELL I want to SEE it – – – he will
> know it afterwards – – – will you bring
> the bottle. Really, have I? – – . Which
> way? Oh did I? WHEN? Too much?
> You are abusing myself. No you would not – –.
> Did you ask Demuth about it?
> You don't remember that ball. Well don't
> do that because I am perfectly sober now
> _____ That's the kid he looks like –. It
> will probably cost me very much I have
> not got money. . . .

This brief excerpt reveals a number of affinities with Apollinaire's best-known conversation-poem. Like "Lundi rue Christine," it juxtaposes fragments of various conversations to form a verbal collage. Although the fragments from different conversations clash with each other, within a given conversation there is a certain continuity. Phrases that are separated physically are connected not only by their common subject matter but by principles such as repetition, cause and effect, and question and answer. Loy even adopts two of Apollinaire's themes. The lady in evening dress whom she dislikes recalls the woman with a nose like a tapeworm in the French poem. So too the individual who has no money resembles the man who is unable to pay his rent. While Loy's characters are mostly artists and writers and Apollinaire's are petty criminals, they are related by the themes of ugliness and poverty. Just as Apollinaire reduces the role of the poet to that of a recorder, moreover, we learn at the end of "O Marcel" that the poem has been "*compiled* by Mina Loy" (emphasis added). The model for the latter text was provided not by "Lundi rue Christine" itself, however, but by the English translation that appeared in *Rogue* in December 1916. Encountering Apollinaire's poem in the pages of a review to which she contributed, Loy could not resist experimenting with this provocative new form.

About the time that the second issue of *The Blindman* appeared Apollinaire received a copy of the first issue, published on April 10, 1917, from Henri-Pierre Roché. Replying on May 8th, he thanked Roché for the copy and proposed that they publicize each other's projects.

Mon cher ami, je vous remercie de m'avoir envoyé *The Blindman* dont j'annoncerai la publication dans les *Echos* du *Mercure de France*. J'en parlerai chaque fois que j'aurai l'occasion, par conséquent continuerez-moi le service. Si vous étiez gentil vous annonceriez la publication du *Poète assassiné* à l'édition Bibliothèque des Curieux, 4 rue de Furstenberg (3,50). Apparition prochaine de *Calligrammes*, poèmes de la paix et de la guerre, au Mercure de France, dessin de Picasso gravé sur bois, exemplaires ordinaires à 7 francs 50, exempl. de luxe à 25 frs. (les demander d'avance) et aussi la prochaine publication par la St Littéraire française avec des illustrations d'Irène Lagut d'un roman, dont la plus grande partie se passe en Amérique vers 1852 et sera je crois la seule résurrection faite avec un soin tout flaubertien de cette curieuse époque de la vie américaine, mal connue des Américains même. Guil Apollinaire[52]

Unfortunately the American publishing venture came to an end before Roché could carry out his part of the bargain. Although *The Blindman* was transformed into a journal entitled *Rongwrong* in June, the latter ceased publication after a single issue. True to his word, Apollinaire announced the creation of the review in the *Mercure de France* on June 1st.[53] Anxious to oblige Roché, whom he knew fairly well, he also told Pierre Reverdy who published the news in the June-July issue of *Nord-Sud*.

On July 16th Roché received a note from Apollinaire asking him for Marie Laurencin's address in Barcelona, which he had mislaid, and thanking him for a copy of his recent book.

> Mon cher ami,
> J'ai relu avec beaucoup de plaisir le petit livre minutieux et simple que vous m'avez envoyé, je l'ai goûté autant en plaquette qu'en feuilleton.
> Je vous remercie beaucoup
> Envoyez-moi je vous prie l'adresse de Marie pour que je lui parle de ses tableaux vus chez Mme Groult.
> > Votre dévoué
> > Guillaume Apollinaire.[54]

Although Apollinaire did not mention Roché's book by name, the work in question was undoubtedly *Deux Semaines à la Conciergerie pendant la Bataille de la Marne* (1916), which had been serialized previously in *Le Temps*. Mme Groult was one of Marie's dealers in Paris and also one of her dearest friends. While Apollinaire made no further mention of Roché's review(s) during 1917, we know from two articles published the following year that he received both *Rongwrong* and the second number of *The Blindman*. In "L'Art tactile," which appeared in February 1918, he discussed a sculpture by Edith Clifford Williams that was designed to be touched by the viewer. Since he had predicted the creation of just such an art in a short story published earlier, he was delighted to discover a photograph of the sculpture in *Rongwrong*.[55] Later the same year Apollinaire discussed the controversy that had arisen in New York when Duchamp was refused permission to exhibit a porcelain urinal at the 1917 Independents show. Drawing heavily on articles published in *The Blindman*, he sided with the artist and labeled the attempt at censorship as patently absurd.[56]

Back in the United States the publication of the first issue of *Nord-Sud* caught the eye of an anonymous critic writing in *Current Opinion*. In July 1917, the latter devoted a penetrating article to this latest manifestation of

the French avant-garde, focusing, like the review itself, on the role assumed by Apollinaire. "Punctuation is unpopular," he reported, "with that new school of young French poets who have grouped themselves about the striking figure of Guillaume Apollinaire, and who are called the *nord-sudistes*, after the new literary monthly which contains their startling productions, entitled *Nord-Sud*. M. Apollinaire is represented in the first number of this new attempt to 'reorganize letters' by a poem of three pages named 'Victory.' This poem contains no more than two commas."[57] Thereafter the commentator described the revolutionary program advocated by Apollinaire in "La Victoire" (OP, 309–12) and presented some of the other poets associated with the review. Returning to their leader finally, he concluded: "it remains for the formidable Apollinaire to direct this work of surveying new roads for poetry and to open new horizons." Not only was the article amazingly sympathetic to the latest French experiments, but it established Apollinaire for once and for all as the head of the avant-garde.

Apollinaire would not receive praise like this again in America until after his death. Indeed, only two mentions of his work appeared the following year, one of which involved a misunderstanding. Both of these were occasioned by an exhibition of African sculpture at the Modern Gallery from January 21 to February 9, 1918. In an essay written for the catalogue, G. Dorlac remarked: "By an audacity of taste, as the poet Apollinaire puts it, we have learned to love the Negro statuette, to understand its expressive power. Vast has been the benefit to us. It has taught us that in art the expression of emotions is more intense than the expression of vision, and that feelings are more positive than understanding."[58] Unfortunately, these comments were somewhat ambiguous, and at least one reviewer attributed the whole paragraph to the poet.[59] In fact, only the initial phrase belonged to Apollinaire, who had devoted one of his columns in the *Mercure de France* to African sculpture the previous year.[60]

If Apollinaire's critical exposure was minimal in 1918, it was through no fault of the poet who not only published two important works that year but was planning—once again—to invade the American cultural scene. On February 21st he sent a postcard to Roché which alluded to this project and which also revealed how well-informed he was about events taking place in New York.

> Mon cher ami, je vous ai envoyé en bonnes feuilles ma pièce des *Mamelles de Tirésias*. Faites en ce que vous pourrez. Je crois que traduite et jouée, elle amusera les Américains.

J'ai eu de vos nouvelles par Reeves et par M. Doucet et aussi par Picabia qui est maintenant à Paris. Je vous envoie toute mon amitié

Votre

Guillaume Apollinaire
202 Bd St Germain (7e)[61]

As this postcard reveals, communication between the New York and the Parisian avant-gardes was surprisingly good. Apollinaire was not forced to depend on ephemeral publications like *The Blindman* for information but drew on a variety of personal contacts. In addition to Francis Picabia, who had returned from a recent stay in New York, his sources included Harrison Reeves and Jacques Doucet who had been corresponding with Roché. Reeves may also have seen him during a trip to the United States. The most interesting piece of news, nevertheless, is that Apollinaire was hoping to stage *Les Mamelles de Tirésias* in New York. Taking advantage of Roché's offer to contact various producers, he sent him the proofs of the recently published text to translate into English. For unknown reasons, like the ill-fated pantomime *À quelle heure un train partira-t-il pour Paris?*, this project never materialized.

The only article on Apollinaire that appeared in America in 1919 was a lengthy and sympathetic obituary published in *Current Opinion*. Probably written by the same anonymous critic who had praised Apollinaire's work in *Nord-Sud*, it was accompanied by two illustrations. Above the caption "He died for France," the first page featured a portrait by Picasso depicting the poet in uniform with his head swathed in bandages. The second page included a reproduction of an early calligram entitled "La Cravate et la montre" (OP, 192).In addition to the patriotic caption, which stressed Apollinaire's contribution to his country, the title and subtitle emphasized his contribution to modern art. "Passing of Guillaume Apollinaire, Explorer of the New Esthetics," the former read, while the latter proclaimed: "He was a Heliogabalus of the Intellect, a Marco Polo of the New Spirit in Art and Letters." An eloquent tribute to the fallen poet, the article itself quoted or paraphrased large sections of "L'Esprit nouveau et les poètes" and drew on an account in French by André Billy:

One of the final victims of the war was Guillaume Apollinaire, interpreter and esthetician of the modern movement in French art and letters. Apollinaire, tho[ugh] of Polish birth, was practically brought up in France, adopted his characteristically French

name, and completely identified himself with all those efforts in art and poetry that were misunderstood and ridiculed by the Parisian press and public. No other litterateur of our own age, one of his friends writes in the Paris *Opinion*, aroused so much anger, so many sneers of misunderstanding. His enemies, this writer claims, were those overpowering allies stupidity, ignorance, and routine. But Apollinaire had only to appear and smile and his enemies were vanquished. He was endowed with tremendous vitality, power, and an insatiable appetite for life. His spirit was radiant, sparkling, yet the flame of his genius, says André Billy, was neither hard nor cold. France owes to Guillaume Apollinaire a renaissance of style, which had been menaced by the prejudices of outworn traditionalism. He loved to explore the vague realms of the probable and the uncertain, leaving to less daring spirits the "sterile certitudes of the past."[62]

Thereafter the writer singled out four characteristics of *l'esprit nouveau* with which Apollinaire had been preoccupied. Drawing heavily on "L'Esprit nouveau et les poètes," which had appeared two months earlier, he cited Apollinaire's disbelief that there was "nothing new under the sun" and his contention that novelty was to be found primarily in surprise. Following sections were devoted to his defense of artistic liberty, his belief that national literatures would continue to exist, and his discussion of the dangers inherent in the avant-garde enterprise.[63] Above all, the reviewer concluded, "the modern spirit in art and letters, as Guillaume Apollinaire understood it, is one of searching, of exploration, of experimentation."

By 1920 the cultural scene in the United States had changed dramatically. As more writers and painters settled in France the center of American cultural activity shifted from New York to Paris. Among other things the shift is evident in the references to Apollinaire in American publications during this period. In 1920, for instance, his name was mentioned by six different authors, every single one of whom resided abroad. Four of them were living in Paris at the time, and the other two would soon decide to join them in the French capital. Typically, two of the references were by French writers, who were beginning to find a wider audience in American periodicals. Writing in *Poetry*, the art critic of *Le Matin* addressed the relationship between art and modernity, which reminded him of some lines by Apollinaire. Quoting from "La Victoire," he cited the latter's opinion on the subject: " 'Let us hurry,' wrote the most striking of all contemporary French poets, Guillaume Apollinaire, who died during the war, 'Let us hurry to love the little train with its blinking engine, run-

ning through the valley. If tomorrow it shall be ancient, everybody will be able to admire it.' "[64]

In actuality, the critic was quoting from memory rather than from the original text. As one soon discovers, the excerpt cited above was a loose paraphrase of Apollinaire's original words. Comparison with the work itself reveals that the poet said something quite different:

> Nous n'aimons pas assez la joie
> De voir les belles choses neuves
> O mon amie hâte-toi
> Crains qu'un jour un train ne t'émeuve plus
> Regarde-le plus vite pour toi
> Ces chemins de fer qui circulent
> Sortiront bientôt de la vie
> Ils seront beaux et ridicules (OP, 310).

The whole point of this section is that one should admire recent inventions, not because everybody else will before long but because soon nobody will. It is not a question of beating the public to the aesthetic punch, as the critic from *Le Matin* implies, but of enjoying new inventions while one still can. Before long they will either lose their novelty or be replaced by other inventions or both. Viewed in more general terms, however, the two versions express the same central concern. In fact, we do not value the joy of seeing beautiful new things as much as we should.

The September issue of *Poetry* included a response to the above article by Muriel Ciolkowska, who disagreed with the critic's remarks about machinery in art. Historically, she declared, Rudyard Kipling and J. M. W. Turner were the first to recognize the beauty of mechanical things, not Marinetti or Apollinaire who were "sequels to these (modest) forerunners."[65] Elsewhere in the same issue, in an article entitled "A Paris Letter," Jean Catel mentioned Apollinaire in connection with a recent book of poetry by Paul Morand. As he noted, the literary cubists were the only group of poets to survive the war. "But [their] leader, Guillaume Apollinaire," he added, "died a soldier, and his was a very pathetic death. Max Jacob, Jean Cocteau, Paul Morand are the only inheritors of Apollinaire's ideas worth mentioning" (pp. 344–45). Writing in *The Little Review* the same month, the poet John Rodker had some kind things to say about Apollinaire during a discussion of Louis Aragon's *Feu de joie*. Not only was Aragon indebted to his predecessor, he reported, but he promised to become his successor: "Poetry—dead in France since Verlaine . . . with only the exception of Apollinaire and de Gourmont—appears to be looking up."[66] In a note attacking Rodker the following

month, an irate Muriel Ciolkowska quoted this sentence as an example of his lack of credentials.[67] To dismiss an entire generation of poets, including some very fine ones, she complained, was simply inexcusable.

The last two articles to refer to Apollinaire in 1920, both of which appeared in October, have already been discussed in connection with the second chapter. Authored by Ezra Pound and Richard Aldington respectively, they presented diametrically opposed views of the French poet.[68] Writing in *The Dial*, Pound compared Apollinaire to no less a personage than Mallarmé and described him as the apostle of modern French poetry. Writing in *Poetry*, Aldington mercilessly ridiculed "À travers l'Europe" and accused him of being the "first French apostle of Steinism." To the former he was the champion of "the young and very ferocious"; to the latter he was simply a practical joker.

HENRY MCBRIDE

The last individual to merit our attention is the eminent art critic and defender of modern aesthetics, Henry McBride. Although the two most substantial texts in which he discusses Apollinaire date from the early 1920s, they are based upon experiences extending back to before the war. Not only did McBride actually meet the poet during a stay in Paris, but he facilitated the international art movement by championing the French cause. He also served as an intermediary between the French and the American avant-gardes. Much of the influence McBride exerted on the developing art scene in the United States resulted from his critical activities. Not only did he write an art column for the *New York Sun* for many years, but he authored innumerable articles on modern art for *The Dial* during the twenties. In 1921 the latter magazine published a reminiscence by McBride in connection with an exhibition at Marius de Zayas' new gallery in New York. Devoted to the Douanier Rousseau, it was the first exhibition in America to occupy itself entirely with this artist and fulfilled a longstanding dream on de Zayas' part, going back to the abortive show he had planned with Apollinaire in 1914.

> The pictures by "the douanier" now at last given a belated one-man show in the De Zayas Galleries vividly recall two sponsors of this artist and both now dead—Guillaume Apollinaire of Paris and Robert J. Coady of New York.
>
> I met the first but once at one of those lightly arranged dinners that were always happening in the days when tourists were thick in Paris. An American traveller just in from Budapest with a pocketful of introductions to "chic types" asked me to meet

some of them in one of the best restaurants on the left bank of the Seine. There was more than the usual animation when it came to fixing upon a menu. The *carte du jour* was so abominably written that our host who was new to Paris threw himself upon our mercy and asked us for suggestions. Immediately a hubbub arose that could be likened now to a peace conference but which at the time had had no parallel! A young gypsy muscian, "of the female persuasion," as George Borrow puts it, expressed a longing for dishes of such startling extravagance (the restaurant was an expensive one even before the war), that others of the guests who had been recruited from the Cour de Dragon and had more modest hopes, expostulated loudly, doubtless fearing that the entire "feed" would be called off. Possibly the dinner never would have been realized had it not been for Guillaume Apollinaire, who somehow managed to gain the ear of one of the least inflammable of the garçons and impressed upon this worthy's memory the details of a perfectly gorgeous dinner which shortly began to come in.

I saw at once that he had exceptional powers but the name which the young gypsy person whispered to me at my request meant nothing to me for at that time the literature of the modern school had not begun to cross the seas. Beyond assuring himself that the dinner orders were exactly carried out, he said little—the young gypsy being the dominating figure at the feast. Later in somebody's rooms he signed a copy of his *Alcools* which our host presented for that purpose, and gave me a copy of his *Soirées de Paris* which he was then editing. When I got home I found my copy of the review to be entirely devoted to an appreciation of Henri Rousseau, whose works I had only just that summer encountered, and to my delight, at the Salon des Indépendants. Apollinaire was at home one day a week, he amiably told me, in rooms on the Boulevard St. Germain. We had agreed on several things, among others that the singing of the gypsy girl was disgustingly affected, so I meant to look him up thinking we might agree some more—but the principal reason was my curiosity in regard to Rousseau. However, the *débâcle* of 1914 put an end to studio life, and Apollinaire marched away to the war. Long before the bit of shrapnel sent him home to die in Paris I had learned to know his singular force as a writer. I yielded to it sometimes when actually thinking the words puerile, but I yielded to the tone rather than the words. Apollinaire spoke as

one with authority, and the most unlikely specimens in Paris took from him what they would have taken from no one else. He was a *"Moi,"* decidedly; the *"moi,"* in fact, of the modern school.[69]

Yet another anecdote to add to the history of the so-called Banquet Years. Although it does not seem possible to identify either McBride's American host or the gypsy singer, the event itself can be dated fairly accurately. According to all indications McBride must have encountered Apollinaire during the summer of 1914. It is also interesting that the dinner guests retired to an apartment in which the poet had copies of his review available to give to strangers. This fact suggests that the apartment belonged to one of the co-directors of *Les Soirées de Paris* or that it was actually the review's office, which in 1914 sheltered several visitors. Whatever the explanation, Mc Bride's appreciation of Rousseau must have benefited considerably from the issue of *Les Soirées de Paris* (January 15, 1914) that was devoted to this little-known painter. While he was eventually to become the dean of American art critics, during this period he was still learning the basics of his profession.

In subsequent years McBride referred to Apollinaire in his art criticism with some regularity and helped to popularize his ideas. On more than one occasion Apollinaire provided him with some valuable information and/or material he could use in one of his columns. When the Modern Gallery exhibited paintings by André Derain in 1917, for example, without a word of explanation in the catalogue, McBride reprinted an essay on the artist "by the celebrated Guillaume Apollinaire." Translating virtually the entire preface to Derain's show at the Galerie Paul Guillaume the previous year, he observed in addition that "Mr. Apollinaire's favorite word [is] *audace*." [70]

Besides appearing in his column from time to time, the French poet was the topic of numerous conversations between McBride and various friends. Whenever he found himself in Paris, it seems, he wound up having dinner with one luminary or another during which the conversation would often turn to Apollinaire. In an article entitled "Luncheon in Paris with Raoul Dufy," which also appeared in 1917, McBride recalled the publication of *Le Bestiaire* (1911). It was "a book of woodprints with text by Apollinaire," he added; "Apollinaire, full of fantasy and an amusing fellow, both M. and Mme Dufy agreed."[71] Similarly, in a column published in 1921, McBride evoked a recent dinner at Gertrude Stein's during which he discussed the poet with Georges Braque and Jacques Lipchitz. This conversation becomes even more interesting when one compares it to Braque's snide remarks about Apollinaire's artistic competence many years later. "Lipchitz and Braque, with whom I dined at Miss Stein's,"

McBride reported, "are still deploring the passing of Guillaume Apollinaire, and insist that what the new movement chiefly lacks is an adequate spokesman."[72]

McBride's most important column on Apollinaire was published in the *New York Herald* in 1922. Entitled "Apollinaire's Cubistic Authority," it was written in response to the first installment of an English translation of *Les Peintres cubistes*, which was appearing in *The Little Review*. Rereading this volume for the first time in many years, McBride was struck by two different things. Not only was the book impeccably writen, he informed his readers, but the author's command of his subject matter was faultless. Although the article primarily addressed Apollinaire's knowledge of Cubism, one of its effects was to confirm his reputation as an exceptionally able critic.

> There was something at once inciting and fortifying to young artists in the methods of the late Guillaume Apollinaire, and, next to the painters that he "put over" upon the public, he becomes more and more the important figure in the art world of the period that produced the great war and Cubism. Apollinaire was jauntier and more human than Ezra Pound, but he had Pound's capacity to give and take intellectual blows in the marketplace and ended in securing a special position and in always being listened to carefully.
>
> Painters are guileless folk and as a rule the greater they are the less guile they have, but some of those that had guile must have laughed up their sleeves occasionally at some of Apollinaire's assertions, for sometimes when writing Apollinaire stuck his tongue in his cheek. But if they did so they kept mum about it and took care to seize all the *réclame* that followed in the wake of the writer's pronouncements.
>
> The first installment of Apollinaire's *Aesthetic Meditations*, translated by Mrs. Charles Knoblauch and printed by the Société Anonyme in the *Little Review*'s Picabia number, will be scanned very closely therefore by the younger Americans, who, however, will not regard it as gospel so much as did the young Frenchmen of a few years ago, though they cannot fail to be stimulated by the puzzling epigrams that Apollinaire shoots off and which compel one to thought.
>
> It is amazing, when re-reading the piece in Mrs. Knoblauch's clear English, to discover how early the beans had been completely spilled by Apollinaire. To this day people are continually asking what Cubism is, and must one like it etc., and yet paragraphs like the following ought to be easily understood.

At this point McBride quoted five paragraphs from *Les Peintres cubistes* concerning a multitude of aesthetic issues. Among the latter were the necessity to abolish the subject in painting and to suppress any attempt at realism. In addition to a discussion of the goals of abstract art, the selection included Apollinaire's analysis of the role of Euclidian and non-Euclidian geometry in modern painting. "This is so precise an exposition of what the best known Cubists were after," McBride concluded, "that it would have seemed that nothing further need have been written upon the subject, yet so slow is this vast modern world in getting to the true founts of knowledge that oceans, as the public knows, of ink were spilled."[73]

Among the German Expressionists

Apollinaire's relationship with Germany was considerably more compli-
cated than his ties to England or North America. An avowed ger-
manophile from his adolescence on, he was forced to revise his opinion
when he found himself fighting on the opposite side during the war.
Whereas he had formerly admired German culture, especially the
Romantic poets, in 1914 the heirs of Goethe and Nietzsche were suddenly
transformed into *Boches.* As is well known, Apollinaire's first, idyllic
phase centered on his *année allemande* when he was employed as a French
tutor in the Rhineland. This experience provided him with a large stock of
motifs, themes, and images which he exploited to good advantage in sev-
eral short stories and many of the poems that later appeared in *Alcools.*[1]
Apollinaire's earliest efforts at criticism also date from this period, which
extended from August 28, 1901, to August 24, 1902. Drawing on his visits
to various parts of Germany, he placed a series of articles in publications
such as *La Revue Blanche, La Grande France*, and *L'Européen.*[2] Indeed, it is
difficult to exaggerate the importance of this *Wanderjahr*, which not only
determined the young poet to pursue a literary career but provided him
with spare time in which to write. Significantly, it was during this period
that he abandoned his given name in favor of a nom de plume.
Professionally he was no longer Wilhelm de Kostrowitzky but rather
Guillaume Apollinaire.

Although he returned to Paris when his contract expired, Apollin-
aire's interest in Germany continued unabated. Indeed, having chosen to
earn his living as a journalist, he often discussed German affairs in the
pages of the newspapers he wrote for. Since he knew the language fairly
well, he was able to follow events that were of interest to his readers.
While much of what Apollinaire reported was concerned with politics or

economics, cultural items also appeared from time to time.[3] Not surprisingly, he was particularly interested in German experiments with modern art, which he learned about from a variety of sources. One of these was the German community in Paris, which included a number of artists who frequented the café Le Dôme in Montparnasse.[4] In addition to figures such as Rudolf Levy and Hans Purrmann it included a descendent of the legendary Baron Münchhausen who was known by the same name.[5] Another source of information was provided by the annual salons, at which Kandinsky and some of his colleagues exhibited. To these sources must be added the constant stream of books and journals that reached Apollinaire from Germany.[6] As early as 1904, for example, he was receiving issues of *Deutsche Kunst und Dekoration* and *Kind und Kunst*. Similarly, when Carl Vinnen and his reactionary associates attacked modern French art in 1911, in *Ein Protest deutscher Künstler*, Apollinaire received not only this volume but a collection of essays defending the opposite view: *Im Kampf um die Kunst*.

Apollinaire gleaned additional information about artistic developments in Germany from visitors to the French capital. By 1912 he had become fairly well known as one of the modern movement's leading spokesmen. As his reputation increased, avant-garde artists and writers in other countries began to contact him to further their mutual interests. One event in particular gave Apollinaire important access to the German art world: his deepening friendship with Robert Delaunay. While Apollinaire was just beginning to attract attention, Delaunay's reputation was firmly established. In Germany his paintings were considered to be the equal of works by Matisse and Picasso. Delaunay was in constant communication with many of the German painters, moreover, whom he succeeded in introducing to Apollinaire. When Paul Klee arrived in Paris in April 1912, for instance, he carried a letter of introduction from Kandinsky which he presented to Delaunay. Through Delaunay's efforts he succeeded in meeting Picasso, Braque, Le Fauconnier, and Apollinaire.[7] When Franz Marc and August Macke knocked on Delaunay's door a few months later, one assumes they were accorded a similar reception.

Although Apollinaire never seems to have met the remaining members of Der Blaue Reiter, we know that Kandinsky was well aware of his importance. Early in 1912, Delaunay wrote the German artist a long letter in which he thanked him for a copy of his recent book *Über das Geistige in der Kunst* (*On the Spiritual in Art*), published in January. "Je vous parlerai dans quelque temps," he added, "du sujet en peinture, de cette conversation palpitante chez Apollinaire, qui commence à croire à nos recherches."[8] While the subject of this conversation has not come to light,

nor the subsequent letter, there is every reason to believe that Delaunay kept his promise. In March 1912, probably at the latter's urging, Kandinsky sent Apollinaire a copy of *Über das Geistige in der Kunst* as well. Dedicated to "Monsieur Guillaume Apollinaire Hommage de l'auteur Kandinsky Munich 13 III 12," the volume is preserved in the poet's library together with *Klänge (Sounds)*, published the following year, and a catalogue of the group's first exhibition in 1911. Apollinaire also received a copy of *Der Blaue Reiter* almanac (1912), a catalogue of Kandinsky's Munich retrospective (1912), and a monograph published in 1913 by Der Sturm.

Associated with Der Blaue Reiter from the very beginning, Delaunay participated in the group's first two shows in Munich and, in March 1912, in another at the Der Sturm gallery in Berlin. During the latter exhibition one of his paintings, entitled *La Tour Eiffel* (1910), was purchased by the wealthy industrialist Bernhard Koehler. When the new owner wrote to ask about his latest acquisition, Delaunay hastened to reply: "But let me return to what you asked me about the painting *Tour*, which you have: I am enclosing Apollinaire's review, whose agile style helps me to express ideas about art that are so difficult to express."[9]

Since the letter is dated March 21, 1912, Karl-Heinz Meissner speculates that Delaunay enclosed a review of the Salon des Indépendants published a few days earlier. However, both columns in which Apollinaire discussed Delaunay were devoted to *La Ville de Paris*, a recent work which, the author claimed, far surpassed his previous efforts. One of these, needless to say, was the picture Koehler had just acquired, which Delaunay would presumably have wished to portray in the best possible light. Since Apollinaire had reviewed this painting the year before at the previous Salon des Indépendants, the artist probably enclosed a copy of the earlier article. "Parmi les mieux doués de ces artistes," Apollinaire declared, "on doit saluer Robert Delaunay, dont le talent robuste a de la grandeur et de la richesse. L'exubérance qu'il manifeste garantit son avenir. Il se développe dans le dessin et dans le coloris qui sont forts et vivants. Sa *Tour Eiffel* a de la puissance dramatique et son métier est déjà très sûr."[10]

As interesting as these preliminary contacts were between Apollinaire and the German avant-garde, they gave no hint of the role he was shortly to assume in Expressionist circles. "If one wishes to designate one . . . writer as being supremely important for the Expressionists," Richard Brinkmann declares, "it is Apollinaire . . . who virtually signals the beginning of the modern literary experiment."[11] While Brinkmann perhaps overstates the case, there is no doubt that Apollinaire was a sig-

nificant presence in Germany in the years preceding the war. Walter Mehring, who witnessed the development of Expressionism at first hand, provides a more balanced assessment. Many years later he recalled his own joyful participation "in Bohemian circles, whose conspirators gathered around tables in the old Café des Westens—Café Megalomania—in Berlin and in every European metropolis, with their consecrated geniuses: the Marquis de Sade, Walt Whitman, Rimbaud, Laforgue, Dostoievsky, and Strindberg; with their secret discoveries (Apollinaire, Franz Kafka, Franz Werfel) who were only known to the initiated."[12]

HERWARTH WALDEN AND DER STURM

The story of how the Expressionists happened to discover Apollinaire revolves about one individual, Herwarth Walden, who provided the initial forum for his views on literature and art. As the director of *Der Sturm* (*The Storm*) in Berlin, Walden was uniquely qualified to publicize aesthetic discoveries emanating from other countries. In addition, he was closely associated with the movement that came to be known as Expressionism, which was gathering more and more adherents. Although *Der Sturm* did not coin either the term "expressionist" or "expressionism," as Peter Selz points out, it helped to popularize both terms. Thus the journal became "the semiofficial spokesman of Expressionism, a movement that included almost anyone whom Walden and his circle liked and publicized at any given time."[13] Despite (or perhaps because of) its persistent eclecticism, *Der Sturm* provided an important focal point for the German movement. Indeed, one suspects that much of Expressionism's vigor derived from its fruitful contact with aesthetic experiments in other lands. As defined by Walden, the movement was a global phenomenon which transcended national boundaries. "Expressionism is not a style," he exclaimed at one point, "but rather an attitude toward life. It is a way of viewing consciousness rather than ideas, a way of viewing the universe of which the earth is only a part."[14]

How Walden eventually became acquainted with Apollinaire, and invited him to contribute to his review, is open to conjecture. Klaus Petersen claims Ludwig Rubiner introduced the two men in Paris, but this does not seem likely.[15] An examination of the chronology reveals that the meeting would have had to take place in November 1912. However, while Walden and Nell Roslund were married in London the same month, they do not appear to have passed through Paris. And since Rubiner only arrived from Germany in November, he could scarcely have invited Walden to visit him as Petersen maintains. The most probable explanation

is that Delaunay served as the intermediary, a role he seems to have relished. Not only was he an extremely important conduit between France and Germany, but he had an excellent reason to put Walden in touch with Apollinaire: a forthcoming exhibition at the Der Sturm gallery. Since Apollinaire was planning to publish an important article on Delaunay in *Les Soirées de Paris* (in December), the artist undoubtedly offered it to *Der Sturm* as well in order to generate a little publicity. At the very least it would have helped to familiarize the journal's readers with his theories.

Walden was delighted with the idea and asked to see a German translation. On November 27, 1912, he replied: "I have read the essay with great pleasure and with much interest."[16] Since he planned to publish it in the next issue of *Der Sturm*, he asked Delaunay to send the French original in order to make a few minor corrections. Entitled "Réalité peinture pure," the article appeared in December as announced.[17] Although the translator was not mentioned, Meissner speculates that either Klee, Marc, or Apollinaire was responsible for the German version. Since the article is readily available, there is no point in quoting it here. Adapting his original study for a German audience, Apollinaire greatly expanded the introduction and added a conclusion. Evoking the furor surrounding modern art in France, he portrayed himself as the champion of Cubism and announced the publication of *Les Peintres cubistes*. He then proceeded to discuss Delaunay, whom, he informed, his readers, was one of the most gifted and daring artists of his generation. The bulk of the article consisted of quotations taken from the artist himself concerning his own works and modern art in general. Apollinaire's brief conclusion celebrated the principle of simultaneity illustrated by Delaunay's compositions, which for both men was synonymous with creativity.

Judging from various indications, Apollinaire's article was well received. Like Walden, Franz Marc thought it was an excellent piece of work and wrote to the painter to say so. On December 13, 1912, he sent a postcard to Delaunay from Berlin in which he declared: "Der Artikel von G. Apoll. im *Sturm* ist sehr interessant." Delaunay replied the very next day with several observations of his own. Although he was presumably pleased with Marc's reaction, for reasons that he did not explain he was also surprised. "J'ai été très surpris de ce que vous écrivez à propos de l'article de G. A.," he remarked parenthetically, as if the reason were self-evident.[18]

Early in January 1913, Delaunay also wrote to Paul Klee, who was translating his essay "La Lumière" for *Der Sturm*, to ask how the project was coming. Since he possessed the original manuscript of Apollinaire's article, together with several other documents, he asked the artist to send

him the German proofs. Klee wrote back on January 6th to say he did not have the proofs and recommended that Delaunay contact either Marc or Walden. Despite the apparently innocuous nature of this remark, it allows one to solve a minor but nagging question regarding the German version: the translator's identity. Although the evidence is circumstantial, it strongly suggests that "Réalité peinture pure" was translated by Klee himself. For one thing, he was translating other documents for Delaunay (and *Der Sturm*) during this period. For another thing, it would explain what he was doing with the article's proofs in the first place. As the translator he would have corrected the initial set before sending them to the journal's editor(s) in Berlin. While Delaunay never explained why he wanted the proofs, the fact that he first wrote to Klee speaks for itself.

At some point, probably in December 1912, Delaunay seems to have written to Walden in connection with several additional projects. An undated reply reveals that one of these was another article by Apollinaire. Walden was interested in the proposal and encouraged Delaunay to send him a manuscript. The other projects were related to the exhibition that was planned for 1913. One of these was an illustrated album of the artist's works with a poem especially composed by Apollinaire. The second was to invite the poet to give a lecture in Berlin in conjunction with the exhibition. As will become apparent, all three projects materialized exactly as planned. For reasons of convenience, Delaunay agreed to oversee the album's printing in Paris. Early in January Marc, who was helping Walden with the final arrangements, wrote to check on the album and to propose yet another project. Fortunately, since his letter does not survive, some of what it contained can be deduced from the artist's reply dated January 11, 1913.[19] Fiercely proclaiming his love of poetry in one place, Delaunay confided that it also played a role in his art. As proof of the common interest linking poetry to painting, he cited two lines from the first Orpheus poem in *Le Bestiaire*:

Elle est la voix que la lumière fit entendre
Et dont parle Hermès Trismégiste en son Pimandre.

These verses were accompanied by Apollinaire's own commentary in the notes to this volume, ending with a sentence that must have greatly appealed to Delaunay: "La peinture est proprement un langage lumineux."[20]

Elsewhere in this long, rambling letter, Delaunay responded to two questions Marc had posed previously. "J'ai fait part de votre désir à Apollinaire," he wrote, "et le bouquin doit paraître dans une huitaine." As Meissner notes, the volume in question was undoubtedly Delaunay's

album, which was to accompany his exhibition. Simply entitled *R. Delaunay*, it contained eleven reproductions of works by the artist and two contributions by Apollinaire. In addition to the celebrated poem "Les Fenêtres" (OP, 168–69), inspired by a series of Delaunay's paintings, it featured an epigraph taken from a work which had not yet appeared in print: *Les Peintres cubistes*. "J'aime l'art d'aujourd'hui," Apollinaire exclaimed, "parce que j'aime avant tout la lumière et tous les hommes aiment avant tout la lumière, ils ont inventé le feu."[21] Interestingly, the album sold like proverbial hotcakes when it went on sale in Berlin. Judging from the advertisements published in every issue of *Der Sturm*, each of which mentioned Apollinaire's poem, the 500 copies Walden ordered were exhausted in less than nine months.

Since the album was already being printed when Delaunay conveyed Marc's request to Apollinaire, this request could not have concerned "Les Fenêtres," which had obviously been commissioned earlier. What, one wonders, could Marc have wished to say to the French poet at such a late date? Since Apollinaire was about to leave for Berlin, why couldn't it wait? The explanation seems to be that Marc wanted Apollinaire to compose a second poem for the exhibition, one that would fit on the back of a picture postcard. Beginning in September 1912, Walden offered a series of *Künstlerpostkarten* for sale with reproductions of paintings by the Italian Futurists. To commemorate Delaunay's exhibition he planned to issue another postcard featuring one of the works on display in the gallery. The painting he finally chose was the portrait of the Eiffel Tower acquired by Bernhard Koehler the previous year. Having decided on this picture, Walden evidently asked Marc to commission Apollinaire to write a poem on the same theme. Entitled "Tour," the accompanying text perfectly complemented the painting and was later included in *Calligrammes* (OP, 200). A miniature portrait of the famous monument, it evoked not only the tower but its distorted reflection in Delaunay's paintings. While the postcard itself has become quite rare, it appears to have enjoyed considerable success. Advertised for the first time in *Der Sturm* in February 1913, it continued to be available for purchase until well into the 1920s.[22]

Although not much is known about Apollinaire's trip to Germany, which lasted approximately one week, the available evidence indicates that he was well received. Similarly despite the relative brevity of the experience, he seems to have greatly enjoyed the opportunity to meet Walden and his colleagues. As the author of two major volumes that were about to appear, this was perhaps his first important triumph. In preparation for his visit, *Der Sturm* (nos. 144–45) included four of Apollinaire's works in a list of recommended books in mid-January. In addition to

L'Enchanteur pourrissant, L'Hérésiarque et Cie, and *Le Bestiaire,* the editors singled out *Les Peintres cubistes* as worthy of the reader's attention. One of the few things that are known about Apollinaire's adventure is the approximate date of his arrival. As soon as he and Delaunay reached the capital, they went to see Walden who gave the poet copies of two of his books. In addition to a copy of *Der neue Weg der Genossenschaft deutscher Bühnenangehörigen (The German Theater Association's New Program),* Apollinaire received a collection of songs by Walden and Arno Holz, both of which are conserved in his library. Entitled *Zehn Dafnislieder [und] Venuslieder (Ten Daphis [and] Venus Songs),* the second volume bore the following dedication: "Am Guillaume Apollinaire herrlichst Herwarth Walden Berlin den 14 Januar 1913."

During the time they spent in the German capital, Apollinaire and Delaunay occupied themselves with various activities. While their trip was motivated in theory by the latter's exhibition, they found time to engage in other pursuits. The very next day, for instance, Delaunay received a note from the brother of a certain Fraulein von Bonin, who was an artist in Paris. Advised by his sister that the two men would love to see his collection of paintings, Karl von Heyt sent them an invitation. They were welcome to drop by any morning, he wrote, between the hours of 10:00 a.m. and 1:00 p.m. The exhibition itself seems to have opened its doors on January 17th and to have lasted slightly more than one month.[23] Apollinaire's lecture, which he presented the following night, appears to have been concerned with modern art in general. As far as can be ascertained, since the manuscript is missing, the poet addressed several topics that were only indirectly related to Delaunay. This lecture will be discussed in connection with subsequent events.

Since Apollinaire's talk was devoted to a subject of great interest, and since the speaker was a prominent member of the French avant-garde, the lecture must have attracted an important audience. Moreover, in view of the prestige *Der Sturm* enjoyed it undoubtedly included many of the leading Expressionist artists and writers. Fortunately, despite the lack of eyewitness accounts, one can gain some idea of the circle Apollinaire moved in during his stay in Berlin. For one thing, the catalogue of his library lists a number of German books that date from this period, many of which were obviously given to him. For another thing, the contents of Apollinaire's address book include a long list of German names.[24] By comparing both documents one eventually arrives at two important discoveries. Not only do both lists complement each other to a considerable degree, but the vast majority of the names belong to persons associated with *Der Sturm.* Judging from appearances, many of the books were pre-

sented to Apollinaire by people he met while he was in Berlin. Similarly, most of the names in his address book were probably jotted down during one of the gatherings sponsored by the journal.

Perhaps the most surprising discovery is that very few names of artists are to be found in either list. Ironically, although Apollinaire was invited to Berlin to discuss modern art, although he met several painters while he was there, he gravitated to individuals who were associated with literature. The only artist listed in his address book is Ludwig Meidner, whom he met at the Café Josty, where Walden and his colleagues liked to congregate.[25] However, Meidner also wrote poetry and short stories. And while Apollinaire acquired more than a dozen books during his trip, none of them was concerned with art. By contrast, the remaining names include a number of important literary figures. Besides the influential essayist Franz Blei, one encounters individuals such as Oscar Bie, who was the editor of *Die Neue Rundschau* (*The New Review*), and Alfred Döblin, who later became famous as the author of *Berlin Alexanderplatz*.

Not surprisingly, quite a few of the names are those of poets. During his stay Apollinaire met Albert Ehrenstein, for example, who presented him with copies of *Tubutsch* (1911), which was equally famous, and *Der Selbstmord eines Katers* (*A Tom-cat's Suicide*) (1912). In memory of this occasion, the author inscribed the first volume "Herrn Guillaume Apollinaire von Erinnerung am Albert Ehrenstein Berlin Januar 1913." The second volume bore an almost identical dedication dated January 18/19, 1913. Since January 18th was the date of Apollinaire's lecture, the slash mark indicates that his talk was followed by a reception lasting far into the night. Besides A. R. Meyer, who will be discussed later, the other poets included Peter Baum and Paul Zech. The former gave Apollinaire a copy of a novel entitled *Spuk* (*Spook*) (1905) and a book of short stories *Im alten Schloss* (*In the Old Castle*) (1908), both of which were cordially dedicated to him. From the latter Apollinaire obtained three volumes of poetry: *Schollenbruch* (1912), *Das schwarze Revier* (*The Black Ward*) (1913), and *Waldpastelle* (*Forest Scenes*) (1910). While the last two bore perfunctory dedications, the first book contained the following inscription: "à Monsieur Apollinaire cordialement en lui serrant la main Paul Zech." To complete the preceding list one must add the names of Mario Spiro, Julius Elias, and Albert Haas, which appear in Apollinaire's address book. While the first individual was associated with *Der Sturm*, the second was a well-known author who wrote for *Die Neue Rundschau*. Albert Haas was the editor of the *Börsen Courier*, which was an evening newspaper.

One of the things Apollinaire and Walden did while the former was in Berlin was to arrange to exchange their respective reviews, including

back issues.[26] The catalogue of Apollinaire's library reveals that he received a complete run of *Der Sturm* extending from 1910 to the beginning of the war. In addition, *Les Soirées de Paris* was advertised in each number of Walden's journal until August 1914, when it no longer became feasible. At some point during the visit, the two men and Delaunay also mailed an illustrated postcard to Henri-Martin Barzun, who had recently sent Walden a copy of *L'Ere du drame*. Barzun, it may be recalled, was the editor of *Poème et Drame* and the founder of Dramatism. As much as anything, the card was intended as a gesture of solidarity.

> Vive le Dramatisme! Vive l'Ere pure! Vive *Der Sturm* qui vient de recevoir ton livre et dont le directeur signe après moi:
> Guillaume Apollinaire, Herwarth Walden et Robert Delaunay![27]

As this document attests, Apollinaire and Barzun were on extremely good terms during this period. Indeed, in some respects the former considered himself to be the latter's disciple. Before the year was out, however, their relationship would disintegrate as a result of a nasty dispute over the paternity of simultanism.

On January 20, 1913, Bernhard Koehler, Jr., who loved modern art as much as his father, sent a letter to Delaunay in which he apologized for not coming to hear Apollinaire's lecture and asked the painter to present his excuses. Whether it reached Delaunay immediately is doubtful since he and Apollinaire left the same day for Cologne, where they spent the night. The next day they went to see August Macke and his wife in Bonn, who introduced them to a young painter named Max Ernst.[28] Although they intended to return to Paris that night, Elizabeth Erdmann-Macke later recounted, various circumstances forced them to revise their plans.

> Apollinaire and Delaunay paid us a visit on January 21, 1913. They had come to Cologne from Berlin, as far as I know, where they had gone to see a Der Sturm exhibition. When they left, Walden presented them with a large package containing issues of his review of the same name. They arrived in the afternoon, intending to take the night train from Cologne back to Paris. However, as can happen when kindred souls get together, no one wanted the animated gathering to end. Thus they wound up staying overnight.
>
> Apollinaire was lively, enthusiastic, and spoke good German. Surprisingly he was familiar with every little town in the immediate vicinity (for example, Heisterbacherrott in the Siebengebirge mountains), so that I secretly wondered whether he might not also be a spy. At that time I didn't know he had

been a private tutor in Honnef for a while and that some of his poems celebrate the Rhine. . . . Our friend Arthur Samuel was also present that night, and I only know we laughed a lot and were exuberant as only young people can be. . . . They had to leave our house early in the morning to take the Rheinland train, which in those days stopped at the Victoria Bridge near us, to Cologne and then the express to Paris. I had prepared everything the night before, and August got up early to fix them a light snack. They had a hard time saying goodbye, and Apollinaire, who limped a little, had to urge them to hurry up: "Il est temps, il nous faut aller." Through the curtains I watched him go down the narrow street at dawn, swinging the thick bundle of *Der Sturms* at the end of a rope in one hand, while August and Delaunay, who had become good friends, kept on shaking hands by the iron gate to the little garden in front of the house.[29]

One week later, on January 28th, Delaunay sent Walden a proposal to reproduce several of his works for sale at the Der Sturm gallery. Included in the list was a painting entitled "*La Ville*, No. 2, Paris, Étude 1910–1911," a reproduction of which appeared in the album. "As a companion text," the artist continued, "Apollinaire gave you a poem that was simply signed 'G. A.'" As Meissner remarks, Delaunay was almost certainly referring to "Tour" (OP, 200), which, because it was drafted at the last moment, was presented to Walden when the poet arrived in Berlin. Judging from this letter, however, the poem was supposed to accompany *La Ville*, No. 2, which like the painting "Tour" was eventually paired with, depicted the Eiffel Tower. Moreover, Delaunay seems to have been under the impression that the text would appear in the album. Whatever the explanation, the artist promised to send Walden a drawing which he wanted to appear opposite Apollinaire's second article in *Der Sturm*. However, he added, it could also accompany a third article Apollinaire was writing for the same review, devoted to Dramatism. Walden replied on January 31st that he would publish the two together, as Delaunay suggested, probably on the front page. "We also think about you and Apollinaire frequently," he confided and sent them both his warmest regards.

Besides an advertisement for Delaunay's catalogue and for *Les Soirées de Paris*, *Der Sturm* listed a volume of poetry in February to which Apollinaire had contributed: a special issue of *Poème et Drame* published the preceding November. For the present purposes, however, the most important document was an article entitled "Die moderne Malerei" ("Modern Painting"), which apparently served as the basis for his January

lecture.[30] Translated by Hans Jacob, who used the pseudonym "Jean-Jacques," the essay focused primarily on modern French art. Despite Walden's recent assurances, Delaunay's drawing was nowhere to be seen. In its present state, the text consists of some thirteen paragraphs arranged in no particular order. Except for the introduction, which is devoted to Impressionism, and the conclusion, which reproduces the epigraph from Delaunay's catalogue (with a few differences), the discussion obeys no obvious logic. Although there is no way of knowing how closely this text approximates the original lecture, one suspects that they had a great deal in common. Indeed, the fragmentary format, which is ill-suited to a comprehensive article, suggests that the lecture was accompanied by slides. Apollinaire profited from this occasion to generate a little publicity for three of his favorite causes: Dramatism, the Orphic painters, and Cubism. Of the three movements, he declared, the second was the closest to modern German art, especially that exemplified by Der Blaue Reiter. In his eyes, the most interesting painters were Wassily Kandinsky, Franz Marc, Ludwig Meidner, August Macke, Alexei von Jawlensky, Gabriele Münter, and Otto Freundlich.

Shortly after February 8, 1913, Delaunay received a postcard from Macke announcing the birth of his second son, Wolfgang. In it Macke asked the French painter to convey his cordial greetings to Apollinaire. If the latter was fondly remembered by his German hosts, moreover, he returned to Paris with pleasant memories of his own. More than anything he seems to have taken advantage of his sojourn in Berlin to learn about contemporary German literature. One week later, on February 16th, Apollinaire demonstrated his newly acquired knowledge in his column "La Vie Anecdotique."[31] This account confirms much of what has previously been deduced concerning his German adventure. In his view, the most promising literary figures associated with *Der Sturm* included Albert Ehrenstein, Peter Baum, Paul Zech, and Alfred Döblin. In addition, Apollinaire clearly admired Walden himself, who occupied a position in Germany that greatly resembled his own. That he had gleaned his information from informants who were intimately acquainted with the contemporary literary scene is also evident. Perhaps the greatest surprise this document contained was reserved for the next to last line, which alluded to another promising young writer: Franz Kafka. As far as can be ascertained, Apollinaire was the first person to mention this author in France. Interestingly, we will see that the situation was reversed shortly after the war when Kafka was placed in a position to comment on Apollinaire.

Apollinaire continued to be involved with the *Der Sturm* group for the rest of the year and most of 1914. A few weeks after his return, he

received a postcard from Berlin postmarked February 17, 1913, signed by Alfred Döblin, Ema Döblin, Walden, Paul Zech, a Dr. Neimann, F. T. Marinetti, and Nell Walden. "Vive le dramatisme!" someone had scrawled in one place; "Noch nicht müde?" ("Still not tired?").[32] In addition, Delaunay sent a picture postcard to Marc on February 21st in which he evoked "Les Fenêtres" (OP, 168–69). At the upper lefthand corner of the photograph, which depicted a dirigible view of L'Etoile, he wrote: "Araignée quand les mains tissaient la lumière. / Les Fenêtres / G. A." More importantly, Walden wrote to Delaunay on February 25th to ask him and Apollinaire to lend their names to a group protest, to be published in *Der Sturm*. The protest itself was occasioned by Kandinsky's one man show in Hamburg, in which the artist had been seriously manhandled by the local press. The following day Walden wrote to Delaunay again to inform him and Apollinaire of the unethical practices of an art dealer named Neumann. In the same letter, he urged him to return the signatures for the Kandinsky protest and added that he had sent Apollinaire the necessary materials as well. Rounding out the month of February, Macke wrote to Bernhard Koehler on the 27th that Delaunay and Apollinaire had stayed overnight with them. He was particularly pleased, he added, that they liked his latest pictures the best. The next day Macke also wrote to Delaunay to tell him how much he enjoyed the color reproductions in his album. Unfortunately, he confided, his appreciation of "Les Fenêtres" was hindered by the fact that a number of the words were not in his dictionary. As usual he asked Delaunay to convey his greetings to the poet.

March 1913 was characterized by a flurry of activity in connection with *Der Sturm*. The first issue that appeared that month contained a brief mention of *La Rome des Borgia*, which was being published by La Bibliothèque des Curieux, and a group statement in defense of Kandinsky. Besides Apollinaire's name, the long list of signatories included Delaunay, Albert Gleizes, Marie Laurencin, Alexander Mercereau, Fernand Leger, and Henri-Martin Barzun.[33] The most important contribution, however, was an article by Apollinaire devoted primarily to the Dramatist movement, to which he himself subscribed. Once again Delaunay's drawing was nowhere to be seen. Entitled "Pariser Brief" ("Letter from Paris"), the article extolled a recent novel by André Salmon, who was not a Dramatist, in addition to a series of works by Barzun, Mercereau, and Georges Polti. For those readers interested in poetry he recommended the *Anthologie des poètes nouveaux*, prefaced by Gustave Lanson, and a curious book by Georges Fourest. On the one hand, Apollinaire declared, Dramatism was the logical outgrowth of certain

Symbolist tendencies. On the other hand, it was strictly a twentieth-century phenomenon, one that "expresses our own age, where the universal and the individual reflect each other in an eternal and admirable conflict."

Later in the month a second issue of *Der Sturm* appeared which contained a number of testimonials in favor of Kandinsky, who continued to receive the journal's strong support. One of the people who came to the defense of the beleaguered artist was Apollinaire, who commented as follows:

> I have often discussed Kandinsky's works during his exhibition in Paris. I am happy to have the opportunity to express my highest esteem for an artist whose art appears to me to be both serious and significant.[34]

Throughout this period, Apollinaire's name continued to appear in Macke's correspondence with considerable regularity. In particular, each time he wrote to Delaunay—for example, on March 10th and March 12th—he included a word of greeting for the poet. Even at the height of the negotiations he was conducting with Delaunay on behalf of Koehler (who was his wife's uncle), he remembered his recent guest. On March 16th, discussing Koehler's proposal to buy several paintings from the Der Sturm exhibition, he found time to ask: "Was macht Herr Apollinaire? ("What is Mr. Apollinaire up to?"). At the same time the German artist served as an intermediary between the wealthy collector and Walden, who wanted to mount a large-scale show in the fall modeled on the Salon d'Automne. Macke wrote to the latter on March 21st to report some very good news: Bernhard Koehler had agreed to underwrite the exhibition to the tune of 4,000 marks. He advised Walden to consult with Delaunay and Apollinaire concerning which French artists to invite. Above all, he insisted, it was essential to obtain works by Matisse and Picasso.

By that time, Walden had left for Paris to persuade several French artists to participate in the exhibition. According to his wife they left Berlin on March 16th and returned toward the end of the month. While they were in Paris they naturally went to see Apollinaire, who introduced them to some of his friends.[35] One of these was Marc Chagall, who at that time was practically unknown in Germany. Chagall fondly evoked his first encounter with Walden, which was to have important consequences, on several occasions thereafter. The most interesting account occurs in his autobiography:

> Here is the garret of Apollinaire, that gentle Zeus.
> In verses, in numbers, in flowing syllables, he blazed a trail for all of us. . . .

In one corner sits a nondescript little man.
Apollinaire goes over to him and wakes him:
"Do you know what we must do, Monsieur Walden?
We must arrange an exhibit of this young man's works.
You don't know him? . . . Monsieur Chagall . . ."[36]

Among other things, April marked the third month in a row in which *Der Sturm* published an important contribution by Apollinaire. Whereas the previous examples had displayed his critical abilities, the latest demonstrated that he was an accomplished poet. Indeed, the text he chose was destined to become one of the more prominent milestones of the modern movement. Published in *Les Soirées de Paris* the previous December, "Zone" (OP, 39–44) became known in Germany (in the original French) at virtually the same moment it appeared in *Alcools*.[37] The same issue of *Der Sturm* included two of Apollinaire's other works in a list of "empfohlene Bücher" ("recommended books"): *Les Peintres cubistes*, published two weeks earlier, and *L'Hérésiarque et Cie*. Walden also advised his readers that the Verlag Der Sturm had become the sole German representative for works published by Figuière in Paris. Since *Les Peintres cubistes* was one of these, the notice indicates that it was available at the Der Sturm gallery. In addition, as will become evident, the agreement covered at least one joint publishing venture.

Judging from the show that resulted, Walden's expedition to Paris was a great success. Aided by Apollinaire and Delaunay, he accomplished a great deal in a short period of time. According to Nell Walden, she and her husband spent no more than eight days in the French capital. In particular Walden visited a number of important artists and convinced them to participate in the Erster Deutscher Herbstsalon in September. In addition he persuaded Apollinaire to lend many of the pictures that graced the walls of his apartment, which he had admired in person. Shortly after Walden departed, however, Apollinaire wrote to him in Berlin to report a change of heart. Postmarked April 6th, the postcard bore the following message:

> Dear Mr. Walden,
> I have not given the pictures to the shipper. I hadn't realized that I would be left without pictures in my apartment, and that would be a shame. I don't want to sell them. I am sending you several copies of *L'Intransigeant*. You took two copies of *L'Hérésiarque et Cie* with you. One was for you, the other was for Gleizes. Please send him his copy. You know his address: 20 avenue Gambetta, Courbevoie (Seine). *Les Peintres cubistes* is

now translated into German. It is ready to be printed, and you will receive copies soon. It was translated by a friend of Cendrars'. I'll send you a "Letter from Paris" tomorrow. Wouldn't you like to publish a chapter from this translation in *Der Sturm*? For example, the chapter on Marie Laurencin, Metzinger, Leger, and Gleizes! Best wishes to you and your wife.

Guillaume Apollinaire.[38]

Reading between the lines, it would appear that Walden had not only asked to borrow some of Apollinaire's art works but had offered to purchase them as well. Since virtually all the pictures were gifts from friends, the second proposal plainly fell on deaf ears. Apollinaire could not bear to be parted from them even for a while. The issues of *L'Intransigeant* which he sent Walden instead were a poor substitute at best. While they may simply have included random examples of his art column, one suspects they contained his recent reviews of the Salon des Indépendants. Walden had apparently planned to visit Gleizes in the countryside at one point, and Apollinaire gave him an extra copy of *L'Hérésiarque et Cie* to take to the painter. The most surprising news by far is that Apollinaire planned to publish a German edition of *Les Peintres cubistes*. Although he did not identify the translator, the latter was almost certainly Ludwig Rubiner, who, as he remarked, was a friend of Cendrars'. One of the bunch that frequented Le Dôme, Rubiner spent all of 1913 and the first half of 1914 in Paris, where he supported himself by writing articles for German publications. He undoubtedly learned of Apollinaire's translation project through Cendrars and agreed to undertake it. Among other things, this would explain why his name is listed in Apollinaire's address book. Unfortunately, the remainder of the story is a total mystery. Despite the fact that it was nearly completed, the project misfired at some point and was never heard of again. One can only conjecture as to what might have occurred.

Shortly thereafter, Walden received a joint communication from Apollinaire and two other individuals. Scribbled on the back of Robert Delaunay's membership card in the Salon des Indépendants, it consisted of three separate messages. One was from Sonia Delaunay who sent her "Viele heurige Grüsse" ("Very best wishes"). Another was from Harrison Reeves (see chapter 3), who, hearing that Walden planned to exhibit in America, wrote: "Success to a 'Sturm' for New York." The third message, which was slightly longer, was from Apollinaire himself. "Hello," he wrote hurriedly, " Will send proofsheets tomorrow. Did *L'Intransigeant* arrive? If the pictures are really necessary, will send them." Subsequent

correspondence reveals that the proofs in question were of a set of block prints by Marie Laurencin. Although his relationship with her had evaporated, Apollinaire was still acting as an intermediary between her and various persons. Two of the prints were published in *Der Sturm* on April 15th, and a third appeared the following month. Despite Apollinaire's offer to reconsider, Walden does not seem to have borrowed any pictures from him. At least none of the works listed in the catalogue of the Erster Deutscher Herbstsalon was from his collection.

On May 4, 1913, Delaunay received a card from Macke, the two Koehlers, and apparently the American artist Arthur B. Frost, Jr. Included among the various messages was one to Apollinaire from Bernhard Koehler, Jr., who sent the poet his "Freundliche Grüsse" ("Friendly Greetings"). One week later, on May 13th, Apollinaire sent Walden another letter which provides a tantalizing glimpse of several new projects. By this time the two men had developed a close working relationship and Apollinaire was on the point of becoming the Parisian correspondent for *Der Sturm.*

> My Dear Friend,
> I have had so much to do with the Salons and no time to write you. This evening I will send you my "Letter from Paris."
> I will send you the lectures soon.
> Please write to Marie Laurencin herself, and then you will obtain the pictures. Return Marie Laurencin's engraved blocks to me. I need. Also send me the proofsheets.
> Miss Laurencin's mother died the day before yesterday.
> Soon you will receive my poetry and the translation of *Les Peintres cubistes.*
> Write soon, and I send you my brotherly kisses.
>
> Guillaume Apollinaire
>
> Send me some anecdotes about yourself so I can write a "Vie Anecdotique" about you.

While the correspondence reveals that a number of ambitious projects were in the works, some of them seem to have been delayed indefinitely. Besides the translation of *Les Peintres cubistes*, which Apollinaire swore was finished, no trace remains of the second "Pariser Brief" nor of the lectures to which he referred. Although he may have been planning to speak at the Erster Deutscher Herbstsalon, he would scarcely have prepared his lecture(s) so far in advance. Instead this observation suggests

that Apollinaire was preparing to do one of two things. Either he was planning to give a series of lectures in Berlin, or he intended to introduce several of Der Sturm's travelling exhibitions, which were becoming more and more numerous. If the reference to "my poetry" was potentially ambiguous, the work in question was without a doubt *Alcools*, which had been published the previous month. Apollinaire first wrote "my book" and then crossed it out when he realized it might be confusing. The paintings of Marie Laurencin's that he mentioned had nothing to do with the various proofs and engraved blocks, which were connected with the prints that appeared in *Der Sturm*. Rather they were works that Walden wanted to borrow for the Erster Deutscher Herbstsalon. Although he presumably took Apollinaire's advice to write to the artist herself, she absolutely refused to lend them.

On May 15th, in an article devoted to literary creation, Gaston Picard treated the readers of *Der Sturm* to a lengthy discussion of Apollinaire's poetics. Taking *Alcools* as his point of departure, he praised the boldness of the poet's enterprise, the beauty of the individual poems, and the voluptuousness of the reading experience. In this connection he singled out "Zone" as proof of Apollinaire's exceptional gifts.

> On a lu ici même un poème de Guillaume Apollinaire, "Zone," plein des plus précieuses beautés. Si Guillaume Apollinaire est quelquefois le poète trop nonchalant des spectacles quotidiens et divers, dans ce poème il affirme des qualités de sensibilité, de pensée et d'expression qui en [sic] fortune presque admirable. On a vu que Guillaume Apollinaire négligeait toute ponctuation. Il n'y a point là absolument une innovation: Stéphane Mallarmé, dans ses sonnets supprimait la ponctuation; mais jamais cela n'avait atteint une centre entière, et le prochain livre des poèmes de Guillaume Apollinaire paraîtra sans qu'un point, une virgule, guident naturellement le lecteur dans la compréhension. Cette hardiesse peut sembler simple; elle n'en demeure pas moins une hardiesse. Ainsi les poèmes se présentent-ils comme de merveilleux secrets. D'abord on tâtonne, on hésite; on saisit ici une lueur, là une autre. Puis, la lumière se fait plus apparente. Enfin les beautés paraissent. C'est une volupté inédite que de promener une curiosité constante dans ces poèmes, constante jusqu'à l'instant où la lumière vous baigne, où la vérité vous étreint, où le secret pénétré s'érige dans le souvenir en triomphateur, avec son magique cortège de réticences et demi-aveux.
>
> À la considérer dans son essence, cette hardiesse est purement typographique. On lui alliera des hardiesses, différentes

mais typographiques également, dont de grands écrivains apportèrent la création.[39]

Two weeks later Walden received a postcard from Apollinaire depicting an ornate monument exhibited at the Salon des Artistes Français the previous year. Sculpted by Georges Delperier, it was entitled "À la mémoire de Ronsard," which some poor soul had translated into English as : "At the Ronsard's Memory." Postmarked June 3, 1913, the card covered much of the same ground as the previous letter. As before, Apollinaire promised to send a column for *Der Sturm*, asked if Walden wanted to publish a chapter from *Les Peintres cubistes*, and suggested he write to Marie Laurencin.

> Dear Friend,
> Received the woodblocks, but there were no proofs with them. You should send ten items. "Letter from Paris" will arrive soon. It is written in German, so I wait each day because I want to write good German. Marie Laurencin is in England. Her mother died. Marie Laurencin returns to Paris next week. Write to her then. Send me anecdotes about yourself or if you know any about Arno Holz. Hervieu is strictly Académie Française just like Sudermann.
>
> > Cordial Greetings
> > from
> > Guillaume Apollinaire

> Don't you want to use the translation of *Les Peintres cubistes*? Have you received my book *Alcools*?

Despite Apollinaire's repeated pleas, Walden never did send him any interesting anecdotes for the *Mercure de France*. Why the poet asked him for stories about Arno Holz is not entirely clear. As one of the founders of German Naturalism, he would certainly have been of interest to a literate audience. Unfortunately, the same cannot be said of Paul Hervieu, who was a hopelessly academic playwright. In a previous letter Walden had presumably asked Apollinaire about this writer who, as he learned, resembled the undistinguished German dramatist Hermann Sudermann. If Apollinaire was finally unable to accomplish all the plans he described to Walden, he kept his promise to send him a copy of *Alcools*. While it took somewhat longer than he had estimated, the book's arrival was signaled in the June 15th issue of *Der Sturm*. One of the questions that naturally arises is why so many of Apollinaire's projects never materialized. What

happened to his plans to give a series of lectures, and to publish *Les Peintres cubistes* in German?

One possible factor (and only one) may have been the publication of *L'Antitradition futuriste* a few weeks later.[40] Not surprisingly, since the aim of Apollinaire's manifesto was to synthesize the entire modern movement, it included several references to developments in Germany. Among the various movements that were grouped together at the beginning, for example, were "expressionisme" and "pathétisme," both of which were German inventions. While the former movement had received a certain amount of publicity in France, the latter was virtually unknown even in its own country. Apollinaire was referring, not to the earlier Neopatetische Cabarett organized by Kurt Hiller (which he doubtless knew nothing about), but to a group of writers who had resurrected the name for their review. Closely allied to *Der Sturm, Das Neue Pathos* (1913–19) published many of the same authors in its pages and shared the same general outlook. One of innumerable Expressionist journals that were springing up everywhere, it included Ludwig Meidner and Paul Zech among its editors and published contributions by Franz Werfel, Gottfried Benn, and Stefan Zweig. Apollinaire's knowledge was probably limited to the single issue he acquired early in 1913. Despite this gesture of solidarity, none of the persons he encountered in Berlin was mentioned by name. Indeed of the seventy-five individuals who were awarded "roses," only two were German: Kandinsky and Ludwig Rubiner. Ironically, the former was a Russian émigré, and the latter resided in Paris. In Apollinaire's defense it should be noted that Walden had originally been included in the list. Angered by some financial problems related to the Futurist show in Berlin, Marinetti omitted his name at the last moment.[41]

Although Apollinaire's manifesto was dated June 29, 1913, it seems to have been issued the following month. In July Macke also sent Delaunay a letter in which he warned him of an unexpected danger. Having recently convinced the majority of members in Die Berliner Secession to secede (!) from the parent organization, the art dealer Paul Cassirer was trying to sabotage the Herbstsalon. Macke asked Delaunay, Apollinaire, and Arthur B. Frost, Jr. to do their best to prevent Cassirer from doing any harm.[42] The same month Apollinaire received a visit from Hanns Heinz Ewers, whom he seems to have met through Marc Henry, a collaborator on *Les Soirées de Paris*. In April Henry had given him a book of French folksongs co-edited by Ewers and himself in German. Now that the former was in Paris, he wanted to meet Apollinaire in person. Among other things this seems to be how the latter acquired four of his books: *Das Grauen (The Horrors)* (1912), *Die Besessenen (The Possessed)* (1909), *Indien*

und Ich (*India and I*) (1911), and *Moganni Nameh* (1910). Consisting of his collected poetry, the last work was dedicated "À Guillaume Apollinaire Hanns Heinz Ewers Paris VII 1913."

The July 15th issue of *Der Sturm* carried an article by Wilhelm Hausenstein that testified to Apollinaire's growing influence in the German art world.[43] Conceived as a review essay, it examined *Les Peintres cubistes*, Gleizes and Metzinger's *Du cubisme*, André Salmon's *La Jeune Peinture française*, and three articles from *Der Blaue Reiter* almanac. "Guillaume Apollinaire has published a book entitled *Les Peintres cubistes* that includes, in a general chapter, a remarkable discussion of Cubism's fundamental principles and, in a more specialized chapter, brief but full profiles of the individual artists." Like *Du cubisme*, the author added, Apollinaire's book was available from *Der Sturm*. While the rest of his remarks were generally favorable, they tended to be descriptive. Thus Hausenstein reported that according to Apollinaire Cubism began with André Derain, who, with Braque and Picasso, was the movement's founder. And a few lines later he echoed the poet's disgust with traditional perspective, which he labeled a "truc misérable." In a similar vein, much of the following page was devoted to Apollinaire's division of Cubism into scientific, physical, Orphic, and instinctive modes.[44] Although Hausenstein thought this terminology was pedantic, he had no quarrel with the classification itself. Above all, he concluded, Cubism was depicted as "eine unhumanistische religiose Kunst" ("a nonhumanistic religious art"). As elsewhere in the article, this expression echoed Apollinaire's own words.

During the remainder of the year Apollinaire's name was invoked by persons associated with Der Sturm on several occasions. The first was in connection with a poem by Alfred Richard Meyer, which was dedicated to the author of "Zone." Published in *Der Sturm* on August 15th, this work will be discussed in a later section. Plainly intended as an act of homage, it reminded the journal's readers that Apollinaire wrote poetry as well as art criticism. The second occasion was provided by the Erster Deutscher Herbstsalon, which ran from September 20th to December 1, 1913. Featuring 366 works by 75 artists from a dozen different countries, it was one of the most important artistic events of the season. Among the various pictures and artifacts on display, the catalogue lists two works by Apollinaire: a copy of *Le Bestiaire* and the proofs for *Les Peintres cubistes*.[45] Since these items were exhibited by Sonia Delaunay, whose simultanist bindings were becoming well known, they were undoubtedly lavishly decorated. On November 15th Apollinaire published a lengthy review of the Herbstsalon based on the exhibition catalogue, which Walden had

sent him.[46] Despite some glaring omissions, he reported, the young French painters were particularly well represented, especially the Orphists. In conclusion, he quoted a letter from someone who had seen the show, writing from Berlin, who was disappointed with the German artists' relatively poor showing.

A few weeks before the Erster Deutscher Herbstsalon opened its doors, the Der Sturm gallery devoted a show to Archipenko's sculpture. Opening in September and extending into the following year, it was accompanied by a catalogue which included an essay by Apollinaire.[47] Since Archipenko had been discovered by the latter, he was the logical choice to introduce him to the German public. Above all, Apollinaire insisted on the religious impulse underlying the sculptures, which linked them to Western sacred art on the one hand, and to primitive religious cults on the other. Citing the influence of Egyptian, Chinese, and African art, he underlined both their debt to tradition and their striking modernity. In his opinion Archipenko was the first sculptor whose works could be said to approach the condition of painting. Like the most advanced artists Archipenko was fascinated by the possibilities offered by abstraction, which he identified with aesthetic purity.

In mid-December *Der Sturm* published an article on another aspect of modern aesthetics by the Futurist Umberto Boccioni. By this time a full-scale war had erupted between the practitioners of simultanism, both in literature and in art, over the question of priority. Not only were Apollinaire and Barzun involved in an ongoing dispute, but Delaunay and the Futurists had joined in as well. More than anything, Boccioni sought to defend the Futurists' claim to have discovered this aesthetic technique. In support of his arguments he cited Apollinaire, who was familiar with the Futurist manifestos and experiments:

> Nous sommes heureux en outre de constater que notre grand ami et allié Guillaume Apollinaire—l'audacieux poète des *Alcools*—nous rend entièrement justice à ce sujet, dans sa belle revue *Les Soirées de Paris* (15 novembre 1913):
>
>> Delaunay, qui par son insistance et son talent a fait sien le terme de simultané, qu'il a emprunté au vocabulaire des Futuristes, mérite qu'on l'appelle désormais ainsi qu'il signe: "le Simultané."
>
> Pour ma sculpture aussi Guillaume Apollinaire constate dans le même article la priorité de la simultanéité sculpturale qui parut pour la première fois dans mon Exposition de Sculpture futuriste (Paris: Galerie La Boétie).[48]

On January 1, 1914, *Der Sturm* published an icy rebuttal by Robert Delaunay, who objected to Boccioni's history of simultanism.[49] More precisely, he objected to the manner in which Boccioni interpreted Apollinaire's remarks in *Les Soirées de Paris*. In the course of his argument, which he insisted was perfectly objective, Delaunay alluded to the poet five separate times. Not only did he reproduce the paragraph above, taken from Boccioni's article, but he quoted another five paragraphs from Apollinaire's original essay. In particular, Delaunay reported, he had recently conferred with the latter in an attempt to establish a history of his own. Since Blaise Cendrars had played a prominent role in the initial simultanist experiments, Apollinaire had asked him to provide a chronology, which would eventually be made public. In any case, Delaunay hastened to add, the discussion in *Les Soirées de Paris* did not apply to his sculpture, which Apollinaire had never seen. And sculpture, as everyone agreed, was at the heart of the simultanist enterprise.

Between this date and the outbreak of the war Apollinaire published three more contributions in *Der Sturm* and advertised numerous activities that were sponsored by the journal. On March 1st, an abbreviated version of his essay on Archipenko appeared in Walden's review.[50] What Apollinaire especially liked about the sculptor's works, he proclaimed, was their extremely modern appearance. As before, he praised Archipenko's experiments with abstract sculpture and predicted that this genre would eventually merge with painting and architecture to form a single mode of expression. Writing in *Les Soirées de Paris* six weeks later, Apollinaire also singled out a series of projects associated with *Der Sturm*.[51] One of these, which was already well under way, was an exhibition of paintings by Marc Chagall. Impressed by Apollinaire's recommendation the year before, Walden had scheduled a joint show with the Czech painter Otakar Kubin. While he sent Apollinaire a catalogue of the latter's pictures, which is preserved in his library, there is no trace of a catalogue for Chagall. About this time Apollinaire also received two volumes of poetry published by Der Sturm. Dating from 1914, August Stramm's *Rudimentar* (*Rudimentary*) and *Sancta Susanna* also seem to have been a gift from the editor.

Another of Walden's plans, Apollinaire announced, was to sponsor an exhibition of paintings by Giorgio de Chirico in the fall. Rendered useless by events beyond their control, the project unfortunately had to be abandoned, depriving the Italian artist of an audience in Germany. As far as can be determined, de Chirico never did have a show at Der Sturm. The last project to which Apollinaire alluded was concerned with Kandinsky, whom he persisted in linking to the Orphist painters. Although this par-

ticular enterprise had recently been completed, it contained the germ of another, equally interesting project.

> La revue *Der Sturm* vient de publier un album sur Kandinsky, peintre slave peignant à Munich et le seul peintre étranger dont les ouvrages ressortissent à l'orphisme. Le grand poète hollandais Albert Vervey a écrit pour cet album un poème singulièrement pénétrant.
>
> La peinture lyrique compte aujourd'hui déjà des ouvrages assez significatifs pour qu'on puisse envisager la possibilité d'une exposition où seraient réunis des tableaux de Picabia, de Marcel Duchamp, de Jacques Villon et de Kandinsky.

May 1, 1914, saw the publication of a second poem by Apollinaire in *Der Sturm*, which had appeared in *Les Soirées de Paris* two weeks earlier. Like "Les Fenêtres" and "Zone," "À travers l'Europe" (OP, 201–2) was a *poème simultané* in which memory, vision, and thought were thoroughly intermingled. If anything, it was even more obscure than its predecessors. Originally entitled "Rotsoge," the composition was dedicated to Chagall, whose studio seems to have served as its point of departure. Among other things, the fact that its publication coincided with the painter's exhibition at Der Sturm suggests it was initially written for this occasion. Indeed, one suspects that Apollinaire's text was first published in the catalogue which must have accompanied Chagall's show. While this document remains to be discovered, it was probably a simple pamphlet like the brochure that Walden printed for Kubin. This impression is heightened not only by Delaunay's album, examined previously, but by the discovery that Apollinaire was preparing to write introductory texts for two other artists: Francis Picabia and Giorgio de Chirico. Like the latter painter, the former was prevented from exhibiting at Der Sturm by the war. On May 18th Apollinaire sent Walden a postcard depicting an installation at the 1913 Salon d'Automne by Paul Huillard, who was an interior decorator. Scribbled across both sides, including the photograph of a model dining room, the message read as follows:

> Dear Friend,
>
> Yes, of course, I have spoken to Picabia, and his exhibition has been arranged for January 15th. If he still has not written, write him yourself. In any case send me something for *Les Soirées*, but no manifestos. Will send article for de Chirico soon and another for Picabia later. I will also send you the address of a very good female painter who is still quite young. When are my

poems going to appear in *Der Sturm*? I am writing in *Paris-Journal* every day now, no longer in *L'Intransigeant*. I have much more space and have already written about *Der Sturm*. Have you read it? I would like to write about each issue of *Der Sturm* and would like to insert notices from your catalogues. So send me everything. I kiss the hand of your beautiful visitor and remain your friend.

Guillaume Apollinaire

With the passage of time it has become increasingly difficult to identify some of the individuals mentioned in this letter. One would love to know who Walden's beautiful visitor was, for example, as well as the identity of the young painter recommended by Apollinaire. Among other things, we know the poet wrote to Picabia on May 7th to arrange an exhibition of his paintings in Berlin.[52] In addition, Apollinaire's query about the fate of his poems reveals that he had sent Walden several new texts. Since he had received the May 1st issue of *Der Sturm*, he could not have been asking about "À travers l'Europe" ("Rotsoge"), which he knew had been published. One of the works to which he referred was undoubtedly "Souvenir du Douanier" (OP, 357–59) which was taken from the same issue of *Les Soirées de Paris* as "À travers l'Europe." Like its companion poem, Apollinaire's touching homage to the Douanier Rousseau was left in the original French. Published in *Der Sturm* on July 1st, it was destined to be his last contribution to that review.[53] As Apollinaire informed Walden, he had recently resigned from *L'Intransigeant* to become the art critic for *Paris-Journal*. Indeed, as he maintained, he had already found an excuse to write about *Der Sturm*. On May 6th he noted that Josef Čapek had published an article on modern architecture in the latest issue of Walden's review.[54]

Judging from subsequent events, Walden seems to have heeded Apollinaire's call to keep him informed about Der Sturm's projects. Over the next two and a half months, at least, the poet managed to publicize a number of activities in *Paris-Journal*. On May 23rd, during a discussion of "Expositions étrangères," he devoted a paragraph to Chagall's exhibition in Berlin. This show, he informed his readers, was sponsored by *Der Sturm*, "l'impétueuse revue, si bien dirigée par Herwarth Walden, le musicien bien connu." At the same time, he added, the gallery was exhibiting pictures by Otakar Kubin and sponsoring a traveling show by Maurice de Vlaminck. Three days later, in a note concerning the art scene in "Allemagne," Apollinaire mentioned that the German magazine had recently published an interesting linoleum print by Vladislas Hoffman.

One of his most important articles was reserved for June 2nd, when he reviewed a brand-new show by Chagall at the Der Sturm gallery.[55] Describing the artist as an imaginative colorist with roots in Slavic folk art, he concluded that he was capable of painting monumental pictures. Apollinaire published another article exactly one month later, entitled "Architecture de verre," which in its own way was equally interesting. A sympathetic review of Paul Scheerbart's *Glasarchitektur*, published by Verlag Der Sturm, it reported that according to the author the modern era was destined to become a civilization of glass. The last article, which was also quite important, appeared on July 3rd.[56] Devoted to Albert Gleizes, Jean Metzinger, Duchamp-Villon, and Jacques Villon, who were exhibiting at the Der Sturm gallery, it complimented their German hosts on their enlightened attitude toward modern French art.

ALFRED RICHARD MEYER

Like a number of individuals associated with Der Sturm, Alfred Richard Meyer was involved in several other enterprises as well.[57] Headquartered in Wilmersdorf, a suburb of Berlin, he presided over his own circle of friends and colleagues who gathered together in a local tavern. A prolific poet, who often wrote under the pseudonym "Munkepunke," he also ran an influential publishing house. Unlike Walden, who was involved with both literature and art, Meyer's interests were primarily literary. In his capacity as editor, he published a journal entitled *Die Bücherei Maiandros* (*The Maiandros Library*) and a whole series of volumes devoted to modern poetry. As such, he helped to publicize a number of important poets and contributed to the general Expressionist enterprise. Although Meyer claimed to have met Apollinaire as early as 1911, this date is almost certainly erroneous.[58] The most likely scenario, one that is supported by the available data, is that he first encountered the poet during the latter's visit to Berlin. Perhaps at this time he gave Apollinaire the copy of *Das Buch Hymen* (*Hymen's Book*) (1912) that is preserved in his library. In addition, the two men may have agreed to exchange copies of their respective reviews. At some point, in any case, Apollinaire acquired a virtually complete set of *Die Bücherei Maiandros*. Similarly, Meyer sent him a second volume of poetry, entitled *Tiger* (1913), later in the year.

　　Like Hanns Heinz Ewers and the editor of *Der Sturm*, Meyer decided to take a trip to Paris several months later. While he was visiting the French capital, he made a point of looking up Apollinaire. Although this visit is mentioned only in passing in Meyer's memoirs, his account permits one to situate it in either June or July 1913.[59] Apollinaire asked him at

the time, he related, if he would be interested in buying a painting by the Douanier Rousseau for only twenty francs. To his later chagrin, Meyer decided instead to spend the sum on an elegant dinner in a restaurant in Montmartre. During his sojourn in Paris he also seems to have written several poems, at least two of which contain traces of Apollinaire's influence. As soon as Meyer returned to Berlin he submitted both works to Walden, who published them in *Der Sturm*. Entitled "Paris," the first poem appeared on August 15th with the following dedication: "à Guillaume Apollinaire avec mille remerciements pour 'Zone.' "[60]

Although the average reader could scarcely have been aware of all its ramifications, the purpose of Meyer's dedication was threefold at least. In the first place, it recorded his enthusiastic discovery of "Zone" (OP, 39–44) in *Der Sturm* four months earlier. For that matter, it may have marked his introduction to cubist poetics in general. In the second place, the dedication acknowledged that Meyer's text was indebted to the earlier work, which it resembled in several respects. As soon as he reached Paris and realized how well Apollinaire had synthesized life in that city, he was inspired to write a similar poem. In the third place, Meyer appears to have obtained the right to translate "Zone" into German. By itself any one of these reasons would have been enough to explain the author's obvious gratitude. Taken together, they help to understand Meyer's frame of mind at the time. For reasons that can only be guessed at, the dedication was omitted in subsequent editions. By 1921, when Meyer's collected verse appeared, it had disappeared altogether. When his collected works were published three years later, it was replaced by an invocation to the elements.[61]

Like Apollinaire's composition, "Paris" is a rather long poem full of surprising juxtapositions and written in free verse. In both works, the narrator follows an itinerary that takes him all over the city and exposes him to different experiences. Despite these and other similarities, there is no danger of confusing the two texts. Whereas Apollinaire continually cuts from the present to the past, from one perspective to another, Meyer's narrative is relatively continuous and situated in the dramatic present. Whereas the former poem evokes one or two architectural creations, the latter is strewn with public monuments from one end to the other. In the same vein, every geographical feature has a name. As this description suggests, "Paris" could only have been written by a tourist. In some respects, moreover, it resembles "Vendémiaire" (OP, 149–54) since it celebrates the French capital's universality. This theme is especially evident in the first section where Paris is swallowed up by Berlin and vice versa.

Of course—
Paris is nowhere near the Seine.

This pervasive error, which dates from Caesar's time,
must finally be laid to rest.
Paris is simply located on Bayrischer Platz
in Berlin.
And its so-called "Préfet de la Seine" is simply named
Karl Scholz.
In fact Paris would have been located on the corner of Grunewald Street
if it hadn't received the twelve-thousandth dash from Loeser and Wolff
and chosen to abut the German Bank.
At night Karl Scholz lets us hoist the Tricolor
over Bickbeer Brandy,
Eiskümmel,
and Cassis.
Each of these colored bottles is an *arrondissement*,
which you can sample according to your taste,
and features a label with verses by Apollinaire.
The Marseillaise bubbles forth
two
three
with every belch.
Drivers play the "Internationale" on their horns.
Miss Trudy Scholz is also there
with her Lutetia hands,
whose lifelines
stretch three kilometers
along the Rue de Rivoli
from the Place de la Concorde
to the Place de la Bastille.
Monico sparkles in her left eye;
the Caveaux des Innocents beckons mysteriously in her right eye.

To the uninitiated Meyer's poem seems to be an exercize in nostalgia. Memories of the poet's recent visit to Paris appear to follow him everywhere he goes, transforming Berlin into a mirror image of the French capital. In actuality, the work is situated in a tavern on Bayrischer Platz where Meyer and his colleagues met several times a week. For reasons known only to himself, he baptized the *Stammtisch* that he founded there "Paris."[62] The poem evokes the merrymaking of the inhabitants of this unusual city, each of whose quarters is represented by a different bottle of liquor. Like Karl Scholz, who presumably ran the tavern, the references to billboards and business concerns on Bayrischer Platz were immediately recognizable to the members of Meyer's circle. Contributing to the osten-

sible theme of Franco-German fusion, the "Namensschilde" ("name-plates") bearing Apollinaire's verses are a nice touch. While they represent German liquor labels on the one hand, they function as French streetsigns on the other. In addition, Meyer is alluding to "Le Musicien de Saint-Merry" (OP, 189), which contains the following advice: "Rivalise donc poète avec les étiquettes des parfumeurs." Giving the line a humorous twist, he imagines a situation in which Apollinaire's poems actually serve as labels. Thereafter the appearance of Trudy Scholz, presumably the owner's daughter, gives Meyer the opportunity to introduce a comic *blason*. Immortalized in paintings by Gino Severini, the Monico was a Parisian dance hall. Situated in the Les Halles district, the Caveaux des Innocents was another popular nightspot. Continuing in the same vein, the narrator discovers the Louvre in Resi Langer's purse, the Arc de Triomphe in Rudolf Leonhard's nose, the Paris zoo in Ernst Wilhelm Lotz' poetry, and the Luxembourg Garden's pigeons nesting in Fritz Max Cahén's hair. The poem concludes with the author himself, who is depicted as the Eiffel Tower.

Two months later Meyer published another poem in *Der Sturm* which also recalled Apollinaire. Entitled "Biesenthal in der Mark," it was written in free verse, like its predecessor, but lacked the latter's grandiose design.[63] A description of a gathering in an artist's studio, the composition resembles not "Zone" so much as "Lundi rue Christine" (OP, 180–82). As before, the resemblance is general rather than specific. While Meyer's style and technique are clearly indebted to the French poet, there are no overt borrowings. The first four lines, with their image of disembodied heads dancing in the smoke-filled room, are typical of the rest of the work: "The whole studio is one great belch, / shooting down cigarette smoke like a spent bullet, / in the midst of which four five ruddy male heads / float in the air like children's balloons."

The full story of Meyer's relationship with Apollinaire cannot be told without mentioning the role played by Fritz Max Cahén. A friend of Blaise Cendrars, like Ludwig Rubiner, Cahén spent the better part of a year in Paris in 1912 and 1913. "Apollinaire's *Méditations esthétiques* had appeared in January," he recalled many years later, "the first important study of Cubist painting. His *Antitradition futuriste*, in which he joined Marinetti's ranks for a while, first appeared in Milan exactly as I was about to leave Paris."[64] In other words, Cahén returned to Berlin at about the same time as Meyer, who had also been visiting the French capital. Scarcely had he returned, when the latter contacted him regarding a translation project. According to Cahén, however, the decision to translate "Zone" was actually

his own. Meyer not only valued his proven ability as a French translator but trusted him to select the best poem from Apollinaire's latest collection.

During this period Meyer was engaged in a lively correspondence with his friend Guillaume Apollinaire. The Frenchman was widely considered to be the official theoretician of modern art and a high-ranking poet. In Germany, except for those who could read French, he was virtually unknown. Only Herwarth Walden had published a few brief translations in *Der Sturm*. Meyer asked Apollinaire for permission to publish one of his works as a "Lyrisches Flugblatt," i.e., a small booklet, and asked me to choose a suitable poem from *Alcools*. I decided on the epic poem "Zone." . . . Thus I became the author of the first Apollinaire translation to appear in German in volume form.[65]

Cahén reported elsewhere that he and Meyer spent a great amount of time together while he was working on his translation. Although little trace remains of their conversations, the two men must have discussed Apollinaire on numerous occasions. By Cahén's own account, Meyer was highly knowledgable when it came to the latter's poetry. The director of *Die Bücherei Maiandros* revealed how well versed he was in modern literature, Cahén recounted, when Henri Guilbeaux paid him a visit. Among the subjects he discussed with enviable mastery were Apollinaire, the Parnassians, and Rimbaud.[66] While Cahén was obviously proudest of his translation of "Zone," in point of fact he was involved in several projects concerning Apollinaire. These projects all reached fruition at the same time, on November 1, 1913, with the publication of multiple texts in a supplement to *Die Bücherei Maiandros*. In addition, the editor announced the imminent publication of "Zone" which, like Gottfried Benn's *Söhne* (*Sons*) and a booklet by Wilhelm Lotz, would join the Lyrische Flugblätter. Almost exclusively devoted to German writers, the volumes in this series were listed on the following page. The only works by foreign authors were "Zone" and Marinetti's *Futuristische Dichtungen* (*Futurist Poetry*). Delighted to add Apollinaire's name to the list, Meyer sent him *Söhne* and several other Lyrische Flugblätter including Max Dauthendey's *Der Untergangstunde der Titanic*, Max Herrmann's *Porträte des Provinz Theaters*, Resi Langer's *Rokoko*, and Rudolf Leonhard's *Angelische Strophen* (*Angelic Verses*).

In addition to the publicity surrounding the publication of "Zone," the supplement featured two other texts that were directly related to Apollinaire. One of these was a translation of "La Dame" (OP, 127) by Fritz Max Cahén, who once again chose a poem from *Alcools*. The other

was a review of the latter volume, also by Cahén, which attempted to explain its mysterious appeal.

> There is much in Apollinaire's book that could be all too quickly dismissed as *vieux jeu* with a shrug of one's shoulders. This illustrates how easily the insistent focus on subject matter, which has become a fad with the younger generation, can cause one to mistake a brief glimpse for the actual determining factors. That is, for one's gradually increasing perception, for the value of the representation itself, and for the rhythm of the discourse. . . . In Apollinaire's poetry many landscapes, many moonlit nights, occupy modern man's field of vision. *Au fond* we are all sentimentalists, and our objection to sentiment is just as false as the aesthetics of sentimentality which we may rightfully oppose. Like Apollinaire the poet must struggle to achieve a personal vision in order not to succumb to temptation like the rest of the world, to irresistable temptation which created Romanticism's *Weltschmerz* and recent poetry's cynicism, whose basic tenet is the limitations of will power. For poems such as the "Rhénanes" in *Alcools*, therefore, there is no need to engage in a literary *recherche de la paternité* (which can be fruitful) because their accents are new and manage to escape the restrictions of current jargon. A zealous French-speaking Christian Polish Jew, perhaps unwillingly, Apollinaire is a romantic rationalist. From this unlikely mixture he clutches at worldly things. In this context is it permissible to quote Goethe: that being a poet depends on "one's lively perception of the state of affairs" and "one's ability to express it"?).

Apollinaire was also well represented in the following supplement, published on February 1, 1914, which emphasized his diverse talents. Much of the front page was taken up by a drawing Marie Laurencin had contributed to his Lyrisches Flugblatt, depicting the poet on horseback.[67] A caption informed the reader that it was taken from Cahén's translation of "Zone." Elsewhere in the same issue Meyer reprinted a succinct appraisal of Laurencin's work that had appeared in *Les Soirées de Paris* a few months before.[68] Finally, the poet was identified as one of the editors of *Les Soirées de Paris*, which was included in a list of recommended publications.

During 1914 Apollinaire continued to receive copies of the Lyrische Flugblätter as they appeared. Early in the year, for example, Meyer sent him Rudolf Leonhard's *Barbaren* (*Barbarians*) and a book by himself entitled, with characteristic whimsy, *Munkepunkes Tanz-Plaketten von ihm*

selbst (*Munkepunke's Very Own Dance Booklet*). Inscribed by the author, the second volume was dated April 29, 1914. The following month witnessed the publication of another supplement, entitled *Das Beiblatt* like the rest, and a new text by Apollinaire. Except for "Zone," which was advertised in another section together with the rest of Meyer's books, "Lundi rue Christine" (OP, 180–82) was his most important contribution to date.[69] Translated by Balduin Alexander Möllhausen, Apollinaire's notorious conversation-poem was revealed to the Berlin avant-garde six months after it appeared in *Les Soirées de Paris*. Unfortunately, only three months remained in which to absorb its lessons.

One year later, writing to Madeleine from the front, Apollinaire devoted a paragraph to Cahén's translation of "Zone" which provides one last glimpse of his relations with Meyer. Unavoidably his remarks were colored by the cataclysmic events of the previous twelve months.

> [L]a dernière année chez les poètes d'avant-garde allemands s'était passée à paraphraser "Zone," qui est le premier poème d'*Alcools*. Ils avaient même de ce poème fait une très jolie édition (traduction naturellement) avec une jolie couverture illustrée, ils l'ont tirée à 15,000 exemplaires, m'en ont envoyè cinq, ont vendu en 8 jours le reste, à 75 centimes le fascicule et ne s'étant pas donné la peine de me demander l'autorisation de faire cette édition, ne m'ont même pas offert de me payer de droits, puis ont fait la sourde oreille à toutes mes réclamations.[70]

In view of Meyer's attempts to adapt Apollinaire's experiments to German verse, the first accusation is perhaps understandable. On the other hand, the production figures cited for "Zone" are obviously inflated. Even if one accepts Apollinaire's estimate of 15,000 copies, the booklet could not have sold out so quickly since it continued to be advertised for at least six months. Indeed, the fact that he never received a penny suggests that relatively few copies were sold. One also wonders whether the editor never bothered to obtain his permission. The booklet itself was proudly labeled "autorisierte Nachdichtung" ("authorized translation").

OTHER PREWAR AUTHORS

As a result of his trip to Berlin, and the exposure afforded him in Walden's and Meyer's publications, Apollinaire developed an extensive network of contacts in Germany. Before long he found himself on the mailing lists of various art galleries, who sent him catalogues, and several publishing

houses, who sent him copies of their journals. The first category included the Alfred Flechtheim gallery in Düsseldorf and the Verlag Neue Kunst in Munich, which was run by Hans Goltz. In addition a number of art dealers subscribed to *Les Soirées de Paris* such as Flechtheim, Paul Cassirer, and Wilhelm Uhde.[71] The second category included art journals like *Die Neue Kunst* and *Zeitschrift für Bildende Kunst,* both of which were edited in Leipzig. It also included Expressionist reviews such as *Das Forum,* published in Munich, and *Die Aktion,* which was edited by Franz Pfemfert in Berlin. The latter was an extremely important periodical devoted to politics, literature, and art. It was perhaps the only Expressionist journal that was as influential and as long-lived as *Der Sturm.*

Although Apollinaire's collection of *Die Aktion* was limited to 1913, it signaled his increasing awareness of the review's importance and vice versa. In this case, the individual who served as the intermediary between them appears to have been Ludwig Rubiner, who has been encountered before. Indeed, Apollinaire's name first appeared in an article by Rubiner, who devoted several paragraphs to him in April 1913.[72] For all practical purposes the poet's collection of *Die Aktion* dated from this event. Rubiner not only asked Pfemfert to mail him several issues but sent him a copy of his recent article. The latter was concerned with the journal *Montjoie!,* which had begun publication in February. "The highly intelligent Guillaume Apollinaire discusses painting in its pages," Rubiner reported, adding that *Montjoie!* had commissioned him to review the most advanced tendencies in modern French art. Since his recent article on the Salon des Indépendants was quite long, Rubiner elected to cite a single line, which originally read as follows: "Salle XIII. Adam et Eve, de Roger Parent, symbolique."[73] What he admired about this comment, he explained, was its admirable concision.

Sandwiched between parentheses, Rubiner's most interesting remark was concerned not with art but with modern poetry. "Apollinaire is the author of one of the best poems in French," he declared in passing; "it is entitled 'Zone,' appeared in *Les Soirées de Paris,* and is the brainchild of a true master." By a happy stroke of fate this comment coincided with the publication of the poem itself in *Der Sturm.* Despite this promising beginning (and Rubiner's interest in his work), Apollinaire was destined to be mentioned only twice more in *Die Aktion,* the first time in circumstances that are rather puzzling. On August 30, 1913, the editor announced that a special issue would appear the following month devoted to modern French poetry. Not surprisingly, Apollinaire was listed among the poets whose compositions were to grace its pages. However, when the issue was printed, on September 13th, it contained no

trace of the latter or his work. Since no explanation was ever provided, why Apollinaire was excluded remains a mystery to this day.

In mid-October, a notice of a different sort appeared in a review called *Der Zwiebelfisch* (*The Printer's Pie*), published in Munich. Devoted to Apollinaire's Futurist manifesto, it was not unsympathetic so much as determined to satirize this astonishing document. Although its author has yet to be identified, the notice is worth reproducing for its documentary interest.

> Speaking from a height of 65 meters above the Boulevard Saint-Germain, Monsieur Guillaume Apollinaire threatens to sh well, to bless the following institutions with his MER DE according to a sweet melody (which he reproduces) in his manifesto *L'Antitradition futuriste*: pedagogues (bravo!), professors (!), ruins, harmonious typography (poor Poeschel!), Venice, Versailles, Pompei, Bruges, Oxford, Nuremberg, Bayreuth (!), Florence, Montmartre, Munich, Dante, Shakespeare, Tolstoi, Goethe, Montaigne, Wagner (!), Beethoven, Poe, Whitman, Baudelaire etc. etc. All this will make a nice family resort, with lots of methane and hydrogen sulfide and a beautiful view of Little Willy up there 65 meters in the air. However, our hero hands out ROSES (roses!!! How passeistical!) to all the hotshots: Marinetti, Picasso, Boccioni, Apollinaire (to himself. If he is so objective, why doesn't he put himself in the first category?), Jacob, Henri Matisse, Archipenko, Jastrebzoff, Kandinsky, Stravinsky, Rubiner, etc. etc.—Our Saviour and Conqueror.[74]

Rounding out the list of authors who referred to Apollinaire in 1913 are two books by persons connected with the art world. Entitled *Neue französische Malerei* (*New French Painting*), the first work was a joint project by L. H. Neitzel, who wrote the introduction, and Hans Arp, who selected the illustrations.[75] Speaking of the different tendencies embraced by the term "Cubism," Neitzel paused at one point to present the classification developed by Apollinaire.[76] The latter, he explained, was an "extraordinarily sensitive writer" and the author of *Les Peintres cubistes*. Despite its fondness for relative judgement, he continued, this fundamental study was indispensable for anyone interested in the subject. These remarks were followed by a brief description of each of Apollinaire's four categories. As far as his own discussion was concerned, Neitzel informed his readers, two of these could be disregarded. In considering the problem of "absolute painting" only scientific Cubism and Orphic Cubism were of any value. Not only were the physical and the instinctive branches irrele-

vant, but the latter, which included Matisse and the Italian Futurists, actually had nothing to do with Cubism.

The second work, which Apollinaire owned, was edited by Paul Mahlberg in connection with a blockbuster exhibition at the Flechtheim gallery near the end of the year. A major show by any standards, the latter consisted of a broad selection of French and German pictures from the period 1880–1913 and marked the gallery's opening. Entitled *Beiträge zur Kunst des 19. Jahrhunderts und unserer Zeit* (*Essays on 19th Century and Contemporary Art*), Mahlberg's volume contained numerous authoritative studies, which were profusely illustrated. Interestingly, Apollinaire's name was invoked in three different contexts. On the one hand, he was identified as the author of *L'Enchanteur pourrissant* in a two-page advertisement published by Kahnweiler. On the other, the illustrations included a 1905 watercolor by Picasso entitled "Ex-Libris Guillaume Apollinaire."[77] Too large ever to serve as a bookplate, it depicted a Rabelaisian king holding a goblet and preparing to dine. In addition to these two references, the book contained an essay by Apollinaire devoted to Picasso. Reprinted from *Les Peintres cubistes*, where it constituted the second half of the corresponding section, it appeared in the original French.[78] Beginning with the phrase "Imitant les plans pour représenter les volumes," Apollinaire compared Picasso to a surgeon, a revolutionary, an explorer, and a newborn baby.

Early in 1914, Apollinaire received a copy of another book by Paul Zech entitled *Die eiserne Brucke* (*The Iron Bridge*) (1914). On January 15th, a column devoted to "Notes allemandes" began to appear in *Les Soirées de Paris*. Ostensibly authored by André Billy, it was almost certainly written by someone else. Indeed one seems to recognize Apollinaire's touch in various places. Among the books that were reviewed were Kokoschka's *Dramen und Bilder* (*Plays and Pictures*), Arp and Neitzel's *Neue französische Malerei*, Mahlberg's *Beiträge*, and a volume by Max Raphael called *Von Monet zu Picasso* (*From Monet to Picasso*), which was described as "une sorte de masturbation intellectuelle." Citing Alfred Jarry in passing, the author predicted a glorious future for Flechtheim's gallery and offered some professional advice. Two weeks later André Salmon published an article on Marie Laurencin in *Die Aktion* which acknowledged Apollinaire's critical expertise in this area. Speaking of the artist's stylistic signature, he declared: "The arabesque which, as Guillaume Apollinaire has rightly pointed out, is the distinctive sign of her art, has attracted the condemnation of our interior decorators."[79]

Retitled "Littérature allemande," the German column in *Les Soirées de Paris* finally reappeared in April. This time it was signed by Ludwig

Rubiner, who reviewed three books of poetry: Zech's *Die eiserne Brücke*, Leonhard's *Barbaren*—both of which were dismissed as inconsequential— and a translation of Michelangelo's sonnets. Inevitably one wonders if the earlier column, which also contained some derogatory remarks, was written by Rubiner as well. A brief remark by Wilhelm Hausenstein in May demonstrated that Apollinaire's review was as highly regarded in Germany as it was in France. Writing in *Das Forum*, he contrasted the "hopelessly provincial attitudes" of the Munich critics with the enlightened ideas typical of *Montjoie!* and *Les Soirées de Paris*.[80] The best illustrations were to be found in the second journal, he noted, which was also more advanced from a technical standpoint. Interestingly, Hausenstein sent Apollinaire a copy of the issue in which his remarks appeared.

On May 9th, Apollinaire authored a brief article in *Paris-Journal* devoted to Alfred Flechtheim's gallery in Düsseldorf.[81] Among the painters whose works were currently on display, he reported, was Maximilien Luce, the former Divisionist and friend of Seurat. This event was noted in *Les Soirées de Paris* as well where it received a scant two and a half lines.[82] In addition, Apollinaire published a long article by Albert Haas, whom he had met in Berlin, evoking the Symbolist milieu in France toward the end of the previous century. Before becoming the editor of the *Börsen Courier*, Haas had spent a number of years in Paris where he frequented Jean Moréas' circle.[83] With one exception, the remaining references to the German avant-garde in 1914 were to events associated with the Flechtheim gallery.[84] Judging from the frequency with which they appeared, this establishment was experiencing a flurry of activity. On May 26th, Apollinaire reported that an exhibition by the German Impressionist Ernet te Peerdt could be seen at the gallery. In June an article appeared in *Les Soirées de Paris* by Flechtheim himself, who sketched a brief history of the development of modern art in Germany. Two days later Apollinaire signaled the publication of Wilhelm Uhde's *Henri Rousseau*, which was also sponsored by Flechtheim. In a more substantial article, published on July 2nd, he publicized yet another show devoted to the German artists who frequented Le Dôme in Paris. Finally, toward the end of the month, he announced the opening of the Werkbundausstellung in Cologne and gleefully observed that most of the works were by French artists.

As Apollinaire declared in his June 17th echo, Uhde's book had been published in French initially by Figuière (in 1911). Besides a copy of this edition, with a cordial dedication by the author, he owned a copy of the German translation as well. Although Apollinaire was cited in three places, his role was peripheral at best. Indeed, one of the references was

not even concerned with Rousseau. An advertisement for Mahlberg's *Beiträge* simply listed Apollinaire as one of the contributors. The other two mentions were related to the artist's portrait of the poet and Marie Laurencin. Stressing the importance of Rousseau's landscape portraits, which allowed him to focus on essential relationships, Uhde called the reader's attention to the brightly colored flowers that surrounded Apollinaire in the painting.[85] Entitled *Guillaume Apollinaire und seine Muse*, the picture itself was included in the volume together with the information that it was owned by Paul von Mendelssohn in Berlin.

Rousseau's painting was also reproduced in Paul Fechter's *Der Expressionismus*, published the same year, which despite its title was concerned with modern art in general. Apollinaire's presence was noticeable in the chapter devoted to Cubism, which drew heavily on *Les Peintres cubistes*. Fechter was particularly interested in his reasons for dividing Cubist painting into four categories, which he discussed in considerable detail.[86] Speaking of physical Cubism, he even quoted part of the original document: "Ce n'est pas un art pur. On y confond le sujet avec les images." Likewise, describing Orphic Cubism in the next section, he quoted Apollinaire to the effect that works in this category should present "un agrément esthétique pur, une construction qui tombe sous les sens et une signification sublime." The other subject that attracted Fechter's attention was Apollinaire's explanation of the fourth dimension in art, which was discussed on the following page. Unfortunately, he found the explanation in *Les Peintres cubistes* to be thoroughly inadequate. While he conceded that Apollinaire was on the right track, he deplored the absence of a rigorous mathematical analysis. Instead of quoting a crackpot philosopher, he maintained, Apollinaire should have consulted a specialist in non-Euclidean geometry.

> In one chapter of his *Les Peintres cubistes*, Guillaume Apollinaire considers the artist's tendency to speak of the fourth dimension. Unfortunately he cites Nietzsche instead of, say, Riemann and utters all sorts of banalities instead of discussing the current generation's attitude toward space or, if he wanted to be completely mathematical, non-Euclidean geometry. This inadequate treatment is nonetheless based upon a solid intuition, namely that Cubism is a symbolic, two-dimensional attempt to grapple with the problem of dimensionality in general and with our three-dimensional existence in particular, which engenders certain attitudes regarding our spatial reality.

Another note of caution was sounded by Wilhelm Hausenstein in *Die bildende Kunst der Gegenwart: Malerei, Plastik, Zeichnung* (*Modern Pictorial Art: Painting, Sculpture, Drawing*), which appeared at approximately the same time. While Hausenstein did not address the question of the fourth dimension, which Fechter found so vexing, he returned to a subject he had discussed the year before: Apollinaire's *quatre tendances.* Whereas he had embraced the latter's classification whole-heartedly in his *Der Sturm* article, by 1914 he was beginning to have some doubts. "The French theoretician of Cubism, Guillaume Apollinaire," Hausenstein announced, "has attempted to divide Cubism into approximately four groups. This classification is scarcely very fruitful."[87] Instead of the four categories identified by Apollinaire, Hausenstein proposed to divide Cubist painting into two groups based on criteria of his own devising.

WORLD WAR I

With the outbreak of the war, of course, cultural exchange between France and Germany came to an abrupt halt. The few bits of information that managed to cross the border from time to time were obliged to take a circuitous path through a neutral country. Once in a while a few courageous authors in Germany, such as Carl Einstein and Ernst Robert Curtius, wrote about French writers, but their subjects were invariably well known. In contrast to André Gide, Paul Claudel, and Romain Rolland, Apollinaire's name was conspicuously absent from the German reviews. At the same time, his name began to be mentioned in Switzerland in connection with the burgeoning Dada movement in Zurich. As Richard Brinkmann observes, Apollinaire's works were freely recited at the Cabaret Voltaire, where they exerted a certain influence. He adds that "the principle of free association according to the laws of chance and simultaneity, which is part of the Dadas' 'method,' was first experimentally applied by Apollinaire."[88] Moreover, two of Apollinaire's poems were published in Dada periodicals situated in Zurich. "2 Cannonier conducteur" (OP, 214–15) appeared in *Der Mistral* in March 1915, and "Arbre" (OP, 178–79) was published in *Cabaret Voltaire* in June 1916. If the first text seems to have gone unnoticed in Germany, the publication of "Arbre" was noted by Wieland Herzfelde in *Neue Jugend* (*New Youth*) in September of the same year.[89]

Coincidentally, Apollinaire was also cited in an article by Daniel Henry Kahnweiler the same month. Writing in *Die Weissen Blätter* (*The White Pages*), which was headquartered in Leipzig, the former Parisian art dealer discussed the subject he knew best: Cubism. Describing the move-

ment's origins, he recalled the extraordinary friendship that bound Picasso and Braque together and the boundless enthusiasm that marked their joint collaboration. Introduced by Apollinaire, he added, they carried out their experiments in a state of euphoria.[90] The only substantial reference to Apollinaire during the war occurred in October 1917, in a journal published in Berlin. The author of a surprisingly detailed account of literary life in Paris, Otto Grautoff alluded to several activities in which the poet was involved. One of these was the creation of *surréalisme* (referred to here as "surnaturalisme") as exemplified by *Les Mamelles de Tirésias*. Another was the appearance of "La Victoire" (OP, 309–12) in the March issue of *SIC*. The author's information was drawn not from the original documents but from an article by Gaston Picard in *Le Pays*. Writing in *Das Literarische Echo*, Grautoff managed to summarize this long article in a single paragraph.

> In this context, it is noteworthy that the French also depend on foreigners to revive their language. Having settled in Paris ten years ago, Guillaume Apollinaire, who is Polish, has contributed his "Orphism and Surnaturalism" to the language, and recently explained his literary and linguistic program in *Le Pays* (June 24th). Following Marinetti, Apollinaire proposes to abolish punctuation marks. However, in his opinion this is not absolutely essential since books in general will shortly disappear and be replaced by movies and phonograph records. Meanwhile here is Apollinaire's program: "il faut exalter l'homme." This program is realized in the following verses.[91]

At this point, the author quoted twelve highly provocative lines from "La Victoire," cited in the earlier article. Calling for a new poetic language, Apollinaire exclaimed, "On veut de nouveaux sons de nouveaux sons de nouveaux sons," and advised his readers to learn how to belch convincingly. In conclusion, Grautoff wondered what defenders of French classicism such as Léon Daudet and Charles Maurras would have to say about this revolutionary program.

In 1918, for no particular reason, German allusions to Apollinaire became slightly more frequent. Once again the latter's Dada connections were responsible for some unexpected publicity he received in the German capital. In February Richard Huelsenbeck, who, was to head his own Dada enclave in Berlin after the war, presented a talk at the Saal der Neuen Sezession. Describing the movement's beginnings in Zurich, which quickly acquired an international cast, he mentioned the group's Rumanian members who "came from France, loved Apollinaire and Max

Jacob, knew a lot about Barzun and *Poème et Drame* and about the Cubists."[92] Two months later, the poet's name surfaced again in an article about August Macke who, like Franz Marc, had been killed early in the war. Evoking the artist's trip to Holland in 1913, the author also mentioned the friendly relations that existed between him and Delaunay, Le Fauconnier, and Apollinaire.[93]

On July 1, 1918, Friedrich Ahlers-Hestermann published a long article in *Kunst und Künstler* (*Art and Artists*) devoted to the German artists who patronized Le Dôme in Paris. More precisely, since the latter had since become enemy aliens, it described life in the French capital before the war. An artist himself and a member of the Dôme crowd, Ahlers painted a detailed picture of the prewar art world. Reflecting the demise of the Belle Epoque, the essay was entirely written in the past tense. Following a description of La Closerie des Lilas, which attracted its own group of artists and writers, he introduced his readers to the Dômiers. Since Apollinaire liked to frequent both cafés, he provided a logical transition.

> The poet and art critic Apollinaire, whose Olympian pseudonym masked a sensitive, shrewd, versatile Eastern European Jew, could be found in both places. Henri Rousseau painted his picture with a muse. He played a role in the modern art movement, beginning with Picasso, that somewhat resembled Theodor Daübler's role in Berlin.[94]

The next month a collection of letters from the Douanier Rousseau appeared in *Das Kunstblatt* (*Art News*).[95] Taken from the January 1914 issue of *Les Soirées de Paris*, like the illustrations that accompanied them, they were addressed to Apollinaire, André Dupont, and Eugénie-Léonie V. Although the eight letters represented only a fraction of the correspondence published in the French journal, the fact that six of them were addressed to Apollinaire called attention to his role in promoting Rousseau's painting. While he was identified simply as "a poet and art critic residing in Paris," he was obviously someone who knew a great deal about the artist.

THE POST-WAR PERIOD

Following the end of the war, artists and writers on each side of the border found themselves free to reestablish contact with their counterparts on the other side. In view of the preceding four years, and the enmity that persisted on both sides, the barriers took a while to come down. Not until the 1920s did members of the two avant-gardes mingle to any extent, and

even then it was with a certain amount of reticence. Perhaps this explains why only one text by Apollinaire appeared in German in 1919. In February *Der Orchideengarten* (*The Orchid Garden*), which specialized in fantastic literature, published a story from *L'Hérésiarque et Cie*.[96] A tale of cannibalism set during the Canadian gold rush, "Cox-City!" was accompanied by four illustrations. In general, references to Apollinaire in German periodicals fell into one of two groups. The first category consisted of allusions to events that the war had temporarily obscured. A mixture of fact and memory, these were essentially cultural survivals. By contrast, the allusions in the second category were motivated by a more recent event: Apollinaire's death in November 1918. Although their tone varied from one writer to the next, this experience was clearly more immediate. Placed in a biographical context, memories and factual material acquired a life of their own.

Among the items included in the first group were assorted forms of advertising. Thus a publicity notice for *Die Bücherei Maiandros* in one review listed Apollinaire as one of its former collaborators.[97] Similarly one of the contributors to another journal included "Zone" in a list of Lyrische Flugblätter published before the war.[98] Not only did Apollinaire's name appear in at least one bibliography, which cited *Les Peintres cubistes*, but two illustrations from *L'Enchanteur pourrissant* accompanied an article devoted to André Derain.[99] In addition, a long article by Theodor Daübler referred to Apollinaire's flirtation with Futurism. Entitled "Im Kampf um die moderne Kunst " ("The Struggle for Modern Art"), it was reprinted in book form the same year. Except for Valentine de Saint-Point, Daübler commented, the members of Marinetti's band were all Italians. "Even Guillaume Apollinaire, who was more closely linked to the Futurists than I, didn't really belong to the group. Nevertheless, Apollinaire and I were the two outsiders who enjoyed the most cordial relations with the Futurists."[100]

As one would expect, the second group of references was dominated by obituary notices. In general, Apollinaire's death did not attract a great deal of attention in Germany. Occurring only two days before the Armistice, it was overshadowed by the events that followed as the nation strove to establish a peacetime economy. The only journal that published an obituary in Berlin, for example, was *Das Kunstblatt*. Drafted by an anonymous author, the following paragraph appeared in February:

> According to a newspaper report, Guillaume Apollinaire passed away recently in Paris, at the age of 38. Apollinaire was the literary interpreter of the latest artistic trends in France. He counted Chagall and Henri Rousseau among his friends and was respon-

sible for discovering Picasso. In one of his books he formulated Cubism's theoretical foundations. In addition Apollinaire was a well-known poet.[101]

Besides the notice quoted above, an obituary appeared in the *Münchner Blätter für Dichtung und Graphik* (*Munich Review of Poetry and the Graphic Arts*) early in the year. Authored by Hans Jacob, who had translated Apollinaire's lecture in Berlin, it was considerably longer and much more effusive. Saddened by the loss of this important spokesman, with whom he had been associated, Jacob reviewed the latter's accomplishments and evoked his association with *Der Sturm*. The first paragraph, which has been omitted below, summarized "Les Commencements du cubisme," published by Apollinaire in 1912.[102] Elsewhere, as he freely acknowledged, Jacob reproduced portions of Apollinaire's "Pariser Brief" concerning Dramatism.

> In his role as art critic for *L'Intransigeant*, Apollinaire was practically the prophet of Cubism. He was the friend of all the young painters—the Douanier Rousseau painted a picture entitled *Apollinaire and His Muse*—and all the young poets. He recognized that the artists who came after the Impressionists were seeking to give new life to the sublime: "l'intention de la peinture moderne me semble être la recherche de la voix personnelle vers l'expression vivante du sublime" (from a lecture in Berlin in 1913). Apollinaire called this art "Orphism," whose most important representatives in his opinion included Marc and Kandinsky. Apollinaire repeatedly came to the defense of the most advanced painting in the pages of the periodicals he wrote for. He never tired of expressing its essence and its goals in new, concentrated formulae, and his campaign against everything that was old, academic, or insignificant was instilled with great ardor and courageous frankness as he struggled simultaneously against the prevailing literary currents, exploring new paths. . . . Apollinaire also wrote *L'Enchanteur pourrissant* and a programatic poem "Zone" whose form, whose uninhibited analogical juxtapositions paved the way for F. T. Marinetti's literary Futurism and its grotesque mathematical exaggerations.
>
> During the war, Apollinare was one of the few who rallied around Romain Rolland in Henri Guilbeaux's journal *Demain*. With J. P. Jouve and Martinet he campaigned against Europe's suicide, against the bloody madness, and later in *L'Éventail* and *Nouveaux Essais* he disassociated himself entirely from his pre-

war style, which despite its great originality was purely formalistic. His painful confession in the poem "Zone": "J'ai vécu comme un fou et j'ai perdu mon temps" was redeemed by his deep love for suffering humanity.[103]

Despite numerous inaccuracies, Jacob's article was clearly motivated by the highest sentiments. While Apollinaire was neither Marinetti's precursor nor associated with Romain Rolland, he was certainly the prophet of Cubism. More importantly, he had devoted a large portion of his life to the advancement of modern literature and art. This is what seems to have made the greatest impression on his former translator. Ironically, Jacob appears to have been impressed more by Apollinaire's role as a defender of modern aesthetics than by his avant-garde poetry. Although he identified "Zone" (OP, 39–44) as one of Apollinaire's most progressive poems, this claim was subverted by the verse quoted in the last line. Much the same thing happened later in an article concerned with recent French literature. Comparing Apollinaire once again to Marcel Martinet, who specialized in proletarian poetry, Jacob quoted another deceptive verse from "Zone": "Seul en Europe tu n'es pas antique ô Christianisme."[104] The kind of poetry he preferred was exemplified, not by "Zone" but by "La Jolie Rousse" (OP, 313–14), which was the implicit subject of the obituary's conclusion. Published in *L'Eventail* in March 1918, the latter's straightforward style persuaded Jacob that the earlier poetry had been superseded. One of the obituary's most interesting statements, regarding the modern artist's relation to the sublime, was taken from Apollinaire's January 1913 lecture. While it confirms that the lecture was in French, it tends to undermine the authority of the version published in *Der Sturm*, which does not contain this statement. Inevitably one wonders how many other lines were omitted.

IWAN GOLL

Important as these documents are, they were overshadowed by another text that appeared in *Die Weissen Blätter* in February. Written by the Alsatian poet Iwan (Yvan) Goll, it was not an obituary so much as a moving tribute to the fallen poet. Unlike Jacob, whose taste was relatively conservative, Goll was attracted to Apollinaire's more daring works. As the text makes clear, his favorite poems were "Zone" (OP, 39–44), "Le Musicien de Saint-Merry" (OP, 188–91), and "Lundi rue Christine" (OP, 180–82). Quoting from these and other works, Goll also celebrated *Les Peintres cubistes* and *Les Mamelles de Tirésias*. Besides Apollinaire's experimental poetry, he stressed his role as an art critic and as the inventor of

surrealism. Written in the form of a letter to the deceased poet, the text is reproduced in full below.

> Dear Guillaume Apollinaire, you and I live solitary lives; we encounter nothing but sorrow and death. We live apart from the others and shed shameful tears in the clouds before breaking into thunder—the world rages in the distance and its tiny drums drown us out. Where others are victorious we are simply mourners.
>
> But what conqueror, no matter how great, would willingly relinquish his triumphal arch?
>
> On the day your country was intoxicated and the November sky decked with red, white, and blue pennants, its best poet lay behind influenza's grey window and died. The four years' dead don't like people dancing on their graves, and your generals' dreadful command: "Debout les morts!" became the fate of the living. The murdered throng's pestilential spirit smouldered in the icy grave and took revenge. It extinguished all joy, and while the victory is being celebrated the slaughter has already begun.
>
> Apollinaire, France has no time to mourn your death. However, tears must be shed if the heart is to be free. And someday France must stand by your coffin—or it will perish itself. Had you and François Villon not bestowed *alve perennius* on Paris, perhaps this city would have disappeared from the world's memory some day like those buried Asian towns. Its citizens thank you both for granting their everyday life eternal stature. Because neither one of you was afraid to inhale the breath of inner reality and the gleam of transcendental truth. Only you managed to turn Paris into Paradise, from which man will be expelled, because you alone were its shameless dancers and pilgrims (Shame had yet to be invented). All the other poets in Paris celebrated Napoleon, the sea, Cleopatra, and the melancholy rain. But François addressed his masters familiarly, and was not ashamed of his whorish Muses. And you, Guillaume, are that immortal musician of Saint-Merry, who is also your creation: [Goll quotes lines 15–20 and 54–56 (OP, 188–89)]. Only he is an "heureux musicien" who knows his fellow men so intimately, for whom each chance encounter becomes a sacred miracle, and for whom the most insignificant event—a name, a gesture, the banal speech of passersby—
>
> (Et ailleurs
> A quelle heure un train partira-t-il pour Paris?)

is endowed with eternal meaning simply because it *exists*. After so many centuries of poetry—Horace, Hans Sachs, Shakespeare, Whitman, Tagore—Guillaume, you were the source of the deepest melody of daily experience, theoretical explanations, and the term "surrealism" which, as everyone knows, has nothing in common with realistic Naturalism.

Thus you used to frequent "Lundi rue Christine," and the crisp, intense drama that unfolded in five minutes will live forever. O poet, traces of whom persist in the smallest details, you are both humble and lofty. You smile from your mountain top where a chimney, a streetcar, or a withered bunch of lilacs move you to compose powerful hymns. You who best knew how to kneel, whose heart was so fused with the world, who were on such intimate terms with everyone that creation's divine frenzy possessed you. Your poem "Zone" was the first to announce our century and was the source of later currents.

Tu ressembles au Lazare affolé par le jour.

After you redeemed mankind, however, you continued on your way toward the horizon. Stones, stars, and flowers arose from your very words as if from their sound and rhythm: from the poem's image. These early attempts were deeply rooted in joyous conviction; but your "calligrammes"' umbels and corollas did not mature in time. We are left with one consolation: the sight of glorious shoots arising from your crumbling coffin.

As is well known, Guillaume Apollinaire, you came from a Polish Jewish background and have always steadfastly denied it. But why? You have given proof of it yourself on every page of your first book *L'Hérésiarque et Cie*, you devoutly ironic believer, you erudite scourge of professors. Whether you are in Graz, in Marseille, or in Rome you run across the Wandering Jew's dark shadow everywhere, and you are frightened, and you take him to task and cannot exorcize him. You yourself choose to flee, perpetual traveler, and always grasp onto a flying coat-tail. You know perfectly well that the earth is round and that it is useless to take another path: it always turns out to be the same one. That is decreed by fate. And perhaps the fact that your prose exhibits such *joie de vivre*, such scholarly sarcasm, such Voltairean flashes and skilfully draws on a whole intellectual library like those of Anatole Frances' *bouquinistes*. And one last argument, you Cabalistic *bon vivant*: you were no less proud of the Goethe's head your friends placed on your shoulders than of your

immense accumulation of learning. For reasons not unlike Franz Blei's, you presided over a gourmet collection of amorous and obscene works reflecting the charms of bygone eras, and you also dared to be the prophet of the new ascetic art of Cubism.

Once again, shoots arise from your art, springing from the purest inspiration. You wrote about your friends Picasso, Braque, and Metzinger (whose artistic ideas and worldview were newly minted coins) in waves of gleaming words that poured from the ocean's eye: purer than any metrical form.

These lines are from an article on Picasso. Can you imagine a reader who would not be moved to tears? [Goll quotes from *Les Peintres cubistes* here.]

Guillaume Apollinaire, I love you. You are not really dead, no more than your father Mallarmé, although France has laid you to rest. A new France will celebrate other victories when you are resurrected. And you have earned that right more than anyone since you wrote a singular play *Les Mamelles de Tirésias*, which is concerned about France's future and which, as the preface announces, pursues a purely social goal: to persuade men and women to make babies. Your play has a social agenda! Surrealism! The eternal is combined with the contemporary. Since women's breasts soar into the sky like balloons, Paris is Zanzibar. Paris is an American metropolis where the wives become mayors and the husbands have 70,000 children who carry out their intrigues from the cradle, earn money, get married. There is no joking, only deadly serious proclamations from the grotesque megaphone. The truth blossoms forth transformed by the poet's new invention: surrealism!

"La grande révolution des arts qu'il a accomplie presque seul, c'est que le monde est sa nouvelle représentation."

Why did you have to die, Guillaume Apollinaire? And on the first day of peace? Did the war finally take its revenge? But you actually loved the war! The heir of Marsyas, you betrayed Apollo! You were assigned to the artillery, and the only stars you saw for a long time were exploding shells:

> Comme un astre éperdu qui cherche ses saisons
> Coeur obus éclaté tu sifflais ta romance
> Et tes mille soleils ont vidé les caissons. . . .

You were very wrong to exchange your human inheritance even for such brilliant stars. You were the agent of death, which

even for such a high ideal was illicit. However, since you died a lonely death your sin atoned for itself. O poet, your sin has been expiated.[105]

Although Goll (who was Jewish himself) was mistaken about Apollinaire's Jewish origins, on the whole his "letter" was remarkably well informed. Projected against the backdrop of World War I, the picture it painted stressed the poet's avant-garde role and his multiform talents. Interestingly, the five quotations from *Les Peintres cubistes* were taken from the section on Picasso, who in many ways resembled Apollinaire.[106] Indeed, one of these was diverted from its original function and applied to the author of *Alcools*. Whereas the latter's cubist poetry received the bulk of Goll's attention, the final section drew on one of the war poems. Focusing on the war's more spectacular aspects, "La Nuit d'avril 1915" (OP, 243) recorded Apollinaire's initial impressions. In Goll's opinion, Apollinaire was not only an accomplished writer but a brilliant poet. Indeed, he deserved to be ranked with such monumental figures as Horace, Villon, and Shakespeare. In particular the late poet's lyric virtuosity led Goll to compare him to Marsyas, who sought to outdo Apollo himself and paid for his audacity with his life.

In April 1919, part of the preceding text was reprinted in *Das Literarische Echo*.[107] For some reason the section the editor chose to reproduce was concerned not with Apollinaire's poetry or his art criticism but with his supposedly Jewish identity. Shortly thereafter Goll published a book-length study in the *Tribune der Kunst und Zeit* (*Tribune of Art and Contemporary Life*) which strove to define the French spirit. Exemplified by Diderot, Cézanne, and Mallarmé, each of whom embodied different aspects, this spirit was likewise to be detected in Apollinaire. Limiting his discussion to the latter's poetry, Goll repeated several of his previous observations.

> Guillaume Apollinaire succeeded in realizing the unprecedented endeavor of transforming the elements of reality into eternal essences. Highly perceptive like Mallarmé, he took the verse instead of the word as his basic unit and managed to make himself equally comprehensible. Each line of Apollinaire's has its own life, separate and complete: a street, a person, a landscape. The poem assembles these various structures and expands to become a world, a cosmos, like those we are accustomed to in "real life." . . . Someday literary historians will date the beginning of the 20th century from the publication of "Zone," Apollinaire's masterpiece. And the "Musicien de Saint-

Merry," whom the poet celebrated in song, will be the official singer of our era.

Formerly verse was considered to be an embellishment, an illusory transcription, an imitation of the world. However, the modern poet realizes that art has another goal besides being "beautiful," namely to reveal extraordinary truths. Besides Apollinaire a whole group of poets is experimenting with new perspectives, searching for a magic formula, in reviews like *Les Soirées de Paris*, *Nord-Sud*, and *SIC*. . . . They transcend reality in order to perceive it more clearly. In this connection their leader Apollinaire invented the term "surrealism." A work of art must transform reality. True poetry also participates in the unreality that hovers over all things. . . . If it were possible, [these young poets] would imitate their brothers, the Cubist painters, and would paste their favorite newspaper clippings and picture postcards in their books. In his last collection of verse, *Calligrammes*, Apollinaire even sought to represent a fountain, a train, or raindrops visually by placing strings of words and syllables above, below, or next to each other.[108]

Despite his tremendous admiration for all that Apollinaire had accomplished, Goll seems to have had a few reservations about the calligrams. In his eyes "La Colombe poignardée et le jet d'eau" (OP, 213), "Voyage" (OP, 198–99), and "Il pleut" (OP, 203) represented a tendency whose potential had yet to be realized. In any case, since he resided in Switzerland during the war, he was able to follow literary developments in Paris quite closely. Since *Les Soirées de Paris* did not survive the war, poets and painters transferred their allegiance, as he noted, to two new journals: *SIC* and *Nord-Sud*.

In 1919 Goll moved to Paris, where he remained for many years, and began to participate in the avant-garde himself. As Francis Carmody observes, this inaugurated his public career as champion of Apollinaire and his school.[109] Three years later he published a lengthy eulogy of the French capital which communicated the tremendous excitement he felt at being a resident. Entitled "Paris Stern der Dichter," ("Paris, Guiding Star of Poets"), it celebrated the city's historical and geographical charms while focusing on modern French poetry.[110] Not surprisingly, references to the author of "Zone" were relatively plentiful. Describing Max Jacob's work, for example, Goll noted that "he stems from the heroic age of Apollinaire." Elsewhere, discussing the role of music, he remarked that Apollinaire taught a whole generation of poets to appreciate the fine points of the German *Lied*. In yet another context, he compared the poet's

craft to that of a skilled artisan. Just as Hérédia's works seem to be carved from ivory and classical verse from marble, Apollinaire's style reminded him of porcelain. In addition to these and other comments, which testify to his continuing admiration, Goll devoted an entire section to Apollinaire. Encountering the rue Saint-Merri during his meanderings through the capital, he recalled one of his favorite poems.

> Hello, Apollinaire:
> [Goll quotes lines 16–20 188)]. That's you: the Apollonian trouba-
> dor of this poor bourgeois town. Poet, you have fastened a hun-
> dred blue eyes to your cloak, as others pin on flowers and golden
> spangles for the world's *bal masqué*. Everyday a love song fills
> your streets. The poet beams down upon their inhabitants. He
> vaporizes them and absorbs them into himself: bus windows in
> which the houses vibrate up and down, avenues projected sky-
> wards, streetlights thrown together like meteors, figures
> snatched up rhythmically, here one, there another.

Je chante toutes les possibilités de moi-même hors de ce monde et des astres.

> An era when the cinema had not yet become an artistic
> form: the culmination of various manifestations. An autumn
> bouquet of stifled smiles, impossible passions, wretched sor-
> rows. A *flâneur* in life's daily philosophy. Eternity divided by
> today's mid-day meal. The little man's cleverness decreed poeti-
> cally. In the halcyon days of prewar Paris—that legendary
> Wonderland—a peculiar kindness could not exist without ulte-
> rior motives.

> Mais nous qui mourrons de vivre loin l'un de l'autre
> Tendons nos bras et sur ces rails roule un long train de
> marchandises

> And one night when the stars above the quays were hurry-
> ing home to Auteuil, an incredible experience occurred: the
> poem "Zone," which provided the twentieth century with a cap-
> tion. There is still time to understand that life and lyric poetry
> must be romantic. The creation of colorful ibises or pihis. To
> praise God. Homeless Jews in the Gare St. Lazare cowering in
> their misfortune. Each and every one. To wrap a strange, warm
> heart in paper and give it to a poor woman in the subway.
> Only a stout man can have a big heart and be a good uncle.
> The skinny ones let the world atone for their leanness.

Apollinaire had no use for mourning. Sitting before a fine roast goose surrounded by seven lustrous wines, you imagine that you are Heine. Unthinkable. That's Guillaume for you. Not a native Frenchman, therefore the first true *Lieder* poet in the history of the French language. "La Chanson du mal-aimé," "Le Pont Mirabeau," "Rhénanes."

Conceived as an act of homage, these paragraphs are filled with images taken from "Le Musicien de Saint-Merry" and "Zone." The pihis, the streets full of music, the Jews in the Gare St. Lazare, the wanderer(s) returning home at daybreak (to Auteuil)—these and other examples are borrowed from Apollinaire. One of the most memorable images occurs near the end, when Goll advises the reader to gift wrap his heart and present it to a poor woman in the Métro. This idea was suggested by a similar verse in "Zone": "Une famille transporte un édredon rouge comme vous transportez votre coeur." Since the circumstances were similar, Goll transformed the heart into a symbol of compassion according to the method invented by Apollinaire. Not only the image but the principle it embodied were indebted to the latter's practice. Indeed, Goll was so deeply committed to Apollinarian poetics that he founded a review two years later entitled *Surréalisme.* "Cette transposition de la réalité dans un plan supérieur (artistique)," he wrote in the preliminary manifesto, "constitue le surréalisme."[111] Unfortunately, the review ceased publication after its first issue. Overwhelmed by André Breton's movement, which subscribed to different principles, it succumbed to Surrealism with a capital "S."

ON THE THRESHOLD OF A NEW ERA

Without really meaning to we have allowed ourselves to be swept into the 1920s, beyond the chronological limits of this chapter. Since many of the persons who wrote about Apollinaire before the war continued to admire his works, to some extent this is inevitable. In the case of one writer, however, a different situation prevailed. In March 1920 Franz Kafka and Gustav Janouch began to meet on a regular basis to discuss their mutual enthusiasms. Many years later, drawing on entries in his diary, Janouch published a fascinating book in which he reconstructed their conversations. Among the numerous subjects they discussed was Apollinaire's poetry which, Kafka revealed, he first encountered shortly before the war.

 "I brought Kafka a special edition of the Prague Czech magazine Červen (*June*), containing a translation of the rhythmically flowing poem "Zone" by Guillaume Apollinaire. But Kafka knew the poem already."

He said: "I read the translation soon after it appeared. I also knew the French original. It appeared in the book of poems, *Alcools*. Those poems, and a cheap new edition of Flaubert's letters, were the first French books I held in my hand after the war."

I asked: "What impression did they make on you?"

"Which? Apollinaire's poem or Čapek's translation?"— Kafka clarified my question in his own sharp, decisive way.

"Both"' I declared, and immediately gave my own opinion. "I'm overcome by them."

"I can quite imagine it," said Kafka. "They're a verbal masterpiece. Both the poem and the translation."

That set me going. I was pleased that my "discovery" had Kafka's approval and so I tried to propagate and explain my enthusiasm. I quoted the lines from the beginning of the poem in which Apollinaire addresses the Eiffel Tower as the shepherdess of a flock of traffic-jammed motor cars, mentioned the clock with the Hebrew numbers on the Jewish town hall in Prague to which he refers, recited his description of the agate and malachite walls of St. Vitus's Cathedral on the Hradschin, and brought my judgement on Apollinaire's work to a climax with the words: "The poem is a great bridge cantilevered from the Eiffel Tower to the St. Vitus Cathedral and spans the whole multicolored phenomenal world of our time."

Yes," said Kafka, "the poem is really a work of art. Apollinaire has combined his visual experiences into a kind of revelation. He is a virtuoso. . . . [However] I am against all virtuosity. The virtuoso rises above his subject because of his juggler's facility. But can a poet be superior to his subject? No! He is held captive by the world he has experienced and portrayed, as God is by his own creation. . . . Virtuosity is the monopoly of comedians. But they always start where the artist leaves off. One can see that in Apollinaire's poem. He concentrates his different experiences in space into a super-personal vision of time. What Apollinaire displays for us is a film in words. He is a juggler, who conjures up for the reader an entertaining picture. No poet does that, only a comedian, a juggler. The poet tries to ground his vision in the daily experience of the reader.[112]

At this point Kafka reached into a desk drawer and pulled out a book of short stories by Heinrich von Kleist. This was how poetry should be written, he explained: using language that was perfectly clear and avoiding verbal flourishes. Ironically, as generations of admirers were to attest,

Kafka was quite a virtuoso himself. What matters here, is not his criticism of Apollinaire's technique—which raises some important issues—but his familiarity with the latter's poetry. Despite Kafka's reservations, he had obviously been a fan of the French poet's at one time. Indeed his enthusiasm for Apollinaire's works spanned precisely the period covered in this chapter. Dating from the appearance of "Zone" in *Der Sturm* in 1913, it was framed by Fritz Max Cahén's German version on the one hand and by Karel Čapek's Czech translation on the other. The former appeared in November 1913, as has been noted, the latter on February 6, 1919. For that matter, Kafka may also have seen a copy of *Alcools* in 1913—it is impossible to tell from his account. The Čapek brothers were great admirers of Apollinaire, whom they met in Paris, and took advantage of every opportunity to sing his praises.[113] What matters in any case is that Kafka knew and admired *Alcools*, which he either owned or borrowed from somebody. That the first French books he sought after the war were by Apollinaire and Flaubert speaks for itself.

During the 1920s, Apollinaire's works became increasingly well known in Germany and enjoyed considerable popularity. Translations of various texts appeared in journals such as *Der Ararat* and *Der Querschnitt* together with critical articles and memoirs translated from the French. This phenomenon was similar to that experienced by North American artists and writers during the same period. Among members of the German avant-garde, as among their American counterparts, Apollinaire was elevated to the status of a cult figure. Similarly, indications that he was assured a prominent place in modern French literature appeared as early as 1920. Judging from an article in *Das Junge Deutschland* (*Young Germany*), his works had already become part of the literary canon.

> Guillaume Apollinaire represents the next stage in the intellectual and chronological series: he is clearly the creative successor to the modern French Classics (Baudelaire-Verlaine-Mallarmé). He himself succumbed to the influenza epidemic last year. Gathered reverently about his memory, and about the remarkable artistic physiognomy of his friend Max Jacob, a group of young poets have continued to work along the same lines in search of new refinements. Apollinaire's attitude toward the war is evident from his wartime writings: he had none, or at least he didn't feel the need to lecture us about it.[114]

One of the most significant texts to appear during the 1920s, and one that provides a fitting conclusion to this chapter, was authored by Walter Benjamin. Commissioned to review *Le Flâneur des deux rives* in 1929, he

took advantage of this opportunity to acquaint his readers with Apollinaire's work in general. Instead of discussing the book in question, which he steadfastly ignored, Benjamin devoted his attention to its remarkable author.

Apollinaire was a poet, indeed a man, *à propos de tout et rien*. He immersed himself in both the present moment and the past so enthusiastically that he may be compared to those anonymous creative artists of Parisian fashion. Indeed, as long as he lived no radical artistic or literary mode appeared that he did not invent or at least help to launch. Together with Marinetti he helped to explain Futurism initially. Then he engaged in propaganda for Dada, for the new painters from Picasso to Max Ernst, and finally for surrealism whose name he invented in the preface to his last play *Les Mamelles de Tirésias*. Curiously, his theories and watchwords seemed to exist beforehand in the style of his life and works. Like a magician from a tophat, he drew whatever was demanded of him from his own existence: omlets, goldfish, fancy gowns, pocket-watches. He was the Bellachini of Literature.

Throughout his lifetime a prophet and a charlatan struggled to control his poetic voice. The former anonymous and melancholy, the latter daring and frenzied. The same individual who feared the masses' unconscious impulses (in his poetic Apocalypse he imagined they would kill all the poets) speculated on their consumerism in his pornographic writings. The same individual who devoted immortal verses to life in the trenches among thousands of unknown soldiers, and who included impromptu poetry in his military correspondence could not distance himself from his uniform and wore a new laurel sprig on his epaulettes.

However, this *côté galon*, which annoyed Apollinaire's friends, was unimaginable to his fellow citizens. If something ribald appeared in his writings, they attributed it to the company he kept. When the *Mona Lisa* was stolen suspicion happened to fall on Apollinaire, who became an outlaw. . . . Apollinaire deserves to be associated especially with his "Anecdotiques," which appeared in the *Mercure de France* for many years and which were full of stories. See Billy's *Apollinaire vivant* and Soupault's little Apollinaire. Those who have encountered his poetry, which represents his purest achievement, regret not being able to hear him recite it. Except those lucky few who have heard the glorious verses Apollinaire recorded one day in Paris.

Thus fulfilling one of the points in his program: henceforth poets were to bequeath not books but records to posterity.

Apollinaire's poems were of crucial importance to his generation. At its best the purity of their inspiration is comparable to Mallarmé's. And yet the two poets are very different. Mallarmé's poetry belongs to the *tour d'ivoire* school. . . . By contrast Apollinaire's verses are the product of social interaction, contain bits of conversations, immerse themselves in everyday experience like the poet himself. They are so unceremonious that they make prose ashamed. They resemble the gay tunes that the "flâneur des deux rives" hummed to himself as he strolled along the quays in the evening.[115]

Homage from Catalonia

The history of Apollinaire's reception in Spain can be divided into two sections according to linguistic and cultural criteria.[1] On the one hand, the Catalan-speaking inhabitants of the region surrounding Barcelona were the first to discover his works. Beginning in 1911, they drew on Apollinaire's writings over a period of some fifteen years. On the other hand, the Castilian experience was much briefer and much more intense. Limited to the postwar period, it lasted four or five years and was connected to one movement in particular. Despite the late nineteenth-century phenomenon known as *modernismo*, the effort to modernize Spanish literature really dates from the First World War.[2] Guillermo Díaz-Plaja distinguishes three distinct (but overlapping) phases in Catalonia during the period leading up the civil war. The first corresponds to "the whole poetic movement that participated in the plastic-typographical experiments of the French cubists and in the dynamism of the Italian Futurists." The second is the neo-popularist movement of Tomàs Garcés and others. The third is the rise of Surrealism, illustrated by Salvador Dalí and J. V. Foix.[3] The section that follows concentrates on the initial phase, which flourished from 1916 to 1924. As Díaz-Plaja implies, the initial program was largely the result of contact with the avant-garde in France and Italy. Headed by Apollinaire and Marinetti respectively, these movements shaped the Catalan response to the twentieth century.[4] Centered around *SIC* and *Nord-Sud*, French literary cubism was so popular in Catalonia that Apollinaire himself commented on it in 1917. "Les Français portent la poésie à tous les peuples," he declared, "en Espagne et surtout dans la Catalogne, où toute une jeunesse ardente, qui a déjà produit des peintres qui honorent les deux nations, suit avec attention les productions de nos poètes."[5]

In 1918, the ties between France and Catalonia were strengthened by the creation of two bilingual journals in Paris: *Plançons* (*Shoots*), edited by Ferran Canyameras, and *L'Instant* edited by Joan Pérez-Jorba. Each devoted considerable space to Apollinaire. Nor did the latter fail to reciprocate with occasional reviews of the Catalan avant-garde.[6] By 1919 Futurism was receding into the background, and Apollinaire had become the dominant influence in Catalonia—both directly and through his disciples. In 1927, the poet J. M. Junoy recalled his importance during this period. "Our group passed through that period full of avant-garde enthusiasm," he wrote; " Guillaume Apollinaire was our beloved master. Our favorite journal was *SIC*, . . . edited by Pierre Albert-Birot."[7] Agustí Esclasans, who also participated in the first avant-garde, offers similar testimony: "Among the young men who were active in 1919, was there one of us who did not swear by the sacred name of Apollinaire—as he had sworn by the sacred name of Marinetti before that? From Futurism to literary cubism and finally dadaism: one long series of enthusiasms and fantasies."[8] Keeping the foregoing remarks in mind, let us try to discover exactly what it was about the French poet that inspired such reverence in his Catalan audience.

JOSEP MARIA JUNOY

There were of course a number of Spaniards living in Paris who knew Apollinaire intimately, the most prominent being Picasso. However, the first person residing in Spain to become acquainted with his work seems to have been Josep Maria Junoy. Born in Barcelona, Junoy abandoned the study of law and medicine to become a poet, artist, and art critic instead. An ardent francophile, he praised French culture in a wide variety of essays extending as far back as 1911. That year he spent the fall in Paris where he improved his knowledge of contemporary French art and discovered the Cubist painters. Following a visit to the Salon d'Automne, where the latter were enjoying a *succès de scandale*, Junoy returned to Barcelona converted to the Cubist cause. On October 24, 1911, he published the first of many articles in *La Publicidad* devoted to the intricacies of the new aesthetics. Although Junoy was the first to encounter Apollinaire's writings, during his sojourn in Paris, he was not the first to mention him in print. That honor went to his friend Jaume Brossa who, apparently irked by Junoy's enthusiasm for Cubist painting, published an unsympathetic account of the movement on October 19th. How

respectable critics like Apollinaire could take Cubism seriously, he declared, defied human understanding.[9]

While this remark implies that Brossa had been exposed to Apollinaire's work previously, the source of his knowledge was undoubtedly Junoy himself who had returned from Paris with several articles by the French critic. We will see in a moment what his plans were and how he put this material to use. Among other things, besides contributing numerous columns to *La Publicidad*, Junoy founded an artistic supplement entitled *Correo de las Letras y de las Artes*. Published in October 1912, the first independent issue contained translations of several articles that had appeared previously in *La Section d'Or*, including a contribution by Apollinaire: "Jeunes Peintres ne vous frappez pas."[10] Written for the landmark exhibition at the Galerie La Boétie, this essay not only defended the Cubists against various accusations but proclaimed that they were "les artistes les plus sérieux et les plus intéressants de notre époque." In a subsequent issue, Junoy called attention to another article by Apollinaire in which he discussed primitive art in the context of modern aesthetics.[11] Previously collected for their ethnographic interest, Apollinaire reported, African sculptures were being acquired by art critics and dealers who recognized their artistic value.

The most exciting event in 1912, was the publication on March 15th of *Arte y artistas* (Barcelona: Llibreria de "L'Avenç"). Admirably informed throughout, the volume was divided into two sections in accordance with Junoy's rather eclectic taste. Whereas the first half was devoted to various Catalan painters, the second half was concerned primarily with Cubism. In 1926 the author recalled: "I published my first book *Arte y artistas* in 1911. . . . At that time my favorite reading material . . . was Paul Claudel's plays, André Gide's criticism, and Guillaume Apollinaire's poetry."[12] Although Junoy was mistaken about the date of publication, he made no mistake in choosing his French models. Two years before the publication of *Alcools* and *Les Peintres cubistes* he was convinced of Apollinaire's talent. At this date Junoy had not begun to write poetry, but his art criticism reveals a sensitive intelligence and the desire to assimilate the latter's most important lessons. As if to acknowledge Apollinaire's role in the development of his critical consciousness, Junoy sent him a copy of *Arte y artistas* when it appeared, together with an issue of the *Correo de las Letras y de las Artes*.[13]

On the whole, Junoy's indebtedness to his French mentor assumed two forms. In the first place, much of *Arte y artistas* recalls Apollinaire's discussion of Cubism in general. Thus we read in one place that "the

Cubists do not simply copy the visible form of objects. They strive above all to determine the planes that reveal their structural laws and their conditions of equilibrium. The object is depicted from every angle—or from those that suit the artist—simultaneously" (pp. 57–59). More than anything, Junoy explains, Cubism is a conceptual art, one that exploits the process of mental abstraction (p. 73). Conceived as an art of contemplation, it rejects traditional mimesis in favor of procedures that are rigorously analytical (p. 57). In the second place, Junoy specifically acknowledges his indebtedness to Apollinaire on several occasions. "These new artists," he says, "are undoubtedly the precursors of a new form of art—'la promesse d'un art simple et noble, expressif et mesuré,' as Guillaume Apollinaire has written" (p. 64). Elsewhere, in connection with a discussion of specific artists, he notes that "Georges Braque has a temperament that is more resistant to classical discipline." As proof that the painter combines both human and superhuman qualities in his art, Junoy cites Apollinaire's lyrical appraisal: "Il exprime une beauté pleine de tendresse, et le nacre de ses tableaux irise notre entendement" (p. 66). Interestingly, both quotes seem to have been taken from an article on Braque published in *La Revue Indépendante* the year before.[14]

With the advent of World War I, the modern spirit began to filter into Catalonia more rapidly. Fleeing war-torn Paris, various members of the French avant-garde settled in Barcelona. There Francis Picabia, Albert Gleizes, Marie Laurencin, Arthur Cravan, and many others rallied around the Dalmau Gallery—with which Junoy was affiliated. In 1916 Junoy founded a review entitled *Troços* (*Pieces*)—later changed to *Trossos*—which published contributions by the newcomers. By 1917 the Catalan avant-garde had become well established. At this date the Barcelona group was headed by Junoy, Joan Salvat-Papasseit, Joaquim Folguera, and J. V. Foix. In July, Junoy demonstrated a thorough familiarity with French periodicals in a review published in *Iberia* that included "*Nord-Sud*, Pierre Reverdy's new journal [which] publishes curious theories and ultra-modern poetry by its director and by Guillaume Apollinaire."[15] In the October issue of *Troços*, he announced that Baudelaire's works had just passed into the public domain and added: "Guillaume Apollinaire . . . remarks in *Nord-Sud* 'qu'il est bon de planter très haut des poètes drapeaux comme Baudelaire,' after noting that 'son influence cesse à present. Ce n'est pas un mal.' Obviously."[16]

In March 1918, *Trossos* noted the publication of *Les Mamelles de Tirésias* and the imminent appearance of *Calligrammes*, but for our purposes the April issue is more interesting. Besides a curious anecdote concerning Max Jacob at the premiere of *Les Mamelles*, one finds the following

note: "*Trossos* announces a Catalan version of Apollinaire's surrealist play *Les Mamelles de Tirésias*. A performance of this work will take place under private auspices if circumstances permit."[17] Unfortunately, the journal ceased publication before these projects could be carried out.

In 1918, Junoy made several trips to Paris, where he had friends in the avant-garde and where he may even have met Apollinaire.[18] In any case, the latter devoted part of his literary column to a visual poem that Junoy had sent him commemorating the recent death of the French war ace Georges Guynemer. Writing in *L'Europe Nouvelle* on April 6th, Apollinaire had this to say about the poem:

> *Guynemer.* La francophilie catalane se traduit de la façon la plus flatteuse pour la jeune école littéraire française.
>
> Pour célébrer Guynemer, le poète barcelonais J. M. Junoy a choisi la forme ultra-moderne du calligramme qui est proprement un poème écrit et dessiné.
>
> Sur une page de japon, en points représentant les constellations, on peut lire "Ciel de France" tandis que la chute de l'avion du grand aviateur est figurée par une courbe qui se lit de bas en haut pour indiquer la remontée au firmament de l'âme du héros—"Dans l'appareil mortellement blessé, le moteur, coeur luisant, gronde encore, mais voici que l'âme intrépide du jeune héros vole déjà vers les constellations."
>
> Ce poème est parlant et frappant. C'est une preuve de l'intérêt que présentent ces tentatives nouvelles car ni sonnet ni stances n'auraient pu indiquer plus vivement ce dont il s'agit.[19]

Written on the eve of the publication of *Calligrammes* (which appeared on April 15th), Apollinaire's column reflects his own preoccupations at the time. By underlining the importance of the calligram, its modernity and its undeniable poeticity, he succeeded in publicizing his own work as well. In particular, Apollinaire was proud of the role he had played in the elaboration of this new form. The very first sentence emphasizes his role as inventor by insisting on the French origins of the genre. The same concerns are evident in a letter of thanks, sent to Junoy four days earlier, in which Apollinaire congratulated the Catalan poet while asserting his own rights as precursor.

2 avril 1918

Mon cher poète:
Je n'ai reçu votre beau calligramme: Guynemer qu'avec un grand retard, car j'etais à l'hôpital où j'ai été couché deux mois.

J'ai été fort heureux de voir et de lire votre beau poème. Je me suis félicité d'avoir imaginé cette plastique poétique, à laquelle vous fournissez son premier chef d'oeuvre. Je m'en félicite doublement comme poète et comme Français puisqu'elle permet à l'amitié catalane de s'exprimer si lyriquement, si finement et si délicatement.

J'aurai l'occasion de parler de ce calligramme qui n'est pas le résultat d'un truc comme a écrit Maurras mais est vraiment le fruit d'une authentique inspiration à la fois lyrique et plastique. Je m'y connais et vous embrasse.

<div align="right">Guillaume Apollinaire.</div>

On April 25th, a Catalan translation of Apollinaire's letter appeared on the front page of *La Publicidad*. In 1920 Junoy reprinted the original document in a book of visual poetry entitled *Poemes i cal.ligrames* (Barcelona: Llibreria Nacional Catalana), where it served as the volume's preface. Traces of another letter to Junoy, written about the same time, appear in an article by Mario Aguilar. "Thanks to you," Apollinaire wrote, "they can't dismiss our school as just another gimmick, because you have succeeded in creating a chef d'oeuvre that is precise, evocative, and classical."[20] Apollinaire was especially sensitive to criticism of visual poetry at this time and welcomed all the support he could get. However the word *truc* (or *truco* = "gimmick"), punctuates the two letters like a handgrenade. If Aguilar indicates that the author of "Guynemer" received congratulations from Maurras and Clemenceau, from Barrès and Apollinaire, in fact the "praise" of the first individual included several accusations. The enemy of modern poetry in general, Maurras condemned the poem but praised the author's patriotism. In *L'Action Française* on March 15, 1918, he devoted a long article to "L'Etoile de Guynemer" in which he declared:

> L'étrangeté de cet arrangement typographique ne doit surprendre personne. Notre prince des poètes, M. Paul Fort, s'est obstiné à écrire son vers pittoresque et chantant comme ligne de vile prose. Ses sujets indignés ont pris la revanche du droit et de la raison en traçant des lignes de simple prose en forme de spirale ou de parabole sur d'immenses feuillets tous blancs. Oeil pour oeil, truc pour truc. . . .
>
> Ce qui ne ressemble plus du tout au dernier truc de la jeune mode parisienne, c'est la note dont M. J. M. Junoy a fait suivre son opuscule.

Put on the defensive by an attack aimed at his own work as well, Apollinaire protested in a letter to Maurras and riposted in his review of "Guynemer" mentioned above.[21] It should be noted that Georges Guynemer had disappeared over Pool-Capelle (Belgium) on September 11, 1917, in an aerial combat that would have been his fifty-fourth victory. Published in *Iberia* on October 6, 1917, Junoy's poem was translated into French and issued in booklet form about March 1, 1918.[22] It was later reprinted in *Poemes i cal.ligrames* with seven other visual poems, most of which had appeared previously in *Troços*. The year 1920 also saw the publication of a book of poetry in French entitled *Amour et paysage*. While Apollinaire's influence is absent from the second volume, one naturally suspects its presence in the first. According to one of Junoy's colleagues, "Guynemer" was a product of the Futurist movement.[23] But at least one historian of Catalan literature claims that this and other visual poems derive directly from Apollinaire's calligrams.[24] In reality, a rapid survey reveals that Junoy's poems borrow heavily from Futurism. Among other things, one finds the same preoccupation with geometric form—spirals, parabolas, zigzags—as in Italy. One of the earliest poems, "Estela" ("Wake"—*Troços*, 1916), commemorates the death of Boccioni on the battlefield.

Although the term *cal.ligrama* comes from Apollinaire, Junoy's visual compositions do not resemble the French prototype. Predominately abstract, they reject the figurative bias of the latter, its fascination with objects, and its pictorial structure. "Guynemer" is the only possible exception because it has a figurative element. Yet it is the words "CEL DE FRANÇA" ("SKY OVER FRANCE"), not the plunging airplane, that remind one of Apollinaire. Composed of dots representing stars, they recall the calligrammatic sky of "Voyage" and the constellation in *Cas du brigadier masqué*.[25] In the latter work, after his encounter with the masked corporal, the poet discovers that the stars have grouped together to form a sign: "VIVE LA FRANCE"' (Prose, I, p. 384). In any case *Le Poète assassiné*, which includes this story, was known in Catalonia as early as November 25, 1916, when Francesc Carbonell published a review of it in *Iberia*.

It should be added that Apollinaire's death in 1918 greatly affected Junoy, who published the following obituary in *La Publicidad* on November 27, 1918:

> What Scythian brass could not achieve, despite having attained the summit—seriously wounded in the head, Guillaume Apollinaire had to be trepanned—a handful of infectious germs has accomplished.
> Apollinaire dead!

Avant-garde aesthetics have lost their greatest leader, their most inspired authority.

Although he was not a pure-blooded Frenchman—far from it—Guillaume Apollinaire managed to embody the spiritual tradition of France, through special intuition or through the deliberate effort of his intellect.

Ordinarily Guillaume Apollinaire's cosmopolitan vagabondage seemed clothed in qualities and virtues that were genuinely French.

Even in those examples of his poetry that are corrosive and disturbing peripherally, a certain winged grace, a certain concrete measure, open like the flowers of the most beautiful and glorious gardens of yesteryear.

Junoy ended his tribute to the fallen poet with a brief bibliography of his more important works. For unknown reasons, however, only a portion of the original article actually appeared in print. The following day Junoy apologized to his readers for this inexplicable oversight and hastened to publish the remaining section:

It goes without saying that we were alluding to the gracious and orderly parks by Le Nôtre, which represent the purest French classicism.

However, an account concerning Apollinaire cannot end in such a manner.

That is to say, with an inadequate and old-fashioned appraisal.

Here is what an inexplicable oversight omitted to say:

Better yet, here is the essence of the entire matter:

Guillaume Apollinaire was MORE THAN ANYTHING a sacred demolition expert.

Despite all his voluntary or involuntary relations and whims that connected him to tradition.

Guillaume Apollinaire's intellectual testament, which is quite clear and conclusive, is summarized by these five lines from one of his last poems: [Junoy quotes the last five lines from "La Victoire" (OP, 312)].[26]

In addition to the critical assessment offered to the readers of *La Publicidad*, Junoy struck a more personal note in a poem published in the commemorative issue of *SIC* (January–February 1919):

 Guillaume Apollinaire
is dead
with his beak a black and yellow toucan emptied the varnish of his
gaze his mouth was adorned with the foam of death's champagne
certainly
but his spirit revolves and will revolve for a long time
among the activists of relative truth
I pray anxiously that an unforeseen
angel
will defend his soul before the Lord and Master of absolute truth
amen.[27]

An ardent Catholic, as this selection reveals, Junoy eventually aban-
doned the modern movement toward 1929 and joined the staff of a reli-
gious daily. This event effectively brought the first Catalan avant-garde
period to a close. With the tragic deaths of Joaquim Folguera in 1919 and
Joan Salvat-Papasseit in 1924, the only remaining leader was J. V. Foix,
whose position was more moderate. Between 1919 and 1929, following a
course which led from the "presidency" of Dada (*Bulletin Dada*, 1920) to
reactionary Catholicism, Junoy wrote two articles on Apollinaire. The first
document, published in 1923, reveals that he had already become quite
conservative. In a "Note" entitled "La Justa subordinació" Junoy attacked
the chaotic experiments of the avant-garde and cited the lesson to be
learned from Apollinaire:

> Much talent and genius has been sacrificed in recent years in
> the desperate pursuit of extreme surprise, novelty, and original-
> ity. From the aesthetic point of view we have been going from
> one monstrosity to the other. From one suicide to the other.
>
> At present . . . we appeal to the late Guillaume Apollinaire
> from whom we received the following message shortly before
> his death: "Artists and writers," he said, "are entitled to com-
> plete liberty and licence as long as they obey their sensibility; let
> us not forget, however, that this liberty and licence *only serve to
> confirm the existence of fundamental laws!*"
>
> This affirmation of the primordial existence of immutable
> laws—by the sovereign pontiff of the anarchic international
> avant-garde— furnishes an admirable subject for meditation.
>
> Let us repeat once more that order and disorder, eternity
> and novelty, are related to the problem of subordination. To the
> problem of *just* subordination.[28]

The same theme occurs in the second document, published in 1926, in which Junoy claims that Apollinaire's experiments were successful because they had traditional foundations. This observation is elevated to the status of a general principle governing aesthetic experimentation. Toward the end the article becomes more emotional, prompted by a photograph of Apollinaire recovering from his war wound in the hospital.

> I have recently had a chance to examine the impressive October 1924 issue of *L'Esprit Nouveau*, devoted to the memory of Guillaume Apollinaire.
>
> This issue evokes several intellectual aspects, several witty anecdotes, several characteristic details of the personality and of the work of the late witty individual, great scholar, and true poet who—despite all his eccentric adventures and his premeditated mystifications—-was Guillaume Apollinaire.
>
> His avant-garde experiments—like all experiments that are long-lasting—drew on a fund of tradition that only connoisseurs and experts could understand and enjoy.
>
> W. de Kostrowitzki (Guillaume Apollinaire) was undoubtedly more like Le Nôtre's gardens, Ronsard's odes, great Burgundy wines than one would have imagined on first reading his works or from the first shake of his cosmopolitan hand.
>
> I examined the various articles in the special issue of *L'Esprit Nouveau*, pausing for a long time before an impressive photograph of the late Guillaume Apollinaire sitting up in his hospital bed, unshaven, his eyes still feverish, his head bandaged.
>
> From this bed of heroism and pain he sent me a message prompted by my calligram "Guynemer." A simple postcard—but the most precious of all my papers.[29]

If Junoy had tremendous admiration for Apollinaire, as we have noted, it is curious that few traces of the French poet appear in his poetry. Except for "Guynemer," none of his poems reminds one of Apollinaire. In view of this situation, the question of influence becomes somewhat problematic. Although Junoy did not borrow specific images from his mentor, he shared many of his aesthetic principles. In 1926, as well as in 1911, he was attracted to Apollinaire by the power of his thought as much as by the power of his poetry. A well-known poet and an established art critic, Apollinaire provided a key to contemporary aesthetics in numerous provocative studies. By means of his theories and his analyses, therefore, Apollinaire helped to form Junoy's critical consciousness. This influence can be seen as much in his manner of thinking as in his actual borrowings. In turn, the Catalan poet played an important role in the avant-garde in

Barcelona by introducing a number of Apollinaire's ideas. Joan Salvat-Papasseit summed up his colleague's significance with an apt formula. According to him, Junoy was a "grumet-guaita" ("a combination cabin-boy and lookout") who served on the flagship of modernity.[30] From his post either at the top of the mast or in the prow he discovered new countries and relayed the news to his companions. More than anything, it was his function as an explorer that oriented him toward Apollinaire— himself in search of vast and strange domains.

JOAN SALVAT-PAPASSEIT

In many respects, Joan Salvat-Papasseit was the most interesting member of the Catalan avant-garde. One critic goes so far as to call him "the most interesting Catalan poet of the first half of the twentieth century" while lamenting that his poetry has been neglected.[31] Happily, this neglect is finally being remedied, and he is beginning to receive the attention he deserves. Born into an impoverished family, Salvat lost his father at the age of seven and spent the next six years in an orphanage. He worked as a nightwatchman for the Port of Barcelona, was apprenticed to a religious sculptor, and eventually managed the book department of the Galeries Laietanes. Along the way, he developed a passion for Anarchism—traditionally a strong political force in Catalonia—and became involved in the struggle for social justice. In 1917 he founded the first of several journals, *Un Enemic del Poble: fulla de subversió espiritual* (*An Enemy of the People: A Review of Intellectual Subversion*), whose title is revealing. Emulating Ibsen's doctor-hero on a political level, Salvat sought to diagnose the ills of society and to prescribe a cure. His attacks on social institutions are noteworthy for their violence and bear the mark of one who has suffered poverty at first hand. Similarly, his poetry is directed toward the general reading public rather than the educated elite. As Josep Batlló remarks, Salvat is the "first proletarian poet writing in Catalan."[32] Fortunately, politics seldom intrudes into the poetry itself.

Díaz-Plaja places Salvat at the crossroads of literary cubism and Futurism, with the rest of his generation, but concludes that his special mixture was a serious mistake.[33] For one thing, as J. V. Foix has observed, the former movement was humanitarian, pacifistic, and internationalistic, while the latter was nationalistic and flirted with Fascism.[34] On the basis of this apparent contradiction, Díaz-Plaja condemns the presence of both attitudes in Salvat's poetry. "It is extremely difficult, " he writes, "to reconcile the tenderness, the calm, and the humanitarianism of certain poems with the violence, the frenetic activity, and the xenophobia of others."

In defense of Salvat, it should be noted that the two styles obviously reflect two very different emotional states: love and anger. These are no more incompatible in poetry than they are in life. Nor is Salvat the first to mix nationalism and internationalism—the same combination occurs in Apollinaire. In any case, a quick survey reveals that the violent poems are very much in the minority. Violence, like politics, is largely relegated to his prose compositions. This is not to deny that the poetry is full of energy and activity. We know from his 1920 manifesto *Contra els Poetes amb minúscula* (*Against Lower-Case Poets*) that Salvat valued enthusiasm above all.[35] Here as in other writings the emphasis is on modernity, novelty, the present, the future, struggle, and youth. Elsewhere he declares: "For the world to proceed smoothly, the old people will have to learn to obey"—a statement that recalls Apollinaire's "Il est temps d'être les maîtres" and its corollary "On ne peut pas transporter partout avec soi le cadavre de son père."[36]

However, Salvat's subtitle *Primer manifest català futurista* reveals that his primary affiliation is with Marinetti. Not only is "el gran boig" ("the great madman") recommended as an example here, but his name is coupled with praise in a number of other texts. Similarly, Futurist influence is widespread in Salvat's early poetry—witness the titles of his 1918 review *Arc Voltaic* (*Electric Arc*) and his first book, *Poemes en ondes hertzianes* (*Wireless Poems*—1919). It is easy to see why one of his contemporaries called him the "Marinetti català."[37] Nevertheless, one should not exaggerate the Italian influence in his work. It is significant that in choosing an epigraph for *Poemes en ondes hertzianes* Salvat settled on an aphorism coined by Oscar Wilde and adopted by Pierre Albert-Birot: "L'Art commence où finit l'imitation" (*SIC*, January 1916). In addition, much of his poetry is indelibly stamped with literary cubism. "Bodegom," "Linóleum"—even the apparently futuristic "54045"—are clearly modeled on poems by Albert-Birot, Reverdy, and Huidobro. The same dual inspiration extends to the visual poetry. While some of the poems incorporate Futurist (nonfigurative) techniques, others embody the figurative principles of Apollinaire. One of these, "Marseille port d'amour" (which is partly in French), resembles the Mediterranean port scene in the latter's calligram to Léopold Survage (Op, 676).

In the absence of any extensive reference to Apollinaire, however, his role in Salvat's art can only be inferred. We do know that Salvat admired the French poet and that he was familiar with his work. Thus in the memorial issue of *Un Enemic del Poble* devoted to Joaquim Folguera, who also wrote visual poetry, he remarks: "Henceforth he will enjoy the same peace as the magnificent Guillaume Apollinaire."[38] We also know that Salvat called his own visual compositions *cal.ligrames*. More importantly,

he deliberately grouped his visual experiments with those of Junoy and Folguera, both of whom were great admirers of Apollinaire. In 1921, he explained that their mutual procedure was to "to write a poem in classically perfect alexandrines before making a calligram of it."[39] While in fact these calligrammatic alexandrines are virtually nonexistent, what matters is the presence of classical discipline. To the extent that this principle is reflected in their visual poetry—as opposed to Futurist chaos—all three may be said to follow in Apollinaire's footsteps.

JOAQUIM FOLGUERA

This brings us to the third member of the trio, Joaquim Folguera, who was an equally important intermediary between France and Catalonia. During his lifetime, most of Folguera's writings appeared in the pages of *La Revista* (*The Review*), which he founded in 1915 with J. M. López-Picó. An excellent poet, through his criticism he helped to order and to systematize the values of modern Catalan poetry. His *Les noves valors de la poesia catalana* (1919) is one of the very first studies of Catalan poetry. In addition, his numerous translations of contemporary French poets made the latest Parisian experiments available to his friends in Catalonia. Collected in *Traduccions i fragments* (1921), these include works by Claudel, Dermée, Reverdy, Drieu La Rochelle, Albert-Birot, Max Jacob, and Apollinaire. While Folguera occasionally flirted with Futurism (cf. his poem "Ambició"), his primary allegiance was to the French avant-garde. This is evident, for example, in the group of translations published in *La Revista* on April 1, 1917: "Usina = Usina" by Drieu La Rochelle, "Paisatge en un plat" by Luciano Folgore, "Plou" ("Il pleut") by Apollinaire, and "Jardins publics" by Albert-Birot. The general heading "Poesia futurista" is clearly misleading. Of the four authors only Folgore qualifies as a Futurist, and even his poem was translated from the French. Like the other three, it was taken from a 1916 issue of *SIC*.

Folguera's translation of "Il pleut" (OP, 203) is particularly interesting. Not only is it a magnificent plastic rendering of the original calligram, but it inspired the translator to write some visual poetry himself. His first attempt, "Vetlla de desembre plujós" ("A Rainy December Evening"), is somewhat restrained but captures the rainy melancholy of Apollinaire's poem. In both works rain and music intermingle on the thematic level, while the rain's vertical trajectory (deflected by the wind) is depicted visually. The next poem, "Musics cecs de carrer" ("Blind Street Musicians"), is actually dedicated to Apollinaire. Once again one finds the characteristic mixture of water, music, and melancholy. Not only is this work boldly figurative, but it has the same visual configuration as its French predecessor.

Consisting of eleven wavy lines extending horizontally, instead of verti-
cally, Folguera's poem represents both sound waves and water. Finally,
the poem "En avió" depicts an airplane in flight. Vaguely reminiscent of
Junoy's "Guynemer," its conscious figuration places it in the tradition of
Apollinaire. All three works were published in the memorial issue of *Un
Enemic del Poble* (March 1919), in which Salvat-Papasseit commended
Folguera to Apollinaire in heaven, and reprinted *Traduccions i fragments*.[40]

Beginning in 1917 and extending into 1918, Folguera enjoyed a per-
sonal relationship with the French poet in connection with a joint Franco-
Catalan project. At some point in 1917, he wrote to Apollinaire to request
a preface for an anthology of avant-garde poetry that was to be edited by a
friend of his. Always eager to further the avant-garde cause, Apollinaire
responded on November 20th with a section from "L'Esprit nouveau et
les poètes," which he had recently completed. Although Folguera's letters
to Apollinaire have yet to be made public, the latter's correspondence
with his Catalan colleague has gradually come to light. In 1927, for exam-
ple, J. M. López-Picó published all the relevant documents in Catalan in
an article that appeared in *L'Amic de les Arts*.[41] Thanks to him, we know
Apollinaire sent the preface to Folguera on November 20, 1917, and that it
was accompanied by the following letter (originally written in French):

> Dear Sir:
> I am enclosing the preface that you requested. I believe it is
> what you wanted, but since the most important thing is to aid
> your cause (which is also mine), please send me whatever sug-
> gestions you have. I will welcome them, and those that seem jus-
> tified will enable me to make the changes you propose.

In 1965, Michel Décaudin published a study of the remaining docu-
ments, which he was able to consult in the Joaquim Folguera Archives in
Barcelona.[42] The manuscript that Apollinaire sent Folguera, he reported,
comprised approximately one-fourth of "L'Esprit nouveau et les poètes."
Beginning with the declaration "C'est que poésie et création ne sont
qu'une même chose," it celebrated the poetic imagination, advised poets
to cultivate the world around them, and stressed the importance of sur-
prise. Other sections recommended that poets explore the world of
dreams, emphasized poetry's prophetic role, and celebrated the extensive
influence exerted by modern French literature, ending with the phrase: "il
faudrait pouvoir supputer tout ce que l'esprit nouveau porte en lui de
national et de fécond."[43] Comparison with the version that Apollinaire
published in the *Mercure de France* the following year reveals very few dif-
ferences. The only substantial change had to do with the phrase "La

France, détentrice de tout le secret de la civilisation," which the author modified to reflect the preface's immediate context. The final, more diplomatic version read instead: "La France, détentrice avec les nations latines, ses soeurs, de tout le secret de la civilisation."

Despite this conciliatory gesture, Apollinaire unwittingly included a reference at one point that was potentially offensive to his Catalan audience. Taking him at his word, Folguera wrote back to ask him to modify one sentence. Whereas the original text evoked the spread of French influence "en Espagne et surtout dans la Catalogne," the version that appeared in print reads simply: "A Catalunya." The problem with the original, Décaudin explains, was that Folguera and his friends did not want Catalonia to be recognized as part of Spain. Neither did they relish sharing Apollinaire's words of praise with their Castillan-speaking neighbors. Apollinaire agreed to the proposed change in a letter filled with affection for Catalonia. According to López-Picó the latter was dated December 27, 1917.

> Cher Monsieur,
> C'est entendu et vous modifierez la phrase en question de la façon que vous me l'indiquez. Je suis heureux qu'elle réponde ainsi à votre pensée et à celle de vos amis. J'ai pour votre race la plus vive estime. Le régiment dans lequel j'ai eu l'honneur de combattre comptait un grand nombre de soldats catalans. Et j'ai eu maintes fois l'occasion d'apprécier leurs qualités de bravoure et d'énergie. En ce qui concerne les arts et les lettres fervents de Verdaguer au courant de l'effort littéraire artistique et musical des Catalans il y a longtemps déjà que je ne cesse de proclamer l'estime où je tiens aujourd'hui votre ingénieuse nation.
> Croyez-moi votre et écrivez-moi quand vous en aurez le loisir.
>
> Guillaume Apollinaire.

In retrospect, the fact that Apollinaire sent Folguera such an important document at such an early date is frankly surprising. On November 20th, he had not yet delivered his lecture on "L'Esprit nouveau et les poètes," which would take place six days later and which would not appear in the *Mercure de France* until the end of 1918. In view of its significance, it is astonishing that this manifesto—even a fragment—was sent to an unknown poet living in another country. This fact suggests that Apollinaire attached considerable importance to the Catalan project in which, to be sure, he was to occupy the place of honor. In addition to the

correspondence cited above, several traces remain of the cordial relations that existed between Apollinaire and Folguera during 1917–18. During this period, for example, the former received at least twelve issues of *La Revista* covering a variety of different material. More telling, perhaps, since they were inscribed by the author himself, are the two books of poetry that Folguera sent Apollinaire. Entitled *El poema espars* (*The Separate Poem*) (1917), one of them contains the handwritten dedication: "À Guillaume Apollinaire cordialement Joaquim Folguera." The remaining volume, which bears the title *Poemes de neguit* (*Poems of Anxiety*) dates from 1915 and is considerably more eloquent. Although the dedication itself is equally brief, it reveals the emotional value that Folguera attached to his association with the French poet. Inscribed on the flyleaf, it reads: "A Guillaume Apollinaire affectuosament Joaquim Folguera."[44]

While the projected anthology never materialized, Apollinaire's preface was published in *La Revista* shortly after his death and was later included in *Traduccions i fragments*.[45] In both instances, it was accompanied by a short introduction by Folguera, who stressed the boldness of Apollinaire's vision and his unrelenting modernity:

> The dizzy course of contemporary values renders yesterday obsolete and actualizes tomorrow. Death itself enters into the scheme and carries off men like Guillaume Apollinaire, who had a life-long obsession with modernity. As a token of the present moment, which is rapidly slipping away, we present a translation of the preface that this interesting poet wrote for a forthcoming anthology of avant-garde poetry, edited by a friend of ours. This preface, with its rudimentary but elegant Gallicism and its excellent critical audacity, will give some idea of the remarkable writer who recently passed away.

In 1918, Apollinaire's name occurred fairly frequently in Folguera's writings. Except for the paragraph quoted above, all the references were to poems in *Calligrammes*, which had replaced the preface as the primary object of Folguera's attention. As much as anything this change in critical focus may be seen in his decision to translate a poem entitled "Le Départ" (OP, 295) into Catalan. Although Apollinaire's melancholy tribute to Blaise Cendrars had appeared in *Nord-Sud* the year before, Folguera chose to translate the version published in *Calligrammes*.[46] Elsewhere, during a discussion of post-Symbolist developments in Catalonia, he included Apollinaire among the major influences on contemporary Catalan poetry (twice). In this context, Folguera singled out another poem in *Calligrammes* in connection with his remarks concerning Eugeni d'Ors.

Comparing the latter's love of unusual metaphors to Apollinaire's, he cited a startling verse taken from "Souvenirs" (OP, 299): "C'etait une voix faite d'yeux."[47] One could speculate indefinitely about the impact of this and similar metaphors on Folguera's contemporaries. First Apollinaire had shocked (and delighted) them with his visual images; now he was repeating the process with his verbal imagery. One would expect to find the same pattern of influence that characterized the Catalan experiments with the calligram—not verbatim borrowing so much as inspired imitation. In both cases, Apollinaire's example prepared the way for a new theory of the poetic image.

Nor did Folguera fail to note the third major contribution of *Calligrammes* to modern French literature. Apollinaire was the only poet to produce a large body of war poetry that rejected patriotic polemics and cheap sentimental effects. In spite of the war, he succeeded in maintaining high lyric standards. Folguera paid tribute to his success in a review of J. Pérez-Jorba's *Sang en rovell d'ou* (*Blood in an Egg Yolk*), also published in 1918. Pausing to praise the lyrical war poetry of one section, he remarked: "Guillaume Apollinaire, with his *Calligrammes* . . . , provides the admirable precedent. We have recently savored the book of this French writer, packed with subtleties, steaming with military comradery, shining with poetic flashes, lively with literary innovation, and through it we have gained an even better idea of the lyrical austerity practiced by French poets, even when they launch poems that resemble bursts of laughter on a bivouac. Pérez-Jorba [follows] the example of Apollinaire's book."[48]

JOAN PÉREZ-JORBA

At least one other individual enjoyed extensive contact with Apollinaire and helped to introduce his work to readers in Catalonia. Leaving Barcelona in 1901, Joan Pérez-Jorba settled in Paris, where he eventually became a member of the avant-garde. Developing considerable fluency in French, he contributed to reviews such as *Le Figaro, Le Mercure de France*, and *La Revue de l'Epoque*. In addition, he published poetry, articles, and book reviews in *SIC* on a regular basis. At the same time he served as a correspondent for *El Globo* in Madrid and some half dozen publications in Barcelona. Much of Pérez' journalistic effort was directed toward furthering Franco-Catalan literary relations. He wrote about French writers in Catalan and about Catalan writers in French. Without a doubt his favorite French poet was Apollinaire, whom he knew personally and whom he idolized. In general his value as an intermediary was as a critic rather than

as a poet. Article after article, for example, was devoted to publicizing his mentor's accomplishments.

While Pérez alluded to earlier works and events, he seems to have met Apollinaire only in 1918. The first mention occurred in an article about Pierre Albert-Birot, published in *Messidor* in February. Actually Pérez referred to Apollinaire several times: once in connection with a recent dramatic production and twice concerning an essay he had written for a volume of Albert-Birot's poems. On the one hand, he quoted two sentences from Apollinaire's preface to the latter's *31 Poèmes de poche* that served as convenient aphorisms. "Ce que fait Pierre Albert-Birot," Apollinaire declared, "est si dépouillé ou plein d'une telle simplicité qu'à l'abord il surprend désagréablement." The second sentence focused on the poet's role as a catalyst: "Pierre Albert-Birot est une sorte de pyrogène." On the other hand, Pérez observed, the author and his colleagues had already put their dramatic theories into practice seven months before. Choosing a theater situated in Montmartre, they initiated their campaign with "l'obra esbalaïdor" ("the astonishing work") by Guillaume Apollinaire, *Les Mamelles de Tirésias*.[49]

In March 1918, two events took place that demonstrated Pérez' increasing interest in Apollinaire. First, he published a translation of "Le Pont Mirabeau" (OP, 45) in the initial and only issue of *Plançons* (*Saplings*), a Franco-Catalan review printed in Paris. Secondly, he wrote to Apollinaire to ask for copies of several of his books. Apollinaire replied that he was unable to send Pérez any copies himself but advised him to contact various individuals who might be able to help him.

> Cher Monsieur,
> Je n'ai plus de mes livres. Je les ai donnés ou prêtés. Mais Reverdy vous prêtera *Alcools* que je n'ai plus et en demandant *Le Poète assassiné* à l'Edition 4 rue de Furstenberg vous recevrez sans doute le livre si vous indiquez que c'est pour en rendre compte. *L'Enchanteur pourrissant* se trouve à la Bib. Nationale et *Le Bestiaire* Dufy 5 impasse de Guelmar vous le prêtera.
> Voilà le principal de mon oeuvre avec *L'Hérésiarque* et *Les Mamelles de Tirésias* que vous avez.
> Mais venez me voir un mardi soit au *café de Flore* où je suis ce jour là vers 6 h. soit chez moi si je ne suis pas au café.
>
> > Cordialement
> > G. Apollinaire.[50]

Because Apollinaire does not mention *Calligrammes*, which appeared in April, Pierre Caizergues dates the letter from the second half of March

1918. Once again, one notes Apollinaire's helpfulness and general availability with regard to a stranger who was involved in the avant-garde cause. Of equal interest is the fact that Pérez already possessed copies of two of Apollinaire's books. From this it would seem that he had been interested in the French poet for some time.

Writing in *El Camí* (*The Road*) in June 1918, Pérez included *Les Mamelles de Tirésias* in a discussion of modern scenography which stressed the role of the imagination. He concluded, among other things, that the play's anti-realistic stance had earned it a place in the history of the modern stage. Initiated by the Ballets Russes and continued by *Parade* and *Les Mamelles de Tirésias*, he explained, "scenography, by breaking with the mishmash of everyday routine, was finally adapted to the determining factor in the scenographer's task: the character of the works themselves. . . . The scenographer finally abandoned photographic servility toward the most ordinary realistic details. Thereafter he strove to make his art conform to the dictates of the imagination."[51] These remarks recall similar observations by Apollinaire in both the preface and the prologue to *Les Mamelles de Tirésias* (see OP, 869, 882). Like the Catalan author, he privileged the imagination over photographic realism and despised what he called "ce théâtre en trompe-l'oeil."

In July, Pérez published the first issue of yet another Franco-Catalan review entitled *L'Instant*. Conceived as the successor to the ill-fated *Plançons* (which was edited by Ferran Canyameras), it too was located in Paris. Among the recipients of the new review was Apollinaire, who continued to receive it as long as he lived. A letter dated July 8, 1918, reveals that he had not yet met the director but that that situation was soon to be remedied.

> Mon cher confrère
> Je vous attendrai demain mardi de 6h. à 7h. à la terrasse du café de Flore Bd St Germain coin de la rue St. Benoît.
> Vous me reconnaîtrez facilement car je porte sur la tete un appareil en cuir noir spécial à ceux qui ont été trépanés.
> Je vous remercie de m'avoir envoyé *L'Instant* où j'ai trouvé des choses intéressantes. Au reste je suis un ami de la Catalogne et un admirateur de Verdaguer.
>
>> Ma main amie
>> Guillaume Apollinaire.

By the following week, Pérez had not only met the French poet but had managed to conduct a lengthy interview that he planned to publish in the Catalan press. Entitled "Paseando con Guillaume Apollinaire," it

appeared in *La Publicidad* on July 24th, ten days after the interview itself. Discovered by Étienne-Alain Hubert in 1968, Pérez' account of his conversation with Apollinaire is much too long to reproduce here.[52] Filled with praise from beginning to end, it resembled a eulogy more than an interview. Comparing Apollinaire's popularity to Gabriele D'Annunzio's success in Italy twenty years before, Pérez evoked the almost irresistable fascination that he exerted on the newest literary generation. Describing the poet as a new sun whose presence illuminated the field of literature, he insisted that Apollinaire had accomplished more than anyone in the realm of modern aesthetics.

Much of the remainder of the "interview" is devoted to lessons extracted from the preface and the prologue to *Les Mamelles de Tirésias* (OP, 866–70, 880–82). Quotations alternate with paraphrases as we read, for example, that Apollinaire "unit sans lien apparent, comme dans la vie, les sons, les gestes, les couleurs, les cris, les bruits, la musique, la danse, l'acrobatie, la peinture, les choeurs, les actions et les décors multiples." Further on we learn that the function of the theater is to interest and to amuse. Another section opposes photographic realism to the powers of the imagination and introduces the concept of aesthetic truth. True art is intuitive, Apollinaire maintained, and has nothing to do with conscious reflection. In one of the last paragraphs, he also denied the possibility of literary cubism. More than a year later, Apollinaire was still fuming over the hostile reception accorded the premiere of *Les Mamelles de Tirésias* by a group of Cubist painters. The last thing he wanted was to be associated with their narrow-minded interpretation of modern art.

Significantly, although Pérez had only known Apollinaire for a few months, he compared their relationship to that between Socrates and Plato. In this context he commented: "Aucun livre de poèmes n'a produit sur notre esprit depuis bien longtemps une aussi grande impression qu'*Alcools*." A moment later, however, he added that even this work was surpassed by the originality and audacity of *Calligrammes*. In view of the master-disciple relationship evoked previously, one would expect to find abundant traces of Apollinaire's presence in Pérez' own literary compositions. Despite his admiration for the French poet, however, his three books of poetry show little sign of Apollinaire's influence. At about this date, Pérez sent the latter copies of the only two volumes that were available, *Poemes* (1913) and *Sang en rovell d'ou* (1918), both of which bore the same dedication: "À Guillaume Apollinaire au grand poète hommage de son admirateur J. Pérez-Jorba."[53] For the most part, these books (and a third volume published in 1921) reflect Symbolist inspiration and use tra-

ditional forms. At best there is some thematic duplication between Pérez and Apollinaire, described by Folguera in the preceding section, and an occasional Apollinarian echo.

Despite the conservative tenor of most of Pérez' poetry, from time to time one finds traces of his interest in the avant-garde experiments then taking place in Paris. The volume that bears the most marks of the modern movement is *Sang en rovell d'ou*. Reviewing this work soon after it was published, J. Massó Ventós discerned the influence of modern French poetry on his colleague as exemplified by two of its leading exponents. "Pérez-Jorba has continually evolved," he observed; "The latest tendencies of modern French poetry, illustrated by Apollinaire and Reverdy, have left their traces on the Catalan poet's concepts and expressions."[54] Although the reviewer did not identify any specific borrowings, the most obvious example occurs in a poem entitled "La polsaguera." Not only did this work furnish Pérez with the image that appears in the book's title, but its conclusion was patterned on the refrain in "Le Pont Mirabeau": "els jorns s'en van els jorns s'en vénen / com la polsaguera" ("the days come, the days go / like a cloud of dust"). Significantly the poem originally appeared in the same issue of *Plançons* (March 1918) as Pérez' translation of "Le Pont Mirabeau." It is interesting to note, that in Catalan Apollinaire's famous refrain becomes "Vinga la nit soni l'hora / Els jorns s'en van jo no encara" (cf. the French: "Vienne la nuit sonne l'heure / Les jours s'en vont je demeure"). The similarity between Apollinaire's verses and those in "La polsaguera" is striking to say the least. Not only do the first lines of each couplet share the same initial hemistich, but their accentual and syllabic patterns are identical. In addition both poems revolve about a single transitory image (the Seine, a dust-cloud) symbolizing life's impermanence and the inexorable passage of time.

In August, Apollinaire figured in two different guises in *L'Instant*. Not only did Pérez reprint his poem "Photographie" (OP, 257) from *Calligrammes*, but he contributed a review of a recent article that had appeared in *Les Arts à Paris*. "Guillaume Apollinaire," he reported, "qui est merveilleux comme poète, conteur, dramaturge et critique, publie un article très pénétrant sur Van Dongen, dont la peinture, suivant lui, sent l'opium et l'ambre. . . . L'auteur de *Calligrammes* ne veut-il pas d'un art qui trouverait ses éléments essentiels dans la saveur et le toucher?"[55] On August 6th, while he was vacationing in Bretagne, Apollinaire wrote to thank Pérez for his two books of poetry and made plans to see him when he returned to Paris. His letter reveals that he had not yet seen the inter-

view in *La Publicidad* and that he was becoming interested in recent Catalan poetry.

> Mon cher poète,
> J'ai tardé à vous remercier de vos beaux livres. Je les ai emportés en permission pour les lire avec vous et j'en aime beaucoup le ton lyrique.
> Je rentrerai à Paris vers le 25 écrivez-moi et venez me voir Je ferai avec vos indications et d'après ce que je sais et je pense un article sur la jeune poésie catalane dans *L'Europe Nouvelle*.
> C'est avec un grand plaisir que je lirai l'article de *La Publicidad*. J'étais très fatigué quand nous nous sommes vus à Paris. L'air de la mer me fait le plus grand bien.
>
> > A bientôt
> > Votre ami
> > Guil. Apollinaire.

The last letter that Pérez received, or at any rate the last that has survived, was little more than a note. According to internal evidence, Pierre Caizergues estimates that it was sent on either August 26th or 27th. By this time, Apollinaire had read the interview in *La Publicidad* and was pleased with what Pérez had to say.

> Merci du très bel et très intéressant article et à mardi—si vous avez le temps à 6h. chez Lipp en face le café de Flore Bd St Germain.
>
> > Ma main très amie
> > Guil. Apollinaire.

Whether or not Pérez continued to correspond with Apollinaire, he continued to heap praise on his work in one article after another. In September he published a long and enthusiastic review of *Calligrammes*, which he signed with his habitual pseudonym "Litus." Here and there he included a sentence from the earlier interview that he thought particularly effective. Whereas much of the interview repeated Apollinaire's published remarks, often nearly verbatim, Pérez managed to reformulate his earlier observations in language that was clearly his own. As before, the finished article resembled a panegyric more than a humble book review.

> Voici un livre grâce auquel la poésie d'avant-garde atteint les plus hautes cimes de l'inspiration moderne. On pourrait se

hasarder même à dire que son lyrisme est marqué d'un sceau d'ultra modernité. L'élan juvenile d'*Alcools*, ouvrage dont les lettres françaises s'honorent, est ici dépassé dans le fol émerveillement de la course vers les régions méconnues de la beauté. Guillaume Apollinaire est un véritable, un grand poète qui n'obéit qu'à la force de son rayonnement intérieur et dont la voix—ô privilège sacré—pénètre au plus profond du lecteur. La poésie vivement l'illumine d'une lumière rare, fait fleurir sur ses lèvres des mots nouveaux et donne à ses vers des accents nouveaux. Y avait-il donc encore quelque chose d'inédit sous le soleil? Cet art de sorcellerie qu'est l'art d'Apollinaire semble vouloir nous le faire croire. Croyons-le donc. N'a-t-il d'ailleurs pas réussi à prêter de la dignité poétique à des expressions essentiellement prosaïques? Voilà qui est audacieux et voilà qui est merveilleux.

Rien ne saurait nous faire aimer autant la poésie d'Apollinaire que son aspect de vigoureuse santé. D'où la puissance de son souffle lyrique. Rien de maladif, rien de vénéneux, rien de déprimant chez elle, même lorsqu'elle s'égare dans les bosquets perdus où le poète chante les joies défendues de l'amour avec des mots crus. C'est cette santé florissante qui lui permet de s'adonner à bien des fantaisies, celles-là plutôt apparentes que réelles. Elles servent en tout cas à former chez lui un lien invisible mais sensible entre la poésie et la réalité. Apollinaire ne cherche pas d'ailleurs les images inédites pour le plaisir de faire systématiquement du nouveau. Ses images répondent presque toujours à une observation aiguë de ce qui l'entoure ou l'irradiation de son soleil intérieur. Souvent il nous mène par des sentiers de détour au domaine de l'art descriptif. Ce n'est pas pour longtemps. Il n'aime pas comme les rhétoriciens recourir à la pelote de ficelle au dévidement facile et s'y attarder.

Guillaume Apollinaire a certainement dans son âme une mandoline toujours prête à laisser entendre sa voix mélodieuse. La valeur intrinsèque de ses poèmes gît précisément dans la mélodie qui se déroule au dedans d'eux-mêmes avec la fluidité des ondes d'un fleuve. Ce n'est pas le résultat de combinaisons verbales où excellent les rimailleurs habiles. La poésie d'Apollinaire a le don de savoir marier, en mettant à profit un sens réel de l'originalité, les exemples d'enchantement imprécis de l'âme avec le contour le plus simple des faits quotidiens. Elle établit de temps à autre un entrelacs d'images célestes avec des

éléments anti-poétiques. Le résultat en est féerique. Ne voyons-nous pas de ses poèmes jaillir des sentiments purs et des émotions naïves conjointement avec des intentions pécheresses et des rires érotiques? Le plus remarquable de cette poésie c'est le penchant très prononcé qu'elle montre pour les suspensions logiques de la pensée. D'où le culte un peu fugace que l'auteur professe pour l'illogique et l'invraisemblable. Le lecteur de sens rassis en perd la tête et reçoit l'impression d'un art invertébré. Par contre, rien ne saurait être intimement plus vertébré que l'art poétique d'Apollinaire. Ce poète ne nous a-t-il pas déclaré son amour pour la représentation des sons, des gestes, des bruits et des détails sans un lien apparent entre eux comme dans la vie? Les invraisemblances ne les emploie-t-il pas de la façon la plus raisonnable du monde? N'éprouve-t-il pas dans sa poésie un certain plaisir à concilier les contraires? Ne le voyons-nous pas joindre l'argot cuivreux de panam ou des tranchées à la joaillerie d'un langage savant? Apollinaire, et c'est là encore un mérite à porter à son actif, fait tout ce qui dépend de lui pour que la liberté rythmique règne dans ses vers comme le sang règne, sous les impulsions affectives, dans les mouvements du coeur.

 Calligrammes a réellement une tout autre valeur que *Alcools*: la voix du poète y est plus forte, plus profonde et plus humaine.

 L'âme à lire ses poèmes est toute soulevée par l'émotion esthétique. Rien de plus émouvant sous ce rapport que le chant dédié à "L'ltalie": là, Walt Whitman est dépassé en hauteur ou peu s'en faut. Nous pourrions citer d'autres pièces de ce recueil dont la beauté est extrême. Le lecteur ne tardera pas avec son esprit fin à les découvrir.[56]

Writing in *L'Instant* in October, Pérez found an excuse to mention Apollinaire in connection with a discussion of the eminent Symbolist poet Francis Vielé-Griffin. "Un autre poète," he declared, "pourrait être placé, sinon au-dessus, dans ce même rang de qui l'éclat d'ailleurs nous éblouit davantage encore: Guillaume Apollinaire, le premier poète français d'aujourd'hui."[57] These were the last words that Pérez was to utter in praise of the poet during his lifetime. Although he could hardly have foreseen that Apollinaire would be dead before the year was out, he could not have chosen a better epitaph. Following Apollinaire's death on November 9th, Pérez published a moving account of his funeral in *La Publicidad*. Describing the festive atmosphere that prevailed in Paris following the recent Armistice, he contrasted the joy of the general populace with the grief of Apollinaire's friends.

That day they buried Guillaume Apollinaire who was another victim, even though indirectly, of the bellicose insanity. The flu had seized him and in the space of only six days had made mincemeat of his robust body. Apollinaire had been wounded twice at the front: one bullet perforated his lung and another struck him in the head. He had to be trepanned. But the song continued to flow in generous spurts from the fountain in the garden of his heart. Until the hour of his death.

We attended Guillaume Apollinaire's funeral. A few birds were chirping in the sunlight. Only ten days before, we had spoken with the great poet in *Excelsior*'s editorial offices. Now we were following his coffin, with an infantry lieutenant's peaked cap on top, among an irridescent cascade of flowers. The flowers of his poems were dropping their petals in our mind.

The funeral procession continued down the Boulevard Saint-Germain. With his face of maize, Picasso presided over the occasion together with Max Jacob and Férat. Picasso was almost cheerful. Wasn't it best to attend your friend's burial with a tender smile? Didn't another great modern poet once say, with profound meaning, in an apparently offhand manner: "je ne sais rien de gai comme un enterrement"? The entourage included Birot, together with his better half; he was clearly preoccupied with the fact of Apollinaire's death. His brows were furrowed. Reverdy was there, shivering from the cold, with a round face and soft speech. Blaise Cendrars was there with only one good arm; he lost the other one to shrapnel in the war. Madame Aurel was there and every member of the avant-garde in Paris who carries a dripping bayonet. Some soldiers from the homeguard were there as well on each side of the funeral coach, carrying their rifles underneath their arms, with their uniforms as sad as ourselves.

At the cemetery no speeches were delivered, no verses were recited. The poet's mortal remains were interred in silence. Supreme, unadorned silence! Roinard, who had brought along who knows how many sheets of paper, was forced to keep them in their folder. This simplicity provided the note of exquisite taste that was needed to pay homage to the best modern French poet. Best because of the newness of his fantasy; best because of his Orphic lyricism; best because of his sacred and penetrating emotion.[58]

The December issue of *L'Instant* was devoted entirely to Apollinaire's memory. Besides an emotional article and poem by Pérez, there were contributions by a number of the late poet's friends, including Blaise Cendrars, Pierre Albert-Birot, Louis de Gonzague Frick, and Raymond Radiguet. Reviewing the posthumous premiere of Apollinaire's play *Couleur du temps,* the latter managed to criticize the production while paying homage to the author himself. Pérez' first contribution, which he signed with his pseudonym "Litus," was dated November 11, 1918, two days after Apollinaire's death. Entitled $\frac{\text{"Victoire X Gloire,"}}{\text{Guerre}}$ it evoked the poet's patriotism and his Mediterranean origins against a general sense of loss as reflected by the city itself.

> Sa joie aux trois couleurs
> il l'avait épinglé sur un drapeau
> qu'il avait acheté rue Saint-Charles pour quelques sous
> co
> co
> ri
> co
> deux et trois fois
> la Seine n'était plus à feu et à sang
> elle ne faisait plus de rêve éblouissant
> sur les quais
> les rues accouraient des façades lézardées
> où les mauvaises moeurs étaient fleurdelisées
> quelle émotion j'étouffe
> le brouillard pendait en loques trouées par des yeux
> un frisson de gloire était aux écoutes
> les pieds sur les pensées
> et cette mer au loin si bonne fille
> et cet amour couleur d'amore
> tous ses ancêtres chevauchèrent sur son âme
> la France
> en vain les morts tentaient de montrer leurs têtes
> au milieu de la foule.

Although the second text was unsigned, a frequent occurence in *L'Instant* since Pérez supplied most of the journal's copy, its lyrical style and insistant praise left little doubt as to the author's identity. Entitled "Notre grand poète," it paid tribute to Apollinaire's manifold accomplishments and celebrated the man himself. An intimate assessment of the poet

and his work, colored by Pérez' affection for his friend and his conviction of the latter's greatness, it served as an excellent obituary.

On a bassement colomnié notre grand poète en le taxant de destructeur, alors qu'il était tout le contraire, un féerique constructeur d'inédit et de nouveau. Guillaume Apollinaire tenait vraiment le rôle d'un grand poète en ce qu'il était divers comme la nature. Sa lyre possédait le pouvoir suprême de faire entendre les mille sons de la poésie. La sienne était en effet une poésie aux mille sons, d'où le trouble délicieux qu'elle jetait dans nos âmes.

Comme ce grand penseur qui fit, à lui seul, toute la grandeur du XIX siècle, il avait proféré et réalisé ce voeu: "J'arracherai de mon coeur toute fibre qui n'est pas raison et art pur." Il ne voulut pas d'une poésie avilie par les enjolivements de la rhétorique traditionnelle. A ce non vouloir, il sacrifia tout succès facile. Il se libéra des entraves déshonorantes de la routine béotienne et poursuivit, avec toute la flamme de son esprit, l'association de la beauté avec la liberté. Que sa mémoire en soit vénérée.

Français et cosmopolite, il le fut avec grâce. Esthéticien d'avant-garde. Prosateur admirablement sobre, mais qui savait à l'envi distiller l'alcool littéraire. Poète à l'émotion rose comme le bouton de rose, au verbe robuste et à la fois éthéré. Créateur de rythmes nouveaux. Divinateur de peintres inconnus et méconnus. Practitien du rire le plus pur et de la joie la plus vermeille, où notre coeur s'accroche aux heures du bitume mélancolique. Joailler qui sut avec un art incomparable extraire les si rares joyaux érotiques pour en parer le bleu du ciel. Voilà quelques-uns de ses titres de noblesse.

Following in Pérez' footsteps, Pierre Albert-Birot devoted an entire issue of *SIC* to Apollinaire's memory in January 1919. In addition to a poem by Josep Maria Junoy, considered previously, he sollicited contributions from two other Catalan poets, one of whom was Joan Pérez-Jorba. Entitled "Arme sous le bras," the latter's contribution included several visual elements. Framed at the top and bottom by opposing V shapes emblazoned with Apollinaire's name, the text was divided into three parts by two crosses. Like the visual composition, the verbal text consisted of three movements as well. The first section introduced two striking metaphors to describe Apollinaire's transition from life to death. Beginning with the image of a trapeze artist, Pérez gradually superimposed the image of a bird in a cage waiting to be set free. The second sec-

tion evoked several prominent themes associated with the poet, especially those related to modern inventions. Like the poem's title, which described the ceremonial position of the rifles carried by the honor guard, the third section recalled events connected with the funeral. Indeed, most of the key images were taken from Pérez' description of the funeral in *La Publicidad*.

Sur le trapèze couleur de pourpre
 APOLLINAIRE
ton triangle s'offre à l'oiseleur
pour le forcer à la libération
céleste
du chant des oiseaux
 elle était pavoisée
 elle étincelait
la locomotive qui sifflait sur ta naissance
 ô rose d'espérance
 POETE SCOLIASTE
 tu marchais sans bâton
 tu volais en avion
aux écoutes sur les usines
dont les cheminées élevaient aux nuées
des symphonies
 il y avait des étoiles
autour de ton front trépané
tes pieds chaussaient des bouquins ailés
 près de ton rire invincible
tu dansais folâtrais et serrais la taille
d'Aphrodite et de Marizibill
 MANDOLINE ET CLAIRON
en coup de vent tu fermas la porte
en coup de vent tu filas
 avec ta jeunesse morte
les fleurs suivaient des yeux ton char funèbre
 flottant de désolation
 un sourire de gloire
 était aux fenêtres des maisons
 vers où montait le jet
 de ton chant comme une aurore
 pour retomber dans le bassin de nos rêves
 APOLLINAIRE.[59]

In January, there were also two brief mentions of Apollinaire in *L'Instant*. Pérez reported that Roch Grey (Hélène d'Oettingen) had just published a booklet devoted to the poet and that an article by Paul Guillaume had appeared in *Les Arts à Paris*. Later the same year, he had occasion to refer to Apollinaire once again. In an article on the well-known cubist poet Pierre Reverdy he remarked: "Reverdy believes that lyricism begins when poetic thought manifests itself in some other way than by direct expression. The delicious, strong, great Apollinaire begins in this manner, brilliantly and melodically."[60] Above all, as this excerpt demonstrates, Pérez prized Apollinaire's poetry for its intensely lyrical qualities. While his references to the poet were limited largely to 1918, during this period he was an extraordinarily faithful propagandist.

ADDITIONAL AUTHORS

Although the influence of Apollinaire's art criticism extends back to 1911, as we saw earlier, it continued to shape the Catalan response to modern painting throughout the First World War. The second earliest reader to familiarize himself with Apollinaire's views—or at any rate to write about them—was Feliú Elíes, who wrote under the pseudonym "Joan Sacs." A talented caricaturist as well, Elíes published a large number of satirical drawings in the Barcelona press at the same time that he was writing about modern art. The pseudonym that he chose for this second profession was "Apa." Since the modern art world was centered around Paris, Elíes experienced a certain difficulty in learning about recent developments. Early in 1914, however, he discovered a solution to his problem when he came across *Les Soirées de Paris*. Whereas the first series had focused on literary concerns, the second—which was inaugurated in November 1913—was devoted to the avant-garde in general. As Elíes soon discovered, the editors were especially interested in modern art.

In April of the same year, Elíes published the first issue of *Revista Nova* (*New Review*), which was closely patterned on Apollinaire's review in Paris. Whereas *Les Soirées de Paris* appeared on a monthly basis, his own journal appeared once a week, eventually becoming a biweekly publication. From the very beginning readers of *Revista Nova* encountered frequent references to *Les Soirées de Paris* and were treated to a wide variety of materials reprinted from the French review. The very first issue included an anonymous poem quoted by Horace Holley in the March issue of *Les Soirées de Paris*. Subsequent issues reproduced large excerpts from the January number devoted to the Douanier Rousseau, including his painting of Apollinaire and Marie Laurencin, and an article by

Fernand Léger published in June.[61] The latter was accompanied by Apollinaire's review of a piano recital by Alberto Savinio, likewise taken from the June issue. To this list should be added a text by G.-P. Fauconnet entitled "Suite d'une conversation échangée," published in *Les Soirées de Paris* in May, which Elíes reprinted on August 13, 1914. In the latter instance, at least, the editor wrote to Apollinaire to ask for permission to reproduce the original article.[62] Although this is the only letter from Elíes to have survived, according to all indications the two men agreed to exchange their respective journals early in 1914. Not only did Apollinaire mention the Catalan review in several of his columns but Elíes sent him each issue of *Revista Nova* as soon as it appeared.[63]

While Elíes continued to draw on Apollinaire's knowledge of modern art over the next few years, 1917 marked the height of his enthusiasm for the French critic. That year he published an important study entitled *La pintura francesa moderna fins al cubisme* which incorporated many of Apollinaire's views. Composed of a series of articles that had appeared in *Revista Nova* the year before, between June and September 1916, the book itself was highly eclectic. On the one hand, much of what Elíes had to say was based on Albert Gleizes' and Jean Metzinger's *Du Cubisme* and several essays by Maurice Raynal, one of which had appeared in *Les Soirées de Paris* in February 1914. On the other hand, many of the author's insights were provided by *Les Peintres cubistes*. Some of the latter borrowings were acknowledged, and others were not. This procedure is illustrated by the following paragraph:

> According to the metaphysical point of view adopted by this new school of painting, nothing should be perceived according to our traditional and daily experience, or with our bodily senses, or with the anthropomorphism or humanism that until now have fundamentally informed aesthetic investigations and the cultivation of the plastic arts. The signs of humanity "are truth, without which we are ignorant of reality," "beauty must be separated from the enjoyment that one person gives another."[64]

Although the author's insistence on Cubism's metaphysical bias was not footnoted, his remarks probably sprang from Apollinaire's observation that the movement sought to "exprimer la grandeur des formes métaphysiques." This impression is strengthened by other developments in the same paragraph, which included two Apollinaire quotations that were footnoted. Thus Elíes rejected traditional objective art in favor of a new, subjective humanism whose signs, according to Apollinaire, "sont la

vérité et en dehors d'elles nous ne connaissons aucune réalité." Adding that the new subjectivity was intellectual rather than emotional, Elíes bolstered his argument with another citation from *Les Peintres cubistes*: "[La peinture moderne] figure le beau dégagé de la délectation que l'homme cause à l'homme."[65] Several pages later he returned to this theme, noting that "Cubism especially seeks to depict metaphysical absolutes." Given the fallibility of the five senses,

> [Cubism] rejects them and searches for inner truths, for absolute subjectivity (Note: Speaking of Cubism, G. Apollinaire calls it "ce grand mouvement subjectif"). . . . If it occasionally uses forms taken from the external world, decomposing them geometrically, . . . it depicts concepts rather than visual appearances, serving as a point of transition between the external world . . . and the world of the imagination.[66]

While only one section was footnoted, both parts paraphrased key passages in *Les Peintres cubistes*. The last section combined Apollinaire's glorification of imagination with his definition of Cubism. "Le cubisme est l'art de peindre des ensembles nouveaux," he noted, "avec des éléments empruntés, non à la réalité de vision, mais à la réalité de conception."[67]

Paraphrases of other sections of *Les Peintres cubistes* could be cited as well, such as the author's discussion of the role of the fourth dimension. In addition, Elíes devoted the better part of three pages to Apollinaire's fourfold classification, which he translated verbatim.[68] Cubism was subdivided into four categories, he explained, some of which could be called pure, and others impure, according to objective criteria: "cubisme científic, òrfic, físic, i instintiu." It is clear that Elíes greatly valued this typology, moreover, for he made use of it again the following year. Writing in *Vell i Nou* (*Old and New*) in August 1918, he published a two-part article on Picasso. Although Apollinaire figured only briefly in the first installment in connection with an early drawing, he dominated the second half when it appeared. Citing the relevant passages from *Les Peintres cubistes*, Elíes utilized his discussion of "les quatre tendances" as a frame for the remainder of the article.[69] As far as he was concerned, Apollinaire was "el definidor del Cubisme," and his system had priority over all the others.

In 1919, this viewpoint was contested by another critic writing in the same journal who questioned the relevance of Apollinaire's categories. In a letter from Paris, Josep de Togores observed: "With all due respect to this great thinker . . . I must say that Guillaume Apollinaire—whose books I have recently reread—was lacking insight here and got entangled in a web of confusions, contradictions, and obscurities and that his definitions and

categories are not valid. Thus there is no scientific, Orphic, instinctive, or physical Cubism except in his imagination."[70] By this date, as Ezra Pound was to note (see chapter 2), Apollinaire's typology was becoming out-moded, but even his detractors had to admire its historical importance.

In addition to Elíe's book on modern French painting, 1917 saw the publication of three prose texts by Apollinaire in Catalonia. Like the for-mer volume, these were occasioned by the mammoth Exposició des Artistes Francesos, which took place in April, or were published in its aftermath. Housed in the Palau dels Bells-Arts, the latter joined four Parisian annual shows together for the first time. Besides Les Artistes Français, it included La Société Nationale des Beaux-Arts, Le Salon des Indépendants, and Le Salon d'Automne. Celebrating this event, a special issue of *La Publicidad* appeared on April 23rd with a contribution by Apollinaire. In reply to the editor's request for an article on modern French art, he sent a lengthy essay entitled "Los comienzos del cubismo" ("The Beginnings of Cubism").[71]

Modeled on an article he had published five years before, Apollinaire's study traced the development of Cubism from Vlaminck and Derain's encounter in 1902 to its latest manifestations in the paintings of Diego Rivera and Léopold Survage. Conceived as an informal history, it illustrated the evolution of Cubist aesthetics with a series of amusing anecdotes. In essence Apollinaire expanded the original article to account for subsequent developments. Since Pierre Caizergues provides an excel-lent discussion of the principal changes, there is no need to dwell on them here. It suffices to note that the difference between the two versions was minimal.[72] Sensitive to the context in which the revised version would appear, Apollinaire added the following definition of Cubism: "Cubism is a Franco-Spanish artistic movement headed by Picasso, a Spaniard whose artistic education is entirely French. Cubism is the most important branch of contemporary painting and occupies the position that was formerly held by Impressionism."

On November 10, 1917, a second event took place that revealed just how far the French avant-garde had managed to penetrate into Catalonia. Less than six months after it had premiered in Paris, the citizens of Barcelona were treated to a performance of the revolutionary new ballet *Parade*. Danced by the Ballets Russes at the Liceu de Barcelona, where it appears to have puzzled much of the audience, the ballet was accompa-nied by the same printed program as before, translated into Spanish. While the translator was faithful to the letter of the original document, he was less mindful of its spirit. Confronted with Apollinaire's preface, in which he introduced the neologism *surréalisme*, the translator neglected to

change the first sentence: "Les définitions de *Parade* fleurissent de toutes parts comme les branches de lilas; en ce printemps tardif . . . ," which clashed with the fall performance. This omission caught the eye of an anonymous reviewer in *La Publicidad* who, referring to Apollinaire as "el sacerdote del cubismo" ("the high priest of Cubism"), heaped abuse on the entire production. Rising to the ballet's defense, an equally anonymous reviewer in *El Poble Catalan* advised his colleague to remedy his apalling ignorance. Among the books that he recommended was *La Peinture cubiste* (sic) by Guillaume Apollinaire.[73]

Published in the original French, a third text by Apollinaire appeared in *Vell i Nou* in December 1917. Appended to an anonymous study entitled " 'El simultanisme' del Senyor i la Senyora Delaunay," which alluded to the previous dispute between Apollinaire and Henri-Martin Barzun, it reproduced one of his columns in the *Mercure de France*. Although the latter dated from 1914, the fact that it concerned Robert and Sonia Delaunay appealed to the author of the Catalan article. In addition, Apollinaire's contribution was highly provocative. Devoted to the artists' attempts to create a new fashion, it described their outrageous experiments with simultaneous clothing.[74] A typical man's costume, he noted, consisted of a red cloak with a blue collar, red stockings, black and yellow shoes, black trousers, a green jacket, a sky-blue vest, and a red necktie. Women's costumes were even more elaborate.

In addition to Junoy and Elíes, Francesc Carbonell figured among Apollinaire's earliest readers in Catalonia. One of a group of writers who were associated with *Iberia*, he published a review of *Le Poète assassiné* in 1916 that was remarkably sympathetic. Judging from this document, he seems to have been surprisingly well informed.

> M. Apollinaire has published various works during the last few years, including the following: *La Poésie symboliste* (1909), *Le Théâtre italien* (1910), *L'Hérésiarque et Cie* (1910), *Méditations esthétiques* (1912), *La Fin de Babylone* (1913), etc. The book whose title graces the beginning of this paragraph was in press when the war broke out, and only the last section, "Le Poète resuscité," which refers to the war, was added later by the author. In this volume, which consists of a number of remarkable stories, notably "Le Poète assassiné," "Le Roi-Lune," "Le Départ de l'ombre," and "Le Fiancé posthume," M. Apollinaire displays both his imagination and his talent. Employing a brilliant literary style filled with lyricism and irony, the author presents various characters—Croniamantal, Macarée, Ygrées, le Roi-Lune, Chislam Borrow, etc.—recounting extraordinarily interesting

stories of the latter that evoke great curiosity on the part of the reader. Promoted to second lieutenant in the infantry, M. Apollinaire was seriously wounded a short time ago and underwent an operation. We wish him a speedy recovery.[75]

Not only is Carbonell's praise totally unexpected, but his assessment was remarkably accurate. Even in Paris, which was accustomed to bizarre works of art, the critical reception was largely hostile. One can imagine the initial response of the Spanish press to this strange, unsettling work. Despite the review's positive, even enthusiastic tone, Carbonell's first reaction was probably not much different. While he stressed the brilliance of Apollinaire's achievement, for example, traces of his initial puzzlement lingered in the word "curiosidad." This trait can be seen more plainly in a later article published in July 1917, which was devoted to recent French books. Appearing in *Iberia* like the earlier review, it focused on a relatively small number of publishers who specialized in literary works. "L'Édition continues to publish ultra-modern works," Carbonell noted, "[including] *Le Poète assassiné* by the incomprehensible Guillaume Apollinaire whose *Les Mamelles de Tirésias* recently premiered in Paris."[76] Although he admired the French writer, much of what the latter was trying to do eluded him.

By 1918, nevertheless, Carbonell had become familiar with the aims of the French avant-garde and had learned to appreciate Apollinaire's work. As he eventually discovered, each was related to the other. In January, during a survey of French periodicals, he called attention to two journals that featured Apollinaire's recent poetry. This time the latter's experimentalism was viewed in a broader perspective:

> *La Grande Revue*, in the November issue, devotes several pages to the remarkable "Poèmes de guerre et d'amour" by Guillaume Apollinaire, the author of *Le Poète assassiné* and *Les Mamelles de Tirésias*, the strange creator of new and original literature who, wounded twice previously, "attend les yeux fixés sur la montre, la minute préscrite pour l'assaut."
>
> The latest issue of *Soi-Même* . . . contains a long article by René-Marie Hermant entitled "Le Poète assassiné," in which the author analyzes several works that have appeared in various reviews by Apollinaire and his disciples, modeled on the new forms that Marinetti invented ten years ago.[77]

As Carbonell noted, the publication of thirteen works in *La Grande Revue* was an important event. While they included a few love poems addressed to Lou and to Madeleine, the vast majority were concerned

with life at the front. Indeed, the collection included several of Apollinaire's best-known war poems, such as "Chevaux de frise" (OP, 302–3), "Dans l'abri-caverne" (OP, 259–60), and "Merveille de la guerre" (OP, 271–72). All thirteen works were eventually published in *Calligrammes*. Among other things, the article may have been the source of the persistent myth in Catalonia, perpetuated by Joan Pérez-Jorba and others, that the poet had been wounded twice. Carbonell was clearly struck by the heroic qualities of Apollinaire's verse and the circumstances in which it had been composed. Evoking the latter's role as soldier-poet, he cited the last line from "Chef de section" (OP, 307), which made it seem like Apollinaire was still fighting at the front. By contrast the article in *Soi-Même* was devoted to another genre made famous by Apollinaire: the calligram. By this date Carbonell should have been aware of the difference between his experiments with visual poetry and those initiated by the Futurists. Although the *parole in libertà* preceded the first calligram by some six months, dating from 1914 rather than from 1908, their influence on the French genre was minimal.

Several additional texts published during 1918 testify to the growing rapport between the Catalan critic and Apollinaire. In March, for example, Carbonell informed his readers that the poet was recovering from a serious illness. For the first time he allowed an affectionate note to color his commentary: "We are glad to report that Apollinaire, who was suffering from a serious pulmonary congestion, is already feeling better."[78] Reviewing *Nord-Sud* two months later, he remarked that Apollinaire was one of the principal contributors and acknowledged his crucial role in reforming modern aesthetics. "Guillaume Apollinaire," he stated, "[is] the principal exponent of the new system and the author of *L'Enchanteur pourrissant, L'Hérésiarque et Cie, Le Bestiaire, Méditations esthétiques, Alcools*, and *Le Poète assassiné*, which we reviewed in these pages when it appeared."[79]

Not until December did Carbonell reveal that he had previously corresponded with Apollinaire. Writing in *Iberia*, he published a letter he had received in which the poet praised the latter journal and proclaimed his admiration for "l'esprit espagnol." Unfortunately, the letter leaves a number of questions unanswered. Since it was not dated, we do not know when the exchange took place. Neither do we know whether the correspondence was limited to a single exchange or whether it extended over a longer period. The fact that Apollinaire's library included eighteen issues of *Iberia*, covering the years 1916–18, suggests that the two men corresponded for some time. At the very least, the letter that follows establishes a personal context for some of Carbonell's remarks:

Votre revue *Iberia* est un excellent périodique, plein de choses très intéressantes. Il y a là des dessins satiriques de premier ordre. Vous savez combien j'aime l'esprit espagnol. Vous savez aussi tout ce que j'ai fait pour sceller le lien intellectuel entre les trois nations latines, France, Espagne, Italie. Cette parenté d'esprit s'est manifestée avant tout dans les Arts d'avant-garde où l'on n'a trouvé jusqu'ici que des artistes de ces trois pays et en tête des Arts du monde entier. Vous menez un bon combat pour l'esprit de la civilisation et je vous serre fraternellement dans mes bras.[80]

Although Apollinaire's reputation was well established in Catalonia by 1918, his influence on major Catalan writers was restricted to Junoy and Folguera—with an occasional nod from Salvat-Papasseit. While Trinitat Catasús' *Vendimiari: poemes* was well received when it appeared in 1921, for example, it bore no relation to "Vendémiaire" (OP, 149–54). The author of these conservative poems chose what appeared to be a revolutionary title simply because they were all situated in September. J. M. López-Picó's enigmatic remarks a few years earlier are no more rewarding. In a discussion of modern poetry in 1919, during which he demonstrated his familiarity with the leading schools, he had this to say about the author of *Alcools*: "If Guillaume Apollinaire were to return to life, he still would not know whether to choose the spectators or the disciples."[81] Whether this was intended as praise or as criticism is hard to say. Perhaps he meant to imply that Apollinaire's disciples had already begun to deviate from the model he had established.

Unfortunately, Guillermo Díaz-Plaja's identification of Apollinarian rhythms in J. V. Foix's early prose is equally disappointing.[82] If *Gertrudis* adopts the characteristic rhythms of modern poetry, as he demonstrates, there is nothing about this practice that specifically links the work to Apollinaire. This is not to say that Foix was ignorant of the poet's existence. To the contrary, we know from the poem he published in the memorial issue of *SIC* that he held Apollinaire in high esteem. His own inspiration was simply so compelling that he felt little need to borrow from other authors. Foix's untitled tribute was remarkable in more ways than one. Filled with military metaphors on the one hand, it evoked Apollinaire's role as leader of the avant-garde and compared him to Maréchal Foch. Both men had achieved stunning victories against overwhelming odds. Filled with cosmic metaphors on the other hand, the poem translated Apollinaire's accomplishments into mythic terms. By rebelling against existence itself, he asserted his Promethean individuality.

BY DINT OF POLISHING THE SKY
VICTORY'S POLICEMEN THOUGHT
TO FLATTER THE VICTORS: THE
COMMANDER OF THE WARTIME ARMY, FIELD MARSHALL
FOCH, AND THE COMMANDER OF
THE POETIC ARMY, FIELD MARSHALL APOLLINAIRE
THE VAIN SOLDIERS
WHO WERE ADMIRING THEIR REFLECTIONS
BATHED THEIR DIVINE FACES
IN IT. IN AN EFFORT TO SURPASS THEM
APOLLINAIRE DROVE HIS BAYONET
INTO THE FIRMAMENT'S RIPEST
TUMOR WITH A SUPREME BLOW
AND LIBERATED HIMSELF
AS ONE EXHALES A BREATH OF AIR
HENCEFORTH HIS FATAL SACRIFICE
WILL BE COMMEMORATED BY
THE MIRACULOUS FISSURE THAT
THE POET OPENED TO THE CURIOSITY OF EAGER MINDS[83]

In the years following the poet's death, articles on Apollinaire in Catalonia became increasingly concerned with anecdotes. As early as 1920, if not before, the eminent critic Eugeni d'Ors employed this technique in a review of a book by Alejandro de la Sota. Reproving the author for the laxity of his prose, which he shared with several other modern writers, d'Ors spent most of his time comparing him to Apollinaire. Beginning with a back-handed compliment that betrayed his lack of sympathy, he warmed to the task at hand. Quoting a passage from the book, he observed: "One finds pages like this in the rarely interesting—but greatly so when he chooses—writer Guillaume Apollinaire." One of the things the two authors shared, d'Ors added, was a certain philological timidity since they were writing in an adopted language. Combined with their rich, largely undisciplined sensitivity, this trait caused them to translate what they felt into the kind of language favored by musicians.

At this point, the reviewer devoted several paragraphs to a portrait of Apollinaire, which he attributed to the Douanier Rousseau. Still hanging in the poet's apartment, which he mistakenly situated in Passy, the picture depicted the seated poet surrounded by a bevy of young women. Judging from this description d'Ors was probably thinking of a painting by Marie Laurencin entitled *Réunion à la campagne* (*A Gathering in the Country*) (1909), which is now at the Centre Pompidou.[84] What interested him, in any case, was the manner in which the figures were arranged. In

particular d'Ors was struck by Apollinaire's hieratic pose, which suggested yet another affinity with the author he was reviewing. "Not only do certain aspects and certain rhythms of Alejandro de la Sota's prose recall Apollinaire," he concluded, " but also his presidential and Britannically impertinent manner, which reflects the admiration and pampering of his 'girl friends' and of 'girls' in general."[85] Not surprisingly, the purported similarity between Alejandro de la Sota and Apollinaire was purely a product of the author's imagination. Although d'Ors was good at entertaining his readers, his critical methodology left a lot to be desired.

Among other things, the preceding article illustrates d'Ors' curious ambivalence with regard to Apollinaire. While he admired the richness of his imagination, he deplored the excesses committed in the name of artistic freedom. On the one hand, d'Ors acknowledged that Apollinaire was an important force in modern literature. During a discussion of H. G. Wells shortly thereafter he observed: "We know how authors whose works are not widely distributed, . . . someone like Apollinaire, can succeed in transcending the intellectual currents of the period."[86] Similarly, examining a copy of a periodical published in Montevideo, he was delighted to find Apollinaire's name juxtaposed with those of Paul Claudel and Marcelino Menéndez y Pelayo. "When a conjunction of stars occurs like this," he exclaimed, "it is a good omen both for civilization and for piety."[87]

On the other hand, d'Ors was anything but effusive when discussing Apollinaire's accomplishments. His review of a posthumous volume in 1928 is typical of his reticence with regard to the French author.

> Neither jubilant nor funereal, Apollinaire's Auteuil—intimate, ambiguous, tart, caricatural in its melancholy—does not caress the fibers of my being, this October morning, any less than Veronese's and Barrès' memory of Venice. . . . But in this case anecdotes intervene. It so happens that Apollinaire's Auteuil was mine, in space as well as in time.
>
> I can respond to anecdotes for a moment, but I quickly forget about them. Having been touched and amused in turn by Guillaume Apollinaire's recent posthumous book *Le Flâneur des deux rives*, which is composed of nothing but anecdotes, I quickly forgot about it.
>
> I also forgot about that third shadow whose exclusively anecdotal outline was projected on the screen provided by my memory. Without a renewed sense of celebration, without a nostalgic lantern; with only an index card to be filed under "curiosities."[88]

Inexplicably, d'Ors made no attempt to relate *Le Flâneur des deux rives* to Apollinaire's life, to his other published works, or to literature in general. Surely, his readers would have been interested to learn, for example, that the poet earned his living writing a column entitled "La Vie anecdotique." What makes the review even more puzzling is d'Ors' disdain for the anecdote as a literary genre. While he professed to hold it in low esteem, his own works were filled with anecdotes.

By 1924, the Catalan avant-garde had absorbed about all the literary cubism it was going to and was becoming infatuated with a new influence—Surrealism. According to Guillermo Díaz-Plaja, a collection of poetry by Sebastià Sànchez-Juan marks the end of the period we have been exploring. Entitled *Fluid: poemes* (1924), it was one of the last books to draw on the French experiments that had fascinated an entire generation of poets. Similar works continued to be written after this date, nevertheless, such as *Radiacions i poemes* by Carles Sindreu i Pons. Published in Barcelona in 1928, this volume contained several visual poems that may have been inspired by *Calligrammes*. Be that as it may, there is no doubt that Sindreu was familiar with Apollinaire's poetry. Appended to the beginning of the work for all to see was the following epigraph taken from "Les Fenêtres": "La fenêtre s'ouvre comme une orange / Le beau fruit de la lumière" (OP, 168). In addition to acknowledging Sindreu's debt to the French poet, these lines served as the model for the "radiations" alluded to in the title. The Catalan equivalent of Ramón Gómez de la Serna's *greguerias*, the latter consisted of short, pithy aphorisms or flights of metaphor.

For the most part, references to Apollinaire in Catalonia after 1924 tended to be anecdotal, to concern Surrealism, and to originate in Paris. Relating a conversation with Charles Maurras, for example, Just Cabot described Apollinaire in 1917 as "a likable and picturesque Pole [who] used to speak of our common devotion to poetry."[89] Long before the Surrealists gained prominence, he declared, Apollinaire had sought to reconcile madness and genius in his poetry. The same year, one of the founders of Catalan Surrealism, Sebastià Gasch, mentioned the poet's name a second time in connection with the new movement. Discussing various theories of Surrealist painting, he relayed André Breton's remark that, according to Apollinaire, Giorgio de Chirico painted his best pictures while suffering from a stomach ailment.[90] The prominence of these and other anecdotes did not mean that Apollinaire had ceased to have an effect on Catalan letters, merely that his earlier influence had been well assimilated.

CHAPTER SIX

Apollinaire's Reign in Spain

Although the development of modern literature in the rest of Spain observed a slightly different chronology, for the most part it paralleled that in Catalonia. Despite the so-called *modernista* movement, which spanned the turn of the century, it was not until the end of the First World War that Castilian authors began to cultivate a truly modern idiom. In general, one may distinguish three evolutionary phases during the period leading up to the Spanish Civil War. The first corresponds to the Ultraist movement grouped around Rafael Cansinos-Asséns and animated by Guillermo de Torre. The second is the rise of neo-popularism, illustrated by García Lorca's *Romancero gitano* and other works. The third is the triumph of surrealism in authors such as Rafael Alberti and Vicente Aleixandre. The present chapter focuses on the first phase which flourished from 1919 to 1923.[1] Situated between the Generation of '98 and the Generation of '27, *ultraísmo* reacted against the one and paved the way for the other. In addition, it influenced the great Argentine writer Jorge Luis Borges during the formative years of his career. Not only did he participate in the initial stages of the movement, first in Seville and then in Madrid, but he established a branch in Argentina when he returned home.

As we will note in the following chapter, Argentine Ultraism enjoyed a large following and was longer-lived than the original movement. Although Ultra in Iberia produced one exceptional poet—Gerardo Diego—and a host of lesser figures, it was essentially a transitional phenomenon. According to Ramón Buckley and John Crispin, the movement's most important feature was its cosmopolitanism: "For the first time since the 18th century, Spain opened its frontiers and participated in the European intellectual currents of the moment with its own unmistak-

169

able voice. Spain joined the rest of Europe beginning with Ultraism, in which Dada was united with Futurism and literary cubism or Creationism."[2] Indeed, Italian Futurism and French literary cubism largely determined the Spanish response to the twentieth century. A somewhat later phenomenon, Dada played a lesser role in defining Ultraist goals.

The first movement had long been familiar to Spanish readers, thanks to several intermediaries. Appearing in *Le Figaro* on February 20, 1909, Marinetti's *Fondation et manifeste du futurisme* was reviewed almost immediately in the Madrid newspaper *El Liberal*.[3] In April Ramón Gómez de la Serna published a Spanish translation in his journal *Prometeo* (*Prometheus*), together with an essay celebrating the new movement. Like the Nicaraguan poet Rubén Darío, who reviewed the manifesto for *La Nación* in Buenos Aires, he was living in Paris at the time. One year later, he published Marinetti's *Proclama futurista a los espanoles* (*Futurist Proclamation to the Spaniards*). Especially commissioned for *Prometeo*, the manifesto was also printed as a handbill and distributed throughout Madrid. Thereafter, until the end of World War I, the two greatest supporters of Futurism in Spain were Gómez de la Serna and the novelist and playwright Pedro Luis de Gálvez.[4] With the birth of *ultraísmo* early in 1919, which exhibited numerous Futurist traits, the Italian movement gained a wider audience and a broader base. However, by 1920 it had begun to recede into the background, and Apollinaire became the dominant influence in Spain— both directly and through his French disciples.[5] These included the literary cubists grouped around *SIC* and *Nord-Sud* (edited by Pierre Albert-Birot and Pierre Reverdy), the Chilean Creationist Vicente Huidobro, and most of the French Dadaists. By 1925 the French influence had so overpowered the Italian that the first historian of Ultra could write: "There is no need to reiterate that the recent origins of the movement are in France."[6]

PEDRO LUIS DE GÁLVEZ

It should be noted that Castilian interest in Apollinaire—and vice versa— antedated the invention of Ultraism by a good many years. While there were individuals living in France who knew the poet personally, the first nonresident to meet him seems to have been Pedro Luis de Gálvez, who passed through Paris in 1913. On March 16, 1913, Apollinaire devoted most of his column in the *Mercure de France* to this picturesque character whose life often surpassed the adventures in his stories.[7] "C'était à Cadix, en 1904," he declared, "au cours d'une réunion politique. Un jeune

homme venait de prononcer un discours très violent où il exprimait des opinions républicaines. Les autorités avisés, on décida de l'arrêter sur-le-champ dans la salle même où il avait parlé." This young man, of course, was none other than Pedro Luis de Gálvez. Invoking one *péripétie* after another, the rest of Apollinaire's account could easily have been written by Alexandre Dumas (Père). Escaping from the authorities with the aid of a revolver, Gálvez was sheltered by an elderly priest and eventually reached Cordoba disguised as an ecclesiastic. There, unfortunately, he was arrested and sentenced to fourteen years of hard labor. He served his term, Apollinaire reported, "au bagne d'Ocaña, le plus terrible d'Espagne, celui où sont enfermés les criminels les plus dangereux." Following an abortive rebellion by the inmates, Gálvez found himself in a dungeon chained to the wall by his left leg: "La chaine scellée au mur n'avait pas cinquante centimètres de long. J'ai vu les jambes de Pedro Luis de Gálvez. La gauche, qui porta la chaîne, est trois fois plus grosse que la droite."

At this juncture, the story took a decidedly melodramatic turn. Confined to a solitary cell, Gálvez passed the time by taming the numerous rats that were his sole companions. His favorite rat, which he had blinded, even used to sleep on his chest at night. Among other things, he taught it to bring back writing materials from a priest who occupied the cell across the way. Thereafter, by the light of a primitive candle he was able to write poems and stories, which greatly impressed his jailer. Learning that the newspaper *El Liberal* had organized a short-story contest, the latter urged Gálvez to enter. Exhausted by his long detention, the prisoner refused even to consider the possibility. Fortunately, Gálvez ceded to his jailer's wishes at the last moment and told him: "Apportez-moi un litre de vin et j'écrirai la nouvelle." Working feverishly all night long, he wrote a story entitled *El ciego de la flauta* (*The Blind Flute-Player*), which not only reached the newspaper on time but eventually won first prize. "Quel ne fut pas l'étonnement des membres du jury," Apollinaire continued, "lorsqu'ayant ouvert l'enveloppe annexée à la nouvelle, ils lurent que son auteur était enfermé pour quatorze ans au bagne d'Ocaña. Ce fut d'abord un beau scandale en Espagne; mais le roi signa bientôt la grâce de Pedro Luis de Gálvez, qui devint correspondant du *Liberal* à Melilla." In keeping with the miraculous turn of events, which demonstrated Gálvez' manifold talents, the tale ended happily.

Although Apollinaire swore the story was true, much if not all of it is difficult to believe. For one thing, it resembles a Romantic adventure novel more than an objective account. For another thing, his very next column, which purported to describe Walt Whitman's funeral (see chapter 2), was admittedly a hoax. Against every expectation, however, most of

Apollinaire's account turns out to be factually correct. Gálvez himself was the author of numerous plays, several novels, and a great number of articles. Leading "une lamentable vida de aventurero" ("a lamentable life as an adventurer") according to one critic, he was a perpetual vagabond who lived by his wits and had even served as a soldier in the Balkans.[8] Interestingly, one of his novels contains traces of the episode described by Apollinaire. Entitled *Existencias atormentadas: los aventureros del arte* (1907), it bears the following dedication: "Al Sr. D. Fernando Cadalso y Manzano, Inspector General de Prisiones. Homenaje de P. L. de G. Ocaña, 1907." Toward the end of the book an advertisement for another novel, *En la carcel* (*In Prison*), adds that he had been sentenced to prison for having engaged in revolutionary propaganda. The following year, the novelist Alberto Insúa devoted a whole article to Gálvez, whose only crime was to have "pronounced the king's name together with a certain adjective during a meeting." Writing in *El Liberal* on January 7, 1908, he stressed the young man's talent, which led him to write and to publish two novels during his stay in prison, and protested against the severity of his sentence. By that date Gálvez had spent three years in prison, following his initial detention, and had three years left to serve. The article concluded with an appeal for clemency in which the author requested that Gálvez be released.

El Liberal had in fact announced a short story contest a few weeks earlier, but the deadline was not until two months later. Headed by the famous novelist Benito Pérez Galdos, the jury awarded the prizes on February 29, 1908. Of the 602 individuals who submitted stories, the author of *Romance* received the first prize, while the second prize went to *El Milagro.* Two entries received honorable mention: *La armadura* and no. 461: *El viejo de la flauta.* The next day, the title was corrected in the newspaper to *El ciego de la flauta.* The day after that, the editors of *El Liberal* informed their readers that the author of the latter work was Pedro Luis de Gálvez. The story itself appeared in the newspaper on March 6, 1908. Although its title inevitably invites comparison with Apollinaire's poem "Le Musicien de Saint-Merry," the two works have nothing in common.[9] Conceived as a *conte noir*, the Spanish tale evokes the pathetic existence of a blind couple and their daughter who earn their living by begging. As soon as Gálvez' situation was called to the attention of the general public, it produced an enormous scandal. In particular his literary colleagues protested en masse against this apparent perversion of justice. An anonymous article published in *El Liberal* on March 4, 1908, reveals the extent of their indignation:

> Yesterday the distinguished novelist Blasco Ibáñez paid a visit to the Minister of Justice and presented him with a petition, signed

by numerous literary figures and journalists, requesting that Pedro Luis de Gálvez be pardoned. . . . Calling attention to the honors accorded Pedro Luis de Gálvez in the recent short story contest sponsored by *El Liberal*, Blasco Ibáñez appealed to the Marquis de Figueroa, as minister and as a man of letters, to bring about the prompt and happy resolution of this matter personally. We join our plea to that of the authors who are represented so eloquently by Blasco Ibáñez.

Released soon thereafter, Gálvez took advantage of his good luck and—incredibly—succeeded in gaining entry to the Spanish court. There, according to the *Enciclopedia universal ilustrada*, he obtained the protection of several important men of letters who assured his literary career. Unfortunately, he eventually managed to alienate his protectors and resumed his poverty-stricken existence.

At this point, let us summarize the principal ways in which Apollinaire's column differs from the account published in *El Liberal*. While the two chronicles diverge at a number of different junctures, the most important discrepancies appear to be the following.

1. Gálvez was sentenced not to fourteen but to six years in prison.
2. Instead of writing poems and short stories in prison, he composed two novels.
3. In reality, therefore, both light and writing paper must have been relatively abundant, which renders the story of the blind rat highly suspect (among others).
4. Gálvez did not wait until the last minute to enter the contest since his story received the number 461, out of a total of 602 entries.
5. Rather than first prize, *El ciego de la flauta* was awarded honorable mention.
6. Although the attendant publicity certainly provoked a protest in the author's favor, the protest followed on the heels of an earlier protest by Alberto Insúa.

From the foregoing list we can draw several important conclusions regarding Apollinaire's compositional habits. Among other things, the discrepancies between the two accounts shed valuable light on the way in which he shaped much of his material. On the one hand, the column that appeared in the *Mercure de France* was relatively faithful to the historical version provided by *El Liberal*. Gálvez was sentenced to prison for verbal attacks against the Crown, wrote a short story while he was imprisoned, won a contest with the same story, and was released following the scandal that ensued. On the other hand, Apollinaire clearly embellished the original story in a number of places. In general, these embellishments assumed

two separate forms: exaggeration and invention. Either the author ampli-
fied an original detail, or he relied on his own imagination to supplement
the original story. This dual process occurs elsewhere in Apollinaire's
work and typifies many, if not most, of his fictional narratives. Reviewing
the series of changes for the last time, one perceives among other things
that the French version contains a number of elements that subvert the
story's realistic premises. Apollinaire chose to parody, not the French
Romantics but the Spanish picaresque novel, which swarms with rever-
sals facilitated by multiple disguises, imprisonments, escapes, and so
forth. As much as anything, his account of Gálvez' remarkable experience
was conceived as a pastiche.

It is entirely possible, that Apollinaire met Pedro Luis de Gálvez in
1913, just as he claimed. In an article published six years later, the
Spaniard mentioned a trip to Italy he had taken "just before the war" in
order to meet F. T. Marinetti.[10] He could easily have adjusted his itinerary
to include a visit to Paris, where he seems to have had friends. Despite his
personal contact with Apollinaire, Gálvez referred to him on only one
occasion in the years that followed. Significantly, this reference was
inserted into an inaugural lecture presented at the Ateneo in Seville on
May 2, 1919. Entitled "Cuartillas" ("Sheets"), the talk opened the very first
literary gathering organized by the Ultraists, which was devoted to recent
poetic tendencies in Spain. Condemning rhetorical rigidity, Gálvez called
for spontaneity, naturalness, and vivacity in literature. In this context, he
added: "In a work entitled 'L'Esprit nouveau et les poètes,' Guillaume
Apollinaire says we should grant the same amenities to Poetry and Fiction
that we grant to newspapers."[11] Like others before him, Gálvez was struck
by a passage in Apollinaire's final article in which he extolled the freedom
of the daily newspaper "qui traite dans une seule feuille des matières les
plus diverses, parcourt des pays les plus éloignés."[12] While Gálvez may
have read this defense of Cubist inspiration in the *Mercure de France*, he
was probably referring to the Spanish translation recently published in
Cosmópolis (to be discussed later). Whatever the source of his information,
he was obviously familiar with the French poet's work. Although he
insisted on the indigenous character of Ultra in the same speech, he cited
Apollinaire as one of the movement's three precursors (together with
Marinetti and Max Jacob).

From 1918 to 1921, as we will discover, the Ultraists published
approximately thirty translations of texts by Apollinaire. An admitted
precursor, the French poet was destined to become one of the most impor-
tant influences on the movement. Among the various poems, short sto-
ries, articles, and novels by Apollinaire that were published in Spanish,

the most curious translation is that which appeared in *Grecia* (*Greece*) in August 1919. Entitled "Pedro Luis de Gálvez," it reproduced Apollinaire's column of the same name and thus brought their relationship full circle.[13] In the absence of any commentary by the editors or the translator, who was presumably Adolfo Salazar, it is difficult to gauge their intentions. However, one has little difficulty in imagining the impression it must have made on Gálvez, who was undoubtedly quite surprised to discover that his life had been transformed into a work of art.

An equally interesting epilogue is furnished by Ramón Gómez de la Serna who, writing many years later, included Apollinaire's portrait of Gálvez in *Nuevos retratos contemporanéos* (*New Contemporary Portraits*) (1945). What makes this so remarkable is that he refused to believe the text had been authored by Apollinaire. Admitting he didn't know why the latter had signed his name to it, he declared that the work had been composed by Gálvez himself and published subsequently in *Grecia*. In the light of Serna's assertion, it suddenly became impossible to distinguish the man from the myth. The historical Gálvez was consumed by his fictional double. Not only was Apollinaire's account accepted as the literal truth, but it was interpreted as an autobiographical narrative by the very person he was writing about. Not only was Apollinaire displaced by Gálvez, but he was swallowed up by his own creation, which had begun to lead an independent existence. Conceived as a harmless parody, the latter came to represent the triumph of artistic illusion—at least in the eyes of later readers.

ADDITIONAL AUTHORS

The second nonresident Castilian who succeeded in meeting Apollinaire was Ramón Gómez de la Serna himself. With the advent of World War I, the modern movement began to filter into Spain more rapidly, encouraged by members of the French avant-garde who took refuge in Barcelona and Madrid. Although the former was the more popular destination, several important artists settled in the capital including Apollinaire's ex-mistress Marie Laurencin and his old friends Robert and Sonia Delaunay. All three were welcomed enthusiastically and immediately developed a following. Among other things, we know that Marie objected to the excessive influence of Futurism in Madrid and that she recommended Picasso and Alfred Jarry to her Spanish acquaintances.[14] Both she and the Delaunays were struck by Ramón's literary resemblance to Apollinaire. However, Marie seems to have met him only once during the eight months she resided in Madrid.[15] Following this brief and rather frigid

encounter, they began to correspond while she was in Malaga, and before long she was serving as an intermediary between him and Apollinaire. We know, for example, that she sent the Spaniard Apollinaire's collection of war poetry *Case d'armons* (OP, 219–44) soon after it appeared on June 17, 1915. Indeed, in all probability she sent him her own personal copy. Since the edition was limited to twenty-five copies, Apollinaire seems to have reserved them for his closest friends. "Marie Laurencin [m'a] fait parvenir *Case d'armons* polycopié sur la culasse d'un canon," Serna recalled a few years later. "Les images neuves de la guerre [étaient] là, entières, parfaites, perpétuables. Toutes les explosions, toute l'originale pyrotechnie de la guerre européenne, Apollinaire [l'a recueilli] dans ce livre."[16]

Writing to Madeleine Pagès on July 18, 1915, Apollinaire quoted part of a letter he had just received from someone in Spain mentioning a newspaper article on Paul Fort, Apollinaire, and Romain Rolland's popularity in Germany.[17] Although he neglected to name his mysterious correspondent, the latter was almost certainly Serna. The article itself, which has not yet been identified, constitutes the first reference to Apollinaire by a Castilian writer. By September 3, the epistolary triangle was so well established that Apollinaire could write to Madeleine: "Ci-joint la traduction d'une de mes lettres écrites à M[arie] L[aurencin] telle qu'elle a paru dans un journal espagnol, elle a été traduite par le poète Gómez de la Serna."[18] Although this letter also remains to be discovered, its mere existence testifies to the growing rapport between the two men.

Undoubtedly, it was about this time that the Spanish author sent Apollinaire a copy of a book he had privately printed. Entitled *Accesos del silencio: tapices por Tristán* (*Outbursts of Silence: Tapestries by Tristan*), the volume is so rare that it is listed in none of the standard bibliographies. From the title one suspects it contained a selection of essays. For our purposes, it suffices to note that the copy Apollinaire received bore the following dedication: "A Apollinaire con toda mi admiración (avec tout admiracion) Ramón Gómez de la Serna."[19] In 1916, after Apollinaire had been wounded and had returned to civilian life, Serna finally succeeded in meeting him during a sojourn in Paris. We know from his own account, moreover, that he attended the banquet in Apollinaire's honor at the Palais d'Orléans on December 31, 1916. Recalling this period in his life, he later wrote: "il y a eu un moment où je me suis senti uni à Apollinaire sans savoir qui était Apollinaire, comme à un frère ainé reconnu seulement une heure après sa mort."[20]

While Serna was never Apollinaire's disciple, properly speaking, he was certainly a fervent admirer. In 1921, for example, he devoted an

important chapter to the French author in a book entitled *El cubismo y todos los ismos*, which we will examine in a moment.[21] The year 1924 witnessed the publication of two additional works in which his admiration was likewise evident. In *La sagrada cripta de Pombo* (*The Sacred Crypt of Pombo*), he evoked Apollinaire's skill not only as a poet but as a novelist and art critic.[22] Discussing Robert Delaunay's art at one point, the author praised "Les Fenêtres" (OP, 168–69), which he called "un poema admirable," and quoted from Apollinaire's 1912 essay "Les Commencements du cubisme." The line from this "celébre artículo" that he chose to translate was the following: "Delaunay, de son côté, inventait dans le silence un art de la couleur pure." Sonia Delaunay created a simultanist necktie for the poet, he added, who was delighted to receive it and who stroked it from time to time like a goatee. Elsewhere in the same book, he linked Apollinaire to Rafael Cansinos-Asséns, whose works will be discussed shortly. In particular, he asserted, the latter's novel *Huelga de los poetas* (*The Poets' Strike*) was indebted in no small part to *Le Poète assassiné*. The second volume to appear in 1924 was a Spanish version of Apollinaire's novel, which included a preface by Serna. Reprinted from *El cubismo y todos los ismos*, it was translated into French the following year and served to introduce the posthumous collection of poetry *Il y a*.

Fortunately, this rather long preface can be summarized without difficulty. Throughout the text one notes the author's admiration for Apollinaire's achievements and his affection for the man himself, with whom he obviously sympathized. Boasting that he was the first to preface a Spanish translation of Apollinaire, Ramón displayed a detailed knowledge of the poet's life and work. Approximately two-thirds of the text was concerned with bio-bibliographical material and made no attempt to evaluate Apollinaire's writings. The remaining third, was devoted to the question of aesthetics. Contrasting Apollinaire's diction with that of Mallarmé, he stressed the importance of everyday language in his literary production. Instead of cultivating a rarefied vocabulary, he declared, "Apollinaire voulait remplir son oeuvre des phrases courantes, des épithètes usées jusqu'à paraître un peu abimés, des mots qu'emploient constamment les journalistes. C'est ensuite qu'il entreprend le jeu difficile d'harmoniser tout cet ensemble de choses concrètes et vives." Following a section celebrating Apollinaire's powers of perception, he also praised his dedication to his profession and his vast experience.

Calling Apollinaire "le théoricien humoristique" in another section, the author emphasized the poet's love of the picaresque and his inexhaustible curiosity. "Il comprenait avant tout," he added, "que l'art d'écrire est l'art de conter. Son sortilège était de faire briller la phrase et

d'obtenir . . . l'expression vitale." The source of that vitality, he continued, was Apollinaire's love of life in all its variety and incongruity. His insatiable appetite for all that life had to offer expressed itself as simultanism in his art. "Un être aussi vivant," Serna concluded simply, "on souffre de le savoir disparu." More than anything, he explained, "il a aimé le difficile et ce qu'il faut animer d'un effort personnel." The proof of this was to be found not only in Apollinaire's calligrams but in his short stories and novels. The invention of the first genre made him an important precursor in this area. His contribution to the second was to revolutionize the principles on which it rested. His achievements in the third genre were exemplified by *Le Poète assassiné*, "qui est sa meilleure nouvelle, [où] l'orgie romanesque parvient au délire, et nous jouissons de ce spectacle, comme, du haut d'un pont, de l'assaut et de la dislocation des eaux qui s'échevèlent en cascades." The key to Apollinaire's aesthetics, Serna asserted, lay in his rejection of mimetic conventions and his adoption of pictorial principles. Borrowing a phrase from *Les Peintres cubistes*, he observed: "Ce qui distingue le cubisme de la peinture ancienne, c'est qu'il n'est pas un art d'imitation, mais de conception, de création; la littérature d'Apollinaire se différenciait de l'ancienne pour les mêmes raisons."

Despite Serna's claim to have written the first preface in Spanish to a text by Apollinaire, another author had beaten him to the punch eleven years before. The honors actually go the Peruvian writer Ventura García Calderón, who wrote a brief introduction for a translation of "L'Emigrant de Landor Road" (OP, 105–6) in 1914. The poem itself was translated by an Argentine poet named Fernán Félix de Amador. Appearing in the March 10, 1914, issue of *La Actualidad* (*Current Events*)—an illustrated supplement to the Paris-based *Revista de América*—it was accompanied by a photograph of the author and a bio-bibliographical sketch. In the course of his introduction García quoted from a letter Apollinaire had sent him and added a number of personal remarks.

> Guillaume Apollinaire was born in Rome on August 26, 1880, of Italian and Slavic ancestry. He came to Paris as a child. Here he has lived, written, and loved. But "I have traveled," he writes me, "and I would like to travel some more." He founded *Le Festin d'Esope, L'Immoraliste*, and *Les Soirées de Paris* which he edits at present. The books he prefers are *L'Enchanteur pourrissant*, 1910; *Le Bestiaire ou Cortège d'Orphée*, 1911; *L'Hérésiarque et Cie*, 1910, a collection of stories that was very well received; and that extremely curious book *Alcools* (from which the following pieces are taken) which is uneven, without punctuation, and adorned with a Cubist portrait by Picasso. His poetry is discon-

certing. Juxtaposed with the deliberate vulgarities and irritating fantasies of a lyric clown, one finds a sparkling image or an admirable verse that cleaves the soul and rises bright and vibrant into the air like a tearful rocket.

Like many of his French contemporaries, García was obviously impressed by Apollinaire's poetry but had trouble reconciling his different styles. One wonders what he thought of *Calligrammes* when it appeared, with its visual effects and devotion to surprise.

Whatever reservations García may have had concerning Apollinaire's experiments, he was clearly convinced of his poetic talent. In addition, while little is known of the relations between the two men, they seem to have been fairly extensive. These impressions are confirmed by a dedication that the Peruvian author addressed to Apollinaire at about this date. Appended to a copy of Rubén Darío's selected poems in French, which were prefaced by García, it reads as follows: "À Guillaume Apollinaire, son admirateur et son ami V. García Calderón."[23] The only other documents that survive were drafted in connection with a literary inquiry conducted by García two years later. Marking the three hundredth anniversary of Cervantes' death, the latter sought to ascertain the lasting value of *Don Quixote* based on responses by various French literati. Although their opinions were eventually published in book form, they appeared as well in the Madrid newspaper *El Imparcial*, where they were translated into Spanish. Accompanied by an introductory paragraph, Apollinaire's contribution was published on February 21, 1916. Summarizing the poet's accomplishments in words that recalled his earlier remarks, García singled out two works in particular:

> Two styles characterize the work of Guillaume Apollinaire, one of the most original writers in modern-day France. Following *L'Hérésiarque et Cie*, a collection of sober tales in the classical mode, he caused a scandal with *Alcools*. Lacking any punctuation whatsoever from beginning to end, written in extremely free verse with admirable musical skill, this work signaled his "conversion" to literary cubism. Here is the ingenious inquiry he conducted himself in reply to the one we sent him.

From these brief observations, it is evident that García was well acquainted with Apollinaire's work. Not only were originality and surprise the hallmarks of his aesthetics, as befitted the leader of the French avant-garde, but they had characterized his compositions for many years. By 1916, García had finally come to terms with the "disconcerting" element in *Alcools*, which he rightly attributed to the influence of modern

painting. That he was familiar with the expression "literary cubism" is also noteworthy, since neither the term nor the concept was widely known in 1916. As García indicated, Apollinaire responded to his initial request with an "ingeniosa encuesta" of his own. Since his (rather lengthy) reply is included in the collected works, there is little point in quoting it here.[24] Writing from the front, where he was stationed with his artillery unit, Apollinaire blamed the enemy for his slight delay in responding and complimented García on the quality of his previous translations. "You translated some of my poems into Spanish perfectly," he observed and recalled that he had written about Cervantes on previous occasions.

Apollinaire's first statement is rather puzzling since only one poem appeared in *La Actualidad*: "L'Emigrant de Landor Road." To further complicate matters, the translator was not García but rather Fernán Félix de Amador. While Apollinaire may have been the victim of a faulty memory, it is possible that these translations are still waiting to be discovered. As soon as he received the Spanish questionnaire, Apollinaire continued, he conducted two investigations on his own behalf. The first, which sought to determine *Don Quixote*'s popularity among the regular and the non-commissioned officers of his battery, produced disappointing results. None of those he questioned had heard of Cervantes or his novel. On the other hand, quite a few of the men from Picardy were familiar with Dulcinea and Sancho Panza. Apollinaire's second investigation stemmed from the first. If *Don Quixote* were really as important as he claimed, his companions replied, he should have no difficulty in locating a copy somewhere before the evening meal. As a prize they offered three bottles of champagne discovered earlier. Although the nearest village was twenty-two kilometers away and in ruins, Apollinaire found a copy of the novel and won the bet. He added that he had read *Don Quixote* many times when he was growing up and that, paradoxically, it had stimulated his interest in chivalric romances. Not only was Cervantes' hero a universal figure in his opinion, but the work itself was without parallel. If anything its marvellous satirical qualities reminded him of Gogol and Molière.

The last trace we have of the link between García and Apollinaire consists of a letter from the latter dated April 14, 1916.[25] Writing from the hospital in Paris where he was convalescing, Apollinaire thanked the Peruvian author for sending him a copy of *El Imparcial* with his discussion of *Don Quixote*. "J'ai fait une amusante remarque," he reported; "c'est que 'brigadier' se traduit en espagnol par *cabo*. Or l'argot du troupier français appelle *cabot* le brigadier des troupes montées et le caporal des troupes à pied." If this letter possesses a certain philological interest, it also reminds

us of an important fact. Although García's translation appeared in *El Imparcial* in 1916, by that date Apollinaire was no longer a brigadier. This means that his response to the initial inquiry was drafted sometime between April 16, 1915, when he was first appointed to that rank, and August 25, 1915, when he was promoted to *maréchal des logis*. The delay in publication appears to have been the result of editorial problems concerning the inquiry itself. The decision to translate the replies into Spanish undoubtedly complicated the editorial process even more.

Although Apollinaire began to gain a following in Catalonia during this period, he did not become popular in the rest of Spain until the end of 1918. Despite this initial lag, his impact on the *ultraístas* was ultimately to surpass his impact on the Catalan poets. Two events conspired to bring Apollinaire to the attention of the Castilian public: the publication of *Calligrammes* on April 15, 1918, and his death on November 9, 1918. As if to underline Apollinaire's tragic fate, "L'Esprit nouveau et les poetes" appeared in the *Mercure de France* three weeks later. Struck down at the height of his career, when his fame and future seemed secure, the poet left this posthumous essay as his legacy to the avant-garde. The significance of this act was especially clear to the Castilians, who were just discovering his work. No sooner did they learn of the existence of this important document, which addressed so many of their concerns, than plans were made to translate it into Spanish. The translation itself appeared in *Cosmópolis* early in 1919.[26]

Significantly, this was the very first issue of *Cosmópolis*, which was published in Madrid by Enrique Gómez Carrillo. The latter was a Guatemalan writer who had lived in Paris for many years, where he collaborated on Rubén Darío's *Mundial Magazine*. A prolific author who loved to travel, Gómez earned his living as a columnist for several newspapers in Spain and Latin America. Between 1899 and 1920, he published no fewer than 2,667 articles in *El Liberal* in Madrid, two of which touched on Apollinaire's role in promoting Cubist aesthetics. The fact that they appeared in 1914, moreover, means that he was the first writer outside Catalonia to mention the poet in Spain. In the spring of that year, in an article devoted to Cubism, Gómez drew heavily on *Les Peintres cubistes*. Purporting to describe a recent tour of a private art collection, his account was based largely if not entirely on Apollinaire's volume. Even his discussion of individual paintings depended on the illustrations at the back of the book. Striving to define Cubism for his skeptical visitor, Gómez' fictitious guide explained at one point:

> One of our leaders has noted that since geometry is the grammar
> of the plastic arts, we are the first to be dissatisfied with Euclid's

rules, preferring to seek the fourth dimension. This fourth dimension is the dimension of immensity and of eternity, the dimension of the infinite, the dimension of the ideal if you prefer this old-fashioned term. . . . Our canon is determined not by human existence but by the universe.[27]

The "leader" in question was of course Apollinaire, who had become a well-known authority on modern art by this time. The passage itself paraphrased part III of the chapter "Sur la peinture," which sought to relate Cubism to recent developments in mathematics. Continuing in the same vein, Gómez' guide added on the following page that the new painters rejected the servile imitation of Nature. "Have you read the studies by the admirable writer Apollinaire," he asked, "who is to us what Ruskin was for the English Pre-Raphaelites and what Gustave Geffroi was for the French Impressionists?" Noting that "este teorizante sutil" ("this subtil theoretician") had divided the Cubists into four categories according to the nature of their inspiration, Gómez' informant presented Apollinaire's analysis in *Les Peintres cubistes* in great detail, quoting much of it verbatim. Shortly thereafter, in May 1914, Gómez returned to the subject of modern painting. What made it so ripe for critical exploitation, he observed, was that plastic principles were no longer paramount but were dominated by intellectual concerns. A clever critic, like Apollinaire and a few others, could write endless volumes about the new aesthetic despite its basic simplicity.[28]

The fact that Gómez Carrillo knew Apollinaire personally undoubtedly contributed to his interest in *Les Peintres cubistes* and in "L'Esprit nouveau et les poètes" in 1919. Unfortunately, nothing is known about the relations that existed between the two men. All that remains are two autographed copies of Gómez' books that he presented to Apollinaire.[29] While the translation of "L'Esprit nouveau et les poètes" that appeared in *Cosmópolis* was not signed, there is little doubt that Gómez himself was responsible. The same thing may be said of the preliminary note accompanying the translation, which revealed a certain familiarity with the poet.

One of the most curious personalities in France, Guillaume Apollinaire, recently passed away. His death has not been greatly mourned. There is simply no time to mourn those who abandon this vale of tears, unless they happen to be named Rostand. And poor Apollinaire, although loaded with talent, was rather obscure. His study of Poetry's new spirit, published below, gives an excellent idea of his intellectual preoccupations and of his artistic preferences.

If the editor of *Cosmópolis* hastened to pay homage to his former colleague, another Spanish writer reacted even more rapidly. Only a week and a half after Apollinaire's death, Enrique Díez-Canedo published a lengthy bio-bibliography of the French poet in the weekly magazine *España* (*Spain*).[30] Accompanied by Picasso's portrait of the poet swathed in bandages, it contained examples of his fiction, poetry, and art criticism. These included a translation of the short story "La Disparition d'Honoré Subrac," taken from *L'Hérésiarque et Cie*, and two poems that had appeared previously in *Calligrammes*: "La Colombe poignardée et le jet d'eau" (OP, 213) and "Le Chant d'amour" (OP, 283). While the first text was reproduced photographically to capture its visual shape, the second was reprinted in Spanish translation. Rounding out the selection, Díez included a section from *Les Peintres cubistes* in which Apollinaire addressed the role of the subject in modern art.[31] Corresponding to section II of the chapter entitled "Sur la peinture" (except for the anecdote taken from Pliny), it included the famous pronouncement: "Un Picasso étudie un objet comme un chirurgien dissèque un cadavre." The main purpose of the section, however, was to denounce realism in art and to defend artistic abstraction. In this context Apollinaire predicted the rise of a "peinture pure" which, like music, would consist of the purely aesthetic juxtaposition of abstract elements.

Díez' sympathetic obituary, which is unfortunately too long to quote entirely, was unusually well informed. Among other things the author presented Apollinaire as "a man of great learning." "Fond of rare books and shocking artistic doctrines, he expressed his curiosity and audacity in his works according to a superior lyricism. In order to increase the power of suggestion, he suppressed commas and periods in the text itself." Noting that Apollinaire had published a translation of Francisco Delicado's *La lozana andaluza*, the author mentioned his taste for erotica and for the unusual. "In Guillaume Apollinaire," he continued, "more than in any other modern French writer, one finds the desire to combine the experiences of life with contributions from all the other arts to create a total work of art." Following this splendid assessment of Apollinaire's contribution to modern literature, Díez recalled his importance as an art critic and as a supporter of modern art in general. "He defended the most advanced artistic movements with ingenuity and enthusiasm," he explained; "he theorized about, explained, extolled, and defended Cubism."

Elsewhere Díez singled out the importance of humor in Apollinaire's works, which he praised for their great originality and for their aesthetic freedom. In particular, he added, "he is not afraid to employ an erotic

image, or even an obscene one, to be deliberately incoherent, or to use incomplete allusions." Faced at the beginning of his career with traditional forms that had become exhausted, the poet invented new ones that brought poetry "a los últimos límites." Díez explicitly placed the calligrams in this last category. Rather than jokes or harmless doodlings, they represented aesthetic experiments that stretched poetry to its ultimate limits: "His plastic imagination produces visual forms that communicate to the eyes, on the one hand, what the letters say on the other." "To complete the portrait of this Protean writer, the author concluded, "one also detects a profoundly human note, a preoccupation with the present moment viewed from the perspective of eternity, when one least expects it, reading him attentively." As examples Díez cited "A la Santé" (OP, 140–45), which he compared to Oscar Wilde's *The Ballad of Reading Gaol*, and five lines in translation from "Tristesse d'une étoile" (OP, 308). As he noted, the first poem was written "when he was imprisoned, in 1911, following the theft of the *Mona Lisa* in which he was believed to be involved," which caused him great anguish. By contrast, the second poem was concerned with a different type of suffering. The verses chosen by Díez (vv. 2 and 9–12) evoke the wound Apollinaire received during the war but in a decidedly metaphysical context. "Le Chant d'amour," which accompanied Díez' article, observed a similar progression from the personal to the universal. The calligrammatic dove and fountain, however, consisted of a series of poignant memories.

Although Díez was not the only Castilian speaker familiar with Apollinaire in 1918, he was undoubtedly the most knowledgeable. A professor of art and of French, as well as an accomplished poet, he had long been a student of modern French poetry. In 1913, together with Fernando Fortún, he co-authored *La poesía francesa moderna*, an excellent anthology with an exceptional bibliography. Appearing when it did, his essay in *España* seems to have acted as a catalyst on the embryonic Ultraist movement, which was beginning to coalesce at about this time. Perhaps the clearest indication of the Ultraists' regard for this article is the fact that they reprinted it in their review *Grecia* the following year (June 30, 1919). Díez himself never became a member of the group but he occasionally participated in their activities. Thus his translation of "La Disparition d'Honoré Subrac" appeared in *Grecia* on July 20, 1919, and his translation of "Salomé" (OP, 86) on August 10, 1919. The latter was reprinted the same year in Cansinos-Asséns' *Salomé en la literatura* (Madrid: Editorial América).

In 1920, Díez published two lengthy essays on Apollinaire in *España*. Since both of these were devoted to recent articles in France by friends of

the poet, his own contributions were minimal.[32] Writing in the *Nouvelle Revue Française*, André Salmon published a series of recollections going back to Apollinaire's earliest days in Paris. In a long article in the *Mercure de France*, André Rouveyre recounted numerous anecdotes concerning the poet and reproduced several epistolary poems. André Billy added his recollections to those of the others in *Les Ecrits Nouveaux*, where he published additional letters and described the genesis of several of Apollinaire's works. While Díez did little more than summarize the contents of these articles, quoting verbatim much of the time, he contributed to the growing interest in Apollinaire's work and helped to further his popularity in Spain. In 1923, as we will see in the next chapter, he referred to Apollinaire once again in *España* in a review of Oliverio Girondo's *Veinte poemas para ser leídos en el tranvía*.

RAFAEL CANSINOS-ASSÉNS

Significantly, the remaining two references to Apollinaire in 1918 came from the two prime movers of Ultra—Rafael Cansinos-Asséns and Guillermo de Torre. The former was to become the theoretician of the movement, the latter its foremost practitioner. As Gloria Videla has shown, two events led to the birth of Ultra in 1918: Vicente Huidobro's visit to Madrid during the summer and the formation of a *tertulia literaria* ("literary circle") later in the year, centered around Cansinos and meeting at the Café Colonial.[33] Adopted by the younger poets as their mentor, Cansinos was an established literary figure, the author of many books and articles, and the editor of the review *Cervantes*. The importance of his role in the Ultraist movement may be seen by the fact that virtually every issue of *Grecia* and *Ultra* began with a contribution by him. Although Videla claims that at least one of the group, Eugenio Montes, had read Apollinaire before joining the *tertulia*, it was largely under Cansinos' guidance that the members encountered his work.[34] Early in 1919, for example, César A. Comet noted:

> Vicente Huidobro, P. Reverdy, Roger Allard, and Guillaume Apollinaire . . . represent the newest intellectual movement in France (Creationism), Cansinos-Asséns being the only Spanish writer who, thanks to his superior understanding, has been able to interpret that movement and give it a Castilian form . . . for which reason it can be said that the modern tendencies in Spanish literature (Ultraism) stem from him.[35]

For reasons that remain obscure, Cansinos himself felt obliged to use the pseudonym "Juan Las" whenever he experimented with the new poetry. While he never adopted an avant-garde style publically, he popularized and interpreted the latest Parisian experiments in a variety of publications. Surveying modern French poetry in the last issue of *Los Quijotes*, for example, he translated poems by Pierre Reverdy, Roger Allard, and Apollinaire.[36] Taking his texts either from *Calligrammes* or from their prior publication in the *Mercure de France* on July 1, 1916, Cansinos chose two war poems: "L'Adieu du cavalier" (OP, 253) and a fragment of "Chant de l'horizon en Champagne" (OP, 267). The latter totaled fourteen lines and corresponded to the section beginning "Un fantassin presque un enfant" and ending with "De la bataille violente." Whereas the first poem proclaimed the folly of war, the second portrayed earthly beauty being consumed by the general conflagration.

The following year, Cansinos mentioned Apollinaire frequently in his writings and published four more translations. Previously translated by Díez-Canedo, "Le Chant d'amour" (OP, 283) appeared in *Grecia* on March 15, 1919. Three additional poems, "Avant le cinéma" (OP, 362), "Fusée-Signal" (OP, 363), and "Océan de terre" (OP, 268) graced the March 30th issue of the same review. With the possible exception of "Océan de terre," all four were taken from back issues of *Nord-Sud*. Unlike the last two, which were devoted to the war, the first two were concerned with life in general. In contrast to the other poems, "Avant le cinéma" was positively frivolous. In March, Cansinos also translated an article on Apollinaire's death by Jean Royère, published previously in *Les Marges*.[37] Interesting as these are, Cansinos' criticism is even more noteworthy. In article after article, he praised Huidobro for introducing Spain to the French avant-garde, insisting on the crucial role of Apollinaire from whom the movement stemmed. "The new poetry," he wrote in January 1919, "not just that which is known as Creationism but in general, begins with Guillaume Apollinaire and today is associated with the names of Reverdy, Allard, Frick, Cendrars, etc.[38]

Earlier in the same article, Cansinos related Huidobro's visual experiments to the larger tradition and left little doubt that in his mind the poet was indebted to *Calligrammes*. Huidobro's later works, he proclaimed, revealed "the skills of those lyric jugglers who, like the Byzantine poets, know how to fashion a chalice or a cross with their verses. *Las Pagodas ocultas*, for example, represents a versicle in the Biblical manner and in the manner of Apollinaire." Discussing Huidobro's lengthy poem *Adan* in another place, Cansinos mentioned the Chilean poet in connection with Apollinaire once more. In his opinion the work's slim lines and unfettered

rhythms represented "an example of the fusion between science and poetry that took place in the crucibles of the great Apollinaire." Without a doubt, the French poet would have been delighted by the reference to alchemy here and to his ability to effect miraculous transmutations. Although the image served primarily as a metaphor, it may also refer to "L'Esprit nouveau et les poètes," in which Apollinaire advised poets to exploit scientific discoveries.[39]

Writing in *Cosmópolis* four months later, Cansinos examined recent Spanish poetry with special attention to Creationism. Once again he insisted on Apollinaire's seminal role in developing the new lyric, both in France and in Spain:

[The] paternity [of Creationism] must be accorded either to Huidobro or to Reverdy, unless in the last analysis we decide to credit it to Apollinaire, from whose open hand, in a profuse cloud, all these seeds have come. . . . The new lyric appears in reviews such as *Nord-Sud* and *Soi-Même*, in which Apollinaire's paternal genius incubates eggs that are destined for glory and directs the flight of lyric airplanes. In *Nord-Sud*, Apollinaire serves as high priest, and under his guidance Reverdy, . . . Huidobro, Aragon, Max Jacob, Dermée, and Tristan Tzara officiate over lesser rites. . . .

However, having developed in the bright shadow of Apollinaire's genius, Creationism signals so to speak a reaction against the master's Panic spirit. To be sure, poems such as "Fusée-Signal" serve as Creationist archetypes insofar as everything is created by the poet and imaginary things assume a lively and disturbing existence. But a Panic yearning, a fiery tornado whose versicular form derives from antiquity, more or less characterizes the multiply symbolic work of the author of *Le Poète assassiné*. The Creationists seek to be more impassive and more distant. . . . We have seen previously how this new lyric mode exhibits the same caricatural aftertaste and fondness for fantasy as the poets who are directly descended from Apollinaire's progeny.[40]

Cansinos' fondness for metaphors is revealing. If previously Apollinaire assumed the role of an alchemist in his eyes, he discerned four additional functions in the selection quoted above. The first two metaphors were concerned with birth and maturation. Apollinaire not only sowed the seeds of the new poetry but watched over the younger poets like a mother hen. The second two metaphors stressed his importance as leader of the French avant-garde. On the one hand, he was por-

trayed as an airport controler, on the other as the head of a religious order. Further proof of Cansinos' high regard for Apollinaire, whom he also described as the father of modern French poetry in the previous excerpt, is to be found in another article published the same month. More precisely, the latter consisted of a selection of modern French poetry in translation preceded by a brief preface. Interestingly, the first three translations were of poems by Apollinaire: "Avant le cinéma," "Fusée-Signal," and "Océan de terre," all of which were reprinted from *Grecia*. These were followed by translations of Paul Valéry, André Salmon, Pierre Reverdy, Louis Aragon, Blaise Cendrars, Max Jacob, and Tristan Tzara. In the preface, Cansinos described his recent investigations of modern poetry. "In numerous articles and translations," he wrote, "I have attempted to sort out the various directions in which the newest poetry is radiating, beginning with Apollinaire who recently joined the Olympians."[41] Among other things, this explains why Apollinaire's three poems occupied the place of honor.

The following month, in a preface to a group of Ultraist poems, Cansinos reiterated his belief that modern poetry stemmed from the author of *Alcools* and *Calligrammes*. "In the last issue," he reminded his readers, "we published an anthology of the most modern French poets, beginning with Guillaume Apollinaire, whose name marks the discovery of the new lyric vein."[42] That Apollinaire himself was the product of earlier schools of poetry in no way detracted from his originality. Indeed, the way in which he drew on the experiments of his predecessors helped to understand the nature of his own contribution. In November 1919, Cansinos published a study of Mallarmé's *Un Coup de dés jamais n'abolira le hasard*, which he translated into Spanish for the first time, in which he believed he could discern traces of Apollinaire.[43] In the course of discussing this work, the Spanish critic detected two lines of development leading to the latter poet. The first had to do with Apollinaire's stylistic achievements ("su poema elíptico e imaginado"), which appeared to mark him as a disciple of Mallarmé. The second concerned "the prophetic strain that Apollinaire refers to in his manifesto," which also linked him to the Symbolist master. The manifesto to which he was alluding, of course, was "L'Esprit nouveau et les poètes," which contained a passage in which the poet sought to justify one of his later themes. Tracing the invention of the airplane back to the fable of Icarus in the preceding paragraph, Apollinaire cited the latter as an example of an artistic prediction which had come true. "L'esprit nouveau exige qu'on se donne de ces tâches prophétiques," he concluded. "C'est pourquoi vous trouverez trace de prophétie dans la plupart des ouvrages conçus d'après l'esprit nouveau."[44]

A prolific author, Cansinos also mentioned Apollinaire in two books he published during the same year. One reference involved a brief comparison and was relatively minor. Discussing Ramón Gómez de la Serna in *Poetas y prosistas del novecientos* (*Nineteenth-Century Poets and Prose Writers*), he observed that the latter's *greguerías* were worthy of the most modern French poets, including Apollinaire.[45] The other reference was more important since it involved the interpretation of an important poem. In a fascinating study entitled *Salomé en la literatura*, Cansinos treated works by Flaubert, Oscar Wilde, Mallarmé, and Eugenio de Castro and concluded with Apollinaire's "Salomé" (OP, 86). This charming, enigmatic poem produced the following response:

> To complete this anthology of Salomé's literary transfigurations, here is a translation of a curious poem by Guillaume Apollinaire (Kostrowitski), the extremely original poet who, spared by the red star on his forehead, which he received in the war, died afterwards from the civilian flu. This little poem illustrates the author of *Alcools'* fantasist technique and transports the figure of Salomé to the furthest limits of the majestic, boundless plain where Mallarmé [left] her. In this poem, Salomé combines tragedy with farce, invades parody's amusing precincts, dances with the innocent air of a village lass, of the niece of a good-natured and domestic king, during a fragrant Midsummer Night extending from the village to the court. Apollinaire plays with all our memories and fantasies and creates a Salomé who is both unique and memorable, who seems to be picturesquely distorted by folklore's cleansing action like the heroines of the songs children sing in the spring. The exquisite poet Enrique Díez-Canedo has skilfully translated this lovely, absurd ballad: [the translation follows].
>
> This early poem by Apollinaire transports us from the more or less historical version of John the Baptist's decollation, from the specific night on which Salomé performed her marvelous, deadly dance—as if in an explosion of bloody ovules—to the annual celebration known as "Midsummer Night."[46]

Cansinos' succinct analysis managed to extract "Salomé"'s essence while respecting its surprising complexity. His most important contribution was to stress the role of folklore in the poem, which has received virtually no attention in the years since. As he clearly realized, the conclusion, in which the characters join hands and dance around John the Baptist's grave, is not as nonsensical as it seems. To my knowledge, he is the only

critic to have recognized that the ending represents a Midsummer Night's May-pole dance.

Cansinos' last explicit reference to the French poet occurred in February of the following year. Illustrating his remarks with examples drawn from Homer, Góngora, Mallarmé, Huidobro, Apollinaire, Reverdy, and Tzara, he devoted most of his discussion to the nature of Ultraist imagery. "These surprising images," he wrote, "which at first glance seem improbable, may be seen to be valid as soon as one decomposes them into their individual elements. For a link always exists that leads to their verification. Thus . . . when Apollinaire mentions 'A regiment of blue days' he is referring to military recruits who are dressed in blue, like so many cloudless days, and they evoke good weather since they are young."[47] Cansinos was referring to "Fusée-Signal" (OP, 363), which he had translated previously and which contained the following line: "Un régiment de jours plus bleus que les collines." As he noted, the unsuspected link between tenor and vehicle was provided by the soldiers' blue uniforms.

After this date, Apollinaire's name ceased to appear in Cansinos' writings, and he concentrated more on contemporary French and Spanish authors. Significantly the *Bulletin Dada* (1920) was shortly to list him as one of the "presidents" of Dada, together with Guillermo de Torre and Rafael Lasso de la Vega. Despite Cansinos' preoccupation with more recent literary phenomena, two events demonstrate that his interest in Apollinaire continued unabated. The first was the publication in 1921 of a satirical novel entitled *El movimiento V. P.* A thinly disguised *roman à clef*, the latter revealed Cansinos' disillusionment with some of the individuals who were associated with the Ultraist movement. As Velázquez has shown, the novel itself was modeled on *Le Poète assassiné*, whose brash tone and anti-traditionalist stance especially appealed to the Spanish author.[48] He argues convincingly that the numerous borrowings from Apollinaire do not represent examples of plagiarism but rather acts of homage dedicated to the poet's memory.

As noted, Ramón Gómez de la Serna also detected Apollinaire's influence in a second novel, published the same year (*La sagrada cripta de Pombo*, p. 447). In his opinion, the dramatic framework for *La Huelga de los poetas* (*The Strike of the Poets*) was provided by the penultimate chapter of *Le Poète assassiné*, entitled "Assassinat." In direct contrast to *El movimiento V. P.*, however, nothing in the second novel specifically evokes Apollinaire. At best, the two works share a certain cynicism concerning human conduct and a lack of respect for established authority. The second significant event was the publication in 1924 of a Spanish version of *Le Poète*

assassiné itself. Translated by Cansinos, it featured a magnificent preface by Serna which was to grace *Il y a* the following year (discussed previously).[49] Long familiar to the Ultraists, Apollinaire's wildly iconoclastic novel was finally made available to a wider public in Spain.

GUILLERMO DE TORRE

Many years later in one of several books he would devote to Apollinaire, Guillermo de Torre recalled how he first became interested in the French poet.[50] According to this account, he learned of Apollinaire and the French avant-garde through Huidobro during the late summer or early fall of 1918. Not only did the latter introduce him to the primary texts, but he presented him to Sonia and Robert Delaunay, who had many precious documents in their possession. In addition to manuscripts by the Douanier Rousseau and Blaise Cendrars, these included corrected proofs of *Alcools* and *Calligrammes.* Although Apollinaire died before Torre could meet him, he made a great impact on the young poet. Emilia de Zuleta summarizes his influence as follows: "From Apollinaire he derived his concept of poetry as a fabric of images and visions superimposed on one another and his use of surprise, the core of innovative aesthetics seen from the creator's perspective rather than the spectator's."[51] To grasp the significance of this contribution fully, we have only to compare this description with Gloria Videla's definition of Ultra. "Ultraism is characterized among other things," she concludes, "by a cult of the image, by a tendency toward playful evasion, the exclusion of the sentimental and the heroic worlds, a taste for ingenuity, a tendency to devalue art, a sense of humor."[52] Even from this brief comparison it is obvious that the two aesthetics were closely related. Since Torre left his imprint on every aspect of the movement, it is not surprising that much of the Ultraist program reflected his admiration for Apollinaire.

Torre's first mention of his future mentor was rather modest. An article published in December 1918 contained a brief but telling reference to "el altísimo Guillaume Apollinaire" ("the great Guillaume Apollinaire").[53] From the context, it is clear that Torre valued him above all the other modern French poets. Despite his relatively tender age, he exhibited a surprising familiarity with the French Symbolists and their successors. The following year Torre expanded this knowledge, translating poems by Apollinaire, Tzara, Reverdy, Cendrars, Huidobro, Dermée, Picabia, Salmon, Aragon, and Breton. In February l919 he published a short story by Apollinaire from *L'Hérésiarque et Cie* entitled "Le Guide." This was followed by translations of "Sanglots" (OP, 365) in August, "Bleuet" (OP,

366) in October, and "Vers le sud" (OP, 234) in December.[54] The first two poems were taken from a back issue of *Nord-Sud*; the third could have come from either *Nord-Sud* or *Calligrammes*. While Torre's lengthy introduction to "Le Guide" was full of admiration for Apollinaire, his remarks were largely biographical. It was not until October, in his preface to "Bleuet," that we find a critical evaluation of the French poet:

> A vibratile spirit, avid, audacious, abundant, and omni-hedric. The author of *L'Héresiarque et Cie* stands out, among the representatives of the French literary avant-garde, in highly suggestive and fascinating relief because of his status as a *fauve* and argonaut plowing immaculate lyric strata.
>
> Following his death, his literary reputation has achieved a triumphant plenitude, anointed with admiring fervor on the part of a phalanx of worthy epigones: Reverdy, Birot, Dermée, Soupault, Roch Grey—fertilized in the secretions of his auroral spirit (O, what centrifugal force this primogenitor of Lutetia's new generation was able to attain!). His libertarian psyche projected itself in Protean fashion into various novelistic and fantasist books: *Le Poète assassiné, L'Enchanteur pourrissant, Les Mamelles de Tirésias, Vitam impendere amor*, etc. His role in the latest pictorial developments is extremely interesting. He foresaw virginal chromatic dissociations and N-dimensional futurist perspectives, strolling arm in arm with the Cubist painters . . . that he extolled in his book *Méditations esthétiques*, the synthesis of his theoretical ardors. He conquered in every direction in his books of poetry *Le Bestiaire, Alcools*, and *Calligrammes*—frontline trenches represented by free verse and figurative poetry in which his aerial acrobatics find marvelous expression.

Written in a quasi-Futurist style, the text was highly enthusiastic and well-informed. Here, as elsewhere in his writings, Torre concentrated on the avant-garde aspects of Apollinaire's work. Stressing the latter's seminal role in modern letters, he focused on his iconoclasm, audacity, and revolutionary aesthetics. The last line, in which he portrayed Apollinaire as an aerial acrobat, harked back to a poem by Torre in *Cervantes* in March 1919. Entitled "Al aterrizar" ("Making a Landing") and dedicated to Robert Delaunay, it featured an epigraph from "Océan de terre" (OP, 268): "Les avions pondent des oeufs / Attention on va jeter l'ancre." Over the years, certain key words occurred again and again in Torre's criticism of Apollinaire: *primogénito, precursor, lucífero*, and *vibrátil*. Thus, discussing Blaise Cendrars in July 1919, he remarked that the latter "describes him-

self as the extremely loyal epigone of Cubism's earliest, heroic light-bearer: Guillaume Apollinaire."[55] In 1919, writing under the pseudonym "Hector," he also mentioned Apollinaire three times in passing in book reviews for *Cervantes.*

Although Torre published no further translations of Apollinaire during 1920, his interest in the French poet continued unabated. By far the most important text was his moving "Epiceyo a Apollinaire" ("Elegy for Apollinaire"), which appeared in *Grecia* on January 20th. A lengthy elegy commemorating the poet's death, it consisted of some forty-four dislocated verses. Torre claimed in later years that the (relatively conservative) typographical effects were inspired by Apollinaire's visual poetry.[56] However, the poem's source was clearly not the calligrams, whose attempts at figuration are lacking, but rather the institution of literary cubism itself. As such, "Epiceyo a Apollinaire" resembles any number of works published in *SIC* and *Nord-Sud.* Judging from Isaac del Vando-Villar's preface, the poem seems to have been composed shortly after Apollinaire's death. "On the first anniversary of Apollinaire's death," he noted, "when even the most stubborn individuals have had to acknowledge his great importance, we thought it would be interesting to publish this Elegy."[57] Evoking Apollinaire's passionate love of life, Vando-Villar joined with his Ultraist colleague in celebrating his extraordinary talent. Like Cansinos and Torre before him, he traced modern poetry back to the late poet, whom he described as the "the driving-force of the newest aesthetic tendencies, whose triumph is becoming widespread today."

Significantly, Torre's "Epiceyo a Apollinaire" took as its epigraph the same five lines from "Tristesse d'une étoile" (OP, 308) as Díez-Canedo in his article of November 21, 1918. While he preferred the original French to the latter's Spanish translation, this apparent borrowing tends to confirm the poem's earlier date. Minus the epigraph, Torre's avant-garde tribute reads as follows:

> From Paris' radiating vortex
> > the pain polarizes itself ellipsoidally.
> The yardarms of my sleepless, wandering
> > > mast vibrate beneath the spray
> > > with plectral sobs:
> A desolate murdered fear,
> > > —avionic Thanatos pours blood—
> from a lyric *fauve*, cotangentially adjacent,
> > > emerges a palpitating telegram.
> And its sad stellar halo,

 mirroring itself emotionally in the
sensorial lakes of the pugnacious bards,
produces eurythmically elegiac concentric waves.

TRAGIC	The lamp-bearer's auroral votive light,
RED	borne on a western Discobolus' wrists,
REAPER	has flickered out in the liberating blue

 U L T R A -T E L L U R I C D A W N

Opalescent fringes with Protean sensibilities
Carmine convolutions of multiple desires
O, Guillaume Kostrowitzsky Apollinaire!
Will your iconographic presence reappear now?
O, the evocative *film* of your vital stages!
Your genetic, radiating, and centrifugal life
 describes a triumphant trajectory;
 ROME—PARIS—BERRY-AU-BAC

Your magnificent intellectual	Your pyrogenic soul
arrogance.	flamed
flamed in the war's pinwheel,	in Lutetia's heroic fields,
in noble combat	transfused with the clay . . .

 Your heart became ecstatic in a high, uneven diastole
 And the bloody rose flowering on your skull
 —oh, the cruel trepanation!—
 has come to crown the floral wreath
 adorning Gaul's very heart.

 How we mourn the absence of your keen Western retina
 which penetrated like an X-ray.
 Your lucid pen drew poetic calligrams
 in plastic terms.
 The algebraic rhythm of your verb
 flowered as far as the cubic horizon
on which marvelous n-dimensional perspectives sail.
 Your intellect forged incredible structures.
 In your yearning for supra-Euclidean spaces
 you extolled pictorial delineations
 that vibrated luminously with
 hexagonal radiation.

O, prophetic sooth-sayer
and drunken futurist!
O, passionate aristocrat!

> Oh hyperborean argonaut
> who tore through the futuristic
> fog in your sailboat!

The magnetic needle
> of your cardiac compass
> > no longer points northward.
> And the cathodic juice, that exosmotically
> irradiated your riverbed, today
> > has progeny everywhere.

Who will appear in your likeness, O great soul!
> in our Iberian fields?
Did your electrolytic krater perhaps
> pour an offering of germinal pollen
> > on the epigonic estuary?

S U N Behind the heroic western deed
R I S E flows the poly-rhythmic tide
> of the Aesthetic Novidimensional Dawn.
On the Future's lyric perimeter
electric asphodels bear tearful blossoms.
And against its oblique, paroxysmic horizon
> the second lieutenant Apollinaire
> > sails away crucified
> between Icarus, Guynemer, and Ganymede.
O, bulbuls singing
> > by the Equatorial canal!
Did you happen to greet
> > the conscious, red sailboat
Manned by his augural soul
> > among the hyaline cirrus clouds?[58]

Despite his love of neologisms and his technological vocabulary, Torre followed elegiac conventions fairly closely. Not only do apostrophes and rhetorical questions abound, but the intensity of his grief is shared by Nature itself. The first few lines recall his initial shock at the news of Apollinaire's death, which he claims to have received via telegram. By contrast, the middle section evokes the poet's role as chief of

the avant-garde. Once again Torre underlines Apollinaire's importance as precursor and as iconoclast. In particular, he emphasizes Apollinaire's forceful intellect and his startling originality. Torre's tribute concludes with a comforting vision projected against the silhouette of the rising sun. While the tropical dawn is filled with the bulbuls' song, the French poet ascends to heaven crucified between Icarus, Guynemer, and Ganymede. Icarus, it may be recalled, appeared in a number of Apollinaire's writings, where he personified the creative imagination. As we saw in the previous chapter, Guynemer was an aerial ace who was killed during the war. The most beautiful of all mortals, Ganymede was carried off to Mt. Olympus to serve as Zeus' personal servant. The final scene was clearly taken from "Zone" (OP, 40), in which an airplane rises toward heaven surrounded by mythological figures associated with flying. Indeed, one of these is Icarus himself. In both poems, the notion of flight is connected to the image of the cross, whose shape resembles an airplane climbing vertically.

In general, Torre's remaining references to Apollinaire in 1920 concerned the relationship between modern poetry and modern art. One notable exception was his review of an obscure French comedy, which he judged to be "in the tradition of *Les Mamelles de Tirésias*, in which Apollinaire established a new dramatic norm."[59] For the most part, his discussions of Apollinaire focused on the question of experimental typography and on the relationship between pictorial and literary cubism. Indeed, these topics occasionally overlapped. In August, for example, in an article devoted to Creationism, Torre explored both subjects simultaneously. On the one hand, part of the article examined Pierre Reverdy's claim that his typographical effects differed from those developed by Apollinaire. On the other hand, Torre sought to analyze literary cubism according to principles presented in *Les Peintres cubistes*. In his eyes, the accomplishments in one medium applied equally well to the other. "Just as the light-bearer Apollinaire divided the tetrahedral limits of pictorial cubism into scientific, Orphic, physical, and instinctive," he declared, "so would I spatialize the various segments of literary cubism in the same manner."

Toward the end of the article, Torre returned to the question of expressive typography in order to disprove Reverdy's earlier statement. Despite the latter's claims of originality, he succeeded in identifying "a typographical spacing derived in part from Apollinaire." A few pages later, Torre turned his attention to *Les Peintres cubistes* again, where he borrowed another pictorial concept which he proceeded to apply to poetry. "The initial Creationist intuitions," he wrote, "next sought out the utopian discovery of the fourth dimension, of hyperspace, presented by

Apollinaire in 1912 in *Meditations esthétiques: les peintres cubistes*, which was the vital plane for Cubism, the imaginary 'golden section.'!" Ignoring Reverdy's and Huidobro's claims to have founded Creationism, Torre concluded his analysis by tracing the movement back to Apollinaire and to Max Jacob.[60] In an article published at about the same time, Torre described Jacob as a "a promoter and practitioner of literary cubism, with priority going to Apollinaire."[61] He apparently revised this opinion a few months later, however, for he struck Jacob's name from the list of founders. Differentiating between Creationism and the "cubismo poético estructural de Apollinaire, Cendrars y Cocteau," Torre claimed that both tendencies had been incorporated into *ultraísmo*.[62]

The following month, during a discussion of contemporary artistic practice, Torre returned to *Les Peintres cubistes*. Continuing his efforts to derive a general cubist aesthetic from the original pictorial principles, he focused on Apollinaire's definition of Cubism in 1913: "According to Apollinaire, what differentiates Cubism from traditional painting is that it is an art of conception rather than imitation, which becomes a principle of artistic creation."[63] Apollinaire's succinct appraisal was quoted verbatim from *Les Peintres cubistes*, where it served to introduce the *quatre tendances* discussed previously. Not only was it an excellent definition of Cubism, as Torre realized, but it described the entire modern movement—in literature as well as in art. Apollinaire's book on Cubism clearly played an important role in the evolution of Torre's thinking, for he returned to it on numerous occasions. Among other things, we know he preferred it to Gleizes and Metzinger's *Du cubisme*, which he thought was inferior. Reviewing an updated version of the latter in December, for example, he wrote: "*Du cubisme* appeared in 1912, almost at the same time as the famous and extremely sagacious book by the light-bearer Apollinaire: *Méditations esthétiques: les peintres cubistes*, which introduced the newest painting into every aesthetic circle."[64]

These remarks were echoed in a similar context nearly twenty-five years later, by which time Torre had gained much more experience in aesthetic matters. If anything, the intervening years had only convinced him of the correctness of his initial judgment. In his opinion, Apollinaire's analysis of Cubist painting represented a milestone in the evolution of modern aesthetics. Inexplicably, it had never received the critical attention it deserved from historians of modern art. Citing Apollinaire's definition of Cubism once again, Torre provided this mature assessment: "These words by Apollinaire . . . represent both the key to and the starting point of virtually every Cubist interpretation. In my opinion, [*Les Peintres cubistes* is] the most original book of artistic theory, the most fertile in intu-

itions and consequences, that has been written since the turn of the century. Its value is very much greater than its scarce or nonexistent distribution would suggest."[65]

Apollinaire's other major critical text, "L'Esprit nouveau et les poètes," seems to have exerted a similar influence on Torre. In 1920, the surest indication of this occurred in an article in which, significantly, he spelled out the Ultraist credo.[66] Published in October, it contained three separate references to the French poet in a variety of contexts. "The new lyric acquired a different emotional temperature beginning with Guillaume Apollinaire," he observed in one place, stressing the French origins of much of Ultra. In another place, he traced the origins of Ultraist typography back to Marinetti and Apollinaire, whose visual experiments, he explained, derived ultimately from Mallarmé. A few pages later, Torre noted two more ways in which *ultraísmo* was indebted to Apollinaire: "We participate in that prophetic light that guides the modern poet, as Apollinaire said, and—to quote him again—we feel that 'one day poets will succeed in mechanizing poetry just as the world has become increasingly mechanized.' " Both references were to passages that occur in "L'Esprit nouveau et les poètes." The first referred to the section mentioned previously by Cansinos-Asséns, beginning "L'Esprit nouveau exige qu'on se donne de ces tâches prophétiques." The second was taken from the very last paragraph, which predicted the invention of talking pictures.

During 1921, Torre referred to Apollinaire fairly often, but his remarks tended to be brief and factual. Thus, writing about Pierre Albert-Birot in March, he quoted the first line of "Poèmepréfaceprophétie" (OP, 684), in which Apollinaire called him a *pyrogène*.[67] Elsewhere in the article, he observed that Birot's play *Matoum et Tévibar* was indebted to *Les Mamelles de Tirésias* and that Apollinaire's calligrams were the source of the visual experiments in *La Joie des sept couleurs*. Similarly, reviewing a book by the Catalan poet Josep Maria Junoy (see chapter 5), he mentioned that "el precursor y lucifero Apollinaire" had praised the latter's "Guynemer" in 1918.[68] Reviewing an exhibition of paintings on May 30th, Torre reported that Apollinaire's concept of peinture pure was finally beginning to bear fruit in Spain.[69] In July, he managed to publish two poems in French periodicals. "Roues" was included in Picabia's *Le Pilhaou-Thibaou*, while "Tour" appeared in *La Vie des Lettres* (where it was dated 1920). Entitled "Torreiffel," a Spanish version of the second poem was published in *Cosmópolis* in October together with "Arco iris." Each work contained visual elements that were reminiscent of Apollinaire's calligrams. Thus in "Torreiffel" the line "ya estoy arriba" ("now I'm up

here"), which meandered across the page in an upward direction, recalled the smoking cigar in "Paysage" (OP, 170). In "Arco iris," both the title and the words "Arco Iris: Inaugural" were curved like a rainbow, a device Apollinaire had used in "Le Pont" (OP, 361) when it appeared in *SIC* in April 1917. Both poems also contained specific references to the French poet. Evoking the latter's own ode to the Eiffel Tower, which was likewise entitled "Tour" (OP, 200), Torre wrote " 'zenit y nadir': Apollinaire." In "Arco iris," which was dedicated to the artist Sonia Delaunay, he mentioned her experiments with simultanist clothing in 1912 and observed that she figured in the novel *La Femme Assise* "por el jovial Apollinaire."

Torre's most interesting contributions were reserved for the month of December, when he discussed Apollinaire in three separate articles. The first recounted a polemic that had erupted in Paris between André Billy and Robert Delaunay over the origins of "Les Fenêtres" (OP, 168-69) and was limited to factual reporting.[70] Whereas Billy claimed Apollinaire had written the poem on the spur of the moment in a café, Delaunay insisted that it had been composed in his studio, where the poet was staying with him and his wife following his break with Marie Laurencin. The second article, which was devoted to Max Jacob, contained an excellent appreciation of Apollinaire as a fellow literary cubist: "An extraordinary temperament, gifted with originality, he possesses a sense of humor to a high degree, loves lighthearted jokes, delights in imaginative leaps . . . exploits the remotest ideological dissociations, and lets himself be carried away by verbal illusions and prismatic images."[71]

The third article, which was concerned with the French literary cubists, was by far the longest.[72] Torre devoted some nine pages to Apollinaire, whom he introduced as the champion of the Cubist painters and the founder of literary cubism. To illustrate the latter style, he included translations of "Les Fenêtres" (OP, 168–69), taken from *Calligrammes*, and "69 6666 . . . 69 . . . " (OP, 544) which had appeared in *Littérature* in November 1919. A critical bio-bibliography punctuated by quotes from various French writers on Apollinaire, the article repeated a number of themes we have encountered previously. As elsewhere in his writings, Torre emphasized Apollinaire's role as a literary precursor and his influence on modern letters. A sort of Christopher Columbus whose discoveries were being explored by the next generation, the poet left his mark, he added, on the founders of *Littérature* in particular. One of the greatest merits of Torre's essay was his refusal to identify Apollinaire's accomplishments by a simplistic label. On the contrary, he insisted on the complexity of the man and the diversity of his work. Apollinaire's love of novelty and his varied inspiration led the author to compare him toward

the end to a tireless performer. In addition, Torre balanced his discussion of aesthetics with an appreciation of Apollinaire's personal qualities. He noted, for example, that friendship meant a great deal to him and that it played an important role in his life.

Although Torre's article is too long to cite entirely, for our purposes a number of sections can be eliminated. The following version preserves the gist of his remarks while suppressing much of the factual material that he included for the benefit of readers who were not familiar with the French poet.

He is the only deceased poet included in this anthology of living poets. Nevertheless, it is he who survives the most successfully since his work, his memory, and his example enjoy a powerful vitality today and an astonishing popularity. A long trail of Apollinarian influence may be seen in the works of comrades and disciples, who exalt his memory and follow his mental guidelines. In addition to his work's intrinsic merit, the figure of Apollinaire possesses a representative transcendant value, incarnates a new kind of luciferous guide who tears through the futuristic mist.... Apollinaire—a landmark, a point of departure for new literary trajectories along the cubist path. Not the only one but the earliest and the most prophetic. This explains why he has acquired great prominence in avant-garde letters as a pioneer. He was the animateur par excellence of the new aesthetic during the early days amid quarrels and contrary claims. He is the inducer of new circuits and polarizations. He is the fervent introducer of *l'esprit nouveau* in its capacity as a polyhedric, refrangible matrix. To borrow a phrase uttered by Salmon concerning Picasso, one may say that the new poetry is still subject to his benign tyranny.

Guillaume Apollinaire is a prismatic and Protean spirit, eager and probing, classical and arbitrary. Whence, paradoxically, the impossibility of defining his significnace with a unilateral adjective or an all-encompassing concept. Lyrically he conquered the most advanced trenches with his calligrammatic poems and his elliptical fantasies, without contradicting his previous verses conceived in the classical spirit.... Apollinaire valued the importance of friendship more than most men, and he spent his life surrounded by noble, fruitful comradeship....

Apollinaire possesses an incomparable poetic temperament which reveals itself both in the scholar and in the curious individual who has crossed every artistic frontier and who bravely

pursues the most improbable mental adventures. He succeeds in channeling his talents into a number of areas, reconciling the different paths taken by his mind. His achievements on the pictorial plane have received even more attention, perhaps, than those on the literary plane. Thus his role as theoretician and instigator of Cubism is relatively well known. Apollinaire contributed to the theoretical elaboration of this pictorial mode from the very beginning, constructing its aesthetic foundation and participating in the savage battles that marked its birth.

Apollinaire's lyricism has no use for solemn motivation or for ritual suggestion. On the contrary, it tends toward the external and the picturesque, indeed the prosaic, which he magnifies with his peculiar grace. His poems combine elements taken from real life, suggestive outlines, and spontaneous visions in a very curious fashion. Apollinaire had no need to isolate himself in order to find himself. On the contrary, he drew his creative inspiration basically from his coexistence with objects and with other individuals, from mutual contact and interaction. . . .

"La poésie d'Alcools évolue sur un tapis bariolé," the Belgian critic Neuhuys rightly observes. The poet combines dissimilar objects and unrelated sensations to form a picturesque hodge-podge illuminated by rare, surprising flashes. This book, in which classical poems exist side by side with cubist verse, reveals the major facets of his complex mind. Characterized by elliptical rhythm, acrobatic humor, and structural innovations, the volume announces the figurative arabesques and typographical whims of *Calligrammes*. . . . Enamoured of plastic representation, [Apollinaire] strives to draw, to trace . . . the poem in graphic outline, appealing to the most immediately sensitive organ: the eye. This operation confirms the theories presented in "L'Esprit nouveau et les poètes," which stresses the importance of visual values in the new lyric rather than auditory values. . . .

Apollinaire abandons himself entirely to momentary suggestions in a synoptic vision of the world within the simultaneous vortex. He ignores habitual, logical connections and discovers subterranean ideological associations, which depend on subtle allusions emitted by invisible antennae.

What a polyhedric, passionate, suggestive figure is Apollinaire! . . . He is an inexhaustible human spectacle. Life's jovial surface, humanity's picturesque gestures, attract his attention. . . . Far from being a pure intellectual, he prefers cordial, human feel-

ings to intellectual abstractions. . . . Nevertheless Apollinaire is not a complete or terminal figure. Rather, he represents an initiating figure just as his work is associated with rupture and renewal. He marks an aesthetic flowering but not its crystalization. He is one of the first poets who aspires to recast life's pragmatic aspects using suggestions taken from all the arts. Somewhat fragmentary, contorted, and pugnacious, he is nevertheless the first inhabitant . . . of a new aesthetic hemisphere, one that today's argonauts aspire to explore totally—provided at last with a compass and maps.[73]

This article represents Torre's definitive statement regarding Apollinaire. Thereafter references to the French poet occurred with less frequency as he began to chart the emerging Surrealist movement in France. In general, Torre's subsequent allusions to Apollinaire were briefer and less inclusive. In 1922, he mentioned him only once and then merely in passing. Reviewing Paul Neuhuys' *Poètes d'aujourd'hui*, he remarked that it covered the full gamut of modern poetry "from the great Apollinaire—whose temperament and intelligence have rarely been equaled—to the recent followers of movements such as Ultra, Dada, and Cubism."[74] In 1923, Torre published a volume of poetry entitled *Hélices* (*Propellers*), whose title testified to the modernity of his inspiration, which also contained several references to Apollinaire.[75] In addition to "Torreiffel" and "Arco iris," discussed above, Apollinaire's name was mentioned on three occasions. One mention occurred in a poem entitled "Emma," which seems little more than a *poème de circonstance*. Immersed in reading Justinian and Apollinaire, Torre is interrupted by Emma's arrival and gladly welcomes the distraction. Her suggestive presence obliterates the attractions of his library, which are undeniably great. Another mention concerned the section bearing the title "Inauguraciones." Serving as an epigraph were the same two lines from "Océan de terre" (OP, 268) that had prefaced Torre's poem "Al aterrizar" in l919: "Les avions pondent des oeufs / Attention on va jeter l'ancre."

However, the most rewarding references to Apollinaire appeared in "Diagrama mental." Apparently dating from 1921–22, it contained a list of Torre's aesthetic preferences. There, amid allusions to Marinetti, Gómez de la Serna, Erik Satie, Darius Milhaud, and others, were three lines that evoked Apollinaire. The first recalled his denunciation of aesthetic absolutes in *Les Peintres cubistes*: "Ce monstre de la beauté n'est pas éternel."[76] "No existe la belleza eternal," Torre proclaimed, since beauty was relative at best and its criteria constantly changing. The second line referred both to "Zone" (OP, 39) and to "Le Musicien de Saint-Merry"

(OP, 189), in which Apollinaire proposed that modern poetry be modeled on posters, handbills, and labels. What appealed to him was the lack of linear, discursive structures in modern advertising—the epitome of modern consciousness. Echoing this idea, Torre wrote: "A single sign—*International Company for European Express Trains*—is worth all the remote suggestions that one finds in exotic poetry." The third line, which envisaged a more informal poetry like that in "Emma," contained a now familiar reference to "L'Esprit nouveau et les poètes."[77] "Isn't circumstantial poetry the most sincere?" Torre asked. "As Apollinaire said, a poem is as free as the page of a newspaper." In calling these three principles to the reader's attention, Torre sought to stress the importance of aesthetic freedom. That they contained the key to the modern movement he knew from personal experience.

In 1924, Torre returned to "Océan de terre" (OP, 268) in an article devoted to the various types of metaphor that were to be found in modern poetry. In metagogic imagery, he explained, inanimate objects assume the properties of living beings. As proof he cited two examples from his own poetry and quoted two verses from Apollinaire's poem: "J'ai bati une maison au milieu de l'Océan / Ses fenêtres sont les fleuves qui s'écoulent de mes yeux."[78] The following year saw the publication of Torre's monumental work *Literaturas europeas de vanguardia*, in which he traced the history of the avant-garde from one end of Europe to the other.[79] Much, if not most, of the material consisted of previous articles, which were skilfully integrated into the volume. His discussion of modern imagery in 1924, for instance, was reprinted verbatim together with the example of metagogic metaphor taken from "Océan de terre" (p. 318).

Although Apollinaire was the subject of an entire section (pp. 134–42), the source of the latter was Torre's *Cosmópolis* article, published in December 1921. He simply appended two pages to bring his remarks up to date. Noting that Apollinaire's influence had been "muy perceptible" during the past five years, he complained that the poet's former friends in Paris were falsifying his memory. Not only had they begun to misrepresent Apollinaire's accomplishments, but they dared to dismiss his more experimental work. "The protean Apollinaire," Torre declared, "was in reality *le flâneur des deux rives*. His mental agility allowed him to leap from one to the other elegantly and effortlessly. Cubism and classicism: the stringing together of refined tradition and carefully balanced modernity." Quoting Apollinaire's defense of classical inspiration in "L'Esprit nouveau et les poètes," he concluded: "he made fertile contributions to both *l'esprit nouveau* and to traditional aesthetics."

As if to echo these sentiments, Torre cited a number of Apollinaire's accomplishments during the course of his general study. Interestingly, since most of the references reflected his own interests, they tended to be drawn from the more experimental work. Despite Torre's praise of Apollinaire's classical spirit, there was not a single reference to *Alcools*. The vast majority of the allusions were directly or indirectly related to Cubism. The text that received the most attention was *Les Peintres cubistes*, followed by *Calligrammes* and, unexpectedly, *Les Mamelles de Tirésias*. During a discussion of aesthetic relativity, Torre quoted from the introduction to the first book: "Ce monstre de la beauté n'est pas éternel" (p. 18). Similarly, recalling the dispute over the paternity of Creationism, he traced the movement back to the passage in *Les Peintres cubistes* in which Apollinaire called for an art of conception as opposed to an art of imitation (p. 87).[80] Noting the symbiotic relationship between the Cubist painters and poets in another place, he cited Apollinaire as the perfect example. Not only was the poet an intimate friend of many of the artists, Torre explained, but he defended the movement in numerous articles and prefaces. "Wielded by Guillaume Apollinaire, who became the Cubist painters' most enthusiastic standard-bearer, dedicating the first book *Méditations esthétiques* to their cause," the term "Cubism" revolutionized the world (pp. 126–27).

At several points, Torre's discussion of Cubist theory expanded to include Apollinaire's experiments with surrealism in *Les Mamelles de Tirésias*. Defining the latter in one chapter as "un hiperrealismo ideal," he related it to the concept of literary cubism from which it seemed to have sprung (p. 105). Elsewhere, insisting on the label's Apollinarian origin, he was more explicit:

> In effect . . . it dates from 1917, when Apollinaire chose to describe his play *Les Mamelles de Tirésias* as *surréaliste*. . . . By surrealism he undoubtedly meant the total predominance of fantasy, of the principles governing imagination . . . which are capable of totally replacing real life; yet another affirmation of art's transmutative power which freely shapes our experience of reality. However, this flamboyantly costumed surrealism, whose body itself was ossified, wasn't it simply an individual instance of Apollinaire's theories concerning artistic "creation" or "invention," formulated as early as 1912 in the preliminary *Méditations esthétiques* of his *Peintres cubistes*? . . . This decanted surrealism embodied no new concepts: it was a continuation of the creative or creationist tendencies informing all the genuine art of our time. (pp. 228–29).

In addition to Cubist painting, Apollinaire's name was linked to two other avant-garde areas in particular. First, it was cited in connection with experiments by his French disciples toward the end of the First World War. Calling attention to Apollinaire's vital role in the creation of *Nord-Sud* (p. 92) and *SIC*, Torre focused on his relationship with the editors of both these reviews. For the most part, Torre's remarks concerning Pierre Albert-Birot were taken from his March 1921 article. Quoting the first line of "Poèmepréfaceprophétie," in which Apollinaire described Birot as a "pyrogène," he discerned several important influences. Not only was Birot's play *Matoum et Tévibar* indebted to *Les Mamelles de Tirésias*, he declared, but the visual experiments in *La Joie des sept couleurs* were clearly derived from the calligrams (pp. 174–77). Second, a number of references to Apollinaire sought to define his relation to Italian Futurism. At one point, Torre reviewed the charges of plagiarism that followed Marinetti's "invention" of *tactilismo* in the early 1920s (p. 255). Not only had Apollinaire predicted the invention of "l'art tactile" in 1917, as his defenders maintained, but he announced the creation of the first tactile art object, by Edith Clifford Williams, the following year.[81]

Elsewhere in the volume Torre focused on the calligrams, whose visual outline, he explained, depicted one of the poem's verbal images (p. 244). Signaling Apollinaire's debt to Marinetti in *L'Antitradition futuriste*, he insisted that their experiments with visual poetry were equally valid. Not only were they perfectly comprehensible, but they represented important aesthetic achievements. "Apollinaire in *Calligrammes* and Marinetti, with his exaggerated *parole in libertà*," he concluded in another place, "have brought every possibility of the new typography to its highest level of development" (p. 330). As Torre had noted previously, Apollinaire was the spokesman not just for a few experimental groups but for the entire avant-garde. What united the different factions, despite their obvious differences, was their search for a new aesthetic language. As much as anything, he declared, this fact was responsible for the convergence of Italian Futurism and Dada (p. 257). It also explained why each issue of *Proverbe*, published by Paul Eluard, carried the following inscription from "La Victoire" (OP, 310):

> O bouches l'homme est à la recherche d'un nouveau langage
> Auquel le grammairien d'aucune langue n'aura rien à dire.

Although Torre continued to cite Apollinaire in articles published abroad (see chapter 7), henceforth he ceased to refer to him in Spain. In 1929, one brief mention appeared in an article devoted to the artist Rafael Barradas, who had recently died. Published in *La Gaceta Literaria*, Torre's

homage to his old friend opened with an epigraph from Apollinaire's poem "Toujours" (OP, 237): "Perdre / Mais perdre vraiment / Pour laisser place à la trouvaille."[82] By this date Torre had settled in Argentina, where he married Norah Borges, and had begun to carve out a new life for himself. For unknown reasons, his enthusiasm for Apollinaire abated until the Second World War, when two events signaled his renewed interest in the poet. The first was the publication of *La aventura y el orden* in 1943, whose title and epigraph were both taken from "La Jolie Rousse" (OP, 313). A collection of essays on avant-garde writers from Whitman to Supervielle, the volume was structured around the dialogue between order and adventure made famous by Apollinaire. The second event was the publication of *Guillaume Apollinaire: estudio preliminar y paginas escogidas* (*Guillaume Apollinaire: A Preliminary Study and Selections*) three years later. Retitled *Apollinaire y las teorías del cubismo* (*Apollinaire and Cubist Theory*) in 1967, when Torre published an expanded edition, it was marked by the same enthusiasm, admiration, and affection for the French poet that had characterized his earlier studies. "Despite his premature death, which left his work unfinished," Torre wrote, "Apollinaire personifies the courageous invader of new territories which others would explore in more detail, perhaps with greater rigor, but not with as much fervor."[83]

OTHER ULTRAIST AUTHORS

The third "president" of Dada, Rafael Lasso de la Vega, wrote much of his poetry in French and seems to have known Apollinaire in Paris. Among the various traces of his presence in the French capital, one finds a poem dating from 1917 which is dedicated "à Guillaume Apollinaire."[84] Entitled "Rose des vents," it contains a kaleidoscopic description of a large ship preparing to depart. Conceived as a *poème simultané*, it juxtaposes bits of conversation, thoughts, and concrete details to form a cubist portrait. While one is tempted to connect the compass rose of the title with earlier examples in Apollinaire, for example "Clair de lune" (OP, 137), the image seems to have been in general poetic circulation. Thus Philippe Soupault published a poem with the same title in *Nord-Sud* in April 1918 and used it two years later for a book of poetry. From the point of view of influence, the poem immediately preceding Lasso's "Rose des vents," which presumably dates from the same period, is much more promising. Entitled "Alas" ("Wings"), it contains a section in which the author evokes nine different species of birds—apparently inspired by a famous passage in "Zone" (OP, 40–41). Lasso specifically mentions the following birds:

eagle, dove, kingfisher, kite, crow, falcon, owl, phoenix, and swan. A quick comparison reveals that no fewer than six of these occur in Apollinaire's poem. The presence of the phoenix is rather curious, for it is the only imaginary bird on Lasso's list. In the introductory section, the poet explains: "Here are the symbolic birds / of all ages—/ stages in the passage / between heaven and earth." Thus their historical symbolism closely approximates that of the birds in "Zone," which symbolize poetic imagination throughout the ages (whence the presence of a phoenix and other mythological creatures). In both poems, moreover, the birds are arranged in a vertical hierarchy. Not only do they participate in an ascent from earth to heaven, but they serve as celestial mediators between man and God.

Although Lasso's translations tended to concentrate on French Dada, which he adored, they also included two works by Apollinaire. Predictably, these were some of his most extreme compositions: *Iéximal Jélimite* and "69 666 . . . 69 . . . " (OP, 594). The latter, which Guillermo de Torre also translated, is an exercise in erotic numerology.[85] The former is an incomprehensible playlet by Croniamantal in *Le Poète assassiné*.[86] Lasso clearly admired the scandalousness of the one and the absurdity of the other. It should be added that the text of the playlet was included in a lengthy article entitled "La 'seccion de oro.' "[87] Devoted to the problem of Creationism versus Cubism, the latter contained some dozen references to Apollinaire. The author began by discussing the concept of the golden section as it was elaborated during the early years of Cubism. "Guillaume Apollinaire introduced this beautiful, jewel-like expression in 1912," he explained. "In his *Méditations esthétiques*, he gave this name to the magic plane on which Cubism aspired to unfold." Unfortunately, Lasso's spirited account contained three serious errors. First, the term "section d'or" was introduced by Jacques Villon rather than by Apollinaire. Second, the expression occurs nowhere in *Les Peintres cubistes*. Third, the concept itself, which was borrowed from classical antiquity, had nothing to do with a magic plane. Apollinaire's reputation as Cubism's patron saint was apparently so firmly established that Lasso assumed he was the source of the term. In addition, he seems to have confused the golden section with another concept discussed at some length in *Les Peintres cubistes*: the fourth dimension.

Following an extensive bibliography of Apollinaire's works, Lasso proceeded to trace the development of literary cubism in France. This time his remarks were right on target. "And finally we come to Max Jacob and Guillaume Apollinaire," he observed, "who have so many affinities with Rimbaud, whose theoretical writings reflect Cubist doctrine.

Aesthetically they combine painting and poetry so as to produce a moment of absolute interpenetration" (p. 645). The thrust of Lasso's argument, however, was that Cubist theory was obsolete. Literary cubism had been supplanted by *creacionismo*, its putative offspring, because the latter more closely met the needs of the present generation.

While the transition from Cubism to Creationism was ostensibly the subject of Lasso's article, the author digressed at virtually every point. "Didn't Apollinaire say," he asked in one place,"—alluding among other things to the reinvention of the calligram—that modern art was the same thing as classical art?"(p. 651). This appears to be a paraphrase of the introduction to "L'Esprit nouveau et les poètes," in which Apollinaire attributed a list of classical properties to the modern movement. Elsewhere Lasso devoted a paragraph to *Le Poète assassiné*, which he greatly admired. In addition to providing an extensive plot summary, he confided that the novel was actually a *roman à clef*: "Faced with the grotesque panorama of those who claimed to follow in his footsteps, Apollinaire translated his humorous thoughts into words. Thus he created the fantastic and absurd character Croniamantal . . . , whose picaresque exploits he describes. The reader must change all the names in the story in order to give the words their true meaning" (pp. 646–67). Returning to *Le Poète assassiné* toward the end of the article, Lasso rhapsodized over Croniamantal's incomprehensible playlet and made some astute observations about Apollinaire's relation to Dada:

> O Croniamantal! How well I remember your *Iéximal Jélimite*! Long live Dada! We have broken loose from our moorings and have finally gotten underway. . . .
>
> Oh, if all of this could only come true in reality! To be sure Apollinaire is amusing himself, but he applauds his hero's actions.
>
> Apollinaire's disturbing, nihilistic attitude is identical to the Dadaists' posture. Like the statue in *Le Poète assassiné* which is made not of bronze or of marble but of nothing, i.e., out of empty space, Dada is nothing. (pp. 665–66).

Here and elsewhere it is evident that Apollinaire's iconoclastic novel had a considerable effect on the Spanish avant-garde.

Rounding out the list of Spanish translations were two contributions by José de Ciria y Escalante—both from *Calligrammes*. The first, which appeared in March 1921, was a sensitive rendition of one of Apollinaire's war poems: "Mutation" (OP, 229). A poignant record of the poet's experience at the front, it consisted of a series of rapid vignettes linked by the

refrain "Eh! Oh! Ha!" The second, a translation of "Liens" (OP, 167), was published approximately one month later.[88] The liminary poem in *Calligrammes*, the latter stressed the continuity of human experience and the common links uniting humanity. The same issue also carried a poem by Ciria himself entitled "Arena" ("Sand"), which was strongly reminiscent of Apollinaire. The first thing that strikes the present reader is how similar its physical appearance is to that of "Mutation." Not only do long and short lines alternate in both poems, but the latter are centered directly under the former. In each case, the short lines are limited to a few syllables, are normally identical, and serve as a refrain:

> Waves
> Pillows for dreaming girls
> Waves
> Glancing beds
> destined for the
> sleepless mariners
> Waves
> Backbone of the flowering horizons
> The sun
> splits open on the beach
> like a ripe fruit.

Apart from its physical appearance, "Arena" was indebted to Apollinaire in other ways as well. The very last section, for example, was derived from "Les Fenêtres" (OP, 169) which featured a similar conjunction of fruit, light, and opening. "La fenêtre s'ouvre comme une orange," Apollinaire wrote, "Le beau fruit de la lumière." In both works, the image of a spherical, radiant fruit provided a striking ending to the poem. Although the Spanish metaphor was less complex than its French model, both were brilliant solutions to the problem of poetic closure. Unfortunately, the story of José de Ciria y Escalante has a tragic ending. Only seventeen at the time this poem was written, he died three years later before he could realize his full potential.

While Ciria's debt to Apollinaire is self-evident, in a number of cases the situation is more ambiguous. Often it is impossible to tell whether a given characteristic derives directly from the French poet or indirectly via one of his disciples. Or again, it may be taken from the broader tradition to which Apollinaire belonged and/or from one of his contemporaries. Humberto Rivas' poem "Ki-Ki-Ri-Ki" ("Cock-a-doodle-do") illustrates the latter situation.[89] The director of *Ultra*, Rivas evoked the splendors of

dawn in a cascade of opulent metaphors. Midway through the poem, which begins and ends with a crowing cock, one encounters the following lines:

> A new Orient
> puts on a golden turban
> and night falls decapitated
> by the dawn's guillotine.

This immediately conjurs up the last line of "Zone": "Soleil cou coupé" (OP, 44), which likewise describes a sunrise. If on one level Rivas' sun is the golden turban of an Arab executioner, on another it is the headless body of the victim. The operative word here is "decapitated." In Rivas'poem, as in Apollinaire's, the sun is compared to the bloody stump of a neck (seen in cross-section). In the former, we glimpse the executioner in action; in the latter, his presence is implicit. In both works, the decapitation metaphor refers to certain atmospheric effects. Given these astonishing parallels, one is sorely tempted to cite "Zone" as the source of the Spanish passage. Nevertheless, the image of the bleeding sun was widespread in Symbolist literature, and Rivas could have borrowed the metaphor from a number of different authors.

Gerardo Diego's poem "Cronos" ("Chronos") exemplifies the first situation, in which a specific Apollinaire invention was cultivated by his disciples.[90] The poet introduces a spatial element at the end to create a striking conclusion:

> And all the leaves
> of
> my
> heart
> are
> falling
> one
> by
> one.

This (broken) line, which is actually an alexandrine, is fragmented and strewn across the page to give the effect of leaves blowing in the wind. Thus the falling motion of the words reinforces the falling emotion of the speaker. The poem ends when the first leaf touches the ground. Now this relatively conservative typographical device occurs several places in Apollinaire, the most notable being "Automne malade" (OP, 146). As in "Cronos," the poem ends with the visual/verbal image of falling leaves: "Les feuilles / Qu'on foule / Un train / Qui roule / La vie s'écoule." Once

again, the final line is an alexandrine. In both works the season is autumn, and the falling leaves symbolize the relentless passage of time. While there is an excellent chance that Diego's conclusion was modeled on Apollinaire's, the situation is rather complicated.

For one thing, falling autumn leaves were a common Symbolist theme. For another, this typographical device was also employed by the *SIC* and *Nord-Sud* poets in the years leading up to 1920. One of the best examples occurs in Huidobro's "Tour Eiffel" (1917), which contains this fragmented line:

Do
　　ré
　　　　mi
　　　　　　fa
　　　　　　　　sol
　　　　　　　　　　la
　　　　　　　　　　　si
　　　　　　　　　　　　do[91]

As in "Cronos," the words descend diagonally across the page, forming a sort of visual decrescendo. Essentially a pun on the word *échelle*, the line reproduces the poet's song / musical "scale" while serving as a "ladder" to the top of the Eiffel Tower. The poem was published in booklet form the following year in Madrid. We know in addition that Diego was greatly influenced by Huidobro, who enlisted him in his Creationist movement.

While the origin of this line is thus uncertain, Diego was certainly familiar with Apollinaire, whom Huidobro also admired. Traveling in Ultraist circles, he could scarcely have avoided hearing about him. Indeed, Diego admitted to Jorge Luis Borges that he became acquainted with Apollinaire's work through a number of Spanish translations.[92] A passing reference to Apollinaire in June 1919 reveals that by that date he had familiarized himself with the latter's poetry, prose, and criticism. Describing the literary scene in Santander, he said the poet José del Río reminded him somewhat of Apollinaire's portrait by Picasso.[93] This means that he had read Enrique Díez-Canedo's magnificent article on the poet, published in *España* in November 1918, which included a wide spectrum of translations as well as the Picasso portrait.

This article seems to have made quite an impression on him, for over the years he referred to it on several occasions. Writing about *creacionismo* in October, for example, Diego admonished his readers to remember "Apollinaire's profound dictum: 'Cubism is to traditional painting what Music is to Literature.' This sentence justifies the entire Cubist

endeavor."[94] The quotation itself was taken from Díez-Canedo's translation of a passage from *Les Peintres cubistes* in which the author discussed the concept of *peinture pure*.[95] Diego was concerned above all with the process of abstraction which he saw as central to both Cubist painting and modern poetry. Realistic poetry, like realistic art, was a thing of the past. The following year he returned to the problem of tradition and innovation and proposed a new solution.

> Traditional art is not dead; it will continue evolving. The attempts to create a new, originary art on another plane (Cubism, Creationism, etc.) do not hinder its development precisely because they exist on another plane. Furthermore, the same artist can produce modern art and traditional art simultaneously (cf. Picasso) whenever he feels like it. It has always been possible to write verse and prose, to speak in person and over the telephone, and to drink and smoke at the same time (as Apollinaire pointed out).[96]

Interestingly, the entire passage is a close paraphrase of the last paragraph of the Díez-Canedo translation of *Les Peintres cubistes*. Arguing that abstract painting will not cause traditional art to disappear, Apollinaire observes that music has not replaced literature, "pas plus que l'âcreté du tabac n'a remplacé la saveur des aliments." Like Guillermo de Torre, Diego clearly valued Apollinaire's analysis of the conflict between order and adventure in the arts.

In 1924, embroiled in a controversy with Eugeni d'Ors over the function of poetry, Diego interpreted the same passage in a different context. In a previous article, which sought to connect modern poetry with Góngora and the baroque, d'Ors had concluded that poetry exists to nourish our souls. In an energetic attempt to refute both these propositions, Diego replied that the purpose of poetry was certainly not nourishment and that in any case he was opposed to the idea of "meaning" in poetry. "Another lay priest, Father Apollinaire," he remarked, "used to say that Cubism is to historical painting what smoking is to drinking. But smoking possesses no nutritive value. It simply reproduces the gesture of sipping, which causes the smoke to tickle the pharynx before being gracefully exhaled. This model describes our poetry, the poetry being written today, perfectly."[97] Although this metaphorical argument would probably have astonished Apollinaire, it remains a lucid, cogent statement of the aims of modern art. Rejecting the concept of a poetic "message," Diego insisted on the experiential nature of poetic creation. While critics have noted occasional echos of Apollinaire in his own poetry, the latter's greatest influence seems to have been in the realm of theory.[98]

While we are on the subject of Gerardo Diego, this is a good place to discuss his associate Juan Larrea. Although Larrea is commonly acknowledged to be the father of Spanish Surrealism, like his close friend and fellow poet he began life as a member of the Ultraist camp. To be sure, both men distanced themselves from the latter school to some extent and adopted a rival epithet: *creacionista*. As the direct descendents of Reverdy and Huidobro in Paris, they claimed to write a more authentic brand of poetry than the Ultraists, who had allowed the tradition to become contaminated. In point of fact, their compositions were indistinguishable from those of their supposed rivals. Not only did they fraternize with the Ultraists on a regular basis, moreover, but they collaborated on virtually all their journals.

While Larrea rarely referred to Apollinaire in print, there is little doubt that he was familiar with his writings. First of all, as Robert Gurney remarks, "Rimbaud, Apollinaire, Tzara, Reverdy and others, including Breton, must have prepared him to break with the old rhetoric and to develop a new language."[99] Secondly, we know that by 1926, when Larrea settled in Paris, his library included both *Alcools* and *Calligrammes*.[100] Indeed, evidence exists that he encountered Apollinaire's work many years before he left Madrid. In 1973, for example, Larrea told one interviewer that he discussed the poet with Huidobro in Madrid in 1921. Following the latter's lecture at the Ateneo in December, the two men talked about recent poetry including "the new French poets and . . . those whom I already knew such as Apollinaire and Mallarmé."[101] As this testimony demonstrates, Larrea was already familiar with Apollinaire's writings. Like Diego and the rest of the Ultraists, he undoubtedly became acquainted with the poet's work in 1918 or 1919.

While it is tempting to trace Larrea's experiments with visual poetry back to *Calligrammes*, such influence, as Gurney observes, was at best both minimal and indirect.[102] The same critic suggests another line of inquiry that is more promising. Although the pattern of influence is complex, it can be documented in more detail. In addition, it concerns one of Apollinaire's major themes—-man's divinity—as it is expressed in two important motifs. In particular, Gurney believes Larrea appropriated the myth of Icarus as it appears in Apollinaire, through the intermediary of Huidobro, who also cultivated the myth. The crucial role of this motif in Apollinaire's work has been noted previously in connection with "Zone" (OP, 40–41) and "L'Esprit nouveau et les poètes." Symbolizing man's creative imagination, the figure of Icarus occurs throughout Larrea's poetry as well. In addition, Gurney thinks Larrea borrowed a second prominent image from Apollinaire: the airplane as a symbol of Christ. As before, he argues that the path of transmission passed through Huidobro, who uses

the image in several works. Interestingly, both motifs occur in a poem by Larrea entitled "Cosmopolitano" which dates from November 1919. The fact that they are linked together increases the likelihood that they were borrowed from Apollinaire, who was the first to combine them. Whether Larrea acquired these motifs from Huidobro or from the French poet himself, however, is difficult to say. Since we know he admired Apollinaire's work, there is no need to posit the existence of an intermediary. The fact that Huidobro cultivated the same motifs can be attributed simply to multiple influence. Whatever the explanation, the conjunction of Icarus and Christ the Aviator in "Cosmopolitano" appears to be yet another of Apollinaire's legacies.

THE ULTRAIST MOVEMENT

Of the remaining two dozen references to Apollinaire between 1919 and 1921, some are significant and some are not. Those in the former category include a lengthy review of *La Femme assise* that appeared in *España* in 1920.[103] Authored by the Mexican writer Alfonso Reyes, who was residing in Madrid, this document will be discussed in chapter 8. Those in the latter category are helpful primarily in recreating the aesthetic climate of the period. For the most part, they consist of brief notes by peripheral figures or anonymous authors. In 1919, for example, Leonardo Marini recalled Apollinaire's admiration for the composer Alberto Savinio and his brother Giorgio de Chirico, whom he termed "the most extraordinary painter of the new generation." Similarly, an article appeared the same year in which Vincent O'Sullivan (see chapter 2) assured his readers that Apollinaire's *esprit nouveau* was alive and well in the United States. Writing in *España*, Mauricio Bacarisse also claimed at one point that the Creationists' fascination with visual effects derived from Apollinaire. Although these statements were perfectly correct, they tended to be rather isolated. Rather than definitive evaluations, they were simply comments made in passing.[104]

The same thing may be said of a number of references to Apollinaire by French authors, whose comments were either reported by the Spanish press or were translated verbatim. These included such bits of information as the fact that *Les Marges* had recently published some unknown letters by the author of *Alcools*. Elsewhere, in a study devoted to Jean Cocteau, Paul Morand noted that Apollinaire had been an important influence on the young poet. An anonymous review of Jules Romains' *La Littérature française contemporaine* was only slightly more informative. Exaggerating the role of Unanimism, the writer divided modern French

poetry between the latter school and the followers of Apollinaire. In this, to be sure, he was following Romains himself, who was the founder of Unanimism. Both schools, the author reported, sought to interpret contemporary reality. Apollinaire's disciples focused on "the absolute subconscious, using the same criteria as the Cubist painters, in order to reconstruct the physical world from its fragments."[105]

The remaining references to Apollinaire tend to fall into three groups, each of which is concerned with a specific Ultraist incident or theme. The earliest collection focused on the first literary *soirée* to be organized under the Ultraist banner. Modeled on similar gatherings by the Dadaists and the Italian Futurists, it was held at the Ateneo in Seville on May 2, 1919. Fortunately for literary historians, Adriano del Valle published a detailed account of the proceedings one week later.[106] Thanks to him, we know that the program began with Pedro Luis de Gálvez' "Cuartillas," discussed earlier, whose author supported his call for artistic freedom with an excerpt from "L'Esprit nouveau et les poètes." Following his impassioned plea, Valle reported, "the young and admirable poet Pedro Garfias . . . recited in masterful fashion a beautiful poem by the precursor of Ultra, Guillaume Apollinaire."

That Valle considered Apollinaire a precursor of Ultra, indeed *the* precursor, is as significant as the event he was relating. For one thing, the fact that his article appeared in the Ultraist review *Grecia* gave it the character of an official pronouncement. For another, it marked an important step in the evolution of Valle's own ideas. One month previously, he had noted Apollinaire's contributions to the modern movement in general. "Guillaume Apollinaire," he declared, "whose initiation into the new lyric rites is well known from his translations of Aretino and from his poems, can be said to have been the founder of the modern school together with Klingsor, Frick, Pierre Reverdy . . . Blaise Cendrars, Max Jacob, Louis Chadourne, Roger Allard, Louis de Gonzaga, and the Chilean Vicente Huidobro."[107] Unfortunately, although Valle's assessment of Apollinaire was correct, his list of co-founders betrayed his lack of expertise. By the date of the first *velada* ("literary evening"), however, he had revised his earlier opinion. Dismissing the bulk of the individuals mentioned above, he focused his attention on the leader of the French avant-garde whose poetry was gaining more and more converts among the Ultraists.

While it would be interesting to know which of Apollinaire's works Pedro Garfias chose to read, none of the original participants mentions the poem by name. Garfias' own account of the gathering simply refers to a "poema de G. Apollinaire."[108] However, the fact that he chose a poem by Apollinaire in the first place is significant in itself. Despite the lack of sup-

porting documents he clearly admired the French poet and thought his work was important. At times Garfias' own poetry seems to owe something to Apollinaire, although the connection is never made explicit. In particular, some of his verses have a distinctly Apollinarian ring to them, for example, "Mi corazón es un pez rojo entre las mallas" ("My heart is a red fish enmeshed in a net").[109] Inevitably, the reader who is familiar with Apollinaire is reminded of an image in "Fusée-Signal" (OP, 363). Juxtaposed with kaleidoscopic references to the war, it contrasts strangely with its surroundings: "Ta langue / Le poisson rouge dans le bocal / De ta voix." We also know Garfias was familiar with "L'Esprit nouveau et les poètes" from a remark he made two months earlier. Praising a poem by Luis Mosquera in the previous issue of *Grecia*, he asked at one point: "Like Apollinaire I can only say, 'Isn't this something new? Don't tell me it isn't!'"[110] Garfias was referring to the section where the poet refuted the notion that nothing was new under the sun. Citing X-rays, airplanes, and the discovery of new planets, Apollinaire called for comparable poetic inventions based on the aesthetics of surprise.[111]

Although individual references to Apollinaire during the gathering in Seville are important, the attitude of the group in general is equally interesting. This was a public celebration, after all, whose purpose was to publicize Ultra and to define its goals. The fact that Apollinaire occupied a prominent position in the proceedings speaks for itself. As the author of the very first poem to be read at the very first *velada*, he assumed a Promethean role in the development of the movement.[112] Something of the excitement that accompanied the initial Ultraist phase was conveyed by Norah Borges de Torre many years later. In the midst of a European tour, the entire Borges family spent the winter of 1919 in Seville, where they became involved with Ultra, before moving to Madrid in the spring of 1920. "Isaac del Vando [-Villar] and Adriano del Valle came to visit us at the Hotel Cecil every night," she recalled, "and to recite their poems. . . . And I remember that we liked Guillermo [de Torre]'s 'Epiceyo a Apollinaire' very much. I was also fond of the poem about John the Baptist, so much that I embroidered a large tapistry inspired by Apollinaire's poem."[113] It is worth recalling that the poem by Guillermo de Torre, whom she was later to marry, was published in *Grecia* on January 20, 1920. The source of the tapistry was, of course, Apollinaire's "Salomé" (OP, 86), which evidently made quite an impression on the Ultraists. As noted previously, a translation by Enrique Díez-Canedo appeared both in *Grecia* (August 10, 1919) and in Cansinos-Assens' *Salomé en la literatura*, published the same year.

Like his sister, Jorge Luis Borges also played an active role in the Ultraist endeavor. A budding poet, he contributed to all the reviews and helped to define the movement's goals. Returning to Argentina in 1921, he introduced Ultra to his native land where it flourished for many years. For this reason discussion of his relation to Apollinaire must be postponed until the next chapter, which is concerned with Argentina and Uruguay. However, a rapid survey of Borges' writings provides valuable information about the origins of Ultra in Spain. In particular, it confirms our impression that Apollinaire exerted extensive influence on the movement. Like his avant-garde colleagues, Borges was intimately acquainted with the French poet's works. Writing in 1925, he recalled Ultraism's early days and the widespread enthusiasm associated with two individuals in particular. "Beneath the lamps' dazzling brightness," he declared, "there were frequent references to Huidobro and Apollinaire in Spanish literary circles."[114] In Borges' eyes, the Ultraist movement was directly inspired by events transpiring in France and thus looked to Paris for aesthetic guidance. As late as 1964, in an interview with Napoléon Murat, he proclaimed: "L'Ultraïsme était un reflet . . . de ce qui se faisait à Paris à cette époque-là, un reflet assez tardif d'Apollinaire par exemple, en même temps des poètes un peu oubliés en France."[115] Nor was this view limited to Borges alone. In 1920, when he first met Guillermo de Torre, the latter expressed the opinion that Spanish literature was hopelessly outmoded. The best solution was to imitate what the French writers were doing, he added, "surtout Apollinaire."[116] This seems to have been one of the few principles the Ultraists agreed upon. The only other person with whom Borges admits discussing Apollinaire was Gerardo Diego. Who declared he had read the poet primarily in Spanish translation.

Although Apollinaire appears to have been the subject of numerous conversations between the Ultraists, virtually no record exists of these discussions. In 1967, however, Borges revealed two valuable pieces of information during another interview. The first, which concerned his personal development, was that he had read Apollinaire very carefully at one time. The second focused on the French poet's reputation among the *ultraístas* in general. One night, he reported, the members of the group sought to determine the most memorable verse in the history of poetry. After much deliberation they awarded this honor to the following line, by Apollinaire: "Ta langue / Le poisson rouge dans le bocal / De ta voix."[117] This remarkable image occurs in "Fusée-Signal" (OP, 363), which Cansinos-Asséns translated and published in *Cervantes* in May 1919. Nor were the Ultraists alone in praising this verse, which was shortly to appeal to the Surrealists as well.[118] Interestingly, a text examined previously confirms the image's

popularity in Ultraist circles. In retrospect, the source of the line from Pedro Garfias' "Sol": "Mi corazón es un pez rojo entre las mallas" ("My heart is a red fish enmeshed in a net") is perfectly clear. On the one hand, Borges' testimony proves that the verse was inspired by Apollinaire. On the other, the existence of the verse itself proves that Borges' testimony can be trusted.

The second group of references to Apollinaire was centered around Vicente Huidobro. Ironically, since the latter resided in Paris, most of his work lies outside the scope of the present study. It suffices to recall that he belonged to the *Nord-Sud* group, which held Apollinaire in high esteem. Among the traces that remain of his friendship with the poet, which resembled that between master and disciple, are two important volumes. The first, a copy of *L'Hérésiarque et Cie* which was decorated by the author, contains the following inscription: "À Vicente Huidobro / son ami / Guillaume Apollinaire / en cordial / Souvenir / 3 juin 1917." Consisting of a copy of *Horizon carré*, the second is inscribed "À Guillaume Apollinaire avec toutes mes sympathies d'amitié et d'art Vicente Huidobro Paris Janvier 1918."[119] We also know the two men used to dine together, at least occasionally. "I will never forget Apollinaire's exclamations and gesture of admiration," Huidobro recalled in 1925, "when I showed him, one afternoon during the war when he was eating at my house, [some] admirable pages by Ben Jonson [from *Volpone*]."[120] Given the Chilean poet's admiration for Apollinaire's aesthetics, which he embraced enthusiastically, one would expect to find a certain amount of influence in his poetry.[121] Indeed, as we discovered earlier, Huidobro seems to have appropriated Apollinaire's use of the Icarus myth, which he may have transmitted to Juan Larrea, as well as the Christian symbolism of Apollinaire's airplane.

As noted, Huidobro's visit to Madrid during the summer of 1918 was a major literary event which, together with other factors, led to the creation of Ultraism. In an article devoted to modern Latin American poetry, published in August 1919, César E. Arroyo went so far as to claim that the entire movement stemmed from Huidobro. Portraying Cansinos-Asséns as the latter's disciple, he wrote: "America has made an extremely important contribution to the profound transformation now taking place in Castilian poetry. A great Chilean artist, Vicente Huidobro, was responsible for introducing the new aesthetic forms that he encountered in Paris in Apollinaire's works and in conversations with Reverdy."[122] Elsewhere in the same article, Arroyo declared that the Mexican poet José Juan Tablada was also a great fan of Apollinaire's, "whose marvelous and unprecedented work he admires." In particular, he reported, Tablada was fond of Apollinaire's very first calligram "la inolvidable 'Lettre-Océan'" (OP,

183–85). We will see in chapter 8 that this "unforgettable" work had recently inspired him to write some visual poetry of his own. If the subject of Tablada's poetry must be postponed, Arroyo's discussion of him is entirely relevant. Not only was the author obviously familiar with Apollinaire himself, but he appears to have shared Tablada's opinions. While the paragraph purports to reproduce the latter, the language in which they are couched betrays Arroyo's own admiration.

A few months later, the name of yet another "president" of Dada began to appear in Ultraist publications. Whether Jacques Edwards ever intended to join the *ultraístas* is difficult to say. A poet of Irish extraction who resided in Paris, he was actually born in Chile where he was known as Joaquín Edwards Bello.[123] In November l919, he published a review of Lasso de la Vega's *Galeria de espejos* (*Hall of Mirrors*) in which he evoked his life in Paris. Posing as a friend of Apollinaire's, he wrote: "The famous Kostro—which is the name by which we, his friends, called Guillaume Apollinaire—used to proclaim that modern poetry is the eternal and the classical stretching toward the future in an arc."[124] The author went on to explain that modern aesthetics demanded the modification not of forms but of concepts and perspectives that had become outmoded.

While Edwards' first statement was perfectly accurate, his second claim was woefully misinformed. More than anything Apollinaire (whose nickname was indeed "Kostro") believed in the immutability of certain classical principles which, unlike formal characteristics, were to be found in the great art of every period. Thus, in the second paragraph of "L'Esprit nouveau et les poètes" he declared: "L'esprit nouveau . . . prétend avant tout hériter des classiques un solide bon sens, un esprit critique assuré, des vues d'ensemble sur l'univers et dans l'âme humaine." In a brief note the following month, Isaac del Vando-Villar added that Edwards was a cousin of Huidobro's, whom he had introduced to modern poetry, and an intimate friend of Apollinaire's.[125] Edwards' poem "El aviador Da-Da," which appeared in *Grecia* on January 20, 1920, was accompanied by a similar note proclaiming that he belonged to "the free and independent group over which his friend Apollinaire formerly presided."[126]

All this was apparently more than Huidobro could bear, for the next issue included an energetic protest to the effect that Edwards was neither his cousin nor a friend of Apollinaire's. "Mr. Edwards never introduced me to Apollinaire," he objected, "nor was he ever his close friend. It was I who introduced Mr. Edwards to Apollinaire, one night when the latter was dining at my house and Mr. Edwards paid a visit after dinner. This was the only time Mr. Edwards saw the ill-fated poet."[126] Denounced in public by his supposed cousin, Edwards soon returned to Paris where he played a minor role in the avant-garde. In December of the following year,

Huidobro himself came to Madrid, where he lectured at the Ateneo on *creacionismo*. Reviewing the lecture, an anonymous writer quoted him as saying that his art was extremely close to Nature because it rejected imitation in favor of pure invention. However, as the reviewer rightly observed, this was true of the entire modern movement, not just Creationism. Citing Apollinaire as an example, he declared "The author of *Calligrammes* adopted the very same attitude when he recommended that the artist create a work in the same way that Nature produces a tree."[128]

The third group of references to Apollinaire concerns Antonio Espina García, who published a hostile article in *España* on October 16, 1920.[129] Not only did he detest Ultraist poetry, but he disliked the French models on which it was based. As the patron saint of Ultra, Apollinaire irritated him in particular. "There is no comparison," Espina sneered, "between the accomplishments of any of the Ultraists and those of Reverdy, Cendrars, or Apollinaire—oh what a fuss they have made over the latter!—despite the fact that these poets belong to the second or third rank." Aside from a certain vulgar appeal, he continued, equating stars with celestial fruits or airplanes with birds was totally uninteresting. Predictably, his article caused a furor in Ultraist circles. One of the most effective rebuttals appeared in *Grecia* two weeks later.[130] Attacking Espina for his remarks about Huidobro and Apollinaire, the anonymous author angrily called him to task for his imprecise references. Not only was it wrong to quote these poets out of context, he complained, but Espina's comments showed that he had never even read them and was relying on hearsay. The author then proceeded to give the correct references, one from *Calligrammes*, the other from *Alcools*. The first was to "Océan de terre" (OP, 268), where the airplanes begin to drop bombs as the poet begins to write: "Les avions pondent des oeufs / Attention on va jeter l'ancre." The second was to a passage in "Vendémiaire" (OP, 149) comparing the night sky to a cosmic grape vine: "astres mûrs becquetés par les ivres oiseaux." In any case, he concluded, Espina was incapable of rising to the heights of these sublime poets. His obvious ignorance was enough to disqualify him.

As one might suspect, Espina was not impressed by these arguments and remained unrepentant to the end. Reviewing an anthology of contemporary poetry for the *Revista de Occidente* (*Occidental Review*) in 1923, he expressed serious reservations about the modern movement in general. "After all," he asked, "what are Cocteau, Apollinaire, Folgore, Reverdy, Marinetti, and so many other standard-bearers of the classical phase of modernism? Simply simulators. Great talents if you insist . . . but simula-

tors. Men of great ingenuity in the highest sense of this term but also men of depressing narrowness, to evoke its less fortunate meaning."[131]

After 1923, references to Apollinaire in Castilian publications decreased sharply—as they did in Catalonia. By this date his aesthetics had been assimilated and Spanish writers were beginning to look in new directions. One of the most striking indications of Apollinaire's status was a curious novel by Nicasio Pajares, *El conquistador de los trópicos* (1923). A labyrinthine work of fantasy in which comic interludes alternated with ironic observations, the latter described the adventures of Ulises Yánez Quintanilla and his two pets: a flashy macaw and a mischievous monkey. While the former was called D'Annunzio, the latter bore the name Apollinaire. This unexpected juxtaposition was not pejorative, however, but simply one of many whimsical touches that grace the novel. Among other things, it implied that the two literary figures had much in common, that they were equals. Pajares clearly chose Apollinaire because, like his Italian colleague, he was a major author whose name was well known. By this date, like D'Annunzio, he had become a historical figure associated with a certain aesthetic and a certain era. In 1923, the Cubist aesthetic was fast becoming obsolete and would be replaced by Surrealism the following year.

The publication of Guillermo de Torre's *Literaturas europeas de vanguardia* in 1925, which summarized Apollinaire's contributions to the modern movement, marked the end of an era. By this date, Ultraism had ceased to exist and the French poet had assumed a place in the literary pantheon. For that matter, most of Torre's book consisted of essays that had been published several years before. Significantly, between 1924 and 1930 only two articles appeared in Spain about Apollinaire—both book reviews—and four brief references.[132] To this list should be added Cansinos-Asséns' translation of *Le Poète assassiné*, which appeared in 1924 with a preface by Ramón Gómez de la Serna. Conceived in part as an homage to Apollinaire, it marked the end of an era as well.

Among other things, this volume prompted the *Revista de Occidente* to commission a book review which was published in the July issue.[133] Managing to ignore Apollinaire's novel entirely, Antonio Marichalar devoted a long essay to the poet's life and work. Reflecting the changing aesthetic climate, his review was frankly mixed. In particular, he deplored "the excessive panegyric" of previous critics and proposed to reassess Apollinaire's literary worth. On the one hand, he praised the poet for his melancholy sensitivity and for his dedication to pure invention. The latter trait, he added, was central to Apollinaire's concept of *surréalisme*, illustrated by the famous dictum: "When man wanted to imitate walking, he

created the wheel, which in no way resembles a leg." This definition occurs in the preface to *Les Mamelles de Tirésias* (OP, 865–66), where the author describes his revolutionary new method. On the other hand, Marichalar accused Apollinaire of being too conservative and objected to "the excessively bookish origins of his methods and his gimmicks." What was initially surprising in Apollinaire's work, he claimed, lost its value once it had been explained or experienced. This was why much of his poetry had become outmoded: "Considerable time has elapsed, and today no one is scandalized by the typographical audacities or by the innovations in punctuation." To a certain extent, Marichalar's criticism was perverse, as he himself admitted, for what was involved was really a change in critical taste. Given the jaded sensibility of his own generation, he preferred the direct expression of emotion to the artificial manipulation of the text. His review ended with two verses from "La Jolie Rousse" (OP, 313): "Soyez indulgents quand vous nous comparez / À ceux qui furent la perfection de l'ordre."

It is worth noting, moreover, that the director of the *Revista de Occidente* was José Ortega y Gasset, who published his famous essay on "La deshumanización del arte" the following year. Although Apollinaire's name is conspicuously absent from Ortega's published works, it is interesting to speculate about the essay's sources. The chronology of its publication, following Marichalar's informative article, and its particular subject matter suggest that Ortega may have been indebted to the French poet for several of his ideas. Significantly, his analysis of modern aesthetics recalls Apollinaire's own pronouncements in several respects. "The poet begins where the man leaves off," he wrote in 1925. "The latter's destiny is to follow his human itinerary; the former's mission is to invent what does not yet exist."[134] What interests us here is the concept of an "inhuman" art, divorced from traditional humanistic concerns, which is ruled by invention and imagination. As we have had ample occasion to note, Apollinaire described the mission of the modern artist in exactly the same terms. "Avant tout, les artistes sont des hommes qui veulent devenir inhumains," he wrote in *Les Peintres cubistes*. And five years later, he declared in "L'Esprit nouveau et les poètes": "On ne doit appeler poète que celui qui invente. . . . Le domaine le plus riche, le moins connu, celui dont l'étendue est infinie [est] l'imagination."[135] That both these texts existed in Spanish translation increases the likelihood that they helped to shape Ortega's response to the twentieth century.

The second book review, by Pierre Picon, appeared in the Surrealist journal *Alfar* in 1926.[136] Reviewing the posthumous volume *Il y a*, which contained a mixture of poetry and art criticism, he succeeded in giving a

more balanced appraisal of Apollinaire than Marichalar had provided. Among other things, he noted that the author was one of the rare individuals who understood modern art and who could discuss its advanced tendencies intelligently. In particular, he praised the texts in *Il y a* that were devoted to the Douanier Rousseau and Picasso. These included the poem "Souvenir du Douanier" (OP, 357–59), an article on Rousseau from *Les Soirées de Paris*, and a contribution entitled "Pablo Picasso." The latter, which Picon found exceptionally penetrating and passionate, was a sort of negative calligram.[137] Published in *SIC* in May 1917, it consisted of a prose meditation on the painter out of which holes had been cut in the shape of Cubist objects. However, Picon devoted most of the review to Apollinaire's poetry which, more than anything, he declared, was responsible for his becoming "un personaje legendario." Containing a sensitive appreciation of the poet and a careful evaluation of his gifts, one paragraph is especially noteworthy:

> A love poet schooled in melancholy subtleties, a careless, frivolous, enthusiastic poet, he continues to be the carefree charmer we loved previously. He sings of tender autumns bathed in rain, of calm nights before the war, which he later had the unpardonable weakness or stupidity to extol. At times, certain harsh accents create a mysterious echo of profound despair which underlies the sentimental complications of his poetry. (p. 26)

As an example of the latter kind of poetry, he quoted the first two stanzas from "Adieux" (OP, 332). Apparently modeled on Ronsard's "Quand vous serez bien vieille," they evoke the march of time which afflicts Apollinaire's mistress but spares the poet himself, thanks to his divine gifts.

Once again the review was mixed. Following the condemnation of Apollinaire's war poetry by the French Surrealists, who misunderstood his motives and his goals, Picon concluded that he sought to glorify battle. In spite of this flaw, he added, Apollinaire was a pioneer in many different areas and one of the few real poets of his generation. If anything, the contents of his latest volume were "a new proof of the man's greatness." While Picon's assessment contrasted with the unqualified admiration of Guillermo de Torre and his colleagues, his final judgment was quite favorable. As such, it typified the attitude of the generation of '27, who, after the Ultraist infatuation with Apollinaire, sought to restore a sense of proportion. Like their predecessors, they agreed that Apollinaire was a great poet. Unlike them, they viewed him as a historical figure—one poet among many worthy of their attention.

Along the Río de la Plata

As one might expect, the history of Apollinaire's reception in Latin America is rather complicated. Since the region comprises some two dozen countries, each with its own national literature, it is difficult to find a common perspective. Those seeking to chart the region's literary history must proceed country by country as they attempt to trace general developmental patterns. Yet, the fact that each national literature possesses its own unique characteristics makes it hard to generalize. Among other things, the individual countries assimilated European contributions— when they assimilated them at all—at markedly different rates. Some nations were more aware of what was taking place in Europe than others, who acquired this information indirectly from neighboring countries. In general, nations with large metropolitan centers followed European developments fairly closely, while the remainder lacked the cultural apparatus to exploit recent discoveries in the arts. Members of these countries who were interested in modern aesthetics tended to settle in France or in Spain, where they could pursue their interests without hindrance. Like Francisco and Ventura García Calderón, who left their native Peru for Paris, the Guatemalan Enrique Gómez Carrillo chose to live in Europe, where he alternated between the French capital and Madrid. Even Rubén Darío, whose greatness was recognized during his lifetime, preferred France to his native land (Nicaragua).

In view of the situation outlined above, there is little point in analyzing each country's response to Apollinaire. Rather than attempt a detailed survey of the entire region, from Guadelajara to Tierra del Fuego and from Lima to Havana, this chapter and the following one focus on three countries in which the European avant-garde played a decisive role: Argentina, Uruguay, and Mexico. Although Apollinaire lacked the finan-

cial resources available to Marinetti, we will see that his presence was every bit as pervasive.[1] Whereas Marinetti traveled to Latin America in 1926, preaching the Futurist gospel in both Argentina and Brazil, Apollinaire exerted a comparable influence through his writings. By that date, in any case, Apollinaire had succumbed to the Spanish flu. Although the Futurists continued to issue proclamation after proclamation, his reputation depended entirely on works published prior to 1919 plus posthumous volumes such as *La Femme assise* (1920) and *Il y a* (1925). While the poet himself was no longer living, the Ultraist reviews introduced his work to the Spanish-speaking world and contributed to his fame in Latin America.

Among the first to learn of Apollinaire's accomplishments were the inhabitants of the river basin bisected by the Río de la Plata in South America. Since Ultra was to exert important influence on Argentine literature, this is not particularly surprising. When the Ultraist movement arrived, moreover, it found a flourishing avant-garde in which to take root and numerous persons who were receptive to its doctrine.[2] "In all Hispanic-America," as one critic remarks, "Argentina (or better Buenos Aires) was in truth the circus of vanguardism. The world was breaking into smithereens, but the Argentinians felt quite confident of the future in those years of prosperity."[3] Despite its seemingly remote location, Argentina, or at least the capital, was surprisingly sophisticated. Jorge Luis Borges reports, for example, that in contrast to many European nations all educated Argentines knew French. Scandalized by Gerardo Diego's admission that he had only read Apollinaire in translation, he concluded: "au Río de la Plata nous étions beaucoup plus près de la France qu'en Espagne."[4]

The fact that a number of prominent Spaniards lectured in Buenos Aires during the 1920s also contributed to its cosmopolitan atmosphere. A rapid survey indicates that these included Ramón Gómez de la Serna, José Ortega y Gasset, Gerardo Diego, and Xavier Bóveda, who, like Guillermo de Torre, eventually settled there. By contrast, cultural life in the neighboring country of Uruguay, like life in general, was more subdued. Traditionally Uruguay has tended to export its best poets—from the infamous Isidore Ducasse (better known as the Comte de Lautréamont) to Jules Laforgue and Jules Supervielle, who spent the rest of his life celebrating his homeland. It comes as something of a surprise, therefore, to learn that Montevideo possessed many of the attractions of its neighbor. Despite its smaller size and slower pace, it was the site of a considerable amount of literary activity. Not only did it count numerous poets among its inhabitants, some of whom were quite good, but it witnessed the publi-

cation of a whole series of literary reviews. For this reason, plus the fact that writers in Uruguay collaborated on magazines in Argentina and vice versa, the two countries will be considered together.

It is interesting to note that Apollinaire himself displayed an interest in this part of the world at various times in his life. In "Zone," for example, evoking the hordes of Europeans who were hoping to find a better life in South America, he described a group of emigrants in the Gare Saint-Lazare preparing to leave for Argentina.[5] Elsewhere he demonstrated a surprising familiarity with a newspaper published in Buenos Aires called *La Nación*. Writing in the *Mercure de France* on February 16, 1914, Apollinaire discussed a recent article by Leopoldo Lugones concerning a lecture he had heard in Paris on the tango.[6] As he observed, Lugones was the "brilliant directeur de la *Revue Sud-Américaine*," which he had just founded, and a prominent *modernista* poet. Although he resided in the French capital during this period, he was one of the leading literary figures in Argentina. Similarly, following Remy de Gourmont's death two years later, *La Nación* published a whole series of articles that attracted Apollinaire's attention. In a lengthy tribute to the man who in many ways had been his mentor, he quoted some of the writers' comments.[7]

One of the writers who noted Gourmont's demise was Francisco García Calderón, who edited the *Revista de América* in Paris. As far as can be determined, the first real contact between Apollinaire and an Argentine author occurred in the pages of the illustrated supplement to this review, entitled *La Actualidad* (*Current Events*). While Apollinaire's name had graced its pages before, in a bibliography devoted to Cubism, the March 10, 1914 issue contained one of his poems. Translated by Fernán Félix de Amador, "L'Emigrant de Landor Road" (OP, 105–6) was accompanied by a photograph of the poet and a brief introduction. As noted in the preceding chapter, the latter was authored by Ventura García Calderón, who was the editor's brother. The story of Ventura's relations with Apollinaire has been recounted previously. What interests us here is the fact that Fernán Félix de Amador hailed from Buenos Aires, where he served as art critic for *La Prensa* (*The Press*). A prolific poet, he won several literary prizes in Argentina and eventually became a professor of art history. Despite his exposure to Apollinaire and other avant-garde poets in Paris, he continued to write in a Symbolist vein. Although "L'Emigrant de Landor Road" must have piqued his curiosity, he made no attempt to imitate its author.

Ironically, the first person in Buenos Aires to promote Apollinaire's ideas was not a *porteño* but a Frenchman. Having grown tired of the life he was leading in the United States, Marcel Duchamp moved to Argentina in

August 1918, where he planned to found an international art colony. Hoping to establish another avant-garde outpost, like those in Barcelona and New York, he set about organizing an exhibition of Cubist painting for the following year. In this connection Duchamp's mission required him to engage in considerable proselytizing. Complaining that modern art was practically unknown in Argentina, he wrote to a friend in Paris to obtain copies of two books on Cubism. If the publisher agreed to send him thirty copies of each, Duchamp explained, he would undertake to distribute and sell them in Buenos Aires. Interestingly, the two volumes he specifically requested were Apollinaire's *Les Peintres cubistes* and *Du cubisme* by Albert Gleizes and Jean Metzinger. In addition, he asked his correspondent to send him issues of several journals dealing with Cubism, including Apollinaire's review *Les Soirées de Paris*. While the exhibition itself never materialized, we know that Duchamp received the books he asked for.[8] Presumably he made them available to the people most likely to benefit from them, which would have included artists, poets, and critics.

BARTOLOMÉ GALÍNDEZ

Judging from subsequent comments, Bartolomé Galíndez may have been one of the persons whom Duchamp succeeded in indoctrinating. A prolific author who published ten volumes of verse in as many years, Galíndez was especially susceptible to French poetry. Since no two of his books resemble each other, he also seems to have been rather impressionable. Whereas *Poemas modernos y exóticos* (1918) was influenced by the Parnassian movement, the following year, in *La Venecia dorada* (*Golden Venice*), he drew on French Romantic and Symbolist poetry as well. Thereafter, for approximately two years, Galíndez succumbed to the spell of the international avant-garde. Always an omnivorous reader, he familiarized himself with the latest developments in France, Spain, and Italy in particular. The fact that his family had originally come from the Italian peninsula encouraged him to pay special attention to the Futurists.

Fired with enthusiasm for his recently acquired knowledge, which was extraordinarily eclectic, Galíndez founded a literary review entitled *Los Raros*. The first and only issue appeared on January 1, 1920, and contained a long, rambling manifesto in which he sought to convert his countrymen to the new aesthetics. A careful reading of this document demonstrates that the author was amazingly well informed. Conceived under the sign of Futurism, Cubism, and Ultraism, it attempted to synthesize the different schools into a single universal movement. Significantly,

the review's title was taken from a collection of essays on the French Symbolists by Rubén Darío. To counterbalance the French and Spanish associations it evoked, Galíndez appended the following subtitle: *Revista de Orientación Futurista*. The fact that he published the issue in book form the same year, under the title *Nuevas tendencias* (*New Tendencies*), is also highly revealing.[9] While the animators of the modern movement were certainly "rare individuals," they were eclipsed by the new tendencies they represented. This explains why Galíndez' allegiance seemed to change from one page to the next—he found all the schools equally appealing. Quoting the Mexican writer Amado Nervo early in the volume, he exclaimed "France is the supreme teacher of our intellectuals" (p. 3). Elsewhere in the same document he proclaimed: "Ultra is the New School of the Future. Long live Ultra!"(p. 37).

Even a cursory glance at *Los Raros* reveals its strengths and its weaknesses. Despite its manifesto format, it was intended to acquaint the reader not with the theoretical premises of modern aesthetics but simply with its existence. As such, it was descriptive rather than analytical and devoted to the author's enthusiasms. Guillermo Ara singles out this last trait in particular. "Galíndez, whose verse is the precursor of formal revolts," he writes, "is less bold in the realm of ideas, which fluctuate between Darío's devotion and Cocteau and Apollinaire's applause."[10] The other distinctive trait of *Los Raros* was its insistence on reducing rival aesthetics to a common denominator. This was how Galíndez was able to reconcile his diverse interests. "Everything is Symbolism my friends," he remarked in one place, citing not only Rimbaud and Mallarmé but Apollinaire and a host of other figures (p. 15). At first glance, Galíndez' endorsement of Symbolism appeared to contradict his statements on the preceding page, motivated by a similar desire to find a common link between literary schools. Nevertheless, while his choice of names varied depending on the context, the guiding principle remained the same.

> Doubtless, it is a question of a single tendency which underlies the various nuances: ultraism and only ultraism, futurism and only futurism. Consider, for example, the Tactilist Guillaume Apollinaire who figured in the Futurist review *SIC*, inspired by Marinetti, that Pierre Albert-Birot used to edit in Paris.

The same thing may also be said of the Creationist movement, Galíndez maintained, which exemplified a general tendency in modern letters. Seen in this perspective, he added, Huidobro was mistaken in taking Rafael Cansinos-Asséns to task for classifying Roger Allard and Louis de Gonzague Frick as Creationists. Nor did it matter much whether

Cansinos grouped Apollinaire and Max Jacob with the Symbolists.[11] The important thing, Galíndez implied, was that these poets shared many of the same ideas. Although his search for a global label seems simplistic in retrospect, it resembles the current Anglo-American preoccupation with "modernism." As such it represents an important critical trend which has continued to interest literary historians. The reference to a polemic between Cansinos and Huidobro, is frankly surprising. While Cansinos could conceivably have committed the first error mentioned by Galíndez, he knew perfectly well that Apollinaire and Max Jacob had nothing to do with Symbolism (see chapter 6).

Galíndez had previously identified Apollinaire as one of the founders of modern poetry, together with eight other individuals (p. 2). Nevertheless, although most of his remarks were pertinent to the poet's aesthetic program, he persisted in classifying the calligrams as examples of *tactilismo*. Listed as a separate school like Cubism and Futurism, the latter was supposedly headed by Apollinaire "who writes and draws at the same time" (p. 13). While Galíndez seems to have intended this heading to cover visual poetry, it was a curious choice in more ways than one. In the first place, as the name implies, *tactilismo* was a movement associated not with visual phenomena but with the art of touch. Second, although the movement had been predicted by Apollinaire as early as 1917, the name itself was chosen by Marinetti four years later—as the title to yet another manifesto. In announcing the creation of the first tactile sculpture, by Edith Clifford Williams in 1918, Apollinaire spoke only of "l'art tactile."[12] What this suggests, therefore, is that Galíndez invented the name independently, probably after reading the latter announcement in the *Mercure de France*. Why he chose to apply it to visual poetry is anybody's guess.

Whatever the explanation, it is clear that Galíndez associated Apollinaire with the latest discoveries in art and literature. In particular, we know he read Enrique Díez-Canedo's detailed study following the poet's death in November 1918 (see chapter 6). Originally published in *España*, the article was reprinted in *Grecia* the following year.[13] Illustrated by Picasso's portrait of Apollinaire swathed in bandages, it was accompanied by a selection of his work in translation. Besides the short story "La Disparition de Honoré Subrac" (taken from *L'Hérésiarque et Cie*), the latter included three paragraphs on modern art and the following poems: "La Colombe poignardée et le jet d'eau" (OP, 213), "Le Chant d'amour" (OP, 283), and excerpts from "Tristesse d'une étoile" (OP, 308; vv. 2, 9–12). As the reader may recall, the dove and the fountain were reproduced photographically in order to preserve the poem's visual shape. In addition, the

passages on art were taken from section II of the chapter entitled "Sur la peinture" in *Les Peintres cubistes*.

Echoing the first paragraph of Díez' article, Galíndez stressed Apollinaire's extraordinary modernity. "As Díez-Canedo rightly remarked concerning Apollinaire," he observed, "during the years when the accomplishments of those rare individuals Maeterlinck and Paul Verlaine were regarded with wide-eyed astonishment, the discovery of a writer like Guillaume Apollinaire would have given critics the impression that they were in the presence of someone from a distant planet" (p. 17). During his brief lifetime, the French poet had completely revolutionized the practice of poetry. Furthermore, his contributions to the history of art were equally impressive. Who would ever have guessed, Galíndez mused on the following page, that two books would be responsible for the incredible success of Cubism, attracting a thousand followers and resulting in innumerable exhibitions? As he may have learned from Duchamp, those books were *Les Peintres cubistes* and *Du cubisme*.

Despite Galíndez' obvious admiration for Apollinaire, he rarely spoke of the poet following the publication of *Los Raros*. Invoking Apollinaire's name for the last time two years later, he stressed the latter's credentials not as a writer but as a critic of modern art. To some extent, his remarks stemmed from his earlier observations. "Guillaume Apollinaire, one of the most restless minds in France," he recalled, "had naturalized the evolution of the modern French painters with his grandiloquent optimism in *Les Peintres cubistes*."[14] Appearing in the Ultraist review *Nosotros* (*Ourselves*), this brief vignette captured two of Apollinaire's most valuable qualities: his continual need to experiment with new ideas and his conviction that modern aesthetics would eventually triumph. As Anna Balakian has pointed out, Apollinaire's untiring optimism contrasted with *fin de siècle* pessimism and all that it entailed.[15] Galíndez was not writing about French achievements, however, but about contemporary painting in Italy. In general, he reported, the Italian artists disdained traditional painting, which strove to represent the subject as realistically as possible. "Guillaume Apollinaire had already addressed this problem in *L'Antitradition futuriste*, and four artists from Italy, Leonardo Drudeville, Achile Funi, Luigi Russolo, and Mario Sironi—like Apollinaire—harshly criticized certain primitive elements whose 'mediocre compositions and paltry talent' sabotaged the transcendental ambitions of the future of painting in Italy" (p. 503).

Although Galíndez gave the impression that the phrase in quotation marks was taken from Apollinaire, in fact it was uttered by someone else. That he chose to cite the poet's condemnation of traditional aesthetics in

L'Antitradition futuriste, which was relatively unavailable, is also interesting.[16] Since this document was published by Marinetti and his friends in Milan, it suggests that Galíndez had acquired a stack of Futurist manifestos. In point of fact, the mysterious quotation appears to have come from one of these, like much of his information. Entitled *Contro tutti i ritorni in pittura* (*There Is No Going Back in Painting*), the manifesto he seems to have consulted was dated January 11, 1920, and bore the signatures of the four painters in question. Ironically, despite his apparent commitment to avant-garde causes, Galíndez does not seem to have profited from any of their lessons. The very year his article appeared in *Nosotros*, he published a book of poetry entitled *Humanidad* (*Humanity*) which explored the human condition. Consisting of rhymed sonnets and elegiac stanzas, the volume could have been written any time between the sixteenth and the nineteenth centuries. The same thing may be said of his subsequent works which, if anything, were even more old-fashioned.

ILDEFONSO PEREDA VALDÉS

While Bartolomé Galíndez was publicizing the modern movement in *Los Raros*, a similar journal began to appear on the other side of the river. Entitled *Los Nuevos* (*The New Breed*), it was published in Montevideo by Federico Morador y Otero and Ildefonso Pereda Valdés, both of whom were practicing poets. Of the two, Pereda was more familiar with contemporary events in Europe, which he examined in a series of articles. In addition to being well versed in modern art, he had an excellent knowledge of modern French poetry. Since he was also a prolific poet, Pereda was able to illustrate some of the latest tendencies as well as to discuss them. Not only did he publish translations of several French poets in *Los Nuevos*, but he adopted a number of recent innovations in his own poetry. Between 1920 and 1926, when the publication of *La guitarra de los negros* signaled the beginning of his "nativist" phase, Pereda strove to modernize Uruguayan letters. Although his poems were not as flashy as those by Alfredo Mario Ferreiro or Juan Parra del Riego, who succeeded him, they represented an attempt to break with *modernismo*.

During its brief existence, spanning the years 1920–21, *Los Nuevos* consistently maintained an international profile. The very first issue introduced its readers to five European authors, a French sculptor (Rodin), and the Russian Ballet. Reflecting the editors' special interests, three of the writers were poets: Charles Vildrac, Gerardo Diego, and Apollinaire. Although no reason was given for this eclectic selection, the underlying rationale is not difficult to discern. Each of the individuals whose poetry

graced the initial issue was a prominent poet associated with the avant-garde. Within the latter's somewhat elastic boundaries, each poet represented a different school. Whereas Vildrac was one of the founders of Unanimism, Diego was one of the leading exponents of Ultraism (or Creationism). Apollinaire was not only the most distinguished literary cubist but also the movement's titular head. For reasons perhaps related to space considerations, the editors chose to include a short poem from *Alcools*: "Les Cloches" (OP, 114).[17] Juxtaposed with a charming painting of a belltower silhouetted against the sky, Apollinaire's text helped to establish the journal's avant-garde credentials. Significantly, it was the only one of the three to be accompanied by an illustration. While the Spanish version was not signed, the translator was undoubtedly Ildefonso Pereda Valdés whose interest in the modern movement is well documented.

Apollinaire's presence was even more evident in the following issue, where he served as the subject of the lead article.[18] Devoted to "Apollinaire y el creacionismo," the article portrayed the poet as head of the Creationist movement and examined his contributions to modern poetry. By this time, at least in Latin America where Creationism received more publicity, literary cubism had been subsumed under Huidobro's conveniently vague title. In practice, the term "Creationist" applied to those writers who were associated with *SIC* and *Nord-Sud* and to their Spanish imitators. Once again the article's anonymous author was almost certainly Pereda. As before, it was accompanied by a striking illustration, in this case the frontispiece to *Alcools*. Any doubt that Apollinaire was a vanguard figure was quickly dispelled by Picasso's Cubist portrait, which testified to his radical ambitions. Although the author praised Apollinaire's disciples for exploring "the immutable symbols of life," he concentrated almost exclusively on Apollinaire himself. To illustrate the latter's aesthetics, he quoted two poems in the original French, both of which were taken from *Alcools*. Unlike "La Blanche Neige" (OP, 82), which exemplified the poet's lyric imagination, "La Dame" (OP, 127) demonstrated his preoccupation with ambiguous circumstances and enigmatic events.

> Much has already been said, but even more remains to be said, concerning the complex, sinuous perspective that the poetry of Apollinaire and the Creationists has bequeathed to contemporary literature.
>
> The illustrious author of "La Vie anecdotique" in the *Mercure de France* has uttered only a few hermetic words concerning his poorly named Cubism.
>
> For minds already habituated to older molds, those words were worrisome and incomprehensible. For younger individu-

als searching for new paths, those explanations were inadequate. Like every innovative act, the explanation was not inherent or immediately apparent.

Although the manifestos in *Nord-Sud* and *L'Élan* were obviously sincere, undeniably attractive, and contained important aesthetic truths, they included lexical eccentricities and conceptual juggling. Their beautiful, obstinate symbolism was subservient to grotesque orthographical whims. Surrounded by these good intentions and speculative ventures, however; tortured by a continual yearning for novelty that would transcend the symbolic rendering of daily existence; the author of *Alcools* demonstrated a powerful, primitive originality seemingly reincarnated after thousands of years.

Dating from just before World War I, his important book encountered resistance and provoked the kind of insidious criticism by sterile professorial "clubs" that great reformers receive—especially in literature—in Paris, here, and everywhere else. From the beginning he refused to ignore failure and human weaknesses. Without imitating Baudelaire's nauseating example, despite "les nuages [qui] coulaient comme un flux menstruel" in "Merlin et la vielle femme," the grotesque images in his poetry astonish the imagination and fill the reader with wonder. He understands, or rather senses, that poetry reflects the total being and that it demands great originality, as his own case demonstrates. . . .

Apollinaire is a sincere artist, a patient, tenacious chiseler of verses that are as childish, spontaneous, and unrefined as toys in a toyshop. Believing that art has a human mission, he admires not only important but insignificant things because both are an integral part of life.

The author of *Alcools* does not possess a distorted vision, as Max Nordau claims, but a spirit that glories in exhalting the principles of life. He sees things like everyone else, but he groups them together to form innumerable combinations whose tremendous significance is obvious to everybody but remains impervious to analysis. One might as well try to get to know all the world's inhabitants one by one.

One of the few generalizations that are permissible is that he refuses to differentiate between concepts, even those that are extremely far apart, except schematically, superficially. [He quotes "La Dame."]

In this brief composition, which is slightly enigmatic and disconcerting, the poet appears to succumb to the poverty of his lexicon. He seems to lament the fact that he is forced to express himself in words.

This is because his vision encompasses more of the world than can be expressed by those docile, miserable signs called words.

Those who prefer the kind of facile, puritanical poetry that suffers from general paralysis; those who are accustomed to the conceptions of a mechanical parthenogenesis, think Creationism is monstruous because it is so simple and natural. Despite several logical accusations that could be made, it is produced spontaneously and calls for gradual deciphering in contrast to previous poetic procedures. [He quotes "La Blanche Neige."]

Only superior poets are capable of appreciating this great poetry, whose forceful lyricism is marvellously suggestive, not mere versifiers.

Pereda's article reveals that he had been a fan of Apollinaire's for quite some time. While his primary access seems to have been through *Alcools*, he was familiar with the poet's column in the *Mercure de France* and with the works that appeared in *Nord-Sud* and *L'Élan* during the war. Although the article leaves no doubt that Pereda admired Apollinaire's poetry, it raises several interesting questions. One eventually realizes, for example, that his lengthy account is curiously one-sided. What he chose to leave out is as revealing as what he decided to include. Despite the author's obvious familiarity with Apollinaire's aesthetics, his discussion contained two glaring omissions. The first example occurred early in the essay where he lamented what he perceived as Apollinaire's reluctance to provide critical guidelines. Although the second paragraph of the above quotation demonstrates that he knew the French poet was associated with Cubism, he clearly did not know Apollinaire had written *Les Peintres cubistes* since he reproached him for his "few hermetic words" concerning that subject.

Whereas this fault was relatively minor, the absence of a second volume was much more serious. Whether it was excluded accidentally or on purpose, there was no mention anywhere of *Calligrammes.* In retrospect, several facts indicate that this was far from accidental. For one thing, all three poems that appeared in *Los Nuevos* (and "Merlin et la vieille femme" which he simply mentions) were taken from *Alcools.* For another thing, Pereda was clearly attracted to Apollinaire's more traditional poems. Compared to, say, "Le Brasier" or even "La Chanson du mal-aimé," "La

Dame" was a minor eccentricity at best. In addition, the fourth paragraph of the above quotation contrasted the solidity of Apollinaire's inspiration with the frivolous experiments that were to be found in the pages of the avant-garde journals. Since the author was offended by their lexical and orthographical liberties, one suspects he was even more outraged by their attempts at visual poetry. Even more than *SIC* (which he probably read as well), *L'Élan* was distinguished by its flamboyant experiments with "psychotypography" and "typometrics." What these facts suggest is that Pereda dismissed Apollinaire's later poetry, especially the calligrams, because he found it disconcerting. For him the poet's lyric gifts had declined following the publication of *Alcools*.

The same issue of *Los Nuevos* carried another article by René Perin, presumably translated from the French, which attacked academics for their lack of imagination and slavish adulation of the past.[19] In particular, Perin castigated professors of literature for refusing to deviate from the traditional curriculum. The problem, he complained, was that modern poets were being totally ignored. For one thing, much of the curriculum was devoted to translations of classical authors. For another, the history of French literature as taught in the classroom ended with the Parnassian movement. What about Tristan Corbière, he demanded, and Arthur Rimbaud? Why weren't they included, together with Stuart Merrill, Apollinaire, and Villiers de l'Isle Adam? In response to his own questions the author concluded that these writers were the victims of a vicious circle. If professors did not know their works because they were absent from the curriculum, the reason they were omitted from the curriculum was because professors remained ignorant of their works.

Apollinaire's name was mentioned twice more in connection with *Los Nuevos*, once in the review itself and once in a related publication. At some point during 1920, Ildefonso Pereda Valdés published a book of poetry entitled *La casa iluminada* (*The Illuminated House*). Released under the journal's imprint, it was divided into several different sections, one of which bore the title "Las palabras" ("Words"). In keeping with the volume's format, it was accompanied by an epigraph borrowed from a prominent literary figure, in this case Apollinaire: "Tous les mots que j'avais à dire se sont changés en étoiles." Although this verse was taken from *Alcools*, it differed in one respect from the previous examples of Apollinaire's poetry. In contrast to his usual practice, Pereda selected one of the poet's more difficult works, "Les Fiançailles" (OP, 130).

The following year, in the last issue of *Los Nuevos*, Pereda published a study of the fourth dimension as it applied to Cubist painting.[20] Once again he seems to have been unaware of Apollinaire's contributions in

this area. Although *Les Peintres cubistes* contained what was probably the most famous discussion of this subject, references to the latter were conspicuously absent. As if to atone for this unfortunate omission, Pereda devoted a short paragraph to Apollinaire's association with literary (as opposed to artistic) cubism. "Today Cubism is at the helm of the entire modern movement," he observed. "Aren't many of Guillaume Apollinaire's poems actually miniature paintings, like André Derain's illustrations?" Instead of pursuing this line of investigation, Pereda dropped it and returned to the subject of painting. One wonders if he felt inadequate to discuss this aspect of Apollinaire's work or if he simply found it annoying. Oddly enough, the very principles that he extolled in Cubist art were unacceptable when they were translated into the realm of poetry. Ironically, what Pereda liked most about the leader of the French avant-garde were his more conservative poems. Among other things, one begins to understand why he played a transitional, rather than a revolutionary, role in Uruguayan letters. Despite his continual fascination with the avant-garde, he never succeeded in overcoming his *modernista* background.

ALBERTO HIDALGO

Another prominent representative of *la nueva sensibilidad* ("the new sensibility") was Alberto Hidalgo, a prolific poet who served as a conduit between Europe and Latin America. Born in Peru, Hidalgo settled in Buenos Aires in 1920 and played an important role in the local avant-garde. Although his first few volumes of poetry were published in Peru, the remainder of his work appeared in Argentina, where he spent the rest of his life. Like Galíndez, Hidalgo was especially susceptible to Italian Futurism. As early as 1917, in *Panoplia lírica*, he explored a number of Futurist themes and sought to glorify the modern machine. At the same time, he was well acquainted with modern French poetry and with literary events taking place in Spain. Since he lived for awhile in both Paris and Madrid, he got to know the various schools of poetry at first hand. We know, for example, that he spent the summer of 1920 in the Spanish capital where he was attracted to the Ultraist movement.

Among other things, Hidalgo's experience in Madrid resulted in a book the following year provocatively entitled *España no existe* (*Spain Does Not Exist*). The outgrowth of a "lecture presented in a Madrid café, before some twenty friends, on July 25, 1920," it was one of the first volumes anywhere to devote a chapter to Ultra. Sketching the movement's historical background at one point, Hidalgo stressed its connection to modern aes-

thetics. Ultraism, he reported, was the logical outcome of work done earlier in other countries. As such it was indebted to various precursors whose experiments paved the way for the impressive achievements of the Spanish school. "It has already been clearly demonstrated," he added, "that several persons outside the group itself, have given proof of positive genius. One such individual was Guillaume Apollinaire, that marvelous spirit who bequeathed to us works such as *Le Poète assassiné* and *Calligrammes*."[21] Since Hidalgo quickly became the most adventurous member of the *vanguardia rioplatense*, he was naturally attracted to Apollinaire's more experimental texts.

Significantly, both *Calligrammes* and *Le Poète assassiné* were to exert important influence on Hidalgo's writing over the next ten years. At no time, however, did he actually borrow from Apollinaire. On the contrary, he took the latter's experiments as his point of departure and developed them in several different directions. In drawing his inspiration from several European movements, he relied on Apollinaire to be his guide. In 1923, for instance, Hidalgo published a book of avant-garde poetry which synthesized the most recent developments in Europe. Entitled *Química del espíritu* (*Chemistry of the Spirit*), it combined assorted sound effects and visual notations in a highly original way. One of the liveliest books to appear in Argentina during this decade, it managed to be irreverent and amusing at the same time. The only one of the visual compositions that recalled *Calligrammes*, however, was "Sabiduría" ("Wisdom"), which bore a superficial resemblance to "Il pleut" (OP, 203).[22] In both works, the lines of poetry descended the page letter by letter to form a series of vertical "bars." Whereas Apollinaire's poem read from top to bottom, Hidalgo's text flowed in the opposite direction. While the former depicted rain streaming down a window pane, in the latter the lines represented music, smoke, and the poet's soul.

In 1925, Hidalgo founded his own movement in Buenos Aires which he called *simplismo*. Not to be confused with *sencillismo*, headed by Baldomero Fernández Moreno, it focused on the primacy of metaphor rather than on themes connected with Argentina. Nor was it to be confused with Ultra, which adopted a fundamentally different attitude toward metaphor. Although Hidalgo was indebted to Dada and Surrealism, his compositions were strangely reminiscent of those by Ramón Gómez de la Serna. Consisting of pithy aphorisms structured around a central metaphor, they resembled the latter's *greguerías* (see chapter 6). The best discussion of Simplism occurred in the long introduction to *Simplismo: poemas inventados*, which included a defense and illustration of Hidalgo's new aesthetics. In this context he drew attention to

Apollinaire's importance as a precursor while maintaining his own relative independence. "The present era begins with Guillaume Apollinaire " he insisted, "however far we may have come since then."[23]

In 1926, Hidalgo founded the *Revista Oral* in which he continued his experiments with modern poetry. The following year he published a collection of short stories entitled *Los sapos y otras personas* (*Toads and Other People*). Profiting from the iconoclastic lessons of *Le Poète assassiné*, the volume possessed the kind of totally madcap humor that came to be associated with Dada. One of the most interesting stories was entitled "El hombre cubista" ("The Cubist Man").[24] Its plot revolved about two lovers, known only as "37" and "65," who decided they wanted to conceive a Cubist baby. Defining Cubism as "a glass of beer mixed with a yard of Cashmere and a dozen buttons," they devised the following plan. All they had to do, "65" assured his partner, was to obtain a book by Apollinaire and a painting by Picasso. Before making love they would dissolve these in an appropriate liquid and give each other injections with a hypodermic needle. The works they finally selected were *Calligrammes* and a picture entitled *Jeune Fille au bras levé*, which were subjected to the process described above. Nine months later, the proud parents were overjoyed by the birth of a bouncing baby boy, whom they named "1." Since he was the heir to a glorious tradition, he was born fully grown.

OLIVERIO GIRONDO

Although Oliverio Girondo was eventually to join the Ultraist camp, his familiarity with developments in Europe antedated the latter movement by quite a few years. "Alone among the Argentine Ultraists," Thorpe Running observes, "Girondo's initiation into avant-garde poetry was independent from, and previous to, Borges' introduction of a formal Ultraist aesthetic in 1921."[25] Thanks to a unique agreement whereby he promised to study law if his parents sent him abroad every year, he vacationed in Europe annually between 1905 and 1922. Most of his time was spent in Paris, where Jules Supervielle introduced him to avant-garde literature and where he witnessed several Dada manifestations. According to one critic, Girondo borrowed his poetic models from Quevedo, Apollinaire, and Paul Morand.[26] It would be more accurate, however, to say that his poetry utilized cubist techniques to achieve some of the goals of Dada. As such it was humorous, fragmentary, and often outrageous. The collection of poems for which Girondo is best known is entitled *Veinte poemas para ser leídos en el tranvía* (*Twenty Poems to Be Read on the Streetcar*) (1922). Written largely in prose and accompanied by his own illustrations,

they earned him a reputation as one of the most advanced poets in Argentina. In an article published in *España* in September 1923, Enrique Díez-Canedo remarked approvingly:

> Oliverio Girondo is a very fine poet. He belongs to the group of poets who exhibit the most modern tendencies while remaining at some distance from the tendencies that predominate in this country. All this poetry is of French extraction. Apollinaire, Reverdy, Cocteau, the Dadaists. Girondo does not profess a Sibylline lyricism, nor does he dissolve into nihilism.[27]

Pleased with the recognition accorded one of their members, the Ultraists reprinted the review in *Nosotros* in November. The following month, one of the editors, Julio Noé, contributed a review of his own in which he agreed that *Veinte poemas* was an exceptional book. Not only was Díez correct in associating Girondo with Apollinaire and Cocteau, he added, but it was possible to detect the influence of Ramón Gómez de la Serna as well.[28] Although most of the influence in *Veinte poemas* concerns its cubist technique, one critic has identified a motif he believes was taken from Apollinaire. The fact that Girondo was obsessed with women's breasts leads Thorpe Running to conclude that he was indebted to *Les Mamelles de Tirésias*, in which breasts play a major role.[29]

During the next ten years, Girondo published two books of poetry that confirmed his reputation as an *enfant terrible*. Between *Calcomanías* (1925), which mercilessly satirized Christianity, and *Espantapájaros* (1932) he composed a series of texts that he referred to as "letterheads" ("membretes"). Although critics had associated his work with Apollinaire for a number of years, this was the first time Girondo mentioned him by name. Conceived as a metaphoric homage to the fallen poet, one text celebrated Apollinaire's brilliant imagination.

> It would have been very easy to foresee Apollinaire's death, since Apollinaire's brain was a fireworks factory that continually invented the loveliest fireworks, rockets with the most beautiful colors, and it was inevitable that the first time he set one off in the muddy trenches a shell fragment would slice into his skull.[30]

If we analyze this statement logically, we are forced to conclude that Apollinaire was the victim of his own imagination. Had he not envisioned himself as the defender of French culture, he would never have joined the artillery. Had he not wanted to become an officer, he would never have asked to be transferred to the infantry, where he was eventually wounded. Brief as it is, this text is valuable for the information it provides about

Girondo's choice of literary models. One is tempted, moreover, to view his own achievements in the light of his remarks about Apollinaire. The successful avant-garde poet, Girondo, implies is one who is not afraid to take risks, who engages in literary pyrotechnics that may explode in his face. As Apollinaire had noted earlier, "l'esprit nouveau est plein de dangers, plein d'embûches."[31] Girondo experimented briefly with one of these dangerous inventions in his next book of poetry *Espantapájaros* (*Scarecrows*) (1932). Marking the emergence of vertical structures in his work, which replaced his reliance on horizontal patterns, the volume began with a visual poem. While the drawing itself was rather rudimentary, the lines were arranged to form a recognizable scarecrow. At least two critics believe the figure was intended as a tribute to Apollinaire's calligrams.[32] Whatever the explanation, Girondo noted a few years later that the French poet had been one of the first to champion the Douanier Rousseau's paintings.[33] When he least expected it, he declared, he continued to find proof of Apollinaire's decisive role in the international avant-garde.

JORGE LUIS BORGES

Ironically, transplanted to South America, Ultra encountered a more enthusiastic reception than it had in Spain. César Fernández Moreno describes the movement's history as follows: "Beginning in 1921, Argentine Ultraism assumed a life of its own, increasing in importance up to 1925 and subsiding from that point until 1927."[34] The date 1927 coincides with the disappearance of *Martín Fierro*, one of the most important journals, which ceased publication in the fall of that year. In a preface to a selection of Ultraist poetry published about the same time, the editor, Evar Méndez, reviewed the movement's origins. Ultraism, he explained, was the echo of European literary modernity reflected in Spain. Above all its sources were French Symbolism and the works of Apollinaire, André Salmon, Max Jacob, and Jean Cocteau.[35] Situated on the fringes of the Argentine group, Carlos Mastronardi recalled the excitement associated with the new sensibility many years later. What impressed him was that "The members of the new sect forgot every notion of literary continuity. In choosing its precepts, so to speak, the ingenuous miracles of Apollinaire (the expression is Gide's), Morand, Jacob, Reverdy, Cocteau were far from irrelevant."[36] Invoking the Ultraists' disdain for *modernismo*, Guillermo Ara describes their sympathetic response both to Marinetti and to Apollinaire. In particular, he reports, they experimented with conversation poems, *poemas-paseos* ("walking poems"), and calligrams composed according to Apollinaire's instructions.[37]

The genesis of the Argentine movement, as is well known, was sparked by the return of Jorge Luis Borges from his sojourn in Spain. "When I came back from Europe in 1921," he later declared, "I came bearing the banners of Ultraism. I am still known to literary historians as 'the father of Argentine Ultraism'!"[38] Paradoxically, Borges eventually grew to despise this period of his life and his role in the Argentine avant-garde. Among other things, he refused to allow his first two collections of essays, *Inquisiciones* (*Inquisitions*) (1925) and *El tamaño de mi esperanza* (*The Dimension of My Hope*) (1926), to be reprinted during his lifetime. He even bought up copies of the two books and destroyed them. Not surprisingly, this situation poses special problems for the literary historian. The trick is to filter out the disparaging comments from Borges' subsequent testimony in order to obtain a glimpse of what this period must have really been like. We can get some idea of his original fervor, and the sensation his presence caused in Buenos Aires, from a manifesto he published several months before his arrival. Stressing the crucial role of metaphor and rhythm in his poetry, he wrote:

> I seek . . . the sensation in itself and not the description of the spatial or temporal premises that encompass it. I . . . long for an art that translates naked emotion, stripped of the additional facts that precede it. . . .
>
> Rhythm: not imprisoned in metrical pentagrams but undulating, free, redeemed, abruptly truncated.
>
> Metaphor: a verbal curve that almost always takes the shortest path between two—imaginary—points.[39]

We noted in chapter 6 that the entire Borges family spent the winter of 1919 in Seville, where they first encountered Ultraism, before moving to Madrid in the spring of 1920. Norah Borges de Torre later recalled this experience fondly, adding that she had been so taken with Apollinaire's "Salomé" (OP, 86) that she embroidered a tapistry based on this poem. In addition, she declared, everyone had been very impressed by Guillermo de Torre's "Epiceyo a Apollinaire" ("Elegy for Apollinaire") when it appeared in *Grecia* on January 20, 1920. Like his fellow Ultraists, her brother regarded Apollinaire with admiration and set out to acquaint himself with his various writings. As Borges admitted many years later, the Ultraist movement was inspired by the French avant-garde and constantly looked to Paris for aesthetic guidance. Reiterating his opinion that it had all been a waste of time, he stated: "L'Ultraïsme était un reflet pas très intelligent de ce qui se faisait à Paris à cette époque-là, un reflet assez tardif d'Apollinaire par exemple, en même temps des poètes un peu

oubliés en France."[40] Although Borges' descriptions of this period are often couched in negative terms, there is no reason to doubt the accuracy of his account.

As noted previously, Apollinaire was the subject of a great many conversations among the Ultraists. Borges himself remembered discussing the poet with Guillermo de Torre and with Gerardo Diego on various occasions.[41] One of the most interesting conversations, which took place during a *tertulia*, concerned the most memorable verse in the history of poetry. In an interview with Jean de Milleret many years later, Borges recounted what transpired:

> J'ai été extrêmement étonné un soir où on a pris comme sujet— un peu fantasque—-de nos conversations: se rappeler quelle était la ligne, quel était le vers le plus mémorable de toute la littérature, ou même de toutes les littératures. On est arrivé alors à la conclusion que c'était un vers d'Apollinaire. Je crois que c'est le pire vers qu'Apollinaire ait écrit dans sa vie. Je ne le connais qu'en espagnol, parce qu'on ne connaissait guère le francais en Espagne. C'était "Tu voz pez rojo. . . . " Non! Non!: "Tu lengua pez rojo en el acuario de tu voz." Et cela était cité comme une fleur de la littérature. Cela m'a étonné. J'ai remarqué qu'au commencement il avait écrit: "Tu lengua pez rojo en el acuario de tu boca"; alors il a dû trouver que c'était trop bête, et il a mis "de ta voix" puisque "voix" est là. Mais ça n' a aucune importance car Apollinaire a fait quelques beaux vers.[42]

Despite Borges' attempts to undercut the thrust of his story, his recollection of this colorful episode is fascinating. First, the event itself clearly symbolizes Apollinaire's central role in the development of the Ultraist movement. Second, that Borges was able to quote the verse from memory testifies to its evocative power. Ironically, his efforts to dismiss the verse—taken from "Fusée-Signal" (OP, 363)—-only demonstrate how successful it is. In fact, Apollinaire's exact words were "Ta langue / Le poisson rouge dans le bocal / De ta voix." The verse evoked a similar response from the French Surrealists, who praised the analogical principle underlying this stunning metaphor.[43] But what makes Borges' words particularly interesting is his attitude toward Apollinaire. While he went to considerable lengths to demonstrate that the verse was ridiculous, he did not attack the poet himself. On the contrary, despite subsequent ideological differences, he rose to Apollinaire's defense. "Mais il a fait de très bons poèmes," Borges insisted, "par exemple ses poèmes de guerre." Fired by his sudden enthusiasm, he continued:

Vous savez ce poème ou il décrit une bataille: "Nuit violente et violette et sombre et pleine par moment . . . " et il termine "Nuit des hommes seulement."

Il y a aussi d'autres beaux vers: "Une belle Minerve est l'enfant de ma tête! Une étoile de sang me couronne à jamais. . . . Et je porte avec moi cette ardente souffrance comme le ver luisant tient son corps enflammé." Puis à la fin, non ce n'est pas très fort, hein?:

"Comme au coeur du soldat il palpite la France
Et comme au coeur des lys le pollen parfumé."

Tout cela est peu idiot, non? Mais. . . . "Une étoile de sang me couronne à jamais"!

As Borges informed his interviewer, these lines were taken from two of Apollinaire's war poems, both of which were included in *Calligrammes.* In "Désir" (OP, 263–64), written the night before a general offensive, the poet projected his manifold desires onto the enemy landscape. In "Tristesse d'une étoile" (OP, 308), composed after he had been wounded, he spoke not of his physical suffering but of his moral predicament. As Emir Rodriguez Monegal observes, Borges made a couple of minor mistakes in the first poem, but it is obvious that he had at one time read Apollinaire very carefully.[44] Nearly fifty years later he continued to respond to the latter's poetry, which clearly moved him, and was able to recall most of the words. It is interesting to note that Borges exhibited a similar regard for Apollinaire's work much later in the interview. Discussing one of his own compositions, "La Noche del Sauzal," he declared that because it was closer to the Parnassians than to Ultra, it would have been condemned by Apollinaire. Correcting himself immediately, he added: "Enfin, dans le cas d'Apollinaire, on ne sait pas puisqu'il jouait à toutes sortes de jeux."[45] As Borges well knew, the French poet cultivated several different styles. Yielding to a momentary impulse to stigmatize him as the leader of the avant-garde, he was forced to admit that he was impossible to stereotype.

One of the first things Borges did upon returning to Argentina was to establish a literary magazine. Entitled *Prisma* (*Prism*), the latter was distributed by pasting it on walls all over Buenos Aires. Before long it was replaced by a second Ultraist journal called *Proa* (*Prow*), which was edited by the same group of eager young poets. In 1924, reviewing a book of poetry by one of his colleagues, Eduardo González Lanuza, Borges took the opportunity to discuss some of the principles on which Ultra was based. Differentiating between the Spanish movement and its Argentine

successor, he compared what he saw as the former's relativity to the latter's quest for the absolute. Ultraism in Seville and Madrid, he explained, was associated with renewal and chose recent inventions, such as the airplane, as its emblems. By contrast, Ultraism in Argentina sought to produce works that did not depend on human chronology. "Beneath the lamps' dazzling brightness," he continued, "there were frequent references to Huidobro and Apollinaire in the Spanish gatherings. On the other hand, we . . . [are seeking to create] a limpid art that will be as timeless as the eternal stars."[46]

Borges' essay was reprinted the following year in *Inquisiciones* together with a number of his previous articles. Reviewing the volume in July, (Alfredo) Brandán Caraffa devised an amusing system of classifications which he applied to important historical figures. According to him, artists and writers could be divided into two categories: aesthetic and sportive. In the latter instance, he explained, even though the final victory was effortless, some sort of struggle was essential. Whereas Titian was aesthetic, he announced, Raphael was clearly sportive. A similar distinction applied to Quevedo and Cervantes, on the one hand, and to Góngora on the other. In the realm of modern French literature, he wrote, one could observe the same dichotomy. While Mallarmé and Rimbaud were preoccupied with aestheticism, Apollinaire adopted a sportive attitude in his writings.[47] In August, Apollinaire's name appeared again in connection with a review of Guillermo de Torre's *Literaturas europeas de vanguardia.* Writing in *Martín Fierro*, Borges examined the book at some length and singled out some of the sections he had especially enjoyed. The best chapters, he declared, were those devoted to Rimbaud, Apollinaire, Góngora, Herrera y Reissig, and Whitman.[48]

Although these references to Apollinaire were relatively minor, Borges devoted a whole article to him in March 1925. More precisely, he utilized a concept developed in one of Apollinaire's poems to frame a discussion of literature in general. Like Guillermo de Torre, he was attracted to the distinction between adventure and order elaborated in "La Jolie Rousse" (OP, 313), which suggested some interesting paths to explore. Like Caraffa's opposition between aesthetic and sportive styles, it promised to satisfy the demands of literary history. Entitled "Sobre un verso de Apollinaire" ("On a Verse by Apollinaire"), the article focused initially on the poem itself. "In a kind of psalm—whose confidential and pathetic diction betrays his debt to Whitman—," Borges began, "Apollinaire separates writers into those who prize Order and those who hunger for Adventure, and after including himself in the latter group he asks to be pardoned for his sins and his errors."[49]

Confessing that he found Apollinaire's poem moving, Borges devoted the rest of his article to exploring the relationship between adventure and order. Ironically, he explained, the two concepts were not opposed to each other but simply different aspects of human experience. With the passing of time every adventure becomes a future norm, every act is absorbed into the fabric of custom. In any case, he added, although Ultraism appeared to some critics to be governed by anarchy, nothing could be further from the truth. Ultra did not represent disdain for order but rather the search for new aesthetic laws. A related theme, which was also present in "La Jolie Rousse," concerned the relationship between the individual and society. "In the long run," Borges insisted, "each individual adventure enriches the order of everyone, and time legalizes its innovations." Like the link between order and adventure, therefore, the relationship between the solitary artist and the larger community was dialectical—as Apollinaire's poem clearly demonstrated. On the one hand, Borges observed, Apollinaire proudly proclaimed his independence, while on the other he asked society to forgive his transgressions.

Borges' essay on Apollinaire was reprinted in 1926 in a collection of articles entitled *El tamaño de mi esperanza*. Thereafter, following the demise of Ultra in Argentina, he turned his back on the avant-garde and began to cultivate other interests. For the next sixty years he concentrated on fiction, which he found more rewarding than poetry and which ultimately earned him the Nobel Prize. With two exceptions, Borges did not refer to Apollinaire in print again during his lifetime. During the 1940's, he developed a new interest in the poet which assumed two different forms. In 1943, he collaborated on a book of detective stories with his friend Adolfo Bioy Casares. Bearing the title *Los mejores cuentos policiales* (*Outstanding Detective Stories*), the volume contained sixteen examples that the authors judged to be exceptionally interesting. One of these was taken from *L'Hérésiarque et Cie* by "el famoso poeta" Guillaume Apollinaire. Accompanied by a brief biographical note, "Le Matelot d'Amsterdam" recounted the tale of a simple sailor who became the victim of a revenge murder between two strangers he had never met.

In 1946, following the end of World War II, Borges published an article entitled "La paradoja de Apollinaire" ("Apollinaire's Paradox"), in which he discussed how his generation's attitude toward the poet had changed in the thirty years since his death.[50] What impressed him the most was that, like most French literary figures, Apollinaire had become associated with a specific historical movement. Whereas Schopenhauer condemned the successive character of human knowledge, he remarked, the latter embraced it wholeheartedly. In poems such as "La Jolie Rousse"

(OP, 313–14), Apollinaire presented himself as the product of a chronological moment. "He did it," Borges added, "while remaining admirably and clearly conscious of the serious dangers associated with his adventure."

> These dangers were real; today, as was true previously, the general value of Apollinaire's work is more documentary than aesthetic. We read him in order to savor the flavor of "modern" poetry belonging to the first decades of our century. Not a single verse allows us to forget the date that it was written. . . . By embellishing his compositions with streetcars, airplanes, and other vehicles, Apollinaire never succeeded in merging with his era, which is also our own.

Apollinaire's paradox, therefore, was the same one that, according to Borges, had plagued the Spanish Ultraists. By incorporating contemporary objects into his poetry, where their function was emblematic, he sacrificed any pretentions he might have had to represent eternal verities.

The remainder of the article was devoted to Apollinaire's war poetry, which Borges particularly admired. Its juxtaposition with Picasso's portrait of the poet swathed in bandages, while probably not intentional, was highly ironic. Above all, the author maintained, Apollinaire regarded the war as a magnificent spectacle. That it constituted an aesthetic experience for him was evidenced both by his poetry and by the letters he wrote at the front. As proof of his thesis, Borges borrowed two examples from Guillermo de Torre's *Guillaume Apollinaire: estudio preliminar*, which appeared the same year.[51] Interestingly, although he never mentioned this book by name, it seems to have inspired him to write his own study. Calling Torre Apollinaire's most lucid and most devoted critic, he cited the following verses from "La Nuit d'avril 1915" (OP, 243): "Le ciel est étoilé par les obus des Boches / La forêt merveilleuse ou je vis donne un bal." In addition, Borges quoted part of a letter Apollinaire sent to one of his friends early in the war. Despite all the hardships he had had to endure, the poet wrote, "La guerre est certainement une belle chose."

Although this image of Apollinaire was far from accurate, it belonged to the mythology that had grown up around his name. Unlike many critics, Borges did not seek to censure the poet. In contrast to the Surrealists, who objected to what they perceived as Apollinaire's attempt to glorify war, he praised the latter's epic spirit. Comparing him to the author of *La Chanson de Roland*, he defended the purity of Apollinaire's intentions. What the French phrase revealed, he insisted, was the poet's lack of experience, his fatalistlc outlook, and his fundamental innocence. Borges' final remarks were no less paradoxical than the contradiction he discerned in

Apollinaire's poetry. While the latter was limited by its thematic approach to modernity, he concluded, the emotions that it expressed were clearly eternal.

> Apollinaire's verse: "La foret merveilleuse où je vis donne un bal" is not a rigorous description of the artillery duels of 1915, but it is an excellent portrait of Apollinaire. Even though he spent his days with the Cubists and the Futurists, he was not modern. He was somewhat less complex and happier, older and stronger. (He was so little modern that modernity always seemed picturesque, even moving, to him.) He was the "sacred winged thing" of the Platonic dialogue; he was a man whose emotions were elemental and thus eternal; at a time when the universe's foundations were crumbling, he was the poet of traditional courage and traditional honor. This can be seen in the following works, which have the same ability to move us as a sudden glimpse of the sea: "La Chanson du mal-aimé," "Désir," "Merveille de la guerre," "Tristesse d'une étoile," "La Jolie Rousse."

GUILLERMO DE TORRE

Together with Borges, Guillermo de Torre served as a link between the Old World and the New and, like his friend, eventually abandoned the former for the latter. Although he did not settle in Buenos Aires until 1927, he collaborated with the Argentine Ultraists from the beginning. Continuing to publish articles in Spain, where he earned his living as a lawyer, Torre regularly contributed to periodicals in Argentina as well. On several occasions, the same article appeared in both countries simultaneously. In January 1925, Torre published an essay in *Proa* which he also included in *Literaturas europeas de vanguardia*. Entitled "Neodadaismo y super-realismo," it was written in response to the publication of the first Surrealist manifesto the previous year.[52] As he reported, a huge controversy had erupted in Paris over the proprietorship and the meaning of the term *surréaliste*. On the one hand, André Breton and his friends sought to connect it with psychic phenomena; on the other, Apollinaire's former friends insisted on retaining its original meaning. Briefly, since the passage is quoted in chapter 6, Torre traced the term back to *Les Mamelles de Tirésias* and offered a provisional definition. In the latter work, he declared, surrealism described the principles governing the imagination, which had the power to shape our experience of reality. Formulated as early as 1912 in *Les Peintres cubistes*, he added, it stemmed from experiments associated with literary cubism.

In September 1925, Emilio Súarez Calimano reviewed *Literaturas europeas de vanguardia* in *Nosotros*. During his discussion, he touched briefly on Torre's volume of poetry, *Hélices*, which although published two years earlier presented numerous points of comparison with the book he was reviewing. In both works, the major avant-garde figures were well represented: Apollinaire, Marinetti, Tzara, and Reverdy. Concerning the first individual, he hastened to add, "the Apollinaire who figured in the book was the author of *Calligrammes*, not the one who wrote admirable verses of classical purity."[53] Torre's preference for the later poetry was so pronounced that he ignored *Alcools* almost entirely. Although the first volume broke with tradition in a number of important ways, the second was more overtly experimental. As such, it appealed to Torre's interest in the avant-garde and influenced his own poetry.

Three months earlier, Torre had published a study of "El nuevo espíritu cosmopolita" ("The New Cosmopolitan Spirit")—whose title recalled Apollinaire's 1918 essay—in the same journal.[54] Discussing Valéry Larbaud in one place, he hazarded the opinion that *Les Poésies de A. O. Barnabooth* (1913) had introduced a new lyric manner that influenced Apollinaire, Blaise Cendrars, and Paul Morand. Elsewhere he reacted indignantly to the belief of most critics that the sources of Morand's style were to be found in La Bruyère and Stendhal. In Torre's opinion, more telling analogies existed between his work and writings by Apollinaire, Cocteau, and Cendrars. While these references seem to imply that Apollinaire was simply one example among many, Torre was alluding not to individuals so much as to their common style. As a subsequent article demonstrated, he believed Apollinaire to be the most important poet not merely in France but in all of Europe. The following year Torre published excerpts from a lecture he had presented in April at the Ateneo in Valladolid. To illustrate the modern *Zeitgeist* he listed the names of five persons, each of whom was the most talented in his particular area. The reader was free to choose between Pirandello in the theater, Freud in psychology, Picasso in art, Proust in the novel, and Apollinaire in poetry.[55]

In 1928, Torre published a lengthy article in which he compared Picasso and Ramón Gómez de la Serna. Appearing in *Síntesis*, edited by his old friend Xavier Bóveda (who had also emigrated to Argentina), it contained several allusions to Apollinaire. One of these concerned the friendship that existed between the latter and Picasso which, Torre declared, had partially determined the paths which his painting would take.[56] Elsewhere he paused to explain the principles of Cubism, whose antirealistic bias had totally revolutionized the history of art.

> [The Cubists] declared that verisimilitude—the words are Apollinaire's—was of no importance since everything was sacri-

ficed by the artist to the demands of a higher order. By eliminating anecdotal elements, verisimilitude, and even comprehensibility, the Cubists insisted that a painting must be judged solely according to the intrinsic quality of its plastic elements. This gave rise to the concept of "pure painting." What does that mean? Listen to the words of its best theorist, Apollinaire: "On s'achemine ainsi vers un art entièrement nouveau, qui sera à la peinture, telle que l'on avait envisagée jusqu'ici, ce que la musique est à la littérature. Ce sera de la peinture pure, de même que la musique est de la littérature pure."

By this time the reader will have no difficulty recognizing the source of Torre's remarks. Not only the passage in quotation marks but the initial sentence were taken from *Les Peintres cubistes*.[57] As before, Torre found Apollinaire's discussion of the principles underlying Cubism to be especially helpful. Indeed, he cited Apollinaire again on the opposite page, which was concerned with the concept of pure creation. In Torre's opinion, the concept originated with Cubist painting, was adopted by the literary cubists, and quickly became the focal point of modern aesthetics. In support of his thesis, he quoted the introduction to the section where Apollinaire divides Cubism into four categories. This paragraph, which stresses the importance of the creative impulse, begins with the familiar words: "Ce qui différencie le cubisme de l'ancienne peinture, c'est qu'il n'est pas un art d'imitation, mais un art de conception qui tend à s'élever jusqu'à la création."[58] Besides Apollinaire's discussion of verisimilitude, pure painting, and creativity, Torre drew on several other passages as well. Sprinkled among the rest of his article were additional references that, while relatively minor, betrayed his widespread debt to *Les Peintres cubistes*.

While the frequency with which Torre evoked Apollinaire declined after this date, he was never entirely absent from his thoughts. On two occasions which deserve to be mentioned, Torre included bits of his poetry in articles that were concerned with other subjects. Reviewing a collection of verse in 1928 by the Basque poet Ramón de Basterra, for example, he detected echos of the Unanimists, Marinetti, and Apollinaire.[59] Elsewhere in the same article, he observed that Basterra's protagonist, who exemplified the modern age, could have appropriated two lines from "Zone" (OP, 39) for himself: "À la fin tu es las de ce monde ancien . . . / Tu en as assez de vivre dans l'antiquité grecque et romaine." In 1929, following the death of the artist Rafael Barradas, Torre composed a moving obituary for *La Gaceta Literaria* in Madrid.[60] Searching for an epitaph that would acknowledge the latter's contributions to the modern movements,

he settled on three verses from "Toujours" (OP, 237): "Perdre / Mais perdre vraiment / Pour laisser place à la trouvaille."

As we saw in the preceding chapter, the 1940s witnessed a renewed interest on Torre's part in Apollinaire's poetry and criticism. With the publication of *La aventura y el orden* in 1943, whose title and epigraph came from "La Jolie Rousse" (OP, 313), he proclaimed his intention to celebrate the latter's achievements. Concentrating on the dialogue between order and adventure that had previously fascinated Borges, the book examined a whole series of writers from Walt Whitman to Jules Supervielle. Unexpectedly, Apollinaire's name was missing from the table of contents. The appearance of *Guillaume Apollinaire: estudio preliminar y páginas escogidas* (*Guillaume Apollinaire: A Preliminary Study and Selections*) in 1946 explained why he had been excluded from the previous study. In view of his tremendous importance, Torre had decided to devote an entire volume to him. One of its immediate effects, as noted, was to galvanize Borges into writing about the paradox he perceived in Apollinaire's poetry. Expanded and retitled *Apollinaire y las teorías del cubismo* (*Apollinaire and Cubist Theory*) in 1967, the book contained Torre's definitive views of the poet. Not surprisingly, perhaps, his admiration for Apollinaire's accomplishments had not diminished with the passage of time. "Despite his premature death, which left his work unfinished," he declared, "Apollinaire personifies the courageous invader of new territories which others would explore in more detail, perhaps with greater rigor, but not with as much fervor."[61]

THE MARTÍNFIERRISTAS

In addition to *Prisma* and *Proa*, which served to propagate Ultraist principles originally, a third journal was born in 1924 which would exert even greater influence on Argentine letters: *Martín Fierro*. Taking its name from an indigenous folk hero, it combined an aggressive avant-garde posture with a dedication to Ultra and related phenomena. In keeping with its combative stance, the organizers published a manifesto in the fourth issue which spelled out their grievances and advocated a specific program. "Given the hippopotamic impermeability of the 'honorable public,'" the manifesto began, " MARTÍN FIERRO [wishes to point out] that we are faced with a NEW sensibility and with a NEW understanding that . . . reveals unsuspected panoramas and new means and forms of expression."

This pronouncement demonstrates that the authors possessed a certain familiarity with Apollinaire whose influence, like that of Marinetti,

was attested by more than one passage. "Nous voulons vous donner de vastes et d'étranges domaines," the poet confided in "La Jolie Rousse" (OP, 313), leading his Argentine admirers to praise the "panoramas insospecha-dos" of the new aesthetics. Elsewhere the manifesto announced that contrary to Solomon's adage in the Bible, everything *was* new under the sun since our way of looking at it was new. The source of this statement was a passage in "L'Esprit nouveau et les poètes" where Apollinaire made a similar point.[62] Citing the recent invention of the airplane, the discovery of X-rays, and the exploration of the universe, he exclaimed that a great deal had happened since Solomon's day. While the world itself had not changed, the manner in which we experienced it had been altered forever by modern science and art.

Although writers in *Martín Fierro* were to refer to Apollinaire numerous times over the years, the most significant document appeared in the very first issue. Drafted by Ernesto Palacio, who was one of the journal's founders, it celebrated the poet's manifold accomplishments.[63] What made Palacio's article so remarkable was not just its length, which was considerable, but the vehemence with which he praised Apollinaire and his work. The latter was not only an excellent poet, he declared, but one of the founders of modern aesthetics.

> Guillaume Apollinaire has been one of the writers who have exerted the most influence on contemporary poetry. From his work and from his futurist propaganda derive all the new tendencies, which have produced such interesting poets as Max Jacob, Reverdy, Cendrars, and Cocteau. A descendent of Symbolism, of which he was a follower and a panegyrist—it is worth recalling his lectures on this group of poets published by "L'Après-midi des poètes"—he soon sought new avenues in order to satisfy his constant thirst for originality. Marinetti's Futurism seduced him at first, and he hastened to write a manifesto; later, the Cubism of Picasso and his disciples, about which he wrote a polemical book. In order to support these campaigns for a new art, he founded several ephemeral journals: *Le Festin d'Esope, Les Soirées de Paris*, etc. Many of the new generation's best members gathered around him, regarding him as their master and admiring, besides his poetic talent, the colorful and inexhaustible ideas of this enthusiastic theoretician, initiated into all of literature's mysteries and those of painting. Because the great poet possessed a vast erudition in artistic bric-a-brac (this image would have pleased him) acquired at random during his trips, by frequenting the ateliers, and by periodical bibliographical

incursions. Since his curiosity was limitless, he was attracted by an infinite number of subjects, exhausting them all with voracious enthusiasm. These innumerable interests, which would have rendered most writers sterile, were extraordinarily fertile in Apollinaire's case, whose generous temperament rescued him from artistic nihilism.

Paralleling his work as critic, bibliophile, and propagandist, and intimately linked to it, Apollinaire's poetic achievement is considerable and offers great unity despite the ideological transformations mentioned previously. *L'Enchanteur pourrissant*, his first volume of Symbolist poetry, contains the seed of all the qualities that were to distinguish his later work: an enthusiasm for originality, the presence of extravagant fantasy, a nomadic instinct, a love of vulgar and ridiculous things, a sense of the grotesque. . . . Qualities that occur as well in his book of short stories *L'Hérésiarque et Cie*, crowned by the Académie Goncourt. But where the great poet reveals himself completely is in *Alcools* and *Calligrammes*. These works, especially the former—*Calligrammes* is a little prone to mystification—marked the beginning of a new literary era since they signified the adoption of foreign tendencies, such as Whitman's Yankee prophetism and Italian Futurism, which in this way were absorbed into the French tradition, joining Rimbaud.

Apollinaire succumbed to one of the post-war epidemics in 1918, at a time when so many still expected so much from him; the young French writers published touching homages to his memory. All this has been revived recently in the literary reviews on the fifth anniversary of his death. Among ourselves he continues to be little known or unknown, despite the existence of an Ultraist group here. . . . In an atmosphere so impregnated with French literature, this neglect is unforgivable. Due to his universality and sympathetic manner, Apollinaire was a typical representative of the French spirit, whatever people like Manoras and Daudet may say, and he possessed the best qualities of his country's genius despite his exotic pseudonym—his name was actually Kostrowitzsky—and his uncertain ancestry.

That Palacio's enthusiastic study coincided with the initial issue of *Martín Fierro* was far from accidental. Like the Ultraists in Seville, who read one of Apollinaire's poems at their first public gathering, the review's founders seem to have commissioned one of their number to write an article about the poet. Among other things, this means that they

regarded Palacio's contribution as an embryonic manifesto. On the one hand, they were anxious to associate *Martín Fierro* with Apollinaire because his name was synonymous with modern aesthetics. Honoring his achievements in the first number ensured that the journal would be regarded as a progressive force. On the other hand, the article itself contained a number of concrete suggestions for those who, like themselves, wished to emulate the French poet. Despite several inaccuracies— *L'Enchanteur pourrissant* was not a collection of poetry, nor did *L'Hérésiarque et Cie* receive the Prix Goncourt—the study identified several important principles in his work. Reflecting Apollinaire's insatiable curiosity, the latter was characterized by enthusiasm, originality, fantasy, vulgarity, and a penchant for the grotesque. These were the qualities that the founders advocated in their attempt to resuscitate modern Argentine literature.

Despite the errors noted previously, Palacio's article was really quite well informed. The book of Symbolist criticism to which he referred was undoubtedly *La Poésie symboliste*, published in 1908. Co-authored with Paul-Napoléon Roinard and Victor-Emil Michelet, it contained three lectures delivered at the Salon des Artistes Indépendants the same year. Ironically, the reference to artistic bric-a-brac would not have amused Apollinaire at all, since Georges Duhamel had used a similar phrase to attack *Alcools* in 1913.[64] Nevertheless, he would have been pleased by Palacio's laudatory remarks and by his spirited defense of his aesthetics. Since France was the poet's country of adoption rather than birth, he would also have been delighted to learn that he personified the French spirit. The allusion in the final paragraph to Léon Daudet and someone called Manoras refers to Apollinaire's non-French origins. The second name was probably a misprint for [Charles] Maurras who, together with Daudet, belonged to the ultra-conservative Action Française. Like similar groups today, they believed France should be reserved exclusively for Frenchmen.

During 1924, Apollinaire was mentioned four more times in the pages of *Martín Fierro*. In May, during a discussion of the Futurist Aldo Palazzeschi, Pedro Juan Vignale noted that the Italian movement had attracted Apollinaire's attention as well.[65] Writing in the July issue, Jean Cocteau complained that the public still tended to confuse Cubism and Futurism. Whereas Apollinaire's allegiance was to Cubism, he admired the Futurist leader whom he used to refer to as "Marinetti the enchanter." In Cocteau's opinion, he was entirely justified.[66] Two months later, Serge Panine published an interesting article in which he elaborated on the journal's association with the modern movement. Those who wrote for *Martín*

Fierro, he observed, were consumed by the same thirst for renewal that was manifesting itself in artistic circles throughout the world. In literature this trend was represented by writers such as Marcel Proust, Jean Giraudoux, Jules Romains, Paul Morand, and Raymond Radiguet—"not to mention Apollinaire."[67] In October, the poet's name occurred once more in an article devoted to the discovery of Cubism. Evoking Picasso's heroic role in the birth of the movement, the author noted that he counted two fervent poets among his friends: Apollinaire and Max Jacob.[68]

Apollinaire was less in evidence the following year, for no apparent reason. The only article in which his name appeared, apart from Borges' review of *Literaturas europeas de vanguardia* in August, was devoted to his former mistress Marie Laurencin. Authored by Eduardo Juan, it praised her delicacy and grace while mentioning that she had been discovered by Apollinaire among others.[69] By contrast, 1926 witnessed an increase in the frequency with which the poet was cited. In May, for example, an anonymous writer reported that Sergio Piñero had just returned from France where he had persuaded Maurice Raynal to contribute to *Martín Fierro*. Together with Apollinaire, Picasso, André Salmon, and Max Jacob, he added, the latter was one of the first promoters of the modern movement.[70] In addition to Raynal, subsequent issues included contributions by a variety of foreign authors. One of these was Nino Frank, living in France, who contributed an article on Futurism. Unexpectedly, he declared that the Italians had long been familiar with the French literary cubists' attempts to liberate poetry, singling out Apollinaire, Jacob, and Salmon in particular.[71]

Another author who resided abroad, the Chilean writer Francisco Contreras, published an article on Valéry Larbaud in October. What impressed him was the discovery that, despite its modern demeanor, *Poésies de A. O. Barnabooth* had been composed between 1902 and 1907 "before Apollinaire helped to found the new lyric movement.[72] In any case, he reported, nothing in the volume recalled the author of *Calligrammes*. Contreras' remarks appeared in the same issue of *Martín Fierro* as Guillermo de Torre's discussion of the contemporary *Zeitgeist*. Ranking Apollinaire's achievements with those of Freud and Proust, as we saw, Torre identified him as the most important modern poet. Rounding out the list was a review of a concert in Buenos Aires, conducted by Ernest Ansermet, that mentioned Apollinaire twice. Among other things, the audience was treated to six operatic pieces modeled on poems in *Le Bestiaire* (OP, 1–35). Composed by Francis Poulenc, these included "Le Dromadaire," "La Carpe," "Le Cheval." "La Puce," "Le Dauphin," and "Le Lapin."[73]

In January 1927, the poet was cited in two separate articles, both of which were authored by French critics residing in Paris. Writing about Max Jacob, whom he knew personally, Georges Mergault recalled that he alluded frequently to his deep affection for Apollinaire.[74] Extolling the freshness of Marie Laurencin's artistic vision, Marcelle Auclair concluded that she deserved to be ranked with the best painters of her generation. "As early as 1913," she added, "Guillaume Apollinaire used to say 'The art of a woman like this honors a whole era.'"[75] The source of this quote was not *Les Peintres cubistes*, as one would expect, but an article written three years before. Nor was the citation itself entirely accurate, even allowing for its translation into Spanish. Reviewing the Salon des Indépendants in 1910, Apollinaire had praised the artist's lyric imagination and concluded: "La pureté d'un tel art est l'honneur d'une époque."[76] Marie Laurencin was associated with a group of poets including Apollinaire, Auclair continued, who were the precursors of Surrealism, and with painters whose aesthetics revolved about surprise.

The last two references to the poet in *Martín Fierro*, which ceased publication toward the end of the year, took the form of quotations from his poetry. In both cases, the verses were taken from *Calligrammes*. Writing in the April issue, the former Spanish Ultraist Adriano del Valle praised the work of a Portuguese author whose compositions reminded him of Cézanne. In this context, they brought another figure to mind as well, one that had greatly interested Valle formerly. "In considering Cesario Verde's work," he observed, "I am automatically reminded of these lines by Apollinaire: 'La fenêtre s'ouvre comme une orange / Le beau fruit de la lumière.' I remember Apollinaire's verses and the geometric drawing by Robert Delaunay that illustrated them."[77] What makes this reference somewhat unusual is not the quotation from "Les Fenêtres (OP, 169), which appealed to numerous poets, but its juxtaposition with Delaunay's drawing. That Apollinaire composed the poem to accompany an exhibition of the latter's paintings in Germany was not widely known. This suggests that Valle had seen a copy of the original catalogue at the Delaunay's apartment in Madrid during the war.

Several months later Raúl Scalabrini Ortiz published a highly ironic article which focused on what he saw as the modern artist's predicament. In a commentary worthy of Nietzsche himself, the author satirized the ambitions of creative individuals to transcend the human condition via their art. Despite their much vaunted dedication to modern aesthetics, he declared, they were helpless to alter their fate. Indeed, since their art was powerless to protect them, they were doomed to renounce it. "Convinced of their impotence to express two bits worth of ideas in a dead language,"

Scalabrini thundered, "[modern artists] bury themselves in the bowels of their art in order to say their piece, individuals who after mocking their art with innocent calligrams, full of humor, ask only for a little pity."[78] For those readers who failed to understand that he was referring to Apollinaire—insofar as he epitomized *l'esprit nouveau*—Scalabrini appended the last five lines of "La Jolie Rousse" (OP, 314).

An interesting epilogue to the history of *Martín Fierro* and Apollinaire is furnished by Lysandro Z. D. Galtier, who represents yet another link between the New World and the Old. Born in Buenos Aires to parents who originally came from France, Galtier wrote virtually all his poetry in French. Presumably because of his ties with his parents' native land, he developed an intense interest in Apollinaire that lasted as long as he lived. This enthusiasm was evinced, on the one hand, by translations of Apollinaire's poetry and, on the other, by several of his own poems that sought to imitate some of the better-known works. The best example of the first activity appeared in 1926 in *Martín Fierro*, which published Galtier's translation of "Zone" (OP, 39–44).[79] Accompanied by a sketch of the poet as a *clochard*, by Picasso, it made one of the century's key texts available to the Argentine public for the first time. Like Ernesto Palacio's article before it, the poem served above all as a manifesto. This was the kind of work the journal strove to promote, work that subjected human experience to the scrutiny of the new sensibility.

One of the persons who responded enthusiastically to "Zone's" discovery was Galtier himself. Inspired by the latter work, he composed a poem entitled "Buenos-Ayres" that appeared in *Martín Fierro* the following year.[80] Like Apollinaire's poem, which celebrated life in the French capital, Galtier's was conceived as an ode to Argentina's chief city. Written in the first person and in free verse like its model, it traced the poet's journey through various sections of Buenos Aires. Intoxicated by the city's rhythms at one point, he exclaimed "Je suis une parcelle ivre au fracas absorbant de la vie." The source of this line was the final section of "Vendémiaire" (OP, 154), in which Apollinaire described a similar intoxication: "Je suis ivre d'avoir bu tout l'univers." Whereas the latter experience was cosmic in nature, the former was associated with the excitement of urban life. Although Apollinaire's autobiographical journey in "Zone" covered twenty-four hours, Galtier's was restricted to the early evening. "Toute la sainte journée j'ai trainé comme une brute," he announced, echoing a verse that occurred in another of Apollinaire's poems, "Les Fiançailles" (OP, 134): "Toute la sainte journée j'ai marché en chantant."

Despite these references, Galtier's poem was primarily indebted to "Zone," which clearly appealed to his imagination. While there are

numerous similarities between them, two examples will demonstrate the way in which he appropriated the earlier work. The first, which is relatively obvious, is provided by Galtier's description of the urban landscape. "Là il y a un carrefour que j'aime," he confided, "accueillant comme un étui." Although the striking simile was the author's own invention, the theme it was meant to exemplify was borrowed from Apollinaire. Describing a privileged street of his own in "Zone," the latter exclaimed "J'aime la grâce de cette rue industrielle." Despite the apparent sterility of city life, the modern poet felt at home in an urban setting. The second example is taken from another section, where Galtier paused to evoke Buenos Aires' most prominent feature. "Me voici aujourd'hui seul au bord de ta lente rivière," he remarked as he contemplated the Río de la Plata. This simple declarative sentence incorporates at least three ideas that derive from "Zone." The construction "Me voici," occurs throughout Apollinaire's poem where it allows him to dispense with logical transitions—exactly as in "Buenos-Ayres." Whereas part of "Zone" is also located near a river, part takes place "au bord de la Méditerranée" as well. That Galtier is "seul," moreover, reflects Apollinaire's situation in the latter poem. Although the issues this work raises are exceedingly complex, ultimately Apollinaire's problems stemmed from the fact that he was alone.

Pleased with his recent success, Galtier set about making more of Apollinaire's works available to the Spanish-speaking public. At the end of two years, when his project was completed, he had translated thirty-two poems into Spanish, which he decided to publish as a volume. In addition to "Zone," the volume comprised nine texts from *Alcools* and another twenty-two poems taken from *Calligrammes*. While the selection included neither "La Chanson du mal-aimé" nor "Les Collines"—two curious omissions—it featured a number of Apollinaire's more memorable works.[81] In general, Galtier presented a balanced assortment reflecting both the poet's enthusiasms and his experience. The texts themselves were accompanied by an excellent bibliography, two portraits by Picasso, and an essay by Jean Cocteau entitled "La mort de Guillaume Apollinaire."

In 1935, a poem by Galtier entitled "Itinéraire" appeared in *La Revue Argentine*.[82] Although it too was modeled on "Zone," like "Buenos-Ayres," there were a number of important differences. By this date, Galtier had thoroughly absorbed Apollinaire's style and had made it his own. While his mature manner was still indebted to the French poet, the way in which this expressed itself was much more subtle. No longer content to copy individual verses, he concentrated on Apollinaire's aesthet-

ics. Significantly, when the poem appeared in book form the following year, it bore an epigraph from "Un Fantôme de nuées" (OP, 194): "Il portait . . . toute son hérédité au visage / Il semblait rêver à l'avenir." Over the years Galtier's enthusiasm for modern French poetry expanded to encompass authors such as Léon-Paul Fargue, Jean Cocteau, Blaise Cendrars, and some of the Surrealists. At the same time, the interest he had shown in translation continued unabated. In 1965, the latter occupation culminated in *La traducción literaria* (*Literary Translation*), whose three volumes included a generous anthology.[83] For unknown reasons, Galtier chose to reprint only four of the poems he had translated in 1929. After many years of reading Apollinaire, the works that he preferred were: "Zone," "Cortège," "Les Fiançailles," and "La Jolie Rousse."

ADDITIONAL AUTHORS

Of necessity, the previous sections have focused on individuals or groups who demonstrated a substantial interest in Apollinaire. And yet, while it is important to know what they thought of the poet, this does not tell the whole story. Indeed, it can be argued that random pronouncements by authors who had no personal stake in the matter provide a more accurate assessment. At the very least, the density of the various references is impressive. Not only do they fill in the space between the different figures examined previously, but they help to redress the literary balance between Argentina and Uruguay. Unlike their counterparts in Buenos Aires, with the exception of Ildefonso Pereda Valdés, none of the poets in Montevideo was particularly drawn to Apollinaire. Instead of concentrating on a few individuals, Apollinaire's influence followed another pattern, contributing to the renewal of Uruguayan poetry in general. In this it resembled his reception across the river but without the peaks of enthusiasm that characterized the latter experience.

As one would expect, the nature of the miscellaneous references differed widely from one to the other. In 1921, for example, Jean Royère published an article devoted to Francisco Contreras in the *Mercure de France*. Pleased with the tenor of his remarks, a reviewer in *Nosotros* noted that he had publicized many important writers including Apollinaire.[84] In contrast to this reference, which was minimal, the mention of two verses from "1909" (OP, 138) by Francisco Luis Bernárdez is potentially more rewarding. Bernárdez was an Ultraist poet who never entirely renounced *modernista* aesthetics. In *Kindergarten* (1923), however, which was published in Spain, he deliberately sought to scandalize his readers. Entitled "Novias niñas" ("Little Girl Friends"), the third section toyed with the socially

unacceptable theme of pedophilia. As an epigraph, moreover, the author chose the following lines which, at least in the original, describe a narcissistic temptress: "Elle était si belle / Que tu n'aurais pas osé l'aimer."[85] For better or for worse, this is the only time Bernárdez referred to Apollinaire in his works. While he was conscious of the poet's importance, he chose to follow other models.

Two allusions to Apollinaire that were more rewarding occurred the same year in *Pegaso* (*Pegasus*), published in Montevideo. Writing in September José G. Antuña took a long look at the poem in prose, which he generally disliked, and excoriated two of its practitioners: Roger Allard and Lucien Fabre.

> However, one must recognize that despite all this nonsense, a few magnificent talents have emerged from the same groups—salvaging the rare essence of their inspiration despite the ridiculous extravagance that surrounds them—and that intense Guillaume Apollinaire, initiated during the Symbolist period, who is superior to his numerous imitators.[86]

One wonders which of Apollinaire's works Antuña was thinking of. While they included a great many compositions in *vers libre*, relatively few poems were written in prose. Almost despite himself, in any case, the author acknowledged the greatness of Apollinaire's achievement. A similar opinion was voiced by José María Delgado in the following issue, who noted the role the poet had played in Spain. Reviewing a book by one of the Spanish Ultraists, he briefly described the movement itself. "The author belongs to that intrepid group of Spanish poets," he explained, "who, horrified by traditional threadbare aesthetics, have launched a movement in search of virgin territory following the trail blazed by Apollinaire."[87] There was no doubt in Delgado's mind that the French poet had opened up the vistas that the Ultraists were currently exploring.

In 1924, Apollinaire's name figured in three separate articles, each of which was concerned with a different artistic genre. Writing in *Teseo* (*Theseus*), likewise published in Montevideo, Juan Parra del Riego invoked his reputation as a writer of avant-garde fiction. A transplanted Peruvian, Parra was a talented poet who died the following year at the age of only thirty-one. Reviewing Jules Supervielle's *El hombre de la pampa* (*Man of the Pampas*), he was struck by the novel's seeming lack of originality. The fantastic genre had already been explored in depth, he complained, by a number of previous novelists. Authors such as Edgar Allan Poe, H. G. Wells, Mark Twain, and Apollinaire had exhausted most of the possibilities—not to mention earlier writers like Rabelais and Voltaire.[88]

That Parra saw fit to include Apollinaire's name in this list of illustrious predecessors is highly revealing. Whether he was referring to the latter's novels or to his short stories, he clearly regarded him as a very talented fiction writer.

Turning his attention to poetry, Émile Malespine discussed the language of the unconscious in the Argentine journal *Inicial*. The editor of *Manomètre* in Lyon, he was well qualified to comment on recent developments in France. The brunt of his argument was that logic and poetry were incompatible, since poetry dealt primarily with emotional truths. To illustrate his remarks, Malespine cited brief selections from Paul Morand, Baudelaire, and Apollinaire. As an example of the latter's imagination, he quoted the second verse from "Zone": "Bergère, ô tour Eiffel le troupeau des ponts bêle ce matin" (OP, 39). Later in the year, the same journal published an article devoted to the Argentine Cubist painter Emilio Pettoruti. Complaining that Pettoruti was hopelessly old-fashioned, Roberto A. Ortelli, who was one of the editors, mounted a savage attack on the artist and his admirers. The latter, he added, were a bunch of professional gossips whose actual understanding of art was nil. Despite recent advances in aesthetics, their idols continued to be Apollinaire and Cocteau, whose theories had been superseded.[89] Ortelli's quarrel was not with the poet himself, who simply belonged to the past, but with those who refused to embrace the present. Among other things, his comments reveal that Apollinaire's name was commonly invoked in connection with Cubism and that it had acquired a certain prestige.

From 1923 to 1928, an important literary journal entitled *Valoraciones* was published in the town of La Plata. In January 1925, an article appeared by Francisco Contreras concerning Jean Royère, the editor of *La Phalange* in Paris. Reviewing the latter's recent book *Quiétude*, which recounted his friendship with various individuals, Contreras noted that these included Apollinaire. "He describes Guillaume Apollinaire," he reported, "as a 'child of the soul,' salvaging from the sea of Death 'the grapes' of his lyricism and the acid fruit of his 'bitter ideal.'"[90] That Royère was fond of the poet, whom he published in *La Phalange*, is attested by other documents as well. For our purposes, the fact that Contreras added his own personal assessment to Royère's is at least as interesting. Listing on the next page some of the individuals who were associated with the review, he included Apollinaire among "the very best young writers."

During the 1920s, *La Pluma* (*The Pen*) was probably the most influential literary journal in Uruguay. Edited by the eminent critic Alberto Zum Felde, who seems to have patterned it on the *Mercure de France*, it

addressed a variety of modern topics. Despite its good intentions, some of the discoveries that it introduced were not as recent as the accompanying notes suggested. In 1927, for example, the review published a selection of modern French poetry translated by Luis Eduardo Pombo. In addition to a poem by Blaise Cendrars, the latter consisted of two texts by Apollinaire: "Nuit rhénane" (OP, 111) and "Les Fiançailles" (OP, 128–36).[91] These works were accompanied by an editorial note specifying that they represented the latest French verse, in which punctuation had been abolished. In reality, Apollinaire had eliminated punctuation many years before, in 1913, which was the date the two poems appeared in *Alcools*. The translator had not even bothered to choose some of his later poetry.By 1927, in any case, Apollinaire was no longer living, and literary cubism had been replaced by Surrealism.[92]

Two years later, the Peruvian author Federico Bolaños, who was well acquainted with modern verse, provided an excellent account of its development in the same review. The revolutionaries who had succeeded in overthrowing the old regime, he declared, were Tristan Tzara, Apollinaire, Max Jacob, Reverdy, Aragon, Soupault, Marinetti, Picabia, Cendrars, and Cocteau.[93] While each of these individuals had helped to revolutionize modern poetry, the mechanism itself had been set in motion by Marinetti and by Apollinaire. This assessment was echoed by the Mexican author Alfonso Reyes in May 1929 who, in an article published in Argentina, acknowledged that he was living in a post-Apollinarian era.[94]

The Mexican Revolution

In contrast to Argentina, where Apollinaire's reception was shaped by Ultraism and related doctrines, Mexico was much less dependent on the Spanish movement. Whereas Jorge Luis Borges occupied a central position in the avant-garde in Buenos Aires, the Mexican movement lacked a comparable leader about whom it could coalesce. In both instances geography played an important role in determining the nature and the extent of foreign influence. Argentina's isolation actually favored its link with Spain, which served as a lifeline between it and Europe. On the other hand, Mexico's proximity to the United States subjected it to different literary currents. Reviewing the relevant documents from this period, one is struck by the degree of Anglo-American presence in Mexican literature. While Mexican writers were interested in events transpiring in Spain and in France, they were attracted to North American experiments as well. In addition, they were aware of Italian Futurism, with its genius for publicity, and of developments in the rest of Latin America.

If "Zone" is the poem most obviously associated with Argentina, "Lettre-Océan" is the work in which Mexico plays the largest part.[1] The first calligram to appear in print, it was addressed to Apollinaire's brother Albert who was employed in a bank in Mexico City.[2] An experiment in visual and verbal simultaneity, the poem included numerous references to Mexico as well as fragments of Albert's letters. On the left the words "REPUBLICA MEXICANA TARJETA POSTAL" were juxtaposed with a Mexican 4 centavo stamp. On the right, beneath an allusion to Chapultepec Park, several Spanish obscenities demonstrated Apollinaire's command of the language. Other lines referred to Mexico's indigenous population, to specific towns, and to an exotic fruit called the *chirimoya*.

Although the calligrams were largely a Cubo-Futurist invention, they were subject to other influences as well. One of these was the Chinese written character, which appears to have served as a model at some point. Another was the Aztec or Mayan glyph, which may have played a similar role. At the very least, an intriguing parallel exists between the two forms. Indeed, Apollinaire called attention to the ideographic properties of ancient Mexican writing himself. Approximately two weeks after "Lettre-Océan" appeared in *Les Soirées de Paris*, he evoked the latter in connection with the work of a modern French sculptor. "Sait-on," he asked, "que les anciens Mexicains avaient réalisé dans un idéogramme merveilleusement abstrait le mouvement qui a toujours été le but de l'art de [Raymond] Duchamp-Villon?"[3] This surprising bit of knowledge was probably communicated by Marius de Zayas, who collaborated with Apollinaire during this period and who originally came from Veracruz (see chapter 3). What makes this reference even more interesting, besides its proximity to the first calligram, is its terminology. As we have seen, Apollinaire insisted that his visual poems were ideograms as well.

Since his brother actually resided in Mexico, Apollinaire took an unusually great interest in what transpired there. In addition he worried continually about Albert's safety. By this date, the Mexican Revolution was in full swing, and his brother was constantly exposed to danger. Some idea of the political situation can be glimpsed from Albert's letters to Apollinaire, bits and pieces of which appeared in the latter's columns. In February 1914, for example, the poet discussed the situation of the French colony in Mexico City and reproduced a secret document describing plans for its defense.[4] Other sources of information about events in Meso-America included the Mexican colony in Paris, which was surprisingly large. A number of its members were artists and writers who were personally acquainted with Apollinaire. Among the various painters whose paths crossed his own, were Angel Zárraga and an artist known simply as Atl, both of whom were destined to make significant contributions to Mexican art. Although few traces remain of the Zárraga's commerce with Apollinaire, we know he was invited to the poet's banquet in 1916 but could not attend. Included in the Apollinaire's voluminous correspondence is the following note: "Guillaume Apollinaire, / Je suis de tout coeur avec ceux qui vous fêtent aujourd'hui. / Angel Zárraga / Ce dimanche 31 X 1916."[5] By contrast, Apollinaire's relationship to Atl (whom Mexican writers always called Dr. Atl) revolved about the the artist's exhibitions. In May 1914, for instance, he published two reviews of

an important show at the Galerie Joubert et Richebourg, which featured a number of Mexican landscapes.[6]

According to Luis Mario Schneider, Apollinaire was also acquainted with the Mexican poet Rafael Lozano, who would edit an international review during the 1920s.[7] Entitled *Prisma* (*Prism*), it was published in Barcelona during 1922 and included a wide collection of fairly conservative poetry. While Apollinaire's name was mentioned on two occasions, these references were minimal. Lozano himself lived in Paris, where he served as a major European correspondent for the Mexican newspaper *El Universal Ilustrado*. Since his poetry was entirely traditional, he does not seem to have played much of a role in the avant-garde. Although these were relatively minor figures, Apollinaire knew at least one Mexican who was destined to become a giant: the artist Diego Rivera. Before he returned to his homeland in 1921, Rivera was a well-known member of the Parisian avant-garde whose friends included many important writers and painters. One of the latter was Pablo Picasso, who introduced him to Apollinaire, who in turn praised his art in a series of sympathetic reviews.[8] In 1960, describing his early days in Paris, Rivera spoke of the poet fondly and recalled that he had been profoundly impressed by one of his works.

> Coming to my defense and advocating my right to paint as I wished, Guillaume Apollinaire wrote a novel in which, conscious of his approaching death and yet in complete control of his expression, he depicted the feelings of an artist in conflict with the vulgar world of the dealers.
>
> Apollinaire's last novel was one of the most forceful and beautiful books I have ever read. It was unfortunately never published for, when Apollinaire died, Rosemberg and other dealers bought the manuscript from his widow and suppressed it, if they did not destroy it.[9]

Precisely which novel this could have been is difficult to say. While Rivera's account specifies that the text was never published, several indications point to works that actually did appear in print. Whereas the first paragraph would seem to describe *Le Poète assassiné*, the second is reminiscent of *La Femme assise*. Whatever the explanation, what matters here is that Rivera was able to read the book in manuscript form. Although his memory may have been faulty, he was obviously on intimate terms with Apollinaire at one time.

JOSÉ JUAN TABLADA

When they eventually returned to Mexico, the individuals mentioned above contributed to the aesthetic revolution that was in progress. Steeped in the latest Parisian doctrines, they participated in various avant-garde manifestations and helped to further Apollinaire's reputation. Within Mexico itself, the first person to refer to Apollinaire in print seems to have been the poet José Juan Tablada. An important transitional figure, Tablada helped bridge the gap not only between the *modernistas* and their successors but between the Old World and the New. In 1912, for instance, he spent some time in Paris, where he was able to observe the avant-garde at first hand. Among other things, we know he visited Diego Rivera's studio and familiarized himself with Cubist aesthetics. Eleven years later, in an article on modern Mexican art, Tablada evoked the painter's early days in Paris. Although by that time Rivera had developed his mature style and was becoming known as a muralist, Tablada insisted that his earlier efforts were equally important. Despite his Mexican background, he declared, "he contributed considerably to the Cubist movement, encouraged by the poet-critic Guillaume Apollinaire, taking a most important place amongst his confrères."[10]

As José María González de Mendoza rightly observed, Tablada was "the first member of the avant-garde" in Mexico.[11] "From the century's begining," he continued, "Tablada heralded each successive assault, but he did not become truly influential until he returned from New York, in 1918, following an absence of four years." What the author neglected to say was that Tablada spent little time in his native country even then. Exiled during the first phase of the Revolution, he spent the years between 1914 and 1918 in New York City. Thereafter he served in the Mexican Consular Service in Colombia and Venezuela until sometime during 1920 when he returned to New York. Throughout this period, he maintained his national identity by corresponding with colleagues back home and by publishing articles and poems in Mexican periodicals. Indeed, Tablada is generally credited with introducing the Japanese haiku to Mexico at this point in his career. In addition, he introduced the Mexican public to visual poetry at approximately the same time.

Literary historians have wondered ever since where Tablada got the idea of writing poems in the shape of objects. While the origins of his haiku are clear, critics have shied away from the problem of his visual sources. Frequently they have been content to evoke vague parallels and improbable coincidences. Insisting on Tablada's role as an intermediary between France and the New World, González de Mendoza declares that "he instructed us in the rhythms of Apollinaire, Claudel, Cocteau, and

Blaise Cendrars."[12] Elsewhere he discerns a "parallel" between Tablada's visual compositions and those by Apollinaire but concludes that this was "a coincidence since certain ideas, certain tendencies, were dissolved so to speak in the atmosphere of [this] particular period."[13]

Since Tablada repeatedly denied being influenced by Apollinaire, González would seem to be on safe ground. Nevertheless, despite the poet's own testimony, circumstantial evidence strongly suggests that this was the case. For one thing, we know Tablada admired Apollinaire's poetry. As Carlos Pellicer testified in 1925, "during this period the lyric experiments of Apollinaire, Cendrars, and Reverdy filled him with enthusiasm."[14] For another thing, he seems to have appropriated the French poet's terminology to describe his visual compositions. Like Apollinaire's "idéogrammes lyriques," whose name acknowledged their debt to the Chinese written character, Tablada's first experiments with plastic poetry were entitled "Madrigales ideográficos." For our purposes, however, the most important evidence is provided by the context in which these works were conceived. By the poet's own admission, his first visual poems were composed in 1915, during his sojourn in New York.[15]

What makes this information so interesting is that Tablada was a close friend of Marius de Zayas, with whom he spent his childhood in Mexico City. In the first volume of his autobiography, Tablada recounted his visit to New York and his joy at being reunited with his former neighbors.[16] Forced to leave Mexico by the dictatorship of Porfirio Díaz, the de Zayas family had settled in New York in 1907, where its members soon began to prosper. In the interim, Marius had become a successful caricaturist and an associate of Alfred Stieglitz, whose "291" gallery was one of the focal points of avant-garde activity. In 1914, as we saw in chapter 3, he witnessed a series of avant-garde experiments in Paris and collaborated on a pantomime by Apollinaire. In addition, he published four abstract caricatures in *Les Soirées de Paris*. Four years later, in an article about Mexican artists living in New York, Tablada recalled the latter accomplishment and described his friend's credentials as an authority on modern art. "In addition to being their intimate friend," he informed his readers, "de Zayas is an artist who is recognized and respected by the princes of Modern Art: the divinely inspired Picasso, the exasperated Picabia, and Guillaume Apollinaire the poet and critic."[17]

In 1915, the date of Tablada's "Madrigales ideográficos," de Zayas opened the Modern Gallery in New York and began to publish the review *291* (in March). Both ventures were patterned on similar models in Paris and allowed de Zayas to channel his enthusiasm for the French avant-garde into concrete projects. Judging from subsequent events, this enthu-

siasm appears to have been contagious. Not only was Tablada exposed to the latest aesthetic doctrines, but he could observe them being translated into works of art. In particular, *291* devoted considerable space to experiments with visual poetry. Beginning with Apollinaire's *idéogramme* "Voyage" (OP, 198–99) in the first issue, a whole series of compositions appeared by a number of different authors. In all probability, this was the experience that spurred Tablada to create his first two visual poems: "El puñal" ('The Dagger') and "Talon rouge."[18] Like Apollinaire, he combined the two poems to form a larger visual composition. Although the latter appeared to be a still-life, in reality it was a symbolic portrait of a *femme fatale*. Juxtaposed with a wicked stiletto, which represented her piercing gaze, a high-heeled shoe betrayed her determination to grind him under her heel. According to all indications, "El puñal" and "Talon rouge" were light-hearted experiments rather than revolutionary statements. Carried away by the exhilarating atmosphere surrounding *291*, Tablada simply tried his hand at the new genre. Thereafter, for the next three or four years, he turned his back on these experiments and occupied himself with other matters. Although he flirted briefly with visual poetry in 1917, in "Impresión de adolescencia," the seeds planted by Marius de Zayas and his friends did not bear fruit until the following year. Since Apollinaire also published *Calligrammes* in 1918, one suspects this was an important factor as well. Toward the end of the year, several events testified to Tablada's renewed interest in the genre. By this time, for one thing, he had decided to devote an entire volume to visual poetry and had completed the first of a new series of visual compositions: "Impresión de la Habana." For another thing, he began to publish these and earlier works in various periodicals.

In December, "Talon rouge" appeared in a journal entitled *Voces* (*Voices*), which was headquartered in the unlikely town of Barranquilla, Colombia.[19] In January 1919, this work and two more like it ("El puñal" and "Impresión de la Habana") appeared in *Social*, published in Cuba.[20] The editor explained that the author had recently passed through Havana on his way to a South American diplomatic post. The most recent example of his "poesía ideográfica" had in fact been composed during his Cuban sojourn. Significantly, it is virtually the only one of Tablada's visual poems that invites comparison with a specific work by Apollinaire. Juxtaposed with the outlines of a lighthouse, a flock of birds recalls the bird in "Voyage" (OP, 198–99), and a swaying palmtree mimics the fountain in "La Colombe poignardée et le jet d'eau" (OP, 213). This unusual combination of forms prompted the Mexican newspaper *El Universal Ilustrado* to reprint the three poems in February.[21] Noting that they illus-

trated Tablada's new cubist style, the editor added that the poet had been named secretary of the Mexican Legation in Ecuador.

Before he had a chance to get settled, Tablada transferred his diplomatic activities to Venezuela, where he remained for at least a year. True to form, he contacted the illustrated weekly *Actualidades* (*Current Events*), published in Caracas, which devoted an entire issue to his work including the visual material. On July 20, 1919, an interview also appeared in which he discussed his recent works.[22] By this date, knowledge of Apollinaire's visual experiments seems to have been relatively common. While everyone naturally assumed Tablada's poems were inspired by *Calligrammes*, Tablada himself did not wish to become known as an imitator. In the interview, as he would do on subsequent occasions, he pointed to other antecedents and adjusted the original chronology. The sources of his poems, he maintained, were the *Greek Anthology* and an obscure book by the novelist Jules Renard in which a line of 3's evoked a procession of ants. While he admitted that Marius de Zayas showed him "Lettre-Océan" in New York in 1915, he insisted that the "Madrigales ideográficos" had already been written. "In any case," Tablada added, "I am an enthusiastic admirer of Apollinaire, and I have the greatest respect for his illustrious memory."[23]

Intended to establish his precedence over Apollinaire, the reference to his experience in New York is curious indeed. Although he was an intimate friend of Marius de Zayas, Tablada made no reference whatsoever to *291*, which he must certainly have seen and which contained a second calligram by the French poet, namely "Voyage." And yet by his own admission, the two men discussed Apollinaire's experiments with visual poetry at a time when de Zayas was pursuing similar experiments himself. The only place Tablada could have seen "Lettre-Océan" initially was in an issue of *Les Soirées de Paris* his friend had brought back from Paris. By 1919, the poem had been collected in *Calligrammes* which, judging from the article, Tablada seems to have acquired. Opening the volume to the appropriate page, he showed the work to his astonished interviewer.

> Tablada showed us the famous "Lettre-Océan," addressed or dedicated to Albert Kostrowitzsky, who lives in Mexico and who is Apollinaire's brother. The poem is a beautiful nebula in a nocturnal sky filled with emptiness and mystery. . . . Ramón Vinyes, the learned critic and editor of *Voces*, the most advanced art review in Columbia, rightly believes that Tablada's synthetic and ideographic poems brilliantly resolve the obscure aesthetic problems initiated by the French poets Apollinaire, Birot, and Reverdy.

Another interesting series of events revolved about an exchange of letters between Tablada and Ramón López Velarde in Mexico. On June 18, 1919, two months after the publication of the "Madrigales ideográficos" in *El Universal Ilustrado*, the latter sent a frank assessment of this new genre to his friend in Venezuela.[24] At this point, López seems to have known little about Tablada's interest in visual poetry except that he planned to include the three poems in a volume entitled *Los ojos de la máscara* (*The Eyes of the Mask*). Visibly pained by the thought that Tablada was cultivating such a frivolous genre, he expressed his reservations while reiterating his belief in the poet's talent.

> Until now ideographic poetry has interested me not so much for itself but because you are cultivating it. When I first saw Apollinaire's poems, I was struck by how conventional they were, and this impression still persists following the publication here of the poems that appeared in Havana. Undoubtedly *The Eyes of the Mask* will enlighten me and cause me to revise my opinion. For the time being, I seriously doubt that ideographic poetry possesses the fundamental conditions that are necessary for the creation of a work of art.

Tablada's reply, which was published in *El Universal Ilustrado* on November 13, 1919, addressed each of his correspondent's objections and sketched a general theory of visual poetry.[25] This important document, which is too long to quote entirely, began with the poet's familiar defense, discussed various aesthetic considerations, and ended with a brief comparison with Apollinaire. In addition to the *Greek Anthology* and Jules Renard's ants, Tablada cited a collection of Confucian hymns as the source of his visual inspiration. "Five years ago in New York," he continued, "I created the 'Ideographic Madrigals.' Later I saw several similar attempts by Cubist painters and a certain *modernista* poet. But they were no better than stuttering, whereas my present poems constitute a distinct language."

Once again these statements are extremely suspect and suggest the author was trying to conceal his debt to the individuals associated with *291*. For one thing, Tablada appears to have deliberately misrepresented the date of composition of his earliest visual works. When the "Madrigales ideográficos" were included in *Li-Po y otros poemas* (1920), they were assigned not to 1914 but to the following year. For another thing, he deliberately eliminated any reference to Apollinaire, whose poetry we know he encountered. The "*modernista* poet" was probably Vicente Huidobro and the Cubist painters, Marius de Zayas and Francis

Picabia. Seeking to justify these curious distortions, at least to himself, he dismissed their efforts as hopelessly amateurish. Since López specifically referred to Apollinaire in his letter, Tablada could not ignore him altogether. "Although my ideographic poetry was similar to Apollinaire's in the beginning," he remarked toward the end, "today it is totally distinct." His recent works were noteworthy for their synthetic view of life, he continued, not for their visual shapes which were largely incidental. Despite his efforts to downplay the importance of visual form in his poetry, Tablada revealed more than he originally intended. Although he refused to acknowledge his debt to Apollinaire, he conceded that the early visual poems were not much different from the latter's calligrams.

ALFONSO REYES

Like Tablada, the poet, essayist, literary critic, and short story writer Alfonso Reyes was often absent from his native land. Like the author of the "Madrigales ideográficos," he spent much of his life in the Mexican diplomatic service, eventually serving as the ambassador to Brazil and to Argentina. The first in a long line of important literary figures who earned their living in the service of the nation, Reyes resided in other countries from 1913 to 1938. During this period, in which he became "Spanish America's foremost humanist and man of letters," he continued to participate in Mexican literary affairs.[26] One of the ways in which he maintained contact with, and influence on, Mexican literature was through his review *Monterrey*, which appeared between 1930 and 1937. Edited first in Rio de Janeiro, then in Buenos Aires, it ignored literary developments in the countries in which it was printed and concentrated on what was happening in Mexico.

During the period 1914–24, Reyes resided in Madrid, where he made a living as a professional writer before joining the Mexican diplomatic service. In 1920, during the height of the Ultraist movement, he published a review of a book by one of the *ultraístas'* favorite authors in the weekly newspaper *España*.[27] Concerned with *La Femme assise*, the review summarized Apollinaire's plot in considerable detail and proceeded to distinguish between two types of novel. In contrast to the traditional novel, Reyes explained, whose duration parallels the hero's education, another kind of novel consists of a series of symbolic moments. In the second instance, the hero's value is decorative rather than psychological and corresponds to the novel conceived as a still-life.

> This describes Apollinaire's present novel perfectly, a novel conceived in the same way as a painter conceives a still-life. And

since the author is Apollinaire, one perceives that his technique is identical to that of the Cubist painters. . . . Everything [is] combined to form an endless kaleidoscope

Having traversed the dislocations caused by Cubism's broken mirrors, we who are shamelessly enamoured of "form" . . . would like to return to the concept of synthesis, as the Cubists in Paris are doing at present, to a drawing of the whole, to the "arabesque" which was spoken of with great disdain before the war, although this concept clearly informed Cubist doctrine. We would like this combination of different places and themes crisscrossing Apollinaire's novel to correspond to a certain sense of necessity and coherence; to a certain sense of rhythm like that experienced by a reader of the Arabic "tale of tales" who perceives its elementary symmetry; to a certain momentary sensation when the central picture expands—like a cell in the process of division—to encompass a second picture. This chaotic combination of episodes and various discourses should be regulated by a superior principle, but I do not believe Apollinaire has discovered one, although he occasionally senses the need for such a principle. In a sense, Apollinaire has written a "primitive" cubist novel without meaning to.

I repeat: without meaning to. Apollinaire never boasted that he was a primitive, which for him would have been the worst sort of affectation. Apollinaire could be brutal—and he often was—but not affected. He is usually unpretentious and somewhat cynical, both in manner and in deed. He neither lards his style with Frenchisms (This would give his writings a false note and would reveal his foreign origins, just as the ancient Athenians recognized that Theophrastus the Elder was not one of them by his excessive Athenian displays) nor flaunts his exotic extraction, although the exasperated Charles Maurras never ceases to attack him in his tireless "foreigner hunt." To the contrary, his language is neutral, colloquial but not excessively so. Here and there one glimpses the curious cataloguer of the Bibliothèque nationale's "Enfer," the naughty collaborator of "Le Coffret du Bibliophile" and other collections that play the same role in French life, more or less, as the "Biblioteca de López Barbadillo y sus amigos" in Spain.

A rapid survey of the principal themes that traverse his work will give some idea of the latter's agreeableness. . . . The reader will already have noted that Apollinaire likes to include

real people among his imaginary characters, as the Cubists paste a piece of wallpaper onto their canvases to represent a wall. . . . [One finds] bits of information about the Mormons in America during the 1850s, presented in a brilliant, caricatural portrait full of vivid visual impressions; . . . anecdotes that resemble either bees (with epigrams) or dragonflies (floating, lyrical, with no barb) in which Apollinaire always excelled. . . . And, lost among the others, the story I have chosen to end with concerning an artist whose town was destroyed during a battle. . . . Returning to the ruins, the artist began to draw what used to be his house. . . . Imagine his amazement when, examining his finished drawing, he discovered that he had drawn a charming picture, full of promises, prophetic, testifying to the hope that was emerging from the ruins. [He quotes a passage in which the drawing serves as a metaphor for post-war vision.] Here ends the story of Apollinaire, a hero from the land of the French.

Although Reyes had no way of knowing Apollinaire's widow had published the wrong manuscript, he sensed that the text was seriously flawed. While he was perplexed by the lack of a unifying principle in *La Femme assise*, his review was clearly sympathetic. As much as anything, Reyes responded to the human dimension in the novel and, despite the author's occasional cynicism, to the pervasive optimism, which revealed itself in episodes such as the one he described. In addition, various references demonstrate that his knowledge of Apollinaire's work was fairly extensive. Indeed, he seems to have been a fan of the poet's for a number of years. At the very least, the fact that Reyes praised Apollinaire's anecdotal skills indicates that he enjoyed his column "La Vie Anecdotique" in the *Mercure de France*. His interest even extended to the erotic classics published by the poet and to *L'Enfer de la Bibliothèque nationale* (1913), co-edited with Fernand Fleuret and Louis Perceau. Since Apollinaire was associated with literary cubism, Reyes deliberately compared him to the Cubist painters in several places. However, what interested him most about the author of *La Femme assise* was his skill as a writer. On the one hand, he praised his vivid portraits, which brought the characters to life. On the other, he praised his excellent style which despite his foreign birth was thoroughly French. The secret of Apollinaire's eloquence, he maintained, was to be found in his style, which was not only cultivated but highly expressive.

Although this was the only article Reyes ever devoted to Apollinaire, his interest in the latter continued unabated over the next forty years. In his eyes, as subsequent allusions reveal, the French author was a major lit-

erary figure to whom it was necessary to return year after year. As time passed and as more and more documents were published by or about Apollinaire, he acquired an encyclopedic knowledge of his life and works. Reviewing Alfonso Hernández Catá's *La casa de fieras* (*The Animal House*) in February 1923, for instance, Reyes remarked that it reminded him of Apollinaire.[28] Judging from the context, he was undoubtedly thinking of *Le Bestiaire*, which in its own way resembled a small zoo. Similarly, in 1929, he published a short article in praise of a newspaper that had recently begun publication in Buenos Aires.[29] What he especially liked about *El Mundo* (*The World*), he declared, was its commitment to brevity and its telegraphic style, echoing recent developments in literature. In view of its synoptic tendencies, he added, one could call it the first post-Apollinarian newspaper. This brief allusion suggests that for Reyes the poet's work was synonymous with modernity. *El Mundo* was "posterior a Apollinaire" not because it superseded the latter but because it was the first newspaper to benefit from his experiments.

In October 1930, an article in which the same writer discussed the Douanier Rousseau's alleged sojourn in Mexico appeared in *Monterrey*.[30] Recalling Apollinaire's affection for the eccentric painter, Reyes referred his readers to an article collected in *Il y a* and quoted several lines of poetry that were relevant. As before, he displayed his familiarity with Apollinaire's column in the *Mercure de France* when he attributed the latter's interest in Rousseau to his fondness for anecdotes.

> For Guillaume Apollinaire, who was naturally curious, the discovery of the Douanier Rousseau must have been welcome in more ways than one; not only was it a pictorial find but a picturesque find as well. Henri Rousseau was one of the centerpieces in his collection of anecdotal lives. And of all the possible adventures of Rousseau's picturesque existence, what better example than a trip to Mexico, in the military service . . . during the intervention by Napoleon's troops? *Il y a* (Paris: Messein, 1925) contains an earlier article by Apollinaire, dated 1914, in which there are occasional references to this problematic sojourn in Mexico, which critics consider the source of two or three of Rousseau's paintings.

At this point, Reyes quoted the first stanza of "Tu te souviens, Rousseau" (OP, 655), which also evoked the artist's Mexican experience. More than anything, he added, Apollinaire's reference to the Emperor Maximilien's execution reminded him of a painting by Manet. Interestingly, both the poem and the article originally appeared in *Les*

Soirées de Paris in January 1914.[31] While the second text was later included in *Il y a*, the first was never collected and by 1930 was virtually unknown. Although Reyes could conceivably have seen the poem in *Les Soirées de Paris*, he may also have encountered it in one of the books devoted to Rousseau that had appeared in the interim.

Subsequent references to the French poet were fairly brief but encompassed a variety of topics. The following year, Reyes mentioned Apollinaire in an article devoted to the theme of virtue rewarded by punishment.[32] Cast in the form of an open letter to the poet Gilberto Owen, the study examined the eighteenth century in particular and focused on the Marquis de Sade, who favored this theme in *Justine* and other works. Indeed, Reyes noted that the novel's earliest version, which Apollinaire first discussed in 1909, was entitled *Les Infortunés de la vertu*. Under the title "Le Divin Marquis," the latter study served as a preface to a selection of Sade's writings published by "Les Maîtres de l'Amour."[33] Judging from the ease with which Reyes was able to provide these bits of information, he almost certainly owned a copy of this edition. Since he also knew Apollinaire wrote for the series "Le Coffret du Bibliophile," and that he had authored *L'Enfer*, he seems to have been interested in erotica himself. One would not be surprised to learn that he possessed many of the volumes edited by Apollinaire.

During a discussion of nationalism's aesthetic pitfalls in 1932, Reyes cited Apollinaire and Joseph Conrad as examples of famous writers who expressed themselves in the language of their adopted countries (*Obras*, 8:444). Had the proponents of national purity prevailed, he reminded his readers, these authors would have been dismissed as half-breeds and "literary pirates." Worse yet, they would never have existed at all. In view of Hitler's rise to power in Germany and the persistent rantings of individuals associated with the Action Française, Reyes' lesson was certainly a timely one. The following year the French writer Camille Pitollet published an article in *Monterrey* devoted to early visual poetry.[34] Labeling Apollinaire the spiritual father of Cubism, he took André Billy's definition of the calligram in *Littérature française contemporaine* as his starting point. In addition to the definition itself, the passage that he quoted contained a succinct appraisal of the calligram's value as a literary form. "Dans cette gageure," Billy announced, "Apollinaire a mis un talent, un esprit, une délicatesse d'invention incomparables."

Reyes returned to Apollinaire's works at least three more times in a collection of articles, dating from 1940, which was published posthumously. Entitled *Apuntes para la teoría literaria* (*Notes on Literary Theory*), the volume touched on a great many subjects and demonstrated the

author's remarkable erudition. Discussing the legend of Lilith at one point, Reyes deftly sketched the myth's evolution from the ancient Sumerians to such modern authors as Anatole France, George Bernard Shaw, and Apollinaire (*Obras*,15:435). Although he did not amplify the latter remarks, he was undoubtedly thinking of Apollinaire's novels, in which she plays an important role.[35] While Lilith also appears in several poems, Reyes' remarks elsewhere in the article suggest that he was thinking of *Le Poète assassiné, La Femme assise*, and perhaps *L'Enchanteur pourrisant*. A few pages later, during a discussion of characterization in the novel, Reyes cited the poet's example once again. Drawing on his 1920 article, he explained that many modern authors resembled the Cubist painters insofar as their works were structured without regard for ordinary logic. This procedure was exemplified by "still-life novels such as *Le Poète assassiné* or *La Femme assise*, by Guillaume Apollinaire, in which the overall impression, like the atmosphere, is produced by the accumulation of disparate elements according to Cubist aesthetics" (*Obras*, 15:441).

Twenty pages later, Reyes returned to the cubist novel in a section concerned with literary form. What interested him in particular was whether it was possible to combine one genre with another to produce a satisfactory hybrid. Attempts to integrate other forms into the novel, he continued, had met with partial success over the years whenever they participated in the novelistic structure. However, works such as *Le Poète assassiné* were predicated on a new vision of reality that questioned the traditional notion of unity. In Apollinaire's case, the absence of unity was partially compensated for by the vigor with which a wide range of elements were incorporated into the finished product.

> Apollinaire's cubist novel *Le Poète assassiné*, which utilizes juxtaposition and whose precarious unity depends on a few general traits (barely delineated), contains something for everyone: versicular dialogues between midwives; a fable of an oyster and a herring; the author's personal observations related in the first person; poems that advertise various medications; allegorical dialogues between abstract characters such as The Theaters, The Actor, The Imbibers; acrostics; "popular" songs invented for the occasion; and a thousand additional fantasies. In this case, however, the traditional criterion of unity is useless, since the very nature of the work discourages the poetic fragments from fusing with its subject without actually preventing them. The following observation, by the author, could well describe the work itself: "Toutes les matières des différents règnes de la nature peuvent maintenant entrer dans la composition d'un costume de femme." (*Obras*, 15:462).[36]

Writing about Mexican literature in 1941, Reyes mentioned Apollinaire's name briefly in connection with an individual we have already examined: José Juan Tablada. Following a period in which the poet published little or nothing, he explained, he began to cultivate synthetic poetry and the Japanese haiku. Echoing the official account, Reyes ascribed the invention of the "Madrigales ideográficos" to Tablada himself. Although the latter's visual compositions resembled Apollinaire's, he asserted, they had been invented independently (*Obras*, 12:202). The following year, Reyes neatly summarized Apollinaire's significance for the modern movement during an interview that was broadcast over the radio. Praising an obscure primitive Mexican painter, he was reminded of the Douanier Rousseau who had exerted such a profound impact on modern aesthetics. "He was discovered by Guillaume Apollinaire," he recounted, "who was of Polish-French extraction, a poet, a scholar, a journalist, and an untiring investigator of human behavior—one of those individuals who insinuate themselves into society by performing useful services and end up at the helm of literary and artistic movements") (*Obras*, 9:253). Once again Reyes remembered reading Apollinaire's column in the *Mercure de France*, whose anecdotes were indeed concerned with "curiosidades humanas." While his remarks about Apollinaire's rise to a position of authority are open to interpretation, he was probably thinking of the poet's importance as a propagandist. Seen in this perspective, Apollinaire's services were primarily journalistic as he defended one aesthetic cause after another. Since he never actively sought such a position, moreover, he was as surprised as anyone to find himself head of the French avant-garde.

In an article entitled "Los estímulos literarios" ("Literary Stimuli"), published in *Filosofía y Letras* in October 1942, Reyes divided authors into three categories. Whereas some writers responded primarily to olfactory stimuli, he declared, others were motivated by palatal or tactile experiences. Indeed whole movements occasionally focused on one or another of these sensations. Such a movement was Marinetti's *tactilismo*, which he proposed in 1921. Several years before that, Apollinaire had announced the birth of tactile art which, like Marinetti's venture, ultimately came to nothing (*Obras*, 14:283). Reyes was referring here to one of Apollinaire's columns in the *Mercure de France* in which he discussed "un plâtre à toucher" that was currently being displayed in New York.[37] Since the poet had imagined just such an art in a previous short story, his attitude was frankly paternal.

Reyes' final reference to Apollinaire occurred some seventeen years later in *Prevision y seguridad* (*Prudence and Security*) (1959). During a learned discussion of Utopian projects, he distinguished between individ-

uals who were content to dream and those who actually tried to implement their plans. The practical Utopians, he continued, were attracted to America in particular where their burning faith served to mask various imperfections. In the New World, no one cared if a prophet consorted with women of the streets, like Apollinaire's Pamela, while he was recruiting new members in Paris. Everything was viewed as grist for the mill (*Obras*, 11:383). Reyes was alluding here to the Mormons, whose history forms the backdrop of much of *La Femme assise*. The episode in question is recounted in a fictitious letter from John Taylor to Brigham Young reporting on his recent activities. Sent to Paris as a missionary, Taylor writes that he has converted the frivolous Pamela Monsenergues and is bringing her back to America with him.[38] Although Reyes' reference was uttered in passing, it testifies to his lifelong interest in Apollinaire's fiction, especially the experiments with cubism. Despite his apparent lack of enthusiasm for *Alcools* and *Calligrammes*, he returned to Apollinaire's novels again and again.

MANUEL MAPLES ARCE

In contrast to the rest of Latin America, the birth of modern Mexico coincided with a period of intense political turmoil. Between 1910 and 1924, following the demise of Porfirio Díaz' dictatorship, the country was racked by one revolution after another. In response to the forces that were reshaping Mexico's institutions, two aesthetic movements emerged which, in their own way, were equally revolutionary. Embracing the period 1921–27, *estridentismo* was the more radical of the two and included poets, novelists, and artists. Centered around the review *Contemporáneos* (1928–31), the second movement was more restrained and limited primarily to poetry. Although members of both groups began writing toward the end of World War I, the Stridentists were the first to form a coherent movement. Adopting the tactics of the Futurists and the Dadaists, as their name suggests, they not only broke with *modernismo* but laid much of the groundwork for those who came after them. The leading authority on the Stridentists describes the group's significance as follows: "It was a hybrid movement since it borrowed from the European schools, taking everything it could to narrate and to sing the sensations associated with the dawn of the new century and at the same time to inscribe itself in an ethic that sought to undermine words, concepts, and actions."[39]

Founded by Manuel Maples Arce in December 1921, Stridentism burst upon the scene without prior warning. Over a period of six years, its scandalous activities were publicized in a series of manifestos, several

official journals, and numerous *veladas* presented at the Café de Nadie ("Nobody's Cafe") in Mexico City. In a study of modern Mexican poetry which has since become a classic, Luis Monguió depicted the Stridentists as a product of their unique time and place.

> They were poets with revolutionary opinions not just about poetry but about life itself. It is true that virtually all the poets in the *Contemporáneos* group also collaborated in the Mexican Revolution's educational, economic, and political endeavors, but it is also true that this collaboration was never explicitly acknowledged in their poetry. . . . The Stridentists, however, tried to exteriorize the social tension of our era in their writings. . . . Maples Arce observed the mechanical objects of our industrial age and, somewhat like the Futurists, attempted to synthesize their recently discovered beauty in his poetic writings. His poetry also sought to express the new economic, social, and political relations existing between the individual and the masses, especially as they referred to the Mexican experience.[40]

At first glance, *estridentismo* would seem to have been rather paradoxical. On the one hand, its foundations were thoroughly European and its models men like Apollinaire, Tzara, and Marinetti. On the other hand, it was also an indigenous movement, one that strove to reflect the immediate context in which it took shape. Despite this apparent conflict, the Stridentists themselves had no problem in reconciling the two points of view. Although they cultivated the latest European techniques, these were subordinated to strictly Mexican concerns. In this way, avant-garde aesthetics were adapted to indigenous demands. That Stridentism was basically a native phenomenon was recognized by, among others, José Juan Tablada, who in 1924 linked it to the national identity. During a lecture on *estridentismo* at the Museo Nacional, he evoked the Aztec sun-god Huitzilopochtli and appointed him protector of the new movement.[41]

Manuel Mapes Arce arrived in Mexico City from Veracruz in order to prepare for a career in law. While he was carrying out his studies, he became increasingly interested in art and literature, which flourished in the capital's cosmopolitan environment. Initially, he later admitted, he knew virtually nothing about recent developments in Europe. With one important exception, his knowledge was limited to traditional examples and to a few transitional figures such as Tablada.

> I knew little about the latest European movements. The only things I had seen were a few calligrams by Guillaume Apollinaire, especially one that began: "It is raining dead

women's voices in my memory," whose novelty resided in the text's typographical arrangement which imitated the rain's diagonal path. The poem itself simply echoed Verlaine's "Il pleut sur la ville comme il pleut sur mon coeur."

However, its curious design seemed to me to be the height of novelty.[42]

While the author had also seen some of Vicente Huidobro's poems, he was struck by the banality of their inspiration. "By contrast," he added, "Apollinaire's 'Zone,' which I encountered later, and Blaise Cendrars' *Profound aujourd'hui*, impressed me as innovative."

If these remarks shed important light on the evolution of Maples' poetry, which was influenced initially by European models, they point to the formative role played by Apollinaire in particular. In the beginning, he informs us, the only modern works with which he was familiar were the latter's calligrams. These texts not only encouraged him to expand his knowledge of the French poet's aesthetics but shaped his subsequent response to other avant-garde figures. Judging from Maples' own account, his initial experience was limited to a small group of poems. It is clear, furthermore, that "Il pleut" (OP, 203) was one of the calligrams in this group. Although Maples could conceivably have seen this work in *SIC* or perhaps in *Calligrammes*, his testimony suggests that he encountered it elsewhere, probably in an article on modern French poetry. While he neglected to specify his source, he added that the experience occurred when he was "about twenty-one." This means that the list of possibilities can be restricted to 1919.

Fortunately, the article in question can actually be identified. Detailed investigation reveals that a study entitled "Guillaume Apollinaire, el Marco Polo del nuevo arte" appeared in the *Revista de Revistas* (*Review of Reviews*) in March 1919.[43] Since only part of it was devoted to Apollinaire, who was portrayed as the leader of the modern movement, this title was somewhat misleading. In addition, the article examined the Italian Futurists, who were credited with having initiated the new poetry, and the French literary cubists. Faced with such radical aesthetics, the anonymous author thought it prudent to insert a disclaimer at the beginning: "The following presentation is strictly for informational purposes; we neither condemn nor support these new literary reforms." Elsewhere, the author reminded his readers that visual poetry was not a modern invention. "The acknowledged Master of the poets belonging to the present 'futurist' school," he continued, "is Guillaume Apollinaire, who during the recent conflagration risked his life on the battlefield heroically defending his beloved France." Following these remarks, the author

listed thirteen poets who typified the new aesthetics. In addition, he appended several articles by other critics that seemed especially relevant. The first was a translation of a lengthy obituary that had appeared the previous month in *Current Opinion* (see chapter 3).[44] Among other things, it was accompanied by two illustrations that had graced the original publication: a reproduction of "La Cravate et la montre" (OP, 192) and Picasso's portrait of the poet swathed in bandages. The remaining articles, which were much briefer, were by Ramón Vinyes who was associated with the journal *Voces* (*Voices*) in Barranquilla, Colombia. Reprinted from that review, they were concerned with Paul Dermée, Luciano Folgore, and Pierre Albert-Birot. Despite the latter's independence, Vinyes reported, "he accepts Guillaume Apollinaire's leadership. . . . And what is amusing in the Master becomes a technical achievement with Pierre Albert-Birot."[45]

As with the *Current Opinion* article, Vinyes' remarks were accompanied by two illustrations possessing great visual appeal. One of these was a sound poem by Albert-Birot entitled (originally) "Poème à crier et à danser." The other, which like its companion was extracted from a previous issue of *Voces*, was a translation of Apollinaire's "Il pleut."[46] As we saw, this group of documents was Maples' first exposure to avant-garde aesthetics. Just how impressed he was by "Il pleut" can be seen from the fact that he was able to quote the first line from memory nearly fifty years later. To be sure, like his rendition of Verlaine's "Il pleure dans mon coeur," his memory of Apollinaire's verse differed slightly from the original: "Il pleut des voix de femmes comme si elles étaient mortes même dans le souvenir." There is no question nevertheless that Maples once knew this poem by heart. Conceived under the sign of the calligram, whose radical aesthetics it embraced, his poetry would be even more heavily influenced by "Zone" (OP, 39–44) and similar works. Culminating in the publication of *Andamios interiores* (*Internal Scaffolding*) in 1922, his first phase was dominated by a literary cubism taken in large part from Apollinaire.

One event in particular was destined to broaden Maples' knowledge of the international avant-garde. In October 1921, his poem "Esas rosas eléctricas" ("Those Electric Roses") appeared in *Cosmópolis*, published in Madrid.[47] As a result, he later related, he began to correspond not only with the Ultraists but with their counterparts in France and Italy, all of whom sent him copies of books, journals, and manifestos.[48] Before long, Maples found to his surprise that he had acquired considerable expertise and decided to found his own movement. Entitled *Actual* (*Today*), the first Stridentist review appeared in December 1921 amid considerable fanfare.

Consisting of a single sheet, it was circulated by being pasted on strategically located walls like *Prisma* in Buenos Aires. The first issue, like those that were to come, was astonishingly eclectic. Among its various tributes to Futurism, were calls for Chopin to be consigned to the electric chair and a statement taken from the first manifesto: "An automobile in motion is more beautiful than the Victory of Samothrace." Elsewhere a "Directorio de Vanguardia" listed the names of a great many individuals associated with the modern movement, including Apollinaire and his colleagues in Paris.

By July 1922, when the third issue of *Actual* appeared, the Stridentists had acquired a style that was instantly recognizable. Heeding Maples' initial call: "Cosmopoliticémonos!" ("Let's cosmopolitanize ourselves!"), they celebrated the excitement of urban life in poetry filled with flashing imagery and staccato rhythms. In contrast to the earlier issues, the third one included a large number of Ultraist contributions that had been published previously in Spain. For our purposes, the most important text was a translation of "Mutation" (OP, 229) by José de Ciria y Escalante.[49] Belonging to *Calligrammes*, the poem contrasted the changes wrought by the war with Apollinaire's unwavering constancy in love. The following year witnessed the publication of three issues of *Irradiador* and the first of several Stridentist manifestos, issued from Puebla. Dated January 1, 1923, the latter document was signed by Maples Arce, Germán List Arzubide, Salvador Gallardo, and four other individuals. Although it did not mention Apollinaire by name, it was inspired by *L'Antitradition futuriste* (1913) at virtually every level.[50] Indeed, of all the imitations that were elicited by *L'Antitradition futuriste*, the Puebla manifesto was perhaps the most faithful. Like the former, which awarded roses or excrement to a long list of people, the latter was divided into two sections entitled "AFIRMEMOS" ("WE AFFIRM") and "CAGUEMONOS" ("WE SHIT ON") respectively. Among the luminaries assigned to the second category were King Alfonso XIII of Spain and, an equally popular target, Uncle Sam.

The publication of *Urbe* (*Metropolis*) in 1924 testified to Maples' increasing preoccupation with political issues. Subtitled *super-poema bolchevique en 5 cantos*, it was simultaneously a paen to the modern city and a call for social revolution. Discussing contemporary literature in July of the same year, Maples explicitly linked the avant-garde to the society from which it sprang.[51] Like other forms of social expression, he insisted, literature participated in the collective ideology of the historical moment. In the present era it was marked by a shift from a reproductive to an interpretive mode. The three individuals who were responsible for instituting this fundamental change, Maples added, were Max Jacob in *Le Cornet à*

dés, Marinetti in his review *Poesia*, and Apollinaire in his theoretical writings on Cubism. While this pronouncement did not address the latter's poetic contributions, it recognized his crucial role in shaping modern aesthetics. Significantly, when Maples drafted his "Ars poetica," toward the end of his life, the first two figures were nowhere to be found. The modern French poets who mattered the most, he observed, were Baudelaire, Rimbaud, Nerval, Mallarmé, Cendrars, and Apollinaire.[52]

LUIS QUINTANILLA

Luis Quintanilla, who liked to sign his last name Kin-Taniya, was another Stridentist poet who attracted considerable attention. A career diplomat like so many of his colleagues, he eventually acquired a Ph.D. from Johns Hopkins and taught political science at several prominent universities. Aside from his academic credentials, what made him unique was the fact that he had been raised in France. Born in Paris in 1900, Quintanilla saw Mexico for the first time in 1917 and decided to renounce his French citizenship. According to his daughter, the family was on good terms with Diego Rivera, Rodin, and Apollinaire in Paris.[53] Not surprisingly, Quintanilla's first poems were written in French and betray the influence of French models. Although they contain few obvious borrowings from Apollinaire, there is little doubt that he was familiar with the latter's poetry. In one instance, for example, Quintanilla imitated the visual outlines of one of the calligrams. In another, he wrote about the poet himself, who had recently succumbed to the Spanish flu.

In October 1917, apparently during his visit to the New World, Quintanilla composed a poem entitled "Lluvia" ("Rain") in which he experimented with visual form. Although he was only seventeen, he had absorbed the most important lessons of the French avant-garde and was writing surprisingly sophisticated poetry. In contrast to the text's beginning and end, whose appearance was unremarkable, the middle section was more experimental. While the former could have been written by any of the literary cubists, the latter was clearly inspired by Apollinaire's "Il pleut" (OP, 203), which had appeared in *SIC* the previous year. Like the French poet, Quintanilla divided the text into five vertical lines which descended the page letter by letter. Unlike Apollinaire, he used relatively short lines and capital, rather than lowercase, letters. Although both poems successfully mimicked the rain, Quintanilla's lacked the delicacy of its original model. Translated from the vertical to the horizontal, the central section read as follows: "TEARS ON YOUR FACE / THE WATER

WEARILY TRICKLES / DOWN THE GREY WINDOW PANES / I FEEL
THE RAIN FALLING / ON MY HUMID HEART."

Even a cursory glance at these two poems suffices to reveal the dif-
ferences between them. Whereas "Il pleut" evoked a series of bittersweet
memories, "Lluvia" was conceived primarily as a love poem. Where they
coincided was in regard to their physical features and in their desire to
create an identical *état d'âme*. Structured around the same central
metaphor, they established a reciprocal relationship between the rain and
human tears. In addition to their visual similarities, both works had a pro-
nounced auditory dimension. To both Quintanilla and Apollinaire, the
sound of the falling rain resembled that of human speech. While the for-
mer compared the raindrops to his beloved's voice, to the latter they sug-
gested the voices of women he had known in the past. Echoing the French
poet's admonition: "Écoute s'il pleut," Quintanilla focused not on the rain
itself but on the absence of background noise:

> *Sh!*
> lis
> ten
> to
> *the silence.*

Since the silence only served to magnify the raindrops' sound, however,
the two lines were virtually identical.

Dated December 12, 1918, after Quintanilla had returned to Paris, the
second poem was entitled "Guillermo Apollinaire ha muerto." Written in
an elegiac mode, it expressed his anguish at the poet's recent death
according to the conventions of the genre.

> *Guillaume Apollinaire is no more*
> Guillaume Apollinaire is no more
> dead and buried
> my great assassinated poet
> Jealous of his ability to create new worlds
> God pierced his rival's skull
> but none of his dreams escaped
> through the bloody hole
> So
> God
> assassinated him
> O my poet
> who rose so high
> that he reached Heaven

Guillaume Apollinaire is no more
A brief mention on a newspaper's last page
Don't you hear the cries of the younger generation
shaking the temples' foundations?
Guillaume Apollinaire

is no more!

And the cats wail
And also the rats
And the gendarmes
And my heart
 as well
Oh! Oh! Oh!
S o r r r o w
Weep. Mourners
Bathe his glorious corpse with your tears
And you buglers
lacerate the bloody western skies
And you poets brothers
let the wind whip your
 frenzied hair
For Guillaume Apollinaire is no more
 my great poet
 lies assassinated.

Cut down at the height of his powers, Apollinaire was portrayed as the victim of divine retribution, as a Promethean figure who had incurred the wrath of God. Despite the poem's formulaic diction, Quintanilla's grief was obviously genuine. One of "los jovenes" who had adopted the poet as their leader, he recognized the full extent of their loss. Without Apollinaire, the avant-garde had no one to consolidate its gains and to spur it on to future victories. That the poet's death was also perceived as a personal tragedy made it even more pathetic. Distributed symmetrically throughout the poem, the refrain "my great poet" indicated that Quintanilla not only admired Apollinaire but that he identified with him. Among other things, the use of the possessive adjective suggests that he had appropriated the latter's poetics.

In keeping with the general theme, Quintanilla alluded to several compositions that seem to have interested him in particular. One of these was *Le Poète assassiné* (1916), which generated the opening sequence. Like Apollinaire's war wound, the author maintained, his death was engineered by God himself who was jealous of his ability to create new worlds. This remark suggests that Quintanilla had read "La Jolie Rousse"

(OP, 313–14), included in *Calligrammes*, in which Apollinaire announced: "Nous voulons vous donner de vastes et d'étranges domaines." He may, however, have been thinking of "L'Esprit nouveau et les poètes," which had appeared in the *Mercure de France* less than two weeks before. Echoing Pascal in one place, Apollinaire spoke of exploring "le domaine des infiniment petits et . . . celui de l'infiniment grand" as well as the possibilities represented by prophecy. Elsewhere in the essay he described the world of dream as a fertile realm for exploration.[54] In fact, Quintanilla added, God was not mistaken in viewing Apollinaire as a dangerous rival, since his divine talent made him the Creator's equal. To express this relationship, he borrowed one of Apollinaire's own images, the airplane, which symbolized modern achievement in "Zone" (OP, 39–44). Implicit in Quintanilla's vision of Apollinaire ascending to Heaven, the flying machine served in this context as a contemporary version of Pegasus.

That Quintanilla likewise associated the airplane with modern achievement can be seen from the title of his first book of poetry: *Avión* (1923). Visibly influenced by the Dada movement, it spanned the years 1917–22 and included both of the works examined above. Since most if not all of the poems seem originally to have been written in French, the volume was also an exercise in translation. Reviewing the latter in *El Universal Ilustrado*, Francisco Borja Bolado insisted that the most interesting literature in Latin America was being written in Mexico. Citing *Avión* as proof, he announced that its publication established Quintanilla as "one of the most promising modern poets, with an original and extensive command of the language, and perhaps the only one whose mental outlook emanates directly from Apollinaire."[55] The following year, Quintanilla published an equally provocative collection of poetry organized around another symbol of modernity: *Radio*. Devoted to modern communication rather than transportation, it consisted of a single telegraphic poem comprising thirteen "messages." Writing in 1925, Eduardo Colin also noted Quintanilla's debt to Apollinaire but insisted that the Mexican poet viewed his works primarily as a point of departure. "Although he occasionally imitates Apollinaire, the Dadaists, etc., to the point of composing pastiches," he declared, "he normally utilizes these European models to express his own concerns."[56] Despite the importance of these formative influences, Quintanilla's poetry transcended the categories to which they belonged.

In 1927, Germán List Arzubide published a book entitled *El movimiento estridentista* which, ironically, marked the end of the movement it sought to promote. A combination anthology, manifesto, and anecdotal history, it was written in the enthusiastic style bordering on

incoherence that had become associated with Stridentist proclamations. A visual as well as a verbal treat, the volume included photographs of masks, paintings, blockprints, sculptures, drawings, and documents covering the years 1921–27. One painting was even reproduced in color. One of the discoveries it contained was that Quintanilla spent much of this period in Paris in the diplomatic service. Together with the French artist and anarchist Gaston Diner, who was also a Stridentist, he strove to publicize the movement in France. Dismissing the French experiments as so many intelligent distractions, List spoke scornfully of "Tristan Tzara's acrobatic cries and the disconnected guffaws of Apollinaire and Max Jacob."[57] To his way of thinking, Stridentism had more to offer than Cubism or Dada. Apparently motivated by this passage in particular, a Cuban named S. Lamar Schweyer took the argument one step further. Insisting that *estridentismo* was an exclusively American phenomenon, he wrote to List: "It contains nothing that is European. Apollinaire and Max Jacob reflected our sensibility in Europe, just as Chateaubriand mirrored our whole romantic orientation previously."[58]

An interesting epilogue to the Stridentist movement was provided twenty years later by Arqueles Vela. A prominent member of the group who concentrated on fiction, Vela was the author of two notorious works: *La Señorita Etcétera* (1922) and *El Café de Nadie* (1926). Although few traces of Apollinaire appeared in his short stories and novels, he published a volume on *modernismo* in 1949 which concluded with a study of subsequent poetry. The most important figure to emerge during the post-modernista period, Vela declared, was the author of *Alcools*. Not only did Apollinaire exemplify the widespread preoccupation with spatial form, but he established many of the criteria that were to govern contemporary aesthetics. His most signifcant contributions, Vela noted, revolutionized our thinking in two separate areas: criticism and poetry. One of the most authoritative critical texts in Latin America, for example, was Jean Epstein's *La Poésie d'aujourd'hui* (1921), which had been translated into Spanish. In point of fact, Vela observed, the author's apparent expertise derived entirely from Apollinaire's poetic practice, whose ideas he simply appropriated.[59] Depicting the French poet as Rimbaud's successor elsewhere in the volume, Vela hastened to acknowledge his seminal influence on modern poetry. "In both Spain and Latin America," he insisted, "the various attempts to transcend *modernismo* stemmed from Apollinaire's discoveries. . . . Creationism, Ultraism, and Stridentism were simultaneous derivations" (p. 219). Ultimately, however, the significance of Apollinaire's poetry lay not in its widespread influence but in the realm of aesthetic achievement. "In the realm of lyric poetry," Vela opined, "no

European or Spanish-American author has surpassed the style and content of Apollinarian poetics" (p. 221).

THE CONTEMPORARIES

Although the review from which the Contemporáneos group took its name was not founded until 1928, the movement itself began to coalesce about the same time as Stridentism. Whereas the latter school adopted a self-conscious avant-garde posture, the former embraced modern aesthetics with less fanfare but equal fervor. Numerous critics have observed that the Contemporáneos were not really a school but a loosely organized confederation of poets, a "grupo sin grupo" ("a group without a group").[60] While they collaborated on various projects and shared similar values, they felt no need to issue manifestos or other official proclamations. Like Maples Arce and the Stridentists, they were keenly interested in developments taking place in France and Spain. As one authority remarks, "They looked toward Europe. They read the *Nouvelle Revue Française*, the *Mercure de France*, and the *Revista de Occidente* eagerly. They were filled with enthusiasm for the work of Juan Ramón Jiménez and Guillaume Apollinaire and, later, for that of the young Spanish and French writers."[61] Unlike the Stridentists, they were also interested in the poetry being written in the United States by poets such as Robert Frost and Edgar Lee Masters.

In general, the Contemporáneos sought to distance themselves from their Stridentist colleagues, whose flamboyant style contrasted with their more conservative approach to modern poetry. Although they admired many of the same authors as the *estridentistas*, they tended to downplay their importance in their writings. This fact, plus differences in taste, explain why references to Apollinaire were relatively infrequent. For the most part, the French poet was associated with two individuals: Salvador Novo and Jaime Torres Bodet. In addition, the two clusters of references were situated at opposite ends of the Contemporáneos' experience. Whereas Novo's flirtation with Apollinaire occurred at the beginning, Torres waited until the movement was approaching its end to call attention to his important contributions. Whereas the former never acknowledged Apollinaire's significance, at least not publically, the latter was convinced that he had altered the course of modern letters.

A prolific author, Salvador Novo was equally at home in either poetry or prose. During the 1920s, he published no fewer than eight volumes including one devoted to North American poetry. Although a book on modern French poetry was also scheduled to appear, this project seems

never to have materialized. For our purposes, the most interesting documents date from the beginning of his career. Between 1918 and 1923, Novo composed three visual poems entitled "Jarrón," "Mariposa," and "Buda."[62] Consisting of horizontal lines of varying lengths, they depicted a vase, a butterfly, and a statue of the Buddha respectively. According to Alí Chumacero, the last two appeared in a student publication entitled *Policromías* in 1920.[63] While the first poem was published in *Prisma* (Barcelona) in 1922, the fact that it precedes the others in the collected works implies that it was composed before them.[64]

Since Novo rarely mentioned Apollinaire, whose work he appears to have known, his situation resembles that of José Juan Tablada. Indeed, Tablada himself must be considered a possible source. On the one hand, the poems could conceivably have been composed before Novo encountered Apollinaire's works, This was the opinion of one of his colleagues, Xavier Villaurrutia, who refused to admit any possibility of influence. "A product of his era," Villaurrutia declared in 1924, "he momentarily shared in Apollinaire's ideographic games and Ultraism's eclecticism without knowing it, without intending to."[65] On the other hand, recent critics have had a hard time reconciling Novo's supposed ignorance with his general critical awareness. Nor is it reasonable to suppose that he would have remained oblivious to the calligrams at a time when they were eliciting considerable interest in Mexico City.

Although Frank Dauster is unimpressed by Novo's visual experiments, he assumes that they stemmed from the "poesía tipográfica de Apollinaire."[66] In his view, they were related to Novo's interest in avant-garde metaphor. Alí Chumacero concurs with Dauster's assessment and provides a brief overview. "The author of *Calligrammes* exerted a superficial influence," he explains, "that was soon obscured by the arrival in Mexico of newer books written by more recent poets, who were mostly French as well."[67] While the evidence is circumstantial, it strongly suggests that Novo's experiments were originally prompted by Apollinaire's. It was certainly no accident that both Novo and Maples Arce became interested in visual poetry at approximately the same time. Besides Tablada's repeated allusions, the anonymous article in the *Revista de Revistas* brought Apollinaire's calligrams to their attention early in their careers.[68]

In 1925, Novo published an essay entitled "De las ventajas de no estar a la moda" ("On the Advantages of Not Being Stylish"), which among other things was probably directed at the Stridentists.[69] Written in an ironic mode, it ridiculed various individuals who insisted on equating novelty with quality. Portraying the latter as compulsive name-droppers,

Novo advised them to be sure to include Jean Cocteau, Paul Morand, and Max Jacob in their conversations. Although they should avoid Victor Hugo at all costs, he added, a little Blaise Cendrars was a good idea from time to time. Later they could hold forth on the merits of Apollinaire or Mexico City's P.E.N. Club, which had become rather fashionable. The object of Novo's attack was not modern French literature, however, but people who were obsessed by the latest literary fashions. Interestingly, his essay permits us to gauge the literary climate in Mexico during this period. By 1925, one gathers, Novo had been repeatedly exposed to Apollinaire's writings and had grown weary of them. At the same time, Apollinaire had become something of a cult figure among the Mexican literati, for whom he personified modern French poetry.

The appearance of two separate works in 1928 marked a significant step in the evolution of the Contemporáneos group. Not only did the group finally acquire a name, but its eight members began to function as a collective entity. In an attempt to establish some critical guidelines, for instance, they published an *Antología de la poesía mexicana moderna*. Although the volume appeared under Jorge Cuesta's name, the selections and the introductory notes were the responsibility of the entire group. In addition to assembling an excellent series of texts, one that successfully influenced the literary canon, the anthology represented an important aesthetic statement. These are the values that matter, it implied, and these are the individuals who embody them. Discussing José Juan Tablada's contributions, the editors observed that he had participated in "todas las aventuras de la poesía contemporánea." While Tablada's curiosity was praiseworthy, they continued, his lack of aesthetic continuity posed certain problems. "These leaps from Baudelaire to Guillaume Apollinaire, from the latter to the Japanese poets, and from them to Ramón López Velarde clearly involve a certain amount of danger."[70]

A second, equally important statement was provided by *Contemporáneos*, whose first issue appeared one month later (in June). Whereas the anthology included poets who were born as early as 1870, the review focused on the current generation. Acting as spokesmen for the latter, the Contemporáneos wrote about their own enthusiasms and offered their compositions as examples of how poetry should be written. One of the journal's editors was Jaime Torres Bodet, who served as the group's French connection. Since his maternal grandparents came from France, Torres learned to speak the language from his mother, who also taught him to appreciate French literature. Indeed, before embarking on a brilliant public career, he earned his living as a professor of French at the Universidad Nacional Autónoma de México. Eventually he served as the

Mexican ambassador to France and the Director General of UNESCO. Although Torres showed no special predilection for Apollinaire, whom he mentioned only once in his writings, we know he was familiar with the poet's works. Judging from this single reference (to a posthumous collection of short stories), he obviously held Apollinaire in high esteem. Reviewing *Les Epingles* (1928) in the third issue of *Contemporáneos*, Torres praised the special quality of his imagination.

> This memory of Guillaume Apollinaire, the geometry of his sinuous lyricism, and, above all, his passionate curiosity about objects and beings which were somehow associated with the "world aborning" still impregnate the most active and characteristic aspects of Surrealism. The creator of myths—a title that Chesterton also bestowed on Dickens—Apollinaire preferred, more than the adventure at the heart of each story, the imaginative border that adorned its outline, the empty space (empty?) that facilitates the play of the imagination between the shape of the real world and its distorted reflection, between nature and its depiction in a landscape, between the narcissistic voice and the water's echo. Tired of tormenting the imperceptible centipedes of our motives on psychology's dissecting table with entomological pins, the novel adopted new analytical instruments under Apollinaire's guidance, and—as in one of the recent stories edited by Philippe Soupault—the pins no longer served to immobilize a dragonfly's colors in his prose but to foretell the future, manipulated by a chiromancer's fingers.
>
> The atmosphere surrounding his characters does not radiate outward in gentle, misty waves. Rather it consists of a series of planes opposed to one another like Good and Evil on a magic chessboard. Thus its imaginative quality recalls Don Quixote's vision in the cubist adventure of Clavileño: a watery sky superimposed on an aery one, a sky of hailstones superimposed on the watery sky and, above that, a sky made of fire. The precious story that I have translated below exemplifies this fantastic, aery atmosphere, which according to Soupault "allows the reader to expect the unexpected, the unreal, and, as Apollinaire himself claimed, the SURREAL").[71]

Above all, Torres portrayed Apollinaire as the father of Surrealism, whose founders included Soupault and his friends. Although he linked him to Cubist aesthetics, what really interested him were his Surrealist credentials. If Cubism had once been the dominant movement in France,

by 1928 it had subsided into the background. The really important work was being carried out by the Surrealists, who were redefining the role of the poet and the nature of the poetic act. Thus Torres neglected Apollinaire's technique, which recalled the earlier movement, and concentrated on those qualities that appealed to a contemporary audience. He correctly observed that Apollinaire discarded the principles associated with the realistic novel, such as objective description and psychological analysis, in favor of others that stressed the author's subjectivity. His works were not only anti-realistic, but imbued with a fantastic atmosphere that resembled the Surrealists' preoccupation with *le merveilleux.* Indeed, Torres reminded his readers, the term "surreal" was originally coined by Apollinaire to describe his radical poetics. Reflecting the poet's insatiable curiosity, the latter exalted the power of the imagination to redefine our relation to the world. What especially fascinated Apollinaire, Torres remarked, was the imaginative process involved in the creation of a work of art. In this he also resembled the Surrealists, who focused on the nature of the creative act. Like Apollinaire, who addressed both subjects in "L'Esprit nouveau et les poètes" (1918), they explored the prophetic possibilities of the written word and sought to create new myths.[72] To illustrate these and other affinities, Torres translated Apollinaire's "Chirurgie esthétique," in which skilled surgeons provided several patients with multiple eyes, mouths, and arms.[73] On the one hand, the story predicted the triumph of medical technology in the years to come. On the other, it demonstrated the aesthetic importance of surprise, which reflected the uncertainties of the human condition.

While Apollinaire's name tended to be associated with the Stridentists in particular, his impact on Torres and his colleagues was far from negligeable. In fact, both schools accorded him a prominent place in the history of modern aesthetics. Reviewing Guillermo de Torre's *La aventura y el orden* sixteen years later, Bernardo Ortiz de Montellano, who belonged to the Contemporáneos, noted with approval the role assigned to the French poet. According to the author, he reported, modern art and literature originated with Picasso and Apollinaire, who were the source of the various movements that came after them.[74] Similarly, evaluating the role of *Contemporáneos* in 1955, Jaime Torres Bodet stressed the importance of his decision to publish Apollinaire in the journal. "Didn't a number of young people first discover Proust, Joyce, and Apollinaire in the pages of *Contemporáneos*. . . . ?", he demanded.[75] That he included Apollinaire in the same category as the authors of *À la recherche du temps perdu* and *Ulysses* proves that he regarded him as a literary giant. One of the review's greatest accomplishments, Torres concluded, was to have

presented these three seminal figures (and Pirandello) to the Mexican public for the first time.

JOSÉ MARÍA GONZÁLEZ DE MENDOZA

Of the various individuals who were aligned with neither the Stridentists nor the Contemporáneos, the most important was undoubtedly José María González de Mendoza. Born in Spain, González was a prolific author who wrote under the pseudonym "El Abate de Mendoza" ("Father Mendoza") and who did much to advance the avant-garde cause in Mexico. Unfortunately, only a fraction of his writings have been collected to date. From 1923 on he resided in Paris, where he studied at the Sorbonne, the Collège de France, and the École du Louvre. Like so many of his colleagues, he eventually entered the Mexican diplomatic corps and was attached to the Legation in Paris. During 1923 and 1924 he spent much of his time with another Mexican expatriate, the poet José D. Frías, who served as foreign correspondent for *El Universal*. Among other things, they amused themselves by sending humorous compositions to various friends.[76]

Since the two men subscribed to different literary theories, González later recalled, their collaboration was somewhat uneven. "Frías' work can be classified as Symbolist," he explained, "whereas my preference is for the poetry that Guillaume Apollinaire associated with 'l'esprit nouveau,' which others have nicknamed 'cubist,' and for José Juan Tablada's haiku. . . . I introduced him to Apollinaire's books, which he found interesting, and I remember his delight when he discovered the poem about the camel in *Le Bestiaire ou Cortège d'Orphée*: 'Le chameau voyage sans boire / Et moi je bois sans voyager.' " Since González seems to have been reciting Apollinaire's verses from memory, they evidently made an impression on him as well. Turning to *Le Bestiaire*, however, one discovers that it does not include this particular poem. While one encounters a composition entitled "Le Dromadaire" (OP, 12), it bears no relation to the couplet cited above. One of several variants that were excluded from the collection, the latter poem was first published in André Billy's *Apollinaire vivant*, which appeared in 1923 (OP, 1038). Arriving in Paris the same year, González probably bought a copy and lent it to Frías, whom he was teaching to enjoy Apollinaire.

The prototype for their collaborative ventures, González added, was a congratulatory poem sent to the writer Francisco Orozco Muñoz on his saint's day (October 4, 1923). Although much of the composition was written in traditional verse, it concluded with four visual poems inspired

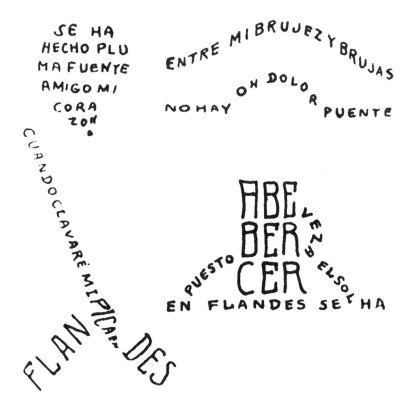

Figure 1. From a letter to Francisco Orozco Muñoz by José D. Frías and José María González de Mendoza (1923)

by Apollinaire and his disciples (figure 1). Three of the texts were authored by Frías and translated into visual terms by his partner. Despite their obvious differences, each contained a witty reference to the fact that Orozco was living in Belgium. Portraying an arching bridge, like one of Apollinaire's calligrams to Léopold Survage (OP, 676), the first poem proclaimed: "BETWEEN MY POVERTY AND BRUGES THERE IS ALAS NO BRIDGE." By contrast, the second text assumed the form of a beer mug: "LET'S HAVE A BEER THE SUN HAS ALREADY SET IN FLANDERS." Shaped like a long lance, the third work juxtaposed an idiomatic expression: "CUANDO CLAVARÉ MI PICA EN FLANDES" ("WHEN I WILL

ACCOMPLISH WONDERS") with its literal meaning: "WHEN I WILL PLANT MY PIKE IN FLANDERS," which it illustrated visually. The fourth poem, a heart-shaped composition, was conceived and executed by González alone. Consisting of a "cardiac calligram," it read as follows: "MY HEART HAS BEEN TRANSFORMED INTO A FOUNTAIN PEN MY FRIEND."

After Frías returned to Mexico in October 1924, the two men began to exchange humorous letters. The following January, Frías sent his friends in Paris a calligrammatic letter which in some respects recalled Apollinaire's famous "Lettre-Océan") (figure 2). Although it did not look much like the latter work (OP, 183–85), it was composed according to similar principles. Written on the stationery of the Hotel Regis, where he was staying, it juxtaposed random thoughts and impressions to form a verbo-visual collage. At the top Frías numbered various letters of the hotel's letterhead so as to spell the Spanish equivalent of "Happy New Year." Accompanied by snatches of music, one of which was addressed to "Valentina," a cruciform refrain extended diagonally across the page expressing his thanks. Toward the bottom, two disembodied arms embraced a list of the poet's friends in Paris, whom he obviously missed. In addition, Frías included a caricature of himself, seen in profile, uttering the words: "beso p[ara]/Azteca pavorosa" ("a kiss for the terrible Aztec"). (The "Azteca" was a female acquaintance who never stopped talking.) González' account of his relations with Frías concluded with a defense of the method he had chosen to employ. Apollinaire himself, he noted, devoted numerous columns to anecdotes in the *Mercure de France*, which were later collected in "an absolutely delightful volume."

In contrast to Frías, who enjoyed Apollinaire but refused to profit from his example, González absorbed many of the poet's lessons and continued to admire him as long as he lived. In 1924, when rival factions were battling in Paris over the right to call themselves Surrealists, he reminded his friend Francisco Monterde García Icazbalceta of the term's provenance. In November Monterde published portions of his letter in *Antena*, which he had recently founded. "Guillaume Apollinaire invented the word in 1917," González wrote, "to describe his drama *Les Mamelles de Tirésias*. That work, others by Pierre Albert-Birot, Alfred Jarry's brilliant play *Ubu roi*, etc. comprise SURRREALISM's original nucleus."[77]

The following year, González published a poem with several visual elements in *La Antorcha* (*The Torch*).[78] Entitled "The Jockey" (in English), it evoked an exciting evening at the popular Montparnasse cabaret of the same name. Since the visual forms were abstract, however, they do not appear to have been inspired by Apollinaire. As noted previously, the

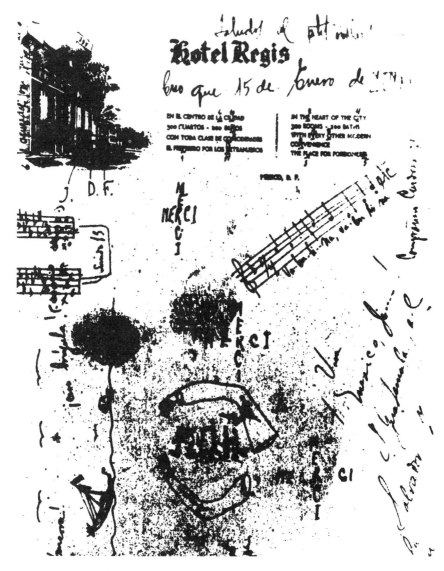

Figure 2. Letter from José D. Frías to friends in Paris, January 15, 1925

French poet preferred realistic shapes that were easily recognizable. Where his influence was discernible, González volunteered two months

later, was in the direction taken by modern literature in Mexico. Discussing Mexican literary trends in *La Revue de l'Amérique Latine*, he attributed a number of recent developments to Apollinaire's example. While some writers cultivated other models, "d'autres jeunes à la suite du maître José Juan Tablada . . . se tournèrent vers 'l'esprit nouveau,' prêché au monde par l'admirable Guillaume Apollinaire."[79] Introduced by Tablada, *l'esprit nouveau* captured the imagination of many of the poets who came after him. As such it represented an important tendency in Mexican literary circles.

What González failed to mention was that much of Apollinaire's success in Mexico was due to his own personal efforts. Convinced of the poet's genius, he persuaded many of his countrymen to read his work for the first time. Moreover, he never tired of discussing Apollinaire's merits with friends and colleagues such as Frías and Monterde. In 1926, the latter published an important article in *Sagitario*, founded by the Spanish Ultraist Humberto Rivas, who had settled in Mexico, in which he openly acknowledged his debt to González. Besides generating yet another myth about Apollinaire, it provided an intriguing glimpse of his brother Albert.

> I owe to my good friend José María González de Mendoza. . . . my knowledge of the great French avant-garde writer Guillaume Apollinaire and of his work. This article contains a number of details that will interest Mexican and French readers alike.
>
> At one time, a Frenchman lived in the Y.M.C.A. named Albert de Kostrowitsky, whose room was near that inhabited by the Abate de Mendoza. . . . They used to encounter each other in the elevator, in the corridors—returning from the shower in the morning with touseled hair that was still wet—and at the cold, white, identical tables of the Triangle Inn at meal times.
>
> One day Monsieur de Kostrowitsky received a telegram that greatly disturbed him. Leaving his meal unfinished, he returned to his room and put on a black suit. When the Abate happened to see him, he asked why he was in mourning:
>
> "I have just received news of my brother's death."
>
> The Abate offered his sympathy and his condolences.
>
> Grateful for his kind words, Monsieur de Kostrowitsky told him a little about his brother.
>
> "You must have read some of his works. He was a poet. Although he was born in Rome, he was a French citizen. . . . He called himself Guillaume Apollinaire."

Guillaume Apollinaire de Kostrowitsky . . . also spent some time in Mexico, like his brother Albert, before becoming involved in the Great War.

Memories of his visit to our country are to be found in his *Poèmes de la paix et de la guerre*: for example, Chapultepec Park, which is depicted in one of the ideographic poems that José Juan Tablada imitated so successfully in his plaquette *Li-Po y otros poemas*, one of those ideographic poems that alarmed the Academy's strait-laced members . . . who didn't know Apollinaire.[80]

The remainder of the article was devoted to "Lettre-Océan" (OP, 183–85), where the reference to Chapultepec Park occurred. Deceived by Apollinaire's apparent familiarity with his country, including various (misspelled) obscenities, Monterde concluded that he had actually visited Mexico. As proof, he reproduced the first half of the poem (omitting the key ring and the letters TSF), which was filled with Mexican references, and quoted relevant portions of the second half. "Thus memories of the Mexican Republic emerge at every turn in Guillaume Apollinaire's *Calligrammes*," he concluded. "He felt a bond between himself and our country because of his recollections and because of his affection for his brother." Unfortunately, this line of reasoning caused Monterde to commit several additional errors. For one thing, he situated the political demonstration in the first circular figure (the keyring) in Mexico instead of Paris. Convinced that it evoked "the anguished cries of our Republic in the throes of revolution," he interpreted it as a gesture of solidarity. For another thing, Monterde believed that the second circular figure (the radio waves) depicted the spiral ramp leading to the castle in Chapultepec Park, which is clearly impossible. That Apollinaire sympathized with the Mexican people, he noted near the end, was demonstrated by a poignant verse taken from another poem. The verse in question, which occurred in "Il y a" (OP, 280–81), was the following: "Il y a des femmes qui demandent du maïs à grands cris devant un Christ sanglant à Mexico."

As we have seen, the Abate de Mendoza's allegiance was to the avant-garde in general rather than to an established school. If some of his compositions appeared in reviews that were affiliated with the Contemporáneos, others were published in journals that were associated with the Stridentists. At least one of his works was included in *Irradiador*, for example, founded by Manuel Maples Arce and Fermín Revueltas in 1923. Whether González contributed to more than one issue is impossible to say since no copies of the review remain. In 1927, however, an article on Mexican poetry appeared in the Argentine periodical *Nosotros* which included a poem published previously in *Irradiador*. Indeed, the author

declared it was probably the best poem the Stridentists had produced. Entitled "La marimba en el patio," it juxtaposed the sounds of an itinerant street musician with the cries of children playing in a courtyard.[81] What made this composition so unusual was that it was cast in visual form. With a little effort, the reader could detect the outlines of the sun, the patio gate, and the marimba itself. Positioned above the latter, six parallel diagonal lines compared the instrument's cascading notes to raindrops. Like Luis Quintanilla before him, González borrowed this device from "Il pleut" (OP, 203), where it served a similar purpose. Whereas it was actually raining in Apollinaire's poem, his own raindrops were purely metaphorical.

Abundant evidence exists of González' continued interest in Apollinaire in subsequent years. In May 1927, he published a prose poem entitled "La virgen y la Torre Eiffel" which contained a reference to *Alcools*.[82] Following a series of extravagant metaphors applied to the Eiffel Tower, he remarked: "Yes, I know, there are better metaphors—by Mallarmé, Apollinaire, Cocteau, and the rest. But they were precursors." The poem of Apollinaire's to which he was alluding was, of course, "Zone" (OP, 39). Superimposing a pastoral metaphor on the urban setting, the poet compared the famous monument to a shepherdess and her flock. Thereafter, during the 1930s, Apollinaire's name cropped up repeatedly in articles devoted to José D. Frías, who had recently died. While the more significant events have been recounted previously, the place that Apollinaire assumed in the two men's lives may be seen from an anecdote published in December 1933.[83] In their enthusiasm for the poet, González and his friend sought out the Caveau du Soleil d'Or on the Place Saint-Michel, where Apollinaire and André Salmon had met in 1903, and had a drink to celebrate the occasion.

Besides the documents discussed above, five additional articles are included in González' *Ensayos selectos* (1970).[84] Comprising thirty-five pages, they are devoted exclusively to Apollinaire and chronicle diverse aspects of his life and work. Since the editors specified neither their date nor their place of publication, they present serious problems for the literary historian. In addition, they are arranged thematically rather than in chronological order. Since the volume is readily obtainable, there is no point in reproducing the articles here. A brief summary will provide some idea of their subjects and will confirm González' high opinion of the French poet. The first essay, which is by far the longest, seems to date from the early 1930s. Drawing on previous studies, it provides a detailed examination of Apollinaire's life and work. The second essay, which may have appeared in the 1920s, contains a review of *La Femme assise*, supplemented

by testimonials from various French critics. The third, in which the author examines Apollinaire's concept of *l'esprit nouveau*, draws on his 1918 article in particular. Filled with various anecdotes, the fourth analyzes the legends that had grown up around Apollinaire since his death. The fifth, which complements (and partially corrects) Monterde's article in *Sagitario*, discusses his relation to Mexico.

Without a doubt the first essay constitutes the most important document. Among other things, one learns that in 1928 a fanciful version of Apollinaire's *Mona Lisa* adventure appeared in two Spanish language newspapers in the United States. Dismayed by such an obvious fabrication, González drafted a letter of protest which eventually appeared in print. The first essay's chief concern, however, was to establish Apollinaire's superiority as a poet. As much as anything it sought to document his contributions to the modern tradition. Much of the essay's tone, and the thrust of González' argument, can be glimpsed in the first paragraph.

> Without resorting to hyperbole one may reasonably assert — reserving the detailed proof for later—that modern poetry stems mostly, and more or less directly, from Apollinaire's initial impulse. He discovered something much more important than a "new wrinkle": a whole new poetic world. He established his era's dominant tone, just as Rubén Darío did in Spanish literature during the first decade of the twentieth century.

Apollinaire was not only one of the greatest French poets of his time, González maintained, but the originator of modern aesthetics.

ADDITIONAL AUTHORS

For the most part, the remaining references adhere to the patterns observed previously. While they help to fill out the picture that has gradually emerged, they present no major discoveries. Like the Abate de Mendoza, several of his colleagues in Paris served as literary conduits between France and Mexico. One of these was Guillermo Jiménez, who contributed a preface to José D. Frías' *Antología de jóvenes poetas mexicanos* in 1922. Although the anthology itself was thoroughly traditional, the preface revealed a certain familiarity with the French avant-garde. Unlike Frías, who had not yet discovered Apollinaire's charms, Jiménez had been exposed to at least some of his poetry. Discussing José Juan Tablada at one point, he praised the dynamism that characterized his recent work and declared that *Li-Po y otros poemas* "possesses the same fireworks and lus-

trous acrobatics that one finds in Guillaume Apollinaire."[85] At the bottom, a footnote referred the reader to *Le Bestiaire* and to *Calligrammes*.

The following year, Jiménez published a poem entitled "La ventana abierta" ("The Open Window") in which he mentioned Apollinaire once again.[86] Appearing in *La Falange* (*The Phalanx*), which was edited by members of the Contemporáneos group, it began with a glimpse of the French capital:

> Paris wrapped in mist.
>> A distant rumbling like a prolonged chord.
>> The erect ears of the Chimeras
>>> keeping watch from Notre Dame's
>> railing register the sounds of a symphony in grey
>>> major and verses by Apollinaire.

In 1929, Jiménez included these verses in *Cuaderno de notas* (*Notebook*) with a few minor changes. In both instances, their effect was identical. Above all, Apollinaire was portrayed as a poet of Paris, whose glories he had celebrated in many of his works. Like Notre Dame, the author implied, he had become a national monument. His poetry represented one of the highest achievements of the French people. In view of the slightly melancholy tone that pervades the Mexican poem, which betrays its debt to *modernismo*, Jiménez may have been thinking of *Alcools* in particular.

An additional link between France and Mexico was provided by José D. Frías himself. Introduced by González de Mendoza to the mysteries of the Parisian avant-garde, he shared his enthusiasms with various friends and colleagues. Returning to Mexico in October 1924, Frías brought a number of exciting books with him that had recently appeared in France. One of these was *Luna Park*, authored by the Guatemalan poet Luis Cardoza y Aragón a few months earlier. Frías immediately made this avant-garde work available to his friends, one of whom published a review of it in *Antena* the very same month. Interestingly, the review contained a veiled allusion to the volume's provenance: "*Entrée*: an offering presented by José D. Frías' ducal hands. Preludes.—Solos: Apollinaire and Laforgue."[87] The "solos" referred to two lines of poetry cited at the beginning of the book. In addition to a quotation from Jules Laforgue, Cardoza chose a verse from "Les Fenêtres" (OP, 168): "Il y a un poème à faire sur l'oiseau qui n'a qu'une aile."

In 1923, Apollinaire was cited in *La Falange* in connection with another Guatemalan author, Flavio Herrera. Reviewing a collection of neo-Symbolist verse by the latter, Salatiel Rosales observed that this mode was almost totally unknown in Latin America. It resembled neither

Dadaism, he insisted, "nor any of the schools born from Creationism's fertile flank, which today endeavor to conquer the ideal plane of the 'Section d'Or' envisioned by Guillaume Apollinaire in his *Méditations esthétiques*."[88] At first glance, the author's description of the golden section as an ideal plane is rather puzzling. At second glance it recalls Rafael Lasso de la Vega's article on the same subject, published two years before (see chapter 6).[89] Writing in *Cosmópolis*, Lasso attributed the term "section d'or" to Apollinaire, cited *Les Peintres cubistes* as its source, and declared that it referred to a magic plane. Unfortunately, none of these statements was true. Since Rosales perpetuated all three of these errors, one suspects that he drew much, if not most, of his information from the earlier article.

In 1925, Apollinaire's name was pronounced by two foreign writers who published articles in *La Antorcha*.[90] Discussing contemporary French poetry in May, Valéry Larbaud emphasized Max Jacob's role in the Cubist movement. "He directly influenced Guillaume Apollinaire," he insisted, "Pablo Picasso, and the so-called 'rue Ravignan group.' . . . Under the duumvirate of Apollinaire and Picasso, the 'Cubists' dominated the art world between 1915 and 1918, until shortly before Apollinaire's death a few days before the Armistice." The effect of these remarks was not to undermine the Cubist leaders' reputations, which were secure, but simply to call attention to Jacob's contributions. If anything, Larbaud's assessment solidified Apollinaire's position as the leading exponent of Cubism. Authored by Guillermo de Torre, the second article concentrated on Dada and Surrealism. Taken from his *Literaturas europeas de vanguardia*, published the same year, it included the discussion of *surréalisme* examined previously (see chapter 6). Stressing the latter's Apollinarian origins, Torre defined it as "the total predominance of fantasy, of the principles governing imagination." Despite the publicity generated by *Les Mamelles de Tirésias*, he added, the concept could be traced back to 1912 (sic), when it was formulated in *Les Peintres cubistes*.

In 1926, Luis Marín Loya published a curious book devoted to the work of three individuals: Manuel Maples Arce, Diego Rivera, and Arqueles Vela. The author was a thoroughly traditional poet who, for reasons known only to himself, chose to frequent Stridentist circles. He apparently saw no contradiction between his own conservative leanings and the avant-garde program espoused by his friends. Marín's paradoxical position can be glimpsed repeatedly in his book, which sought to make *estridentismo* more respectable. To this end, he minimized its revolutionary aspects and reduced its flamboyant aesthetics to a series of traditional principles. Defending Maples Arce at one point, Marín contrasted his most recent poetry with the supposed excesses of the Creationists. "*Urbe* illus-

trates the need to develop a new syntax," he argued, "one that is vastly superior . . . to that envisaged by Apollinaire's questionable heirs as regards Creationism. We are no longer astonished by the various eccentricities concocted under the auspices of the aforementioned pontiff. . . ."[91] Although the author did not reproach Apollinaire himself, whom he apparently respected, he had nothing but disdain for his disciples.

The final miscellaneous item concerns a fantastic story by Luis Cardoza y Aragón, whose *Luna Park* had been reviewed in *Antena* three years earlier. Purporting to describe the theft of France's most important monument, it appeared in *Sagitario*, where it attracted a certain amount of attention. Something of the story's hallucinatory quality was reflected in its epigraph, which proclaimed that it was dedicated "to marijuana." Under the influence of this drug, Cardoza reported, he and some of his friends had kidnapped the Eiffel Tower in the middle of the night. Stunned by this unprecedented event, the entire French nation went into mourning. While the poets all dressed in black, various paintings of the Tower were draped with funerary decorations. "Flowers and black crepe surrounded the famous portrait by Delaunay," the author declared, "which Apollinaire regretted the painter had not made life-sized."[92] Exactly which painting Cardoza was thinking of is difficult to say. Nor is Apollinaire's amusing observation, which should simplify the task, any easier to identify. While it sounds like something the poet could have said, it does not appear in his collected writings. What this suggests is that Cardoza was repeating yet another anecdote that had come to be associated with Apollinaire. To be sure, no one would have been more amused than the author of "La Vie anecdotique," who fabricated a few stories himself during his lifetime.

Notes

1. INTRODUCTION

1. Letter from Raúl González Tuñón to Enrique González Tuñón dated November 1929. Repr. in Horacio Salas, *Conversaciones con Raúl González Tuñón* (Buenos Aires: Bastilla, 1975), 176.
2. Guillaume Apollinaire, "Henri Matisse," *Klingen*, 1. 11–12 (August–September 1918); Richard Vowles, "Expressionism in Scandinavia" in *Expressionism as an International Literary Phenomenon*, ed. Ulrich Weisstein (Paris: Didier; Budapest: Akadémiai Kiadó, 1973) p. 223.
3. Paul van Ostaijen, "Over Dynamiek," *De Goedendag*, 23.6 (April 1917): pp. 83–86 and 23.7–8 (May–June 1917): 101–8. Repr. in his *Verzameld Werk* (Amsterdam: Bakker, 1979), 4:20–31.
4. Guillaume Apollinaire, "A kubizmus," tr. Dénes Zsófia, and "Esik," tr. Illyés Gyula, *Ma*, 4.2 (February 26, 1919): 16–21 10.1 (January 15, 1925). Myroslava M. Mudrak, *The New Generation and Artistic Modernism in the Ukraine* (Ann Arbor: UMI Research Press, 1986), 35. See especially Peter Por, "La 'Fortune d'Apollinaire en Hongrie," *Amis européens d'Apollinaire*, ed. Michel Décaudin (Paris: Sorbonne Nouvelle, 1995), 198–216; Vladimir Brett, "Apollinaire et les Tchèques," *Du monde européen à l'univers des mythes*, ed. Michel Décaudin (Paris: Minard, 1970), pp. 48-64; Gaston Bouatchidzé, "Apollinaire en URSS," *Apollinaire en son temps*, ed. Michel Décaudin , 133–66; and appendices in Apollinaire, *Oeuvres poétiques* and *Oeuvres en prose*.
5. See Aracy Amaral, *Blaise Cendrars no Brasil e os modernistas* (São Paulo: Martins, 1970) and Alexandre Eulalio, *A aventura brasileira*

de Blaise Cendrars (São Paulo: Quirón/Ministério da Educação e Cultura, 1978).

6. Pierre Caizergues, "Fortune et infortune d'Apollinaire en Suisse" in *De l'ordre et de l'aventure: mélanges offerts à Pierre Olivier Walzer*, ed. Jean Roudaut et al. (Neuchâtel: La Baconnière, 1985), 121–36.

7. See Michel Sanouillet, "Sur trois lettres de Guillaume Apollinaire à Tristan Tzara," *Revue des Lettres Modernes*, 104–7 (1964), special issue *Guillaume Apollinaire* 3, 5–12, and *Dada à Paris* (Paris: Pauvert, 1965), 96–100. Entitled "La mort de Guillaume Apollinaire," the poem is reproduced in Tristan Tzara, *Oeuvres complètes*, ed. Henri Béhar (Paris: Flammarion, 1975), 1:209.

8. Guillaume Apollinaire, "Arbre," *Cabaret Voltaire*, May 1916, p. 11. Repr. in Guillaume Apollinaire, *Oeuvres poétiques*, ed. Marcel Adéma and Michel Décaudin (Paris: Gallimard/Pléiade, 1965), 178–79.

9. The interaction between Apollinaire and Tzara has been studied by Michel Sanouillet in particular (see above, n. 7). Among other things we know that the former received copies of several Dada publications as well as two books of poetry by Tzara. In return he sent him a copy of *Le Poète assassiné* inscribed: "À Tristan Tzara / très amical Hommage / Guillaume Apollinaire." See Gilbert Boudar et al., *Catalogue de la bibliothèque de Guillaume Apollinaire* (Paris: CNRS, 1983 and 1987), 1:154, 2:26, 31. Also Victor Martin-Schmets, "Index des dédicaces de Guillaume Apollinaire," *Le Livre et L'Estampe*, 25:132 (1988): 230.

10. P. A. Jannini, *La fortuna di Apollinaire in Italia* (Milan: Istituto Editoriale Cisalpino, 1965), 2nd ed. This work, which remains the basic text in the field, is complemented by the following studies: Guillaume Apollinaire, *Lettere a F. T. Marinetti*, ed. P. A. Jannini (Milan: Pesce d'Oro, 1978); Sergio Zoppi, "*Apollinaire et l'Italia en 1918*" in *Apollinaire en 1918*, ed. Jean Burgos et al. (Paris: Méridiens Klincksieck, 1988), 137–51, and *Al festino di Esopo* (Rome: Bulzoni, 1979), 105–15; Willard Bohn, "Une Lettre à Marinetti," *Revue des Lettres Modernes*, 677–81 (1983), special issue *Guillaume Apollinaire 16*: pp. 176–78, idem, "Sur la Butte: Apollinaire et Savinio," *Que Vlo-Ve?, Bulletin International des Etudes sur Apollinaire*, second series, 13 (January–March 1985): 5–9, idem, *Apollinaire et l'homme sans visage: création et évolution d'un motif moderne* (Rome: Bulzoni, 1984)—tr. as *Apollinaire and the Faceless Man: The Creation and Evolution of a Modern Motif* (Madison, NJ: Fairleigh Dickinson University Press, 1991), rev. ed.—and idem *The Aesthetics of Visual Poetry, 1914-1928*

(Cambridge: Cambridge University Press, 1986), 9–45; Luca Pietromarchi, *Dal manichino all'uomo di ferro: Alberto Savinio a Parigi (1910-1915)* (Milan: Unicopli, 1984); and Franca Bruera, " 'Mon beau navire ô ma mémoire': Savinio et Apollinaire," *Que Vlo-Ve?*, third series, 1 (January–March 1991): 9–13.

11. *Quaderni del Novecento Francese*, 13 (1992), ed. Lucia Bonato and 14 (1991), ed. Franca Bruera. See Also Franca Bruera, *Apollinaire & C.: Ungaretti—Savinio-Sanguineti* (Rome: Bulzoni, 1991 and Alessandro de Stefani, "Apollinaire et C.G. Sarti" in *Amis européens d'Apollinaire*, ed. Michel Décaudin (Paris: Sorbonne Nouvelle, 1995), 63–76. Also Lucia Bonato, "Aux Sources de la Modernité" ibid., 77–102, and Franca Bruera, "Du mythe de Paris au mythe d'Apollinaire," 103–23.

12. For a day by day account of the proceedings as related in the French press, see Christine Jacquet and Michel Décaudin, "Il y a soixante-quinze ans—La Santé," *Que Vlo-Ve?*, second series, 19 (July–September 1986): pp. 3–26; Willard Bohn, "Géry Pieret au bord du Pacifique," *Que Vlo-Ve?*, second series, 22 (April–June 1987): 8–9; Christine Jacquet and Michel Décaudin, "Note conjointe," ibid., 9–11; Christine Jacquet-Pfau and Michel Décaudin, "L'Affaire des statuettes," *Que Vlo-Ve?*, second series, 23 (July–September 1987): 21–23, and third series, 12 (October–December 1993), 89–96.

13. Anon., "The Lost Gioconda," *London Times*, September 13, 1911, p. 3.

14. Anon., "Various 'Clues' to Robbery of the *Mona Lisa* but Paris Fears that Picture is Lost Forever," *New York Times*, September 17, 1911, section C, p. 3. The same day the *New York Evening World* reported: "Another clue . . . concerns the doings of Géry Pieret, secretary to the journalist Guillaume Apollinaire, on the day of the theft. . . . Because Apollinaire said he had given Pieret a ticket to Marseille, he was arrested and held in prison five days" ("Paris Still Says an American Got Its *Mona Lisa*," September 17, 1911, section N, p. 3).Jacqueline Stallano provides a valuable complement in "Une relation encombrante: Géry Pieret," Décaudin, *Amis européens d'Apollinaire*, 10–29.

2. APOLLINAIRE AND THE ENGLISH MUSE

1. For a history of their relations see Guillaume Apollinaire, *Oeuvres en prose complètes*, vol. 3, ed. Pierre Caizergues and Michel Décaudin (Paris: Gallimard/Pléiade, 1993), 105–9. Cited in the

text hereafter as *Prose.* The story of Konitza's metamorphosis into Benjamin de Casseres is pure fantasy. In reality he continued to publish under his own name in the United States and was associated with the Albanian embassy in Washington, D.C. See also Luan Starova, "Faïk bég Konitza: une Symphonie inachevée" in *Amis européens d'Apollinaire,* ed. Michel Décaudin (Paris: Sorbonne Nouvelle, 1995), 171–85. Peter Read provides an excellent overview of Apollinaire's reception in England, from which I have taken several references, in "Présence et réception d'Apollinaire en Grande-Bretagne et aux Etats-Unis," published in *Apollinaire en 1918* (Paris: Klincksieck, 1988), 91–98, 105-13.

2. René Taupin, *L'Influence du symbolisme français sur la poésie américaine (de 1910 à 1920)* (Paris: Champion, 1929), 129. For a detailed analysis of Flint's role, see LeRoy C. Breunig, "F. S. Flint, Imagism's 'Maître d'École,'" *Comparative Literature* 4.2 (1952): 118–36.

3. F. S. Flint, "Verse Chronicle," *Criterion* 11.65 (July 1932): 687. See also Taupin, *L'Influence du symbolisme français,* 87, and James Naremore, "The Imagists and the French 'Generation of 1900,'" Contemporary Literature, 11.3 (Summer 1970): 354–55.

4. See, for example, Taupin, *L'Influence du symbolisme français,* 91, 128, and Christopher Middleton, "Documents on Imagism from the Papers of F. S. Flint," *The Review* 15 (April 1965): 35.

5. F. S. Flint, letter to the editor, *Times Literary Supplement,* January 27, 1950. Virtually all the material is in the Harry Ransom Humanities Research Center, The University of Texas at Austin. Except as otherwise noted, this collection is the source of the personal documents, both by and to F. S. Flint, discussed in this section. Besides Middleton's article, which draws on this collection, see Cyrena N. Pondrom, *The Road from Paris: French Influence on English Poetry 1900–1920* (Cambridge: Cambridge University Press, 1974). Six letters belonging to Harvard University are reproduced in Breunig, "F. S. Flint, Imagism's 'Maître d'école."

6. For the entire work, see Guillaume Apollinaire, *Oeuvres poétiques,* ed. Marcel Adéma and Michel Décaudin (Paris: Gallimard/Pléiade, 1965), 46–59. Cited hereafter in the text as OP.

7. See "The Complete Poetical Works of T. E. Hulme," in Ezra Pound, *Ripostes* (London: Swift, 1912).

8. Like the following four letters, Mercereau's reply is reproduced in Pondrom, *The Road from Paris,* 65–71.

9. Letter from F. S. Flint to Alexandre Mercereau, May 7, 1912. Together with the next three letters, it is reproduced in Pondrom, *The Road from Paris*, 73–83.

10. Letter from Alexandre Mercereau to F. S. Flint. Reproduced in Pondrom, *The Road from Paris*, 80–82. Although this document is dated by Flint "Received 9/11/12," in view of what transpired it must have been written before his article went to press.

11. F. S. Flint, "Contemporary French Poetry," *The Poetry Review* 1:8 (August 1912): 362.

12. F. S. Flint, "French Chronicle," *Poetry and Drama*, 1:2 (June 1913), 217–31.

13. Letter from Alexandre Mercereau to F. S. Flint, dated by the latter June 14, 1913.

14. F. S. Flint, "French Chronicle," *Poetry and Drama* 1:3 (September 1913): 357, 361, and 362 respectively.

15. Letter to the author from Mrs. Ianthe Price (Flint's daughter).

16. F. S. Flint, "French Chronicle," *Poetry and Drama*, 1:4 (December 1913). The entire discussion occupies pp. 481–83.

17. F. S. Flint, "French Chronicle," *Poetry and Drama* 2:5 (March 1914): 100.

18. Ibid., 103–4.

19. Gilbert Boudar et al., *Catalogue de la bibliothèque de Guillaume Apollinaire*, vol. 2 (Paris: CNRS, 1987). Apollinaire's library contains issues of two other magazines associated with Imagism: *The Egoist* and *Poetry*.

20. F. S. Flint, "French Chronicle," *Poetry and Drama*, 2:6 (June 1914): 220.

21. Boudar et al., *Catalogue de la bibliothèque*, 2:200.

22. "Manuscrits et documents à la Bibliothèque nationale," *Que Vlo-Ve?, Bulletin International des Etudes sur Apollinaire*, second series, 3 (July–September 1982): 14.

23. Amy Lowell Collection, Houghton Library, Harvard University.

24. Pp. 372–74 and 379–83. Comparison with a typed copy in the Harry Ransom Humanities Research Center, The University of Texas at Austin, reveals that it was printed word for word by Apollinaire.

25. In addition to the three principles evoked in his article "Imagisme," published the previous year, Flint added a fourth principle: "le mot juste." The former appeared in *Poetry* 1:6 (March 1913): 198–200. Flint wrote another article in French on the same subject several years later in which he referred to his review

in *Les Soirées de Paris*. Entitled "L'Imagisme," a draft is included in a notebook belonging to the Harry Ransom Humanities Research Center, The University of Texas at Austin. Although Middleton dates it 1915 ("Documents on Imagisme," p. 44), Flint mentions Edouard Dujardin's *De Stéphane Mallarmé au prophète Ezéchiel*, which was published in 1919. This is probably the article that appeared in the Belgian journal *L'Art Libre*, mentioned by Breunig ("F. S. Flint," p. 125), which began publication in April 1919.

26. To be sure, Apollinaire employed a pseudonym: J[ean] C[érusse], "Surnaturalisme," *Les Soirées de Paris*, 24 (May 1914): 248. See F. S. Flint, "French Chronicle," *Poetry and Drama*, 2:7 (September 1914): 302–4.

27. Leigh Henry, "Liberations: Studies of Individuality in Contemporary Music, No. IX. Fantaisiste Spirit in Modern French Music," *The Egoist* 3:1 (January 1, 1916): 3–4.

28. Leigh Henry, "Liberations: Studies of Individuality in Contemporary Music, No. VI. The Dramatic Conceptions of Alexander Scriabine," *The Egoist* 1:14 (July 19, 1914): 271.

29. Guillaume Apollinaire, *Oeuvres en prose*, 1, ed. Michel Décaudin (Paris: Gallimard/Pléiade, 1977): 497–99.

30. F. S. Flint, "Some Modern French Poets," *The Monthly Chapbook* 4 (October 1919): 5–10.

31. [F. S. Flint] "French War Poetry," *Times Literary Supplement* 18:924 (October 2, 1919): 522.

32. "Notes on Baudelaire," *Times Literary Supplement* 18:935 (December 18, 1919): 762. "Parody à Outrance," *Times Literary Supplement* 19:974 (September 16, 1920): 599. "The Younger French Poets," *The Chapbook* 17 (November 1920): 8, 14. Although the first two articles are anonymous, throughout 1919 and 1920 Flint was the *Times'* French poetry critic (Breunig, "F. S. Flint," p. 132).

33. *Rhythm* 1:3 (Winter 1911), inside front cover.

34. Francis Carco, "Lettre de Paris," *Rhythm* 2:2 (July 1912): 66–67.

35. Huntly Carter, *The New Spirit in Drama and Art* (New York and London: Mitchell Kennerly, 1913): 242–43.

36. According to an anonymous note, Barzun planned to publish the poem in a future issue of *Poème et Drame* ("La Phalange héroïque s'accroit," *Poème et Drame*, second series, 7 [January–March 1914]: 72). Dated December 7, 1913, the letter is reproduced in Henri-Martin Barzun, *Orpheus: Orphic Art* (New York: Liberal Press, 1956), 29–30; see also p. 8. Additional information about the poem

is provided by Ellen Ginzburg Migliorino, "Aspects of Simultaneity in England and the United States," *Quaderni del Novecento Francese* 10 (1987): 306–7.

37. Richard Aldington, "Some Recent French Poets," *The Egoist* 1:12 (June 14, 1914): 221.

38. Ibid., 223. Originally published in *Les Soirées de Paris* 15 (April 1913) and 23 (April 15, 1914) respectively. The first poem was reprinted in *Le Gay Scavoir* in March 1914, the second in the *Mercure de France* on May 16, 1914 (quoted by Charles-Henri Hirsch in his column "Les Revues," p. 398).

39. The above information was kindly provided by Gilbert Boudar. Peter Read quotes the first few lines in "Présence et réception d'Apollinaire," 110.

40. Boudar et al., *Catalogue de la bibliothèque*, 2:157–58.

41. Richard Aldington, "Reviews," *The Egoist* 1:13 (July 1, 1914): 248.

42. Nicolas Beauduin, "The New Poetry of France," tr. Richard Aldington, *The Egoist* 1:16 (August 15, 1914): 315–16.

43. Wassily Kandinsky, *The Art of Spiritual Harmony*, tr. M. T. H. Sadler (London: Constable, 1914), xix, xxvii. *Les Peintres cubistes* also attracted the attention of a prolific author named Vincent O'Sullivan, who proposed to translate it into English. For a description of his correspondence with Apollinaire in 1914, see Read, "Présence et réception d'Apollinaire," pp. 110–12. In 1919 O'Sullivan referred to Apollinaire in an article published in *Cosmópolis* (see chapter 6, note 104). Subsequently he defended the poet's reputation in a long letter to the editor of *The Dublin Magazine* (January–March 1936): 90–94). The Scottish artist S. J. Peploe also owned a copy of *Les Peintres cubistes*, which he acquired during a stay in Paris. See *S. J. Peploe, 1871–1935* (Edinburgh: Scottish National Gallery of Modern Art, 1985), 57.

44. See, for example, William C. Wees, *Vorticism and the English Avant-Garde* (Toronto: University of Toronto Press, 1972), 115, 161, and Reed Way Dasenbrook *The Literary Vorticism of Ezra Pound and Wyndham Lewis: Toward the Condition of Painting* (Baltimore: Johns Hopkins University Press, 1985), 24. For the manifesto, see Apollinaire, *Oeuvres en prose complètes*, 2:937–39.

45. Apollinaire, *Oeuvres en prose complètes*, 3:218. An earlier review appeared in *Paris-Journal* on July 15, 1914. Repr. in Apollinaire, *Oeuvres en prose complètes*, 2:827–28. Like *Des Imagistes, Blast* was undoubtedly for sale at Horace Holley's Ashnur Gallery on the Boulevard Raspail. In a letter to Frederick Etchells, who was in

Paris during this period, Wyndham Lewis suggested that he post prospectuses for the Rebel Art Centre in "the American artshop in the Boul. Raspail" and promised to send him copies of *Blast* when it appeared; see *The Letters of Wyndham Lewis*, ed. W. K. Rose (London: Methuen, 1963), 60. Gertrude Stein reports that the publisher John Lane brought her a copy toward the end of June; see *The Autobiography of Alice B. Toklas* in *Selected Writings of Gertrude Stein*, ed. Carl Van Vechten (New York: Modern Library, 1962), 132.

46. Wyndham Lewis, "Vorteces and Notes," *Blast* 1 (June 29, 1914): 132.

47. Richard Aldington, "The Case of French Poetry," *The Little Review* 1.11 (February 1915): 19.

48. "Periodical Not Received," *The Egoist*, 2.8 (August 2, 1915): 131.

49. Alec W. G. Randall, "*Der Sturm*," *The Egoist*, 2.10 (October 1, 1915): 159; Muriel Ciolkowska, "Passing Paris," *The Egoist* 3.1 (January 1, 1916): 11. Sébastien Voirol, "French Poems," *The Egoist* 3.4 (April 1, 1916): 53.

50. Huntly Carter, "The Rebirth of the Importance of France," *The Egoist* 4.9 (September 1917): 123.

51. "Death of Guillaume Apollinaire," *The Egoist* 5.10 (November–December 1918): 137.

52. Huntly Carter, "The Old Master as Grotesque, VIII.—Negrotesque," *The New Age* Vol. XXV, No. 25.27 (October 30, 1919): 443.

53. M[uriel] C[iolkowska], "The French Idea," *The Egoist* 6.1 (January–February 1919): 9–10.

54. Harold Monro, *Some Contemporary Poets* (London: Parsons, 1920): 105.

55. "Unanimiste Prose," *Times Literary Supplement* 19.940 (January 22, 1920): 48. Although this and many of the following articles are anonymous, Flint wrote to LeRoy Breunig that he was the *Times'* French poetry reviewer throughout 1919 and 1920 and that Aldington was the French prose reviewer. That the latter authored the articles discussed here is corroborated by comparison with signed reviews.

56. "Guillaume Apollinaire," *Times Literary Supplement* 19.962 (June 24, 1920): 396.

57. Richard Aldington "The Disciples of Gertrude Stein," *Poetry*, 17.1 (October 1920): 37–38.

58. "New Foreign Book," *Times Literary Supplement* 20.1014 (June 23, 1921): 404.

59. Richard Aldington, "The Poet and His Age," *The Chapbook* 29 (September 1922): 8-9.

60. Ezra Pound, "Editorial Comment, Status Rerum," *Poetry* 2.4 (January 1913): 123.

61. This encounter is described in Ezra Pound, "Remy de Gourmont," *The Fortnightly Review* 104 (December 1, 1915): 1162.

62. On April 10, 1913, Pound wrote to Flint to ask him to send a congratulatory letter on behalf of "The English Society of Ideologists" (Harry Ransom Humanities Research Center, University of Texas at Austin). For Brisset himself, see André Breton, ed. *Anthologie de l'humour noir* (Paris: Pauvert, 1966): 233–37.

63. As late as 1918, Pound still thought Unanimism was the most vital movement in Paris. See his "A Study in French Poets," *The Little Review* 4.10 (February 1918): 59.

64. Ezra Pound, "The Approach to Paris," *The New Age* 13.20 (September 11, 1913): 577. He repeated this claim the following month in an article entitled "Paris," *Poetry* 3.1 (October 1913): 27.

65. Ezra Pound, "The Approach to Paris," *The New Age* 13.19 (September 4, 1913): 552

66. Letter from Ezra Pound to James Laughlin dated January 30, 1934. Repr. in *Ezra Pound and James Laughlin: Selected Letters*, ed. David M. Gordon (New York: Norton, 1994): 21.

67. Noel Stock, *The Life of Ezra Pound* (New York: Avon, 1970): 187–88.

68. Ezra Pound, "The Approach to Paris," *The New Age* 13.25 (October 16, 1913): 728.

69. Ezra Pound, "Paris," 30.

70. For Whitman's influence among Apollinaire's contemporaries, see Betsy Erkkila, *Walt Whitman Among the French: Poet and Myth* (Princeton: Princeton University Press, 1980).

71. Ezra Pound, "Ferrex on Petulance," *The Egoist* 1.1 (January 1, 1914): 9–10. Signed Ferrex.

72. Ezra Pound, "The New Sculpture," *The Egoist* 1.4 (February 16, 1914): 68.

73. Ezra Pound, *Collected Early Poems*, ed. Michael John King (New York: New Directions, 1976): 284.

74. Ezra Pound, *Personae: The Collected Shorter Poems* (New York: New Directions, 1950), 239. Cited in the text hereafter as *Personae.*

75. Ezra Pound, "Vorticism," *The Fortnightly Review*, n.s., 96.578 (September 1, 1914): 461–71. Pound refers to the earlier lectures in *Gaudier-Brzeska: A Memoir* (London and New York: Lane, 1916), 93.

76. Guillaume Apollinaire, *Méditations esthétiques: les peintres cubistes* in *Oeuvres en prose complètes*, 2:6. Apollinaire uses "transporter" rather than "porter," but the sense is the same.

77. Ezra Pound, "Status Rerum—The Second," *Poetry* 8.1 (April 1916): 41.

78. Anonymous, "Introducing Jean de Bosschère," *The Little Review* 3.7 (November 1916): 11. Dated June 30, 1916, the letter itself is reproduced in *Pound/The Little Review: The Letters of Ezra Pound to Margaret Anderson*, ed. Thomas L. Scott et al. (New York: New Directions, 1988), 1.

79. Letter from Ezra Pound to Margaret Anderson, dated September 13, 1917. *Pound/The Little Review*, 123.

80. Letter from Ezra Pound to Margaret Anderson, dated November 5, 1917. *Pound/The Little Review*, 140.

81. Ezra Pound, "Art Notes: At the Alpine Club Gallery," *The New Age* 22.26 (April 25, 1918): 504. Signed B. H. Dias.

82. Ezra Pound, "What America Has to Live Down," *The New Age* 23.17 (August 22, 1918): 267.

83. Apollinaire, *Oeuvres en prose complètes*, 3:138-40. Apollinaire's column also seems to have received a certain amount of attention from the American press. On May 23, 1913, Adelaide Estelle Bear, who was preparing a book on Whitman, wrote from New Jersey to ask him for a copy of his attack on the poet. See Peter Read, "Présence et réception d'Apollinaire," 109.

84. Pound's reconciliation with Whitman is described in "A Pact," which appeared in *Poetry* in April 1913. See *Personae*, 89.

85. Ezra Pound, "The Island of Paris: A Letter," *The Dial* 69.4 (October 1920): 407.

86. Letter from Ezra Pound to Wyndham Lewis, dated April 27, 1921. *The Letters of Ezra Pound, 1907–1941*, ed. D. D. Paige (New York: Harcourt, Brace, and World, 1950), 230.

87. Letter from Ezra Pound to Wyndham Lewis, dated July 14, 1922. *Pound/Lewis: The Letters of Ezra Pound and Wyndham Lewis*, ed. Timothy Materer (New York: New Directions, 1985), 133.

88. Letter from Ezra Pound to Charles Henri Ford, dated February 1, 1929. Paige, *The Letters of Ezra Pound*, 223.

89. *Pound/Zukofsky: Selected Letters of Ezra Pound and Louis Zukofsky*, ed. Barry Ahearn (New York: New Directions, 1987), 106. For more details of this project see Zukofsky's letters dated July 12, 1931, and December 15, 1932, as well as Pound's replies on December 6, 1932, and January 8, 1933.

90. Charles Norman, *Ezra Pound* (New York: Macmillan, 1960), 316.

91. Ezra Pound, *Guide to Kulchur* (London: Faber, 1938), 203. Pound had previously asked Zukofsky if he knew of an Apollinaire-Frobenius connection, but the latter was unable to help him. See *Pound/Zukofsky*, 109.

92. In a letter from St. Elizabeth's Hospital he wrote : "H[enri] G[audier-Brzeska] had been browsin in Bib[liothèque] Na[tion-ale] / Paris when Apollinaire was robbin the Toccerdero, etc. and had heard of cave-men." *Pound/Lewis*, 252.

93. See chapter l, note 12.

94. Ezra Pound, "Epstein, Belgion and Meaning," *The Criterion* 9.36 (April 1930): 474–75.

95. Guillaume Apollinaire, "L'Esprit nouveau et les poètes," *Mercure de France* 130.491 (December 1, 1918): 396. Repr. in Apollinaire, *Oeuvres en prose complètes*, 2.6.

96. Herbert Read, *Annals of Innocence and Experience* (London: Faber, 1940), 96.

97. Norman, *Ezra Pound*, 316–17.

98. Andrew Clearfield, "Pound, Paris, and Dada," *Paideuma* 7.1–2 (Spring–Fall 1978): 131–32.

99. Letter from Ezra Pound to James Laughlin, dated January 30, 1934. *Ezra Pound and James Laughlin*, 21. Pound added that he couldn't find much to say about *Alcools* in his 1913 review(s) and that he didn't remember ever corresponding with Apollinaire.

100. See Henri Meschonnic, "Apollinaire illuminé au milieu d'ombres,' *Europe* 91.451-452 (November–December 1966): 168–69.

101. The line occurs in both "The Picture" and "Of Jacopo del Sellaio." See *Personae*, 73.

102. See *Personae*, 109. Pound describes the elaboration of this poem in "Vorticism," 465–67.

103. Ibid., 467.

104. Guillaume Apollinaire, "Simultanisme-Librettisme," *Les Soirées de Paris* 25 (June 15, 1914): 324. Repr. in Apollinaire, *Oeuvres en prose compètes*, 2:976. For an excellent discussion of *La Prose du transsibérien*, see Marjorie Perloff, *The Futurist Moment: Avant-*

> *Garde, Avant Guerre, and the Language of Rupture* (Chicago: University of Chicago Press, 1986), 3–29.

105. In addition, Peter Read suggests that the conclusion of Canto LXXX deliberately echoes the end of "Zone" (OP, 44) ("Présence et réception d'Apollinaire," 108). Whereas Apollinaire's poem concludes with the verse "Soleil cou coupé," Pound writes: "sunset grand couturier."

106. Clearfield, "Pound, Paris, and Dada," 132n59.

107. See Georges Duhamel's savage attack on *Alcools* in the *Mercure de France*, 103.294 (June 16, 1913): 800–801.

3. THE NEW SPIRIT IN AMERICA

1. I am thinking in particular of T. S. Eliot and Ezra Pound, both of whom would seem to owe more to French literary cubism than to Symbolism. Much of the confusion regarding the extent of Symbolist influence appears to have been generated by René Taupin's *L'Influence du symbolisme français sur la poésie américaine (de 1910 à 1920)* (Paris: Champion, 1929). Taupin mistakenly believed that the French contemporaries of the Imagists were all Symbolists and that Imagism itself was nothing but an American version of Symbolism.

2. Peter Read provides an excellent overview of Apollinaire's reception in America, from which I have extracted several references, in "Présence et réception d'Apollinaire en Grande-Bretagne et aux Etats-Unis," published in *Apollinaire en 1918* (Paris: Klincksieck, 1988), 91–92, 98–104, 109–10. On the subject of Apollinaire's relation to America in general, see Scott Bates, "Apollinaire et l'Amérique," *Savoir et Beauté* (Belgium), Nos. 2-3 (1964), pp. 2675-80.

3. Read, "Présence et réception d'Apollinaire," 109.

4. Repr. in Guillaume Apollinaire, *Anecdotiques*, ed. Marcel Adéma (Paris: Gallimard, 1955), 299.

5. *The Howard and Muriel Weingrow Collection of Avant-Garde Art and Literature at Hofstra University: An Annotated Bibliography*, ed. Barbara Lekatsas (Westport, Greenwood, 1985), 9, n. 55. For Konitza and Casseres see Guillaume Apollinaire, "Faik bég Konitza," *Mercure de France* 97.267 (May 1, 1912): 211–14. Repr. in Guillaume Apollinaire, *Oeuvres en prose complètes*, vol. 3, ed. Pierre Caizergues and Michel Décaudin (Paris: Gallimard/Pléiade, 1993), 105–9.

6. See J.-C. Chevalier and L. C. Breunig, "Apollinaire et *Les Peintres cubistes*," *Revue des Lettres Modernes* 104–7 (1964), special issue *Guillaume Apollinaire 3*, 108, 112n36.

7. John Weichsel, "Cosmism or Amorphism," *Camera Work* 42–43 (April-July 1913): 80. See Guillaume Apollinaire, *Méditations esthétiques: les peintres cubistes* in Apollinaire, *Oeuvres en prose complètes*, 2:5, 9.

8. Christian Brinton, "Current Art, Native and Foreign," *The International Studio* 49.195 (May 1913): lvi.

9. Maurice Aisen, "The Latest Evolution in Art and Picabia," *Camera Work*, special issue dated June 1913, p. 18.

10. See Apollinaire, *Les Peintres cubistes*, 16.

11. Anonymous, "Vers l'amorphisme," *Camera Work*, special issue dated June 1913, p. 57. See Apollinaire, *Les Peintres cubistes*, 16–17 and 10 respectively.

12. William Agee, "New York Dada, 1910–1930," *The Avant-Garde*, ed. Thomas B. Hess and John Ashberry (London: Collier-Macmillan, 1968), 105–13. This publication corresponds to the *Art News Annual* for 1968.

13. Frank Jewett Mather, Jr., "The New Painting and the Musical Fallacy," *The Nation* 99.2576 (November 12, 1914): 588. Mather expressed essentially the same opinion thirteen years later in *Modern Painting: A Study in Tendencies* (New York: Holt, 1927), 365.

14. Arthur J. Eddy, *Cubists and Post-Impressionism* (Chicago: McClurg, 1914), 67–69 and 80–81 respectively. See Apollinaire, *Les Peintres cubistes*, 14–28, 11–12. The bibliography lists the latter work, a 1907 essay on Matisse, and two articles that appeared in *Der Sturm* (in 1912 and 1913). It announces that Apollinaire will direct a series of books on modern art for the publisher Figuière, including his own forthcoming volume *Les Peintres orphiques*.

15. Man Ray, *Self-Portrait* (Boston: Little, Brown, 1963), 43–44. For the history of Ray and Lacroix (whom he calls Donna Loupov in his memoirs), see Francis Naumann, "Man Ray and the Ferrer Center: Art and Anarchy in the Pre-Dada Period," *Dada/Surrealism* 14 (1985): 21.

16. Ezra Pound, "Paris," *Poetry* 3.l (October 1913): 30.

17. The following reconstruction of de Zayas' Paris visit is based on his correspondence with Stieglitz in the Alfred Stieglitz Archive, Collection of American Literature, The Beinecke Rare Book and Manuscript Library, Yale University.

18. Guillaume Apollinaire, "En Amérique," *Paris-Journal*, May 25, 1914. Repr. in Apollinaire, *Oeuvres en prose complètes*, 2:729.
19. "Marius de Zayas," *Paris-Journal*, July 8, 1914. Repr. in Apollinaire, *Oeuvres en prose complètes*, 2:812–13.
20. Guillaume Apollinaire, *Oeuvres poétiques*, ed. Marcel Adéma and Michel Décaudin (Paris: Gallimard/Pléiade, 1965), 188–91. For a fuller account of the collaboration and an analysis of the pantomime see Willard Bohn, *Apollinaire and the Faceless Man: The Creation and Evolution of a Modern Motif* (Madison, NJ, Fairleigh Dickinson University Press, 1991), rev. ed., 41–76.
21. Besides a copy of the pantomime, entitled *À quelle heure un train partira-t-il pour Paris?*, Apollinaire gave him the manuscript and corrected proofs for "Paysage" (OP, 170). See Willard Bohn, "Landscaping the Visual Sign: Apollinaire's 'Paysage,'" *Philological Quarterly* 65.3 (Summer 1986): 345–69.
22. Letter from Samuel Halpert to Alfred Stieglitz, dated July 30, 1914. Alfred Stieglitz Archive, Collection of American Literature, The Beinecke Rare Book and Manuscript Library, Yale University.
23. Guillaume Apollinaire, "Simultanisme-Librettisme," *Les Soirées de Paris* 25 (June 1914): 323–25. Repr. in Apollinaire, *Oeuvres en prose complètes*, 2:975–77.
24. Ibid., 976.
25. "Watch Their Steps," *291* 3 (May 1915): 4.
26. An advertisement in the *New York Evening Post*, on March 18, 1913, announces "Afternoon Tea in the Luncheon Restaurant, Three to Six" (p. 3).
27. Guillaume Apollinaire, *Lettres à Lou*, ed. Michel Décaudin (Paris: Gallimard, 1969), 308, 314, 431.
28. See Willard Bohn, *The Aesthetics of Visual Poetry, 1914–1928* (Cambridge: Cambridge University Press, 1986), 185–203.
29. See ibid., 9–28.
30. On November 3, 1915, Stieglitz wrote to Pound at 5 Holland Place Chambers: "Mr. Kreymborg has requested me to send you a set of *291*. A set is going to you under separate cover as well as a few copies of *Camera Work* including the one called 'What is 291'" The same day he sent a similar letter, a set of *291*'s, some *Camera Works*, and an article by John Weichsel to Huntly Carter in London, who had requested the latter item. Carter published an article about Stieglitz and "291" a few months later, based on these materials. See "Two-Nine-One," *The Egoist* 3.3 (March 1, 1916): 43. Carbon copies of both Stieglitz letters are in the Alfred

Stieglitz Archive, Collection of American Literature, The Beinecke Rare Book and Manuscript Library, Yale University.

31. Amy Lowell, "The New Manner in Modern Poetry," *The New Republic* 6.70 (March 4, 1916): 124.

32. George Wickes, *Americans in Paris* (Garden City, NY: Doubleday, 1969), 114ff.

33. Richard Aldington, "The Case of French Poetry," *The Little Review* 1.11 (February 1919): 19.

34. Alec W. G. Randall, "International Magazines in Germany," *Bruno's Weekly* 1.14 (October 21, 1915): 142.

35. Judith Zilczer, "Robert J. Coady, Man of *The Soil*," *Dada/Surrealism* 14 (1985): 34–35.

36. Willard Huntington Wright, *Modern Painting: Its Tendency and Meaning* (New York and London: Lane, 1915), 341.

37. Willard Huntington Wright, "The Aesthetic Struggle in America," *The Forum* 55.2 (February 1916): 210.

38. Willard Huntington Wright, *The Creative Will: Studies in the Philosophy and the Syntax of Aesthetics* (New York and London: Lane, 1916), 261.

39. At least one letter exists from Patrick Henry Bruce to Apollinaire. Peter Read provides a summary in "Présence et réception d'Apollinaire," 110. See also Willard Bohn, "O. W. Gambedoo, H. H. et *Les Soirées de Paris*," *Revue des Lettres Modernes* 249–53 (1970), special issue *Guillaume Apollinaire 9*, 135–41, and "Apollinaire chez les Stein," forthcoming in the same journal.

40. See Willard Bohn, "Apollinaire et les peintres: Morgan Russell et Carlo Carrà," *Revue des Lettres Modernes* 576–81 (1980), special issue *Guillaume Apollinaire 15*, pp. 111–13. The Montclair Art Museum, Montclair, New Jersey, possesses the following note from Apollinaire to Russell dated October 10, 1913: "Cher monsieur, / Un mercredi où vous aurez le temps venez me voir vers 3 heures / Votre / Guillaume Apollinaire / 202 Bd St Germain."

41. The letter from Apollinaire to Russell belongs to the Montclair Art Museum, Montclair, New Jersey. The letter from Apollinaire to Stieglitz and the Russell-Stieglitz correspondence belong to the Alfred Stieglitz Archive, Collection of American Literature, The Beinecke Rare Book and Manuscript Library, Yale University.

42. Muriel Ciolkowska, "Passing Paris," *Bruno's Weekly*, 2.4 (January 22, 1916), 397. Repr. from *The Egoist* 3.1 (January 1, 1916): 10–11.

43. Ezra Pound, "Status Rerum—The Second," *Poetry*, 8.1 (April 1916): 41, and Anon., "Introducing Jean de Bosschère," *The Little Review* 3.7 (November 1916): 11.

44. Marius de Zayas, "Cubism?," *Arts and Decoration* 6.6 (April 1916): 285–86. See Apollinaire, *Les Peintres cubistes*, 14–18.

45. Anonymous, "291—A New Publication," *Camera Work* 48 (October 1916): 62.

46. James Huneker, *Unicorns* (New York: Scribner's, 1917), 293.

47. Harrison Reeves, "The Tragedy of Alan Seeger," *The New Republic* 10.123 (March 10, 1917): 160.

48. See, for example, the note from E. C. Macomber in Read, "Présence et réception d'Apollinaire," 109–10. Among other things, the poet dedicated a copy of *Alcools* to him: "A mon cher Harrison Reeves, son ami Guillaume Apollinaire" (Victor Martin-Schmets, "Index des dédicaces de Guillaume Apollinaire," *Le Livre et L'Estampe* 35.132 [1989]: 210). Two letters from Reeves to Apollinaire, a letter from Apollinaire to Reeves, and an invitation from Cocteau to dine with him and Reeves are included in *Correspondance Guillaume Apollinaire Jean Cocteau*, ed. Pierre Caizergues and Michel Décaudin (Paris: J.-M. Place, 1991), 104,109–14. For a letter from Reeves supporting the poet during the Whitman controversy see Apollinaire, *Anecdotiques*, 300–302. Reeves wrote about detective stories, and Seeger about baseball, in *Les Soirées de Paris* in March 1914 and July 1914 respectively. For Apollinaire's opinion of Seeger, see *Oeuvres en prose complètes*, 2:1185–86, and 3:300–302.

49. See George H. Bauer, "Enamouring a Barber Pole," *Dada/Surrealism* 12 (1983): 20–36.

50. Peter Read analyzes this connection in detail in "Guillaume Apollinaire, Richard Mutt et Marcel Duchamp," *Revue des Lettres Modernes* 677–81 (1983), special issue *Guillaume Apollinaire 16*, 117–32.

51. Read, "Présence et réception d'Apollinaire," 99–100.

52. Postcard From Guillaume Apollinaire to Henri-Pierre Roché, postmarked May 8, 1917. Harry Ransom Humanities Research Center, The University of Texas at Austin.

53. Guillaume Apollinaire, "*The Blindman*, gazette américaine," *Mercure de France* 121.455 (June 1, 1917): 576. Repr. in Apollinaire, *Oeuvres en prose complètes*, 2:1329-30.

54. Letter from Guillaume Apollinaire to Henri-Pierre Roché, dated "Juillet 15" in the latter's hand. Harry Ransom Humanities Research Center, The University of Texas at Austin.

55. Guillaume Apollinaire, "L'Art tactile," *Mercure de France* 125.472 (February 16, 1918): 751–53. Repr. in *Oeuvres en prose complètes*, 3:270–71.

56. Guillaume Apollinaire, "Le Cas de Richard Mutt," *Mercure de France* 122.480 (June 16, l918): 764. Repr. in Apollinaire, *Oeuvres en prose complètes*, 2:1378-80.

57. Anonymous, "Passing of Punctuation," *Current Opinion* 63.1 (July 1917), 48.

58. G. Dorlac, preface to *Exhibition of African Negro Sculpture* (New York: Modern Gallery, January 21–February 9, 1918).

59. Helen Appleton Read, "American Museum of Natural History Shows African Negro Art," *The Brooklyn Eagle*, January 27, 1918. Repr. in Marius de Zayas, "How, When, and Why Modern Art Came to New York," ed. Francis Naumann, *Arts Magazine* 54.8 (April 1980): 112.

60. Guillaume Apollinaire, "Mélanophilie ou mélanomanie," *Mercure de France* 120.451 (April 1, 1917): 559–61. Repr. in *Oeuvres en prose complètes* 3:252–55. Entitled "À propos de l'art des noirs," the article was reprinted with only minor changes in *Sculptures nègres* (Paris: Galerie Paul Guillaume, 1917).

61. Postcard from Guillaume Apollinaire to Henri-Pierre Roché, postmarked February 21, 1918. Harry Ransom Humanities Research Center, The University of Texas at Austin.

62. Anonymous, "Passing of Guillaume Apollinaire, Explorer of the New Esthetics," *Current Opinion* 66.2 (February 1919): 119.

63. Guillaume Apollinaire, "L'Esprit nouveau et les poètes," *Mercure de France* 130.491 (December 1, 1918): 385–96. Repr. in Apollinaire, *Oeuvres en prose complètes*, 2:943–54. References are to pp. 949, 945, 946, and 947–48 respectively.

64. Fritz R. Vanderpyl, "Art and Eiffel Towers," *Poetry*, 16.2 (May 1920): 101.

65. Muriel Ciolkowska, "Machinery in Art," *Poetry* 16.6 (September 1920): 347.

66. John Rodker, "Other Books," *The Little Review* 7.3 (September–December 1920): 66–67.

67. Muriel Ciolkowska, "Mr. Rodker and Modern French Poetry," *The Little Review* 7.4 (January–March 1921): 44.

68. Ezra Pound, "The Island of Paris," *The Dial* 69.4 (October 1920): 407. Richard Aldington, "The Disciples of Gertrude Stein," *Poetry* 17.1 (October 1920): 40.

69. Henry Mc Bride, "Modern Art," *The Dial* 70.3 (March 1921): 356–57.

70. Henry McBride, "Derain, the Modern French Soldier Painter," *New York Sun*, November 18, 1917. Repr. in de Zayas, "How, When, and Why," 122–23. See Apollinaire, *Oeuvres en prose complètes*, 2:859–61.

71. Henry Mc Bride, "Luncheon in Paris with Raoul Dufy," *New York Sun*, December 30, 1917. Repr. in Henry McBride, *The Flow of Art: Essays and Criticisms*, ed. Daniel Catton Rich (New York: Atheneum, 1975), 144.

72. Henry Mc Bride, "Modern Art," *The Dial* 71.6 (December 1921): 720.

73. Henry McBride, "Apollinaire's Cubistic Authority," *New York Herald*, October 15, 1922, section 7, p. 6. See Apollinaire, *Les Peintres cubistes*, 8–11. McBride quoted all of section II, except the anecdote from Pliny, and the first half of section III.

4. AMONG THE GERMAN EXPRESSIONISTS

1. See for example Ernst Wolf, *Guillaume Apollinaire und das Rheinland* (1937; Frankfort: Lang, 1988) and Pierre Orecchioni, *Le Thème du Rhin dans l'inspiration de Guillaume Apollinaire* (Paris: Minard, 1956). Other pertinent studies include Marc Poupon's "Sources allemandes d'Apollinaire," *Revue des Lettres Modernes* 530–536 (1978), special issue *Guillaume Apollinaire 14*, 7–49, and three articles by Raymond Warnier: "Guillaume Apollinaire et l'Allemagne," *Revue de Littérature Comparée* 28.2 (April–June 1954): 168–90; "Guillaume Apollinaire," *Romanische Forschungen* 65.3–4 (1954): 392–410; and "Apollinaire et l'Allemagne," *Annales du Centre Universitaire Méditerranéen* 19, (1965–66): 213–14.

2. These articles have been collected in Guillaume Apollinaire, *Oeuvres en prose complètes*, 2, ed. Pierre Caizergues and Michel Décaudin (Paris: Gallimard/Pléiade, 1991).

3. See for example Pierre Caizergues, ed. *La Démocratie Sociale* (Paris: Minard, 1969).

4. Friedrich Ahlers-Hestermann provides one of the best accounts of this group (and valuable illustrations) in "Der deutsche Künstlerkreis des Café du Dôme in Paris," *Kunst und Künstler* 16.10 (July 1, 1918): 369–402. Other issues contain studies of individual members of the group.

5. Eberhard Leube, "Un exemplaire dédicacé d'*Alcools* jusqu'à présent inconnu," *Revue des Lettres Modernes* 677–81 (1983), special issue *Guillaume Apollinaire 16*, 181–82.

6. The German volumes in his library are listed in Gilbert Boudar et al., *La Bibliothèque de Guillaume Apollinaire*, vol. 1 (Paris: CNRS, 1983), 191–99, and vol. 2 (Paris: CNRS, 1987), 151–56. Devoted to periodicals, the second volume lists numerous catalogues as well (both foreign and domestic).

7. Peter Selz, *German Expressionist Painting* (Berkeley: University of California Press, 1957), 270–71.

8. Undated letter from Robert Delaunay to Wassily Kandinsky. Cited in Robert Delaunay, *Du cubisme à l'art abstrait*, ed. Pierre Francastel (Paris: SEVPEN, 1957), 179.

9. Letter From Robert Delaunay to Bernhard Koehler dated March 21, 1912; originally in French. Cited in Karl-Heinz Meissner, "Delaunay-Dokumente" in *Delaunay und Deutschland* by Peter-Klaus Schuster (Cologne: DuMont, 1985), 491.

10. Guillaume Apollinaire, "La Jeunesse artistique et les nouvelles disciplines," *L'Intransigeant*, April 21, 1911. Repr. in Apollinaire, *Oeuvres en prose complètes*, 2:318. See pp. 428 and 437 for *La Ville de Paris*.

11. Richard Brinkmann, "Dada and Expressionism," in *Expressionism as an International Literary Phenomenon*, ed. Ulrich Weisstein (Paris: Didier and Budapest: Akadémiai Kiadó, 1973), 103.

12. Walter Mehring, "Berlin Avantgarde" in *Expressionismus: Aufzeichnungen und Erinnerungen der Zeitgenossen*, ed. Paul Raabe (Freiburg: Walter, 1965), 117. Maria Brümann provides a useful survey of the Berlin avant-garde in *Apollinaire und die deutsche Avantgarde* (Hamburg: Krämer, 1988).

13. Selz, *German Expressionist Painting*, 256.

14. Herwarth Walden, *Die neue Malerei* (Berlin: Der Sturm, 1919), 5.

15. Klaus Petersen, *Ludwig Rubiner: eine Einführung mit Textauswahl und Bibliographie* (Bonn: Bouvier, 1980), 9.

16. Letter from Herwarth Walden to Robert Delaunay dated November 27, 1912. Cited in Meissner, "Delaunay-Dokumente," 496. Unless otherwise noted, subsequent references to correspondence concerning Delaunay and/or August Macke are to this collection.

17. Guillaume Apollinaire, "Réalité peinture pure," *Der Sturm* 3.138-39 (December 1912): 224–25. Repr. in Apollinaire, *Oeuvres en prose complètes*, 2:494–96, 1592–94.

18. Letter from Robert Delaunay to Franz Marc dated December 14, 1912. Cited in Delaunay, *Du cubisme à l'art abstrait*, 181. The date is provided by Meissner in "Delaunay-Dokumente" (p. 498), who gives only German translations of Delaunay's letters.

19. Letter from Robert Delaunay to Franz Marc dated January 11, 1913. Cited in Delaunay, *Du cubisme à l'art abstrait*, 187–90.

20. Guillaume Apollinaire, *Oeuvres poétiques*, ed. Marcel Adéma and Michel Décaudin (Paris: Gallimard/Pléiade, 1965), 33.

21. Guillaume Apollinaire, *Méditations esthétiques: les peintres cubistes* in Apollinaire, *Oeuvres en prose complètes*, 2:18. An earlier version appears in "Die moderne Malerei"(see note 3).

22. For a photograph of the postcard see Pierre Cailler, *Guillaume Apollinaire: documents iconographiques* (Geneva: Cailler, 1965), plate 82. In *Du cubisme à l'art abstrait* (p. 171), Delaunay relegates this project to 1912, but it clearly dates from the following year.

23. According to Meissner the dates were January 17–February 20, 1913 ("Delaunay-Dokumente," 499). Although one of the January issues of *Der Sturm* declared that the show would open on January 27th, this statement is contradicted by the date on the handbills that were distributed (January 17th). Gerhard Dörr studies Apollinaire's activities during this period in "Apollinaire et *Der Sturm*, Berlin, Janvier 1913" in *Amis européens d'Apollinaire* , ed. Michel Décaudin (Paris: Sorbonne Nouvelle, 1995), 151–61.

24. Christine Jacquet, "Manuscrits et documents à la Bibliothèque nationale," *Que Vlo-Ve?*, *Bulletin International des Etudes sur Apollinaire*, second series, 3 (July–September 1982): 3–29.

25. Thomas Grochowiak, *Ludwig Meidner* (Recklinghausen: Kunsthalle, 1966), 224.

26. See Guy Habasque, ed., *Les Soirées de Paris* (Paris: Knoedler, 1958), item 45.

27. Letter from Guillaume Apollinaire, Herwarth Walden, and Robert Delaunay to Henri-Martin Barzun. Cited in Fritz Lautenbach, "À propos d'un article inconnu d'Apollinaire dans *Der Sturm*," *Revue des Lettres Modernes*, 327–30 (1972), special issue *Guillaume Apollinaire 11*, p. 133.

28. William A. Camfield, *Max Ernst: Dada and the Dawn of Surrealism* (Munich: Prestel, 1993), 361.

29. Elisabeth Erdmann-Macke, *Erinnerung am August Macke* (Frankfurt: Fischer, 1987), 257–58.

30. Guillaume Apollinaire, "Die moderne Malerei," tr. Hans Jacob, *Der Sturm* 3.148-49 (February 1913): 272. Repr. in Apollinaire,

Oeuvres en prose complètes, 2:501–5; see p. 1595. Originally signed "Jean-Jacques."

31. Guillaume Apollinaire, "Bibliothèques," *Mercure de France* 101.448 (February 16, 1913): 884–85. Repr. in Apollinaire, *Oeuvres en prose complètes*, 3:1154–55.

32. Repr. in *Quaderni del Novecento Francese*, ed. Lucia Bonato, 13 (1992): 23.

33. "Für Kandinsky," *Der Sturm* 3.150–51 (March 1913): 277–79.

34. Guillaume Apollinaire, "Für Kandinsky," *Der Sturm* 3:152–53 (March 1913): 288. Repr. in Apollinaire, *Oeuvres en prose complètes*, 2:526.

35. Nell Walden and Lother Schreyer, *Der Sturm: ein Erinnerungsbuch an Herwarth Walden und die Künstler aus dem Sturmkreis* (Baden-Baden: Klein, 1954), 17.

36. Marc Chagall, *My Life*, tr. Elisabeth Abbott (New York: Orion, 1960), 113. See also Chagall's remarks on the occasion of Walden's 50th birthday in *Der Sturm* in September 1928. Repr. in Nell Walden, *Herwarth Walden: ein Lebensbild* (Berlin and Mainz: Kupferberg, 1963), 131.

37. Guillaume Apollinaire, "Zone," *Der Sturm* 4.154–55 (April 1, 1913): 4–5.

38. Postcard from Guillaume Apollinaire to Herwarth Walden postmarked April 6, 1913. Staatsbibliothek Preussischer Kulturbesitz, Berlin. This collection includes four additional letters, which are quoted later in this chapter. I would like to thank James Van Der Laan for deciphering some particularly illegible passages.

39. Gaston Picard, "Créations," *Der Sturm*, 4.162–63 (May 15, 1913): 35.

40. Guillaume Apollinaire, *L'Antitradition futuriste* in *Oeuvres en prose complètes*, 2:937–39.

41. P. A. Jannini, *Le avanguardie letterarie nell'idea critica di Guillaume Apollinaire* (Rome: Bulzoni, 1971), 151–52. The manuscript itself is reproduced in Apollinaire, *Oeuvres en prose complètes*, 2:1675–82.

42. Although Meissner identifies the third individual as Paul Fort ("Delaunay-Dokumente," 507), the editors of Macke's correspondence are undoubtedly right that the letter names Frost. See August Macke, *Briefe an Elisabeth und die Freunde*, ed. Werner Freset and Ernst-Gerhard Güse (Munich: Bruckmann, 1987), 308. Daniel Briolet sheds important light on Ewer's visit to Paris in "Guillaume Apollinaire et Hanns Heinz Ewers," *Amis européens d'Apollinaire*, ed. Décaudin, 133–50.

43. Wilhelm Hausenstein, "Vom Kubismus," *Der Sturm* 6.170–71 (July 25, 1913): 67–70.

44. Apollinaire, *Les Peintres cubistes*, 16–17. For the earlier reference to perspective , see p. 44.

45. *Erster Deutscher Herbstsalon* (Berlin: Der Sturm, 1913), items 106 and 116.

46. Guillaume Apollinaire, "Chronique mensuelle," *Les Soirées de Paris* 18 (November 15, 1913): 2–5. Repr. in Apollinaire, *Oeuvres en prose complètes*, 2:621–24.

47. Guillaume Apollinaire, "Alexander Archipenko" in *1913–1914 siebzehnte Ausstellung: Alexander Archipenko* (Berlin: Der Sturm, 1913). Repr. in Apollinaire, *Oeuvres en prose complètes*, 2:656–60. That the exhibition opened in September is confirmed by *Erster Deutscher Herbstsalon*, 32.

48. Umberto Boccioni, "Simultanéité futuriste," *Der Sturm* 4.190–91 (December 15, 1913): 151.

49. Robert Delaunay, "Lettre ouverte au *Sturm*," *Der Sturm* 4.194–95 (January 1, 1914): 167.

50. Guillaume Apollinaire, "Alexander Archipenko," *Der Sturm* 4.200–201 (May 1, 1914): 194. Repr. in Apollinaire, *Oeuvres en prose complètes*, 2:660-61

51. Guillaume Apollinaire, "A voir" and "Albums d'art," *Les Soirées de Paris* 23 (April 15, 1914): 192 and 193 respectively. Signed "X."

52. Letter from Guillaume Apollinaire to Francis Picabia dated May 7, 1914. Repr. in *Correspondance Guillaume Apollinaire Jean Cocteau* ed. Pierre Caizergues and Michel Décaudin (Paris: J.-M. Place, 1991), 106.

53. Guillaume Apollinaire, "Le Los du Douanier," *Der Sturm* 5.7 (July 1, 1914): 53.

54. Guillaume Apollinaire, "Architecture," *Paris-Journal*, May 6, 1914. Repr. in Apollinaire, *Oeuvres en prose complètes*, 2:678.

55. Guillaume Apollinaire, "Marc Chagall," *Paris-Journal*, June 2, 1914. Repr. in Apollinaire, *Oeuvres en prose complètes*, 2:745–46.

56. Guillaume Apollinaire, "Quatre Nouveaux Artistes français," *Paris-Journal*, July 3, 1914. Repr. in Apollinaire, *Oeuvres en prose complètes*, 2:803–4.

57. Roy F. Allen gives an excellent account of Meyer's activities in *Literary Life in German Expressionism and the Berlin Circles* (Göppingen: Kümmerle, 1974), 338–82

58. Alfred Richard Meyer, *Die Maer von der Musa expressionistica* (Düsseldorf: Die Fähre, 1948), 57. Meyer cites Apollinaire's four-

fold classification of Cubism and discusses his calligrams on pp. 54–57.

59. Ibid.

60. Alfred Richard Meyer, "Paris," *Der Sturm* 4.174–75 (August 15, 1913), 85–86.

61. Alfred Richard Meyer, *Die Sammlung* (Berlin: Meyer, 1921), 199–202, and *Der Grosse Munkepunke: gesammelte Werke von Alfred Richard Meyer* (Hamburg and Berlin: Hoffmann und Campe, 1924), 54–57.

62. Fritz Max Cahén, *Der Weg nach Versailles: Erinnerungen 1912–1919: Schicksalsepoche einer Generation* (Boppard-on-Rhein: Boldt, 1963), 25.

63. Alfred Richard Meyer, "Biesenthal in der Mark," *Der Sturm* 4.182–83 (October 13, 1913): 119.

64. Cahén, *Der Weg nach Versailles*, 20.

65. Ibid., 29–30.

66. Fritz Max Cahén, "Der Alfred Richard Meyer-Kreis," *Imprimatur*, n.s., 3 (1961–62): 190–93. Repr. in Raabe, *Expressionismus* (1965), 113–14.

67. This drawing is reproduced in Pierre-Marcel Adéma and Michel Décaudin, *Album Apollinaire* (Paris: Gallimard/Pléiade, 1971), 180.

68. Guillaume Apollinaire, "Die Formel Marie Laurencins," *Das Beiblatt der Bücherei Maiandros*, February 1, 1914, p. 3. Originally published as "Marie Laurencin," *Les Soirées de Paris*, 18 (November 15, 1913): 8. Repr. in Apollinaire, *Oeuvres en prose complètes*, 2:617.

69. Guillaume Apollinaire, "Montags rue Christine," tr. Balduin Alexander Möllhausen, *Das Beiblatt der Bücherei Maiandros*, May 1, 1914, pp. 6–7.

70. Letter from Guillaume Apollinaire to Madeleine Pagès dated July 18, 1915. Repr. in Guillaume Apollinaire, *Tendre comme le souvenir* (Paris: Gallimard, 1952), 64.

71. Habasque, *Les Soirées de Paris*, item 46. Pierre-Marcel Adéma, *Guillaume Apollinaire* (Paris: Table Ronde, 1968), 232.

72. Ludwig Rubiner, "Eine Zeitschrift ist etwas Wichtiges," *Die Aktion* 3.15 (April 9, 1913): 414–15.

73. Guillaume Apollinaire, "À travers le Salon des Indépendents," *Montjoie!* 1.3 (March 18, 1913), supplement, p. 1. Repr. in Apollinaire, *Oeuvres en prose complètes*, 2:531.

74. n. l. a. "Der Futurist droht, schirme auf!!," *Der Zwiebelfisch* 5.4 (October 1913): 143.

75. Hans Arp and L. H. Neitzel, *Neue französische Malerei* (Leipzig: Weissen Bücher, 1913).

76. Apollinaire, *Les Peintres cubistes*, 16–17.

77. Paul Mahlberg, ed., *Beiträge zur Kunst des 19. Jahrhunderts und unserer Zeit* (Düsseldorf: Ohle, 1913), 149. See Francis Steegmuller, *Apollinaire: Poet Among the Painters* (New York: Farrar, Straus, 1963), p. 153. The watercolor is presently in the collection of the Harry Ransom Humanities Research Center at the University of Texas.

78. Mahlberg, *Beiträge*, 109–11. See Apollinaire, *Les Peintres cubistes*, 23–25.

79. André Salmon, "Marie Laurencin," *Die Aktion* 4.5 (January 31, 1914): 100.

80. Wilhelm Hausenstein, "Kunst," *Das Forum* 1.2 (May 1914): 114–20.

81. Guillaume Apollinaire, "Maximilien Luce," *Paris-Journal*, May 9, 1914. Repr. in Apollinaire, *Oeuvres en prose complètes*, 2:687–88.

82. Guillaume Apollinaire, "Les Arts," *Les Soirées de Paris*, 24 (May 15, 1914): 250. Repr. in Apollinaire, *Oeuvres en prose complètes*, 2:704.

83. Albert Haas, "Souvenirs de la vie littéraire à Paris," *Les Soirées de Paris*, 24 (May 15, 1914): 251–74.

84. Except as noted, the following notices appeared in *Paris-Journal*: Guillaume Apollinaire, "Expressionistes Rhénanes," May 20, 1914; "Peintres allemands," *Les Soirées de Paris*, 25 (June 15, 1914): 305–6; "Le Douanier Rousseau," June 17, 1914; " 'Le Dôme' et les 'Domiers,' " July 2, 1914; and "La 'Werkbundausstellung' de Cologne," July 27, 1914. Repr. in Apollinaire, *Oeuvres en prose complètes*, 2:715, 732, not included, 774–75, 802, and 847 respectively.

85. Wilhelm Uhde, *Henri Rousseau* (Düsseldorf: Flechtheim, 1914), 46–47.

86. Paul Fechter, *Der Expressionismus* (Munich: Piper, 1914), 37–38. See Apollinaire, *Les Peintres cubistes*, 16–17 and (for the fourth dimension) 11–12.

87. Wilhelm Hausenstein, *Die bildende Kunst der Gegenwart: Malerei, Plastik, Zeichnung* (Stuttgart and Berlin: Deutsche Verlag, 1914), 316.

88. Brinkmann, "Dada and Expressionism," 103. For one such soirée, on April 14, 1917, see Tristan Tzara, "Chronique zurichoise,

1915–1919" in Richard Huelsenbeck, *Dada Almanach* (Berlin: Reiss, 1920), 10–29.

89. Wieland Herzfelde, untitled notes, *Neue Jugend*, Vol I, No. 9 (September 1916), p. 186.

90. Daniel Henry [Kahnweiler], "Der Kubismus," *Die Weissen Blätter* 3.9 (September 1916): 214.

91. Otto Grautoff, "Französische Brief," *Das Literarische Echo* 20.l (October 1, 1917), p. 48.

92. Richard Huelsenbeck, "Erste Dadarede in Deutschland," February 1918. Repr. in Huelsenbeck, *Dada Almanach*, 105.

93. Walter Bombe, "August Macke," *Das Kunstblatt* 2.4 (April 1918), 98.

94. Ahlers-Hestermann, "Der deutsche Künstlerkreis," 399.

95. "Briefe Henri Rousseaus," *Das Kunstblatt* 2.8 (August 1918): 254–59.

96. Guillaume Apollinaire, "Cox-City," *Der Orchideengarten* 1.4 (February 15, 1919): 15–17. Signed "Apollinarius, Wileem."

97. *Der Einzige* 3 (February 2, 1919): 36.

98. Klabund [Alfred Henschke], "Lyrische Flugblätter. Verlag A. R. Meyer, Wilmersdorf-Berlin," *Die Neue Bücherschau* 1.4 (1919): 17.

99. Franz Landsberger, *Impressionismus und Expressionismus: eine Einführung in das Wesen der neuen Kunst* (Leipzig: Klinkhardt und Biermann, 1919), 47. Daniel Henry [Kahnweiler], "André Derain," *Das Kunstblatt* 3.10 (October 1919):288–304.

100. Theodor Daübler, "Im Kampf um die moderne Kunst," *Tribüne der Kunst und Zeit* 3 (1919): 54. Repr. in book form the same year, with the same title and pagination, by Erich Reiss Verlag in Berlin.

101. Anonymous, "Notizen," *Das Kunstblatt*3.2 (February 1919): 64.

102. Guillaume Apollinaire, "Art et curiosité: les commencements du cubisme," *Le Temps*, October 14, 1912, p. 5. Repr. in Apollinaire, *Oeuvres en prose complètes*, 2:1514–16.

103. Hans Jacob, "Guillaume Apollinaire," *Münchner Blätter für Dichtung und Graphik* 1.3 (March 1919): 48.

104. Hans Jacob, "Zur neueren französischen Literatur," *Münchner Blätter für Dichtung und Graphik* 1.5 (May 1919): 80.

105. Iwan Goll, "Brief an den verstorbenen Dichter Apollinaire," *Die Weissen Blätter* 6.2 (February 1919): 78–81.

106. Apollinaire, *Les Peintres cubistes*, 19–20, 24.

107. Anonymous, "*Die Weissen Blätter*," *Das Literarische Echo* 21.14 (April 15, 1919): 869–70.

108. Iwan Goll, "Die drei guten Geister Frankreichs," *Tribüne der Kunst und Zeit*, 5 (1919): 72–75.
109. Francis J. Carmody, *The Poetry of Yvan Goll: A Biographical Study* (Paris: Caractères, 1956), 38.
110. Iwan Goll, "Paris Stern der Dichter," *Neue Deutsche Rundschau* 1 (1922), 634–46.
111. Ivan Goll, "Manifeste du surréalisme," *Surréalisme* 1 (October 1924).
112. Gustav Janouch, *Conversations with Kafka*, tr. Goronwy Rees (New York: New Directions, 1974), 162–63. I would like to thank Naomi Ritter for calling this passage to my attention.
113. See Vladimir Brett, "Apollinaire et les Tchèques," in *Du monde européen à l'univers des mythes*, ed. Michel Décaudin (Paris: Minard, 1970), 48–64.
114. Sylvain Cahn, "Französischer Literatur in und nach dem Kriege: Panorama," part IV, *Das Junge Deutschland* 1.12 (April 1920): 349–50.
115. Walter Benjamin, "Bücher, die übersetzt werden sollten," *Die Literarische Welt* 5.25 (June 21, 1919): 7–8. Repr. in Walter Benjamin, *Gesammelte Schriften*, ed. Hella Tiedemann-Bartels (Frankfurt: Suhrkamp, 1972), 3:176–78.

5. HOMAGE FROM CATALONIA

1. Pierre Caizergues provides a valuable complement to the present study in "Apollinaire et l'avant-garde catalane (1912–1918)," *Quaderni del Novecento Francese* 1 (1984): 143–58, from which I have taken a number of references.
2. For a stimulating discussion of the earlier movement in Catalonia, see Eduard Valenti, *El primer modernismo literario catalán y sus fundamentos ideológicos* (Barcelona: Ariel, 1973).
3. Guillem Díaz-Plaja, *L'avantguardisme a Catalunya i altres notes de critica* (Barcelona: "La Revista," 1932), 17–18. As he notes, the same tripartite evolution exists in Castilian literature as well.
4. Ironically Italian Futurism seems to have taken its name from an earlier movement headed by the Catalan Gabriel Alomar. See, for example, Lily Litvak de Pérez dela Dehesa, "Alomar and Marinetti: Catalan and Italian Futurism," *Revue des Langues Vivantes* 47.6 (1972): 585–603. However, even Alomar—who thought most later movements repeated his own—saw that Marinetti had invented something quite different. In a letter to

Xavier Bóveda in 1919, he wrote: "Doesn't the slogan ULTRA also come from my 'Futurism'—whose name was later adopted by Marinetti *for very different ends*? We are all following the same Epiphanic star. Excelsior!" (emphasis added). See the untitled note in *Cervantes*, March 1919, p. 69.

5. Guillaume Apollinaire, "L'Esprit nouveau et les poètes," *Mercure de France* 13.491 (December 1, 1918): 395. This text was originally given as a lecture on November 26, 1917. Evidence of Apollinaire's interest in Catalonia exists as far back as July 13, 1914, when he published an article on Antoni Gaudi. Later the same month he noted that the latest issue of *Revista Nova* contained "un très intéressant article de Joan Sacs sur la peinture murale." Repr. in Guillaume Apollinaire, *Oeuvres en prose complètes*, 2:953, 821, and 841 respectively.

6. For example, he reported on July 20, 1918, that Joan Capdevila Rovira was planning to publish an anthology of Catalan poetry in translation. See Apollinaire, *Oeuvres en prose complètes*, 2:1458-59. The author of this projected anthology, which never materialized, was associated with *L'Instant* in Paris.

7. Quoted by Josep Maria López-Picó in "Notes per a la biografia de Joaquim Folguera," *L'Amic de les Arts* 2:17 (August 31, 1927): 63.

8. Agustí Esclasans, "L'obra d'En Joan Salvat-Papasseit," *La Revista* 10.215–16 (September 1, 1924): 106.

9. Jaume Brossa, "Ecos mundiales: el cubismo," *La Publicidad*, October 19, 1911. Cited by Jaume VallcorbaPlana in his introduction to Josep Maria Junoy, *Obra poètica* (Barcelona: Quaderns Crema, 1984), xxxiii.

10. Guillaume Apollinaire, "Jeunes Peintres ne vous frappez pas!", *Correo de las Letras y de las Artes* 1.1 (October 1912). See Vallcorba-Plana, "Introducció," liii–llv, and Caizergues, "Apollinaire et l'avant-garde catalane," 147 and 169. The article appeared originally in *La Section d'Or* 1.1 (October 9, 1912): 1–2. Repr. in Apollinaire, *Oeuvres en prose complètes*, 2:484–85.

11. Guillaume Apollinaire, "Exotisme et ethnographie," *Paris-Journal*, September 10, 1912. Repr. in Apollinaire, *Oeuvres en prose complètes*, 2:473–76. See Caizergues, "Apollinaire et l'avant-garde catalane," 147–48.

12. Josep Maria Junoy, *El gris i el cadmi* (Barcelona: Llibreria Catalònia, 1926), 198.

13. Gilbert Boudar et al., *Catalogue de la bibliothèque de Guillaume Apollinaire* (Paris: CNRS, 1983), 1:206, 2 (1987): 160.

14. Guillaume Apolliinaire, "Georges Braque," *La Revue Indépendante* 3 (August 1911): 167ff. This article reproduces a text from 1908, with several differences. Repr. in Apollinaire, *Oeuvres en prose complètes*, 2:110–12, 1549–50. For a 1911 preface that includes most of the first quote, see p. 358.

15. Josep Maria Junoy, "1914–1917, La França editora," *Iberia* 3.119 (July 14, 1917): 7.

16. Anonymous, "Baudelaire deslliurat . . . ," *Troços* 2:1 (October 1, 1917): 3. The quotations are taken from Guillaume Apollinaire, "Baudelaire dans le domaine public," *Nord-Sud*, 3 (May 15, 1917): 5.

17. Anonymous, "Una adaptació catalana," *Trossos* 2.5 (April 1918): 7.

18. According to Raymond Warnier, in "Apollinaire, le Portugal et l'Espagne," *Bulletin des Études Portugaises* 22 (1959–60): 246, Junoy made several trips to Paris beginning in 1916. He adds that Francis de Miomandre "a évoqué une rencontre avec cet 'ami de notre littérature' [*Les Marges*, March 15, 1919] qu'il juge 'admirablement au courant des derniers états de notre vie intellectuelle,' rappelé qu'il le rencontra déjà en 1918 à Vernet, où Junoy lui donna des nouvelles de divers écrivains, dont Apollinaire." A poem by Junoy entitled "El petit Arc del Carroussel," which appeared in *Iberia* on April 20, 1918 (p. 20), testifies to a trip to Paris that spring. In *El gris i el cadmi*, Junoy recalls a sojourn in Paris during the last two months of 1918 and the first half of 1919 (p. 184).

19. Guillaume Apollinaire, "Echos," *L'Europe Nouvelle*, April 6, 1918. Repr. in Apollinaire, *Oeuvres en prose complètes*, 2:1417–18. According to Boudar et al., *La Bibliothèque de Guillaume Apollinaire*, his copy was inscribed "À M. Guillaume Apollinaire cordial hommage de l'auteur" (1:89). The same authorities report that Junoy sent Apollnaire four isses of *Troços* as well.

20. Mario Aguilar, "En honor de J. M. Junoy," *Iberia* 4.159 (May 4, 1918): 8. See Michel Décaudin, "Apollinaire outre-Pyrénées," *Revue des Lettres Modernes* 123–126 (1965), special issue *Guillaume Apollinaire 4*, 101.

21. Letter from Guillaume Apollinaire to Charles Maurras dated March 15, 1918. Repr. in Apollinaire, *Oeuvres en prose complètes*, 2:996–1000. For Maurras' article see p. 1709.

22. Anonymous, "Acaba de sortir," *Trossos* 2.4 (March 1918): 2.

23. Francesc Carbonell, "Revistas y notas de Francia," *Iberia* 3.104 (March 23, 1917): 7.

24. Díaz-Plaja, *L'avantguardisme a Catalunya*, 26.

25. Guillaume Apollinaire, *Oeuvres poétiques*, ed. Marcel Adéma and Michel Décaudin (Paris: Gallimard/Pléiade, 1965), 198–99. *Oeuvres en prose*, 1:384. The same idea occurs in "Merveille de la guerre" (OP, 271) where Apollinaire imagines a sky filled with flares.

26. Josep Maria Junoy "Al Margen—Guillaume Apollinaire," *La Publicidad*, November 27, 1918, and "Al Margen," *La Publicidad*, November 28, 1918. Cited in Caizergues, "Apollinaire et l'avant-garde catalane," 166–68.

27. J. M. Junoy, "Guillaume Apollinaire," *SIC* 4.37-39 (January–February 15, 1919): 296.

28. Josep Maria Junoy, *Conferències de combat 1919–1923* (Barcelona: Editorial Catalana, 1923), 85. The quotation by Apollinaire, given only in Catalan, may well come from the same letter as the fragment cited by Mario Aguilar (see above, note 20).

29. Junoy, *El gris i el cadmi*, 202–3.

30. Joan Salvat-Papasseit, "La Ploma d'Aristarc," *La Publicidad*, June 24, 1921. Repr. in *Mots-propis i altres proses*, ed. J. M. Sobré (Barcelona: Edicions 62, 1975), 91–93.

31. Interview with Joan Alavedra by Joan Agut, "El primer poeta anarquista de Catalunya," *Indice* 21.209 (1966): 36–37.

32. Josep Battló, Preface to Salvat-Papasseit, *Cincuenta poemas*, 2nd ed., bilingual (Barcelona: Lumen, 1977), 4.

33. Díaz-Plaja, *L'avantguardisme a Catalunya*, 32.

34. J. V. Foix, "Algunes consideracions sobre l'art d'avantguarda," *Revista de Poesia* 3.2, 925. See the preceding note. According to Díaz-Plaja, this dichotomy leads Foix to classify Salvat as a "fals avant-guardista."

35. Issued as a pamphlet in July 1920, the manifesto is reprinted in Salvat-Papasseit *Mots-propis i altres proses*, 81–83. Elsewhere he proclaimed: "El Poeta serà, doncs, l'home entusiasta" ("The Poet should be enthusiastic"). See "Concepte del Poeta," *Mar Vella* 4 (December 1919); repr. in *Hélix* 2 (March 1929) and in *Mots-propis*, 79–80.

36. Salvat-Papasseit, *Mots-propis*, 24, and Guillaume Apollinaire, *Les Peintres cubistes* in Apollinaire, *Oeuvres en prose complètes*, 2:5.

37. Agustí Carreres, "J. Salvat-Papasseit, professió de fe," *Hélix* 1 (February 1929): 2.

38. Joan Salvat-Papasseit, "A Joaquim Folguera, mort," *Un Enemic del Poble*, 16 (March 1919). Repr. in Salvat-Papasseit, *Mots-propis*, 51.

39. Joan Salvat-Papasseit, "La ploma d'Aristarc," *La Publicidad*, June 24, 1921. Repr. in Salvat-Papasseit, *Mots-propis*, 91–93. Salvat also includes J. V.Foix in this group; Foix encouraged visual experimentation but rarely engaged in it himself.

40. Joaquim Folguera, *Traduccions i fragments* (Barcelona: "La Revista," 1921): 207–11. The translation of "Il pleut" appears on p. 45.

41. López-Picó, "Notes per a la biografic de Joaquim Folguera," 62–64.

42. Décaudin, "Apollinaire outre-Pyrénées," 98–101.

43. Apollinaire, "L'Esprit nouveau et les poètes," 950–53. For editorial reasons "C'est que" was suppressed at the beginning, and the final sentence was slightly modified: "Aquestes preguntes la història literària contemporànea pot suggerir-les, no pot resoldre-les, i aquest prefaci no sabria fer altra cosa que iniciar-les" (contemporary literary history can only pose these questions, without being able to answer them, and this preface can only initiate them").

44. Boudar et al., *La Bibliothèque de Guillaume Apollinaire*, 1:69, 206; 2:160.

45. Guillaume Apollinaire, "La poesia actual," *La Revista*, 4.77 (December 1, 1918): 410–11; Folguera, *Traduccions i fragments*, 147–53.

46. Folguera, *Traduccions i fragments*, 46.

47. Joaquim Folguera, *Les noves valors de la poesia catalana* (Barcelona: "La Revista," 1919), 107–10.

48. Joaquim Folguera, *Articles* (Barcelona: "La Revista," 1920), 95–96.

49. J. Pérez-Jorba, "Pierre Albert-Birot, poeta nunista," *Messidor*, February 1, 1918, pp. 37–39. See Guillaume Apollinaire, "Poème-préfaceprophétie" in *31 Poèmes de poche*, by Pierre Albert-Birot (Paris: "SIC," 1919). Repr. in OP, 684–88. The same two quotes reappear in J. Pérez-Jorba, *Pierre Albert-Birot* (Paris: "L'Instant," 1920).

50. Cited, like the rest of the correspondance between Apollinaire and Pérez-Jorba, in Caizergues, "Apollinaire et l'avant-garde catalane," 168–69.

51. J. Pérez-Jorba, "Cap a la revolució de l'escenografia," *El Cami* 1.6 (June 1918): 9.

52. For a French translation see Apollinaire, *Oeuvres en prose complètes*, 2:991–95.

53. Boudar et al, *La Bibliothèque de Guillaume Apollinaire*, 1.122, 206. Apollinaire's library also included three issues of *L'Instant*; 2:46.
54. J. Massó Ventós, "Un libro de Pérez-Jorba," *España* 4.172 (July 25, 1918): 10.
55. Anonymous, "Les Revues, *L'Instant* 1.2 (August 1918). See Guillaume Apollinaire, "Van Dongen," *Les Arts à Paris*, March 15, 1918. Repr. in Apollinaire, *Oeuvres en prose complètes*, 2:1404–6.
56. Joan Pérez-Jorba, "Les Livres," *L'Instant* 1.3 (September 1918): 18–19.
57. Anonymous, "Les Revues," *L'Instant* 4–5 (October–November 1918).
58. J. Pérez-Jorba, "Los albañiles del ensueño," *La Publicidad*, November 27, 1918. Cited in Caizergues, "Apollinaire et l'avant-garde catalane," 165–66.
59. J. Pérez-Jorba, "Arme sous le bras," *SIC* 4.37-39 (January–February 15, 1919): 298–99.
60. J. Pérez-Jorba, "Pierre Reverdy, poeta i novel.lista d'avant-guarda," *Messidor*, May 31, 1919, p. 305.
61. X, "L'ingenuitat del pintor-burot Enric Rousseau," *Revista Nova*, 3, p. 10, and Fernand Léger, "Les realitzacions picturals actuals," ibid., 13, p. 11.
62. Caizergues, "Apollinaire et l'avant-garde catalane," 149. Elíes' letter was dated July 11, 1914.
63. According to Boudar et al., Apollinaire received the first fifteen issues of *Revista Nova*, covering the period from April to July 1914 (*La Bibliothèque de Guillaume Apollinaire*, 2:161).
64. Joan Sacs, *La pintura francesa moderna fins al cubisme* (Barcelona: "La Revista," 1917), 120.
65. Apollinaire, *Les peintres cubistes*, 12, 8, and 17 respectively.
66. Sacs, *La pintura francesa moderna*, 122–23. The Apollinaire quote is from *Les Peintres cubistes*, 17.
67. Cf. ibid., 16–17. The exact quote seems to come from an article entitled "Le Cubisme," published in *L'Intermédiaire des Chercheurs et des Curieux* on October 19, 1912. See Apollinaire, *Oeuvres en prose complètes*, 2:1519.
68. Sacs, *La pintura francesa moderna*, 123–25. See Apollinaire, *Les Peintres cubistes*, 16–17.
69. Joan Sacs, "La pintura d'"En Picasso," *Vell i Nou* 4.72 (August 1, 1918): 287–93, 4.73 (August 15, 1918): 307–10.
70. Josep de Togores, "El viure de Paris," *Vell i Nou* 5.98 (September 1, 1919): 327.

71. Guillaume Apollinaire, "Los comienzos del cubismo," *La Publicidad*, April 23, 1917. Repr. in Caizergues, "Apollinaire et l'avant-garde catalane," 161–65. For the editor's letter to Apollinaire, see the description on p. 157, no. 8.

72. The 1917 article was based on two versions of the same essay entitled "Les Commencements du cubisme," of which one appeared in *Le Temps* in 1912 and the other belonged to Robert Delaunay. See Apollinaire, *Oeuvres en prose complètes*, 2:1514–16, and Robert Delaunay, *De cubisme à l'art abstrait* (Paris: SEVPEN, 1957), 151–54. The story of Apelles and Protogenes, with which it concludes, was taken either from an earlier article (See Guillaume Apollinaire, *Chroniques d'art 1902–1918*, ed. L. C. Breunig [Paris: Gallimard, 1960], 278) or from *Les Peintres cubistes*, 10.

73. This exchange is recounted by Caizergues in "Apollinaire et l'avant-garde catalane," 153. For Apollinaire's untitled preface see *Oeuvres en prose complètes*, 2:865–67.

74. Guillaume Apollinaire, "Els Delaunay i la moda des vestir," *Vell i Nou* 3.57 (December 15, 1917): 679. See Apollinaire, "Les Réformations du costume," *Mercure de France* 107.397 (January 1, 1914): 219–20. Repr. in Apollinaire, *Oeuvres en prose*, 1.416.

75. Francesc Carbonell, "*Le Poète assassiné*," *Iberia* 2.86 (November 25, 1916): 13.

76. Francesc Carbonell, "La França editora 1914–1917, " *Iberia* 3.120 (July 21, 1917): 8.

77. Francesc Carbonell, "Tot llegint," *Iberia* 4.142 (January 5, 1918): 14.

78. Francisco Carbonell, "Revistas y notas de Francia," *Iberia* 4.153 (March 23, 1918): 8.

79. Francisco Carbonell, "De Francia," *Iberia* 4.160 (May 11, 1918): 14.

80. Francisco Carbonell, "Las Revistas," *Iberia* 4.191 (December 14, 1918). Cited in Décaudin, "Apollinaire outre-Pyrénées," 101. For Apollinaire's copies of *Iberia* see Boudar et al., *La Bibliothèque de Guillaume Apollinaire*, 2:159-60.

81. J. M. López-Picó, "Poetes nous," *La Revista* 5.95 (September 1, 1919): 259.

82. Guillem Díaz-Plaja, *De literatura catalana: estudis i interpretacions* (Barcelona: Selecta, 1956), 204.

83. J. V. Foix, untitled poem, *SIC* 4.37-39 (January–February 15, 1919): 291.

84. See Pierre-Marcel Adéma and Michel Décaudin, *Album Apollinaire* (Paris: Gallimard/Pléiade, 1971), . 142–43.

85. Eugenio d'Ors, *Nuevo glosario* (Madrid: Aguilar, 1947), 1:240–41. Included in *Hambre y sed de verdad* (1920), the article originally appeared in the Basque periodical *Hermes*, where it was entitled "Sobre *Divagaciones de un transeúnte.*" See *La "Belle époque" bilbaína, 1917–1922* (Bilbao: El Cofre del Bilbaíno, 1964), 77–78.

86. D'Ors, *Nuevo glosario* 1.567. Published previously in *Los diálogos de la pasión meditabunda* (1922).

87. Ibid., 2:944. Published previously in *Las Entrehuelgas* (1933).

88. Ibid., 2:355. Published previously in *Juliano y San Pablo* (1928).

89. Just Cabot, "Una conversa amb Maurras sobre la poesia (francesa) contemporánia," *La Nova Revista* 3.10 (October 1927): 172.

90. Sebastià Gasch, "La moderna pintura francesa, del cubismo al superrealismo," *La Gaceta Literaria*, October 15, 1927. This essay appeared previously in Catalan in *La Nova Revista*.

6. APOLLINAIRE'S REIGN IN SPAIN

1. See for example Guillermo de Torre, "Contemporary Spanish Poetry," tr. Robert C. Stephenson and Miguel González Gerth, *Texas Quarterly* 4.1 (Spring 1961): 60–62.

2. Ramón Buckley and John Crispin, eds. *Los vanguardistas españoles (1925–1935)* (Madrid: Alianza, 1973), 9–10.

3. Marinetti reprinted excerpts of this and other reviews in *Poesia*, 3–4 (April–July 1909).

4. See, for example, Pedro Luis de Gálvez, "Marinetti, el estilo y el hombre," *Grecia* 2:14 (April 30, 1919): 7, in which he recounts a visit to the leader of the Futurists in Milan a little while before the war.

5. For a rapid survey of Apollinaire's reception in Spain (excluding Catalonia), see J. Ignacio Velázquez E., "Apollinaire et l'Espagne en 1918," *Apollinaire en 1918*, ed. Jean Burgos et al. (Paris: Klincksieck, 1988), 115–17 and passim.

6. Manuel de la Peña, *El ultraísmo en España* (Madrid: Fernando Fé, 1925), 10.

7. Guillaume Apollinaire, *Oeuvres en prose complètes*, 3:131–34.

8. *Enciclopedia Universal Ilustrada* (Madrid: Espasa-Calpe, 1924), 25:558.

9. Guillaume Apollinaire, *Oeuvres poétiques*, 188–91.

10. See note 4.

11. Pedro Luis de Gálvez, "Cuartillas," *Grecia* 2.16 (May 20, 1919): 3. For additional references to Apollinaire see José María Barrera

López. *El ultraísmo de Sevilla (Historia y textos)* (Seville: Alfar, 1987), 1.49, 68 and 2.233–34, 235, 241.

12. Guillaume Apollinaire, "L'Esprit nouveau et les poètes," *Mercure de France*130.491 (December 1, 1918): 387. Repr. in Apollinaire, *Oeuvres en prose complètes*, 2:945.

13. Guillaume Apollinaire, "Pedro Luis de Gálvez," tr. A. S., *Grecia* 2.24 (August 10, 1919): 6–7.

14. Letter from Marie Laurencin to Henri-Pierre Roché dated May 1, 1915. Harry Ransom Humanities Research Center, The University of Texas at Austin.

15. Through the painter María Gutiérrez Blanchard. On June 26, 1915, she wrote: "Je l'ai vu une fois chez lui, avec des bois nègres et des curiosités du Rastro, intérieur genre Apollinaire, mais propre et bien songé. Il m'a été aussi antipathique que possible" (Harry Ransom Humanities Research Center, The University of Texas at Austin). For a similar description, see her letter to Louise Faure-Favier quoted by Raymond Warnier, "Apollinaire, le Portugal et l'Espagne," *Bulletin des Études Portugaises* 22 (1959–60): 235. Arriving in Madrid on August 25, 1914, Marie left for Malaga at the end of April 1915.

16. Ramón Gómez de la Serna, "Préface," tr. Jean Cassou in Guillaume Apollinaire, *Il y a* (Paris: Messein, 1925), 27.

17. Guillaume Apollinaire, *Tendre comme le souvenir* (Paris: Gallimard, 1952), 63. See Warnier, "Apollinaire, le Portugal et l'Espagne," 230.

18. Apollinaire, *Tendre comme le souvenir*, 121.

19. Gilbert Boudar et al, *La Bibliothèque de Guillaume Apollinaire* (Paris: CNRS, 1983), 1:207. Published with no indication as to date or place, the book bore the author's real name Ramón Gómes Zehler.

20. Gómez de la Serna, "Préface," 10. For a facsimile of Apollinaire's menu with the Spaniard's signature, see *Que Vlo-Ve? Bulletin International des Études sur Apollinaire*, second series, 27 (July–September 1988): 18–27.

21. Ramón Gómez de la Serna, *El cubismo y todos los ismos* (Madrid: Biblioteca Nueva, 1921); reissued as *Ismos* in 1931. Originally entitled "Apollinerismo," the chapter is reproduced as "Guillaume Apollinaire" in *Retratos completos* (Madrid: Aguilar, 1961).

22. Ramón Gómez de la Serna, *La sagrada cripta de Pombo* (Madrid: Hernández y Sáez, 1924), 289–93, 447. See Guillaume Apollinaire, "Art et curiosité: Les Commencements du cubisme," *Le Temps*, October 14, 1912. Repr. in Apollinaire, *Oeuvres en prose complètes*,

2:1514-15. Serna had quoted the same line previously in "El Simultanismo," *El Figaro*, October 23, 1918; repr. in *Ismos*, 165–78.

23. Boudar et al., *La Bibliothèque de Guillaume Apollinaire*, 1:52.

24. The various contributions were published in *Une Enquête littéraire: Don Quichotte à Paris et dans les tranchées*, ed. Ventura García Calderón (Paris: Centre d'Études Franco-Hispaniques, 1916). For Apollinaire's response, see his *Oeuvres en prose complètes*, 2:1221–22. The French version omits the salutation ("Distinguido señor: Le contesto con lígero retardo. Excúsame usted: los *boches* tienen la culpa") and the conclusion ("Reciba usted, mi muy querido traductor, los mejores cumplidos de cabo de artillería de montaña").

25. Letter from Guillaume Apollinaire to Ventura García Calderón dated April 14, 1916. Repr. in Apollinaire, *Oeuvres complètes*, ed. Michel Décaudin (Paris: Balland-Lecat, 1965–66), 4:924. Cited in the text hereafter as OC.

26. Guillaume Apollinaire, "El espíritu nuevo y los poetas," *Cosmópolis* 1.l (January 1919): 17–28.

27. Enrique Gómez Carrillo, "El Cubismo," *El Liberal*, 1914. Repr. in his *Obras completas* (Madrid: Mundo Latino, 1919–23), 4:67.

28. Enrique Gómez Carrillo, "El cerebrismo y la naturaleza," *El Liberal*, May 1914. Repr. in his *Obras completas*, 6:80.

29. Boudar et al., *La Bibliothèque de Guillaume Apollinaire*, 1:43 and 77–78. *Fleurs de pénitence* is dedicated "À Guillaume Apollinaire hommage de Gómez Carrillo." The copy of *La Grèce éternelle* is simply inscribed "Hommage de Gómez Carrillo."

30. Enrique Díez-Canedo, "Guillaume Apollinaire," *España* 4.189 (November 21, 1918): 11–14. Repr. in *Conversaciones literarias (1915–1920)* (Madrid: América, 1921), 215–19.

31. Guillaume Apollinaire, *Les Peintres cubistes*, in *Oeuvres en prose complètes*, 2:8–10.

32. Enrique Díez-Canedo, "El recuerdo Apollinaire," *España* 4.292 (December 4, 1920): 10–11, and "Más de Apollinaire," *España* 4.294 (December 18, 1920): 10–11. The first was devoted to the following articles: André Salmon, "Vie de Guillaume Apollinaire," *Nouvelle Revue Française*, November 1, 1920, pp. 675–93, and André Rouveyre, "Ombres de Guillaume Apollinaire," *Mercure de France*, September 1, 1920, pp. 291–331. The second concerned an article by André Billy in the October issue of *Les Écrits Nouveaux* entitled "Apollinaire vivant" (pp. 3–25).

33. Gloria Videla, *El ultraísmo* (Madrid: Gredos, 1971), 2nd ed. 27–34.

34. Ibid., 153.
35. César A. Comet, "Anales literarios: una época de arte puro," *Cervantes*, April 1919, p. 90.
36. "La modernísima poesía francesa," tr. Rafael Cansinos-Asséns, *Los Quijotes*, 4.88 (October 25, 1918): 157.
37. Jean Royère, "Novísima literatura francesa sobre Guillaume Apollinaire," tr. Rafael Cansinos-Asséns, *Cervantes*, March 1919, pp. 70–76.
38. Rafael Cansinos-Asséns, "Un gran poeta chileno: Vicente Huidobro y el creacionismo," *Cosmópolis* 1.1 (January 1919): 72. Repr. in *La nueva literatura*, vol. 3: *La evolución de la poesía (1917–1927)* (Madrid: Páez: 1927), 201.
39. Apollinaire, "L'Esprit nouveau et les poètes," 954. On p. 952 he advised modern poets to engage in "alchimies archilyriques."
40. Rafael Cansinos-Asséns, "La nueva lirica," *Cosmópolis* 1.5 (May 1919): 73.
41. Rafael Cansinos-Asséns, "La novísima poesía: antología lírica," *Cervantes*, May 1919, p. 90.
42. Rafael Cansinos-Asséns, "Los poetas del 'Ultra': antología," *Cervantes*, June 1919, p. 84.
43. Rafael Cansinos-Asséns, "Un interesante poema de Mallarmé," *Cervantes*, November 1919, pp. 64–70.
44. Apollinaire, "L'Esprit nouveau et les poètes," 950.
45. Rafael Cansinos-Asséns, *Poetas y prosistas del novecientos (España y América)* (Madrid: América, 1919), 267.
46. Rafael Cansinos-Asséns, *Salomé en la literatura (Flaubert, Wilde, Mallarmé, Eugenio de Castro, Apollinaire)* (Madrid: América, 1919), 241–43.
47. Rafael Cansinos-Asséns, "Instrucciones para leer a los poetas ultraístas," *Grecia* 2:41 (February 29, 1920): 2.
48. Velázquez E., "Apollinaire et l'espagne en 1918," 125–35.
49. Guillaume Apollinaire, *El poeta asesinado*, tr. Rafael Cansinos-Asséns (Madrid: Biblioteca Nueva, 1924). Serna's preface is entitled "Apollinaire, el precursor" (pp. 5–32).
50. Guillermo de Torre, *Guillaume Apollinaire: estudio preliminar y páginas escogidas* (Buenos Aires: Poseidon, 1946). Repr. with several new chapters as *Apollinaire y las teorías del cubismo* (Barcelona and Buenos Aires: EDHASA, 1967), 13, 21–25.
51. Emilia de Zuleta, *Guillermo de Torre* (Buenos Aires: Ediciones Culturales Argentinas, 1962), 38.
52. Videla, *El Ultraísmo*, 22.

53. Guillermo de Torre y Ballesteros, "Hermeneusis y sugerencias," *Cervantes*, December 1918, p. 80.

54. "El guía," *Cervantes*, February 1919, pp. 89–95. "Sollozos," *Grecia* 2.26 (August 30, 1919): 5. "Opalinidad," *Grecia* 2.30 (October 20, 1919): 5. "Vers le sud," *Grecia* 2.36 (December 20, 1919): 4.

55. Guillermo de Torre, preface to Blaise Cendrars, "Nuevas modalidades del cubismo," *Grecia* 2.23 (July 30, 1919): 5.

56. Torre, *Apollinaire y las teorías del cubismo*, 26.

57. Isaac del Vando-Villar, preface to Guillermo de Torre, "Epiceyo a Apollinaire, *Grecia* 2.38 (January 20, 1920): 13.

58. Guillermo de Torre, "Epiceyo a Apollinaire, *Grecia* 3.38 (January 20, 1920): 13–15.

59. Guillermo de Torre, "Bibliografía de la novísima lírica francesa," *Cervantes*, August 1920, p. 124. The play was *Le Soleil enchainé ou la dame au champignon* by Jean Cassou and Georges Pillement.

60. Guillermo de Torre, "La poesía creacionista y la pugna entre sus progenitores," *Cosmópolis* 2.20 (August 1920): 589–605. For the French sources see Apollinaire, *Les Peintres cubistes*, 16–17 and 11–12 respectively.

61. Guillermo de Torre, "Madrid-Paris: album de retratos," *Grecia* 3.46 (July 15, 1920): 14.

62. Guillermo de Torre, "El movimiento ultraísta español," *Cosmópolis* 2.23 (November 1920): 481.

63. Guillermo de Torre, "Interpretaciones críticas de nueva estética," *Cosmópolis* 2.20 (September 1920): 92. See Apollinaire, *Les Peintres cubistes*, 16.

64. Guillermo de Torre, "Libros escogidos," *Reflector* 1.1 (December 1920): 19.

65. Guillermo de Torre, *La aventura y el orden* (Buenos Aires: Losada, 1943), 151.

66. Guillermo de Torre, "Teoremas críticos de nueva estética," *Cosmópolis* 2.22 (October 1920): 284–96. See pp. 298, 291, and 295 respectively. The references to Apollinaire's "L'Esprit nouveau et les poètes" are to pp. 950 and 954.

67. Guillermo de Torre, "Antología crítica de la novísima lírica francesa: Pierre Albert-Birot," *Ultra* 1.4 (March 1, 1921): 4.

68. Guillermo de Torre, review of J. M. Junoy, *Amour et paysage, Cosmópolis* 3.27 (March 1921): 571. The *ultraístas* were surprisingly well informed about the Catalan avant-garde. See, for example, Guillermo de Torre, "El movimiento intelectual de Cataluña,"

Cervantes, May 1920, pp. 85–97. On July 1, 1920, Joan Salvat-Papasseit joined the staff of *Grecia* as its Barcelona editor.

69. Guillermo de Torre, "Dos pintores de vanguardia: Ruth Velázquez y Santiago Vera," *Ultra* 1.12 (May 30, 1921): 4.

70. Guillermo de Torre, "Un poema discutido de Apollinaire," *Ultra* 1.19 (December 1, 1921): 2.

71. Guillermo de Torre, "Los nuevos valores literarios de Francia: Max Jacob," *Ultra* 1.20 (December 15, 1921): 3.

72. Guillermo de Torre, "Los poetas cubistas franceses," *Cosmópolis* 3.36 (December 1921): 603–28.

73. Ibid., 612–18.

74. Anonymous, "Indice de lecturas," *Cosmópolis* 4.38 (February 1922): 79.

75. Guillermo de Torre, *Hélices: poemas (1918–1922)* (Madrid: Mundo Latino, 1923). For "Diagrama mental" and "Emma" see pp. 86 and 92.

76. Apollinaire, *Les Peintres cubistes*, 5.

77. Apollinaire, "L'Esprit nouveau et les poètes," 945.

78. Guillermo de Torre, "La imagen y la metáfora en la novísima lírica," *Alfar* 45 (December 1924): 26.

79. Guillermo de Torre, *Literaturas europeas de vanguardia* (Madrid: Rafael Caro Raggio, 1925). Still one of the best books on the subject, it was reissued in an expanded version in 1965 as *Historia de la literaturas de vanguardia* (Madrid: Guadarrama, 1965).

80. See Apollinaire, *Les Peintres cubistes*, 5 and 16 respectively.

81. Guillaume Apollinaire, "L'Art tactile," *Mercure de France* 125.472 (February 16, 1918): 751–53. Repr. in *Oeuvres en prose complètes*, 3:270–71.

82. Guillermo de Torre, "Adiós a Barradas," *La Gaceta Literaria*, May 15, 1929. Repr. in Jaime Brihuega, ed. *Manifiestos, proclamas, panfletos y textos doctrinales (Las vanguardias artisticas en España: 1910–1931)* (Madrid: Cátedra, 1979), 375.

83. Torre, *Apollinaire y las teorías del cubismo*, 28.

84. Marqués de Villanova [Rafael Lasso de la Vega], *Pasaje de la poesía (1911–1927)* (Paris: La Boussole/La Brújula, 1936), 28. The volume also contains two poems dated "Paris 1914"—one dedicated to Louis de Gonzague Frick.

85. Guillaume Apollinaire, "69666 . . . 6 9 . . . ," tr. Rafael Lasso de la Vega, *Ultra* 1.4 (March 1, 1921): 3.

86. Apollinaire, *Oeuvres en prose*, 1:259.

87. Rafael Lasso de la Vega, "La 'sección de oro,'" *Cosmópolis* 3.24 (December 1920): 642–67.
88. Guillaume Apollinaire, "Mutación," tr. José de Ciria y Escalante, *Ultra* 1.7 (April 10, 1921): 3.
89. Humberto Rivas, "Ki-Ki-Ri-Ki," *Ultra* 1.10 (May 10, 1921).
90. Gerardo Diego, "Cronos," *Cervantes*, February 1920, pp. 54–55.
91. Vicente Huidobro, "Tour Eiffel," *Nord-Sud* 6–7 (August–September 1917): 24–25.
92. Jean de Milleret, *Entretiens avec Jorge Luis Borges* (Paris: Belfond, 1967), 23.
93. Gerardo Diego, "Anales literarios: Santander literario," *Cervantes*, June 1919, 60.
94. Gerardo Diego, "Temas literarios, posibilidades creacionistas," *Cervantes*, October 1919, 24.
95. Apollinaire, *Les Peintres cubistes*, 9.
96. Gerardo Diego, "Intencionario," *Grecia* 3.44 (July 15, 1920): 6–7.
97. Gerardo Diego, "Minuta y poesía," *Alfar*, 45 (December 1924):3
98. C. Rivas Cherif, for example, finds the sources of *Imagen* (1922) in "las vocalizaciones banvillescas del Valle-Inclán de *La pipa de kif*, en las experiencias de Apollinaire, y en . . . Góngora." See his review in *La Pluma* 3.24 (May 1922): 311.
99. Robert C. Gurney, "Larrea y la poesía francesa anterior al surrealismo (de Nerval a Valéry)," *Al amor de Larrea*, ed. J. M. Díaz de Guereñu (Valencia: Pre-Textos, 1985), 34.
100. Juan Larrea, "Considerando a Vallejo . . .," *Aula Vallejo* 5–7 (1963–65), 175. See Gurney, "Larrea y la poesía francesa," 13.
101. Robert Gurney, *La poesía de Juan Larrea* (Bilbao: Universidad del País Vasco, 1985), 167.
102. Gurney, "Larrea y la poesía francesa," 29.
103. Alfonso Reyes, "La novela bodegón," *España*, 1920. Repr. in his *Obras completas* (Mexico City: Fondo de Cultura Económica, 1955–63), 4:93–99.
104. Leonardo Marini, "Cronica de Italia," *Cosmópolis* 1.5 (May 1919): 108, and 1.7 (July 1919): 550. Vincent O'Sullivan, "Estudios cosmopolitas: la literatura norteamericana," *Cosmópolis* 1.5 (May 1919): 66–67. Mauricio Bacarisse, "Otra vez Herrera y Reissig," *España* 301 (February 5, 1921): 11–12.
105. Anonymous, "Revista de revistas," *Cervantes*, December 1919, p. 157; Paul Morand, "Los novísimos escritores en Francia: Juan Cocteau," tr. César A. Comet, *Cervantes*, August 1919, p. 74;

Anonymous, review of *La Littérature française contemporaine*, by Jules Romains, *La Pluma* 3.24 (May 1922): 317–18.

106. Adrianus, "La fiesta del Ultra," *Grecia* 2.15 (May 10, 1919): 19–20.
107. Adriano del Valle, "La nueva lírica y la revista *Cervantes*," *Grecia* 2.12 (April 1, 1919): 13.
108. Pedro Garfias, "La fiesta del 'Ultra,' " *Cervantes*, May 1919, p. 76.
109. Pedro Garfias, ""Sol," *Grecia* 2.25 (August 20, 1919): 8.
110. Pedro Garfias, "Anales literarios: El Ultra," *Cervantes*, March 1919, p. 68.
111. Apollinaire, "L'Esprit nouveau et les poètes," 949.
112. Curiously, Juan González Olmedilla, who also spoke at the celebration, traced modern poetry back to Max Jacob. "La nueva lírica," he wrote, "arranca de 1906 con Max Jacob; y forman en sus avanzadas Klingsor, Paul Fort, Saint-Pol-Roux, Apollinaire, Allard, Frick, Cendrars, Reverdy y Huidobro." See "Mosaico leído por Juan González Olmedilla en la fiesta del Ultra," *Grecia* 2.18 (June 10, 1919):2.
113. Letter to the author from Norah Borges de Torre.
114. Jorge Luis Borges, *Inquisiciones* (Buenos Aires: Proa, 1925), 96.
115. Jorge Luis Borges, "Entretiens avec Napoléon Murat," *L'Herne*, 1964, p. 374.
116. De Milleret, *Entretiens avec Jorge Luis Borges*, 32.
117. Ibid., 33–34.
118. See André Breton, *La Clé des champs* (Paris: Pauvert, 1967), 178. Also Paul Eluard, *Oeuvres complètes*, ed. Marcelle Dumas and Lucien Scheler (Paris: Gallimard/Pléiade, 1968), 1:538–39, 1490.
119. Juan Manuel Bonet, "El caligrama y sus alrededores," *Poesía* (Madrid) 3 (November–December 1978): 14. Boudar et al., *Catalogue de la bibliothèque de Guillaume Apollinaire*, 1:86.
120. Vicente Huidobro, "Manifeste manifestes" in *Manifestes* (Paris: Revue Mondiale, 1925). Repr. in Hugo J. Verani, *Las vanguardias literarias en Hispanoamérica (manifiestos, proclamas y otros escritos)* (Rome: Bulzoni, 1986), 247.
121. See for example David Bary, "Apollinaire y Huidobro," *Insula* 25. 291 (February 1971): 1, 13–14.
122. César E. Arroyo, "La nueva poesía en América," *Cervantes*, August 1919, p. 103. This version of the events was disputed in the following issue by J. Rivas Panedas who, emphasizing the difference between Creationism and Ultra, sought to minimize Huidobro's contribution.

123. Rafael Cansinos-Asséns devotes a chapter to this curious figure in *Verde y dorado en las letras americanas* (Madrid: Aguilar, 1947), 403–13.

124. Jac Edwards, "*Galería de espejos* (autoversiones del francés)," *Grecia* 2.33 (November 20, 1919): 7.

125. Isaac del Vando-Villar, "París," *Grecia* 2.36 (December 20, 1919):12.

126. Anonymous, "Jacques Edwards," *Grecia* 3.38 (January 20, 1920): 5. For a revised version of this poem, entitled "Aviación," see Joaquín Edwards Bello, *Metamorfosis* (1921) (Santiago de Chile: Nascimento, 1979), whose author is described as "Chargé d'Affaires Dada au Chili."

127. Letter from Vicente Huidobro to Isaac del Vando-Villar dated January 22, 1920. Repr. in *Grecia* 3.39 (January 31, 1920): 2.

128. Anonymous, "Conferencia de Vicente Huidobro," *Ultra* 1.20 (December 15, 1921): 3.

129. Antonio Espina García, "Arte nuevo," *España* 285 (October 16, 1920): 12–13.

130. Anonymous, "Panorama ultraísta," *Grecia* 3.50 (November 1, 1920): 16.

131. Antonio Espina García, "Ivan Goll, *Les 5 Continents: anthologie mondiale de poésie contemporaine*," *La Revista de Occidente*, 1.2 (August 1923): 248–49.

132. Two references, by Guillermo de Torre, have been discussed previously. Apollinaire's name also figured in a review of Pajares' *El conquistador de los trópicos* by Juan G. del Valle in *Alfar* in October 1925. Four years later Luis Cernuda, writing on "Jacques Vaché," cited the latter's dislike both of Rimbaud and Apollinaire. See *Revista de Occidente* 26.76 (October 1929): 144.

133. Antonio Marichalar, "El poeta asesinado," *Revista de Occidente* 2.13 (July 1924): 130–34.

134. José Ortega y Gasset, *La deshumanización del arte* (Madrid: Revista de Occidente, 1962), 30–31.

135. Apollinaire, *Les Peintres cubistes*, 8, and "L'Esprit nouveau et les poètes," 950.

136. Pierre Picon, review of *Il y a*, *Alfar* 6.56 (March 1926): 26.

137. Guillaume Apollinaire, *Poèmes à Lou* preceded by *Il y a* (Paris: Gallimard/Poésie, 1969), 82.

7. ALONG THE RÍO DE LA PLATA

1. For an excellent survey of the Latin American response to Futurism, see Nelson Osorio Tejeda, "La recepción del mani-

fiesto futurista de Marinetti en América Latina," *Revista de Critica Literaria Latinoamericana* 8.15 (1982): 25–37.

2. For an excellent study of the evolving avant-garde in Argentina see Francine Masiello, *Lenguaje e ideología: las escuelas argentinas de vanguardia* (Buenos Aires: Hachette, 1986).

3. Enrique Anderson Imbert, *Spanish-American Literature: A History*, tr. John V. Falconieri (Detroit: Wayne State University Press, 1963), 371.

4. Jean de Milleret, *Entretiens avec Jorge Luis Borges* (Paris: Belfond, 1967), 23.

5. Guillaume Apollinaire, *Oeuvres poétiques*, ed. Marcel Adéma and Michel Décaudin (Paris: Gallimard/Pléiade, 1965), 43.

6. Guillaume Apollinaire, "Le Tango," *Mercure de France* 107.400 (February 16, 1914): 871–75.

7. Guillaume Apollinaire, "Remy de Gourmont et la critique étrangère," *Mercure de France* 115.406 (May 16, 1916): 367–73. For this reference and the previous one I am indebted to Pierre Caizergues, "Apollinaire journaliste: textes retrouvés et textes inédits avec présentation et notes," doctoral diss. Université de Paris III, 1977.

8. The preceding information is provided by two letters from Duchamp to Jean Crotti, dated October 26, 1918, and March 9, 1919, respectively. See Francis M. Naumann, "Affectueusement, Marcel," *Archives of American Art Journal* 22.4 (1982): 11–12.

9. Bartolomé Galíndez, *Nuevas tendencias* (Buenos Aires: Los Raros, 1920). Page references to this text are to this edition.

10. Guillermo Ara, *Suma de poesía argentina 1538–1968: critica y antología* (Buenos Aires: Guadelupe, 1970), 1:73.

11. Galíndez may have been referring to the following article: Rafael Cansinos-Asséns, "Un gran poeta chileno: Vicente Huidobro y el creacionismo," *Cosmópolis* 1.1 (January 1919): 68–73.

12. Guillaume Apollinaire, "L'Art tactile," *Mercure de France* 125.472 (February 16, 1918): 751–53. Repr. in Apollinaire, *Oeuvres en prose complètes*, 3:270–71.

13. Enrique Díez-Canedo, "Guillaume Apollinaire," *España* 4.189 (November 21, 1918): 11–14. Repr. in *Grecia* 2.20 (June 30, 1919): 1–2, and in *Conversaciones literarias (1915–1920)* (Madrid: América, 1921), 215–19.

14. Bartolomé Galíndez, "Los nuevos pintores de Italia," *Nosotros* 42.163 (December 1922): 501.

15. Anna Balakian, *Surrealism: The Road to the Absolute* (Chicago: University of Chicago Press, 1986), 95, 99.
16. The manifesto is reprinted in Apollinaire, *Oeuvres en prose complètes*, 2:937–39.
17. Guillaume Apollinaire, "Las campanas," *Los Nuevos* 1.1 (1920): 26.
18. Anonymous, "Las modernas tendencias (Apollinaire y el creacionismo)," *Los Nuevos* 2.1 (1920), pp. 1-5.
19. René Perin, "El profesor de literatura," *Los Nuevos* 1.2 (1920): 44.
20. Ildefonso Pereda Valdés, "El cubismo y la cuarta dimensión," *Los Nuevos* 2.6 (December 1921): 9–10.
21. Alberto Hidalgo, *España no existe* (Buenos Aires: Mercatali, 1923), 25.
22. Alberto Hidalgo, *Química del espíritu* (Buenos Aires: Mercatali, 1923), 25.
23. Alberto Hidalgo, *Simplismo: poemas inventados* (Buenos Aires: El Inca, 1925), 15.
24. Alberto Hidalgo, *Los sapos y otras personas* (Buenos Aires: El Inca, 1927), 63–71.
25. Thorpe Running, *Borges' Ultraist Movement and Its Poets* (Lathrup Village, MI: International Book Publishers, 1981), 131.
26. Juan Carlos Ghiano, *Poesía argentina del siglo XX* (Mexico City: Fondo de Cultura Económica, 1957), 113.
27. Enrique Díez-Canedo, review of Oliverio Girondo, *Veinte poemas para ser leídos en el tranvía, España*, September 8, 1923. Repr. as "Los escritores argentinas juzgados en el extranjero," *Nosotros*, 45.174 (November 1923): 388.
28. Julio Noé, "Letras argentinas: prosa," *Nosotros*, 45.175 (December 1923): 474.
29. Running, *Borges' Ultraist Movement and Its Poets*, 135.
30. Oliverio Girondo, *Obras completas* (Buenos Aires: Losada, 1968), 140.
31. Guillaume Apollinaire, "L'Esprit nouveau et les poètes," *Mercure de France* 130.491 (December 1, 1918): 389. Repr. in Apollinaire, *Oeuvres en prose complètes*, 2:947.
32. Enrique Molina, "Hacia el fuego central o la poesía de Oliverio Girondo" in Girondo, *Obras completas*, 23–24. Running, *Borges' Ultraist Movement*, 129–31.
33. Oliverio Girondo, *Pintura moderna* (Buenos Aires: Museo Nacional de Bellas Artes, 1937), 219.

34. César Fernández Moreno, *La realidad y los papeles: panorama y muestra de la poesía argentina contemporánea* (Madrid: Aguilar, 1967), 143.

35. Evar Méndez, "Doce poetas nuevos," *Síntesis* 1.4 (September 1927): 21.

36. Carlos Mastronardi *Memorias de un provinciano* (Buenos Aires: Ediciones Culturales Argentinas, 1967), 218.

37. Ara, *Suma de poesía argentina*, 1:75.

38. Jorge Luis Borges, "Profiles: Autobiographical Notes," *The New Yorker*, September 19, 1970, p. 62.

39. Jorge Luis Borges, "Anatomía de mi 'Ultra,'" *Ultra* 1.11 (May 20, 1921): 1.

40. Jorge Luis Borges, "Entretiens avec Napoléon Murat," *L'Herne*, 1964, p. 374.

41. De Milleret, *Entretiens avec Jorge Luis Borges*, 32 and 23 respectively.

42. Ibid., 33.

43. See André Breton, *La Clé des champs* (Paris: Pauvert, 1967), 178. Also Paul Eluard, *Oeuvres complètes*, ed. Marcelle Dumas and Lucien Scheler (Paris: Gallimard/Pléiade, 1968), 538–39 1490.

44. Emir Rodriguez Monegal, *Jorge Luis Borges: A Literary Biography* (New York: Dutton, 1978), 160.

45. De Milleret, *Entretiens avec Jorge Luis Borges*, 101.

46. Jorge Luis Borges, "E. González Lanuza," *Proa*, second series, 1.1 (August 1924): 30. Repr. in Jorge Luis Borges, *Inquisiciones* (Buenos Aires: Proa, 1925), 96–97.

47. Brandán Caraffa, review of Jorge Luis Borges, *Inquisiciones*, *Sagitario* 1.2 (July–August 1925): 230.

48. Jorge Luis Borges, "Guillermo de Torre: *Literaturas europeas de vanguardia*," *Martín Fierro* 2.20 (August 5, 1925): 4.

49. Jorge Luis Borges, "Sobre un verso de Apollinaire," *Nosotros* 49.190 (March 1925): 320. Repr. in Jorge Luis Borges, *El tamaño de mi esperanza* (Buenos Aires: Proa, 1926), 70.

50. Jorge Luis Borges, "La paradoja de Apollinaire," *Los Anales de Buenos Aires*, August 1946, pp. 48–51.

51. Guillermo de Torre, *Guillaume Apollinaire: estudio preliminar y páginas escogidas* (Buenos Aires: Poseidon, 1946), 35–36.

52. Guillermo de Torre, "Neodadaismo y superrealismo," *Proa*, second series, 2.6 (January 1925): 51–52. repr. in his *Literaturas europeas de vanguardia* (Madrid: Rafael Caro Raggio, 1925), 228–29.

53. Emilio Súarez Calimano, review of Guillermo de Torre's *Literaturas europeas de vanguardia, Nosotros* 51.196 (September 1925): 104.

54. Guillermo de Torre, "El nuevo espíritu cosmopolita," *Nosotros* 50.193 (June 1925): 211–24.

55. Guillermo de Torre, "Objeciones y precisiones," *Martín Fierro* 3.34 (October 5, 1926): 5.

56. Guillermo de Torre, "Paralelismos entre Picasso y Ramón," *Síntesis* 1.9 (January 1928): 303.

57. Guillaume Apollinaire, *Médtations esthétiques: les peintres cubistes,* in *Oeuvres en prose complètes,* 2:9.

58. Ibid., 6.

59. Guillermo de Torre, review of Ramón de Basterra's *Vírula. Mediodía: poemas, Síntesis* 1.11 (April 1928): 106–9.

60. Guillermo de Torre, "Adiós a Barradas," *La Gaceta Literaria,* May 15, 1929. Repr. in *Manifestos, proclamas, panfletos y textos doctrinales (Las vanguardias artisticas en España: 1910–1931),* ed. Jaime Brihuega (Madrid: Cátedra, 1979), 375–80.

61. Guillermo de Torre, *Apollinaire y las teorías del cubismo* (Buenos Aires and Barcelona: EDHASA, 1967), 28.

62. Apollinaire, "L'Esprit nouveau et les poètes," 949.

63. Ernesto Palacio, "Guillaume Apollinaire," *Martín Fierro* 1.1 (February 1924): 6.

64. Georges Duhamel, review of Apollinaire's *Alcools, Mercure de France* 103.294 (June 16, 1913): 800–801.

65. Pedro Juan Vignale, "Aldo Palazzeschi," *Martín Fierro* 1.4 (May 15, 1924): 7.

66. Jean Cocteau, "De 'carte blanche,'" *Martín Fierro* 1.7 (July 25, 1924): 1.

67. Serge Panine, "Acotaciones a un tema vital," *Martín Fierro* 1.10–11 (September – October 9, 1924): 2.

68. Sandro Piantanida, "El descubrimiento del cubismo," *Martín Fierro* 1.12–13 (October – November 20, 1924): 7.

69. Eduardo Juan, "Marie Laurencin," *Martín Fierro* 2.23 (September 25, 1925): 1.

70. Anonymous, "Sergio Piñero," *Martín Fierro* 3.27–28 (May 10, 1926): 2.

71. Nino Frank, "Marinetti y el Futurismo," *Martín Fierro* 3.29–30 (June 8, 1926): 3.

72. Francisco Contreras, "Valéry Larbaud y su obra," part 2, *Martín Fierro* 3.34 (October 5, 1926): 11.

73. J. F. [Jacobo Fijman?], "Conciertos Ansermet y Bathor—Conferencias Aubry," *Martín Fierro* 3.33 (September 3, 1926): 2.

74. Georges Mergault, "Max Jacob (recuerdos de 1913)," *Martín Fierro* 4.37 (January 20, 1927): 4.

75. Marcelle Auclair, "Marie Laurencin," *Martín Fierro* 4.37 (January 20, 1927): 7.

76. Guillaume Apollinaire, "Prenez garde à la peinture!," *L'Intransigeant*, March 18, 1910. Repr. in Apollinaire, *Oeuvres en prose complètes*, 2:143.

77. Adriano del Valle, "Semaforo literario," *Martín Fierro*, 4.40 (April 28, 1927): 7.

78. Raúl Scalabrini Ortiz, "Variaciones sobre una conferencia," *Martín Fierro* 4.433 (July 15 – August 15, 1927): 3.

79. Guillaume Apollinaire, "Zona," tr. Lysandro Z. D. Galtier, *Martín Fierro* 3.32 (August 4, 1926): 6 and 11.

80. Lysandro Z. D. Galtier," Buenos-Ayres," *Martín Fierro* 4.40 (April 28, 1927): 7.

81. Lisandro Z. D. Galtier, *32 poemas de Guillaume Apollinaire* (Buenos Aires: Proa, 1929). The following poems were included: "Zone," "Les Colchiques," "Cortège," "Le Voyageur," "Poème lu au mariage d'André Salmon," "Nuit rhénane," "Signe," "Les Fiançailles," "1909," "Cors de Chasse," "Liens," "Les Fenêtres," "Arbre," "La Petite Auto," "Ombre," "Visée," "Reconnaissance," "La Nuit d'avril 1915," "Le Palais du tonnerre," "Dans l'abri-caverne" "Fusée," "Désir," "Chant de l'horizon en Champagne," "Océan de terre," "Merveille de la guerre," À l'Italie," "Il y a," "Le Chant d'amour," "L'Avenir," "Chef de section," " La Victoire," and "La Jolie Rousse."

82. Lysandro Z. D. Galtier, "Itinéraire," *La Revue Argentine*, 6 (February 1935): 31–37. Repr. in *Itinéraire* (Buenos Aires: n.p., 1936).

83. Lysandro Z. D. Galtier, *La traducción literaria, con una antología del poema traducido*, 3 vols. (Buenos Aires: Ediciones Culturales Argentinas, 1965).

84. Memento, "Las Revistas," *Nosotros* 39.148 (September 1921): 61.

85. Francisco Luis Bernárdez, *Kindergarten: poemas ingenuos* (Madrid: Riva de Neyra, 1923), 61.

86. José G. Antuña, "Versos en prosa y prosa sin poesía," *Pegaso* 6.64 (October 1923): 100.

87. José María Delgado, review of Rogelio Buendia's *La rueda de color*, *Pegaso* 6.64 (October 1923): 100.

88. Juan Parra del Riego, *"El hombre de la pampa,* de Julio Supervielle," *Teseo,* 1924. Repr. in *Prosa* (Montevideo: Biblioteca de Cultura, 1943), 129.

89. Roberto A. Ortelli, "Arte novísimo," *Inicial* 1.7 (December 1924): 46.

90. Francisco Contreras, "Jean Royère y *La Phalange," Valoraciones* 2.15 (January 1925): 154.

91. Guillaume Apollinaire, "Noche del Rhin" and "Bodas" in "Poetas franceses modernos," tr. Luis Eduardo Pombo, *La Pluma* 1.3 (November 1927): 109–13.

92. Conducting an "Autopsia del superrealismo" three years later, Cesar Vallejo declared that Surrealism was based on ideas by the author of *Calligrammes,* whom however he associated with Cubism. (*Nosotros,* 250 [March 1930]: 342–4 7 and *Amauta,* 30 [April–May 1930]: 44-47; repr. in Hugo J. Verani, *Las vanguardias literarias en Hispanoamerica: manifiestos, proclamas y otros escritos* (Rome: Bulzoni, 1986), 199–203). Reviewing a play by Arturo Capdevila the following year, Manuel Castro acknowledged the triumph of André Breton's Surrealism but noted that the term had been invented by Apollinaire in 1917. See his "Teatros," *Síntesis* 4.41 (October 1931): 192.

93. Federico Bolaños, "La nueva literatura peruana," *La Pluma* 3.10 (February 1929): 74.

94. Alfonso Reyes, "Elogio de un diario pequeño," *El Mundo,* May 14, 1929. Repr. in his *Obras completas* (Mexico City: Fondo de Cultura Económica, 1955–63), 8:248–49. See chapter 8 for a more detailed account.

8. THE MEXICAN REVOLUTION

1. Guillaume Apollinaire, *Oeuvres poétiques,* ed. Marcel Adéma and Michel Décaudin (Paris: Gallimard/Pléiade, 1965), 183–85.

2. Some idea of Albert's existence can be glimpsed in Guillaume Apollinaire, *Correspondance avec son frère et sa mère* (Paris: Corti, 1987). For an analysis of "Lettre-Océan," see Willard Bohn, *The Aesthetics of Visual Poetry, 1914–1928* (Cambridge: Cambridge University Press, 1986), 9–24.

3. Guillaume Apollinaire, "Quatre Nouveaux Artistes français," *Paris-Journal,* July 3, 1914. Repr. in Guillaume Apollinaire, *Oeuvres en prose complètes,* ed. Pierre Caizergues and Michel Décaudin (Paris: Gallimard/Pléiade, 1991), 2:804.

4. Guillaume Apollinaire, "Français à Mexico," *Mercure de France* 107.399 (February 1, 1914): 664–66. Repr. in *Oeuvres en prose complètes*, 3:184–86

5. Letter from Angel Zárraga to Guillaume Apollinaire dated December 31, 1916. Harry Ransom Humanities Research Center, The University of Texas at Austin.

6. Guillaume Apollinaire, "Exposition Atl," *Paris-Journal*, May 4, 1914 and "Les Volcans au Mexique," *Paris-Journal*, May 5, 1914. Repr. in *Oeuvres en prose complètes*, 2:669–71 and 674 respectively.

7. Luis Mario Schneider, *El estridentismo o una literatura de la estrategia* (Mexico City: Bellas Artes, 1970), 22.

8. Guillaume Apollinaire, "Le 30e Salon des 'Indépendants,' " *Les Soirées de Paris* 23 (March 15, 1914): 188; "Une Préface singulière," *Paris-Journal*, May 7, 1914; "Les Arts," *Les Soirées de Paris* 24 (May 15, 1914): 250. Repr. in Apollinaire, *Oeuvres en prose complètes*, 2:655, 681, and 704 respectively.

9. Diego Rivera, *My Art, My Life: An Autobiography*, tr. Gladys March (New York: Citadel, 1960), 117.

10. José Juan Tablada, "Mexican Painting of Today," *International Studio* 76.308 (January 1923): 276.

11. J. M. González de Mendoza, *Los cuatro poetas* (Mexico City: Secretaria de Educación Publica, 1944), 145.

12. José María González de Mendoza, ed., *Los mejores poemas de José Juan Tablada* (Mexico City: Surco, 1943), 8.

13. José María González de Mendoza, "Trajectoria de José Juan Tablada;" repr. in *Ensayos selectos* (Mexico City: Fondo de Cultura Económica, 1970), 118. Internal evidence reveals that this essay was written after 1946.

14. Carlos Pellicer, "Una nota sobre Tablada," *La Antorcha*, 1.24 (March 14, 1925): 21.

15. See, for example, José Juan Tablada, *Obras*, ed. Héctor Valdés (Mexico City: UNAM, 1971), 403.

16. José Juan Tablada, *La feria de la vida (memorias)* (Mexico City: Botas, 1937), 354–58.

17. José Juan Tablada, "Tres artistas mexicanos en Nueva York: Marius de Zayas, Pal-Omar, Juan Olaguíbel," *El Universal Ilustrado*, January 17, 1919, p. 3. Tablada's dispatch was dated "Nueva York, noviembre de 1918."

18. Tablada, *Obras*, 404.

19. This work is reproduced in Germán Vargas, ed. *Voces, 1917–1920* (Bogota: Instituto Colombiano de Cultura, 1977), 298.

20. José Juan Tablada, "Algo nuevo en poesía: madrigales ideográficos," *Social* 4.1, (January 1919): 22.

21. Anonymous, "La nueva poesía de José Juan Tablada," *El Universal ilustrado*, February 21, 1919, p. 13.

22. Tattler, "La nueva poesía de José Juan Tablada," *Actualidades*, 3.29 (July, 20, 1919). Repr. in Nelson Osorio T., *La formación de la Vanguardia Litéraria en Venezuela (antecedentes y documentas)* (Caracas: Academia Nacional de la Historia, 1985), 205–6.

23. Echoes of the *Actualidades* interview appeared in a Spanish journal only two weeks later. Following his discovery of the *Greek Anthology* and Jules Renard, César E. Arroyo reported, Tablada encountered Creationism and "the unforgettable 'Lettre-Océan' by the ill-fated Apollinaire, whose memory he holds in the greatest respect and whose marvelous unprecedented work he admires" (*Cervantes*, August 1919, p. 112). In *Grecia* on September 20, 1919, Rafael Cansinos-Asséns announced Tablada's adherence to the modern movement and published two (nonvisual) poems. On November 20th, *Grecia* reprinted an interview with Cansinos, published in *La Acción*, in which the Mexican poet was listed as an Ultraist.

24. Letter from Ramón López Velarde to José Juan Tablada dated June 18, 1919. Repr. in Ramón López Velarde, *Obras*, ed. José Luis Martínez (Mexico City: Fondo de Cultura Económica, 1986), 769–70.

25. Virtually the entire letter is quoted in José Emilio Pacheco, ed. *Antología del modernismo (1884-1921)* (Mexico City: UNAM, 1970), 2:61–63.

26. Barbara Bockus Aponte, *Alfonso Reyes and Spain* (Austin: University of Texas Press, 1972), 3.

27. Alfonso Reyes, "La novela bodegon," *España*, 1920. Repr. in Alfonso Reyes, *Obras completas* (Mexico City: Fondo de Cultura Económica, 1953–63), 4:93–99.

28. Alfonso Reyes, "La casa de fieras," *Social*, February 1923. Repr. in *Obras*, 7:429.

29. Alfonso Reyes, "Elogio de un diario pequeño," *El Mundo*, May 14, 1929. Repr. in *Obras*, 8:248–49.

30. Alfonso Reyes, "Rousseau el Adouanero y México," *Monterrey* 3 (October 1930): 3. Repr. in *Obras*, 8:302–3.

31. Guillaume Apollinaire, "Le Douanier," *Les Soirées de Paris* 20 (January 15, 1914): 7–29; repr. in *Oeuvres en prose complètes*, 2:626–41. "Tu te souviens, Rousseau" was included in Maurice

Raynal's article "Le 'Banquet' Rousseau," published in the same issue (p. 71).

32. Alfonso Reyes, "El mal recompensado," *Monterrey* 6 (October 1931). Repr. in *Obras*, 8:68.

33. See Guillaume Apollinaire, *Les Diables amoureux*, ed. Michel Décaudin (Paris: Gallimard, 1964), 178–232.

34. Camille Pitollet, "La poesía tipográfica," *Monterrey* 10 (March 1933): 190–91.

35. For a discussion of Apollinaire's use of Lilith, see Scott Bates, *Guillaume Apollinaire*, rev. ed. (Boston: Twayne, 1989), 31–32 and passim.

36. The last sentence is taken from section XIII of *Le Poète assassiné*; see *Oeuvres en prose*, 1:275.

37. Guillaume Apollinaire, "L'Art tactile," *Mercure de France* 125.472 (February 16, 1918): 751–53. Repr. in *Oeuvres en prose complètes*, 3:270–71.

38. Apollinaire, *Oeuvres en prose*, 1:439ff.

39. Luis Mario Schneider, ed., *El estridentismo: antología* (Mexico City: UNAM, 1983), 5.

40. Luis Monguió, "Poetas post-modernistas mexicanos," *Revista Hispánica Moderna*, 12 (1946): 262.

41. Carlos Monsivais, *La poesía mexicana del siglo XX* (Mexico City: Empresas Editoriales, 1966), 48.

42. Manuel Maples Arce, *Soberana juventud* (Madrid: Plenitud, 1967), 121.

43. Anonymous, "Guillaume Apollinaire, el Marco Polo del nuevo arte," *Revista de Revistas*, March 9, 1919, pp. 14–15.

44. Anonymous, "Passing of Guillaume Apollinaire, Explorer of the New Aesthetics," *Current Opinion* 66.2 (February 1919): 119–20.

45. Ramón Vinyes, "Quién es Pierre Albert-Birot," *Revista de Revistas*, March 9, 1919, p. 15. See Vargas, ed., *Voces 1917–1920*, 295–96.

46. Guillaume Apollnaire, "Lluvia," tr. Ramón Vinyes, *Revista de Revistas*, March 9, 1919, p. 14. Originally published in *Voces* 3.27 (June 30, 1918): 274.

47. See Manuel Maples Arce, *Las semillas del tiempo: obra poética 1918–1980* (Mexico City: Fondo de Cultura Económica, 1981), 37–38.

48. Maples Arce, *Soberana juventud*, 124.

49. Guillaume Apollinaire, "Mutación," tr. José Ciria y Escalante, *Actual*, 3 (July 1922). Repr. from *Ultra* 1.5 (March 17, 1921: 4.

50. See Apollinaire, *Oeuvres en prose complètes*, 2:937–39.

51. Manuel Maples Arce, "La sistematización de los movimientos literarios," *El Universal Ilustrado*, July 10, 1924, 57.

52. Maples Arce, *Las semillas del tiempo*, 116. Although the poem is not dated, internal evidence reveals that it was written after 1976.

53. Lourdes Quintanilla Obregón, "Prólogo," *Obra poética* by Luis Quintanilla (Mexico City: Domés, 1986),. v. All references to Quintanilla's poetry are to this (unpaginated) volume.

54. Guillaume Apollinaire "L'Esprit nouveau et les poètes," *Mercure de France* 130.491 (December 1, 1918): 387 and 394 respectively. Repr. in Apollinaire, *Oeuvres en prose complètes*, 2:945, 952.

55. Francisco Borja Bolado, "Bajo la sombra del ala, poemas de Kyn Taniya," *El Universal Ilustrado*, August 23, 1923, 26.

56. Eduardo Colin, "Poetas de ahora: Luis Quintanilla," *La Antorcha* 2.3 (October 1925): 10.

57. Germán List Arzubide, *El movimiento estridentista* (Jalalpa: Horizonte, 1927), 40–41.

58. The letter is cited in its entirety in Germán List Arzubide, *Opiniones sobre el libre "El movimiento estridentista"* (Jalapa: n.p., 1928), 18.

59. Arqueles Vela, *El modernismo: su filosofía, su estética, su técnica*, 3rd ed. (Mexico City: Porrúa, 1974), 233. For Vela's other comments about Apollinaire, see 214–21.

60. Xavier Villaurrutia, *La poesía de los jóvenes de México* (Mexico City: Antena, 1924), 5.

61. Frank Dauster, *Ensayos sobre poesía mexicana: asedio a los "Contemporáneos"* (Mexico City: De Andrea, 1963), 5.

62. Salvador Novo, *Poesía, 1915–1955* (Mexico City: Impresiones Modernas, 1955).

63. Alí Chumacero, "Prólogo," *Obras* by Xavier Villaurrutia, 2nd ed. (Mexico City: Fondo de Cultura Económica, 1966), x.

64. Salvador Novo, "Jarrón," *Prisma* (Barcelona) 2.3 (July 1922): 172. Described as a "poema ideográfico," the poem was unpunctuated and contained a single variant: "Bello" in line 14.

65. Villaurrutia, *La poesía de los jóvenes de México*, 23. See his *Obras*, 851.

66. Dauster, *Ensayos sobre poesía mexicana*, 75.

67. Chumacero, "Prólogo," x.

68. See note 43.

69. Salvador Novo, *Ensayos* (Mexico City: Editorial, 1925), 7–9.

70. Jorge Cuesta, *Antología de la poesía mexicana moderna* (Mexico City: Contemporáneos, 1928), 62.
71. Jaime Torres Bodet, "La cirugía estética: genero suprarrealista," *Contemporáneos* 1.3 (August 1928): 330–31.
72. Apollinaire, "L'Esprit nouveau et les poètes," 950.
73. Guillaume Apollinaire, "Cirugía estética," tr. Jaime Torres Bodet, *Contemporáneos* 1.3 (August 1928): 331–34.
74. Bernardo Ortiz de Montellano, "La aventura y el orden," *El Hijo Pródigo*, February 15, 1944, pp. 120–21. Repr. in his *Obras en prosa* (Mexico City: UNAM, 1988), 280–81.
75. Jaime Torres Bodet, *Tiempo de arena* (Mexico City: Fondo de Cultura Económica, 1955), 254.
76. The following events are narrated in José María González de Mendoza, *Ensayos selectos* (Mexico City: Fondo de Cultura Económica, 1970), 275–77, 279–80. Entitled "Los poemas 'al alimón' de José D. Frías," the first selection originally appeared in the *Revista de Revistas* 27.1416 (July 11, 1937).
77. Anonymous, "1924," *Antena*, November 1924, p. 15.
78. El Abate de Mendoza, "The Jockey," *La Antorcha* 1.32 (May 9, 1925): 18.
79. J.-M. González de Mendoza, "Les Tendances de la jeune littérature mexicaine," *La Revue de l'Amérique Latine* 10.43 (July 1, 1925): 18.
80. Francisco Monterde García, "Guillaume Apollinaire en México," *Sagitario* (Mexico) 4 (September 1, 1926): 7. See also González de Mendoza, *Ensayos selectos*, 550–51.
81. Agustín Loera y Chavez, "La poesía contemporánea mexicana," *Nosotros* 55.213 (February 1927): 184. The article was dated "París 1926."
82. José María González de Mendoza, "Dos cuentos," *Sagitario* (Mexico) 14 (May 31, 1927): 14.
83. González de Mendoza, *Ensayos selectos*, 296.
84. Ibid., 550–85. The essays are entitled "Guillaume Apollinaire," "*La Femme assise*," "El espíritu nuevo," "La leyenda de Guillaume Apollinaire," and "Apollinaire en México" respectively.
85. Guillermo Jiménez, "Prólogo," *Antología de jóvenes poetas mexicanos*, ed. José Dolores Frías (Paris: Franco-Ibero-Americana, 1922), 19–20.
86. Guillermo Jiménez, "La ventana abierta," *La Falange*, July 1, 1923, 210–22.

87. P. G. C., review of *Luna Park* by Luis Cardoza y Aragón, *Antena*, October 1924, p. 9.
88. Salatiel Rosales, review of *Las nuevas capillas* by Flavio Herrera, *La Falange*, January 1, 1923, p. 117.
89. Rafael Lasso de la Vega, "La 'sección de oro,'" *Cosmópolis* 3.24, (December 1920): 642.
90. Valéry Larbaud, "Poetas franceses contemporáneos," *La Antorcha* 1.34 (May 23, 1925): 9–11. Guillermo de Torre, "Teodadaismo y superrealismo," *La Antorcha* 1.40 (July 4, 1925: 17.
91. Luis Marín Loya, *El meridiano lírico* (Mexico City: n.p., 1926).
92. Luis Cardoza y Aragón, "El rapto de la Torre Eiffel," *Sagitario* (Mexico) 10 (March 1, 1927): 11. The composition itself was dated "París, 1926."

Index

Apollinaire, Guillaume: and
 Argentina, 178, 225–32, 237–59;
 and Belgium, 2, 4; and Brasil, 3;
 and Catalonia, 129–67; and
 Denmark, 2; and Eastern Europe,
 2–3; and England, 9–41; and
 Germany 75–128; and Holland, 2;
 and Hungary, 3; and Italy 4–5; and
 Mexico, 263–303; and Scandinavia,
 2; and Spain; and Sweden, 2; and
 Switzerland, 3–4; and the Ukraine,
 3; and the United States, 43–73;
 and Uruguay, 232–37, 259–62.
 Works: "L'Adieu du cavalier," 186;
 "Adieux," 223; "A la Santé," 184;
 Alcools: in England, 13–14, 17, 18,
 19, 20, 21, 28, 29, 39, 40; in the
 United States, 47, 70; in Germany,
 75, 89, 92, 93, 104, 105, 106, 126; in
 Catalonia, 131, 145, 148, 151, 163;
 in Castile, 178, 179, 188, 189, 191,
 192, 201, 213, 220; in Uruguay,
 233–34, 235–36, 262; in Argentina,
 249, 253, 254, 258; in Mexico, 278,
 287, 299, 301, 315n99, 320n48; "A
 l'Italie," 152; *L'Antitradition futur-*
 iste, 13, 22, 29, 31, 94, 205, 231–32,
 282; *A quelle heure un train partira-t-*
 il pour Paris?, 49–50, 66; "Arbre," 4,
34, 112; "A travers l'Europe," 21,
 27, 69, 98–99; "Automne malade,"
 210–11; "Avant le cinéma," 186,
 188; *Le Bestiaire*, 6, 71, 80, 82, 95,
 146, 163, 178, 192, 255, 274, 293,
 301; "La Blanche Neige," 233–35;
 "Bleuet," 191–92; "Le Brasier,"
 235; *Calligrammes*: in England, 13,
 17, 19, 24, 26, 27, 33; in the United
 States, 47, 63; in Germany, 103,
 108, 122; in Catalonia, 132, 133,
 144–45, 148, 149, 150, 152, 163, 167;
 in Castile, 182, 183, 186, 188, 191,
 192, 199, 201, 204, 205, 208, 209,
 213, 220; in Uruguay, 235; in
 Argentina, 238, 239, 244, 249, 253,
 255, 256, 258; in Mexico, 268, 269,
 278, 280, 282, 286, 289, 298, 301,
 351n92; *Case d'armons*, 17, 54–55,
 176; "La Chanson du mal-aimé," 9,
 10, 124, 235, 248; "Le Chant
 d'amour," 183–84, 186, 230;
 "Chant de l'honneur," 19; "Chant
 de l'horizon en Champagne," 186;
 "Chef de section," 163; "Chevaux
 de Frise," 19, 163; "Chirurgie
 esthétique," 292; "Clair de lune,"
 206; "Les Cloches," 233; "La
 Colombe poignardée et le jet

Apollinaire (*continued*)
d'eau," 122, 183, 230, 268;
"Cortège," 259; "Cox-City," 115;
"La Cravate et la montre," 55, 66,
281; "La Cueillette,"35; "La
Dame," 104, 233–36; "Dans l'abri-
caverne," 163; "Le Départ," 144;
"Désir," 244, 248; "2 Cannonier
conducteur," 112; "La Disparition
d'Honoré Subrac," 183, 184, 230;
"L'Emigrant de Landor Road,"
178, 180, 227; *L'Enchanteur pourris-
sant*, 20, 21, 27, 57, 82, 109, 115, 116,
146, 163, 178, 192, 253–54, 276; *Les
Epingles*, 291
"L'Esprit nouveau et les poètes": in
England, 37; in the United States,
66–67; in Catalonia, 142–43; in
Castile, 174, 181–82, 187, 188, 198,
201, 203, 208, 213, 215, 216, 219,
222; in Argentina, 249, 252; in
Mexico, 286, 292, 300; *La Femme
assise*, 13, 25, 199, 214, 226, 265,
271–73, 276, 278, 299; "Les
Fenêtres," 52, 81, 87, 98, 167, 177,
199, 209, 256, 301; "Les
Fiançailles," 34, 236, 257, 259, 262;
La Fin de Babylone, 161; *Le Flâneur
des deux rives*, 126, 166–67; "Fusée-
Signal," 186, 187, 188, 190, 216–18,
243; "Le Guide," 191–92
L'Hérésiarque et Cie: in England, 13,
20; in Germany, 82, 89–90, 115,
119; in Catalonia, 146, 161, 163; in
Castile, 178, 179, 183, 191–92, 218;
in Argentina, 230, 246, 253–54; "Il
pleut," 122, 141, 238, 279–80, 281,
283–84, 299; "Il y a," 298; *Il y a*, 177,
191, 222–23, 226, 274, 275;
"Inscription pour le tombeau du
peintre Henri Rousseau
Douanier," 21; "La Jolie Rousse,"
18, 117, 222, 245–47, 248, 251, 252,
257, 259, 285–86; "Léo Larguier
soldat mystique," 17; "Lettre-
Océan," 48–49, 51, 52, 55, 218–19,

263– 64, 269, 296, 298, 351n2,
352n23; "Liens," 209; "Lundi rue
Christine," 51–52, 61, 62–63, 103,
106, 117, 119; "La Maison des
morts," 14, 39
Les Mamelles de Tirésias: in England,
23, 29; in the United States, 65–66;
in Germany, 113, 117, 120, 127; in
Catalonia, 132–33, 146, 147, 162; in
Castile, 192, 196, 198, 204, 205,
221–22; in Argentina, 240, 248; in
Mexico, 296, 302; "Le Matelot
d'Amsterdam," 246; "Merlin et la
vieille femme," 234–35; "Merveille
de la guerre," 163, 248, 333n25;
"Mon Cher Ludovic," 16, 23;
"Montparnasse," 14; "Mort de
Pan," 38; "Le Musicien de Saint-
Merry," 49, 55, 103, 117–18,
121–22, 123–24, 202–03;
"Mutation," 208–09, 282; "La Nuit
d'avril 1915," 121, 247; "Nuit rhé-
nane," 262; "Océan de terre," 186,
188, 192, 202, 203, 220; "Pablo
Picasso," 223; "Paysage," 199
Les Peintres cubistes: in England, 2,
20, 21, 31; in the United States, 44,
45, 46, 47, 60, 72–73; in Germany,
79, 81, 82, 89–91, 94, 95, 103,
108–09, 111–12, 115, 117, 120–21; in
Catalonia, 131, 158–59, 161, 163; in
Castile, 178, 181–82, 183, 192,
196–98, 202, 204, 207, 212, 222; in
Argentina, 231, 248, 250, 256, 302,
211n43; in Uruguay, 235, 237;
"Photographie," 149; "Poèmepré-
faceprophétie," 198, 205; "Poèmes
de guerre et d'amour," 162; *La
Poésie symboliste*, 161, 254
Le Poète assassiné: in the United
States, 63; in Catalonia, 135, 146,
161, 162, 163; in Castile, 177–78,
187, 190–91, 192, 207, 208, 221; in
Argentina, 238; in Mexico, 265,
276, 285, 306n9; "Le Pont," 199;

"Le Pont Mirabeau," 124, 146, 149; "Rhénanes," 105, 124; *La Rome des Borgia*, 87; "Salomé," 184, 189–90, 216, 242; "Sanglots," 191; "Simultanisme-Librettisme," 39–40, 51; "69 6666...69...," 199, 207; "Souvenir du Douanier," 99, 223; "Souvenirs," 145; "La Synagogue," 14; *Le Théâtre italien*, 161; "Toujours," 206, 251; "Tour," 81, 85; "Tristesse d'une étoile," 184, 193, 230, 244, 248; "Tu te souviens Rousseau," 274; "Un Fantôme de nuages," 259; "Vendémiaire," 101, 220, 257; "Vers le sud," 192; "La Victoire," 65, 67–68, 113, 136, 205; *La Vie anecdotique*, 17, 33, 44, 86, 91, 167, 233, 273, 296, 303; *Vitam impendere amor*, 192; "Voyage," 52, 55, 56, 122, 268–69

"Zone": in the United States, 50, 55; in Germany, 89, 92, 95, 98, 101, 103, 104, 105, 106, 107, 115, 116–17, 119, 121, 123–24, 125, 126; in Castile, 196, 202, 206–07, 210, 213; in Argentina, 227, 250, 257–58, 259; in Uruguay, 261; in Mexico, 263, 280, 281, 286, 299, 316n105

Adams, Henry, 36
Agee, William, 46
Aguilar, Mario, 134, 333n28
Ahlers-Hestermann, Friedrich, 114
Aisen, Maurice, 46
Albert-Birot, Germaine, 23
Albert-Birot, Pierre, 130, 140, 141, 146, 153, 154, 155, 170, 192, 198, 205, 229, 269, 281, 296
Alberti, Rafael, 169
Aldington, Richard, 16, 19–27, 33, 57, 69, 312n55
Aleixandre, Vicente, 169
Allard, Roger, 185, 186, 215, 229, 260, 344n112
Alomar, Gabriel, 330–31n4

Amador, Fernán Félix de, 178, 180, 227
Anderson, Margaret, 32, 33
Anssermet, Ernest, 255
Antuña, José G. 260
Apa. *See* Feliú Elíes
Ara, Guillermo, 229, 241
Aragon, Louis, 68, 187, 191, 262
Arbuthnot, Malcolm, 22
Archipenko, Alexandre, 96–97, 108
Arensberg, Walter, 56, 62
Aretino, Pietro, 215
Arp, Hans (Jean), 108, 109
Arroyo, Cesar E., 218–19, 353n23
Atl, 264–65
Auclair, Marcelle, 256
Aurel, 153
Austin, Ernest, 16

Bacarisse, Maruricio, 214
Balakian, Anna, 231
Barradas, Rafael, 205–06, 250
Barrès, Maurice, 134, 166
Barzun, Henri-Martin, 12, 13, 20, 50, 84, 87, 96, 114, 161, 310n36
Basterra, Ramón de, 250
Battló, Josep, 139
Baudelaire, Charles, 47, 108, 126, 132, 234, 261, 283, 290
Baum, Peter, 83, 86
Bazalgette, Léon, 33
Bear, Adelaide Estelle, 44, 314n83
Bell, Clive, 57
Beauduin, Nicolas, 21
Benjamin, Walter, 126–28
Beethoven, Ludwig van, 108
Benn, Gottfried, 94, 104
Bernárdez, Francisco Luis, 259
Berthier, René, 17
Bie, Oscar, 83
Billy, André, 66–67, 109, 127, 185, 199, 275, 293
Bioy Casares, Adolfo, 246
Blasco Ibáñez, Vicente, 172–73
Blei, Franz, 83, 120
Boccioni, Umberto, 96–97, 108

Bolaños, Federico, 262
Bomberg, David, 22
Bonin, Fraulein von, 82
Borges, Jorge Luis, 5, 169, 211, 217–18, 226, 241–48, 251, 255, 263
Borges de la Torre, Norah, 206, 216, 242
Borja Bolado, Francisco, 286
Borrow, George, 70
Bosschère, Jean de, 32, 60
Boudar, Gilbert, 311n39
Bóveda, Xavier, 226, 249, 330–31n4
Braque, Georges, 51, 60, 71–72, 76, 95, 113, 120, 132
Breton, André, 24, 124, 167, 191, 213, 248
Breunig, LeRoy, 312n55
Brinkmann, Richard, 77, 112
Brinton, Christian, 46
Brisset, Jean-Pierre, 28
Brossa, Jaume, 130–131
Browning, Robert, 38
Bruce, Patrick Henry, 58, 319n39
Bruno, Guido, 56, 57, 60
Buckley, Ramón, 169–70

Cabot, Just, 167
Caizergues, Pierre, 4, 146, 150, 160
Cahén, Fritz Max, 103–06, 126
Cansinos-Asséns, Rafael, 169, 177, 185–91, 193, 198, 216, 217, 218, 221, 229–30, 346n11, 353n23
Canyameras, Ferran, 130, 147
Capdevila, Arturo, 351n92
Capdevila Rovira, Joan, 331n6
Capek, Josef, 99, 125–26
Caraffa, Brandán, 245
Carbonell, Francesc, 135, 161–64
Carco, Francis, 20
Cardoza y Aragón, Luis, 301, 303
Carmody, Francis, 122
Carter, Huntly, 20, 23, 24–25, 29, 318n30
Casseres, Benjamin de, 44, 307–08n1
Cassirer, Paul, 94, 107
Castro, Eugenio de, 189

Castro, Manuel, 351n92
Catasus, Trinitat, 164
Catel, Jean, 68
Cendrars, Blaise, 3, 34, 40, 90, 97, 103, 144, 153, 154, 186, 187, 191, 192–93, 197, 215, 220, 249, 252, 259, 262, 267, 280, 283, 290, 344n112
Cernuda, Luis, 345n132
Cérusse, Jean, 310n26
Cervantes Saavedra, Miguel de, 179–80, 245, 291, 339n24
Cézanne, Paul, 121, 256
Chadourne, Louis, 215
Chagall, Marc, 88–89, 97–100, 115
Chennevière, Georges, 28
Chirico, Giorgio de, 97–98, 167, 214
Ciolkowska, Muriel, 23–24, 25, 60, 68–69
Ciria y Escalante, José de, 208–10, 282
Chateaubriand, François René de, 287
Chesterton, G. K., 291
Chopin, Frederic, 282
Chumacero, Alí, 289
Claudel, Paul, 112, 131, 166, 266
Clearfield, Andrew, 38, 40
Clemenceau, Georges, 134
Cleopatra, 118
Coady, Robert J., 69
Cocteau, Jean, 23, 36–37, 68, 197, 214, 220, 229, 240, 241, 249, 252, 254, 258, 259, 261, 262, 266, 290, 299, 320n48
Colin, Eduardo, 286
Columbus, Christopher, 199
Comet, Cesar A., 185
Conrad, Joseph, 275
Contreras, Francisco, 255, 259, 261
Corbière, Tristan, 236
Cravan, Arthur, 132
Crispin, John, 169–70
Crotti, Jean, 346n8
Cuesta, Jorge, 290
Cummings, E. E., 56
Curtius, Ernst Robert, 112

Dalí, Salvador, 129
D'Annunzio, Gabriele, 148, 221
Dante Alighieri, 108
Darío, Rubén, 170, 179, 181, 225, 229, 300
Daübler, Theodor, 114, 115
Daudet, Léon, 113, 253–54
Dauster, Frank, 289
Dauthendey, Max, 104
Décaudin, Michel, 142–43
Delaunay, Robert, 50, 58, 76–77, 79, 91, 94, 96–98, 114, 161, 175, 177, 191, 192, 199, 256, 303, 324n22, 335n72
Delaunay, Sonia, 40, 90, 95, 161, 175, 177, 191, 199
Delgado, José María, 260
Delicado, Francisco, 183
Delperier, Georges, 93
Derain, André, 20, 21, 57, 60, 71, 95, 115, 160
Dermée, Paul, 141, 187, 191, 192, 281
Deubel, Léon, 12
Díaz, Porfirio, 267, 278
Díaz-Plaja, Guillermo, 129, 139, 333n34
Dickens, Charles, 291
Diderot, Denis, 121
Diego, Gerardo, 169, 210–13, 217, 226, 232–33, 243, 343n98
Díez-Canedo, Enrique, 183–85, 186, 187, 193, 211–12, 216, 230–31, 240
Diner, Gaston, 287
Döblin, Alfred, 83, 86, 87
Döblin, Ema, 87
Doolittle, Hilda. *See* H. D.
Dorlac, G., 65
D'Ors, Eugeni, 144–45, 165–67, 212
Doucet, Jacques, 66
Dostoievsky, Feodor, 78
Drieu La Rochelle, Pierre, 141
Drudeville, Leonardo, 231
Ducasse, Isidore. *See* Comte de Lautréamont
Duchamp, Marcel, 61–62, 64, 98, 227–28, 346n8
Duchamp-Villon, Raymond, 100, 264

Dufy, Raoul, 6, 71, 146
Duhamel, Georges, 12, 13, 28, 254
Dujardin, Edouard, 310n25
Dumas, Alexandre (père), 171
Dupont, André, 114

Eddy, Arthur J., 47
Edwards, Jacques. *See* Joaquín Edwards Bello
Edwards Bello, Joaquín, 219, 345n123
Ehrenstein, Albert, 83, 86
Einstein, Carl, 112
Elias, Julius, 83
Elíes, Feliú, 157–61, 331n5
Eliot, T. S., 38, 43, 316n1
Eluard, Paul, 205, 344n118
Epstein, Jacob, 22, 30
Epstein, Jean, 287
Erdmann-Macke, Elizabeth, 84
Ernst, Max, 84, 127
Esclasans, Agustí, 130
Espina García, Antonio, 220–21
Etchells, Frederick, 311n45
Ewers, Hanns Heinz, 94–95, 100

Fabre, Lucien, 260
Fargue, Léon-Paul, 259
Fauconnet, Guy, 158
Fechter, Paul, 111, 112
Férat, Serge, 23, 108, l52
Fernández Moreno, Baldomero, 238
Fernández Moreno, Cesar, 241
Ferreiro, Alfredo Mario, 232
Flaubert, Gustave, 125–26, 189
Fletcher, John Gould, 28–29
Flechtheim, Alfred, 107, 109, 110
Fleuret, Fernand, 12, 273
Flint, F. S., 9–19, 20, 21, 23, 24, 25, 26, 27, 28, 29, 33, 309–10n25, 310n32, 312n55, 313n62
Florian-Parmentier, Ernest, 11, 61
Foch, Ferdinand (Maréchal), 164–65
Foix, J. V., 129, 132, 137, 139, 164, 333n34, 334n39
Folgore, Luciano, 141, 142, 220, 281

Folguera, Joaquim, 132, 137, 140, 141–45, 149, 164
Ford, Charles Henri, 35
Fort, Paul, 134, 176, 325n42, 344n112
Fortún, Fernando, 184
Fourest, Georges, 87
France, Anatole, 119, 276
Frank, Nino, 255
Freud, Sigmund, 249, 255
Freundlich, Otto, 86
Frías, José D., 293–96, 297, 299, 300, 301
Frick, Louis de Gonzague, l54, 186, 215, 229, 344n112
Frobenius, Leo, 36, 315n91
Frost, Arthur B., Jr., 58, 91, 94
Frost, Robert, 288
Fry, Roger, 57
Funi, Achile, 231

Galdos, Benito Pérez, 172
Galíndez, Bartolomé, 228–32, 237
Gallardo, Salvador, 282
Galtier, Lysandro Z. D., 257–59
Gálvez, Pedro Luis de, 170–75, 215, 337n4
Garcés, Tomàs, 129
García Calderón, Francisco, 225, 227
García Calderón, Ventura, 178–81, 225, 227
García Lorca, Federico, 169
Garfias, Pedro, 215–16, 218
Gasch, Sebastià, 167
Gaudi, Antoni, 331n5
Gaudier-Brzeska, Henri, 22, 30, 31, 315n92
Gautier, Théophile, 28–29
Gavarni, Paul, 26
Geffroi, Gustave, 182
Gide, André, 112, 131, 241
Giraudoux, Jean, 255
Girondo, Oliverio, 185, 239–41
Gleizes, Albert, 87, 89–90, 95, 100, 132, 158, 197, 228
Goethe, Johann Wolfang von, 75, 105, 108, 119

Gogol, Nikolai, 180
Goll, Iwan (Yvan), 117–24
Goltz, Hans, 107
Gómez Carrillo, Enrique, 181–82, 225
Gómez de la Serna, Ramón, 5, 167, 170, 175–78, 189, 190, 191, 202, 221, 226, 238, 240, 249, 338n15
Góngora y Argote, Luis de, 190, 212, 245, 343n98
González Lanuza, Eduardo, 244
González de Mendoza, José María, 266–67, 293–300, 301
González Olmedilla, Juan, 344n112
González Tuñon, Raúl, 2
Gourmont, Remy de, 28, 68, 227
Grautoff, Otto, 113
Grey, Roch. *See* Hélène d'Oettingen
Groult, Mme, 64
Guilbeaux, Henri, 104, 116
Guillaume, Paul 49, 157
Gurney, Robert, 213–14
Gutiérrez-Blanchard, María, 338n15
Guynemer, Georges, 133, 135, 196, 198

H. D. (Hilda Doolittle), 16
Haas, Albert, 83, 110
Halpert, Samuel, 50, 58
Hausenstein, Wilhelm, 95, 110, 112
Haviland, Paul B. 48
Heap, Jane, 32
Heine, Heinrich, 124
Henry, Leigh, 16
Henry, Marc, 94
Hérédia, José-Maria, 10, 123
Hermant, René-Marie, 162
Hernández Catá, Alfonso, 274
Herrera, Flavio, 301
Herrera y Reissig, Julio, 245
Herrmann, Max, 104
Hertz, Henri, 12
Hervieu, Paul, 93
Herzfelde, Wieland, 112
Heyt, Karl von, 82
Hidalgo, Alberto, 237–39
Hiller, Kurt, 94

Hoffman, Vladislas, 99
Holley, Horace, 157, 311n45
Holz, Arno, 82, 93
Homer, 190
Horace, 119–21
Hubert, Etienne-Alain, 148
Huelsenbeck, Richard, 113–14
Hugo, Victor, 290
Huidobro, Vicente, 140, 170, 185, 185,
 186–87, 190, 191, 197, 211, 213, 214,
 215, 217, 218–20, 229–30, 233, 245,
 270, 280, 344n112, 344n122, 346n11
Huillard, Paul, 98
Hulme, T. E., 10, 30
Huneker, James, 6l

Ibsen, Henrick, 139
Insúa, Alberto, 172, 173

Jacob, Hans, 86, 116–17
Jacob, Max, 12, 32, 68, 86, 108, 113–14,
 122, 126, 132–33, 141, 153, 174, 187,
 197, 199, 207, 215, 230, 241, 252,
 255, 255, 256, 262, 282, 287, 290,
 302, 344n112
Jammes, Francis, 28
Jannini, P. A., 4
Janouch, Gustav, 124
Jarry, Alfred, 109, 175, 296
Jastrebzoff, Serge. *See* Serge Férat
Jawlensky, Alexei, von, 86
Jiménez, Guillermo, 300–01
Jiménez, Juan Ramón, 288
Jonson, Ben, 218
Jouve, Pierre Jean, 28, 29, 32, 115
Joyce, James, 38, 292
Juan, Eduardo, 255
Junoy, Josep Maria, 130–39, 141, 142,
 155, 161, 164, 198, 332n18, 332n19

Kafka, Franz, 78, 86, 124–26
Kahn, Gustave, 33
Kahnweiler, Daniel Henry, 109, 112–13
Kandinsky, Wassily, 21, 31, 47, 76–77,
 87–88, 94, 97–98, 108, 116

Kerfoot, J. B., 55
Kipling, Rudyard, 68
Kleist, Heinrich von, 125
Klingsor, Tristan, 32, 215, 344n112
Klee, Paul, 76, 79–80
Knoblauch, Mrs. Charles, 72–73
Koehler, Bernhard, 77, 81, 87–88, 91
Koehler, Bernhard, Jr., 84, 91
Kokoschka, Oskar, 109
Konitza, Faïk beg, 9, 44, 307–08n1
Kostrowitzky, Albert de, 263–64, 265,
 297–98, 351n2
Kreymborg, Alfred, 56, 318n30
Kubin, Otakar, 97–98

LaBruyère, Jean de, 249
Lacroix, Adon, 47
Laforgue, Jules, 78, 226, 301
Lagerkvist, Pär, 2
Lagut, Irène, 23, 63
Lane, John, 311–12n45
Langer, Resi, 103, 104
Lanson, Gustave, 87
Larbaud, Valéry, 249, 255, 302
Larguier, Léo, 17
Larrea, Juan, 213, 218
Las, Juan. *See* Rafael Cansinos-Asséns
Lasso de la Vega, Rafael, 190, 206–08,
 219, 302
Laughlin, James, 28, 38
Laurencin, Marie, 64, 87, 90, 91–93, 105,
 109, 111, 132, 157, 165, 175, 199,
 255, 256
Lautréamont, Comte de, 47, 226
Lebesgue, Philéas, 13–14
Le Fauconnier, Henri, 76, 114
Leger, Fernand, 87, 90, 158
Le Nôtre, André, 135
Leonhard, Rudolf, 103, 104, 105, 110
Levy, Rudolf, 76
Lewis, Wyndham, 22, 30, 35, 36,
 311–12n45
Lipchitz, Jacques, 71–72
List Arzubide, Germán, 282, 286
Litus. *See* Joan Pérez-Jorba

López-Picó, Josep Maria, 141, 142–43, 164
López Velarde, Ramón, 270–71, 290
Lotz, Ernst Wilhelm, 103–104
Lowell, Amy, 9, 56
Loy, Mina, 62–63
Lozano, Rafael, 265
Luce, Maximilien, 110
Lugones, Leopoldo, 227

MacDonald-Wright, Stanton, 58
Macke, August, 76, 84–88, 91, 94, 114
Macomber, E. C., 320n48
Maeterlinck, Maurice, 231
Mahlberg, Paul, 109, 111
Malespine, Emile, 261
Mallarmé, Stéphane, 34–35, 47, 69, 92, 120, 121, 126, 128, 177, 188, 189, 190, 213, 229, 245, 283, 299
Mandrin, Louis, 12
Manet, Edouard, 274
Maples Arce, Manuel, 278–83, 288, 289, 298, 302
Marc, Franz, 76, 79, 80–81, 86, 87, 114, 116
Marichalar, Antonio, 221–22
Marín Loya, Luis, 302–03
Marinetti, F. T., 7, 16, 27, 68, 87, 94, 103, 104, 108, 113, 115, 116–17, 127, 129, 130, 140, 170, 174, 198, 202, 205, 220, 26, 229–30, 232, 241, 249, 250, 251, 252, 254, 262, 277, 279, 283, 330–31n4, 337n3, 337n4
Marini, Leonardo, 214
Martinet, Marcel, 116
Masiello, Francine, 345n2
Massó Ventós, J., 149
Masters, Edgar Lee, 288
Mastronardi,Carlos, 241
Mather, Frank Jewett, Jr., 47
Matisse, Henri, 2, 76, 88, 108, 109
Maurras, Charles, 113, 134–35, 167, 253–54, 272
McBride, Henry, 69–73
Mehring, Walter, 78

Meidner, Ludwig, 83, 86, 94
Meissner, Karl-Heinz, 77, 80, 85, 324n23, 325n42
Mendelssohn, Paul von, 111
Méndez, Evar, 241
Menéndez y Pelayo, Marcelino, 166
Mendoza, Abate de. *See* José María González de Mendoza
Mercereau, Alexandre, 11, 12, 13, 14
Mergault, Georges, 256
Merrill, Stuart, 235
Metzinger, Jean, 90, 95, 100, 120, 158, 197, 228
Meyer, Agnes Ernst, 55
Meyer, Alfred Richard, 83, 95, 100–06
Michelangelo, 110
Michelet, Victor-Emil, 254
Milhaud, Darius, 202
Milleret, Jean de, 243
Miomandre, Francis de, 332n18
Modigliani, Amedeo, 2
Molière, 180
Möllhausen, Balduin Alexander, 106
Monguió, Luis, 279
Monro, Harold, 11, 25
Montaigne, Michel de, 108
Monterde García Icazbalceta, Francisco, 296, 297–98, 300
Montes, Eugenio, 185
Morador y Otero, Federico, 232
Morand, Paul, 68, 214, 239, 241, 249, 255, 261, 290
Moréas, Jean, 110
Mosquera, Luis, 216
Münchhausen, Baron, 76
Münter, Gabriele, 86
Murat, Napoléon, 217
Murray, John Middleton, 20

Napoleon Bonaparte, 274
Nayral, Jacques, 11
Neimann, Dr., 87
Neitzel, L. H., 108, 109
Nerval, Gerard de, 287
Nervo, Amado, 229

Neuhuys, Paul, 201–02
Nevinson, C. R. W., 22
Nietzsche, Friedrich, 75, 111, 256
Noé, Julio, 240
Nordau, Max, 234
Normal, Charles, 35
Novo, Salvador, 288–90

Oettingen, Hélène d', 157, 192
Orozco Muñoz, Francisco, 293–94
Ortega y Gasset, José, 222, 226
Ortelli, Roberto A., 261
Ortiz de Montellano, Bernardo, 292
Osorio Tejeda, Nelson, 345n132
O'Sullivan, Vincent, 214, 311n43
Owen, Gilberto, 275

Pajares, Nicasio, 221
Pagès, Madeleine, 176
Palacio, Ernesto, 252–54, 257
Palazzeschi, Aldo, 254
Panine, Serge, 254
Parent, Roger, 107
Parra del Riego, Juan, 232, 260–61
Pascal, Blaise, 286
Pellicer, Carlos, 267
Peploe, S. J., 311n43
Perceau, Louis, 273
Pereda Valdés, Ildefonso, 232–37, 259
Pérez-Jorba, Joan 130, 145–57, 163
Perin, René, 236
Petersen, Klaus, 78
Pettoruti, Emilio, 261
Pfemfert, Franz, 107
Picabia, Francis, 45, 46, 48, 49, 50, 61,
 66, 72, 98–99, 132, 191, 198, 262,
 267, 270–71
Picard, Gaston, 92–93, 113
Picasso, Pablo, 13, 19, 22, 31, 46, 48, 49,
 50, 51, 52, 60, 63, 76, 88, 95, 108,
 109, 113, 114, 115, 120–21, 127, 130,
 153, 159, 160, 175, 183, 200, 212,
 223, 239, 249, 252, 255, 255, 265,
 267, 292, 302; portraits of Apol-
 linaire, 66, 109, 178, 183, 211, 230,
 233, 247, 258, 281

Picon, Pierre, 222–23
Pieret, Géry, 6–7, 307n14
Piñero, Sergio, 255
Pirandello, Luigi, 249, 293
Pitollet, Camille, 275
Playden, Annie, 9, 13
Plato, 148
Pliny, 183
Poe, Edgar Allan, 108, 260
Poeschel, 108
Polti, Georges, 87
Pombo, Luis Eduardo, 262
Poulenc, Francis, 255
Pound, Ezra, 5, 9, 16, 22, 27–41, 43,
 47–48, 56, 60, 69, 72, 160, 313n62,
 313n63, 315n89, 315n91, 315n92,
 315n99, 316n105, 315n1, 318n30
Proust, Marcel, 249, 255, 292
Purrmann, Hans, 76
Putnam, Samuel, 35

Quevedo y Villegas, Francisco Gómez
 de, 239, 245
Quintanilla, Luis, 283–88, 299

Rabelais, François, 260
Radiguet, Raymond, 154, 255
Randall, Alec W. G., 57
Raphael, 245
Raphael, Max, 109
Ray, Man, 47, 56
Raynal, Maurice, 158, 255, 353–54n31
Read, Herbert, 38
Read, Peter, 62, 316n105
Reeves, Harrison, 61, 66, 90, 320n48
Renard, Jules, 269, 270, 353n23
Reverdy, Pierre, 64, 132, 140, 141, 146,
 149, 153, 157, 170, 185, 186, 187,
 190, 191, 192, 196–97, 213, 215, 218,
 220, 220, 240, 241, 249, 252, 262,
 267, 269, 344n112
Revueltas, Fermín, 298
Reyes, Alfonso, 214, 262, 271–78
Riemann, Georg Friedrich Bernhard,
 111

Rimbaud, Arthur, 47, 78, 104, 207, 213, 229, 236, 283, 287, 345n132
Río, José del, 211
Ritter, Naomi, 330n112
Rivas, Humberto, 209–10, 297
Rivas Panedas, J., 344n122
Rivera, Diego, 160, 265, 266, 283, 302
Roché, Henri-Pierre, 61–66
Rodin, Auguste, 232, 283
Rodker, John, 68–69
Rodriguez Monegal, Emir, 244
Roinard, Paul-Napoléon, 153, 254
Rolland, Romain, 112, 116–17, 176
Romains, Jules, 28, 32, 214–15, 255
Ronsard, Pierre de, 223
Rosales, Salatiel, 301–02
Rostand, Edmond, 182
Rousseau, Henri (the Douanier), 21, 49, 50, 69–71, 99, 101, 110–11, 114, 115, 116, 157, 165, 191, 223, 241, 274–75, 277, 353n31
Rouveyre, André, 185
Royère, Jean, 12, 186, 259, 261
Rubiner, Ludwig, 78, 90, 94, 103, 107, 108, 109–10
Running, Thorpe, 239, 240
Ruskin, John, 182
Russell, Morgan, 58–59, 319n40
Russolo, Luigi, 231

Sachs, Hans, 119
Sacs, Joan. *See* Feliú Elíes
Sade, Marquis de, 78, 275
Sadler, M. T. H., 21
Saint-Point, Valentine de, 115
Saint-Pol-Roux, 344n112
Salazar, Adolfo, 175
Salmon, André, 12, 87, 95, 109, 185, 187, 191, 200, 241, 255, 299
Salvat-Papasseit, Joan, 132, 137, 139–41, 142, 164, 333n34, 333n35, 334n39, 341–42n68
Samuel, Arthur, 85
Sànchez-Juan, Sebastià, 167
Satie, Erik, 16, 202

Savinio, Alberto, 50, 158, 214
Scalabrini Ortiz, Raúl, 256–57
Scheerbart, Paul, 100
Scholz, Karl, 102
Scholz, Trudy, 102
Schneider, Luis Mario, 265
Schweyer, S. Lamar, 287
Seeger, Alan, 61, 320n48
Selz, Peter, 78
Seurat, Georges, 110
Severini, Gino, 22, 24–25, 103
Shakespeare, William, 108, 119–21
Shaw, George Bernard, 276
Sindreu i Pons, Carles, 167
Sironi, Mario, 231
Socrates, 148
Soffici, Ardengo, 22
Sota, Alejandro de la, 165–66
Soupault, Philippe, 127, 192, 206, 262, 291
Spiro, Mario, 83
Stein, Gertrude, 26–27, 43, 57, 58, 69, 71, 311–12n45
Stendhal, 249
Stramm, August, 97
Steinberg, 23
Stieglitz, Alfred, 44, 45, 48, 49, 50, 51, 52, 54, 56, 58–60, 267, 318n30
Stravinsky, Igor, 108
Sudermann, Hermann, 93
Supervielle, Jules, 206, 226, 239, 251, 260
Strindberg, Johan August, 78
Súarez Calimano, Emilio, 249
Survage, Léopold, 140, 160, 294
Symons, Arthur, 57

Tablada, José Juan, 218–19, 266–71, 277, 279, 289, 290, 293, 297, 298, 300, 353n23
Tagore, Rabindranath, 119
Taupin, René, 9, 35–36, 316n1
te Peerdt, Ernet, 110
Titian, 245
Togores, Josep de, 159–60

Tolstoi, Leo, 108
Torre, Guillermo de, 169, 185, 190, 191–206, 207, 212, 216, 217, 221, 223, 226, 242, 243, 245, 247, 248–51, 255, 292, 302, 341n68
Torres Bodet, Jaime, 288, 290–93
Traubel, Horace, 34
Turner, J. M. W., 68
Twain, Mark, 260
Tzara, Tristan, 4, 187, 190, 191, 213, 249, 262, 279, 287

Uhde, Wilhelm, 106, 110–11

Vaché, Jacques, 345n132
Valle-Inclán, Ramón del, 343n98
Van Der Laan, James, 325n38
Van Dongen, Kees, 149
Valéry, Paul, 188
Valle, Adriano del, 215, 216, 256
Valle, Juan G. del, 345n132
Vallejo, Cesar, 351n92
Vando-Villar, Isaac del, 193, 216, 219
Varlet, Théo, 12
Vela, Arqueles, 287, 302
Velázquez E., J. Ignacio, 190
Verdaguer, Jacint, 143, 147
Verde, Cesario, 256
Verhaeren, Emile, 28
Verlaine, Paul, 68, 126, 231, 280–81
Veronese, Paolo, 166
Vervey, Albert, 98
Videla, Gloria, 185, 191
Vielé-Griffin, Francis, 152
Vildrac, Charles, 28, 32, 232–33
Vignale, Pedro Juan, 254
Villaurrutia, Xavier, 289
Villiers de l'Isle-Adam, Auguste de, 236

Villon, François, 118–21
Villon, Jacques, 98, 100, 207
Vinnen, Carl, 76
Vinyes, Ramón, 269, 281
Visan, Tancrède de, 12
Vlaminck, Maurice de, 99, 160
Voirol, Sebastien, 23
Vollard, Ambroise, 49
Voltaire, 119, 260

Wadsworth, Edward, 22
Wagner, Richard, 108
Walden, Herwarth, 5, 78–100, 104, 106
Walden, Nell, 78, 87, 89
Warnier, Raymond, 332n18
Weichsel, John, 45–46, 318n30
Wells, H. G., 166, 260
Werfel, Franz, 78, 94
Whitman, Walt, 134, 29, 33–34, 43–44, 61, 78, 108, 119, 152, 171, 206, 245, 251, 253, 314n83, 320n48
Wickes, George, 56
Wilde, Oscar, 140, 184, 189
Williams, Edith Clifford, 64, 205, 230
Williams, William Carlos, 16, 38, 56
Wood, Beatrice, 62
Wright, Willard Huntington, 57–58, 60

Zárraga, Angel, 264
Zayas, Marius de, 48–56, 60–61, 69, 264, 267–69, 270
Zech, Paul, 83, 86, 87, 94, 109, 110
Zukofsky, Louis, 35–36, 38, 315n89, 315n91
Zuleta, Emilia de, 191
Zum Felde, Alberto, 261
Zweig, Stefan, 94